Praise for *Seduction*

"A first-rate work of cultural curation, in which Longworth combs the countless stacks of Hollywood memoirs and biographies, with a focus on the pathological predations of Howard Hughes, Texas millionaire, starmaker and film producer." —*USA Today* (four stars)

"An astute and entertaining takedown of the movie industry, the press and the multimillionaire turned wannabe filmmaker Howard Hughes. Hardly anyone emerges from the pages of *Seduction* unblemished by selfishness and greed once they are touched by the movie business and its promise of wealth, power and fame."

—Associated Press

"A candid portrait of the multifaceted millionaire. . . . As his romantic tastes shifts from known quantities—like Hepburn, Rogers and Gardner—to powerless unknowns, *Seduction* reveals the root of Hughes's interest in women: a desire to exert total control, rather than true affection." —*Washington Post*

"From the force behind the *You Must Remember This* podcast comes a book exploring the glamour of classic Hollywood cinema through the lens of Texas business magnate, filmmaker (*Hell's Angels, Scarface*), and notorious womanizer Howard Hughes—think a Harvey Weinstein–esque character decades before #MeToo."

—*Vanity Fair*

"Longworth blasts through the seductive narratives propagated by men in the film business to uncover the dark stories underneath."

—The Cut

"Longworth pulls back the curtain on Hollywood's golden age to reveal, through the stories of some of the actresses pursued by legendary millionaire mogul Howard Hughes, its dark and lasting legacy of power inequity, harassment, and abuse." —Bustle

"*Seduction* reads like a scandal sheet tempered with primary and secondary research." —Los Angeles Review of Books

"Audacious and welcome." —*Sight & Sound*

"Jam-packed with Hollywood scandal and history." —Refinery29

"Karina Longworth loves Hollywood the way it ought to be loved—mercilessly. She is a skeptic without cynicism, a feminist without apology, and in *Seduction* she has found the great subject that her essential podcast has long promised: the cracked colossus Howard Hughes and the women who orbited around him, around some of whom he himself orbited. This is a deep and radiant book, and Longworth is a national treasure." —James Kaplan, author of *Sinatra*

"Karina Longworth casts a gimlet eye over the dark corners of movie history, taking us on an entertaining and timely tour of early Hollywood mores and manipulation. Using mogul and womanizer Howard Hughes as a prism, *Seduction* delves into the stories of dozens of women in his orbit, many of whom (Jean Harlow, Katharine Hepburn, Ginger Rogers, Ida Lupino, Jane Russell) are cinema legends. No matter how much you think you know about golden age Hollywood, Longworth serves up fascinatingly fresh perspective on the ways male desire and power shaped movie mythology."
—Joy Press, author of *Stealing the Show*

"Full of insight. . . . Illuminating and memorable." —*Booklist*

"A history that shows clearly how powerful men exploited actresses long before the #MeToo movement began. Hollywood historian Longworth has mined memoirs, biographies, magazines, newspapers, and archives to create an entertaining, gossip-filled portrait of the film capital's golden age. . . . A lively—and often sordid—Hollywood history." —*Kirkus Reviews*

"Throughout this densely researched and lively book the siren song of the new medium of film is heard." —*Cineaste*

SEDUCTION

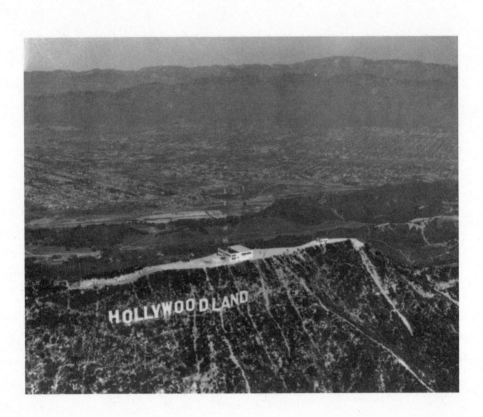

SEDUCTION

SEX, LIES, AND STARDOM IN HOWARD HUGHES'S HOLLYWOOD

KARINA LONGWORTH

CUSTOM
HOUSE

A hardcover edition of this book was published in 2018 by Custom House, an imprint of William Morrow.

FIRST CUSTOM HOUSE PAPERBACK EDITION PUBLISHED 2019.

Designed by Bonni Leon-Berman
Frontispiece © Hulton Archive/Stringer/Getty Images

The Library of Congress has catalogued a previous edition as follows:

Names: Longworth, Karina, 1980–author.
Title: Seduction : sex, lies, and stardom in Howard Hughes's Hollywood / Karina Longworth.
Description: First edition. | New York, NY : Custom House, 2018. | Includes bibliographical references. | Includes filmography.
Identifiers: LCCN 2018029872 (print) | LCCN 2018042755 (ebook) | ISBN 9780062440532 (ebook) | ISBN 9780062440518 (hardcover) | ISBN 9780062440525 (pbk.) | ISBN 9780062859679 (large print) | ISBN 9780062898210 (ANZ edition)
Subjects: LCSH: Motion picture industry—California—Los Angeles—History—20th century. | Hughes, Howard, 1905–1976—Relations with women. | Motion picture producers and directors—United States—Biography. | Motion picture actors and actresses—United States—Biography. | Hollywood (Los Angeles, Calif.)—History.
Classification: LCC PN1993.5.U65 (ebook) | LCC PN1993.5.U65 L595 2018 (print) | DDC 338.7/67092 [B] —dc23
LC record available at https://lccn.loc.gov/2018029872

ISBN 978-0-06-244052-5 (pbk.)

19 20 21 22 23 10 9 8 7 6 5 4 3 2 1

For Rian

CONTENTS

CAST OF CHARACTERS

NAMES ABOVE THE TITLE

HOWARD HUGHES

Hughes defied his family by investing his inherited riches in Hollywood, beginning in 1925. As a director and producer, Hughes established a reputation for discovering female talent. Later, as the owner and manager of RKO Pictures, Hughes consistently challenged the Hollywood status quo, particularly the industry's censors. His reputation as an iconoclast was challenged only by his reputation as a playboy who romanced dozens of actresses, from the town's biggest stars to countless nameless aspirants.

BILLIE DOVE

Major silent star Billie Dove's reputation was based primarily on her unusual beauty. She left both her husband and her studio when she fell in love with Howard Hughes, putting both her heart and her career into the young tycoon's hands.

JEAN HARLOW

This nineteen-year-old, curvaceous blond bit player became an instant, international star after Howard Hughes cast her as the femme fatale in *Hell's Angels*. When Hughes sold Harlow's contract to MGM, she became the biggest sex symbol/comedienne of the decade.

IDA LUPINO

After appearing in several films in her native England, the bleached-blond Ida was brought to Hollywood at the age of fifteen and signed to Paramount Pictures. When blond bombshells went out of fashion, Ida transformed her career, and eventually, with Hughes's support, became the only female feature film director in the Hollywood of the 1950s.

GINGER ROGERS

The biggest female dancing movie star of the 1930s, Rogers spent that decade,

in partnership with Fred Astaire and on her own, dominating the box office with her persona as a hardworking, clean-living, all-American beauty.

KATHARINE HEPBURN
In the 1930s, Katharine Hepburn was Hollywood's embodiment of a woman who lived by her own rules, flouting conventional ideas about femininity and sexuality in nearly all of her films, and in her personal life.

JANE RUSSELL
Nineteen-year-old Jane Russell was introduced to the world as Hughes's new bombshell in Hughes's second directorial effort, *The Outlaw*. She would become the focal point of his experiments in suggestive promotion and the cultivation of controversy.

AVA GARDNER
Hughes pursued Gardner, a young brunette under contract at MGM who had yet to make an impact on-screen, immediately after her separation from her first husband, Mickey Rooney, made headlines.

FAITH DOMERGUE
Faith Domergue was a teenage beauty whose contract Hughes had purchased from Warner Bros. For years he promised Faith that he would marry her and make her a big movie star.

JEAN PETERS
Hughes met this brunette starlet on Fourth of July weekend, 1946—a holiday that he punctuated by crashing an experimental plane into a Beverly Hills neighborhood. Like many other women before her, she believed she and Howard were in love and would marry.

TERRY MOORE
The young star of animal movies like *Son of Lassie* and *Mighty Joe Young* began dating Hughes in late 1948. Moore was a Mormon, and she would not go to bed with Hughes, until they made it official.

SECONDARY AND MINOR PLAYERS

RUPERT HUGHES

Writer, silent film director, and uncle to Howard Hughes who gave young Howard his early introduction to the Hollywood scene.

ELLA RICE HUGHES

A Texas debutante who in 1925 became Howard Hughes's first wife, and moved with him from Houston to Los Angeles so that Hughes could pursue his interest in moviemaking.

LINCOLN QUARBERG

Hughes's publicist from 1928 to 1932.

BEN LYON

One of the two male stars of *Hell's Angels*, his antics were responsible for one of Hughes's early PR headaches.

ANN DVORAK

Female star of *Scarface* who publicly accused Howard Hughes of having "sold [her] down the river" when he unloaded her contract to another studio.

PAT DE CICCO

An agent for cameramen who was reputed to have mob ties, De Cicco served as one of Hughes's "talent scouts" and close confidants for many years.

BETTE DAVIS

Warner Bros.' top star of the 1930s.

OLIVIA DE HAVILLAND

Davis's frequent costar who dated Hughes briefly in 1938–39.

RUSSELL BIRDWELL

The architect of the "search for Scarlett" which helped keep *Gone With the Wind* in the news for two years before its release, Birdwell was hired by

Howard Hughes to create a similar campaign to promote Jane Russell and *The Outlaw*.

GLORIA VANDERBILT
Teenage heiress who dated Howard Hughes.

JOHNNY MEYER
Former aide to Errol Flynn and Warner Bros. publicist who became another of Hughes's "talent scouts" in the early 1940s.

YVONNE DE CARLO
The future Lily Munster accompanied Hughes on the last leg of his mid-1940s "walkabout" from Hollywood.

LANA TURNER
MGM's top post-Harlow blonde and sometime girlfriend of Hughes.

LINDA DARNELL
Minor but incredibly beautiful brunette star who believed her affair with Hughes would lead to marriage.

GINA LOLLOBRIGIDA
Italian bombshell whom Hughes saw in a magazine and lured to Hollywood.

ROBERT MITCHUM
RKO's top male star while Hughes owned the studio from 1947 to 1955.

WALTER KANE
A key Hughes aide in the 1940s and '50s who coordinated many efforts to find and sign new "contract girls."

YVONNE SCHUBERT
Probably the last "contract girl" with whom Hughes had a romantic or sexual relationship.

SEDUCTION

PART I

HOLLYWOOD BEFORE *HELL'S ANGELS,* 1910–1928

THE AMBASSADOR HOTEL, 1925

It was like something out of a movie.

The Ambassador Hotel had opened, with much fanfare, in 1921, and had since become a nexus for power, money, and fame in a Los Angeles that was not yet the sole movie capital of the universe. Over the next few years, as the East Coast's film industry dispersed west, the Ambassador, located eight miles due south of the Hollywood sign, would be a place where the fantasy worlds on-screen bled into real life. In the hotel's nightclub, the Cocoanut Grove, tables were nestled and dancers nuzzled under an "actual" grove of papier-mâché palm trees, recycled from the set of a Rudolph Valentino movie—an ersatz tropics in the middle of a desert that had only recently been irrigated, and with great difficulty. With its Spanish-style main building surrounded by bungalows, and a floor plan that filled every room with sunlight and allowed for an unobstructed view straight through the building and fifteen miles out to the sea, the Ambassador had been intentionally designed as a testament to the utopian qualities of the West—both the real things that California actually offered, and the projected fantasies for which all that wide-open space provided a blank screen.

On this night in 1925, a group of powerful Hollywood producers and executives had gathered at the Ambassador for a celebratory dinner, and, for at least some of the men assembled, a handful of fantasies were about to come true. As servers brought out dessert, the sweets were accompanied by a selection of cheesecake. Frederica Sagor, a twenty-five-year-old secretary turned screenwriter whose adaptation of the 1924 college party novel *The Plastic Age* was about to turn a

Brooklyn tomboy named Clara Bow into a major star, watched as a group of "starlets, nightclub belly dancers, and ladies of the evening" sauntered toward the dinner tables. The male dinner guests—many of them Sagor's bosses—let out a drunken whoop, and soon each man was joined by a new friend. In groups of twos and threes, they began abandoning the dessert and disappearing together into bungalows.

Frederica was not surprised when her "date" for the evening, a sixty-something writer with whom she had been assigned by MGM to develop a feature called *Flesh and the Devil* for a twenty-year-old Swedish beauty named Greta Garbo, went AWOL with the rest of the men. She also wasn't surprised when she saw her direct work supervisor, dimple-chinned Harry Rapf, among the "undressed, tousled men" who "chased naked women, shrieking with laughter." And she wasn't even all that surprised to see "immaculate" MGM boy wonder producer Irving Thalberg, who would soon marry the studio's superstar Norma Shearer, "drunk, drunk, drunk." She *was* surprised to see Antoinette—Frederica's dressmaker, a French woman of about thirty who made reasonably priced copies of designer fashions—as one of the women hired for the evening's entertainment.

Frederica would describe Antoinette as "gifted" and "hardworking"—meaning, in Sagor's mind, the two women were alike. Neither of them was one of *those* girls, one of the thousands of chippies who came to town with nothing but their looks to recommend them, who had no qualms about doing whatever it took to stay afloat. Frederica had thought both she and Antoinette were earning their own livings on their own talents, neither of them having to sell her beauty or her body to do it. "Yet here she was," Frederica marveled. "Antoinette, a call girl—half-naked, lying across a chair, her hand stretched out to receive the hundred-dollar bill being pressed into it by Eddie Mannix—gross, ugly, hairy, vulgar Eddie Mannix,[1] Louis B. Mayer's bodyguard."

[1] In addition to being "gross, ugly, [and] hairy," Eddie Mannix would distinguish himself as MGM's key "fixer," who made scandals go away. Allegedly, some of these scandals included Mannix's own abuse of women. See David Stenn, "It Happened One Night . . . at MGM," *Vanity Fair*, April 2003.

The female body has always been a key building block of cinema—a raw material fed into the machine of the movies, as integral to the final product as celluloid itself. Few stories lay bare the imbalanced gender politics of this mechanized process, off-screen and off-set, as blatantly as Sagor's tale of watching Antoinette at this party. But Frederica's is also a story of persona, and perception. Here we have one woman who is struggling to sell something other than her body to Hollywood's men, both eyewitnessing the debasement of a woman who she thought was like her, and also passing judgment on that woman for submitting to her own commodification. "I'd seen firsthand how Hollywood can bring you down if you allow it to do so, and I—unlike Antoinette and so many others—had enough basic self-respect not to let that happen to me," Frederica declared. The unsaid realization in Sagor's observation is that for Antoinette, being "gifted" and "hardworking" were not enough, that she also could only get something else that she wanted by becoming, or pretending to be, what men wanted her to be.

In this, she was like so many women integral to the rise of the movies, and to Hollywood's ultimate domination of mid-twentieth-century popular culture: in an industry run by men and fueled by male desires, most women found they could find the most success by leaving something of their "real" selves behind. In exchange for the transformative boost of stardom, they allowed—not that it was always much of a choice—their bodies, personalities, backgrounds and/or names to be reinvented and sold. They took on personas, personas that, in some cases, so obscured who they had been that the kernel of truth behind the false front fell away.

If Howard Hughes was in attendance at this business dinner turned orgy, Sagor failed to notice him, but there was a reason why the Ambassador was the site nineteen-year-old Hughes chose around this time as the first home for him and his first bride, the former Ella Rice, upon moving to Los Angeles in 1925. The Texas millionaire—who in the years to come, between stints as a record-breaking aviator, a visionary inventor, and a harried defense contractor, would carry on an erratic career as a film producer—was naive about a lot of things

when he arrived in Los Angeles, but the Ambassador wasn't one of them. In fact, he probably knew the hotel better than any other single location in the city. His father, Howard Hughes Sr., had lived there for most of the last year of his own life, a time when he soothed the wounds of recent widowerhood with the excesses available to a man in Hollywood with money to spend. Howard's uncle, the writer and director Rupert Hughes, had lived at the hotel with his own new (third) bride just a few months earlier.

The Ambassador had been the right place for one middle-aged Hughes man to enjoy the spoils of new bachelorhood, and for another middle-aged Hughes man to honeymoon with a woman less than half his age. The hotel, located about a mile due east from the bubbling crude of the La Brea Tar Pits, was also a logical launching pad for the youngest Hughes, whose inherited fortune was dependent on oil, and whose future would be a tapestry of movies, money, women, and blue-sky dreams. Indeed, it was the perfect set on which to begin staging a movie career during which—through the promotion of bombshells like Jean Harlow and Jane Russell and a consistent antagonism of censorship standards for on-screen titillation and movie marketing—he would aim to concentrate male desire into a commodity more blatantly than any mainstream filmmaker of his era.

Howard Hughes's reputation as a filmmaker who was unusually obsessed with sex dovetails with his image as one of the most prolific playboys of the twentieth century. His supposed conquests between his first divorce in the late 1920s and his final marriage in 1957 included many of the most beautiful and famous women of the era, from silent star Billie Dove to the refined Katharine Hepburn to bombshells like Ava Gardner, Lana Turner, and Rita Hayworth to countless actresses who are today relatively obscure. For decades, gossip columns were full of items about the starlets he was supposedly on the verge of marrying.

How many of these stories were true? How many women did Howard Hughes really seduce? We will never know for sure, because, of all the fields he dabbled in, from aviation to corporations to entertain-

ment, the area Howard Hughes truly mastered was publicity. "The romance stories were a lot of bologna," posited Bill Feeder, a *Variety* reporter whom Hughes lured away to serve as director of RKO Public Relations in the 1950s. From the late 1920s through his acquisition of RKO Pictures in 1948, Hughes personally employed some of the most aggressive publicists in Hollywood in order to sell an image of Hughes as a genius scout of female talent. By the end of World War II, Hughes also had all the major gossip columnists and entertainment reporters of the era, including Hedda Hopper, Louella Parsons, and Sheilah Graham, in his pocket. These journalists were so dependent on Hughes (who knew all and saw all thanks to his blanketing of the movie colony with hired detectives and bribed eyes) for tips that they'd happily spin the stories he fed them to his liking. And, for all of his later secrecy and seclusion, during the peak of his Hollywood visibility Hughes showed an uncommon knack for getting photographed in the right place at the right time. "Hughes knew how much mileage he could get from being seen with the right woman," remembered Feeder. "Sex and showmanship were the same thing to him." Publicity was just another form of seduction.

One of the most written about but least-known famous men in Hollywood history, Hughes began playing a tug-of-war with the media shortly after arriving in Hollywood in 1925, using cooperative journalists to help him build a persona in which famous women would play a key role. Believed to be the heir to an oil fortune (in fact, Hughes had fully mortgaged his father's company in order to seize sole ownership of drill bit manufacturer Hughes Tool), and perceived as a rube by the Hollywood elite, Hughes was a quick study when interested. With only a little experience he understood rapidly, and perhaps better than anyone else of his era, how to use publicity to project an image that could then become real—or, at least perceived to be real. Above all, Hughes understood how easily the gap between perception and reality could be made to disappear, and how to manipulate the blurred line to his advantage.

These skills served Hughes well during his rise and reign as a

Hollywood iconoclast, through the release of spectacles like *Hell's Angels*, *Scarface*, and *The Outlaw*, and a number of scandals and controversies. Then Hughes nearly died in a plane crash in 1946, and after that, much changed. His masterful ability to use the media to control the public's perception of him slipped as he first became overextended as the owner and manager of RKO, and then began to slip away from a conventional public life, and conventional reality. After his disastrous stint as a studio chief ended in 1955, in January 1957 Hughes married actress Jean Peters, and shortly thereafter he began to hide out from all business and social obligations in screening rooms—and hotel rooms that, thanks to an army of assistants, were transformed into screening rooms. He'd spend much of the last decade of his life in bed, watching movies most of the time that he was awake. A failure as both an artist and a mogul, he became a full-time spectator.

By the end of Hughes's life, when he was a codeine addict who spent his days and nights nodding in front of the TV, the former star aviator playboy would suddenly perk up when an actress he had once spent time with appeared on the screen. Hughes would allegedly call over one of his many aides, point, and say, "Remember her?" and then drift off into a grinning daydream of better days, days when his power to draw women to him and control not just their emotions but their movements, appearances, and identities was apparently limitless.

"NOT HALF A DOZEN men have ever been able to keep the whole equation of pictures in their heads," F. Scott Fitzgerald wrote in the unfinished draft of what was to be his last novel, *The Love of the Last Tycoon*. He unwittingly set the template for the next seventy years of film writing with his next sentence: "And perhaps the closest a woman can come to the set-up is to try and understand one of those men." But how to approach understanding Hollywood's women, and their experiences of those men? As we move into an era in which there is frank public discussion of the exploitation, subjugation, manipulation, and abuse of women by men in positions of power, it's time to rethink

stories that lionize playboys, that celebrate the idea that women of the twentieth century were lands to be conquered, or collateral damage to a great man's rise and fall. One way to begin that rethink is by exploring a playboy's relationship with some of the women in his life from the perspective of those women.

This is a book about a few of the dozens of women who encountered Howard Hughes in Hollywood between the mid-1920s and early 1960s, whose lives and careers were impacted by their relationship with him. Some of these women were involved romantically with Hughes, others weren't, but all found the course of their careers marked by his presence. Many are women whom Hughes manipulated, spied on, and even essentially kept prisoner—some of whom Hughes may not have had any sexual relationship with at all, and one of whom was his second wife. These were women whose faces and bodies Hughes strove to possess and/or make iconic, sometimes at an expense to their minds and souls. This is a book about the lives and work of women whose careers would stall out at a variety of points on the Hollywood totem pole, from never-known to canonical star to has-been, and it's about where they were in those lives and careers when Hughes came along, where they ended up after he moved on from them, and the roles these women and Hughes played in the construction of one another's public personae.

Mainly, it's about what it was like to be a woman in Hollywood during what historians call the Classical Hollywood Era—roughly the mid-1920s through the end of the 1950s, the exact period of time Hughes was active in Hollywood. This period was marked by a number of evolutions and flash points, including the transition from silent film to sound; various sex and drug scandals that led to the institution of Hollywood's self-censorship via the Production Code; the perfection of star-making through publicity practices that sometimes constituted more satisfying storytelling than the motion pictures themselves; the anti-Communist blacklisting of writers, directors, and stars; the government-mandated consent decree through which movie studios were forced to sell the movie theaters they owned in order to stay in

production; and the decline of the star and studio systems in the wake of this monopoly-busting.

There are two important things to note about the events listed above. They all had an impact on the kinds of opportunities available for women in movies, on the screen and behind the scenes. And, Howard Hughes managed to have a hand in all of them.

HOLLYWOOD BABYLON

An orgy enjoyed by movie folk was the stuff of the worst nightmares of the original settlers of Hollywood. Places like the Ambassador became the sites of such casual debauchery in part because the neighborhood proper was so unwelcoming of it. Nestled into foothills and sprawling into wide, flat streets, the city of Hollywood grew slowly over the first decade of the twentieth century. The soon-to-be movie capital originally functioned as a hybrid suburban/rural village, with its population composed in large part of individualists: prohibitionists, suffragettes, retirees, and refugees from bleaker climes, all looking to cash in on the land. Independence came at a price, however, and by 1909, the city of Hollywood, population 10,000, was collapsing due to problems with sewage, drainage, and water. Unable to thrive on its own, the next year Hollywood was incorporated into the city of Los Angeles. By then a slow exodus had begun of film producers, directors, and performers from the East Coast to the West.

In keeping with its maverick spirit, the city of Hollywood had been resistant to the new fad. Many of those who had established roots in and around Hollywood prior to 1910 looked down on those involved with newly imported trade, who, they felt, were a low class of people whose very presence threatened to destroy their oasis. The locals derisively called these workers "movies"—the new medium's detractors showing their disdain by not bothering to distinguish between

producers and product.[1] But this ridicule was not enough to stop East Coast "movies" from flocking to the West, often in search of literal changes of scenery. By the end of 1911, fifteen motion picture outfits had set up shop around Hollywood.

In 1910, the heads of a New York–based outfit called the Biograph Company came to Los Angeles to explore the area's potential for location filmmaking. They were driven around town by an eighteen-year-old kid, Marshall "Mickey" Neilan, a high school dropout turned car salesman with a ready grin and a shock of red hair. On this trip, Biograph's top director, David Ware Griffith, made a number of short films. One of them, called *In Old California*, would go into some records as the first motion picture made entirely within the community of Hollywood. Other reports say the first film shot in Hollywood was another Griffith production, *Love Among the Roses*, starring a fifteen-year-old Mary Pickford. The fact that fourteen titles separate these two films on Griffith's IMDb page gives a sense of the volume of production in 1910: it was a quantity business. In a few years, Griffith would stake a claim for quality.

Nineteen fourteen saw the release of the final Griffith film for Biograph, the biblical epic *Judith of Bethulia*, which became notorious for its so-called orgy scene, featuring the highly choreographed writhing of female dancers in semidiaphanous costumes. The first feature-length film produced by that studio (running sixty-one minutes and requiring two reel changes), it starred the cream of Biograph's crop: sisters Lillian and Dorothy Gish, Blanche Sweet, Mae Marsh. Mickey Neilan, the kid who had driven the Biograph guys around on their first trip, also played an uncredited role. By now he was a screen veteran, having appeared in nearly ninety films in two years; he was also beginning to try his hand as a director.

[1] The Random House Dictionary dates the use of the word *movie* to refer to a "moving picture" to 1905–10. Silent film historian Kevin Brownlow suggests that those who used "movies" as a slur for people were "ignorant" that the term was in use to refer to the product. Kevin Brownlow, *The Parade's Gone By* . . . (Berkeley: University of California Press, 2009) 36.

The year after *Judith*, Griffith cemented Hollywood's evolution toward a model based on feature film production with the biggest hit of the silent era, *The Birth of a Nation*. Today, *Birth of a Nation* is widely credited with having resurrected the Ku Klux Klan, and at its centenary, the three-hour epic would be considered by consensus to be, as one 2015 critic put it, "the most virulently racist major movie ever released in the U.S." In 1915, *Birth of a Nation* was highly controversial for its content, but it was also an undeniable game-changer for the business of the movies, offering empirical evidence that a medium that most people assumed was merely an amusement could actually be both a viable moneymaking enterprise and a significant form of art. Griffith's feat was more one of curation than invention—he was not the first person to innovate film techniques like montage, fade-outs, and close-ups, but he did include numerous such innovations all in one film with a fluidity that blew contemporary moviegoers away. Audiences had never seen anything like it. "We sat in the front row of the balcony, and it is a wonder I did not land in the orchestra," recalled Frederica Sagor, who was fifteen when she saw *Birth* for the first time. "The picture had me on the edge of my seat in riveted attention."

Griffith and *Birth*'s financiers became the film industry's first millionaires. A tidal wave soon followed: all over the country, members of the audience were inspired to pick up and head west in search of work making the movies. For the first time in the history of American gold rushes, a majority of the rushers to Hollywood were female. Hollywood became known as a place where women could immigrate in search of legitimate work, and do it without the help or chaperoning of men.

Back then, it wasn't such a huge leap from sitting in a theater seat to imagining oneself in Hollywood, working face-to-face with the people on-screen. Beginning in 1914, the popular serial *The Perils of Pauline* was marketed to young women through media stories about the exaggerated off-screen persona of actress Pearl White, who was described as a single woman who had traveled the world and ended up in the ultimate locus of adventure: the movies. "News" stories, often

as fictionalized as the movies themselves, about stars like White stoked the imaginations of girl viewers, as did the design of the magazines the new celebrities appeared in. If the motion picture camera fetishized faces through the close-up, *Photoplay*, *Motion Picture* (both founded in 1911), and other such publications took the icon-making process a step further by distributing printed images of those faces—eyes, lips, and hair, all frozen in perfection—often accompanied by heavily embellished origin stories. As moviegoing became more central to young Americans' lives, the surrounding media swelled with adulation for the stars, and beautiful and ambitious people in every town where motion pictures could be seen started to believe that a greater destiny lay in the West. "Hollywood" was, according to a scrapbook kept by the Studio Club—a home for single women around the corner from the Hollywood Forever Cemetery, founded by Mary Pickford in collaboration with the YWCA—"a magic name to the ambitious, career-seeking girl." And the fantasy seemed like it was just a bus ticket away from a reality.

This is how it was for Lillian Bohny, who went to her first movie in 1915, when she was about twelve. Soon thereafter, she was so taken with *Birth of a Nation* that she wrote her first fan letter to one of the boy actors in the movie. (Her first lesson in the dynamics of stardom: despite the connection she had felt watching him on-screen, he didn't even write back.)

Growing up in the north Manhattan neighborhood of Washington Heights, Lillian and her girlfriends would sit on each other's stoops and talk about the movies. All of them imagined themselves on the screen, and all of them talked about it—except for Lillian, whose fantasies felt so powerful to her that she didn't dare share them.

"I'm not psychic," she would say many years later, "but there have been instances in my life when I have been absolutely so sure of something and this was one of them." Her friends were just schoolgirls, dreaming, yet when Lillian Bohny went to the movies, she felt that something different was happening to her: she felt the pull of destiny. "I knew I was going to be in pictures," she later said. "There was no

doubt about it. I didn't know where or how or when. I didn't want the stage, I wanted motion pictures."

The where, how, and when tripped up most dreamers, but in Lillian's case, fate or coincidence contrived to give her a neighbor who worked as a film extra. Lillian's mother took her daughter to the neighbor's agency, where she was signed as an extra, and soon she was appearing in the background of westerns and comedies, shot in New York or New Jersey. It would be years before she would get to Hollywood.

Many women who were entranced by the movies envisioned themselves as stars, but in the industry's early days, it was easier than it would become later for women to find positions of power behind the camera as well. By the time Lillian was seized by the vitality of moving pictures, one of her future collaborators was already in Hollywood and on the path to becoming one of the most respected filmmakers of her generation. Lois Weber had been a stage actress, but when she married another actor, Phillips Smalley, she put her own career aside to go on the road with him. Stir-crazy, Weber began writing motion picture scenarios to amuse herself. She was as surprised as anyone when these scenarios began attracting the attention of Los Angeles–based film studios. "Not that I doubted their meriting production," she explained later, "but I imagined they had to be introduced to the scenario editor by some person with influence. I was wrong, and the check I received testified to the illusion under which I had labored."

Weber soon signed a contract with the Rex Motion Picture Company, where Smalley and Weber would collaborate on about one film per week for almost two years, with Lois writing and directing vehicles in which both she and Phillips would star. By 1913, Rex had been absorbed into a new conglomerate of independent companies called Universal, headed by Carl Laemmle—a friendly, folksy German Jewish immigrant who over the past twenty years had gone from working in a Chicago department store to owning movie theaters, to successfully challenging motion picture patent troll Thomas Edison's monopoly on the tools of the trade, to leading a number of other companies to unite as the Universal Film Manufacturing Company of

Fort Lee, New Jersey. In 1913, Universal, with Laemmle at its head, took over a plot of land in the hillside just north of Hollywood, where the studio was installed on a ranch large enough that Laemmle was able to promote his new fiefdom as Universal City. This studio-as-city was proudly utopian: in a September 1913 publicity stunt, Lois Weber ran for mayor of Universal City, and won. A New York newspaper claimed she was the only female mayor in the world at the time, and called Universal "the only bona fide woman's sphere on the map, where women do all the bossing, and where mere man is just tolerated—that's all, just tolerated."

But as with any gold rush, eventually there was not enough work to go around for the cascade of hopeful, naive pilgrims. As early as 1914, the *Hollywood Citizen-News* was reporting, "Hollywood is honeycombed with prostitutes." Casting offices were full of hungry young women suffering from various degrees of disillusion, depending on how long they had been in town. A typical day for a would-be starlet involved a commute of six to ten miles in each direction via packed streetcar or city bus, for the privilege of waiting around an office for hours, only to be told that their services weren't needed. In a 1927 *Photoplay* magazine exposé that reads like propaganda meant to discourage young women from heading west, reporter and critic Ruth Waterbury described a scene she witnessed in a casting office: An actor, feeling flush, produced a roll of breath mints and told the desperate ladies sitting around waiting for their big break that they could each have one. He was rushed by one particularly hungry girl, who snatched the mints out of his hand and gulped them all at once: "To her, plainly, they were food."

Why didn't these wannabes give up and go home once they saw how slim their chances really were? Putting aside pride, there were just enough success stories in plain sight to allow all but the most over-it to hold on to hope—and, sometimes, that success happened to real underdogs. In 1922, Lillian Bohny from Washington Heights was on a film set, about to take top billing for the first time, in the feature

Beyond the Rainbow. One of her costars in the film would be even less experienced than Lillian, a total newcomer fresh out of Brooklyn. Lillian was unimpressed. "She was not well dressed," the slightly more established actress, who was making a cool fifty dollars a week as a featured player, observed of Clara Bow. "She looked as though she'd just come off the streets from playing tag or something like that." Within five years, Clara Bow would be Lillian's only rival as the most popular actress in Hollywood.

Those who worked steadily lived well, and partied as if the flush times would never end. Former car salesman Marshall Neilan was one such success story. By 1913 Neilan was both an in-demand actor and a learning-on-the-job director. In 1915 he played Pinkerton to Mary Pickford's Cho-Cho-San in the first screen adaptation of *Madame Butterfly*; within two years of that, Mickey Neilan was directing "America's Sweetheart" Pickford in one of her biggest hits, *Rebecca of Sunnybrook Farm.*

Neilan could be found most nights holding up the bar at the Hotel Alexandria in downtown Los Angeles. The Alexandria's grand lobby, flanked by marble columns and canopied with a gold-leaf ceiling, functioned as a kind of living room for the toast of peak silent-era Hollywood. "You could get laid, you could become a star, you could start a new movie company, and you could go broke, all in that same place the same afternoon," remembered Budd Schulberg, whose father, future Paramount exec B. P. Schulberg, made the Alexandria the family's first stop upon their arrival in Los Angeles in 1918. Neilan and Griffith would meet to sip champagne cocktails while Mack Sennett and Charlie Chaplin made the rounds. Joe Schenck, later the president of United Artists and the chairman of 20th Century Fox, would be there with wife/protégée Norma Talmadge; Louis B. Mayer would show up with not-wife/protégée Anita Stewart. Mayer wasn't yet a bigwig—MGM, the studio to bear his name, wouldn't be formed until 1924—but that was part of the allure of the Alexandria scene: the most important people in Hollywood were hanging around in

plain sight, and even if you were a nobody, if you could muster the courage you could go right up to them and talk to them. And that conversation could change your life.

The predecessor to the Ambassador in more ways than one, the Alexandria was not just a place to see, but to be seen: for the thousands of young women newly arrived in town looking for their chance to break into the movies, the Alexandria lobby became a popular place to perch and wait for some producer to like the look of you. If you were lucky, you could end up as Mack Sennett's newest Bathing Beauty—meaning you'd parade through Sennett's comedy short films in a beach costume, as one of a line of anonymous smiling girls, few of whom merited an individual credit.

If you weren't so lucky, you might be roped into an even less savory "acting" engagement. Con men were known to seize upon young women who bore a resemblance to the big screen stars—Gloria Swanson, say, or Phyllis Haver—and put them to work in a scam preying on the one demographic even more naive: the tourists who came to the Alexandria hoping for a glimpse of a movie star. The con man would strike up a conversation with one of these lonely lads in the bar, eventually letting it slip that such-and-such big star was—would you believe it?—a bona fide nymphomaniac: "After she finishes a picture all she likes to do is stay upstairs in her room and get laid by strangers about ten times a day." The tourist would happily agree to pay a twenty-dollar finder's fee to his new friend for an introduction. Such was the power of the female celebrity persona already that a good hustler could make a hundred dollars a day introducing suckers to facsimiles of "Gloria Swanson."

Those were the days of innocence—in that the public was generally ignorant of such goings-on in the movie capital, and the "movies" seemed to believe that, while the media successfully crafted the illusion that performers on-screen were accessible and knowable off-screen, what they did in their personal lives could remain secret. It probably should have, or would have in another place, in another industry. As gossip columnist Louella Parsons later put it, "The trouble is that the

same thing could happen in a small town, human nature being what it is, but you wouldn't hear about it. The butcher might be flirting with the milkman's wife; or the dry goods merchant might fall in love with the banker's wife. But you wouldn't hear about it." But in Hollywood, such gossip was a business in and of itself—and that business was about to get much more problematic.

The industry's party scene was initially inherently surreptitious, in part because Hollywood the city had done such a good job of legislating against immorality. No one who wanted booze had any trouble getting it, although with Hollywood establishing prohibition before it was a national law most parties were private rather than out in the open, and this feeling of "going underground" just to drink champagne may have normalized the consumption of other intoxicants, and other types of vice that could flourish in the dark.[2] But as the city plumped with attention-seekers—and journalists—it began to be difficult even in private to party like a movie star. Despite a media landscape that had been remade by yellow journalism, in which scandal sold papers, the studios hadn't yet built the sophisticated publicity machines that would protect their most valuable assets, and stars hadn't learned to be wary of spies in their midst. Between the fall of 1920 and early 1922, three scandals would fundamentally change the way the film industry conducted itself on and off screen.

The 1920 film *The Flapper* popularized that term for a young girl who drank, danced, smoked, wore new boyishly cut fashions, and generally defied convention. The star of the movie was twenty-five-year-old Olive Thomas, a Ziegfeld Follies import who was married to Jack Pickford, hard-partying brother of "America's Sweetheart" Mary. One September night, upon returning to her room at the Hotel Ritz in Paris, where the couple was on a delayed honeymoon, Olive couldn't sleep. She got up to use the toilet, and Jack yelled at her for turning on the light. A little while later, Olive reached for a sleeping

[2] It was actually harder to go out for a drink in Hollywood before prohibition took hold nationally—after the law passed, speakeasies began to proliferate. See Jim Heimann, "Those Hollywood Nights," *Los Angeles Times*, May 21, 2006.

pill. This time she fumbled around in the dark so as to not wake her cranky husband. What Olive ended up grabbing and ingesting was not a sleeping solution, but bichloride of mercury. In some press accounts, the bichloride of mercury was said to be a cleaning product left behind by housekeeping, but it soon became legend in Hollywood that Olive had actually swallowed tablets that Jack had allegedly been prescribed as a topical solution to treat syphilis, and which acted as poison when taken internally.

Thomas's death via what was likely an accidental poisoning was painted in the press as the consequence of the wild Hollywood lifestyle that gave innocent young girls a fatal taste for illicit thrills. American newspapers ran stories with headlines like, "What Olive Thomas Saw in Gay Paris Before She Killed Herself," claiming that Olive had fallen to the floor after swallowing poison with the cry, "This is what Paris has done to me!" What "Paris had done" to her was implied in the same article's incredibly detailed narrative of a supposedly typical night in a Montmartre club, featuring "wild cat combat" between two women, a buffet of cocaine and morphine proffered to American girls by "disreputable young noblemen," and an "entertainment" in which "a negro fights a big rat and eats it alive." Perhaps because her association with the flapper and Hollywood's infectious depiction of a new species of party girl, Olive Thomas's death became the catalyst for protests against Hollywood from religious groups, as well as calls for censorship.

Most of the blame for this horrible event was cast on the dead actress and her sordid trip down the Parisian rabbit hole, with little reserved for her surviving husband, who continued his hard-partying ways and married another not-long-for-this-world actress, Marilyn Miller, less than two years after his first wife's death. Yet the focus on Olive's supposed degradation over Jack's verifiable self-destruction wasn't mere sexism: Jack Pickford's sister Mary was too powerful and important to the twin industries of picture making and picture gossip to allow such sordidness to touch her. If any publication had pressed too hard

on Jack, they would risk losing access to Mary, and that was too steep a price to pay for printing the truth.

A year later, fledgling actress Virginia Rappe was pronounced dead at a sanitarium in San Francisco after suffering a ruptured bladder. Rappe had attended a party a few days earlier, hosted by the screen comedian Roscoe Arbuckle, whose bag-of-frosting physique had earned him the marketing moniker "Fatty" Arbuckle. With the absence of hard evidence as to the cause of Rappe's fatal illness, newspapers hammered home a tale of murderous rape, suggesting that Arbuckle had crushed Rappe's bladder with his massive girth. Arbuckle was tried for the crime three times within one year. The first two trials ended with hung juries, and in the third, Arbuckle was acquitted, but his career never recovered—and neither did Hollywood.

In February 1922, a month before Arbuckle's third and final trial began, director William Desmond Taylor was found dead in his bungalow apartment on South Alvarado Street, a mile and a half east of the Ambassador. The Taylor murder has never been conclusively solved, but it continues to fascinate to this day, not least because three actresses are among those who have been suspected of involvement: aging child star Mary Miles Minter; Margaret Gibson, a costar of Taylor's when he was acting in the teens, who at the time of his death was having trouble getting back to work after arrests involving prostitution and blackmail; and Arbuckle's frequent costar and Olive Thomas's good friend, the comedienne Mabel Normand, who was allegedly struggling to overcome addictions to drugs and alcohol at the time. This trio of suspects could not have been better or more diversely cast to present a portrait in triptych of the fragility of the female experience in Hollywood: the virgin, the criminal/whore, and the falling star. Not a single one would manage to do anything for the rest of their lives that transcended their rumored association with Taylor's murder—or, if they did, it didn't merit any headlines. Gibson, who had never been interrogated, even made a last-gasp bid for immortality by confessing to Taylor's murder on her deathbed.

Immortality-via-headline was, increasingly, all that mattered. Careers and lives be damned, there was money to be made creating a tug-of-war between industrious moralizing, and thrilling to the immorality of the new elite, while trapping the female members of that elite into archetypical narratives of victimhood or guilt. No Hollywood film producer would throw so much of his lot behind capitalizing on this tug-of-war as Howard Hughes, although he wouldn't stumble onto a formula that worked for another decade.

In the meantime, there was dissolution. In 1918, a symbol of the film colony's growing pains stood in ruins at the corner of Sunset and Hollywood Boulevards. The reigning king of Hollywood after the triumph of *The Birth of a Nation*, D. W. Griffith poured some of his proceeds from that film into an even more epic follow-up. To shoot a single segment in *Intolerance*, Griffith built a model of Babylon, complete with statuary of giant elephants, on Hollywood Boulevard massive enough to be captured in wide angle from the hill at Barnsdall Park, a half mile away. The movie was not a hit, and the Babylon set was left standing to decay. Legend has it that newspapermen, watching tourists and neighboring kids climbing through the ruins, coined the phrase "Hollywood Babylon." To the original settlers of Hollywood, to pair the name of their town with the ultimate signifier of decadence would have been an oxymoron. To future consumers of the movies—many of whom were enticed consciously or otherwise by scandals like the ones that shone a spotlight on the industry in the 1920s—"Hollywood" and "Babylon" would become synonymous.

In 1919, the ruins of Griffith's Babylon set were finally torn down. Griffith's reputation had taken a hit when *Intolerance* had failed to reach the cultural and financial mark of its predecessor, and though he still had hits in his future, at the end of the 1910s he returned to the East Coast and began a long process of alienation from the center of the industry that would end with him dying in obscurity, sixteen years after his last directorial credit. With Hollywood's biggest-name director to date falling out of favor, producer Samuel Goldwyn spotted a vacuum of quality filmmaking and an opportunity to broaden the appeal

of motion pictures by lending them a pedigree. The former Samuel Goldfish had been a pioneer of feature-length moviemaking, having partnered with Jesse L. Lasky and Cecil B. DeMille in 1914 to produce Hollywood's first three-reeler, *The Squaw Man*; Goldwyn would then manage an early incarnation of Paramount Pictures, and Goldwyn Pictures, his going concern in the late teens, would eventually be acquired and rolled into what became Metro-Goldwyn-Mayer. That 1924 merger was a long way off when Goldwyn launched a campaign called Eminent Authors, designed to bring literary stars to Hollywood to translate their talents to the writing of photoplays. Goldwyn's big get was Rupert Hughes.

CHAPTER 2

THE MANY
MRS. HUGHESES

Rupert Hughes's life was the stuff of an epic novel. Born in 1872 in Idaho to a prominent judge, by the late 1910s Hughes had circled the globe working for *Encyclopaedia Britannica*, had served as a captain in the Mexican border service and then a lieutenant colonel in World War I, become a literary celebrity writing bestselling novels and hit plays that made him the toast of New York, and made a tidy profit in secondary sales to Hollywood. Rupert had authored his first original film scenario in 1916, *Gloria's Romance*, collaborating on the script with his wife, Adelaide. (*Gloria's Romance* was promoted as "A Motion Picture Novel by Mr. and Mrs. Rupert Hughes.")

Adelaide, a former actress and aspiring poet with striking scarlet hair, had married Rupert in 1908; they'd met when he cast her in a play. It wasn't the first wedding for either of them. From a previous marriage, she had two kids, Rush and Avis. Rupert's first marriage, to Agnes Hedge, had fallen apart in 1903, sparking a sensational separation trial, at which Agnes testified that Rupert had slurred her as "a Bowery washerwoman and had told her she was living an adventurous and adulterous life." In describing Rupert's "degenerate tastes and habits," she claimed he "boasted openly of his illicit relations with other women." When asked on the stand if she had seen her husband kiss her female best friend, Agnes responded, "I have seen Mr. Hughes

kiss nearly every woman who ever came into our house." The divorce
was eventually settled out of court.

Rupert and Adelaide began their marriage in New York, but after
1919, Rupert's new career demanded that the couple spend increasingly
more time in California. In defiance of the myth of the Golden West's
restorative powers, upon arrival in Los Angeles, Adelaide Hughes al-
most immediately started suffering from severe colitis. Adelaide came
to believe that what she needed was an escape from paradise: as her son
Rush later put it, his mother wished "to take a cruise around the world
on a tramp steamer, wanted to get away from it all, and this caused
some conflict in the household."

The conflict stemmed from the fact that Rupert did not want "to
get away from it all." He had quickly fallen in love with Hollywood,
so much so that he felt protective of his new home. That home would
soon need protecting. Louella Parsons, one of the most powerful jour-
nalists in twentieth-century Hollywood, would later credit events like
the deaths of Olive Thomas, Virginia Rappe, and William Desmond
Taylor for awakening mainstream America to the intoxicating behind-
the-scenes narratives coming out of the place. "Hollywood wasn't even
on the map then," Parsons said of the early 1920s, "but when these
stories hit the front pages, it gave a very bright picture to the industry."
That bright spotlight led to calls for Washington-based censorship of
the movies, which moved the studios to preemptively band together to
create a group called the Motion Picture Producers and Distributors
of America, through which they hired former postmaster general Will
Hays to oversee the industry's efforts at self-regulation.

Not a full month after the death of William Desmond Taylor, who
had been one of the most vocal opponents of institutionalized censor-
ship of the movies, Will Hays arrived in Hollywood. He was much
feted. A banner stretched across Hollywood Boulevard at Cahuenga,
reading, "WELCOME WILL H. HAYS TO THE MOTION PIC-
TURE CAPITAL OF THE WORLD." His first week in town, Hays
was the guest of honor at a party at the Ambassador, where Rupert

Hughes gave the toast. Hughes was vehemently against censorship, but then, so, in theory, was Hays—that was why the studios had pursued him to run the organization that would gesture at self-regulation while silencing calls for government censorship.

By this time, Rupert Hughes was known nationally as a fixture of the new movie smart set. He was included prominently alongside Charlie Chaplin, Gloria Swanson, and Buster Keaton in a caricature by *Vanity Fair* cartoonist Ralph Barton, and the *Los Angeles Times*' Society column would relate, with no small bit of amusement, his social antics, some of which involved his brother, Howard Robard Hughes Sr.

Howard Sr. was the epitome of the early-twentieth-century bounder turned businessman. After briefly attending Harvard, he passed the bar exam, but never practiced law. Instead, he worked as a telegraph operator and newspaper reporter, until he was drawn to the mining boom of the late 1800s. As he put it, "I decided to search for my fortune under the surface of the earth."

Howard Sr. would find it, but it ended up being a circuitous route. He struck out mining for silver in Colorado and zinc in Missouri before ending up in Beaumont, Texas, where oil got into his blood. It was the beginning of a new century, and, infected with millennial optimism, Howard managed to successfully woo Allene Gano, the granddaughter of a prestigious Confederate general who pioneered livestock ranching in Texas, raising new breeds on land that had never been used before. Allene's parents had recently sold the five-acre peach orchard outside of Dallas on which they had been living, because Allene was now nineteen, and that meant it was time to present her to society and help her snag an appropriate husband. Allene's eligibility as a prize to be won motivated an entire household's migration.

After their marriage in 1904, Allene and Howard lived itinerantly, traveling from one oil town to another hoping to hit pay dirt. Their only son, Howard Jr., whom they called "Sonny," was born on Christmas Eve, 1905, in Houston; not long after, the Hugheses ended up in Caddo Parish, Louisiana. With no other reliable source of income, Howard Sr. became the town's postmaster. His fortunes began to turn

in 1908, when, after observing the difficulty every oil prospector had puncturing through many layers of hard rock to get to the reserves of crude down below, he began developing a conical drill bit. Refined over the next year through exhaustive testing bankrolled by his business partner Walter Sharp, the Sharp-Hughes bit could crush through layers of hard rock more efficiently and faster than anything else available, and it soon became an indispensable expedient to the oil boom.

The drill bit would make Howard Hughes Sr. rich, although Sonny's dad saw himself not as a businessman, but as an explorer, a conqueror. Describing his ambition "to drill the deepest well in the world," in 1912 Big Howard mused, "The outermost ends of the earth have been found; the road towards the center is still virgin soil."

The drill bit business steadily grew, and after 1912, when Walter Sharp died and Howard Sr. bought out the shares that had been inherited by Sharp's wife, Estelle, the entire company belonged to Hughes. His identity as an individualist bled into his business strategy. The design secrets of the Hughes drill bit were heavily guarded, and protected by an innovative system of distribution which Howard Sr. devised. Because the company would only lease drill bits, and never sell them, they collected more frequently from each individual customer, and in requiring the eventual return of each bit, also protected themselves from the risk that some entrepreneur would buy their invention, take it apart to figure out how it worked, and improve upon it. In other words, the first Howard Hughes's fortune was built on secrecy, and in the sense that Hughes Tool prevented its customers from learning how its product was really made, Howard Sr.'s company had something in common with Hollywood.

By the time Sonny was a sentient child, his father was comfortably wealthy, and the boy never lacked for material comforts. Houston was segregated along both race and class lines, and though Howard Sr.'s riches may have been nouveau, he and his pedigreed bride and young son easily slipped into the highest echelon of local society. This bubble was threatened in 1917. With the United States' entry into World War I, a battalion of 156 African American soldiers was sent from

New Mexico to Houston to guard the construction of a new military base there. A pattern of aggression from the local white police force toward the black troops snowballed over the course of several weeks. On the night of August 23, word hit the camp that a corporal had been killed by the police. In fact, this corporal had been beaten and shot at by cops who eventually arrested him, but the rumor and subsequent rumblings that a white mob was heading for the camp prompted the alarmed servicemen to organize a mutiny, seizing weapons to defend themselves. What ensued came to be known as the Houston Riot of 1917, and it left nineteen people dead—fifteen of them white. It was the first recorded race riot in the nation's history to end with a higher white death toll than black. After a court-martial, nineteen black soldiers were executed, but an eye for an eye was hardly the end of it. Howard Hughes, who was eleven going on twelve that summer, would hold the events of August 23, 1917, in his memory for the rest of his life. "I lived right in the middle of one race riot in which the negroes committed atrocities to equal any in Vietnam," Hughes claimed, many years later. His childish picture of what had happened in Houston curdled into an acute racism: Howard Hughes Jr. grew into an adult who didn't just dislike black people or think them to be inferior to himself—he was mortally afraid of them.

Months later, after his twelfth birthday, Sonny was sent off to boarding school. He was extremely distraught to be separated from his mother. Allene Hughes had been an almost suffocating presence in her son's life, but young Howard had come to depend on her coddling. She closely monitored her only son's hygiene (even performing nightly checks of his feces) and apparently instilled in him the belief that he was an exceptional creature who needed to be protected from the pestilence of the outside world. Though he played with local kids and developed a close relationship with Dudley Sharp, the son of his father's business partner, Sonny had also spent much time at home, under the watchful eyes of Allene, tinkering with inventions and devices like a motorized bicycle and a ham radio station. Mother and son's first significant separation had come when she sent him to summer camp

at the age of ten, a separation cut short when she picked him up early out of paranoia that he could contract polio. What Howard seemingly took away from the experience was not the freedom to find himself that Allene briefly allowed him, but the danger awaiting him in social situations should his mother fail to ultimately rescue him. When he then went to boarding school, first in Massachusetts and then in Ojai, California, Sonny isolated himself and was generally miserable.

Allene Hughes died suddenly and almost inexplicably in March 1922, losing consciousness in the midst of a routine curettage procedure, involving the scraping of tissue from the uterus. "She was taken for a minor operation and they gave her too much anesthetic, I think," recalled Allene's sister Annette. Sonny had just turned sixteen. It was a devastating loss for Howard Sr., who could not bear to return to the house he had shared with Allene in Houston. He decided to relocate to Los Angeles, where by now his parents and brother Felix had settled, along with Rupert. Sonny's latest boarding school, the Thatcher School in Ojai, was not far north.

Howard Sr., lonely in Los Angeles and wanting the familial company of his son, eventually pulled his son from school entirely after Christmas 1923, rendering Howard Hughes Jr. a high school dropout. Though he evidently took classes at the California Institute of Technology (Caltech), Sonny was more enthusiastic about his off-campus education. He'd follow Rupert to Goldwyn Studios and wander around, asking questions, soaking up the process of filmmaking. He acted as a part-time playmate and protégé for his father, who took him along to parties, modeled the process of wooing starlets, and gave him lectures about business. The father stressed to his son the importance of autonomy. "Never share control," Howard Sr. told Howard Jr. "Never share credit, and never share profits."

With business his foremost priority and his social life a close second, Big Howard proposed a deal to Annette Gano, Allene's sister, who had been living with Allene and Howard Sr. in Houston since 1919. Allene's widower wanted Annette to move out to Los Angeles with him and Sonny for one year, so that she could help take care of the teenage boy.

After the year was up, Annette would be free to return to Houston and marry her fiancée, Fred Lummis. Annette agreed, with the proviso that she could bring her cousin, Kitty Callaway, with her.

Annette, Kitty, and Sonny lived at Vista del Arroyo, a then-brand-new resort hotel in Pasadena—a good twelve miles from the Ambassador, where Big Howard set up shop in a luxury suite. (Before the construction of freeways, this was a significant distance.) Sonny, according to Annette Lummis, was then "a charming young boy, and that year I was with him in California he couldn't have been more thoughtful. We ate dinner together every night." Big Howard, Annette said later, "was keeping an eye on us. But he was really interested in the movies, movie people."

Possibly one movie person in particular. There is some evidence that Howard Sr. had begun an affair with future silent film star Eleanor Boardman before Allene's death; Noah Dietrich, who would work for Howard Hughes Jr. for three decades, claimed he found a letter from Allene to Big Howard, telling him she forgave him for this illicit relationship.

The year of Allene's death was a watershed for Boardman. After years of modeling in New York (as "the Kodak girl" her face was used by the manufacturer to sell film), she was selected by the powers that were at Samuel Goldwyn Pictures as one of the "New Faces" of 1922, an honor that included train fare to Los Angeles and a token contract with Goldwyn's studio. Was it mere coincidence that Goldwyn was the studio home base of Howard Hughes Sr.'s brother?[1] Boardman's first film part came in *The Strangers' Banquet*, directed by Marshall Neilan,

[1] An unsourced anecdote in Richard Hack's *Hughes: The Private Diaries, Memos and Letters; The Definitive Biography of the First American Billionaire* claims Howard Sr. met Boardman in New York in 1916, when she was an eighteen-year-old model, and that Hughes offered to introduce the young, aspiring actress to his brother Rupert on that first meeting. Whether or not this meeting occurred as outlined by Hack, and whatever the exact nature of Howard Sr.'s interest in Boardman before Allene died, it seems likely that he had something to do with his brother's studio selecting Eleanor as one of their two "new faces" and signing her to a contract. The fact that she was beautiful and talented didn't hurt. See Richard Hack, *Hughes: The Private Diaries, Memos and Letters; The Definitive Biography of the First American Billionaire*, Phoenix Books, Kindle edition, locs. 711–19.

who had become friends with the elder Hughes men. Her second and third parts were in movies made by Rupert Hughes, *Gimme* and *Souls for Sale*.

Based on Hughes's own novel, *Souls for Sale* anticipates the French New Wave maxim that every fiction film acts as a documentary of the moment in which it was made. Featuring an unprecedented glimpse behinds the scenes of the film factory, with Charlie Chaplin, Neilan, and other power players of the day playing themselves, *Souls* was Hughes's passionate defense of the film industry against its scandal-mongering detractors. Between priceless footage of the real Hollywood of 1923 and propagandistic title cards, *Souls* tracks the adventures of an ingenue with the unlikely name of Remember "Mem" Steddon (Boardman, very good), a young bride who feels a "sudden revulsion" for her husband en route to their honeymoon. Mem ends up jumping off a train and wandering, dehydrated and confused, into the desert shoot of a movie. Mem's dad is a fire-and-brimstone preacher who rails against Hollywood as "movie-mammon," but the film colony Mem falls into bears no resemblance to the hellhole she's heard of in headlines and church: the movie folk are kind and helpful, and their party habits are constrained by the fact that they have to get up at the crack of dawn every morning and work eighteen hour days in order to make the products that "thrill millions." At one point, Mem even watches a gorgeous girl offer to "pay the price" to a casting director, who rejects her: "You poor simp!" he exclaims. "It's the public you've got to sell yourself to!" In every way, Rupert Hughes depicts Hollywood as a paragon of American hard work and ethical virtue—which is notably lacking outside of the movie colony, as shown in the return of Mem's husband, who has turned out to be a thief, con artist, and serial wife killer. When he demands the return of his "property"—meaning Mem, who is now a star—she stands up for her own autonomy: "I don't belong to you, or anybody," Mem says. "I belong to myself." This may be the boldest aspect of Rupert Hughes's polemic: while insisting that almost every scary thing that God-fearing Americans had heard about Hollywood was untrue, in Mem he boldly confirms Hollywood's detractors' fears

that the film industry was in fact breeding and cultivating independent women who posed a real threat to the default patriarchy.

It seems likely that whatever kind of relationship Big Howard had had with Boardman, by this time they were not engaged in a serious romance. Immediately after *Souls for Sale*, Boardman made her first film for director King Vidor, whom she would marry in 1926. And Howard Hughes Sr. was enjoying being single in Hollywood, during the peak of his brother Rupert's film fame.

Souls for Sale would open in March 1923, two months after the wide release of *Gimme*, which was promoted as "the truest film play you ever saw . . . picturing the real joys and monthly bills of wedded bliss." "Mrs. Rupert Hughes" had collaborated with her husband again, but this time she did not merit a writing credit, and her contributions were no longer highlighted in the press. Adelaide herself was floating out of the center of Rupert's sphere of influence. The physical pain she was in and her depression fed on one another. Eleanor Boardman saw Adelaide popping pills on the set of a film and thought, "There was something the matter with her."

As her husband had been busily crafting his cinematic love letter to Hollywood, Adelaide had given up on her dream of traveling the world with Rupert. Instead she embarked on the voyage without him, sailing to China accompanied by a nurse. Adelaide returned to Los Angeles in early 1923, at which point Rupert was beginning to direct *Reno*, another film about marriage. His biographer James O. Kemm notes that *Reno* "gave Rupert an opportunity to expound on his views about the unfairness and inconsistency of divorce laws." These views were by now legion, part of his persona as expressed to the movie press. "Marriage is the greatest bunco game in the world," he had declared two years earlier in *Photoplay*. "If a man has a wife he doesn't like, he should get rid of her as soon as he possibly can." In the plot of *Reno*, a bigamist deals with the consequences of having taken three concurrent wives, each his legal bride in a different state. Rupert himself was more of a serial monogamist than a bigamist: losing interest in his second marriage, he would soon begin the relationship that would become his

third. A small part in *Reno* was played by a redheaded actress born as Elizabeth Patterson, who went by the screen name Patterson Dial. If Rupert had a type, Patterson was it; when Eleanor Boardman first met Patterson, she thought that she looked like a younger version of Adelaide.

In August 1923, Adelaide decided to take another cruise to the Far East. Again Rupert stayed home. She arrived in Peking and, enraptured by her surroundings, began devising an idea for a film set in China. She wrote to her husband about her idea, but Rupert shot her down, telling her the concept sounded impossible. Dejected, Adelaide's depression worsened. She began suffering from an earache, and got off the boat in Haiphong to see a doctor. She returned to the boat on the evening of December 13, 1923, in a terrible mood. The next morning Adelaide's lifeless body was found hanging from a luggage strap. Rupert learned the news from a man named A. M. Kirby, who worked for Standard Oil in Haiphong. The following morning's *New York Times* carried a story including both the text of Kirby's telegram ("Adelaide Hughes committed suicide here today") and a two-paragraph statement from Rupert, in which he called Adelaide "a brave, brilliant woman whose lack of self-confidence alone prevented her from being known to the world as I know her."

One month and one day after Rupert Hughes's wife hung herself, he got word of the death of his brother, Howard Robard Hughes Sr. Howard had gone back to Houston for meetings at the Hughes Tool factory, and had dropped dead of a heart attack at work. His eighteen-year-old son, who had himself returned to Houston to take classes at a free public college called Rice Institute, was now an orphan. Like thousands of other orphans before and after, he went to live in Hollywood.

HOWARD JR. ARRIVED IN Los Angeles around the same time as Mata Stoddard, a gorgeous twenty-year-old woman from St. Louis. Mata's mom owned a chain of movie theaters, and she had grown up

glued to the screen. In the 1920s, if you were the prettiest girl in your town or on your block or in your school, and you loved movies, people would start telling you that you ought to be in pictures, and because you wanted to believe that so much, you'd make your way to Los Angeles, and until fate connected you with your big break, you'd get a job pouring coffee at a hotel diner. That was what Mata was doing the night of February 7, 1924. Mata finished her shift at the Pot and Spigot Grill in the Hayward Hotel and got into a waiting Packard driven by Hal Conlin, a married ex-policeman now working as a chauffeur. Mata and Hal stopped at her apartment, she changed her clothes, and minutes later they crashed into a telephone pole at the corner of First and Commonwealth. Newspaper accounts of the accident revealed that the car belonged to "Howard R. Hughes Jr., son of the late president of the Hughes Tool Company and nephew of Rupert Hughes, motion-picture producer and director." The location of the crash was in between Stoddard's apartment in Hollywood and the mansion on Western Avenue where Howard was living with his uncle Rupert. Stoddard's family suspected that Mata, a former beauty queen and fur model, may have been en route to a late-night date with Hughes at the time of the crash.

At an inquest two days later, Conlin attended "swathed in bandages" due to a scalp injury he suffered in the crash, and said he didn't remember anything—other than the fact that Stoddard had been driving, while Conlin snoozed in the passenger seat. In his testimony, Hughes admitted that he had spent time with Conlin earlier that evening. Much of the inquest questioning of Hughes revolved around the fact that Stoddard's corpse was found not fully dressed. A policeman claimed that when Hughes was asked to come identify Stoddard's body, he wanted to know if the deceased had been found wearing stockings, and when he was told "no," Hughes responded, "Then that's her." Hughes first denied he had said that, and then clarified that Mata's roommate had told him over the phone that she had left the house with bare legs.

Whatever Howard's connection to Mata Stoddard, after his mother,

his father, and his aunt Adelaide, she was the fourth person Hughes knew personally who had died far before her time in a matter of two years. How was all this death affecting him psychologically? Asked at the inquest to demystify the number and nature of his meetings with the deceased, Hughes said, "I can't remember. I can't remember everything for the past two years." This baffled his questioners and they quickly moved on, but given that almost exactly two years had passed since the death of his mother, this seems like it could be a revealing statement about the teenager's state of mind.

When Howard Jr. had relocated to Los Angeles, his father's family expected to be taking in a young man in need of parenting. What they got instead was a teenage boy with no real idea of how the world worked, who was determined to make his way in that world entirely on his own. Right away, there were problems. Sonny's inability, willful or otherwise, to play by the rules had been readily apparent before his father's death, when he was living in Houston with Annette and Fred Lummis. Unwilling to carry a house key, when Howard Jr., would get home late at night, multiple times he grabbed a brick and smashed the glass on the French doors. Said Fred Lummis, "It was a constant problem of discipline." This may have been spoiled rich boy stuff—no one had ever instilled in Howard the awareness that broken things can be expensive to fix—but he also seemed uninterested in acquiring such an understanding.

In a posthumous study of Hughes's psychological history, psychologist Raymond D. Fowler concluded that Sonny was incredibly traumatized by losing both of his parents—"the only two people with whom he had a close relationship"—in such quick succession. In the months following his father's death, the teenager was overwhelmed with thoughts of death, which may at least in part explain the fatalistic recklessness that Howard's family had so little patience with. Fowler suggests that young Howard needed something to hold on to, to help pull himself out of the abyss, and he found it in pursuing control of Hughes Tool. This may be true. It is equally true that Howard Hughes Jr. was, in early 1924, an eighteen-year-old boy, heretofore a sheltered

and pampered loner, who was now tantalizingly close to controlling a fortune. He could have waited another three years to come into his inheritance—a period during which his family would probably have forced him to attend school, while keeping him from pursuing his real interests, like airplanes, movies, and women. Or he could shake off his family and start becoming the man he felt determined to be.

WHEN ALLENE DIED, HER son stood to inherit her 50 percent share of Hughes Tool. With those shares added to the shares willed to him by his father, in 1924 three-quarters of the company belonged to the teenager—or, would, when he turned twenty-one. Hughes Tool was not, at that time, the gold mine that it would be made out to be in later press about Hughes. Though it had just experienced its most profitable year in 1923, its success had been inconsistent, and its patent on the drill bit was due to expire in just two years, rendering the future uncertain. Believing he was the only one who could protect his father's legacy, Howard became determined to overcome the few obstacles keeping him from assuming total control of the company. One of those obstacles was Howard Sr.'s father, and Sonny's grandfather, Felix Hughes, who along with his wife and son Felix Jr. had been willed the remaining quarter of the company. Howard Jr. became determined to buy them out.

That was easier said than done. After a round of negotiations in which Howard's grandfather drove a hard bargain, the relatives eventually agreed to a deal that would have each of them pocketing $117,000—almost double what Hughes Tool had estimated their shares were worth—but at the last minute Uncle Felix decided that he would not sell for less than $150,000. Howard was set to agree to his uncle's demands, but then the other relatives withdrew entirely. Bitter correspondence between Howard and his elders followed. Howard's grandfather made the case that he had always been his father's silent but equal partner, having invested in his drill bit experiments from the beginning. The grandfather referred to what Howard was offering

as "a bare pittance," and a bad trade for the time and money he had already put into the business. Felix Sr. also felt it unfair that he should have to settle for so little "while you (and I say this in all tenderness) had such a fortune, at your age, for the rest of your life."

This letter was dated January 28, 1924—just two weeks after Howard Sr. had died. Felix Sr. then threatened to take the matter to court, to apply for a receivership with the intention of destroying the company's reputation and stock price. "Grandfather proving difficult," Howard wired Colonel Kuldell, the manager of Hughes Tool. "My father bragged so much to him about the Company that he thinks it is worth twelve million dollars." The actual worth of the company in early 1924 was a fraction of that.

Howard was advised by Kuldell that a lawsuit could be a disaster—not least because the "Conlin affair may have serious developments" and if Kuldell was called under oath, "everything will come out." Howard apologized for being "indiscreet in the Conlin affair" but explained that Conlin had been a friend of his father's who had helped Howard Sr. with his speeding tickets when Conlin was a policeman, so "I thought it only just to try to help him." The "indiscretion" in question may have been Hughes's testimony on behalf of Conlin, but the "help" might have gone further. Conlin was found guilty of manslaughter and sentenced to probation; he went to San Quentin in 1926 after violating parole. Conlin's correspondence with Hughes's attorney Neil McCarthy suggests that Hughes was sending Conlin money in prison and had possibly offered him a job upon his release. Whether the "everything" that Kuldell didn't want to come out was a pattern of possible hush money payments from Hughes to Conlin or not, Hughes was sufficiently convinced that he didn't want to go to court.

By March, Rupert—who was not named in the will, and was never going to personally gain financially from any deal—was extremely bitter. In a letter to his mother he wrote that Howard's "conduct in general throughout the will, has been an absolutely astounding display of grasping—dishonorable ungenerous selfishness. . . ." In his time in Los Angeles, Howard, according to Rupert, had "lied flatly again and

again and altogether behaved outrageously," as part of what Rupert believed was his nephew's vicious scheme to cheat his paternal relatives out of their inheritance from Howard Sr. Rupert ordered his mother to evict Howard Jr. from the family house.

So, exiled, Howard returned to Houston, and in April, Rupert and Howard exchanged fierce correspondence, with Rupert slinging accusations at Howard, and Howard refuting them one by one, amid declarations that he could not "forgive . . . my uncle, and one whom I considered my friend, calling me a liar, a thief and a miser. . . ." Howard would indeed not forgive, nor forget; their relationship would never recover.

Finally, after a contentious conference between Howard Jr. and Felix Sr., Howard's lawyers advised him to pay off his relatives in cash and be done with it. The relatives demanded a total of $464,000 and got it. These disbursements depleted the company's ready cash flow, forcing Hughes to put up his own shares as collateral in order to get a loan so that the company—and his own lifestyle—could continue without interruption. "I may have owned it," Hughes said in 1954, "but I had it in hock up to my neck to the bank."

But the precarious financial situation was worth it to Howard, who had bought peace of mind. "The thing I knew," Howard would say, summing up the situation of 1924 many years later, "was that I would never be able to get along with my relations and that's why I was determined to buy them out and go it alone. If I hadn't been a brash kid, I never would have had any such idea—and I don't advise other brash kids to do what I did. I'll admit I didn't realize what hazards faced me—so maybe what I didn't know couldn't hurt me."

Now the only obstacle in Howard's way was his age: he would still be considered a legal minor until age twenty-one. Certainly, his family treated him like a spoiled child, but their low assessment of his maturity made the young man all the more determined to prove himself, to step out from his father's shadow. In order to take financial control of his father's estate, wield executive control of his company, and have the

freedom to pursue his real interests, Howard needed the law to brand him as an adult.

Howard learned that a Judge Walter Montieth in Houston was, like him, an avid golfer and a member of the Houston Country Club. Howard began cozying up to Montieth on the golf course, and when he felt they had established an affinity, Hughes had his lawyers file in Montieth's court an application to be legally considered an adult, for the purposes of taking on his inheritance. The crux of Howard Jr.'s argument in court was his own admitted lack of patience: Hughes was already due to inherit three-quarters of his father's estate at the age of twenty-one, so why not let him have access to it two years earlier? The day after Howard's nineteenth birthday, on December 24, 1924, Judge Montieth granted Hughes his majority.

Hughes could have lived a comfortable life in Houston, funded by the profits of the company he now controlled. But he had other ideas for those profits, and for his life. In 1930, Howard described having seen Howard Sr.'s imagination "stimulated by thinking that tools he had devised were ripping up the soil of Mesopotamia and Borneo and Siberia. He was plowing up the face of the earth and turning up new wealth and being an influence on the course of the world in an indirect way." Young Howard longed for the same kind of influence, power, and reach, and he wasn't content getting it filtered through his father's achievements. "I wasn't building anything for myself," Howard explained. "My father had been a pony express rider, I was being a postman."

Having retreated to Houston and moved into his parents' empty mansion after the Rupert-mandated eviction from his grandmother's house near Hollywood, Howard began plotting his return to the West Coast. Los Angeles was a hotbed of growth in two industries that had caught his fancy—aviation and the movies—as well as the nation's most picturesque climate for his favorite hobby, golf. He planned to use the income from Hughes Tool to make a name for himself in all three fields, but if he was going to physically leave the site of that business,

he couldn't afford for the people who actually ran the company to get the impression that he was some silly kid on walkabout. He needed the Hughes Tool management and workers to believe the company was— and would continue to be—financially secure.

"He needed to convince everybody that he was a steady, sober young man," recalled Noah Dietrich, who in time would become one of Howard's closest working employees. "He figured, 'the best thing I can do is marry the best girl that I know.' That turned out to be Ella Rice, who was from a good Houston family."

Ella Botts Rice had dark hair, which she wore in fashionable but not flamboyant waves. Her almond-shaped eyes were heavily lidded and her mouth looked like a heart. Her grandfather's brother, William Marsh Rice, had been the richest man in Houston circa the Civil War and had bequeathed much of his estate to the founding of Rice Institute (now Rice University), which Howard had briefly attended. Several men in Ella's family had served as mayor of Houston. Ella and Howard had been classmates as children, and Howard's aunt Annette Lummis believed her nephew had harbored a boyhood crush. As an adult, Ella herself was now friends with Annette; one of Ella's father's sisters had also married a Lummis man, which made Ella, Annette, and Howard all vaguely related by marriage.

Dietrich, one of the few witnesses to the Rice-Hughes marriage who was still around after Howard's death, claimed that Howard wooed Ella by convincing his doctor to help him fake a life-threatening illness. "The doctor called Ella, told her that Howard was extremely ill and that he kept calling out for her in his semi-conscious state. That proved irresistible to Ella and she rushed to his side. They soon after got engaged."

If Howard wanted Ella to believe he was a romantic, it was a cruel trick to play on a girl who would find out the truth only after it was too late. (Dietrich would also claim that he "never saw the slightest sign of affection displayed" between Howard and Ella.) But Aunt Annette was operating under the same illusion. She claimed that Howard had set his eyes on Ella in elementary school, where "she was the queen,

and apparently he was in love with her from then on." Though Annette had her doubts about the coupling, she agreed to facilitate, negotiating with Ella's aunt Mattie to in essence arrange the marriage, in order to give her nephew some kind of grounding in where he came from before he disappeared to Hollywood: "I said, 'I can't send him with all that money to California with all those vampire movie people,' and Aunt Mattie said she agreed with me."

Ella's family believed Ella should marry the most eligible man who asked, and Howard was certainly eligible. In addition to the fortune promised by his ownership of Hughes Tool, Hughes at age nineteen was, if too slim to qualify as strapping, certainly tall, dark, and handsome, with sparkling dark eyes and an impish, closed-mouth grin. On paper and in the flesh, it would look like you could do worse. And while Ella was in what she believed to be a serious relationship with another man, James Winston, he could not keep her in the lifestyle that her family believed was her birthright. So Ella broke off her relationship with Winston, and on June 1, 1925, she and Howard were married.

BY MID-1924, RUPERT WAS openly in a relationship with Patterson Dial, the actress whom he had met on the set of *Reno*. The pair would marry in December 1924 and move into—you guessed it—the Ambassador Hotel, before embarking on the construction of a new, *Arabian Nights*–inspired Moorish-style mansion on Los Feliz Boulevard, east of Hollywood, at the base of Griffith Park, a 4,300-acre wilderness in the middle of the city.

The timing of these events was enough to sour Adelaide's children from her previous marriage, Rush and Avis, on the man who had unofficially adopted them. Recalled Rush Hughes, "Rupert had allowed my mother to go off alone on a trip around the world on a boat that had no medical officer," and their worst fears of what could have happened if their mother had been left without emotional or physical support had come true. Then Rupert had found a way to rub salt in the wound: "very shortly after my mother's death, he made an association

with another much younger woman." (Rupert was fifty-two; Patterson was twenty-two.) Rush and Avis never saw Rupert again after the announcement of his engagement to Dial; Rush claimed that Rupert and Patterson had maliciously cut him and his sister off.

If Rush Hughes had a rival for his stepfather's animosity, it was Howard Hughes Jr. Eleanor Boardman reported that Rupert told her that Howard would "throw his mother down the stairs if it was to his advantage." Alston Cockrell Jr., a nephew of Patterson's who briefly lived in Rupert's house on Los Feliz, said that when it came to his aunt and Howard Hughes Jr., "She wouldn't let that son-of-a-bitch in the house!"

Not that the son of a bitch was banging down the door. Howard was clearly determined to leave behind where he was from, and prove to the Hugheses and everyone in Houston that he didn't need them. He had already done much to distance himself from his paternal bloodline, even putting his father's legacy in jeopardy by draining the reserves of Hughes Tool to buy out his grandparents and uncle. But Hughes was still a Hughes: in the fall of 1925, he and his bride Ella moved into the Ambassador Hotel. Their suite had twin beds.

NO TOWN
FOR A LADY

There were a lot of things pulling Howard Hughes to Hollywood. He genuinely liked watching movies: "I went to see them even when I knew they were cheesy," he admitted. "I came to the conclusion that I could make better pictures than were being made." Inducted into the local social scene by his father and uncle, he had quickly taken to this world of uncommon beauty and possibility, populated by strivers from all over, none of them encumbered by the concern for history, propriety, and decorum that patrolled social life in Houston. All of this was part of it, but an added bonus was that success in Hollywood would allow Howard Hughes to enact revenge on the still-living men in his family who had condescended to him, told him he'd never be able to hack life on his own, and grubbed for every penny of his father's fortune, which Howard had been forced to dole out to them. He was determined to make a name for himself, and have that name drown out that of the already-famous uncle against whom Howard now held a permanent grudge.

Hughes's unofficial film school came via Ralph Graves, a crony of Howard Sr.'s who, from 1924 to 1926, starred in a run of two-reel comedies at Sennett Studios. After Howard Sr. died, Graves became golf buddies with his son. Once Howard had legally secured his inheritance, Graves casually mentioned that he had an idea "that will make a hell of a movie." Graves explained the premise of *Swell Hogan*, a

comedy about a Bowery bum. Graves would write, direct, and star; all he needed was the money. Howard asked him how much. "We could bring it in for $40,000," Graves said. Howard reportedly guaranteed Graves that he'd cover the entire budget, on one condition: "You'll let me watch."

Filming got under way while Howard was in Houston arranging to marry Ella, and three days after the wedding, Howard got a telegram indicating that postproduction was not going smoothly. Ten days later, Hughes was informed that the situation was getting worse, and the director was "alternately enthused and disgusted." Graves's cut of the film proved to be unsalable; several exhibitors declined to take *Swell Hogan* on because it was "not up to [their] standard." Rumors have circulated for years that Hughes, embarrassed at his first effort as a producer, ordered the work print burned. Hughes denied this; the official line on *Swell Hogan* went that Hughes, as a first-time film producer and an independent one at that, was unable to find a distributor, which was true. That said, distribution problems would only explain why *Swell Hogan* was not released in 1926; it would not explain why the film was, after its first screening, apparently permanently lost.

What does seem clear is that by May 1926, Hughes had cut Graves out of the process. Over the next forty years, Graves would do his best to remain a thorn in Hughes's side, frequently writing to the famously rich man with sob stories and asking for money, insisting that Howard Jr. owed Graves a "lifelong debt" relating to some unspecified work he had done for Howard Sr. just before he died. Finally, beginning in the mid-1960s, Graves began harassing Hughes through his aides to the verge of blackmail, threatening to publish a tell-all on Hughes and his businesses, and even putting an ad in a local newspaper soliciting "investors." This book of Graves's did not materialize.

After *Swell Hogan* proved to be a disaster, Howard took a call from ever-helpful Uncle Rupert, who told his nephew that he had had his fun, but it was now time for him to give up on Hollywood, to take what was left of his money and go home to Houston and become a serious man. Director Lewis Milestone recalled that Howard had told him he

had been self-pityingly thinking the same thing—but that Rupert's admonishment turned him around. "My family made it a challenge," Hughes told Milestone. "I had to prove me right, and them wrong."

"Failure was unconscionable to him," Noah Dietrich observed. Dietrich came into Hughes's life in the fall of 1925 and would stay there for more than thirty years. A former Certified Public Accountant, Dietrich was hired by Hughes on Thanksgiving 1925 to organize the management of Hughes Tool so that Howard could focus on his true passions. "My first objective is to become the world's number-one golfer," Hughes told his new employee. "Second, the top aviator,[1] and third I want to become the world's most famous motion picture producer." Finally, the kicker: "Then, I want you to make me the richest man in the world."

The Howard Hughes whom Noah Dietrich got to know in the mid to late 1920s was not yet famous, had little ready fortune to speak of, and had not yet accomplished any of the achievements that he and his publicists would later be able to trumpet as evidence of his greatness. But already certain eccentricities were apparent, most notably the paranoia that guided him in business and in life. He refused to carry money and was constantly borrowing the price of lunch or a tank of gas from friends and employees. "Goddammit, Noah," he explained to his incredulous deputy, "there are people in this country who will knock you off if they think you have five hundred dollars in your pocket. I want everyone to know that I don't carry any money." Hughes was also resistant to any kind of written correspondence. He told Dietrich, "I don't want to go on record where they can pin me down."

Though a bit chastened by the *Swell Hogan* experience, Howard was again an easy mark when another actor turned director (and associate of his father and uncle), hard-drinking, fun-loving Marshall

[1] Hughes first flew in a seaplane as a passenger in 1920, at the age of fourteen, and became fascinated with aviation. Over the next few years, his parents refused to allow him to learn to pilot. It wasn't until after Howard had settled in Los Angeles that he began taking private flying lessons. He earned his pilot's license in January 1928.

Neilan, came calling with a movie pitch of his own. At least Neilan had a proven track record as a filmmaker, having recently left MGM after directing a few films there starring his superstar wife, actress Blanche Sweet.

Neilan is an interesting character in the Hughes mythology, one whom the Hughes camp initially celebrated, and then tried to erase. A publicity biography of Hughes dated 1930 credited Howard's "friendship with Marshall Neilan" for igniting Hughes's interest "in the making of movies." Almost a quarter century later, Hughes would request that journalist Stephen White remove an innocuous reference to Neilan from a profile White was writing on Hughes for *Look* magazine. By that time, Neilan hadn't directed anything in twenty years, and he was living out his last years in obscurity at Hollywood's fading Knickerbocker Hotel, scrawling his never-to-be-published memoirs in longhand on yellow legal pads. Many readers of *Look* in 1954 probably wouldn't have recognized Neilan's name; by the 1950s, Hughes wasn't interested in sharing credit with anyone, let alone a has-been.

But back when Hughes arrived in Hollywood, Mickey Neilan was notorious. Not only was he one of the top directors in the business, but by his own admission, he regularly partied till dawn, continuing past last call at the Alexandria by driving five miles south to the Vernon Country Club to "roar on into the night." According to Frederica Sagor, the social scene of Hollywood in the mid-1920s "was a bachanal," and Neilan was second only to the "depraved" Edmund Goulding, a director who would later work with Hughes, as ringmaster of the circus.

"These two men initiated more young women—and men—into more kinds of kinky sexual practices than one can possibly imagine," alleged Sagor. "Morally, Mickey was a shade above the hedonist Goulding, but was louder and cruder," Sagor wrote. "Neilan's weakness," she added, "was pretty virgins." These assignations often had an implied quid pro quo: "The carrot stick that they dangled was the promise of a screen test, a good part in some picture in which they were involved, or that they would use their clout with some other director

shooting a picture on the lot," Sagor claimed. "Few, if any, of these seductions bore fruit."

Soon thereafter, Howard Hughes would begin replicating this behavior exactly—including the failure to make good on the promise, implied or directly stated at the beginning of the sexual transaction, to provide work in exchange for the services rendered. "Howard was a sort of protégée of mine," Neilan would boast years later. "Shy on the social side, Howard had met very few stars outside of those he met at my parties." Eventually Hughes would find other men to replace Neilan as an introducer/procurer, but in the meantime, the young man absorbed all his mentor had to teach about how to acquire women.

Hughes gave Neilan $75,000 to make *Everybody's Acting*, a kind of proto–*Three Men and a Baby* about four vaudeville performers who adopt a baby girl. This time Hughes left the director alone, and this time, the film netted a 50 percent profit. With that success, word started spreading around town that there was a new young Texan oilman looking to finance pictures. Emboldened, Hughes began hiring people under the auspices of his new production company, which he dubbed Caddo—the name of his father's original oil drilling outfit, and the Louisiana parish where it began.

Hughes's first contract signee was director Lewis Milestone, who set to work making *Two Arabian Knights*, a World War I adventure-comedy in which two American soldiers escape German capture and vie for the love of Mary Astor. His next effort as a producer was *The Racket*, which, along with the almost simultaneously released Josef Von Sternberg silent *Docks of New York*, would essentially invent the gangster film. *The Racket*, directed by Milestone, became Howard's first experience with the promotional power of controversy. A ripped-from-the-headlines crime picture tracing how police and institutional corruption made gangsterism possible, *The Racket* was considered so realistic in its language and action that it was widely censored; its subtitles referring to graft were removed in New York, and it was outright banned in Chicago. Hughes began speaking out against the local

censorship boards who sought to sanitize films made for adults rather than letting the viewers think for themselves. "I won't tone anything down," Hughes declared. "I believe the screen is a powerful influence on the thoughts of the average citizen. It's a powerful instrument. It bores through opinions like my father's bits bore through rock."

By the time Hughes was making these lofty statements of intent, he had already seen that censorship battles acted as free publicity for the movie in the places where it was screened without restriction or cuts. Where did his stated ideals end and his business savvy begin? "If my pictures didn't make money, I'd go in some other business," he acknowledged. But so far, so good: *Two Arabian Knights* and *The Racket* were both hits, and would be feted at the first Academy Awards ceremony, with Milestone winning the first (and only) prize for Best Comedy Direction. Hughes himself had been nominated for Outstanding Picture (later renamed Best Picture) for producing *The Racket*.

Buoyed by these early successes, in December 1927 Hughes took the most concrete step he'd ever take toward establishing roots in the Hollywood area. Tooling about the Hancock Park neighborhood in a red sports car, probably before or after a round of golf, he spotted a house in construction adjacent to the course's ninth green. Hughes jumped out of his car and announced to the construction workers that he wanted to buy the house they were building, and that he'd be willing to offer "any price."

The house at 211 Muirfield Road was a Spanish-style hacienda built for socialite Eva K. Fudger, but it was only hers briefly, and once Hughes took it over, it would come to loom large in his legend. When Hughes became determined to live there, Fudger agreed to lease it to him, furnished with her own hand-picked antiques, for $1,000 a month (about $14,000, adjusted for inflation). Fudger would later sell Hughes the residence, fully loaded, for $135,000, or about $2 million in 2017 dollars—a relative bargain for a two-story, thirty-room manse tastefully outfitted with authentic Spanish tile, exposed beams stretching across the high ceilings of the vast den and study.

It was a great house. But why did it have to be *that* house? Certainly, its proximity to the Wilshire Country Club golf course would have been attractive to a young man who still aspired to become a champion in that sport. But it was also within a block from a far more modest home owned by Felix Hughes, one of Howard's father's two brothers. With the successes of *Everybody's Acting* and *Two Arabian Knights* under his belt, Hughes felt he was on his way to amassing a filmography that would prove that his family had been wrong to try to keep him away from the family fortune. The mansion on Muirfield Road, virtually in plain sight from his uncle Felix's front door, would just further rub it in.

IN DECEMBER 1925, IN advance of what would have been their first Christmas together as a couple, Howard told his wife to go home to Houston and await his arrival. His subsequent actions suggested he was not eager for a romantic reunion in the hometown that he had dramatically abandoned. "Cannot understand why I have not heard from you today," she cabled Howard at 11 P.M. on December 22. Two days later, the night of Christmas Eve and her husband's birthday, Ella had still not heard from Howard. "Did you attend to my account at the bank if not please do so," began her nightly missive to her husband at the Ambassador Hotel. "And be sure and tell me that you are leaving tomorrow Love Ella." Hughes arrived in Houston by New Year's Eve, but he spent the day wiring Dietrich instructions for work he wanted done on the holiday.

This would be Ella Rice's experience of marriage to Howard Hughes in a nutshell. He kept her well-supported financially, but also kept her waiting, nearly every day of their marriage, for some sign of affection. She would not be the only woman to relate a similar experience with Hughes—in fact, going forward, once he felt secure that a woman's affection was trained solely on him, Howard would begin to disappear, and his absences would become more frequent than his presence. He

seemed to draw comfort, if not pleasure, from knowing women were waiting for him to pay attention to them—and then withholding that attention.

If you were the new bride of a handsome, wealthy young man who was so obsessed with learning his chosen trade that he'd sometimes work around the clock to better understand that trade's tools, maybe you could forgive waking up on occasional mornings to find that your husband had never come to bed. But Howard wouldn't just occasionally burn the midnight oil, spending all night in an editing room taking film prints apart and trying to put them back together—he would disappear for nights and days at a time, with no word to Ella as to where he was going, or, when he did return, where he'd been. In what would become a lifelong pattern, when Howard didn't want to be found, he couldn't be. Even when at home, Howard tended to lock himself up in his study, far away from his wife.

BY THE END OF October 1927, Hughes was in production on the film to which he was devoting himself body and soul, and on which he was staking his reputation and the financial stability of the company his father had built.

When their first collaboration proved to be a success, Neilan approached Hughes with an idea he had been working on for a long time. It would be an aviation epic, taking advantage of aircraft leftover from World War I that Neilan had scouted on trips to Germany and England. Neilan even claimed that he had made "a tentative deal" with controversial Dutch airplane designer Anthony Fokker to borrow his fleet of combat planes. When Neilan finished his pitch, Hughes was enthusiastic. "Sounds great," he said. "Let's make it."

"Christ!" Neilan shouted at Hughes. "Do you know what it will cost?" Neilan estimated that the film he wanted to make could tally $500,000 just to shoot, never mind the additional expenses of editing, film printing, and whatnot.

"What's the difference," Hughes shrugged. "Let's make it."

The original plan was for Neilan to direct and produce *Hell's Angels*, just as he had with *Everybody's Acting*. But where Hughes had been an absentee producer on that film, he decided to take a much more active role this time around. Hughes camped out at Neilan's house in Silverlake, east of Hollywood and north of the Ambassador, and with the help of Paul Bern, a rising producer, they fleshed out the story. Neilan soon found his young financier overruling him on a number of fronts, from Neilan's plan to shoot with the European planes in Europe (which Hughes vetoed because he did not want to miss a golf tournament coming up in Carmel, California) to the casting of the two male leads. "The story called for two wild American kids like we see every year on our own football teams," Neilan noted, adding that Hughes instead insisted on casting experienced silent film leading men James Hall as the cuckolded Roy and Ben Lyon as the only marginally wiser Monte—actors whom Neilan dissed as "Vaseline-haired pretty boys."

Exasperated, Neilan made an excuse to back out of the directing assignment, and Hughes hired Luther Reed, an aviation reporter turned screenwriter, in Neilan's place. Reed simply wasn't much of a director, so Hughes then hired Edmund Goulding, party pal of Neilan, but Goulding wasn't long for the project, either. Finally, Howard Hughes decided that if he wanted *Hell's Angels* done his way, he was going to have to direct it himself.

PRODUCTION OF *HELL'S ANGELS* began on Halloween of 1927 at Metropolitan Studios on Romaine Street in Hollywood.[2] Hughes spent two months shooting interior scenes with his actors Hall and Lyon and a Swedish beauty named Greta Nissen. All of the main characters in *Hell's Angels*, a love triangle set against the aerial fighting of World War I, were meant to be English. Greta didn't have a great command of the English language, but this was a silent film, so that didn't matter. Hughes got what he needed out of his performers relatively

[2] Today called the Sunset Las Palmas Studios.

quickly, and after Christmas, he moved on to what he was really excited about: the flying footage.

By January 1928, when Hughes transferred the production to an airfield in Inglewood, California (which would later become Los Angeles International Airport), to complete the airplane stunts, *Hell's Angels* already had a price tag of $400,000. This was an enormous figure, especially considering that Hughes had only captured footage of actors miming in rooms thus far, and the air battle scenes would undoubtedly be extremely expensive to pull off.

Those scenes didn't need to be quite as expensive as they ended up being, but Hughes seemed determined to prove to Hollywood that money was no object for him. He exhibited zero sense of economy. In the name of historical authenticity, he assembled a private fleet, the largest anywhere in the world, made up of eighty-seven pieces of antique aircraft actually used in World War I. (He spent more money on airplanes, $500,000, than he had spent on the first two months of shooting.) He kept a hundred mechanics on the payroll to service his rickety old birds. After two months, *Hell's Angels* outgrew the space available in Inglewood, so Hughes—and his cast, crew, mechanics, and air fleet—moved twenty-three miles north, to Van Nuys, where Hughes was able to commandeer a hangar and landing strip surrounded by farmland. When his stunt flyers would accidentally take out a row of crops, Hughes would show up with a wad of cash to reimburse the farmer for his lost lettuce. As a director, Hughes was exacting, but his shooting method was not precise. He'd have multiple cameramen shoot the same things over and over again. For a single flying shot that would run about sixteen seconds in the movie, Hughes directed almost four hours' worth of footage.

After twelve months in production, Hughes had just two sequences remaining to film. One was an air battle involving forty planes, flying through clouds. But Hughes wasn't satisfied with the look and feel of the clouds in Van Nuys, so once again, the entire, massive company packed up and moved, this time 350 miles farther north, to Oakland Airport. There Hughes kept his cast, crew, and air fleet parked for four

months, until the weather changed and he got the aesthetically exciting clouds he wanted.

Finally, the production moved one more time, back to Los Angeles, to film the last remaining sequence: the spectacular crash of a German bomber, shot down by the heroes. Hughes's priority was authenticity, so for this thrilling scene he insisted that an actual bomber plane be flown into a tailspin, which he wanted the pilot to pull out of at the last minute, once the shot was completed, in order to save his own life. Under duress from Hughes, stunt flyer "Daredevil Al" Wilson and mechanic Phil Jones took off in the bomber, with Wilson piloting and Jones operating a smoke special effect from the rear of the plane. Wilson manufactured a tailspin, and then jumped, floating to safety out of view of the camera thanks to a parachute. Perhaps the correct moment to jump was not properly conveyed to Jones, or maybe he got stuck in the fuselage. Either way, he stayed with the craft to the end, crashing to his death.

Jones was just one of four members of Hughes's crew to die during the making of the movie. Three deaths were without a doubt the result of the film: in addition to Jones going down with the bomber, stunt pilot Al Johnson was killed moving a plane, and another pilot, Clement Phillips, was killed in a crash. The fourth death was not incontrovertibly connected to the shoot, but happened in the midst of it: cameraman Burton Skeene, who had shot much of the film's aerial footage, died of a heart attack.

The body count racked up by the movie would rival its bloated budget as a talking point in the run-up to and aftermath of the film's release. Hughes himself did not emerge physically unscathed. He wanted airplanes to do near-impossible things in the movie—certainly, things that had never been done in front of a rolling motion picture camera. He had assembled the best team of stunt flyers in the world, but eventually he dreamed up a stunt that even they refused to do.

"Howard wanted to film a low-altitude maneuver in which the planes swooped past the camera at an elevation of two hundred to three hundred feet, performed a left bank, and returned, all in camera range,"

remembered Noah Dietrich. The expert pilots told Hughes such acrobatics couldn't be done at such a low altitude. Determined, as always, to prove naysayers wrong, Hughes said he'd show them—he'd pilot the stunt himself. However, the plane, as *Photoplay* magazine put it, "was powered with a rotary motor and Mr. Hughes was unfamiliar with the eccentricities of rotary motors." Exactly what Hughes was warned would happen happened: he couldn't make the maneuver at low altitude—and crashed.

According to Dietrich, Hughes lost consciousness in the crash, and when he regained it at the hospital, his disorientation was such that he couldn't recognize people he saw every day. His face had been crushed by the impact. Surgeons were able to repair the damage to some extent, but they couldn't reconstruct his left cheekbone. He never looked quite the same again.

This deformation, confirmed by a letter from Aunt Annette to Howard,[3] was erased from the record by the time the movie was finished. *Photoplay*, printing Hughes-approved spin, made the crash sound like magic: "As he whirled earthward someone was heard to murmur, 'My God, there goes fifty million dollars and my job!' They rushed to the wreckage to find Mr. Hughes combing pieces of motor out of his hair and rubbing numerous contusions and abrasions. There were no broken bones. The next day he was back on the job."

Relative to comparable films of the era, there is an extensive litany of detail available about the production of *Hell's Angels*, from the process through which Hughes himself came to direct the movie, to the day-to-day doldrums of the crew who were forced to wait for weeks at a time for Hughes to become satisfied with the size and shape of the clouds backdropping his authentic fleet of World War I planes. But the sheer volume of information made public about *Hell's Angels* actually

[3] "I am distressed to hear that you have been suffering from your fractured cheek bone but I suppose the first report that you were just scratched slightly was just too good to be true." Annette Lummis to "Dearest Howard," January 19 (no year), Annette Lummis folder, TSA.

complicates any attempt to figure out the truth, because most of that information was provided or vetted by Hughes's new publicist, Lincoln Quarberg.

Quarberg began putting out fires—and setting them—for Hughes in 1928. As *Hell's Angels* stumbled into its second and third years in production, it became the most written-about film of its day. Magazines like *America Cinematographer* would note that their stories were based on "information [that] comes from the Caddo office direct," which implied an inside scoop, but did not guarantee authenticity. In the guise of radical transparency, Quarberg issued reams of writing about *Hell's Angels*, much of it taking kernels of truth and exaggerating them into self-serving mythology, often transforming potential criticisms of the film and its maker into selling points. As a result, even publications that intended to antagonize Hughes and his aviation folly ended up folding much of his carefully constructed mythology into their critique. *Photoplay* magazine ran a sprawling, would-be serious work of reporting that took Hughes's irresponsibility to task in its headline: "4 Million Dollars, and Four Men's Lives." And yet, these were the story's thesis sentences: "For over two years, *Hell's Angels* has had the cinema industry gossiping, scoffing, laughing up its sleeve and right out in public, admiring, doubting, amazed, astonished, goggle-eyed and simply flabbergasted. . . . It is surely the most amazing thing that has ever happened in a business where odd and peculiar hocus-pocus is no novelty." Hughes may have been irresponsible, reckless, tacky, and dangerously ignorant—but he was also entertaining, and Lincoln Quarberg made sure everyone knew it.

Part of Quarberg's job was to respond to requests from newsmen for "feminine art," meaning cheesecakey publicity photos that journalists could either print in their publications, or keep for their personal use. But some fans would write directly to their favorite stars to ask for photos. On July 9, 1928, a fan from San Bernardino named Caroline Black sent a handwritten note to Ben Lyon, who had already been shooting *Hell's Angels* for nearly nine months.

"You are one of my favorite actors, and I never miss one of your pictures," Black wrote. "Would you please send me one of your photos. I would like to have one very much."

Lyon responded by sending not an official autographed head shot, but instead a snapshot of himself, wearing a sweater and slacks, straddling a tree stump, grinning. A thick branch protruded between Lyon's legs, curling slightly toward his face, unmistakably suggesting what would qualify as history's largest erect penis. And, from Lyon's huge smile to the way his left hand spanned the base of the branch, it seemed clear that he was in on the joke.

What Lyon apparently didn't know when he sent this dirty visual prank was that his adoring fan Caroline Black was just fourteen years old. Lyon was soon made aware of this fact by a letter from Caroline's father:

"Now, I don't know whether this is your idea of a practical joke or whether you make a practice of sending obscene photos to young girls, but whether it was intended for a joke or not has no bearing on the fact that this picture has aroused a curiosity in the mind of my daughter who heretofore was entirely innocent of even a thought of anything sexual.

"My wife wept for hours over this thing," Mr. Black added. "I have turned this picture over to [my attorney] and told him to prosecute to the fullest extent of the law. Furthermore, we are going to take this up with the women's clubs and request that they bar your pictures from this community."

Black's attorney, Bruce G. Sebille, then began a correspondence with Hughes's attorney Neil S. McCarthy. "The act of which Mr. Lyon has been guilty is of such a salacious and obscene nature, that I dislike exceedingly to see it publicized," Sebille wrote. "Mr. Black is of the opinion, however, that an opportunity has been offered to bring before the public the pernicious practices peculiar to the profession your client is engaged in." In a phone conversation, McCarthy had apparently suggested that someone had been playing a joke on Lyon by sending the picture—a claim that could be bolstered by another doc-

ument in Quarberg's files, which appears to be a draft of a letter sent to Ben Lyon from an unnamed "District Attorney of San Bernardino County," which may be a fake concocted as part of an elaborate scheme to scare the actor. However, Lyon did pose for this photograph, and Sebille, who was a real lawyer, remarked in his letter to McCarthy that Lyon's facial expression in the snapshot "does not impress me as that of a man violently agitated by his evident knowledge that his picture was being taken. His obscene posture appeared to afford him rather fatuous amusement."

Assuming this was a real scandal (or, at least, a legitimate attempt at blackmailing Lyon to ensure a payout from Hughes), it was the rare *Hell's Angels*–related event that Quarberg covered up rather than disseminated, under the assumption that all press would do Hughes some good. The final cost to produce *Hell's Angels* would, according to Hughes's own figures, swell to roughly $4 million before it was finished, after three years in production—roughly the same amount spent to make *Gone with the Wind*, a much longer film produced a decade later. As production dragged on, Hughes and Quarberg decided that their best strategy was not to downplay the profligacy of Hughes's pet project, but to play up the hugeness of ambition and resources possessed by this boy wonder who, over a period during which an increasing segment of the audience for movies would struggle financially, "sacrificed" a great portion of his personal fortune in order to make what was promised would be a giant entertainment for the masses—if he ever finished it.

WITH *HELL'S ANGELS* A full-time rival for her husband's attention, Ella Hughes's energy for maintaining a semblance of marriage began to flag. Annette Lummis got a wire from a friend of the family urging her to come to Los Angeles quick—Ella wanted to return to Houston and get a divorce.

"I think it was a heck of a life [for Ella], if you ask me," said Annette of her niece-in-law and close friend. "[Howard] was making *Hell's*

Angels, and he wasn't home at all. He would come home for two hours in the daytime and get a sandwich and then he would go out and fly."

Meanwhile, Ella retained close ties to her family in Houston, and in Houston, Howard's Hollywood activities were looked down upon. It was apparent to the Hughes Tool employees there that the head of their company in literal name only was, as one employee complained to Noah Dietrich "only interested in making movies. He's a spendthrift kid who's taking all the money out of this company and spending it on wild living in Hollywood."

In an attempt to find some kind of equivalent of the Houston society scene in which she felt comfortable, Ella began spending time in Pasadena, hotbed of what passed for "old money" in the still relatively newly developed area of Southern California. She joined the Junior League and made attempts to include her husband in her new social whirl. But Howard had his own social whirl, and didn't want the two to meet. "I think she didn't like the people [in Hollywood]," mused Aunt Annette, adding that Hughes, for his part, "did not want Ella to meet any of the movie people. I don't think he thought they were her equal." Given that Hughes's movie friends were mostly debauched party animals like Goulding and Neilan, it's no wonder he didn't want his refined wife to meet them.

"Ella was a pretty girl and well brought up, but she was lacking in the qualities that Howard favored after his marriage," Dietrich later observed. "She was far from the extroverted, voluptuous actresses his name was later connected with." This may have been true, but this statement, essentially implying that Ella wasn't sexy enough for Howard, belittles the serious cultural divide that had carved a fault line in the middle of a marriage whose stitching showed from the start. Though much had changed since the first years of the film industry's colonization of Hollywood, when street prostitution was rife and boardinghouses hung signs reading "No Movies" in their windows, the difference between a Houston society belle and the average actress, in terms of birth, breeding, and perceived class, was still vast.

Ella came from one of the most storied, wealthy families in Houston, a place where ideas of social standing were, as Annette's husband Fred put it, "all mixed up with Klan, prohibition, religion . . ." She would have been raised to believe that her destiny was to be wife to a rich man, which meant that while she might devote any free time she had to charity, her real job was to conform to a traditional ideal of a wife. Before their marriage had a chance, her husband had dragged Ella into a place and an industry that was doing much to threaten those Victorian ideas about men and women. The Hughes family had supported Howard's marriage to Ella in the hopes that it would serve as a link back to his past, but Howard wasn't interested in the past, only in realizing his giant dreams for the future.

The divorce agreement, dated October 28, 1929, stipulated that Ella would receive a total settlement of $1.25 million, disbursed over four years. Ella Rice Hughes's life in Hollywood officially ended in September 1930, almost a year after the settlement, with a single-sentence gossip item in the *Los Angeles Paper*. "The divorced wife of Howard Hughes, young Hollywood producer-millionaire, has returned to Houston." As far as the local media was concerned, once she ceased to be Mrs. Hughes, Ella's name was no longer worthy of mention. For his part, Hughes was never interested in offering much insight into the breakup. "What is there to say about it?" he said in 1948. "We got married and it didn't work, so we got a divorce."

Dietrich claims that Hughes immediately moved a "beautiful movie actress" into the house before anyone other than Howard and Ella knew that the pair had officially separated, but Hughes would later insist that he was not a playboy during this period. "I didn't go around with these girls while I was married," he told journalist Stephen White in 1954. When asked by White directly if the separation was precipitated by his involvement with other women, Hughes responded, "Absolutely not. I neglected her—I wasn't in love with her—so we called it off." He added, "I have been accused of practically everything, but the one thing I have not been accused of is cheating on this girl [Ella]." Nearly

thirty years after the fact, he was adamant that he had been faithful to his wife during the period of their cohabitation—yet phrased it less like "I didn't do it" and more like "You can't pin it on me."

Whatever wild oats Hughes did or did not manage to sow during or after his first marriage effectively ended, within months of Ella's return to Houston, Howard Hughes was seriously involved with the woman who many expected would become his second wife.

PART II

BILLIE AND JEAN, 1928-1936

CHAPTER 4

THE GIRL WITH THE SILVER HAIR

While Will Hays had arrived in Hollywood in 1922, and first established a Production Code with the intention of regulating on-screen morality in 1930, he was not able to mount a fully functional and effectively prohibitive censorship system until 1934. The years between 1930 and 1934, called the Pre-Code Era, are sometimes remembered as an anything-goes free-for-all when screens were full of sex and degradation. In fact, the demarcation between pre-Code and post-Code cinema was less like a switch flip than a slow fade. Filmmakers who intended to push the envelope had plenty of trouble with the Hays Office in the late 1920s and early 1930s, as the censors made increasingly toothsome efforts to regulate the perception of "sin" on-screen throughout the early sound period. While there were exceptions (such as glimpses of Clara Bow's bare breasts in 1927's *Wings*), for the most part sex and nudity on-screen were hardly explicit even before the Code took hold; cinematic eroticism was mostly prologue and epilogue, inherently chaste images implying that something was about to happen or that it had happened already—it was Greta Garbo, swooning while leaning against a tree that reminded her of her lover John Gilbert in *A Woman of Affairs*, or Billie Dove, throwing off her fur and disappearing out of frame while the camera focused on the discarded garment, in *Adoration*.

Billie Dove was the name adopted by Lillian Bohny, the Washington

Heights dreamer who finally arrived in Hollywood in 1922 and in a few years would become perhaps the most objectified American actress in movies—even more so than Garbo, because unlike that enigmatic Swede, Dove's sexuality was neither exotic nor ambiguous. Nicknamed the "American Beauty" after the title of one of her films, Billie was promoted as the most gorgeous woman of her time. Late in life, sixty years after her retirement, Dove was sheepish about her reputation, without denying its accuracy: "It sounds like I'm bragging, but that's what they said," she admitted.

Certainly, unlike Garbo, there was nothing about Dove that seemed subversive. Her round face—the perfect canvas for the dark, defining eye and lip makeup required by film stocks of the silent era—was anchored by a long, slightly underturned nose; her body was neither overly voluptuous nor wraith-thin. She never really looked young, and she vanished from the screen before she looked old. Though Billie sometimes played tragic figures, and often had to feign peril on-screen, in photographs she almost always smiled, more often than not showing teeth. She looked like she was having fun. Maybe that's why singer Billie Holiday, born Eleanora Fagan in 1915, sought solace from a troubled childhood in Dove's films, eventually taking the first half of her stage name in tribute to her favorite movie star.

Holiday wasn't alone. By the end of the silent era, Dove was regularly receiving 37,000 fan letters a month, a statistic that she was happy to cite well into her nineties, as it was as valuable a measure of popularity then as an actress's number of Instagram followers would be now. Like today's social media stars, much of Dove's celebrity was based on the supposedly superficial appeal of her looks ("supposedly superficial" because then, now, and in any era, popular beauty standards have much to say about a culture's values and ideals). It was presumed that the fans didn't love Dove because she could act, and even if she could, the journalists of her day seemed to be too stunned by her beauty to notice. One profile after another took note of attributes like her "large, alluring eyes, the small, perfect nose and mouth, and the silver-flecked long bob." "Her brown hair started to turn gray when she was 13,"

explained Sidney Skolsky in his "Tintype" column on Dove.[1] "She has never dyed it and never will. It's very becoming." Skolsky's tintypes were generally structured as love letters compiling press release–style data about a star with a couple of "intimate" details designed to suggest to the uninitiated that Skolsky had gotten to know his subject very well indeed. In his tintype on Dove, in addition to praising the actress's natural hair color, Skolsky added his approval of another Dove "imperfection": "She has a mole on the lower part of her back. Going mole hunting on Dove is a pleasure."

Before she had had a chance to develop herself as an actress, Dove was initially relegated to roles that sought only to exploit her unusual beauty. She was slotted into the action films of her husband, director Irvin Willat, as an eye-candy damsel-in-distress, because it was easy for her to do and she was there. Only later in her career did Dove get a chance to star in films that tried to speak to her female fans.

Dove believed she had manifested her stardom (which lasted for about a decade of her nearly century-long life) by looking up at the screen and wishing that it would happen, and she believed that most of her audience was composed of young women doing the same thing. "Did you ever watch a girl fan at the theater?" Dove asked a journalist at the peak of her career. "She puts herself in the place of the heroine. She imagines what she would say under the same circumstances. I know because I was once a fan." She was acutely aware of the powerful influence her image could exert, and even once that influence had waned, she was careful about her self-presentation.

In her post-Hollywood years, there were two subjects the ever image-conscious Billie Dove supposedly didn't like to talk about. First was her age. (Until her death in 1997, Dove kept a scrapbook of clippings, mostly from the late-1920s peak of her fame, and she scrupulously marked those documents to strike suggestions about her birth date that she didn't like, suggesting that rumors of her touchiness

[1] Skolsky's "Tintype" column began when he was a Broadway reporter at the New York *Sun* and ran for decades, in his home newspapers (he put in time at the New York *Daily News* and *Daily Mirror*, as well as the *New York Post*) and syndicated nationally.

about that subject were accurate.[2]) The other touchy subject was her romantic relationship with Howard Hughes, which began while both were unhappily married to other people, and fell apart under mysterious circumstances about three years later. Her resistance to discussing Hughes broke down toward the end of her life. In the early 1990s, she still owned a sofa that Hughes had given her during their relationship, and once, while being interviewed a few years before she died, tears came to her eyes as she sat on that couch, reminiscing about their time together.

When Howard Hughes and Billie Dove were together, in the late 1920s and early 1930s, she was essentially the Elizabeth Taylor of her generation. Dove and Taylor were both considered their era's most beautiful women in movies, if not in the world, but it wasn't just her beauty that made Dove a Taylor-esque target of fascination. In divorcing her husband to take up with Hughes, Dove predated Liz's high-profile partner-swapping drama, too. In the analogy to Taylor's many husbands, Hughes would at first seem to have been the Mike Todd—the rich guy who swooped in and rescued Dove from a passion-free marriage—but the mythology surrounding their relationship has positioned Hughes in Dove's life as her Richard Burton: the true love that got away for reasons that seemed inconsequential decades later, when he was dead and she was alone.

This is a glowing mythologization of a romance that ended amid a failed professional partnership between the lovers. The Willat-Dove-Hughes triangle was not Hollywood's first or biggest divorce scandal (the carefully managed union of Mary Pickford and Douglas Fairbanks beat them to it by about a decade), but the pairing of "most beautiful

[2] Dove was probably born between 1900 and 1904. In handwritten notes on a copy of a biographical article about her written by DeWitt Bodeen in the magazine *Films in Review*, which stated her birth year as 1901, Dove crossed out the year and wrote "Mother and Father hadn't met yet," but she did not supply her "correct" birth year. Billie Dove's annotated copy of DeWitt Bodeen, "Billie Dove, An American Beauty," in: *Films in Review* 30 (1979): 193–208. According to the 1920 census, Dove was born in 1903, but she also crossed out this year in a studio bio kept in her personal files. Both documents found in the Billie Dove collection.

girl" and "richest boy" was an irresistible one in the eyes of the movie media—which Hughes and his men attempted to manipulate to the advantage of both star and star-maker. Their relationship spanned the period in which Hughes would finally unveil *Hell's Angels* and begin to demonstrate his masterful understanding of Hollywood publicity. Its end essentially coincided with the end of Dove's movie career.

BILLIE HAD COME TO Hollywood from Broadway's Ziegfeld Follies, where she was promoted as "The Girl in the Hoop." This was a literal description of her job. Several illustrated advertisements for the Follies in 1919 and 1920 showed a woman in profile or seen from behind, posed against a circle. In one, the scantily clad miss brings an exotic bird in for a kiss; in another, a fully naked woman holds a champagne glass aloft from her perch on a hoop on the inside curve of the moon, while the man in the moon smirks. This latter image echoed Dove's big moment in the show. She would sit inside a circular frame, in which she would be lifted with pulleys, so that she'd hover over the stage, like a bird in a cage, while the leading man sang a love song as if howling up at the moon. Lillian's stage name seems to have preceded her big, avian break; later in life, she explained that she had combined "Billie" with "Dove" because "one counters the other. Dove takes the boyishness out of Billie, and Billie takes the sweetness from Dove." The change was done with movie stardom on her mind: "It was a short name, and when you put it on the marquee, you had Billie Dove there and still had room for the title of the picture." But sitting up in the hoop felt a long way from being up on the screen, and Billie's opportunity to show her talents was limited. As she recalled it, "I just sat up there smiling."

Billie was never happy as a showgirl. When she first met Follies impresario Florenz Ziegfeld, Billie remembered, "he took it for granted that I wanted to be in the show. He didn't even ask me. He just said, 'Well, now, you go two doors to your right. You'll find a door there saying "Ned Wayburn." You go in there and he will be there with a

little rod in his hand. There'll be girls walking in a circle and they will be learning how to do the Ziegfeld walk. So you'll just join them.'"

She was considered one of his "special girls," which meant she wore an individualized costume, and occasionally got to deliver an actual line. And as she kept threatening to quit, Ziegfeld kept raising her salary in order to keep her. But floating above the stage on the hoop was not like having your face suspended on-screen, and that was still where she was determined to see herself. So she did some extra work—producers in New York were always in need of pretty girls for crowd scenes—and that led to silent comedian Johnny Hines asking her to star with him in a one-reel short film. More work followed in equally minor movies. But the ball was rolling now, and it kept on going concurrent with Billie's Follies gig, until 1922, when she was offered a contract by Metro Pictures Corporation in Hollywood.

The urban legend about the flight of Billie Dove from the Ziegfeld stage to Hollywood sound stages holds that Dove was having an affair with Florenz Ziegfeld, and that Billie Burke, Ziegfeld's Broadway actress wife, arranged Dove's first studio contract in order to ensure her rival would be shipped off to Los Angeles. Dove denied this vehemently, saying that not only did she not sleep with Florenz Ziegfeld, but she refused to sleep with anyone. "Growing up, I knew nothing about sex, nothing at all," Dove explained. She was so naive, she said, that when she first began menstruating, "I thought I was dying." Suddenly she was sharing a dressing room with sexually active chorus girls, who kissed-and-told nightly. After listening to these stories, at first wide-eyed and then wise, Billie decided to remain a virgin until she married.

Dove would credit her hop to Hollywood to Joe Engel, a Metro executive who used to come to the Follies regularly and take her out for drinks after the show. Once she was in Hollywood, Engel admitted he was in love with Billie. The problem was, as Engel told her, "I promised my mother, while she was alive, I would only marry a Jewish girl." Billie, who had been oblivious to Engel's affections, couldn't have been less disappointed.

Billie's second Hollywood film shot on location off the coast of San Francisco. *All the Brothers Were Valiant* was a seafaring adventure, with Malcolm McGregor and Lon Chaney as the brothers and Billie as the girl. Every morning at four the cast and crew would meet at the docks and board a real whaling ship, which would take them out into the middle of the ocean for the shoot day. Literally at sea, twenty-ish Billie caught the eye of her director, Irvin Willat. A former film editor, Willat had made a name for himself as a "man's director" with movies like the 1919 Harry Houdini star vehicle *The Grim Game*, which featured a midair collision between two airplanes. One of these planes was flown on-screen by Willat himself, with an actor hanging from the plane by a rope. "We didn't kill him," Willat said. "But he was red as a flame."

The way Billie described it, Willat's courtship was more like harassment. On the long boat ride to location, and stranded all day at sea, she couldn't escape him. "All the way out there and all the way back and between scenes, all he would say was, 'Marry me, marry me, marry me, marry me, marry me.' That's all I heard, and we were gone for an entire month. Finally, I said yes, just to get him to shut up."

Before the ceremony in October 1923, Willat suggested they both see a doctor, "to make sure that we're okay to get married." Billie's doctor had been recommended to her by Joe Engel. A few days later, Billie ran into Engel, who told her he was "perplexed": the doctor had told him that Billie really was the virgin she claimed to be. So much for doctor-patient confidentiality.

The marriage caused an irreparable rift between Dove and Engel, which resulted in the termination of her contract at Metro. Luckily, her new husband was able to cast her in his films at Paramount. In Willat's 1924 picture *Wanderer of the Wasteland*, Dove became just the third actress to star in a feature shot in Technicolor.

Willat could be a taskmaster, but Billie admired his work, comparing him to John Ford, for whom she'd star in *The Fighting Heart* in 1925. However, Willat's repertoire was limited (as Billie put it, "He did Westerns and boat pictures"), and under her husband's thumb, Billie

was limited to being a man's film heroine. When Douglas Fairbanks called and asked her to star in his next adventure movie, she jumped at the chance because it was Fairbanks—the biggest star around— but also because *The Black Pirate* would be shot in Technicolor, and Dove's beauty had already proven to be a good match for the medium. Yet once again, the part of the damsel in distress was typically unchallenging. As Billie put it, "I just stood around and looked scared."

Still, *The Black Pirate* made Billie a bona fide star. Every studio wanted to sign her, including MGM, which had absorbed Metro and had swiftly become the place where every star wanted to be. Billie looked at MGM's roster and saw Norma Shearer, Joan Crawford— nothing but competition for the roles she wanted to play—so she signed instead with First National, where she'd only have to compete with Colleen Moore. That was okay, because she liked Colleen Moore, and they contrasted well. Unlike Moore, whose biggest hit was the flapper soap *Flaming Youth*, Billie wasn't a comedienne or a girlish, flat-chested disrupter of gender norms. Curvaceous and sensuous, now Dove was being actively promoted as "the most beautiful woman in the world." But Lois Weber made her an actress.

In 1915, Lois Weber had been Universal's star director. Her image as a rather dowdy middle-aged married woman served as convenient cover, taking the edge off her tendency to use her films to tackle controversial topics such as capital punishment (*The People vs. John Doe*), birth control (*The Hand That Rocks the Cradle*), and poverty (*The Blot*). With Weber as their figurehead, Universal proudly promoted themselves as a women-friendly workplace. Off that success, Weber was able to launch her own personal production company, Lois Weber Productions.

The Blot would be Weber's final, self-produced film. Within a year of its 1921 release, her longtime marriage to actor-director-producer Phillips Smalley, with whom she had been co-credited on many of her directorial efforts, would break up. Weber cited her husband's "habitual intemperance" as the cause. When pressed, Lois admitted that she and Smalley had "not lived together as man and wife for sev-

eral years," because "our philosophies of life made the marital relation-
ship impossible."

It was not easy for an independently minded writer-director of any
gender to thrive in an evolving Hollywood, but Lois Weber had the
added challenge of being a female filmmaker newly divorced from the
male partner with whom she had shared credit. Rupert Hughes had
advocated for men to "get rid of" wives they had lost interest in with
ease, but the sexual revolution he had promoted was not equal oppor-
tunity: Lois Weber couldn't cavalierly dispose of her husband without
facing career consequences. A woman who directed in partnership
with her husband could be perceived as merely a helpful wife, not the
threat to gender norms that she'd be as a divorced woman, continu-
ing the same work on her own. As the film industry became more
corporatized and vertically integrated, effectively marginalizing many
female writers and directors who had worked during the teens, Weber
was determined not to let it happen to her. After her production com-
pany fell apart, she returned to Universal to remake one of her early
silent films, but it was an unsatisfactory experience that left her vowing
to quit the business. She further worried that in Will Hays's Holly-
wood there was no place for an independent artist with something to
say—never mind a female filmmaker whose movies asked real ques-
tions about the world she lived in. "The producers select the stories,
select the cast, tell you how much you can pay for a picture and how
long you can have to make it in," Weber protested. "All this could be
borne. But when they tell you that they also will cut your picture, that
is too much."

Eighteen months passed before Weber made another film, and
during that time, she reportedly suffered from crippling depression. She
emerged in 1925, when she was hired back at Universal to run a new
story department dedicated to creating big-budget movies. This went
well, and Weber was allowed to direct two films of her own, *The Mar-
riage Clause* and *Sensation Seekers*. Both of these would star Billie Dove.

Weber had spent the previous few years contemplating the decreas-
ing variety of female types depicted in American films. "The real

American girl is not a flapper," the director declared. The precocious party girls who dominated screens, Weber said, were nothing but "cute little dolls dressed up in clothes that they do not know how to wear."[3] The women Weber knew were modern and sophisticated, but otherwise had little in common with the carelessly consumerist and arguably amoral characters she saw on-screen. She was frustrated that movies were putting forth the idea that liberation meant that women were free to drink and smoke and dance and shop, so as to better suit a male fantasy of woman unchained. "The modern girl," Weber argued, "does not demand jazz parties, cocktails and late hours nearly as much as she demands freedom of thought and action."

Billie's favorite film of her career, released in 1926, was Weber's *The Marriage Clause*. The plot has Billie playing an actress who falls in love with her (male) director, but their happiness is wrecked by a scheming, exploitative producer, who manipulates the actress into signing a contract forbidding her to marry. The actress finds that stardom reached on the terms of a man who has essentially made her his property and prisoner, and at the expense of personal freedom and happiness, is so suffocating that it makes her physically sick. Weber's critique of Hollywood, especially as it related to its female workers, was barely veiled: what's the point of winning at a game designed to benefit someone else, and that requires you to sacrifice your soul in order to play it?

Actress and director were on the same page. Up until now, Billie's purpose in movies had been to embody a female ideal of "glamour" that girl fans ate up, and which also played to the fantasies of men. At the end of *The Marriage Clause*, when Billie's character is dying of a broken heart, "I didn't want to look glamorous," Dove remembered. "I wanted to look ill." Weber agreed, and shot Dove with no beauty makeup, and, in fact, dark lines penciled in under her eyes. It was the first time a director not only cared about what Dove thought about her

[3] A doll-like young girl dressed up in a comically overly sophisticated costume is literally the plot of the film that started the trend, *The Flapper*.

character, but appreciated her ability to convey something on-screen other than beauty and desirability.

The following year, Weber and Dove reteamed to make *Sensation Seekers*. Here Billie played Egypt, a "liberated woman" of the Jazz Age who learns to reject cheap thrills and embrace a less selfish, more spiritual life. Egypt was a socialite and not an actress, but again Dove's character would connect back to her life in Hollywood. Weber was using Dove, one of the most glamorous products of the late-silent-era star system, to critique the shallow models of womanhood that Hollywood presented fetishistically, and to suggest that even the most beautiful girl in the world could be more than "just" a beauty. Both *Marriage Clause* and *Sensation Seekers* posit that a happy ending includes a male savior and domesticity, but Weber was not a traditionalist suggesting that women were meant to serve men. She simply believed you could be a modern girl with a desire for independence and freedom of thought without conforming to the movie image of modernity, which more often than not was of a flapper either preoccupied with frivolity or striving to submit herself to a sexual economy that primarily benefited men.

Weber's Billie Dove movies, which were championed effusively in the local industry trade press, transformed the way that Hollywood saw Dove, and suddenly studios wanted her for something other than submissive, token female parts in action films like the ones made by her husband. Billie began starring as a true leading lady, playing in the late silent era the kinds of woman-in-trouble-in-exotic-locations roles that Marlene Dietrich and Joan Crawford would dominate in the 1930s. In *The Love Mart* (1927), Billie played a woman mistakenly believed to be a "quadroon" and subsequently sold into slavery in nineteenth-century New Orleans. She transitioned to talking pictures relatively seamlessly, beginning with the partial-sound films *Careers* and *Adoration*, both of which featured Dove as wives wrongly suspected of infidelity.

The respect that Billie had earned with her performances for Lois Weber, and the experience of being included in the process of making

films about women who chafed against expectations to find and grab
the lives that were right for them—all of this might have contributed
to Dove's increasing dissatisfaction in her marriage to Irvin Willat.
But Willat contributed, too. Letting the line blur between director and
husband, he was obsessed with maintaining Billie's image as a docile
object of desire. To that end, he wouldn't let her smoke cigarettes. That
meant something different in the 1920s than it would today; back then,
smoking was a significant way a young woman showed that she was
modern, and to be barred from doing so by your paternalistic husband
was seriously stifling. In short, "He tried to run my life," Billie would
explain. When Willat would become particularly overbearing, Billie
would leave for a few nights, and then her husband "would beg me to
return. I did so until the last time, when we separated for good."

After the separation, Billie moved in with her mother. Still just in
her mid-twenties, the movie star submitted to a social whirl led by her
best friend, Marion Davies. At dinners at the opulent Hearst Castle,
where William Randolph Hearst would attempt to regulate his mis-
tress Marion's intake of booze, Billie and Marion would sneak off to
the powder room, "because Marion had a special butler who always
stocked it with champagne."

Billie was too famous to get tipsy just anywhere. Her gorgeous
face shone out from the covers of movie magazines; if she tried to
go out shopping she was mobbed; the postmaster of Burbank certi-
fied that she received more than a thousand letters each day. Women
were desperate to look like her, to the extent that she popularized a
new haircut called the "shingle," which was sort of like a bob gone
extreme, invented, Billie said, when she went to a man's barbershop
and asked, "Would you mind cutting the back of my hair like you cut
a man's, only not that short?"

She and her friends moved in packs, and only went to places where
there would be no outsiders, no autograph hounds. One of those places
was the Biltmore Hotel in downtown Los Angeles, an opulent palace
full of crystal chandeliers, dark wood beams, and plush gold carpets.
More grandiose than the Alexandria or even the Ambassador, the Bilt-

more became known for its in-house speakeasy, called the Gold Room after the color of its satin curtains and painted tin ceiling, and complete with a secret door through which VIP clientele like Billie and Marion could slip in and out surreptitiously. One night, Davies pushed through the crowd to find her girlfriend and whisper exciting news in her ear.

"Billie, Howard Hughes asked to meet you!"[4]

Hughes was then the talk of Hollywood. Everyone was curious about this movie he was working on. Everyone was predicting he'd lose millions of dollars—of his own money, no less. Billie was excited to make his acquaintance.

Hughes did not make a stellar first impression. Billie was accustomed to lively conversation. Through Marion's nephew, Charles Lederer, Dove had been inducted into the Algonquin Roundtable set; she was good friends with Dorothy Parker, and Scott and Zelda Fitzgerald had been guests at her and Irvin's house parties, crawling in on their hands and knees when they arrived late, after the group had already started watching a movie. And Billie was a movie star—people usually tried to impress her. Howard didn't.

"He would just glare at me," she recalled. "He didn't talk or anything." To Billie, Howard seemed like "a zombie."

And soon he became a stalker. Virtually every time Billie left the house, wherever she went, Howard ended up there, too. "Knowing him later, I have an idea he had me cased," Dove said. "Every time I would be at a place where there was dancing, pretty soon the door would open and there would stand Howard. He'd look around, spot the table I was

<hr />

[4] Dove is fuzzy on dates. In a deposition dated July 23, 1981, she acknowledged not being able to remember specific dates fifty years after the fact, but noted that she was certain she and Hughes were together when the stock market crashed in October 1929, and believed they were together for three years but had broken up by the time she shot her two Hughes-produced films. The first of those films was released in October 1931. In her interview with Ankerich, she says she met Howard in late 1929—which, importantly, would have been after her separation from Willat—and that their relationship was over in early 1932. News reports suggest their professional relationship was dissolved in the spring of 1932. In her interview with Drew, she mentions more than once that she and Howard were together for "three and a half years." Analyzing all available information, I believe they became lovers in the fall of 1928 and split up in the early spring of 1932.

at, make a bee-line for me and pull up a chair and stay the whole evening."

Howard's persistence worked, and eventually Billie fell into what she called "deep love." They started spending whatever free time they could steal aboard Howard's yacht, which they'd sail to Catalina. On the island there would be two horses waiting for them, and they'd ride off and get lost. Back in Los Angeles, in the middle of the night, Howard would call Reggie Callow, the assistant director of *Hell's Angels*, and ask him to send a projectionist over to meet them at the screening room for a 3 A.M. movie.

The intimacy they developed spending all this time alone together helped the relationship move fast. "Howard wanted to get married right away," Billie recalled. "We were very much in love, but he was only halfway through his divorce, and I was still Mrs. Irvin Willat." Hughes started looking for ways to nudge both disentanglements along.

Willat knew Howard Hughes. Willat had first met him while visiting Houston, before Hughes started making his own movies. "I think I probably had something to do with interesting or at least stimulating Howard in pictures," Willat later remembered. According to him, once the Texan had moved to Los Angeles, Hughes would come to his house in Hollywood "and talk to me by the hour" about the motion picture business. Willat was under the mistaken impression that Howard's father had given him "something like twenty million dollars with which to play with the motion picture business." Believing Hughes had disposable cash, Willat entertained his question-and-answer sessions, hoping Howard would bring him into some kind of production venture, or at least pay him to direct a movie. Hughes never did.

According to Willat's son Boyd, it was during these living room film school sessions that Hughes met Dove, long before the introduction by Davies that Dove herself described. Acknowledging that "Dad and Billie were already in trouble," Boyd would insist that the married couple's separation did not predate Dove's involvement with Hughes. "Howard Hughes lured her," he said in 1998.

Though his story of how the relationship began differs from Dove's, Boyd Willat confirmed Billie's account of what happened next. When Irvin found out his wife was involved with Hughes, Willat accepted a payoff to relinquish his wife to the competition.

"You have to understand—Billie and my father were going to make movies together forever," Boyd Willat said in defense of his father. "That was my father's plan. She was, in a sense, his livelihood." And by that point, "The Hughes people were known for making payoffs." Boyd Willat said the negotiations were probably made not by his father, but by his father's brothers, but he doesn't argue with the result: for agreeing to divorce Billie Dove, Irvin Willat was paid $350,000, in cash, delivered all at once in a valise.

When Billie heard about this deal, it broke her heart. "I was very much against the idea of paying money to Irvin," she said, "I begged Howard not to do it, but he did." Acknowledging that $350,000 is "a hell of a lot of money, especially in those days," Dove never forgave her ex-husband for accepting even such a high price to let her go. "I felt like I'd been bought and sold." According to Boyd Willat, it was not a cavalier thing for his father to accept this payment, and Irvin loved Dove until the day he died. But accept it he did. "After that," Billie added, "I lost all the respect I had for Irvin Willat." Remarkably, all of Billie's anger was reserved for the seller, and not the buyer. "Howard and I were still very much in love," she recalled.

The next step was to legally obtain her divorce, so they could marry. Until California reformed its divorce law in 1969 to allow "no-fault" divorces based on "irreconcilable differences," the only way to legally end a marriage in the state was for one spouse to sue the other for breaking the bonds of matrimony. At least one public hearing or trial would ensue, and if through that process the divorce was granted, after the final court date the plaintiff would be able to file an interlocutory decree, which would start the clock on a one-year waiting period. Even after the year had passed, the divorce would be final only if the plaintiff went to court to receive a final decree. Because this process was so convoluted and took so long, many people who were anxious to be rid

of their spouses traveled to Nevada, where the filing process was much simpler, and could begin after the plaintiff had been in residency in the state for just six weeks. This would have been the standard way of doing things for a movie star looking to quickly trade one husband for another, so Billie told Howard she'd go to Las Vegas, where she could get her divorce after just six weeks in residence.

Howard responded, "What, you go to Las Vegas? Without me?" It would have been unacceptable—unthinkable—for him to let her out of his sight for a month and a half, so Hughes came up with an alternate, extremely unconventional plan. He told Billie to instruct her maid to get her "a dress, very plain and long, something that a farmer's wife would wear, and get some horn-rimmed glasses and some little thing for the top of your head." Billie didn't question what for, she just told her maid to do it, and when the day came, she put the workaday outfit on. Howard picked her up, and he too was wearing "ordinary clothes." They boarded a train, keeping their distance from one another until they began to pull away from the station, so that if anyone recognized either of them through their normal-person disguises, they wouldn't connect one to another and blow the plan. Not that Billie knew the plan; they were on their way before he told her, "We're going to Nevada, but you're not going to Las Vegas."

"After we got off the train," Billie recalled, "we drove for miles and miles and miles." Someone on Howard's team had arranged for the couple to board as workers on a farm. There, incognito and under assumed names, the lovers would pose as brother and sister. They were housed not in the main farmhouse, but in a structure that Billie remembered as "a funny-looking thing, not half as large as your kitchen probably. I think maybe it was built to store food for the winter and then they abandoned it." It was a concrete rectangle, with two rooms—separate bedrooms for each "sibling"—a doorway unoccupied by a door, and holes cut out for windows, but no glass. If either of the lovers had been hoping for a romantic, rural adventure, they didn't find it: Billie and Howard, trapped in the fiction that they were down-on-their-luck siblings, were barely able to spend any time together.

Howard went out into the fields with the men all day, and Billie stayed in the main house with the housewife, helping with the kitchen work. Even though she was the one who needed the fast divorce, Billie was merely along for the ride of Howard's preposterous plan; she just made an effort to keep her head down and do what she was told. "I never asked any questions of the farmer and his wife with whom we were staying."

Nor did she evidently ask questions of Howard, who had cooked up this cockamamie scheme and put it into motion without realizing that Billie would be hard-pressed to prove the residency required for a quick divorce in Nevada if she spent the six weeks boarding on a farm under an assumed identity. It was all for nothing: according to Dove, they were there only a few days before they called it off.[5] "We didn't stay because it didn't work out the way we wanted. We did it all wrong and it would be another year before I got my final divorce."

By then, Howard's fame would rival Billie's, thanks to *Hell's Angels*—a movie that gave Hughes a taste for the kind of star-making that Billie had left Willat to avoid.

[5] It's difficult to know exactly when the masquerade in rural Nevada happened because Billie Dove is the only detailed source on the matter and she is not at all reliable on dates. In many interviews, she noted that she couldn't remember the specific year when anything happened. I assume the aborted attempt at Nevada residency took place in the spring of 1930, before the *Hell's Angels* premiere, because her court date where she sued Willat for divorce was in July 1930, and that court date happened only because the Nevada plan didn't work. She also commented in an interview printed in *Screenland* magazine in November 1931 that she had been "a free woman for a month," suggesting her divorce was finalized in late summer 1931.

A BODY LIKE A DUSTPAN

The screen test was a rush job, its subject hustled into costume and before the camera before she had a chance to think about what was happening. She wore a borrowed white satin gown, stretched to its horizontal limit by the bell of her hips. Her face puffed out around a pout, like she had recently been crying, or drinking. Worst of all, her hair was the same color as the dress—a cloud of ashes atop a girl whose stardom seemed to be dead on arrival to the jaded men who filled the room. The girl had been in movies—playing small parts, breezing through the background—but she had never been the sole focus of a camera's attention. When a spotlight was turned onto her face, she couldn't help but squint.

Joseph Moncure March, a screenwriter who had been called in to rescue the movie she was auditioning for, stood on the sidelines, watching what was shaping up to be the kind of epic failure that he and the boys would laugh over for days. Up walked James Whale, a British director who had been hired to supervise the performances of the new dialogue that March was writing.

The cinematographer shooting the test complained to Whale that the aspiring actress, a bundle of nerves, couldn't stand still. Whale tried to calm her down in a number of ways, and finally suggested she brace one arm against the doorjamb to steady herself, which at least allowed her to get through the test.

Whale asked March what he thought of this girl, this Jean Harlow. March stared and said, "She has a shape like a dust pan."

"Yes, she does rather," said Whale.

The next day, Howard Hughes would cast Jean Harlow in *Hell's Angels*, and sign her to a personal contract, but no one who saw her screen test really understood why. Watching the test from the sidelines, March thought, "There's a girl who has absolutely nothing."

Jean Harlow would have agreed with him. She was a nineteen-year-old divorcee who had been desultorily working as an extra to please her overbearing mother, who was insistent that "the Baby," as everyone called Harlow, find the stardom that the mother herself had been distracted away from by motherhood. Jean Harlow had no confidence in her acting talent, but she was a realist: she knew that people liked to look at her, and she knew that letting them do it would make her mother happy. And making her mother happy made Jean happy, too, for a while.

IN FEBRUARY 1929, AFTER spending $2 million to get a silent version of his aviation epic in the can, Howard Hughes decided to reshoot *Hell's Angels* as a talkie.

By then the film had burned through three directors, and the fourth—Hughes—had dragged production out as long as possible, in search of perfection. Lincoln Quarberg had spent more than a year answering requests from all manner of publications, as far afield as Japan and the Philippines, for stills and information regarding *Hell's Angels*. As late as June 1929, he couldn't comply with a request from *Sportsman Pilot* magazine for a synopsis of *Hell's Angels*. "Film still far from completed," he wired. "Making important changes now in editing and cutting . . ." Foremost among those "important changes" was the recasting and reshaping of the female lead.

While Hughes tinkered with *Hell's Angels'* cut, the film industry transitioned from the silent era to the early talkie era, and by 1929 it would have been foolish to release a fully silent feature and expect to

make even a fraction of the production budget back, especially as an independent producer, because movie theaters simply didn't want to rent and project silent product. This made the remaking of *Hell's Angels* a simple business decision. Having already gotten what he wanted from the aerial footage, Hughes was able to relinquish some control, hiring director Whale to work with the actors on the new dialogue scenes. Now all he needed was dialogue.

How had he strung his cast and crew along to this point, and why did they keep coming back to work on a movie that gave all appearances of not wanting to be born? The simple answer is that money talked and Hughes had enough of it so that few would tell him no. But there was also something about Hughes himself. He had star quality.

Joseph March had met Hughes after hearing stories about the fool millionaire boy who was pouring his fortune into a folly. "Nobody had seen the picture," the screenwriter recalled, "but the rumor was that it had all the makings of a super colossal bust." March, a New York intellectual newly arrived in Hollywood, had been around enough rich phonies to be cynical, but upon encountering the Texan he immediately understood why people remained loyal to Hughes, and did his bidding even against their better instincts. Hughes's eyes sucked him in. "They were brown and lustrous and limpid like the eyes of a young fawn or a doe," March recalled. "They gave his face a look of such guileless innocence that you couldn't believe the brain behind them had ever thought anything devious or malicious." Added the writer, "He had that rare and mysterious quality called charisma, which made people overlook his defects."

"I want you to look at a picture I've made, and tell me what you think of it," Hughes said to March. March agreed to watch the three-hour cut of Howard's vanity project.

"What I saw on the screen for the first hour was so bad it was embarrassing," March wrote later. "Cheap slapstick comedy, insipid love scenes, characters without any character and a wavering storyline that lacked dramatic impact. It was silent Hollywood at its worst. I had al-

ready decided that I didn't want to have anything to do with this film, and then the air sequences began. They were magnificent."

March was so inspired by the best of the film that he agreed to come on and rewrite the worst of it. Always conceived as a love triangle between two buddy pilots and the Englishwoman they both fall for, the first version of *Hell's Angels* had starred the beautiful, but decidedly not English, Swedish actress Greta Nissen. March crafted a completely new female protagonist, one inspired in part by Ernest Hemingway's Lady Brett Ashley in *The Sun Also Rises*, and described by March as "a beautiful, upper-class slut with a talent for fornication who got tired of her conquests very quickly and left a trail of shattered males in her perfumed wake." This was the role that would turn Jean Harlow from a "nothing" into the first blond-bombshell movie star.

THERE WERE TWO JEAN Harlows, and they both first arrived in Hollywood in 1923. The twelve-year-old who would eventually become a legend was then going by her birth name, Harlean Carpenter. Harlean had been brought west by her mother, the original Jean Harlow; "Harlean" had been the mother's first attempt to turn her daughter into her namesake, by contracting "Harlow" and "Jean." Recently divorced from Harlean's father, a Kansas City dentist, this original Jean Harlow now decided it was time to claim the stardom that she was sure was her birthright.

But by the time Jean Harlow ditched her husband and landed with her daughter in a single rented room in a Sunset Boulevard mansion, she was thirty-four years old—not exactly a prime age for a would-be ingenue in the mid-1920s. Two years passed, and Jean's dwindling finances forced a move first to a less lustrous address in Hollywood, and then back to Kansas City. Jean moved in with her well-to-do parents, and fourteen-year-old Harlean was sent to boarding school, and then summer camp, where in 1926 she contracted scarlet fever. That fall, on

a double date, Harlean met Chuck McGrew, an orphan with a sizable trust fund. The two youngsters fell in love at first sight.

Harlow didn't approve of her daughter's new love; McGrew was rich, but he wasn't rich *enough*. Jean was involved with a married man named Marino Bello, who agreed that the teenager should make it a priority to marry for more money than Chuck McGrew had. By early 1927, Bello had divorced his wife and married Harlean's mother. Nine months later, in one of the few instances when the daughter went against her mother's orders, Harlean and Chuck snuck off and had their own wedding. A few months after that, McGrew turned twenty-one and received the first six-figure installment of his inheritance.

The newlyweds did not handle their financial independence particularly responsibly. It was 1927. They were young, in love, and frequently drunk. And Harlean wasn't fully independent, anyway, because her mother was always hanging around, trying to control her life. In an effort to have his wife to himself, Chuck booked passage for the couple on a cruise from New York to Los Angeles, through the Panama Canal. Once arrived, McGrew bought a house in Beverly Hills, and he and Harlean began introducing themselves to the locals by hosting parties.

At the end of one daytime gathering at their house, Harlean hospitably provided a ride to one of her guests, Rosalie Roy, an actress who had an appointment at 20th Century Fox but no car in which to get there. Living the life of leisure, Harlean didn't have anywhere to be, so she offered to wait for Rosalie and drive her home when she was finished with her meeting. When Rosalie exited the building, several male executives walked out with her and noticed Harlean leaning against her car. Stunned by her beauty, the execs offered her a letter of introduction to Central Casting, which the major studios had collaboratively established in 1925 as a clearinghouse for extras and background players, in part so that each studio could lessen its individual burden of besieging wannabe stars. Harlean, who didn't have her mother's ambitions, took the letter, thanked the men, but didn't think anything about it until Rosalie brought it up at another luncheon. Harlean's friends

started teasing her about being too shy to ever do anything about having been "discovered." It was a hell of a joke: all the beautiful blondes in Los Angeles, and the Fox execs somehow stumbled on the one who couldn't care less about being in the movies.

What her friends didn't count on was that when Harlean was made the butt of a joke, she, much like Howard Hughes, became determined to prove the jokers wrong.

The next day, Harlean showed up at Central Casting, letter of introduction in hand, and registered for work under her mother's name, Jean Harlow. By the time a casting agent called for "Miss Harlow" a few days later, Harlean, who had already put the visit to the casting agency out of her mind, answered the phone and was confused as to why anyone would call her house looking for her mom. When she told the real Jean Harlow about this lark, her mom insisted that her daughter accept the next offer. Harlean did what her mother told her to.

It really can't be overstated what a powerful force the elder Jean exerted over her daughter. Harlean didn't need the money she'd make from acting—her husband had money, enough money so that the single-figure paydays she'd net as an extra would seem like a pittance. And she didn't need the attention—she got attention, everywhere she went, for her milky white skin and cloud of blond hair and gorgeously curvaceous figure. She pursued an acting career simply to please her mother, who had decided to live out her own dreams of stardom vicariously through her daughter. The new Jean Harlow felt it was easier to make her mother happy than to worry about her own happiness. "Nothing on earth," she would confide to an aunt, "is worth what I go through when I don't let her dominate."

The day after Christmas in 1928, seventeen-year-old Jean Harlow signed a five-year contract with director-producer Hal Roach. That weekend, Jean and Chuck went to San Francisco, where, in a drunken rage, Chuck destroyed their hotel room. He had taken his wife halfway across the country to avoid the very kind of intervention into their marriage on the part of his mother-in-law that had resulted in his wife selling herself to a movie studio.

One might argue that if he didn't want his gorgeous teenage wife to be drawn into the industry for which teenage beauties were the primary raw material, then he should have taken her somewhere other than Beverly Hills. But there was something real, not totally unreasonable, and very of the moment going on here. In previous generations, a man with money could marry a young woman and pretty much ensure that it would be he who would control her destiny, at least as long as he could afford to "keep" her. But in 1928, the passing of women's suffrage was nearly a decade in the rearview, and rising levels of female enfranchisement were difficult to ignore. The American workforce was, on average, 25 percent less male than it had been before World War I, and while the defining youth culture fad of the decade, the flapper, was somewhat superficial in its liberation of women from old-fashioned modes of dress and social behavior, revolution was quietly rumbling. The flapper was a shallow, unsatisfactory model of "new woman" to the Lois Webers of the world, who noted that the biggest change of the decade was that the new working girls were now welcomed to seize their "empowerment" as consumers. But spending power was at least as tangible to the Chuck McGrews of the world as the political power represented by the vote—and maybe, it was even more threatening, because if a girl like Harlean didn't need a man like Chuck's money, then what *did* she need him for? No wonder he would react so violently to his underage wife signing a long-term contract to be in movies. Especially since he knew that it wasn't Harlean's dream, but her mother's.

Two months later, after having completed three films for Hal Roach, Harlean appeared in his office accompanied by her mother and her mother's husband, to ask for a release from her contract. She told Roach that her husband didn't approve of her working in the movies. As Roach recalled, Harlean said, "It's breaking up my marriage, what can I do?" Roach agreed to let Harlow go. This was the hoped-for result of a plan cooked up by Mama Jean, who strategically sent the Baby to seek an out from her Roach contract just before she turned eighteen. After that birthday, Harlean wouldn't need her husband's permission

to sign a new contract elsewhere. Mama Jean hoped that, with neither the Roach contract nor McGrew holding them back, she could take her daughter to a bigger studio, and cash in.

Soon enough, Harlow discovered that she was pregnant, and appealed to her mother to let her follow her own dream: she wanted to be a wife and mother. But Mama Jean prevailed. By the summer of 1929, Harlow had terminated her pregnancy and filed for divorce. As Mama Jean later told a fan magazine, "Chuck went away and Marino and I came to live with the Baby." "The Baby" was now eighteen years old. This, according to Mama, "was the way she wanted it."

The ease with which Jean was able to obtain both an (illegal) abortion and a divorce was further testament to changing times. And now she'd labor for her freedom: separated from McGrew and his relative fortune, Jean Harlow had no choice but to pursue acting in order to support herself, as well as her mother and Bello. As she later put it, "I had to work or starve." Much of this work was less than illustrious, but wherever she went, Harlow made an impression. When she walked on the set of *The Saturday Night Kid*, rumors swirled that the ostensible star of the film, Clara Bow, demanded that the newcomer be sent home and told not to come back. Harlow stayed in the movie and began dating one of its stars, actor James Hall. That relationship was short-lived; meanwhile, Jean continued taking what few small parts she could get. And then, in the summer of 1929, she was on the lot of Metropolitan Pictures for an extra gig when she ran into Hall, who was there doing reshoots on a picture that should have been long finished.

Months had gone by since Joseph March had gone to work, and still Hughes had been unable to decide on a new actress for *Hell's Angels*'s now-talking female lead. Hall and Ben Lyon, who had been working on the film off and on for almost two years, had been reshooting their parts with March's new dialogue while they waited for Hughes to decide on a female point of the film's love triangle. When Hall ran into Harlow on the studio lot, he figured the desperate Hughes could do worse, and Hughes agreed to give Harlow a screen test that day. She was given lines and a gown, and cameraman Tony Gaudio was instructed to set

up two cameras, to get double the angles in half the time. The process was painful for all involved, but Hughes liked the result. He signed Harlow to a five-year contract on October 24, 1929—Black Thursday.

The coming Depression years would mark some of the greatest and most decadent for on-screen Hollywood glamour, and here Harlow, and Hughes, were ahead of the curve. Hughes had initially been worried that Harlow's extremely light blond hair wouldn't photograph well. Now, he, March, Whale, and Gaudio watched a number of tests of her in different wigs. Her face and personality seemed completely mutable according to the color and style of her coif, and Hughes finally decided that it was her shock of white hair that made her special. Harlow was subsequently coined, in releases written by Quarberg and pounced on by a movie press desperate for light, escapist subject matter, as the "Platinum Blonde." Here was another case of Hughes's publicist spinning a potential liability into a selling point. In such branding, Quarberg and Hughes evoked a powerful symbol of sex, wealth, and military might that was incredibly alluring at a time when the collective American spirit could hardly have been lower.

But as with everything involving *Hell's Angels*, the process of getting a winning performance from the selling point was more easily glossed over in press releases than done. Surprising everyone who looked at her and assumed she was a natural temptress, Harlow had particular trouble with a *Hell's Angels* scene in which she was meant to seduce Ben Lyon. She was happy to try to do whatever dialogue director James Whale wanted her to do, but Whale, annoyed at having to work with what he considered to be a tawdry-looking beginner, wasn't very forthcoming with instruction. "The harder she tried the worse it got," March remembered. In the end, Jean begged for Whale to tell her exactly how to do it.

"My dear Miss Harlow," Whale sighed, "I can't tell you how to be a woman."

Hughes was not so concerned with whether or not Harlow could convincingly speak seductive dialogue to Lyon. In many ways, *Hell's Angels* was Howard's attempt to one-up the aviation film that had won the first Best Picture Oscar, *Wings*. And while that movie had offered

audiences a flash of Clara Bow's bare breasts, Hughes intended to go a step further, making his actress's mammaries—and the effect Harlow had on men in real life, merely moving her body through a room—as much a centerpiece of the movie as the aviation footage that four men had died helping to create.

This in mind, Hughes decided to create a Technicolor sequence to try to capture what was inherently spectacular about his female star. He had a gown designed and constructed for Harlow to wear in the sequence—skintight, in a light red that would appear on-screen to be in the same tone family as Harlow's flesh. At the fitting, Hughes snatched the scissors out of the costume director's hands and cut the fabric so that the skin between Harlow's breasts would show all the way down to her waist. There was no back, either—the front of the dress was held up by thin rhinestone straps that resolved in a single strip running down Harlow's spine. In the scene in which she wears it, Harlow's Helen dances with Lyon's Monte, the brother of the man to whom she's supposedly attached. She expresses her obvious attraction for Monte by staring at him and breathing heavily, and in the slip of fabric that almost melts into her skin, her breasts pulse up and down for a sustained moment. This is before the pair even hit the dance floor. "Of course we all held our breath every time she shrugged or lifted an arm," March recalled. "We were waiting for those slender straps to break and finally one of them did." Knowing the entire cast and crew were lying in wait to leer over a wardrobe malfunction made Harlow incredibly uncomfortable.

That Harlow took no pleasure in putting herself on display made the pleasure Hughes took in forcing her to do so all the more sadistic. Though Whale was directing the reshoots involving dialogue, Hughes took it upon himself to sit by the camera during the shooting of a scene in which Harlow was dressed in a negligee. When Harlow walked on set ready to shoot, Hughes gestured to the already flimsy piece of lingerie and said, "Open it wider in front."

She manipulated the garment to bring the neckline down by a couple of inches.

Hughes sat there, staring. "Wider," he called out to Harlow, whose face flushed with embarrassment.

It got worse. "Before they got through," March recalled, "the negligee was open practically to her navel, showing a generous view of her large breasts." Only then was Hughes finally satisfied. "That's better," he announced, finally sitting back in his chair to watch the take.

By this time, March had come around on Harlow, charmed by her spirit if not her talent. "The whole thing must have been a nightmare for her," March acknowledged. "But she had guts. She set her beautiful white teeth and gave it everything she had and never let out a whimper."

BY THE SPRING OF 1930, *Hell's Angels* was finally almost finished, but it had been such a long haul that anyone who had heard of the film assumed it was a disaster.[1] To counteract the negative rumors, once a date for the unveiling was set, Hughes and his team put together the biggest spectacle of a film premiere that Hollywood had ever seen. In what would become a lifelong pattern, Hughes seemed to figure that if he wasn't sure he could be the best at something, he'd make damn sure his effort was the greatest—as in, largest in size, most extravagant, most expensive.

On the night of May 27, 1930, miniature replica planes were strung up all along Hollywood Boulevard, illuminated by $14,000 worth of arc lights shining so bright and hot that, as one reporter put it, "ducks flying over the street would have been roasted by the heat." An astonishing fifty thousand people mobbed the streets outside the Chinese Theatre, waiting hours for a glimpse of stars. And there were plenty of them. Marshall Neilan, with whom Hughes had remained friends after parting ways over the movie, supervised the guest list for the evening, and he was able to lure silent-era biggies like Gloria Swanson and Charlie Chaplin. Neilan noted that these stars RSVP'd "more out

[1] On March 20, Lincoln Quarberg received a letter from a friend congratulating him on his recent marriage. "May it endure until hell freezes over—I mean *Hells Angels* [sic] comes out." Letter from Paul Moore to Lincoln Quarberg, March 20, 1930.

of curiosity" than faith in Hughes; they planned to spend the night "laugh[ing] at what they thought would be a sure flop, as it didn't stand to reason that a long lanky rube from Texas could crash Hollywood and in two years time turn out a colossal hit."[2] Instead, the audience, superstars included, was wowed by the film Hughes had made and, maybe more so, by the spectacle he had mounted to showcase it.

As far as that spectacle went, the big lights and little planes were just set dressing. Even with all the established stars in attendance, the biggest entrance was made by Harlow, who arrived two hours after the movie had been scheduled to start, floating down the red carpet in all white, steadied by the arm of MGM executive Paul Bern, her late entrance surely part of Quarberg's plan. The program handed out that night—bound in brown leather and tied up in silky gold rope, its cover painted with a comically macabre image of a pilot escaping a plane as it plummets onto a battlefield—made sure to position Harlow as a special attraction. Every other actor in the book is pictured in costume, and in character. The head shot of Harlow, on the other hand, shows that whatever she's wearing, it's so sleeveless, strapless, and low-cut that it appears to be nonexistent. Her body is turned in profile, her bare shoulder, arm, and exposed upper back guarding us from fully glimpsing what appear to be bare breasts. Her face is turned to us, and with her dark painted pout, lidded eyes, and perfect crown of platinum curls, she looks defiant, unwelcoming—and totally cool. A version of this image would appear on some of the *Hell's Angels* posters that advertised the movie to the public; other posters would show more of Harlow's body, posed bending over backward in fleshy ecstasy as airplanes crashed around her. The implication was that the death and destruction depicted in the film was brought on by this barely clothed blond woman's sexuality.

[2] Neilan's recollection that Hughes "crash[ed] Hollywood and in two years time turn[ed] out a colossal hit" is misleading in at least two ways: Hughes had been in Hollywood now for nearly five years, and the two and a half years that he spent in production on *Hell's Angels* was much longer than standard. Writing about twenty-five years later, Neilan's memory was either fuzzy, or colored by the still-lingering glow of Hughes's success, and his own role in it.

This kind of marketing, as much or maybe more than the actual film, implanted into the collective imagination the idea of Jean Harlow as the most authentically "bad" girl that movies had ever seen. The public loved this. While *Hell's Angels* was a hit (albeit not the money minter Hughes's team would make it out to be—it could never recoup its enormous expense), Harlow became its breakout star among audiences eager for new faces of talking cinema. Arbiters of taste were less enthused. *Photoplay* continued to be *Hell's Angels* most committed critic. In response to a letter from a reader taking the magazine to task for not rating the finished product higher in their August issue, editor James R. Quirk wrote, "This picture is guilty of the highest of all motion picture crimes—bad taste. The character played by Miss Jean Harlow is one of which the motion picture cannot be proud. It is sex in its most disgusting phase, naked, vulgar, unnecessary. Our review of *Hell's Angels* stands as printed."

But while national and trade reviewers lumped the character's indecency with Harlow's unsophisticated acting ability, the star quality she brought to the irredeemable role struck others as nearly revolutionary. "No star ever began in a part that seemed so unfavorable. The character portrayed by Miss Harlow is an out-and-out feminine rotter," wrote the motion picture editor of the *Kansas City Star*, Jean's hometown paper. "A youthful, thrill-crazy neurotic, produced by a Zeppelin tortured generation, she lives a heady and ruthless life in pursuit of sensation." What made Harlow's character a woman of her time—and only her time, because within a few years the Hays Code would legislate girls like her off the screen—was that she began defiantly amoral and stayed that way. "Retribution does not overtake her, because Howard Hughes has observed that the wages of sin are not always paid with theatrical promptness. She spreads her spiritual destruction and moves out of the story.

"You hate Jean Harlow every moment she is on screen in *Hell's Angels*, yet the seductive mannerisms with which she has endowed the part are fascinating," the *Star* concluded. "Where other stars had sought to appeal through virtue, she dazzled the public through wickedness."

Those close to Harlow recognized that this "wickedness" was all a put-on—which made it hurt all the more that so much of the press around the film was about Harlow's body and the supposed looseness with which she displayed and shared it. "I hate Hollywood," she sighed to a *Photoplay* reporter after a night out at the Cocoanut Grove nightclub sent tongues wagging. "I suppose it sounds like biting the hand that feeds you. But I mean, I hate it because I just can't be myself— they won't let me."

Hughes was photographed with Harlow at the *Hell's Angels* premiere, fueling the legend that he'd taken advantage of a producer's prerogative with his handpicked star. In reality, the still-married Billie Dove was Howard's secret date that night. "We sneaked in a side door early in order to avoid the crowds," Dove confirmed. "We sat on the back row, so no one would recognize us, and then we slipped out before the picture was finished."

Sneaking out while the lights were still down, Billie and Howard reemerged moments later at the Cafe Montmartre, where Dove would host an invite-only private party for Hughes after the premiere. A few years earlier, this restaurant and nightclub had been the first place in Hollywood proper to match the kind of boozy, starry, in-crowd scene of the downtown hotel bars. There was dancing; there was an in-house bootlegger; there was Louella Parsons, sitting at a corner table, collecting gossip that she could judiciously either publish or trade with the subject for a story they would prefer to see in print. But by that night in 1930, the Montmartre, owned and managed by a local character named Eddie Brandstatter, was already on the decline. Competition had begun to spring up throughout the area, not least from Brandstatter's own private Embassy Club, and in 1932, Brandstatter would file for bankruptcy and sell the Montmartre. Soon thereafter he would be convicted for absconding with the club's drapes, china, and pride-of-place decoration: a giant marble statue of a nude woman.

As went the fortunes of the Montmartre, so would eventually go the fortunes of the couple at the center of attention there the night of the *Hell's Angels* premiere. At the beginning of the evening, Howard Hughes

had been an up-and-comer and Billie Dove had been a superstar. After *Hell's Angels* played, when they walked into the fading cafe together and through the crowd of curated, friendly faces, Hughes had transformed into a superstar, and though neither understood it in the moment, Billie's moment was on the wane. The Montmartre was of Billie Dove's era, and by the end of the night, Howard Hughes's era had begun.

A month later, Dove finally appeared in divorce court. On the stand, dressed stylishly in black, she acknowledged that she and her husband had been separated since September 15, 1929. She described several incidents over the course of their six-year marriage during which Willat "struck me and knocked me down." Billie's brother Charles and maid Mary Fitzpatrick testified to corroborate the beatings, and the maid recalled that Willat had once told her "he wouldn't be responsible for what he did, that he was going to 'clean up' on his wife." Dove was granted the divorce—Willat didn't show up to contest it—and her claim of having been battered by Willat was splashed across the front page of the *Los Angeles Times*. (This was perhaps Dove's way of getting revenge against Willat for having "sold" her to Hughes. Late in life, she told interviewer Michael Ankerich that Willat had never actually abused her.)

Now Billie and Howard were legally free to pursue a life together. But instead of locking her down in matrimony, Hughes, high on all the accolades for having discovered Harlow, sought to tie Billie down professionally. He maneuvered to free Dove from her contract with First National and signed her to a new contract with his Caddo Company, through which he made a deal to produce five films with her as the star, and pay her $84,000 for each.

"Billie Dove 'At Liberty,'" read the headline in the *Los Angeles Times*. According to columnist Alma Whitaker, Dove was "a beautiful slave recently freed from servitude," having left both her husband and her studio, First National. Whitaker asked her if the rumors were true, that she had sought a divorce in order to marry Howard Hughes. "Oh, I couldn't marry for a year anyway. And in the meantime, I am free. . . ." Dove told the columnist.

She may have even believed it.

CHAPTER 6

A *COCK* VS.
THE CODE

The story of the end of the silent era that has been disseminated through movies like *Singin' in the Rain* and *The Artist* has it that many, if not most, silent film stars saw their careers collapse with the advent of sound—unless they could sing and/or dance. Of course, it's true that some performers had heavy accents that did not match the images they had established in silent film, or they simply lacked the ability to clearly or convincingly speak dialogue. But for few major stars was it as simple as the microphones turning on and their livelihoods simultaneously turning off. The whole film industry underwent a major transition in the late 1920s, and there were performers who lost their grip on the popular imagination during this time for reasons having nothing to do with their speaking voice—just as stars of today ebb and flow and slip in and out of favor, sometimes very quickly and without a cause that's obvious to outside observers.

Billie Dove's career peaked in 1926–27—just before the silent era ended—and was over by the end of 1932, but she was not a casualty of the talkie revolution. Dove initially made a smooth transition to sound. Her first talking picture, *Adoration*, is remembered as one of her best films and biggest hits. In 1928 and 1929, while Billie and Howard were building their relationship, she continued to star in (and speak in) well-received, prestige projects. Though it can be difficult to measure accurately the box office impact of all but the biggest hits of the 1920s,

it seems that the last of Billie's high-quality starring vehicles was *Her Private Life*, an Alexander Korda–directed melodrama that was widely seen and well liked on its release in September 1929.

For some reason, after *Her Private Life*, Billie's studio, First National, began casting Dove in less distinguished fare—mostly B-movies with shorter running times, many of which were never given high-wattage premieres in cosmopolitan capitals like New York and Los Angeles, and primarily played in the provinces. This began with *The Painted Angel*, a western musical with Billie as a saloon chanteuse. This was "a bad piece of casting," *Variety* lamented when they reviewed *The Painted Angel* in January 1930, because "Miss Dove has no singing voice." Another of the five Billie Dove pictures released by First National in 1930, *A Notorious Affair*, earned $29,000 in its first week at the Strand in New York—making it May's lowest-grossing opening at the major picture houses in that city per *Variety*. Reviews of *Affair* suggested that critics had started to notice a pattern: Billie's studio was doing her a disservice by casting her in bad films, with shoddy writing and in roles for which she was unsuited. "It won't be long, Billie Dove, if these unfortunate pictures keep turning up," warned the *Daily Mirror* that spring. Of *Sweethearts and Wives*, released that summer, *Variety* acknowledged, "Billie Dove carried the story and gave it what small measure of entertainment it had," but her heavy lifting was not enough: "[I]t is no role for this engaging actress, whose progress has been sadly hampered with poor scenarios and hurried product." The film's "moderate" box-office numbers in Pittsburgh "attested to Billie Dove's waning popularity." After a weak showing in Louisville, *Variety* warned, "Dove still needs better scripts."

She was not going to get them from First National; that same summer, Howard purchased Billie's contract, and from then on, generating quality scripts would be his responsibility. But before the first Hughes-Dove collaboration could be made, First National released the dregs of the Billie Dove library that they still had on the shelf. When *One Night at Susie's*, a cut-rate gangster flick running less than an hour in which Dove had a secondary role, opened in October 1930, *Variety* called it a

"below average programmer" even while admitting it was doing well in tertiary markets like Pittsburgh, "probably due to cast names"— suggesting that Dove's name still had some box-office value. In May 1931, the trade paper called *The Lady Who Dared*, Billie's last remaining First National release, Dove's "return" to the screen, eight months after *Susie's*. But *The Lady* performed "very bad" in San Francisco, and *Variety*'s review wrote it off as "weak in every department. Instead of reviving Billie Dove, poor lighting shows her in most semi-close-ups to disadvantage."

It was almost as if, since around the middle of 1929, First National had gone out of its way to hobble Billie Dove's stardom. Why would they have done this, a full year before actually selling her contract? Could Dove's progressing affair with Hughes have had something to do with it? By Billie's own (admittedly not entirely reliable) memory, she left Irvin Willat, who was also under contract to First National, in September 1929. Excluding Hughes and his tendency to antagonize Hollywood's establishment from the equation, First National may have shown that they had taken Willat's side in his dispute with Billie by refusing to give her access to their best scripts and directors. That said, Willat himself never again worked at First National at all—he took two years off after Billie left him, and the remaining four pictures he is credited with directing were made at independent studios.

This period of Billie's decline from top-echelon star to unfortunate passenger in marginal B-vehicles ran in parallel with her relationship with Hughes, and put all the more pressure on her collaborations with her new boyfriend-benefactor to reverse her career fortunes. The two films Hughes produced for Dove, *The Age for Love* and *Cock of the Air*, did not do well, and shortly after they were released, the couple's romantic and professional partnerships both fell apart.

Billie Dove never spoke candidly in public about why her relationship with Howard Hughes came to an end, although she took pains to correct assumptions that his philandering had something to do with it. Whenever given the opportunity, she would vehemently deny that Howard had cheated on her with other women, or that he had lost

interest in her. "I was in love with him," she insisted, "and I was the one who told him to go."

"At the time I knew him, Howard was not the womanizer he later became," Dove said many years after their breakup. "He was the jealous type and possessive of me." It's the latter part of this statement that might provide a clue as to why, two years after he purchased her contract, Hughes and Dove parted ways romantically, and also never worked together again. Dove's split from her allegedly abusive, "man's man" director husband was positioned in the press as the liberation of a modern woman. But her new romantic partner was even more controlling than her husband had been, and as the manager of her career, he squandered her as a resource, taking an asset that had recently been misused and running it fully into the ground. He doesn't deserve all the credit, but within a few months after Billie Dove's split from Howard Hughes, her movie career would be over. And, for a while, it looked like his was, too.

HUGHES COULDN'T BEAR TO let Dove out of his sight, treating her like a precious treasure under twenty-four-hour guard. Howard would follow Billie to the bathroom at parties, waiting outside the door like a bodyguard until she was finished. At first, Billie fully embraced Howard's oddities. She was compassionate about Howard's issues, like his encroaching, hereditary deafness (which had been exacerbated by all the time he had spent so close to very loud airplane engines), going so far as to accompany him to Czechoslovakia to see a hearing specialist, and she learned "how to regulate my voice for him" so that she could communicate with him in a way no one else could. She even accommodated his germ phobia, which was apparent by 1930. (On their trip to Europe, Dove later remembered, Hughes's favorite place to stay had been a brand-new hotel in Paris, because "it hadn't been used.")

Around 1930, Dove, and possibly Noah Dietrich, were the only people who were able to see Hughes's weaknesses—outside of his most inner circle, he seemed invincible. In the year after *Hell's Angels*'s pre-

miere, he became the talk of the town, his next move eagerly speculated in industry gossip columns. As one fan magazine put it, Hughes was "one of Hollywood's—if not the world's—most eligible young men. Shrewd, canny, with a boyish charm, he has whipped a business that called him a green young fool and a wealthy playboy." He was rumored to be on the verge of acquiring Universal Studios and a branch of United Artists. While all of that gossip was unfounded, he did acquire a doomed color film production company called Multicolor, and struck a deal with Joseph Schenck at United Artists to guarantee the distribution of Hughes's next batch of films.

The first of those films to see release, in spring 1931, was *The Front Page*, a Lewis Milestone–directed adaptation of the hit Broadway play set in a newsroom. In the run-up, Quarberg promoted Hughes as a maverick with an unblemished record of success. The publicist distributed sample articles to newspapers to set the tone of their coverage of the film and, more important, its producer. A typical document recapped Hughes's recent past: "*Hell's Angels* made motion picture history, but above all it made Howard Hughes—revealed him as a man who had the courage of his convictions, and who had the money to carry them out even in the face of adverse predictions—and there were no end of them concerning *Hell's Angels*."

Quarberg's thesis was that his boss beat the moguls at their own game by challenging the game: "[Hughes] defies traditions—and makes money at it." To support this thesis, Quarberg repeatedly claimed Hughes had never lost money on a film investment—a lie that, apparently, no one fact checked at the time, as *Swell Hogan* remained hidden, and the accounting on *Hell's Angels* was a black box. If Hughes and company said it was a phenomenal moneymaker, the press and the public believed it to be so. Hughes's lack of regard for "the rules" of Hollywood had promotional value, but behind the scenes, his ignorance was at times almost embarrassing. Caddo sent United Artists a sketch for a movie poster that the distributor rejected because, as UA sales manager Al Lichtman put it in a telegram, "it could not be read from any distance nor could it be seen at night."

The Front Page was a kind of beta prototype of the screwball comedy—"beta" because it came before that subgenre had codified with films like *It Happened One Night* (1934), and because, with its all-male cast, *Front Page* was devoid of the strong female characters who would make screwballs sing. The film was released in April 1931 and was another hit for Hughes. And yet, by September of that year, Hughes was already telling his employees that he was going to scale back on film production until after the worst of the Depression passed—a stance that was reaffirmed two months later, after *The Age for Love* opened.

The Age for Love would be his first production for Billie Dove, and no expense was spared in its promotion. The campaign had begun eight months before the film was released, when *Photoplay* ran a profile of Hughes in their February 1931 issue titled "Hollywood's Hundred Million Dollar Kid." The ostensible purpose of the profile was to promote *The Front Page*, a film that ended with an artful sound edit to leave the conclusion of the phrase "son of a bitch" not quite audible, and was thus being teased as a quasi-profane event. (Posters branded it "The !@$:*=x%-est Picture Ever Produced.") Perhaps because profanity didn't make a movie about newspaper men sexy to *Photoplay*'s largely female reader base, Billie was featured as a co-subject of the Hughes profile. Or, maybe it was the other way around: maybe Hughes was using the publicity draw of his edgy new movie to help reframe the conversation around his girlfriend and new contract starlet.

The article, which Dove kept in her scrapbook until her death, featured a stunning glamour shot of Billie dressed in a pair of flowing silk pajamas with ornate brocade trim and kitten heel slippers, posing with chin on hand and elbow on knee, her shoulder-length curls brushed out as though she were headed to a very luxurious bed. "In a story about Howard Hughes, Billie Dove must appear," read the photo caption. The story continued to describe how Billie and Howard's relationship defied local convention. "It burns Hollywood to a crisp that Hughes and Billie Dove, in the face of the utmost that Hollywood tongues can do, go serenely and happily about everywhere together without both-

ering to make the slightest reply to questions. They simply won't tell what their plans are. It's nobody's business. Ask Billie Dove, and she answers nothing. Ask young Hughes, and if he answers at all, it's to tell you [where] to go. . . . In the meantime, they're seen everywhere together."

Another profile of Billie and Howard quoted Billie on her desire for "happiness": "I make no plans for my career, if you call it that. I don't want to continue it when it ceases being a source of happiness to me. What I want of life is happiness. That is, I imagine, what every woman wants. Happiness to me is love. If I found all my happiness in love, I would desert the screen . . . my career. I would, of course, want babies. . . ." Reporter Dorothy Spensley noted that in the room of Dove's home where she was interviewed, a bridal fashion magazine sat on the coffee table.

Howard and Billie were far from setting a wedding date, but there may have been other reasons why Dove would hint in this interview that she would soon retire for marriage and motherhood. Times were changing fast, and though unlike other silent stars the quality of Billie's voice was no impediment to her transitioning to sound film, even as a relatively young woman she was unquestionably a holdover from an era that had ended when talkies had taken over and swept in a new wave of celebrities. One of those new stars was Howard Hughes, and in 1931 his name was considered to be more valuable than that of any performer whose contract he controlled. In 1931, evaluating how to promote another Caddo film on the docket, *Scarface*, United Artists concluded that Hughes's was the only name with promotional value. As publicist Hal Horne wired Quarberg, "CONSENSUS OPINION HERE HUGHES NAME STRONGEST EXPLOITATION ANGLE . . . BELIEVE OTHER NAMES UNIMPORTANT SHOULD BE OMITTED ON POSTER."

United Artists and Caddo came into conflict on the matter of how, or even if, to promote Billie Dove. Despite *Photoplay*'s eager complicity in keeping up Billie's glamour girl image, and Quarberg's claims in press releases that Dove was "a first-ranking star of United Artists,"

United Artists itself viewed Dove as old news. The Hughes camp and the UA executives went back and forth over whether to even include Dove in the posters or the on-screen credits for *The Age for Love*.

After this exchange, Quarberg went into overdrive to promote Dove as a star resurrected, through a number of biographical press releases attempting to recast this "also ran" as a woman of her moment. Quarberg's press claimed that *The Age for Love*, scheduled to premiere in November 1931, would be Dove's "return" after an eighteen-month absence from the screen, which wasn't true—*The Lady Who Dared* had opened in limited release in May. The publicist would pretend that none of the movies released since Billie left First National existed—and he got away with it, because most audiences probably hadn't seen these minor films or even registered their releases. Quarberg's promotion sold a Billie Dove brand based on uniqueness and independence—that no one owned her. Quarberg sent magazines an article on beauty with Dove's byline, in which "Billie" advocated exercise and "right eating" and stopped just short of shaming other women for wearing too much makeup. Billie Dove, we were meant to think, was the genuine article, a real beauty and a unique woman—not some manufactured glamour girl. She would thus be the perfect match for the independently wealthy, independently minded Howard Hughes. And the perfect star for a film that claimed to deal with the conundrum, already not fresh by 1931, of the "new woman."

The Age for Love has, like many silent films, been lost, and there's very little writing available that would give a sense of what it was like to watch, but it was promoted as "a motion picture based on the day's most common problem—should the young wife work?" This was copy that made it into the full-page ads placed in magazines like *Modern Screen*. Quarberg's files show draft copy that was somewhat less pious and socially conscious: "SHE DIDN'T WANT TO BE SHACKLED!" a proposed poster might have blared in block letters. "She was chained to convention—a wife who wanted a career. She was handcuffed to a home and a husband—a prisoner in the bondage of boredom. . . . And her soul cried out for freedom!"

The irony, of course, was that in real life Dove was a divorcee whose "freedom" Hughes had paid cash for, as easily as he had purchased her contract from First National. Here was a woman who felt that she had been bought from one man and sold to another—and whose career resurgence relied on the support and good sense of her new "owner"— starring in a film being promoted as a saga of female liberation from "the chains of convention." Meanwhile, the press couldn't wait for her to go back to being a missus, even as her would-be second husband's company was promoting her new movie as her triumphant return to the realm of career woman.

Billie feared that no marketing could compensate for the fact that *The Age for Love* was "no good," even "namby-pamby." After a preview of the film held for critics, she betrayed her nerves as reporters began pelting her with questions about her relationship with Hughes.

"Someone give me a cigarette," Dove said.

The questions kept coming. "Are you ever going to marry Howard Hughes?"

"Give me a break. I've only been a free woman for a month."

"We are burning to know."

"He's a marvelous air pilot and plays a first class game of golf. But what I am burning to know is whether this picture, which I enjoyed making more than any I have ever done, is a success."

According to the *Screenland* reporter who accosted Dove at the screening, *The Age for Love* was bound to be divisive: "It's a feminine picture out and out. The average male won't like it a bit."

Nor did anyone else. *The Age for Love* became Hughes's first released film to flop so badly that even Quarberg couldn't spin it any other way. It opened to tumbleweeds at the Rivoli in New York, setting a record for the lowest opening day of any film at that theater, and business only dropped off from there. In a dubious achievement that not many films matched at that time, it was pulled from release after just one week.

Thanks to this poor performance, it was decided not to publicize the next Billie Dove picture, which was already in production, as a "Billie Dove picture." "Of course I cannot stop the publicity which has

already been planted in the movie magazines in which Miss Dove is featured," warned a frustrated Lincoln Quarberg in a letter to United Artists. "Naturally we are very disappointed in the apparent inability of Billie Dove's name to attract any customers at the box-office—even with a good picture and with a good performance on her part." Hal Horne at United Artists concurred on the sad state of affairs, writing to Quarberg that if the studio "had our way we would publicize her to the stars in every city in the country. The fact remains however that the exhibitors do not want her. . . ."

At the very least, the next Dove-Hughes collaboration wouldn't be "namby-pamby." *Cock of the Air* was designed to stir controversy. It was a big-budget movie set in palaces and luxury hotels in Great War–era Europe, made in the depths of the Depression. Quarberg's publicity tried to turn its unseemly extravagance into a selling point: "Producer Hughes recognizes that this is the time to economize, but he doesn't believe it is economy to short-change the public at a time when the fans are demanding better pictures."

Dove's performance in the film was very good (if slightly broad), as Lili, a respected French stage actress and liberated woman who is asked by a multinational tribunal to leave France for being too much of a distraction to various military men. She goes to Italy, where she learns that an American air pilot (Chester Morris) is cavalierly plowing through the local girls, and she decides to teach him a lesson. The rest of the movie essentially consists of Dove's Lili—who is dressed for much of it in a skintight lace gown cut to reveal the top half and side quarter of her breasts—teasing the so-called cock until, in the last frames, he finds himself proposing marriage, almost as if under a spell. There is a scene in which Morris spanks Dove's character as punishment; there is another in which they play a drinking game and she matches him shot for shot; and there is a scene of his "air exploits," which is remarkably boring compared to the bawdy conversational sex farce, scripted by Marion Davies's nephew Charles Lederer and Algonquin Roundtable wit Robert Sherwood, that occupies the bulk of the film's action on the ground.

Cock was deliberately flagrant, in its content and in its marketing, in a way that was designed to inflame the censors. Sex had helped sell *Hell's Angels*, and public conversation over "decency" had boosted the profile of both *The Racket* and *The Front Page*. *Cock of the Air* was a test of just how far Hughes could push the censorship envelope before the censors pushed back.

The answer: not very far. Proving that even in the pre-Code era there were limits, *Cock of the Air* hit resistance from the Hays Office for its "obscene and immoral . . . title, theme, and portrayal," which led to clumsy last-minute edits; the censored version bombed on takeoff. "Will Hays cut about 800 feet from the film," Dove alleged. "So it was hard to tell where we were and what was happening. It made no sense the way they released it."

Actually, Will Hays himself never cut a foot of any film, and in the case of *Cock*, his office gave Hughes ample opportunity to "fix" the picture to the satisfaction of both parties. Many of their suggestions were nonsensical—"We believe it is quite important to omit any suggestion of a bedroom," commented the censors on the sex farce's first script—but Hughes could have complied with them in a way that resulted in a coherent film. Instead, Hughes deliberately antagonized the Hays Office. The cut of the film submitted in mid-November 1931 ignored every request the censors had made on their review of the script, wherein the Hays Office had been vehemently opposed to the very idea of a movie about "the maneuvering of a lecherous young man in his attempt to carry out one more seduction." A conference was held between producer Charles Sullivan, director Tom Buckingham, and various representatives of the Code, "with a view of finding a means of eliminating the pointed motivation of most of the story." (The "pointed motivation," of course, was sex.)

But Hughes did nothing to placate the censors, and by the end of December the Hays Office had received word from the New York censorship board that Hughes had shipped the unmodified cut of the film to state censors, thereby pulling an end run around the Hays Office. Colonel Jason Joy, who had been appointed by Hays to enforce the

Code through a body called the Studio Relations Committee, furiously wired his boss: "While desiring to help this man [Hughes] am certain steps should be taken to keep him from breaking down the machinery." Will Hays himself wrote to Joe Schenck, president of UA, to essentially tell on Hughes to his corporate father figure. Hays then sent a letter to Hughes telling him that Schenck had been told of his bad behavior. By December 30, Hughes had requested that the uncut film be re-reviewed by a Code jury. The appeal failed, and the picture was deemed in violation of the Code and unfit for release. Sometime over the next week, Hughes gave in and cut out all of the offending lines, as well as a scene in which the "cock" approaches Dove, who is wearing a suit of armor, and makes a crack about the difficulty in opening "foreign cans."

Cock of the Air, which the Academy of Motion Picture Arts and Sciences reconstructed, reinstating much of the previously cut footage, in 2016, probably wouldn't have made much sense even if it hadn't been cut to suit the censors: the almost nonexistent plot defies not just logic, but a raison d'être. Also baffling are many of the censor's decisions regarding what to cut: for instance, a scene in which Morris's valet is revealed to be keeping a notebook in which he bets on whether the pilot "does" or "does not" score with women at each given opportunity was shorn, but the aforementioned spanking sequence, and full reels in which two-thirds of the braless Dove's breasts are plainly visible, were allowed to stay.

It's not a wonder that *Cock of the Air* wasn't a hit, but in a just world, critics should have championed Dove's performance in it. The film's considerable value lies in its showcasing of Dove's beauty and comic timing—her look and her performance feel shockingly modern almost ninety years later—and of Hughes's continued genius for putting his actresses in costumes that turn women like Dove, like Harlow before her, into spectacles at least as riveting as the aerial sequences that Hughes was possibly more passionate about. But in the form in which it was released, *Cock of the Air* could only hasten Dove's career decline. Unlike so many other silent stars, it wasn't the transition to talkies that

had cut Billie's career off at the knees—it was trying to sustain her career in a new era in which stars were being imported from the New York stage every day that was the challenge. After the wave of low-quality First National pictures, followed by the one-two punch of *The Age for Love* and *Cock of the Air*, she would get only one more chance.

BILLIE DOVE HAD DECLARED that she would leave her career behind when it was no longer a source of happiness, and nothing about *The Age for Love* or *Cock of the Air* made her happy. She had also said that once she was done with her career, she wanted to have babies. Off-spring was something Hughes had no interest in—after his own battle as an heir, he was determined not to create a person who could fight with him over a stake in his fortune. Given his refusal to have a traditional family life, and his bungled handling of Billie's career, Dove's suggestion that she walked out on him seems totally plausible—what would have been left for her in this relationship? At the same time, Hughes had pursued Dove when she was an unquestionable trophy. Now her star had faded. If his own profile couldn't get a jolt from being seen in public with a given woman, it stands to reason that he would have lost interest in continuing a relationship with her in private.

Dove would say that her romance with Hughes was over by the time *Cock of the Air* opened in January 1932, and that in fact they couldn't bear to see each other by this point. But Hughes spent the first quarter of 1932 on a yachting vacation around Cuba and Florida, and based on a telegram Dove sent Quarberg on March 17, 1932, it appears that she was with him on that trip, and that Hughes and Dove were planning to return to Los Angeles together. "Finally tearing ourselves away from Florida," she wired. "Arriving Monday morning do you think anyone will remember us . . ." That month, a rag called the *Hollywood Tatler* reported that the Dove-Hughes engagement was off. Shortly after that, Hughes was very publicly seeing other people.

At the time of Dove's telegram, Quarberg was desperate for word from his boss, because of a crisis over another film that had been in

production since before Howard's Depression-motivated decision to scale back on his cinematic investments. *Scarface*, a ripped-from-the-headlines Chicago gangster drama directed by Howard Hawks and starring urban everyman Paul Muni as a character inspired by Al Capone, was virtually a sound-era remake/update of Hughes's previous hit, *The Racket*. Quarberg fervently believed that United Artists and the Hays Office were in cahoots to suppress *Scarface* in order to spite Hughes. Howard was not so convinced, at least not right away. In late January 1932, a week after Hughes sent the agitated Quarberg a telegram politely requesting that he understand that Hughes had to compromise with UA in order to release his films, Quarberg's hours were cut in half. Quarberg flipped out, and Hughes wired him that he was "terribly sorry," but it wasn't personal—everyone was taking a pay cut "with few exceptions." Hughes encouraged him to "give all your time as long as same is advisable for whatever salary we are able pay you." Quarberg responded that very day with a confidential letter to Hughes in which he tried to demonstrate his loyalty and indispensability to the Hughes organization by ranting about how "Will Hays and the Big-Shot Jews, particularly the MGM moguls, are secretly hoping you have made your last pictures" and recommending Hughes publicly break from Hays and announce his intention to refuse to follow the Code.

Quarberg's anti-Semitic paranoia aside, Hays's correspondence with his deputies around this time suggests that the censorship authorities were so exasperated over Hughes's defiance on *Cock of the Air* that they were not inclined to do him any favors on *Scarface*. This may not have been equivalent to a conspiracy to force Hughes out of Hollywood, but the Hays Office definitely held a grudge, and they wanted to teach Hughes to stay in his lane.

Quarberg sent and received much correspondence on these matters in early 1932. It was clear to all that there was some hypocrisy in the application of censorship: at least *Cock of the Air* contained dialogue that clearly sought to push the limits of decency; *Scarface* was being censored mainly for humanizing a criminal—or at least, that's what

Hays and his cohorts were claiming, even though the narrative of the film ultimately aligned with the spirit of the Code in its message that a life of crime is a short one bound to resolve in a bloody end. And yet, for months, at no point did Hughes or UA encourage Quarberg's conspiracy theories. In fact, on the contrary, everyone pretty consistently requested that Quarberg find some chill. Then suddenly, in April 1932, Hughes essentially did exactly what Quarberg had been pushing for six months: he announced that he would go to the courts to fight the Hays Office, and that he had hired a number of attorneys around the country to represent him, including Clarence Darrow.

Hughes had apparently decided that the conspiracy line might play after all, although unlike Quarberg, he positioned the plot against the film as not one of Hollywood politics, but electoral politics. Hughes, who the *Los Angeles Paper* noted had "recently returned from a yachting cruise in South Atlantic waters," declared that a conspiracy was afoot to bring down *Scarface* for painting a too realistic portrait of the crime wave taking over major cities, rendering law enforcement impotent.

"It becomes a serious threat to the freedom of expression in America, when self-styled guardians of the public's welfare, as personified by our film censor boards, lend their influence to abortive efforts of selfish and vicious interests to suppress a motion picture simply because it depicts the truth about conditions which constitute front-page news," Hughes stated. "I expect to have the support of Will H. Hays, head of the Motion Picture Producers and Distributors Association, who has said he believes censorship is un-American."

Howard Hughes would make a career out of fighting the Hays Code and its enforcers, but usually he would be fighting to push the boundaries in terms of sexual content. With *Scarface* he claimed he was fighting to make movies about things that were really happening in America, even if they challenged America's image of itself. And for the only time in his career, his stubbornness with the censors paid off, without incurring damage to his reputation. When the Hays Office refused to clear *Scarface* even after Hughes had made a number of requested

changes, Hughes decided to release the uncut version of the film in territories without a local censorship board, beginning in New Orleans in March. Then, after a press screening of that unamended version was rapturously received in Los Angeles, journalists started criticizing the Hays Office for its stance. "The absurdities of film censorship have never been carried further than in the case of Howard Hughes's new screen sensation—*Scarface*," declared the *Los Angeles Times*. The Hays Office, recognizing they had been beaten by Hughes's manipulation of the media narrative, began recasting their failure as a victory, claiming that the version shown to the press had been cut and improved by the censor's suggestions, which it had not.

After the disappointments of the Billie Dove movies, and another misbegotten Hughes production, the Spencer Tracy aviation pic *The Sky Devils*, *Scarface* was a huge victory for Hughes—morally and financially. It was United Artists' biggest hit of 1932, and Hughes's contract entitled him to receive 75 percent of the profits netted from the film's $900,000 gross. It would also be his last hurrah in Hollywood for most of the rest of the 1930s, at least as a producer.

With Dove in his rearview, Hughes sent the message he was diversifying his interests by showing up at *Scarface*'s Hollywood premiere with a new actress on his arm. In 1932, Ginger Rogers was fresh in town. A teenage vaudeville trouper from Texas, she had found stardom on the Broadway stage in the Gershwin musical *Girl Crazy*, but she had yet to play a leading role in a Hollywood film. She was, however, already a divorcee. At seventeen, Rogers had married Jack Culpepper, a dancer she had had a crush on ever since he had dated her aunt when Ginger was a prepubescent girl. Six years after the onset of Ginger's crush, Ginger had become a professional dancer, too, and Jack visited her backstage after she performed in Dallas. Rogers had thought about her aunt's ex-boyfriend constantly in the interim years. As her career was gearing up and taking the teenager far from home, Culpepper became a frequent fantasy object, as much a nostalgic symbol of home as a prize for the sexually naive Rogers to aspire to be worthy of winning.

When Jack proposed for a few weeks later, Ginger said yes. Rogers later recalled, "I really had never been alone with a man."

Her mother, Lela, threatened to disown her, and yet still Ginger married Jack, and went on tour with Culpepper's dancing act, putting her own career aside to do so. In her autobiography Rogers remembered watching Jack's show from the wings, sad and bored. Instead of performing, Ginger recalled, her "wifely duties" extended to making sure Jack's toupee was cleaned after each show. "Otherwise, I was more or less like a third thumb." Culpepper was also, according to Ginger, a drunk. The newlywed teenager found it "impossible to communicate with any individual who continuously indulges in alcohol." (Ginger would become one of Hollywood's most famous teetotalers.) Around the time of her eighteenth birthday, Ginger left Jack and went back to her mother, and back to work. Two years later came *Girl Crazy*, during which she was spotted on stage by a scout from RKO, and after *Girl Crazy* closed in June 1931, Ginger and Lela took a train west for Los Angeles.

In these pre–Code era days of 1932, Ginger kept busy filming saucy chorus girl parts. She began dating director Mervyn LeRoy, who suggested that she be cast in Lloyd Bacon's musical *42nd Street* as chorus girl "Anytime Annie." LeRoy would then direct Ginger himself in *Gold Diggers of 1933*. Both of these films featured psychedelic musical numbers choreographed by Busby Berkeley. In many Berkeley numbers, countless girls were styled to look virtually identical, so that the eye was overwhelmed by multiple, indistinguishable women, rather than by one stunning face. But in *Gold Diggers*, Rogers was memorably placed front and center in the opening number, leading dozens of women singing "We're in the Money" while dressed in bikinis made from giant trompe l'oeil silver dollars. At the end of the song, the creditors of the show-within-the-film's producers attempt to repossess Ginger's costume—while she still has it on.

LeRoy and Rogers were dancing at a nightclub one night in the spring of 1932 when Ginger realized she was being watched. As they

both spun around the room with their dates, a tall man she had never seen before would occasionally catch her eye, and attempt to smile. He wasn't very good at it—smiling, that is; as a dancer, he wasn't bad. The tall man eventually maneuvered his date so that they were dancing alongside Mervyn and Ginger. Ginger's date warned her what was coming. "That's Howard Hughes," he said. "The Texas oilman who wants to be a movie producer." Mervyn and Howard consulted with one another in whispers for a while. Finally, Howard raised his voice so that Ginger could hear him ask LeRoy if it would be possible to loan her out for a dance. Merv grinned. "If you can keep up with her!"

He could. Hughes danced well enough to get in Ginger's head, and under her skin, activating reveries not unlike those she harbored for her first husband back when he was unattainable. On the ride home with Merv, Ginger thought about Howard and, as she put it chastely in her autobiography, "wondered what he'd be like as a date."

She found out soon enough. As Rogers remembered it, Hughes called her at home a few days later and told her mother Lela he wanted to take her daughter to the *Scarface* premiere. Ginger agreed. It would be her first Hollywood premiere, and the first of many dates with Hughes, whom she'd be involved with on and off for the next eight years.

Howard's pickup of Rogers was typical behavior for him in the early to mid 1930s, when he frequented Sunset Strip nightclubs such as the Clover, the Colony, and the Trocadero. Hughes was part of a gang of young men making the scene, including Pat De Cicco and Albert "Cubby" Broccoli, two cousins from Calabria by way of Queens. Broccoli, who would go on to produce the James Bond movies but was then managing a company that manufactured coffins, had come out to Hollywood to console De Cicco, an agent for actors and cameramen, who was splitting up with his movie star wife, Thelma Todd. Broccoli and De Cicco each had the experience of showing up at a nightclub with a young lady only to have Howard Hughes horn in on their date.

This was the period when Hughes was the most social, and the most visible. If invited for the weekend to one of the Hearst properties, or Palm Springs, or Catalina Island, Howard would fly the boys there in

one of his planes. Hughes even, on at least one occasion, hosted a party of his own. The *Los Angeles Times* would report Billie Dove's attendance at the opening of a new nightclub at the airport, where Hughes entertained fourteen guests, in May 1932. This was the last mention of the pair together in their hometown's paper of record.

Hughes was putting on a devil-may-care show in public, but privately he was increasingly cash poor. In May 1932 he had to restructure his agreement with Ella to give him more time to pay off her settlement. The new arrangement stipulated that Hughes may "not engage in any new, major under-taking, and particularly will not engage in the production of a motion picture," nor was he allowed to sell or trade Hughes Tool stock without essentially asking his ex-wife's permission. Between securing both his own divorce and Billie's, and funding the two failed Billie Dove pictures, Hughes had committed a fortune to a romance that was now over. This was on top of losses he had sustained producing *Hell's Angels* and creating the public perception that the film had been highly profitable. Now he would remain financially hamstrung for the next few years, at least temporarily unable to further his ambitions in Hollywood.

In fact, due to his frittering away of Caddo's assets, Howard's financial connection to Billie would last much longer than their romantic relationship. Hughes's lawyers and Dove's were engaged in a battle over Billie's contract to Hughes for years. Still owing Dove $252,000 as of April 1934, Hughes had petitioned to settle for a note worth $100,000, on the grounds that "the liabilities" of his film company Caddo had become "greatly in excess of its assets." Dove was willing to settle for less than half the worth of the contract, but only if Hughes paid cash. As Hughes's attorney Neil McCarthy later explained it, they could not do so, because "the Caddo Company did not have any money"—it had been depleted by Hughes's investments in Multicolor and an exhibition business, as well as, of course, failed films. In September 1935, Dove's lawyers cited "corporate fictions" that allowed Hughes to claim that his film company was in the red while in fact the finances of all of his companies were tied together, meaning he was technically capable

of reaching with Dove "a mutually satisfactory and fair arrangement." Genuinely afraid of a lawsuit that would expose all manner of the inner workings of Hughes's businesses, not to mention the Billie-Howard romance, by the end of 1936, Hughes Tool paid Dove $100,000 in cash.

By that point, Billie Dove no longer existed; the actress who played her was long retired. Billie's final film, made in the wake of her breakup with Hughes, was *Blondie of the Follies*, in which she costarred with Marion Davies. It was financed, like all of Davies's pictures, by William Randolph Hearst, who shut down the production before the last scene was shot, and held a cast and crew screening. It was obvious that Billie had stolen the picture. "I had given a damned good performance," she boasted many years later. That was the problem. Hearst demanded rewrites and reshoots so that Marion could steal the movie back—and so that Billie could be minimized, and recast as the villain. The final version of *Blondie of the Follies* was so different from what Billie had agreed to appear in that if it had been produced by anyone else, she might have filed a lawsuit. "I couldn't sue Marion and Mr. Hearst," Dove explained decades later. "They were friends of mine." When Billie went to see the finished film, it was a painful experience—halfway through, she turned to her date and said, "Let's go. I've had enough."

For a couple of years, while working with Lois Weber, Billie Dove had been able to transcend the typical petty politics of Hollywood and star in films that sought to speak to female viewers, and asked them to question the images of femininity they were generally given by the movies. By 1932, however, that brief two-film run seemed very far away. *Blondie of the Follies* had been written by women (Frances Marion and Anita Loos), but they were women in the pocket of Hearst, who sought to protect and promote Marion Davies at all costs. Billie had had her own version of Hearst in Hughes, but that hadn't worked out professionally or personally. She didn't go into *Blondie of the Follies* thinking it would be her last movie, but it ended up that way. Soon after, in May 1933, Billie married a wealthy rancher named Robert

Kenaston, with whom she would have a son and adopt a daughter. Marriage to Kenaston allowed an opportunity for early retirement, before she could age into anything other than the most beautiful woman in movies.

Like so many silent stars, much of Billie's work eventually went missing, and other than *The Black Pirate*, none of the extant films are well known today. Late in life, Billie (now Lillian Kenaston) was not only still carrying around that letter sent by the Burbank postmaster in 1926, demanding that she pay for extra staff to handle all of her fan mail, but would pull it out of her purse to show to virtual strangers at Palm Springs garden parties. All of that ambition of the girl in the movie house, looking up at the screen and imagining herself there, had not fully burned out. With the period of her stardom so many decades past, the failures and the heartbreak faded away, she held tightly to the memory of what it felt like to be on the highest pedestal in moving pictures, even if just for a little while. "All my life has been interesting, but back in my picture days, I was happy all the time," Dove said. "I was on the screen."

Of course, she hadn't been happy *all* the time. She hadn't been happy when Irvin Willat was running her life; it didn't make her happy when he sold her off to Howard (and for more than three times what she had netted from her own settlement with Hughes). She hadn't been happy when Hughes had squandered what remained of her star power, forcing her to carry subpar material and leaving her to answer to critics of *The Age for Love* alone; she hadn't been happy when William Randolph Hearst had dismantled the performance that could have been her comeback. But all of those troubles receded when she looked back from so many decades into the future. Sitting on that old couch that Howard had given her, all she recalled was the kind of glamour staring back at her from her scrapbook. All she remembered were the bright lights, the silk pajamas, and the thrill of knowing there were girls like her, in the audience, watching.

CHAPTER 7

"A BITCH IN HEAT"

"Would things have been different if Jean Harlow's first picture had been for someone other than Howard Hughes?" mused her friend, columnist Adela Rogers St. Johns, long after "things" with Harlow had ended. The columnist believed that once Hughes had created the indelible image of Harlow the bombshell, "no producer in his right mind would throw away the box office draw represented by Harlow to put her in another type of role."

Harlow would get stuck for much of her career in a trap of typecasting, forced to embody a sexual fantasy that felt to her nothing like the real her. This made Harlow's already shaky self-worth plummet—because clearly there must be something wrong with the real her if all Hollywood wanted was for her to pretend to be someone she was not. Of course, the truth was that it wasn't personal; Hollywood wasn't judging her as a person, but as a commodity.

"I feel like a bitch in heat," Harlow complained. "With the way men behave, even my stepfather, even my best friends' husbands—that's what I feel like." Harlow was aware of the irony: "And I'm not all that interested in sex."

Harlow's best films would reveal the nihilistic sex bomb caricature of *Hell's Angels* to be a farce. Not coincidentally, the first of those films would be written by the most subversive female screenwriter of the Classical Hollywood era.

MOST PEOPLE WHO WANTED to work in the movies on the cusp of the 1920s were heading west. Anita Loos, who already had the scripts for five Douglas Fairbanks hits, including *His Picture in the Papers*, under her belt, went the other way. Her husband John Emerson (the second Mr. Anita Loos) was licking his wounds after having directed Mary Pickford's first flop. In New York, the pair could start over.

In Manhattan, Loos was drawn to a group of male intellectuals, including journalist H. L. Mencken. Highly observant of socio-sexual dynamics, and never afraid of taking the piss out of the supposed "great men" in her midst, Anita wrote a short story mocking Mencken's relationship with what Loos described as a "stupid little blonde." When Mencken first read it, he said, "Do you realize, young woman, that you're the first American writer ever to poke fun at sex?" Published first as a serial in *Harper's Bazaar*, *Gentlemen Prefer Blondes* made Loos a star—and put strain on her marriage. "From the beginning, my tough little blonde proved to be a healthy financial enterprise," Loos recalled, adding in her perfectly dry, ironic tone that she "never had to bother my head with business, for John, as usual, took my money as soon as it came in."

Then Loos discovered her husband was having an affair. When she confronted Emerson and asked if he wanted a divorce, he said, "I'll never leave you; you're so gullible you might fall into the hands of some crook who'd get ahold of your money." Instead they separated, and John gave Anita an allowance drawn from what they had accumulated during their marriage, much of which Anita had earned. After the stock market crash, Emerson suggested Loos go looking for work, for the better of their shared bottom line. "And then," Loos recalled, "with poverty drawing closer and closer, there suddenly came out of left field an offer from MGM for me to write a movie script at $3500 a week!"

Irving Thalberg, the head of production at MGM, had sent for Loos to rescue a screenplay that was in trouble. It was based on the best-selling novel *Red-Headed Woman*, a pulpy story of a social climbing sexpot. The most recent attempt at an adaptation had been penned by

F. Scott Fitzgerald, who, Thalberg exclaimed, "tried to turn the silly book into a tone poem!" Thalberg had hired Loos, as he told her, "To make fun of the sex element, as you did in *Gentlemen Prefer Blondes*." It would be the only way to get a film about sex as big-game hunting, in which an independent-minded woman was the hunter, to get a pass from a censorship board so literal-minded that it performed line edits on song lyrics and used a stopwatch to patrol kiss length.

For Thalberg and Loos, the challenge was to figure out how *Red-Headed Woman*, a story about a girl who steals a foolish husband away from his wife, could work as a romance: "The poor girl has the flashy type of looks that frighten off any man with the qualities of a hero," Thalberg mused. "Who is there for her to love, when she only attracts fools?"

Such was essentially the lifelong dilemma of Jean Harlow, who had become incredibly famous since meeting Howard Hughes. This eighteen-year-old girl suddenly skyrocketed from nobody to internationally known femme fatale on the steam of one inexpert performance in a heavily hyped but—aviation spectacles aside—not very good movie. All eyes were on what she'd do next.

Other than moving into a new house in Beverly Hills, Harlow had not been able to make the most of this moment, because her contract to Howard Hughes forbid her to work for anyone but him without his permission. And after *Hell's Angels*, Hughes didn't have any movies with parts for Harlow ready to go into immediate production. (This, in the long run, was for the best, judging by the material Hughes was able to scrounge up for Dove.) Instead of casting her in movies, he sent Harlow on a never-ending publicity tour. First, there were appearances at the *Hell's Angels* premieres in New York and Seattle, and then in her hometown of Kansas City, where she greeted a crowd of four thousand at the Midland Theater and had an awkward reunion with her estranged father. Then it was back to New York for more publicity.

By the end of 1930, it had been more than a year since she had been on a movie set, and an incredibly frustrated Harlow felt that Hughes was taking advantage of her. With Jean having relinquished mana-

gerial control over her career to her mother and stepfather, Marino Bello approached Hughes and accused him of breach of contract for not providing Jean with opportunities to actually act. In response, a Hughes lawyer sent an extremely strongly worded telegram, asserting that Harlow had been "generously treated and splendidly handled." Hughes, the lawyer added, would "refuse to cancel [the] contract and resent her ingratitude in requesting it." Harlow was then ordered to "comply or we will no longer be responsible for her hotel bills which by the way have been extremely large." There persists to this day the myth that Harlow and Hughes had a sexual relationship, but this telegram seems more indicative of their dynamic, which was not only strictly professional but, in every way imaginable, made her feel terrible.

Finally, at the urging of Paul Bern, the writer and producer at MGM to whom Harlow had long been confiding her troubles, Hughes began lending Jean out to other studios, with Hughes pocketing a substantial loan-out fee every time. Soon Harlow found herself with the opposite problem of unemployment: she had been loaned out to work on three films simultaneously, at three different studios. In a typical deal, Hughes would net $1,000 a week for her services. Harlow's weekly salary was a quarter of that.

This was a relatively good cut for Harlow compared to the discrepancy between what Hughes earned and what she did on her personal appearances. Hughes could command as much as $3,500 (about $55,000 in 2018 dollars) for a week of Harlow appearances at a Chicago theater; Harlow still got only her standard salary of $200 a week. Adjusted for inflation, Harlow was pocketing $3,200 a week in 2018 dollars, which wasn't a pittance, but was definitely a mere fraction of what Hughes made on the deal. Jean's frustration over feeling that she was being cheated out of her fair share would have been bad enough, but the "act" Harlow had been sent to perform was totally humiliating: the evening's MC would drop his handkerchief, and Harlow would bend over to pick it up. That was it. "That was all she had to do," according to actor Reginald Owen, "because those wonderful breasts almost fell out, and that was worth any price for admission." These

shows got terrible reviews. Now Hughes was making a killing by putting Harlow's body on display to be ogled, offering up what appeared to be a lack of natural talent for ridicule.

Though she was cast during this time opposite James Cagney in the breakthrough gangster talkie *The Public Enemy* (released a year before *Scarface*), Harlow's part was small (and there was gossip that her role had been cut in half because she just wasn't good enough to handle more to do).[1] Her first really substantive role after *Hell's Angels* came in a film called *Gallagher*, about a newspaper reporter played by Robert Williams, who ignores his smart, career-girl colleague, played by Loretta Young, and falls under the spell of a rich bitch, played by Jean Harlow. The movie was directed by Frank Capra, who claimed that he cast Harlow "for sex," knowing "Harlow's breastworks [would] burst their silken confines on magazine covers and pin-up walls." And yet the film gave Harlow a chance to show that she was more than the sum of her swollen parts. There's one scene in which the camera tracks backward to capture Harlow and Williams walking from one room into another. As Harlow's body jiggles freely under her satin gown, Williams trails behind her, making a rambling joke about "an attack from the rear." But Capra shows us not the rear, but Harlow's face, smirking and sighing, conveying the annoyance of a woman who hears this kind of thing every day.

You've never heard of *Gallagher*, because by the time it was released in October 1931, it was called *Platinum Blonde*. Hughes convinced Columbia, to whom he had loaned Harlow, to change the title of the picture to Harlow's brand identifier, even though brunette Loretta Young was the first-billed actress in the movie, and its romantic victor. But *Platinum Blonde* was the right title for a movie about a regular joe, suckered into a fantasy of sex and wealth, who learns that living that fantasy means selling his soul.

As *the* platinum blonde, Harlow would come to represent an intermingled fantasy of security and sex while maintaining a neighborhood-

[1] Frances Marion and Darryl Zanuck reportedly spread this gossip. See Berg, *Goldwyn*, 215.

girl feel that made her an accessible icon to millions of women. A lot of those women wanted to look like her, which led to a rise in the popularity of hair bleaching. Harlow swore publicly that she didn't dye her own hair, but of course, she did, and touched up her roots every Sunday. Her hairdresser used a combination of peroxide, ammonia, Clorox bleach, and Lux soap flakes. Women all over the country attempted to replicate the results with household bleach, often with disastrous results.

The full platinum blonde look went beyond the hair: copies of the slip Harlow wore in *Hell's Angels* were sold in department stores, allowing viewers of the movie to literally try the costume of the heartless temptress on for size. Harlow may have been naive to the ways of Hollywood, but one thing she was used to was being objectified by men because of the way she looked. What she wasn't used to was being idolized by women and girls, who were drawn to the sexual power Harlow showed on-screen, but instead of wanting to conquer her, these women wanted to emulate her. It was men who put Harlow's sexuality up for sale, but a lot of women were buying.

After *Platinum Blonde*, Harlow's stepfather took a cue from Hughes and booked Harlow on yet another personal appearance tour. Harlow hated these personal appearances, but she hated Hughes more, and at least this time, he wouldn't be involved.

These "shows" started out disastrously—Harlow still didn't have an act beyond parading her body for the aggressively withering gaze of strangers—and at some point she collapsed and was diagnosed with an intestinal illness. After that, changes were made. Now the curtain would come up to reveal a spotlit Harlow, dressed in an elegant white gown, at the top of an art deco staircase. Harlow, agent Arthur Landau remembered, "shimmered in the light like a star in heaven—the blond shining hair—the gorgeous figure and most of all her smiling beautiful face and just enough of her breasts showing, solid as two rocks to make the men squirm and the women say 'Ah' and then applaud." The show itself wasn't that different in this incarnation—Harlow still didn't really do anything but present herself to be looked at, although at least

now there was no comedian goading the audience to laugh and setting Jean up to bend over—but the new aesthetics and presentation made all the difference. Stripping her persona down to just the platinum aspects turned the audience's gaze from a mean-spirited gawk into an act of worship. Literally on a pedestal, it seemed like she was the one with all the power. The crowds went wild.

Hughes and Quarberg may have given Harlow her branding nickname, but they had nothing to do with the final polish on her persona, nor did they play any kind of part in how she triumphed with it. Give that credit to Anita Loos, Irving Thalberg, and Harlow herself.

In March 1932, Hughes finally agreed to sell Harlow's contract to MGM. The studio only wanted Harlow because Paul Bern wanted her, but soon they found something to do with her. Thalberg had seen Harlow in *Hell's Angels* and thought she had the right look for the film that Loos was rewriting; he just wasn't sure if she could play comedy, given that the only laughs she had inspired in Hughes's movie had been those of derision.

At her MGM screen test, Jean showed her off-screen comedy chops in conversation with Thalberg. "How did you make out with Howard Hughes?" he asked her, hoping for gossip that could top off what he had already heard.

"Well, one day when he was eating a cookie he offered me a bite."

Thalberg and Loos laughed, but then Jean offered the real punch line. "Don't underestimate that. The guy's so frightened of germs, it could darn near have been a proposal!"

Then Thalberg asked, "Do you think you can make an audience laugh?"

"Why not?" Harlow shrugged. "People have been laughing at me all my life."

With that, Jean gave the second most powerful man at MGM and one of the most famous female writers in America a cheeky nod, and was out the door.

"I don't think we need to worry about Miss Harlow's sense of humor," Thalberg said.

Loos wrote the nod into the movie. "She knew exactly how people were going to react to her," Loos marveled. "If men were stupid they'd fall for her; if they had good sense, they'd laugh her off."

At the first preview of *Red-Headed Woman*, audiences didn't know if they were allowed to laugh at Harlow, whom Anita Loos affectionately referred to as "our sex pirate." Thalberg ordered her to write a new prologue, to "tip the audience off that the movie's a comedy." This prologue gives an ironic cast to the whole film. The first line of the movie comes from a newly ginger-coiffed Harlow: "Gentlemen prefer blondes, do they?" winking at both star and screenwriter's greatest claims to fame. A few minutes later Jean lasciviously tells her friend that she's hoping to "take dictation," mocking a similar joke from *Grand Hotel*, which was released by the same studio just two months earlier. In that movie, 1932's epitome of a prestige picture, the "dictation" suggestion is just as weighted with double entendre, but it's said by John Barrymore to Joan Crawford, who rebuffs it. In *Red-Headed Woman*, Jean Harlow made Joan Crawford's shopgirls look like duchesses. Harlow's Lil is a pure social climber who makes every rich man she meets look like a fool, so cannily that it feels like she's advancing not on her feminine wiles so much as on male stupidity.

The final shot of the movie shows that the rich men she becomes involved with are disposable, and that she has maintained a lasting relationship with a working-class immigrant (a chauffeur played by Charles Boyer). In its very weird way, *Red-Headed Woman* actually accomplishes the goals of the Hays Code—shaming adultery, or at least the men who are suckered by young floozies into committing it—even while depicting the wanton promiscuity that the Code had forbidden. Loos turned the Harlow character's pursuit of her married boss into a joke, and showed the whole idea of preying on easily seduced men to be a lark.

Not only is Harlow very good in the picture, but it's fair to say that she was uniquely equipped to pull off *Red-Headed Woman*'s balancing act. Loos observed the odd disconnect between the roles Harlow played and the actress's own feelings about her sexuality. She described

Harlow as "unselfconscious . . . rather like a boy. She was completely frank. She had absolutely no feeling about the sensation she created wherever she went. And she had no vanity whatsoever." Harlow was sexy enough to manipulate men, but she wore and wielded her desirability in an offhanded way that didn't make other women feel threatened. Instead of alienating female viewers with her sexuality, the distance she was able to maintain from the way men saw her allowed her to draw women into complicity with a character like Lil. She gave female viewers the vicarious pleasure of being able to use their sexuality to win, rather than have it be a source of weakness or shame.

Once her transfer over to the rarefied space of MGM was complete, Harlow started downplaying Hughes's role in discovering and mentoring her. In an interview in March 1932, Harlow explained that James Hall had introduced her to Ben Lyon, which was how she ended up screen testing and getting her first significant part. "Those two boys practically directed the picture," Harlow said of *Hell's Angels*. "And they made me, for I knew nothing about the game and they could have had me with my back to the camera from morning until night, if they had wanted to keep me in the background. Instead, they gave me every opportunity and how kind they were to me, the picture shows." Quarberg clipped this article and sent it to Hughes, scrawled with a note: "Here's gratitude for you!"

Harlow was not the only "ungrateful" starlet to cause trouble for Hughes that year. By the end of 1932, he had lost control of three significant actresses in whose stardom he had once been invested. "Howard Hughes has made a neat little role for himself buying up beautiful girls, putting them in expensive pictures, and then selling them retail to a 'paying' studio," gossiped *Screen Land* magazine, citing Harlow, Billie Dove, and Ann Dvorak as examples.

A few months earlier, twenty-year-old Dvorak, an atypical beauty whose parents had worked in silent film, had made headlines claiming she had been "sold down the river" by Hughes, who had unloaded his contract with Dvorak to Warner Bros. after the actress's performance in *Scarface* had turned her from an unknown bit player into a budding

star. Unlike Harlow, Hughes couldn't even claim to have discovered Dvorak: she had been cast in *Scarface* after her friend, actress Karen Morley, had invited her to a party at director Howard Hawks's house before shooting began. At the party, Ann had asked *Scarface* actor George Raft to dance and he declined. "She was a little high [drunk]," Hawks remembered, "and right in front of him starts to do this sexy undulating dance, sort of trying to lure him on to dance with her. She was a knockout. She wore a black silk gown, almost cut down to her hips. I'm sure that's all she had on." Eventually Raft gave in, and according to Hawks, he and Dvorak proceeded to dance "a sensational number which stopped the party."

Hawks ended up casting Dvorak in *Scarface* as Cesca, the sister with whom the titular two-bit gangster has a quasi-incestuous bond, and the director even inserted a scene in the movie replicating Dvorak's party dance with Raft. Hughes soon decided that if Hawks was so interested, Dvorak must be a valuable commodity, and in August 1931, Hughes signed her to a long-term contract. He also tried to date her, but Dvorak was too nervous to accept his overtures; though she had stunned as a glamour girl in *Scarface*—and when drunkenly cavorting with Raft on the dance floor—this had been a performance from a young woman who thought of herself as a mousey wallflower, and she didn't want her boss to find out about the real her. As a result, when Hughes would call, Dvorak would make her mother answer the phone and tell the millionaire that Ann was off doing something exciting and glamorous, when in reality, Ann would be sitting by the phone, "shivering and shaking with excitement . . . her face cold-creamed, eating a ham sandwich."

Hughes never got further with Dvorak. There were rumors the actress and director Hawks had an affair on the set of *Scarface*, and Hawks did cast her in his next film, *The Crowd Roars*, which required Warner Bros. to rent her services from Hughes. Warner Bros. paid Hughes $600 for Dvorak, and Dvorak, like Harlow before her, got $200 a week. Hughes kept renewing Dvorak's contracts through the middle of 1932, but he didn't give her much to do. He allegedly tried to get his

old friend Lewis Milestone to cast Dvorak in his adaptation of Somerset Maugham's *Rain*, but Joan Crawford got the part instead. Hughes cast Dvorak in just one more film, the Spencer Tracy vehicle *Sky Devils*, and then continued to loan her out to Warner Bros. On the set of one of these WB films, Dvorak met the man who would become her first husband, actor Leslie Fenton.

After Dvorak had shot five Warner Bros. films, Hughes finally decided to sell her contract to the studio, which paid Hughes an exorbitant $40,000. After filming her sixth film at Warner Bros., *Three on a Match*, opposite Humphrey Bogart, Dvorak decided that she wanted out. Warners had taken their time drafting a new contract, and Dvorak's weekly salary hadn't yet been raised from the bargain-basement rate Hughes had set—plus, after filming *Match*, Dvorak learned that the toddler who had played her son in the film had been paid the same salary as she. In addition, Fenton, whom Dvorak had impulsively married, was making a movie in Germany. Ann didn't want to be separated, and per the times, if anyone was going to shirk their professional responsibilities for the good of the marriage, it was going to be the wife. So Ann walked out on her commitment to Warner Bros. and traveled to Europe with her husband.

In breaching her contract, Dvorak didn't seem to think she was giving up much. She was annoyed that Hughes had signed her to a seven-year deal and had essentially pimped her out before selling her like chattel. And she wasn't happy with how Warners had used her thus far. "I made nine pictures in eight months,"[2] Dvorak said, summing up her career thus far. "Quantity, not quality."

In Dvorak and Fenton's absence, her agent had already tried to negotiate with Warners to double Ann's paltry salary, to no avail. So on July 19, 1932, two weeks after Dvorak had absconded from Hollywood with her husband, the actress, Fenton, and a Hungarian actor named Vic-

[2] Dvorak may have been slightly exaggerating here: her IMDb profile shows she had significant roles in seven films that had likely been shot in the eight months prior to July 1932. She had walk-on/uncredited parts in two films released in mid to late 1931, which she may have been counting as well.

tor Varconi spoke to the press in New York and announced that Dvorak had been "sold down the river" by Hughes. Fenton and Varconi had what seemed like rehearsed statements ready to go. "Producers look at you for how much money they can squeeze out of you," Fenton declared. "A contract's a sentence to hard labor. There's no regard for personality. Stars are being sent to sanatoriums because they can't stand the pace. That's not going to happen to Ann." Varconi piped in with a virtual non sequitur: "There is little culture in Hollywood," he sniffed. "I hope I shall be able to arrange my affairs so that I will not have to return there."

Within a day, Howard Hughes had responded to Dvorak's claims with a statement that can only be described as a masterwork of rhetoric, far exceeding in tone and strategy Dvorak's clumsy appropriation of the language of the slave trade. "Ann Dvorak was not 'sold down the river;' and she was misinformed if she thinks so," the statement began. It went on to argue against each of Dvorak's main points, even correcting some of Dvorak's math about his own share of profits, before damning Dvorak with praise: "Of course, some producers might be highly indignant at Miss Dvorak's statement and if they were in my position they might denounce her ingratitude, proclaiming loudly: 'Miss Dvorak still would be working for $75 a week if we had not given her a part in *Scarface*,' but I don't feel that way. Producers are not entirely responsible for the success of a star. . . . I think some credit should be given for Miss Dvorak's ability."

The Dvorak situation brought an echo of Hughes's conflicts with Harlow, but if Harlow managed to shrug off Hughes and move on to bigger and better things in a way that made Hughes look expendable to her success, the opposite fate would befall Dvorak. His statement elegantly put her in her place and made Hughes—who could barely string together a sentence in a social situation—look like a font of wit and charm. It served as the perfect mic drop for Hughes, who would take his leave from Hollywood around this time, putting into motion the first in what would over the years become a pattern of disappearances.

This time Hughes vanished from Hollywood to take a job as a co-pilot at American Airlines, under the pseudonym Charles Howard.

This was supposedly done discreetly, at least at first, but it was reported by a Los Angeles newspaper in September, as an aside in a story otherwise mostly about Hughes's struggles with Multicolor, the color film plant he had bought but couldn't keep afloat. While Hughes was still perceived as fabulously wealthy in Hollywood, in actuality he was drawing no income from previous efforts at moviemaking and was not flush enough to mount new films. His personal finances would dissipate so much that by the summer of 1934, he would once again have difficulty making Ella's alimony payments.

Meanwhile, the star who had helped launch the Hughes myth was doing just fine without him, at least professionally—but her personal life was soon to turn tragic. In July 1932, Jean Harlow had married Paul Bern. Their coupling had shocked those who knew both well. Harlow had the most sexual persona of any movie star of her day, but off-screen, according to Anita Loos, she was "completely sexless." It's possible that Harlow was drawn to Paul Bern *because* he wasn't sexually aggressive. (She was supposed to have said that Bern was different, because unlike all the other men she knew, "He doesn't talk fuck, fuck, fuck all the time.")

Loos claimed that Bern had wooed Harlow by promising to help advance her career. By helping her escape Hughes and bringing her into the fold at MGM, he had done just that. This may have been enough, in Harlow's mind, to overcome the rumors about Bern that Harlow surely would have heard.

Bern was notorious for pursuing beautiful women, and for mysterious (and much gossiped-about) reasons, not consummating those relationships. Adela Rogers St. Johns reported that Barbara La Marr—a gorgeous silent-era actress who had costarred in *Souls for Sale*—had rejected Bern's marriage proposal in the 1920s. She went on to die in 1926 of illnesses related to her chronic drug use—but not before telling St. Johns "what kind of person Paul was and why she wouldn't marry him." St. Johns said in 1971 that Harlow had told her that Bern was impotent, but that she didn't care, because "he's paid me the highest compliment I've ever had. No man has ever loved me before for

what's best in me." "Bern adored Jean as abjectly as only a German psycho might," Loos acknowledged. But St. Johns "had no sympathy" for what she called "Paul Bern's nonsense." She repeatedly told a story about how after La Marr's rejection, Bern had tried to drown himself by sticking his head in a toilet.

If history repeats itself, usually the first time as tragedy and the second time as farce, with Paul Bern it was sort of the other way around. The official story of Bern's last days holds that Bern and Harlow spent the Saturday of Labor Day weekend apart. Harlow was expected on the set of the Clark Gable picture *Red Dust* early Sunday morning, so she went to sleep at her mother's house, which was closer to the MGM lot. Meanwhile, her husband spent the night at home alone, reading a haul of books he had purchased the day before, including one on the study of glands, which was very trendy in Hollywood at the time, particularly among those who believed that homosexuality and other forms of "deviance" could be "cured." The next day, Bern was found in his bedroom, curled up on the floor, a fatal gunshot wound in his head and a .38 revolver in his right hand. A mysterious note was found in a guest book near the body. It reads: "Dearest dear, Unfortunately this is the only way to make good the frightful wrong I have done you and to wipe out my abject humiliation. I love you. Paul" Then, below the signature, a sort of postscript: "You understand last night was only a comedy."

The book was not left open to this missive from "Paul." It was discovered when the MGM crisis team arrived on the scene after Bern's butler found his body, and they decided to present the guest book entry as a suicide note, evidence of a tortured man's motive to end his life. When MGM finally allowed Harlow to be questioned by detectives a full day later, she insisted she had no idea what the note meant. Meanwhile, the studio leaked an autopsy report, which included the detail that Bern had "a physical condition which left him unfit for matrimony": his genitals were "underdeveloped."

Certainly, MGM seems to have performed some kind of cover-up, or massaging of the presentation of facts, perhaps just to give Harlow an alibi so that she wouldn't have to testify to an incredibly traumatic

incident that Adela Rogers St. Johns claimed she definitely was present for. "She was there in that house that night," St. Johns wrote in 1978. "No reason not to tell it now. She'd heard the shot. She would hear it as long as she lived. After Jean's call for help we went, another close friend and I; we took her to her mother's. When the police and press got to the house of tragedy they found only that hideous note that made her—a girl men killed themselves over."

Anita Loos confirmed this version of the story. According to Loos, when Bern and Harlow's sexual incompatibility had proven to be irreconcilable, the actress had cheerfully suggested that Bern "find yourself someone else." As Loos describes the evening in question, Harlow had been asleep at home, in her separate bedroom (which was a necessity so that she could wake early for call times, never mind whatever extramarital arrangement she and Bern may have had), under the assumption that Bern was spending the night with a lover. Bern had even given Harlow a friendly kiss good night before leaving for his date. Loos says that when Harlow woke up the next morning, Bern's "suicide note" had been slipped under her door. It was then that she went into his bedroom and found his body, and saw that "he had killed himself while looking in a full-length mirror."

In her column many years later, Hedda Hopper cited an anonymous "prominent and respected doctor who knew both Bern and Jean intimately" with the story that two weeks before Bern's death, he came into Harlow's bedroom and started hitting her with a whip. "She took it out of his hand and broke it," Hopper wrote. "That was the basis of the 'last night was a comedy' reference in the note he left behind."

Harlow's friends worried that she would never recover from the shock of her husband's death, and the implication that his failure as a man that supposedly led to his suicide was a consequence of her failure as a woman. "If she had hated herself before," St. Johns mused, "what must she have felt then?"

She did not have much time to process any feelings. A few days later, Harlow was back at MGM, continuing to shoot *Red Dust*, a film in which she'd famously appear to be bathing naked in a barrel. The

scene is the epitome of pre-Code bawdiness, and also an example of
how even in this supposedly freer time, the limits on what could be said
in plain language in a movie forced filmmakers to, well, code story-
telling about female sexuality. Jean played Vantine, who, after running
away from some kind of "trouble" (it's heavily implied that she is or
has been a sex worker), ends up on a rubber plantation in French In-
dochina run by Clark Gable, whose character begins the film openly
hating women and frequently complaining about what a nuisance they
are. (The ladies shouldn't feel singled out: he's also casually abusive
and demeaning toward the natives who actually do the work on his
plantation.) Gable's Dennis succumbs to Vantine's feminine wiles, but
then a wealthy, classy couple arrive and Gable, who takes an interest
in the wife (Mary Astor) while the husband is sick, becomes embar-
rassed that Jean is still hanging around. Vantine's open-air bath seems
to be her way of flaunting her sexual daring so as to antagonize her
rival and draw Gable's attention back to her. This scheme backfires:
Gable's reaction to finding Jean all soaped up in the barrel reveals that
he finds her shameful and dirty ("You know we drink that water," he
says, with disgust in his voice), hammering home the distinction be-
tween Jean Harlow and Mary Astor, whose character Gable has al-
ready admiringly described as "decent"—and who is also a married
woman whom the virile plantation manager is hoping to corrupt and
lure into adultery with him. At the end of the scene, Gable pushes Har-
low's head underwater to punish and humiliate her—but she bounces
right back, refusing to allow this man to shame and bury her.

Though it will take Gable's character the rest of the film to come
around, this dunking and her resilience puts the audience in sympathy
with Harlow, whose unwillingness to apologize for the kind of woman
she is still resonates today—and which struck her costar as heartbreak-
ingly inspirational on the day the scene was filmed. Watching Harlow
play this scene, so soon after her husband died and her own sexual
persona was all but labeled as the cause of death, Gable was in tears.
"There's the best gal that ever lived," he marveled. "Every man on the
set," claimed St. Johns, "was weeping openly."

THE BOMBSHELL IMPLODES

Six weeks after Paul Bern's death, *Red Dust* was released and became a massive hit. In the middle of the Depression, the movie's gross tripled what the film had cost to make and earned Jean Harlow the best reviews of her career to date, establishing Harlow and Gable as a gold-minting on-screen team in the process.

Harlow was at the peak of her stardom, and in 1933 she would make her best film, *Bombshell*, a satire of a movie star not unlike Harlow. The crux of *Bombshell* is the love-hate relationship between Harlow's Lola Burns and her publicist, a savvy snake played by Lee Tracy. The plot covers a couple of days in the life of mega-sex-symbol Lola, who grows tired of being exploited by the men in charge of her career, and milked dry by her army of hangers-on. After a series of misadventures, Lola flees Hollywood for a desert retreat, where she meets a pretentious millionaire (Franchot Tone), who says he has never heard of her. They fall in love, but soon headlines about Lola's unsavory reputation reach the rich guy, and he calls their engagement off. With the one person who seemed to love Lola for "the right reasons" revealing himself to be as shallow as all the rest, Lola heads back to Hollywood, and does so happily—at least until she realizes that Tone's character was an actor paid by her publicist to sour Lola on "real life" and get her to come back to work.

All of this could be played as tragedy, and if the movie consistently

empathized with Harlow as though she were a real person, it might be horribly sad instead of often riotously funny. But that was the magic of Harlow: her platinum exterior worked like Teflon, allowing her characters to roll through all kinds of potential humiliations or devastations without leaving a scratch on the glamour girl. In *Bombshell*, you love her and root for her in every scene, while also laughing at her. By the end of the film, we understand that Hollywood is the only place for a girl like Lola, who exists to give others the pleasure of looking at her and laughing at her—and who, through strategic in-jokes, we are meant to believe is essentially synonymous with Jean Harlow. The real hero of the movie becomes the smarmy publicist who brings her back to where she belonged all along. It's a particularly layered and sophisticated example of a Hollywood film that ostensibly reveals the horrible inner machinations of the Hollywood system while also slyly shoring up the viewer's fascination with, and devotion to, the products of that system.

If made a year later, when the Code began to be more strictly enforced, *Bombshell* would have had to have been much more coy about its heroine's sexual reputation, which would have dulled its appeal both as a comedy and as a meta-event about the real Jean Harlow. As it was, the film came along at the exact right moment, helping to establish the rapid-fire style that would become a signature of comedies of the decade. Its highly influential breakneck pacing was a necessity: in order to ensure that a 160-page script could produce a film of about ninety minutes, Victor Fleming directed scenes to play almost twice as quickly as usual. Harlow proved herself not only capable of performing lightning-fast, overlapping dialogue, but she did it without losing a touch of her physical allure. Subsequent screwball comedies would allow women dressed as sex goddesses to step off their pedestals and compete on the same level as men, via banter and one-upmanship and kooky physicality. In this genre, Harlow found her métier.

Harlow and her team believed that *Bombshell* was her greatest triumph, and they weren't wrong. But while *Bombshell* grossed twice what it cost to make, it wasn't even Harlow's biggest hit of that year—*Dinner*

at Eight, in which she had a smaller but indelible part as the floozy wife of a boorish rich guy, had been a mega-blockbuster, ending the year as 1933's seventh-highest-grossing film.

In the interim between the releases of these huge hits, Harlow married cameraman Hal Rosson, who had worked on a number of her films, including *Red-Headed Woman* and *Red Dust*. The marriage appears to have been arranged by MGM in order to sanitize Harlow's off-screen persona in the aftermath of the Bern suicide, and amid an affair Harlow was apparently having with boxer Max Baer, who had a wife of his own. Harlow and Rosson were married for about seven months, much of which they spent apart. Three weeks after the wedding, Harlow was rushed to the hospital to have an emergency appendectomy. After two weeks in the hospital, Harlow's mother insisted that instead of returning to her husband, the Baby should continue her convalescence at her mother's house. Harlow never moved back in with Rosson. The charade of their marriage legally and publicly ended after a year.

Moviegoers didn't know the messy details—indeed, as far as the public was concerned, Harlow had overcome the tragic death of her husband, and she was stronger than ever. Certainly, by the time *Bombshell* was released in the fall of 1933, Harlow was the biggest female star at MGM, if not in Hollywood on the whole.

No wonder MGM's competitors went looking for blond bombshells of their own. In August 1933, weeks after *Dinner at Eight* opened, fifteen-year-old Ida Lupino arrived in Los Angeles to sign a contract with Paramount, who had seized on the pint-size bleached blonde as a potential British Jean Harlow. She was a little young for a sex goddess, but that could be fixed. As she walked into her first press conference, a publicist whispered in her ear, "Now you are 16."

Lupino had been working since she was twelve. The daughter of silent film comic Stanley Lupino and tap dancer Connie, the child had talked her way into her screen debut, a walk-on in one of her father's films, and soon thereafter convinced her parents to let her quit school. Her first big movie role, in an Allan Dwan film called *Her First Affaire*, was that of a nymphet besotted with an older man. Dwan's film

became such a showcase for the budding star that Lupino's name was billed above the title. She plays a young blond strumpet obsessed with the author of *Fires of Impulse*, a new romance novel that has given her new ideas about new women. "Marriage is a little old-fashioned, isn't it?" Lupino's character asks her young boyfriend. "You approve of convention, of course. A man can be free but a woman must be chained." Her boyfriend is so annoyed by this spouting of feminist rhetoric that he agrees to introduce her to the author, assuming the bloom will be off the rose once she meets him. Instead she works her way into the author's household and refuses to leave, much to the bemusement and then concern of his wife. The movie's ultimate attitude toward the social-order-shaking ideas within it are summed up when a woman of grandmother age mockingly refers to Lupino's character as a "modern vampire."

Of course, there would always be older men who lost their heads over young pretty blondes, and so naturally the "new" Jean Harlow found herself in the crosshairs of Howard Hughes soon after she arrived in Hollywood. There's a famous photo of the pair taken in Palm Springs: he tieless in a light suit and sunhat, straddling a bicycle, looking annoyed, she in a button-down coat and dark lipstick, hair bleached white, looking like she's trying to appear much older than her fifteen years. In fact, Ida considered herself to be not just an adult, but a show-biz veteran. Paramount's first inkling was to cast her in the lead of *Alice in Wonderland*, but a test proved that she couldn't play younger than her age. In her first one-on-one newspaper interview in Hollywood, Lupino told columnist Alma Whitaker, "You cannot play naive if you're not. I never had any childhood."

Rather than try to mask her eccentricities, Ida took pride in flaunting them, and flouting convention. She believed herself to be psychic, and when an old boyfriend died shortly after she arrived in America, Ida claimed that his ghost would visit her while she was in bed at night. Hughes threw Lupino a party for her sixteenth birthday, and when he asked her what she wanted as a present, he expected to hear the usual: a bottle of Chanel perfume. Instead she told him she wanted a

pair of binoculars. "Binoculars?" Howard said, "What on earth would you want binoculars for?" The Hollywood newcomer responded, "I wanted to look at the stars."

At that point, the star in whose image Lupino was being molded was going through a rough time. After Bern's death, Harlow had started drinking much more heavily, which her mother believed was making her sick. Actually, the drinking may have obscured other health problems, and Mother Jean's control over her daughter was by no means grounded in a healthy outlook. Jean Harlow Sr. was an intermittent Christian Scientist, but above all a capitalist, concerned with maintaining her daughter's stardom for as long as possible, no matter the cost. When a film would go into production, under her mother's supervision Harlow would stick to a strict diet of cottage cheese, corn bread, and black coffee, which surely could have led to anemia, making the already sickness-prone Harlow even weaker. By 1936, Harlow was losing her luminescence. Thanks to ten years of weekly bleaching, if not other health issues, her hair was falling out in clumps. Meanwhile, MGM had to face the fact that with the Hays Office increasingly exerting its power to ban even the implication of anything outside of maritally sanctioned procreative congress, Harlow's whole devil-may-care attitude toward sexuality needed to be reformed.

Harlow's physical changes, including her hair loss, and the sense that her star image had grown stale, compelled the studio to give her a minor makeover. The Platinum Blonde was given wigs in a darker, much more natural hue, and in the press she was rebranded "the Brownette." Less-than-ultraglamorous and certainly anti-trampy roles followed. The new Harlow was fully on display in *Wife Versus Secretary*, released in early 1936, in which she played the "realistically" attractive, completely morally upstanding clerical assistant to Clark Gable, who is truly in love with wife Myrna Loy and doesn't want to cheat on her. Loy's suspicions build until Harlow gives a speech about how lucky Loy is to be married to a decent guy. A few months later came the excellent romantic roundelay *Libeled Lady*, in which Harlow played the long-suffering fiancée of Spencer Tracy, while Harlow's

then real-life love, William Powell, wooed rich princess Loy. Earlier in her career, Jean Harlow's gowns, though skintight enough to make it readily apparent that there was only skin underneath, always seemed to fall open in the right places. In *Libeled Lady*, it is costar Loy whose bralessness seems brazen, while Harlow is suspiciously fussy-looking, and often covered up in long sleeves and big furs. Comparatively conservative wardrobe aside, the film's characters still treat her like a dumb blonde until a final scene in which she tells them all off for underestimating her.

These more mature films reflected where Harlow wanted to be in her personal life. She was deeply in love with William Powell, but Powell, who was divorced from Harlow's comic-bombshell rival Carole Lombard, didn't want to get married again, and certainly not to Jean Harlow, whom he seemed unable to distinguish from her screen persona. "You don't marry someone half of America wants to sleep with," he said of his girlfriend, whom he'd string along for over three years. Harlow told her pal, gossip columnist Dorothy Manners, that she felt the romance was one-sided. "I'm the one who does all the giving."

"Baby, all men do that," Manners said.

Harlow responded, "He's breaking my heart."

Harlow asked for Adela Rogers St. Johns's help in luring Powell to the altar. "He won't believe me when I tell him I only want him and a home," Jean told the columnist. But St. Johns refused to intervene.

"How could I?" She later explained. "He was a wise, intelligent, experienced man of the world. He was over 21. He knew Jean. I couldn't interfere."

IN DECEMBER 1935, IDA Lupino and her parents, Stanley and Connie, threw a party at the Trocadero nightclub in Hollywood to celebrate their good friend, comedienne Thelma Todd, who had known Ida's father and mother through the vaudeville circuit for years. Known as the "Ice Cream Blonde," Todd had been suggested for the

Harlow role in *Hell's Angels* by Marshall Neilan, when he was still on board as that film's director. She had since appeared in *Monkey Business* and *Horse Feathers* with the Marx Brothers, and had starred with Zasu Pitts in a series of comedy shorts.

Pat De Cicco, Howard Hughes's friend and right-hand man and Todd's ex-husband, had approached Ida a few days before the party to ask for an invitation. Thelma and Pat had been divorced for more than a year and a half, and though she had won the divorce on charges of cruelty—in fact, she was said to have regretted the marriage almost as soon as the wedding was over, thanks to De Cicco's uncontrollable temper—Thelma still spoke to her ex. Ida extended the invitation to Pat, and even set a place for him at the dinner, but he didn't show up—at least, not for dinner: at some point in the evening Ida spotted him elsewhere in the supper club, dancing with another actress.

Todd would leave the Lupino party at 3 A.M. and would be found dead a few hours later, in her car, parked in the garage downstairs from the popular cafe that she owned on Pacific Coast Highway. Todd had an apartment on the property, as did her business partner and lover, Roland West. Roland West also had a wife.

The cause of Todd's death was carbon monoxide poisoning. West articulated a theory that many believed to be plausible: There was an outside door to Todd and West's apartments that West left unlocked as long as he was awake, but by 2:30, he couldn't stay up waiting for Todd any longer, so he had locked the door and gone to sleep. Thelma had returned home at 3:30. A little drunk, and not thinking about the fact that she hadn't brought her key, she had dismissed her chauffeur before she tried the door. Finding it locked, according to West, "she didn't make any noise or attempt to awaken me. Instead, she must have walked up the hill to the garage in which she kept her car and becoming cold, started the motor. Thelma was very considerate."

Though the coroner initially declared Todd's death an accidental suicide, an inquest was held. Taking the stand before a grand jury, Ida explained that Thelma had been in high spirits the night of her death, so suicide seemed unlikely. However, Ida noted that Todd had what

Ida called a "death complex"—she believed in living life to the fullest, because one could go at any time. Ida also noted that she and Thelma had both been surprised and hurt to see Pat at the Trocadero with another woman.

The grand jury closed the case without reaching a conclusion—which only left a vacuum for speculation. The most colorful theory regarding Todd's death, elaborated on in Andy Edmonds's book *Hot Toddy*, published in 1989, claims that mobster Lucky Luciano killed or had Todd killed because, though they were having an affair, she had refused to turn her cafe into a gambling den controlled by him. But William Donati, who has authored biographies on Lupino, Luciano, and Todd, could find no evidence that the latter two ever met, and in her book on Todd, *Ice Cream Blonde*, Michelle Morgan also dismantled the Luciano legend.

Though no solid evidence has ever been produced to back them up, from the beginning there were whispers that Pat De Cicco, who had boarded a flight for New York the night Todd's body was found, was somehow involved in his ex-wife's death. These whispers were still swirling around town years later, when De Cicco was functioning as a "talent scout" for Howard Hughes.

Less than a year after Todd's shocking death, Irving Thalberg would die from pneumonia at the age of thirty-seven, and there would be a sense around town that something essential to what Hollywood had been for the last decade or more had died with him. It was, according to columnist Florence Fisher Parry, "the biggest single blow the motion picture industry could possibly have suffered." MGM shut down for a full day for the funeral. Thalberg had had more to do with Harlow's continued success than any other man in the industry, but if she attended the funeral, photographs of her there did not circulate widely. Most major newspapers instead ran a photograph of Harlow's opposite number at MGM, Joan Crawford.

By now Harlow was in bad shape. Her relationship with Powell had all but petered out. "I am so constantly trying to be what Bill wants me to," she told Louella Parsons, "but I know we have a feeling we'll never

be married." In March 1937 she discovered she needed to have all of her wisdom teeth removed, and Mother Jean found a dentist who was willing to extract all four teeth at once, so that "the Baby" would be able to swiftly return to work. After the third tooth was removed, Harlow's heart stopped beating briefly. She managed to recover enough to report for work on a new movie, *Saratoga*, but two months after the surgery she was still draining fluid from her infected mouth.

On the set of that film, in late May, she started complaining of abdominal pain. She went home for the weekend to Powell's mansion and spent the weekend in bed with what everyone thought was the flu. On Wednesday, now vomiting and becoming delirious, Jean finally was seen by a doctor, who diagnosed a swollen gallbladder and prescribed dextrose injections. On June 3, the Associated Press claimed Powell had gone to visit a hospitalized Harlow, who had "virtually recovered today from what her doctor diagnosed as a cold." This doesn't jibe with eyewitness accounts of Harlow's last days, and was likely fed to reporters by Harlow's mother.

In fact, ostensibly because of the elder Jean's allegiance to Christian Science and desire to control the story, Harlow was treated at home for most of her illness. This decision proved fatal. The first doctor's gallbladder diagnosis had been wrong, and when she failed to get better, a different doctor came to see her and declared that it was her kidneys that were the problem. Those kidneys had probably been degenerating for years, since an infection that followed the scarlet fever she had contracted as a teenager, and now the hydrating fluids that had been prescribed by the first doctor to treat her, which her kidneys couldn't process, were killing her. Harlow was finally admitted to the hospital on the evening of June 6. Her kidneys had caused her whole body to swell so severely that, as one doctor recalled, "her face looked like Fatty Arbuckle." The next day, a doctor told journalists waiting outside the hospital that Harlow had already had "two blood transfusions and intravenous solutions" and was now on a respirator, but "there does not seem to be much chance to save her life."

Today, Jean Harlow would benefit from modern antibiotics, dialy-

sis, or even a kidney transplant. Then, two days after her correct diagnosis, on June 7, 1937, Jean Harlow died.

It all happened so fast, or maybe it had been happening slowly for years. And by the end of it, the Baby had given up. In her last days, a visitor to her bedside tried to console her, by telling her she'd get better. Possibly delirious, the girl born Harlean Carpenter said, "I don't want to."

Loos believed that Harlow had died of a broken heart, a heart broken by William Powell. "After Bill's rejection, Jean seemed to lose interest in everything; and, when stricken, she refused to put up a fight."

It seemed impossible that someone so beautiful and young, whose screen presence was so full of energy and vitality, could have just died like that. Maybe that's why rumors persisted that there was something else going on. The most Hollywood of these was the one that held that Jean Harlow had died from long-term exposure to the bleaching chemicals she used every Sunday, but in truth, Harlow's hair bleaching habit destroyed only her hair—and that hair helped to invent a new lineage of Hollywood star, the blond sex goddess. In 1937, an eleven-year-old girl named Norma Jean would identify herself as one of Jean Harlow's biggest fans. Within fifteen years, Norma Jean would have remade herself in Harlow's image, even visiting Harlow's own hairdresser, under the name Marilyn Monroe.

"I think it was a great shame about Jean. I really do," sighed St. Johns. "What was done to that child. And also again they did it to Lana Turner. Ava Gardner. I mean, I think these were women who were fine actresses and could have had a good career as actresses. If they hadn't been such great sex appeal that that's all anybody ever thought of or only cast them for or all they were ever allowed to do."

Howard Hughes was not the only mogul in Hollywood who profited off treating actresses as sex goddess flavors of the month, good for consumption in a brief window but disposable as soon as the next variety came along. As with so much in his career, Hughes did the same things that other men did—he just did them more crudely, and with even less of a regard for the person these actresses were before

they came into his life, and what would become of them once he had moved on. And he always, eventually, moved on. By the time Howard Hughes's first Hollywood discovery shuffled off this mortal coil, Hughes was deep into a new career. A new, persona-defining romance would follow.

PART III

HEPBURN AND AND ROGERS AND RUSSELL, 1932–1940

THE WOMAN WHO LIVED LIKE A MAN

Technically, it was a crash landing. The prop plane had run out of fuel midair, and the pilot had no choice but to bring it down into a field of beet plants outside Santa Ana. But once the gleaming silver craft finally reached a complete stop, having plowed a runway for itself amid the greens, the pilot emerged grinning, victorious. It was September 13, 1935, and Howard Hughes had just set a new record land speed time of 347 miles per hour. "She'll do better," he said of his plane. "We'll fix her up and try again."

In the mid-1930s, while his father's drill bit company steadily re-filled the coffers Hughes had depleted on his first go-round in the film colony, Howard turned his professional attentions to aviation. He spent much of the mid-1930s obsessed with speed, and tasked pilot and mechanic Glenn Odekirk with rebuilding a Boeing prop plane into the fastest aircraft in the world. Hughes Aircraft thus born, Hughes began a run of breaking and setting new aviation records. In 1933 he estab-lished a new world land speed time of 352.388 mph, flying over Santa Ana, a mark that he broke two years later with the flight that ended among the beets. In January 1936, he set a new nonstop transcontinen-tal flight time record, making it from Burbank to Newark in 9 hours, 25 minutes, 10 seconds. When asked for comment on landing, Hughes said, "I wanted to go to New York, so I tried to see how fast I could do it in." A year later, he shaved a full two hours off this landmark time,

landing at Newark on January 19, 1937, just 7 hours and 28 minutes after leaving Los Angeles.

Having transitioned his professional attention from moviemaking to these cockpit victories, Hughes would literally fly into the life of a woman who would become key to both his lasting legacy as a romantic hero and his reentry into the film business.

Katharine Hepburn has been depicted, in biographies of herself and of Howard Hughes, as one of the eccentric aviator's very few true loves, a portrayal that domesticates a nontraditional relationship between two self-styled mavericks into something easily digestible in gossip columns (including a multipart series by Adela Rogers St. Johns published in April 1947, nearly a decade after the Hepburn-Hughes affair ended) and stylized biopics like Martin Scorsese's *The Aviator*. Hughes left behind faint but tangible traces of his obvious lasting affection for Hepburn: a letter here, a stray comment to a later girlfriend there. But Hepburn said much more publicly about Hughes than vice versa, and her version of the story made their relationship out to be a passionate fling, reaffirming for Hepburn that her main priority in life during the 1930s was not a man—not even the man she would describe as "the best lover I ever had"—but herself.

Very shortly after her romance with Hughes ended, Hepburn met and became involved with Spencer Tracy, the actor whom Hepburn herself would put forth as her great love. Hepburn outlived Tracy by thirty-six years, and over those decades, in writings and in interviews, she placed her relationship to the actor and the films they made together at the core of her legacy. In fact, because their real-life relationship and the films they made together combine so powerfully as a Hollywood love story, the history of Katharine Hepburn's life and career can be divided into Before Spencer and After Spencer.

Hepburn's lasting legacy is as an iconoclast who demanded a level of liberation uncommon for women of her day, and though there is a lot of truth to that image, as an actress in the 1930s Hepburn was able to carve out spaces for her own freedom thanks to her alliances with powerful men. From the vantage point of today, we can see that

a variety of different men helped to influence and support Hepburn in the Before Spencer years: directors George Cukor and John Ford; her frequent costar Cary Grant; her agent turned lover Leland Hayward; and Howard Hughes. And since confirmation of her off-screen relationship with Tracy was withheld from the public until after Tracy's death, Hughes remained the most public paramour of Hepburn's acting career.

Grant and Hughes are the two men most visibly associated with Hepburn's legacy as a romantic heroine in the late 1930s. With Grant as her on-screen partner, Hepburn would make one of the greatest screwball romantic comedies in *Bringing Up Baby*, and perhaps the most utopian romantic film of the decade, in *Holiday*. With *The Philadelphia Story*, they would collaborate to create the sterling example of what philosopher Stanley Cavell would dub the comedy of remarriage—referring, essentially, to the plot device in which lovers are torn apart so that they can work their way back together. Meanwhile, off-screen, Hepburn and Hughes would star in a drama that proved to be irresistible to the press, and circulated a more conventionally lovable idea of Hepburn than the one she put forward in most of her films. The span of their romance would coincide with the peak of Hughes's global celebrity; his daring feats in the realm of aviation and reports of his movie star girlfriend combined for a potent image of a 1930s idol.

In discussing the ways in which Hepburn and Grant, and Hepburn and Hughes, projected fantasies of heterosexual romantic ideals, it should be noted that the sexual preferences of all three have been a matter of speculation. Hepburn acknowledges in her memoir *Me* that there were rumors about her lesbianism from the moment she arrived in Hollywood, because she lived not with her husband, but with her best female friend, heiress Laura Harding. Her "unconventional" taste in clothes was also frequently noted, with magazines like *Modern Screen* drawing connections between Hepburn and all-but-confirmed bisexual Marlene Dietrich in reporting things like "Miss Hepburn was going Miss Dietrich one better by going around town in blue overalls."

Biographers working in cooperation with Hepburn or her estate

have dismissed or ignored these rumors and insinuations, while others have seized on them. William J. Mann, who is also the author of several books on the contributions of gays and lesbians in Hollywood, suggested in *Kate: The Woman Who Was Hepburn* that Hepburn and Spencer Tracy were beards for one another. Mann's star source was Scotty Bowers, a self-proclaimed "madam" to the stars who told Mann that he (Bowers) had a sexual relationship with Tracy. Bowers later wrote in his own book *Full Service* that he had procured "over 150 different women" as dates for Hepburn. "Hepburn was a lesbian," Bowers insisted, "and I could not imagine this incontrovertibly butch lady having an affair with a man, any man."

Writing after the release of Mann's *Kate* and a year before Bowers's book was published, Spencer Tracy's biographer James Curtis furiously discredited both Mann and Bowers, writing off the former's book as "part of a curious sub-genre pandering to an audience that apparently wants to be told that practically everyone in Old Hollywood was secretly gay" and accusing Mann of falling into the laziness of stereotyping and guilt by association. Curtis also used his formidable knowledge of the timeline of Tracy's life to refute many of Bowers's claims, all of which, he noted, remain "cheerfully unverifiable" so many years after so many of their subjects are dead.

In *Full Service*, Bowers, whose matchmaking operation was based out of the fuel station where he pumped gas on Hollywood Boulevard, boasted that he had "got into a lot of sexual mischief" with Cary Grant and Randolph Scott, the actor who served as Grant's roommate before and after they came to Hollywood. Grant would marry five women over the course of his life, and though those close to him and involved in his estate have defended his heterosexuality, stories like Bowers's continue to circulate. One of the venues in which they have circulated are selected biographies on Howard Hughes.[1] What we know to be

[1] Darwin Porter, author of *Howard Hughes: Bisexual Billionaire*, has written and self-published dozens of "unauthorized" biographies of public figures, all of them thick with what reads as highly embroidered, bawdy dialogue, and dramatizations of pansexual incidents. Charles Higham (*Howard Hughes: The Secret Life*) had his reputation impugned

true for sure is that Grant and Hughes were close friends from the early 1930s until late enough in Hughes's life that Jean Peters, Hughes's final wife, assumed Grant would be assigned to oversee Hughes's estate. For what it's worth, Bowers claims that Hughes was "straight as an arrow and really liked women but, ironically, he hardly ever had sex with them" because he insisted that all of his paramours have immaculate skin—which, Bowers notes, Hepburn did not.

I bring this up not because I intend to prove who these now long-deceased people really had sex with; I don't, because I don't think it matters. What does matter is that three of the most famous and glamorous figures of the 1930s, who worked together to model, on-screen and in real life, powerful heterosexual romantic fantasies, have over time had their authenticity as messengers for those fantasies called into question. Particularly in the case of Grant and Hepburn, the efforts to out their alleged secret gay lives after their deaths robs the stars of the agency they exercised while alive to define their own public personas. Even if Cary and Kate had worked in a Hollywood era in which they could have openly identified with a more complex, less heteronormative sexuality, we can't know exactly how they would have identified themselves, and what they would have chosen to share with the public about their private lives.

Hepburn's case is unique, though, because unlike Cary Grant's, her screen presence was never a conventionally heteronormative one. Hepburn presented herself and projected something, from the very beginning of her time in movies, that seemed like a threat to the dominant, patriarchal order. The lesbian rumors about Hepburn began in part because her life and persona so defied expectations for straight women in the early to mid twentieth century. Whether or not Hepburn

after his book *Errol Flynn: The Untold Story*, in which Higham claimed the swashbuckling *Robin Hood* actor had been a Nazi spy and a bisexual whose same-sex lovers included Hughes, was accused of containing distortions and inaccuracies. Two books were later published disputing Higham's portrait of Flynn: *My Days with Errol Flynn*, by Buster Wiles and William Donati; and *Errol Flynn: The Spy Who Never Was*, by Tony Thomas. Porter and Higham have each published books on Hepburn, Hughes, and Grant.

had intimate physical relationships with women, the fact that she was suspected of being queer before anyone knew anything about her other than that she had a female roommate and appeared in public wearing pants has more to do with the limited, and sexist, vocabulary available until relatively recently to describe women who don't try to conform to expectations set by the male gaze—or deliberately set out to defy them.

This matters because, for a period in the late 1930s, it seemed like Katharine Hepburn was not going to survive in Hollywood. She was too "unusual," and because she wasn't a previously branded "type," producers and studios struggled to know what to do with her. After her meteoric initial rise, audiences seemed to be indifferent to her. By the end of the decade, this had changed, and she was thus set on the path of one of the longest, steadiest careers of any actress in Hollywood history.[2] It was in the interim that she was very publicly linked to Howard Hughes.

KATHARINE HEPBURN ARRIVED IN Hollywood on July 4, 1932, an apparent bachelorette, escorted not by the husband whom she would neglect to tell the media about until they asked, but instead by Laura Harding—and Harding's two dogs and mountain of Louis Vuitton luggage. Hepburn, who had just turned twenty-five in May, had left Ludlow Ogden Smith ("Luddy"), to whom she had been married for four years, back in New York, planning to make her first movie, *A Bill of Divorcement*, and then head back east as soon as possible.

Hepburn had been lured from the New York stage by director George Cukor, who had already helped to launch the careers of female stars such as glamour queen Kay Francis and operetta diva Jeanette MacDonald. Cukor would become known as a famously fantastic "woman's director," and female star after female star would testify to

[2] Her longevity became so much a part of her persona that it is noted in the first paragraph of Hepburn's Wikipedia profile, which describes her as having been "a leading lady in Hollywood for more than 60 years."

the confidence he inspired in them. Some historians have noted that to describe Cukor as a "woman's director" was to reveal homophobia: it was a coded way of acknowledging that Cukor was gay, and a backhanded way of suggesting that a gay man could not succeed in genres geared toward straight men. Hepburn herself made the latter suggestion in her autobiography, in a statement about why she wanted George Stevens to direct her and Spencer Tracy in *Woman of the Year* instead of Cukor: "I had to explain to Cukor that this script had to be directed by a very macho director from the man's point of view and not the woman's."

Perhaps it would be too much to ask even a gender-standards iconoclast like Katharine Hepburn to stay within the lines of twenty-first-century political correctness. As disappointing as her conflation of "macho" and "heterosexual" reads today, it seems likely that Cukor's sexuality played into his success directing many of the great female stars of the twentieth century in performances that humanized them and/or depicted a wider range of female experience than was typical in Hollywood at that time. It stands to reason that these actresses were able to let their guards down and communicate in a different and more open way with Cukor because, unlike so many men in power in their industry, he wasn't sexually predatory toward them.

Cukor's empathetic sensibility when it came to actresses put him at cross-purposes with RKO production chief David O. Selznick, the brilliant maverick producer who behaved for much of his career as though capturing beautiful women in a predatory gaze were the whole point of making movies. Selznick didn't understand what Cukor saw in Hepburn at all, and had tried to get the director to consider other options. "I hear great things about a girl named Peggy Entwistle," Selznick wrote to Cukor. Cukor did consider Entwistle for the female lead in *A Bill of Divorcement*, but she ended up being cast instead in another RKO film, *Thirteen Women*—in a part that was cut down to almost nothing, when the Hays office forced Selznick to remove an implied lesbian relationship from the story. *Thirteen Women* would turn out to be Entwistle's first and last movie: in September 1932, two weeks

before *A Bill of Divorcement* premiered, Entwistle would climb to the top of the *H* of the Hollywood sign and jump to her death, leaving behind a note that was interpreted as blaming her suicide on her failure to achieve movie stardom.

Selznick eventually gave in on the casting of Hepburn, but once she arrived in Hollywood, he changed his mind. The producer had seen photographs of Hepburn that seemed promising ("What legs!" Selznick's wife, Irene, exclaimed on first viewing of one of Hepburn's Broadway publicity stills), but Hepburn gave a different impression in person. "I don't know where she got her clothes," Adela Rogers St. Johns cattily commented on Hepburn's appearance on her first day at RKO. In fact, Hepburn had got her clothes at the New York atelier of radical feminist designer Elizabeth Hawes, a place where women only shopped if, as Irene Selznick put it, they were "out to make a statement."

This was not a statement to which the chief of production at RKO was receptive. When Hepburn was brought to meet Selznick in the commissary, he was allegedly so unnerved by her appearance that he turned his table over and stormed out. As Selznick's lunch companions were dealing with the spilled food in their laps, the producer got Cukor on the phone and told him in no uncertain terms: "Send her back to New York."

Selznick was serious. He really believed Katharine Hepburn was not good-looking enough to be in movies, and, unable to imagine a movie viewer responding to an actress whom Selznick himself wasn't sexually attracted to, he figured *A Bill of Divorcement* was doomed with her in it. But George Cukor threatened to quit if Selznick sent Hepburn away, so both stayed.[3]

In the end, Hepburn would look as conventionally lovely in *A Bill of Divorcement* as she ever would. Hepburn played Sydney, a young

[3] Hepburn's unconventional looks would continue to worry executives throughout production. After an otherwise successful test screening, executive Merian C. Cooper wrote to Cukor, suggesting reshoots of some of Hepburn's close-ups, which he described as "very bad." Interdepartment correspondence from Merian C. Cooper to George Cukor, August 17, 1932. George Cukor Collection, Margaret Herrick Library, Folder 34.

woman who is seemingly happily engaged to a milquetoast named Kit, until Sydney's father (John Barrymore), long interred in an asylum, returns home and throws her household into crisis. Her mother has divorced the father in absentia and is on the verge of marrying someone else. The father is devastated by this news. Sydney feels a connection to her dad, and once she learns from a doctor that her children could suffer from the same mental illness, she decides she will never—can never—marry. "You must . . . go away," she tells her fiancé. He does, and the film ends with Sydney and her father together, having decided that the people they love will be better off without them.

This ending is shocking today, so you can only imagine what it would have been like in 1932, when being a never-married woman was more widely considered to be a much bigger disaster than it is nearly a century later. With *A Bill of Divorcement*, from the beginning of her movie career, Katharine Hepburn was embodying a young woman who didn't fit the mold, and who chose to go against the conventional path of matrimony.

Predictably, not everyone was pleased. *The Hollywood Reporter*'s extremely negative review declared that Hepburn "might have been good if given a chance," had she not been "forced to dress like, talk like, and slouch like Greta Garbo." This doesn't seem anything like an accurate criticism of Hepburn's performance—in fact, her bright-eyed self-possession seems like the polar opposite of Garbo's woozy exoticism—but it speaks to the lack of vocabulary that the media had for unconventional women in 1932. Hepburn was only similar to Garbo in that Garbo was a handily available example of a woman who wasn't easily classified, who projected an ambiguous, often cold sexuality on-screen and wore pants off-screen, and whose unknowability and novelty posed an intangible but distinct threat to the patriarchy as defined by the way the movies depicted options available to women other than traditional marriage.[4]

[4] *The Girls: Sappho Goes to Hollywood*, Diana McLellan's book on the so-called sewing circle of Hollywood lesbians and bisexuals, including Garbo, barely mentions Hepburn, but does note that Hepburn and Garbo became acquainted through Cukor.

Like Garbo before her, Hepburn embraced her difference. She insisted on playing golf on Sundays on a course reserved for men, on the grounds that, as she put it, "I was a man because like them I only had Sundays off, too." And in just her second film, she boldly abandoned the Victorian style of feminine dress she had worn like drag in *A Bill of Divorcement*, to embody an image of modern womanhood that was much closer to her own experience.

Christopher Strong was directed by Dorothy Arzner, the female filmmaker with the most sustained career in early-twentieth-century talking pictures. It's a romantic tragedy about a woman marked as a sexual outsider, doomed to suffer for her attempts to live and love because she cannot conform to the hypocritical standards of her society. Hepburn's Lady Cynthia, a daring aviatrix, is lured into the decadent world of Monica (Helen Chandler), a wild party girl whose constant carousing and affair with a married man conspire to drive mad her angelic mother (Billie Burke) and politician father Lord Christopher (Colin Clive, already famous for having played the Doctor in *Frankenstein*). In the course of a party game, Monica and her beau are sent out looking for a married man who has never been unfaithful, and a woman over the age of twenty-one who has never had a love affair. Monica drags in Lord Christopher as an example of the former, and Cynthia is discovered to be the latter. When the model married man meets the freak of sexual virtue—who has chosen her aviation career over romance, and who insists that she's "not attractive that way" while dressed for a costume ball in a slinky silver lamé gown and moth antennae headdress—his streak of fidelity snaps. But though Hepburn is styled, framed, and lit like Garbo or Marlene Dietrich (high-glamour androgyny, supersexiness mixed with strangeness, as in that insane insect costume), Lady Cynthia is not a typical movie temptress. She doesn't seduce Lord Christopher; instead, his unwillingness to take no for an answer slowly wears down her resolve, and then at the moment of her peak success as an aviator, having won a round-the-world flying race, she agrees to give up her thrilling career in order to be his mistress.

Arzner depicts Lady Cynthia's movement into the realm of the sexual—and thus, from the rarefied space literally above sexuality and onto the playing field of the average, sullied woman—as a fall from grace into bondage. The initial consummation is elided; we see only Cynthia's arm wearing a large bangle, and hear her tell her lover, "I love my beautiful bracelet . . . Now I'm shackled." Shortly thereafter, Arzner shows us Christopher's wife, sadly removing a whole armful of bangles when she realizes her husband isn't coming home to her. As the affair progresses, Lord Christopher shows only weakness, refusing to leave one woman for the other, even as party girl Monica and her rake boyfriend reform their ways and join conventional society in matrimony and parenthood. When Lady Cynthia becomes pregnant, she is forced to understand that there will be no "going straight" for her. She and her unborn child attempt to break another aviation record, and then, in a fleeting moment of desperation, she removes her oxygen mask, immediately loses consciousness, and plummets to her death.

A Bill of Divorcement introduced Hepburn as an unconventional new leading lady, but *Christopher Strong* really pushed this new star into a realm of subversion that suited her well. You could say Katharine Hepburn got into movies at both the right time and the wrong time. The early 1930s was the only period of the first half of the twentieth century that could have accommodated both Hepburn's inherent refinement (which read as rich and entitled, even when, as in *Christopher Strong*, her character is the only one in the movie who works for a living) and the new concepts of womanhood that she embodied. And yet, as she was building her screen career, the Hays Code and the process of enforcing standardized film censorship was solidifying. More often than not in the 1930s, Hepburn would find herself in films that attempted to thread a very tight needle between subversion and conformity. In a perfect world, she would have gone on to play nothing but Lady Cynthias, and at least some of those Lady Cynthias would have been allowed to fly away from cowardly Lord Christophers, and raise their babies as single working women.

Hepburn faced a similar challenge off-screen. She was a married

woman working three thousand miles away from where her husband lived, and in her initial encounters with the Hollywood press, she neglected to mention that she was married at all. When reporters figured it out, they were happy to deliver the fiction that Hepburn's failure to publicize her husband was a consequence of Katharine's confusion in the suddenly descending spotlight, and fear that "Hollywood and the curse it puts on all its marriages might shatter her own marital security."

In reality, while RKO cast her in one film after another, the marriage remained in purgatory. Luddy seems to have been happy to take what he could get. Hepburn seems to have been willing the marriage to fade away.

"I look back in horror at my behavior," Hepburn wrote in her autobiography. "At the time, I was looking forward to the future and not *our* future but definitely *my* future. I was obviously trying to climb to the top of the ladder." The worst part? "I was apparently totally unaware of my piggishness."

And then she began having an affair with her agent, Leland Hayward. Hayward, like Hepburn, had a spouse kept in distant New York. Kate eventually told Luddy about her affair, and he insisted it didn't matter. In late 1933, Hayward proposed to Hepburn. The agent was prepared to leave his spouse, if Hepburn would leave hers. Hepburn prevaricated. Having returned to New York to star in the play *The Lake* (a disaster, inspiring Dorothy Parker's famous comment that Hepburn ran "the gamut of emotions from A to B"), Katharine asked Luddy to move out of their shared apartment in New York. He relocated into a flat so nearby that he could see into her bedroom from the window of his.

On March 16, 1934, less than two years after her arrival in Hollywood, Hepburn won her first Oscar, for the backstage romance *Morning Glory*, in which Hepburn gives a truly great performance as a fully naive aspiring actress who is crudely taken advantage of by an older, male producer. After spending the night with her, this producer doesn't even offer her a role as trade, and it falls to his playwright partner to

secretly nurture the actress and set her up for her big break. This may have been a milieu Katharine knew well, but the character's deluded self-determination, which blurred the line between eccentric and clinically insane, was not who Hepburn was; nor was the story, about a girl who is such a failure at self-sufficiency that she would literally starve to death if not for the intervention of a series of men, drawn from Hepburn's real life.

Shortly after she was honored for this performance, Katharine went to Mexico to get a quickie divorce. Fan magazines suggested Hepburn was heartbroken, and that it was her own fault. In a story headlined "Can Hepburn Ever Find True Love?" *Hollywood* magazine claimed that Hepburn had "tried to save her romantic happiness by hiding her un-photographed husband . . . but divorce ended her romantic dreams and he fades into the background, a victim of her career." Leland Hayward assumed that he was the true love that Katharine had found, and he swiftly obtained his own Mexican divorce. But Hepburn didn't want to get remarried right away.

The peak of Hepburn's first wave of stardom came with Cukor's adaptation of *Little Women*, which allowed her to add the iconoclastic Jo to her repertoire of convention-defying women. Hepburn's Jo would inspire a generation of girls, among them a twelve-year-old named Ernestine Jane. A skinny tomboy herself—the kids on the schoolyard teased her with the nickname "Bones"—Jane was so enamored with Hepburn that, in a fan letter, she asked the patrician star to come visit her at home, on the ranch where she lived with her family in the San Fernando Valley. "I thought she was the living end," Jane recalled later, after she had become a very different kind of movie star under the name Jane Russell.

Hepburn's work spoke to adolescent girls, who saw in her ideas about femininity that were otherwise largely absent from movies. And yet some close to Katharine—particularly men—insisted on lecturing the actress as to how she could better represent her gender. One male friend wrote to Katharine that his "generation has waited for the appearance of an actress with the ability to play great parts at an age

when her charm and loveliness are near their height, and when such a century bloom appears, must we get" films like *Morning Glory* and *Little Women*, which he wrote off as merely a story "of a girl seeking and finding success through the love of a good man. . . . In short, it's superficial stuff, and superficial stuff, my dear Katharine, is not for such as you."

Later, in 1935, Russell Davenport, editor of *Fortune* magazine and an old friend, sent Hepburn a long letter assessing her career and her latest film, *Break of Hearts*, a romance featuring Hepburn as a composer smitten with Charles Boyer's conductor. "As an artist, who and what are you?" Davenport asked, before falling back on negatively comparing Hepburn to her predecessor in ingenue mold-smashing. "Garbo has never to my knowledge played in a picture in which she lost as much personal dignity as you [in *Break of Hearts*]." Finally, citing Hepburn's recent film *Sylvia Scarlett* as an example of what Hepburn should not be doing, Davenport proclaimed, "You are a full grown woman and you must step into women's roles. Let Sylvia be the last."

Sylvia Scarlett featured Hepburn as a young woman who decides to dress as a boy in order to travel with and protect her father. It took what was now the Hepburn brand—the woman who refuses to accept her lot as a member of the second sex and infuriatingly insists on acting like a man, or at least demanding some of the privileges reserved for men—to the point of parody. Unfortunately, it was not intended as a comedy, and both Cukor and Hepburn would agree that it was their most regrettable collaboration. Nonetheless, it would bring two men into Hepburn's life who would have lasting impact.

Scarlett would be the first film in which Hepburn would appear opposite Cary Grant, who would become her most reliable on-screen partner until she was paired with Spencer Tracy. They shot much of the film at Trancas, up the California coast north of Malibu. One day, at lunchtime, an airplane circled above the long picnic table where the cast and Cukor had congregated to eat, and then landed—so close to the lunch party that a wing could have swept the table clean.

"Who the hell would—" Kate began.

Grant finished: "That's my friend Howard Hughes."

Grant quickly explained that Hughes had wanted to meet Hepburn, so Grant had suggested he come to lunch. Hepburn was furious that Grant had not only invited an interloper, but had created this situation in which Hepburn, with no advance warning, would be expected to play the role of the damsel charmed by the prince in the biplane. "So staged," she recalled. "False. There was nothing spontaneous about it. I was so angry I ate my lunch without looking at either one of them."

She softened a bit when, awhile later, Howard repeated the trick, landing in the middle of her golf lesson at the Bel Air Country Club. The move was vintage Hughes—completely selfish, oblivious to how it impacted others, plainly disrespectful of convention, and totally spectacular. "I must say it gave me pause," Hepburn wrote. "I thought that he had a hell of a nerve and was very pushy. The Club was furious. Howard Hughes was nothing daunted."

Over the first months that Hughes was attempting to insert himself into Hepburn's life, she was emotionally preoccupied with a much tougher customer. After filming *Scarlett*, Hepburn went right into starring in *Mary of Scotland*, directed by John Ford. If Cukor was Hollywood's top "women's film" director, Ford was the quintessential "man's man" director. Hepburn and Ford became close on the set of the film, developing a relationship that wasn't quite a romance, but wasn't entirely platonic. Usually when a movie wrapped, John Ford went on a long drinking binge, with the blessing of his wife, Mary. When *Mary of Scotland* wrapped, Ford accompanied Hepburn to New York, and then to Fenwick, her family's rambling estate on Block Island Sound in Connecticut, where the Hepburns regularly congregated. The clan consisted of Katharine's parents, urologist Thomas Hepburn and women's rights advocate Katharine Martha Houghton, and five additional children; their eldest son, Tom, had died by an apparent suicide in 1921. The Hepburns were monied, thanks to Thomas's successful medical practice, but also extremely progressive and eccentric. When they all got together at Fenwick, they made a tough crowd for an outsider to break into.

But Ford quickly endeared himself to the Hepburns at Fenwick. Though they were careful not to be photographed in public together, that summer John Ford was by Katharine Hepburn's side as though he were her boyfriend. Though she found Ford "sexy," Hepburn said, the two "never had a physical affair" because of Ford's marriage. Theirs, said Hepburn, was "a sort of affair of the minds. Ours was a special friendship, and it might have been more had the circumstances been right."

While this was going on, Hepburn believed herself to still be in a relationship with Leland Hayward, despite the fact that she had rejected several marriage proposals from the agent and had become close to other men, not only Ford but also her *Alice Adams* director, William Wyler. "You might say I lived like a man," Hepburn mused years later of this period, when she explored intimacies without monogamy. But freedom to spread one's wings brings with it the risk of a fall, and Hayward was about to show her the potential consequences of her aversion to, as she put it, "the business of capturing anyone into a marriage."

Hayward spent the fall of 1936 in New York, where two of his clients, writer Edna Ferber and actress Margaret Sullavan, were launching a new play, *Stage Door*. The play was a hit and Sullavan became the toast of the town. As Hepburn put it, "Leland—well, he always liked toasts."

Then Sullavan became pregnant. Hepburn was at Cukor's house one night when news of Leland's marriage to Sullavan came over the radio. Hepburn was hurt and furious. Amid this romantic turmoil, she left Hollywood; she had committed to starring in a touring stage production of *Jane Eyre*. Staying at the Ritz in Boston, she noticed in the newspaper that Hughes was also in town. Then she realized he was staying at her hotel. Lonely on the road, she agreed to have dinner with him that night after the show. This soon became a nightly routine.

If you had only ever met Hughes with a group of people around, spending time with him one-on-one was like meeting a new person. "He had guts and he had a really fine mind, but he was deaf—quite

seriously deaf—and he was apparently incapable of saying, 'Please speak up. I'm deaf,'" Hepburn wrote. "I think that this weakness went a long way toward ruining Howard's life and making him into an odd-ball." In the intimate environment of a late-night dinner table, Hughes shined, and by the end of the Boston engagement of *Jane Eyre*, Hepburn had been charmed.

Hughes spent the first days of 1937 in Los Angeles, preparing to break his own cross-country speed record. The flight took place on January 19, and it was harrowing—at one point Hughes began to lose consciousness in the air and had to drop to an elevation of 1,500 feet—but he made it in 7 hours, 28 minutes. Two days later, Hughes met up with Hepburn in Chicago. "I stayed at the Ambassador Hotel," Hepburn recalled. "Howard took a suite there too. Yes—same floor. Yes—you're right of course—inevitable."

What was inevitable—that they'd consummate their relationship? Or that the media would seize on it? Both. Reporters surrounded their hotel and followed Hepburn wherever she went. On January 21, national papers reported that the pair would marry before leaving Chicago. They didn't, but at the end of the tour, the couple returned to Los Angeles and Hepburn moved into Hughes's house on Muirfield Road. Howard gave her Ella's old room. Katie, as Hughes had started calling her, brought three servants with her.

BOX-OFFICE POISON

Katharine Hepburn wasn't blind to the problems in her career. She knew that for every hit she had had over the last five years (*A Bill of Divorcement*, *Little Women*, *Alice Adams*), there was a flop so undistinguished that history all but forgets about them (*Spitfire*, *Break of Hearts*, *Quality Street*). But there would be no brushing *Sylvia Scarlett* under the rug. The film lost $200,000 and was believed by RKO execs to be an embarrassment. "It is just a bad picture," wrote RKO's Ned Depinet to the studio's vice president, B. B. Kahane, "and it has undoubtedly hurt Hepburn." The studio was desperate for their star to help them help her career by being friendlier to the press, but they didn't have much luck there. "Any one but Hepburn would see readily that she has reached a point in her career when she needs all the help possible to stay up where she is," wrote Kahane to Depinet, "but Katharine is just one of those peculiar girls who is not logical or normal in her viewpoints and attitude."

Hepburn badly needed a hit, but *Mary of Scotland* didn't catch fire the way all involved had hoped. Hepburn was then reduced to sharing billing with RKO's other top female star, Ginger Rogers, in *Stage Door*—the movie adaptation of the play that had served as the staging ground for the Hayward-Sullavan affair. This was just one feature of the production conspiring to put Hepburn at a disadvantage. The RKO rumor mill was expecting friction between the two female stars, who

were not only jockeying for top position at the studio, but also had a common history with Howard Hughes.[1] Not since *A Bill of Divorcement* had Hepburn played anything but an on-a-pedestal lead, and when she found herself on set of her first true ensemble film, she felt humiliated to be "listening in on scenes instead of dominating them." She complained to RKO exec Pandro Berman, who told it to her straight: "Listen, Kate, you'd be lucky to be playing the sixth part in a successful picture." Then she complained to director Gregory LaCava, who, Hepburn claimed, "got sorry for me . . . and handed me the whole last part of the movie."

To hear Ginger Rogers tell it, this type of manipulation was typical of Hepburn, who in Ginger's eyes was the unimpeachable mean-girl queen of the RKO lot.

"Kate always wanted her way and usually got it," Ginger remembered. "I steered clear of her, not trusting what she might do if I in any way crossed her. I recognized she had little empathy for me." Rogers claimed that Hepburn once poured a glass of water on her from a second-story window while Rogers was showing off a new mink coat. Hepburn—who had always had money, and thus never needed to draw attention to her ability to wear that money on her back—allegedly taunted Ginger, "If it's a real mink, it won't shrink!"

Rogers had been so keen to play Queen Elizabeth in *Mary of Scotland* that she had done an incognito screen test, arriving at the studio disguised as a fictional character, a London stage star calling herself Lady Ainsley. Producer Pan Berman and others on set were apparently duped, but Hepburn, who was to also appear in the test, was not. According to Rogers, Hepburn actually kicked her under the table at one point and whispered, "Who do you think you're fooling?" Rogers didn't get the part—it went to Florence Eldridge—leaving Ginger free to smugly note that *Scotland* wasn't a hit, anyway. For her part, Hepburn spoke cattily about Rogers decades later, mocking the amount

[1] As Hepburn later put it, "I was told there was gossip circulating about a rivalry between Ginger and me, about bad feelings because we'd both had relationships with Howard Hughes." Chandler, *I Know Where I'm Going*, 111–12.

of time the other actress spent on her hair and concluding, "I thought about it later and decided maybe it wasn't that Ginger was so vain as it was that she was insecure and felt dependent on her looks."

Hepburn and Rogers were sometimes considered for the same roles at the studio, despite the fact that they were very different "types," and this went beyond Rogers's "dependen[ce] on her looks." In the mid to late 1930s, Hepburn still represented a patrician privilege that was out of fashion and struck the majority of moviegoers, who were still struggling through the Depression, as out of touch. Rogers did a much better job of threading the needle of the 1930s: her persona was that of the working girl next door who occasionally (as in several scenes in each of her musical collaborations with Fred Astaire) found herself in glamorous environments in which she got to wear decadent confections of taffeta and silk—and she wore them extremely well. But the grass is always greener, and Rogers desperately wanted to be taken seriously as an actress, the way that Hepburn was. "We all wanted to be Katharine," fellow RKO contract girl Lucille Ball once said. "Even Ginger. No, especially Ginger."

Stage Door made a modest profit—just enough to solidify Rogers's perceived value to RKO, but not enough to rescue Hepburn's reputation as a drag on grosses. Though the film's plot allowed Hepburn to play out on-screen a patrician-lady-redeems-herself-among-the-plebs narrative, audiences didn't seem ready for the star to recharge her career along those same lines. Her next film, *Bringing Up Baby*, would decades later be reevaluated as the pinnacle of the screwball romantic comedy, but in the icy early months of 1938 it made no noise at the box office. Neither the studio nor the star knew that *Bringing Up Baby* would be the final film Hepburn would make under contract to RKO, but in the months after its disastrous release (*Baby* lost $365,000 in its first run), they could not agree on her next steps. The studio asked Hepburn to star in *Mother Carey's Chickens*, a period family drama that they hoped could be another *Little Women*. Hepburn refused to make the movie, and the two parties were at an impasse. And then, on the morning of May 3, 1938, Hepburn, along with half a dozen other sup-

posedly major stars, was drawn into a confrontation they couldn't ignore.

"Wake Up! Hollywood Producers" blared the headline of the sponsored editorial, taking up half a page of *The Hollywood Reporter*. It was signed by Harry Brandt on behalf of the Independent Theatre Owners Association, a consortium of movie theaters that weren't the property of the studios, but who were nonetheless pretty much at the mercy of the collected studios' whims and self-serving policies. The ugly truth that the theater owners wanted the producers to wake up to? That some of the most major stars of the 1930s, including Mae West, Marlene Dietrich, Greta Garbo, Joan Crawford, and, yes, Hepburn, had become "poison at the box office."

The problem wasn't with the stars themselves, exactly, except insofar as they couldn't stop their own appeal from turning stale. The real problem was with the studios who kept paying these stars enormous amounts of money through long-term contracts, regardless of how their movies performed, leaving the theaters stuck releasing movies starring performers their audiences had grown tired of. Hepburn was singled out for more specific criticism than anyone else, even if some of the sniping was paired with praise: Hepburn, Brandt wrote, had "turned in excellent performances in *Stage Door* and *Bringing Up Baby* but both pictures died." The message was that it was no longer feasible for studios to throw money at great artistry; not when their losses were essentially being passed down to the small business owners and operators who exhibited their movies, and not when MGM was breeding much cheaper, younger stars like Mickey Rooney and Judy Garland, whose movies had so far been guaranteed winners. RKO had treated Hepburn like an A-list star from *A Bill of Divorcement* on, despite the fact that more of her movies were money losers than big hits. The "box office poison" ad, as it became known, is a work of hyperbolic propaganda, but in Hepburn's case, it wasn't totally inaccurate.

RKO didn't need Brandt to tell them any of this; his arguments against Hepburn were the gist of what the execs had been saying among themselves for a long while. In fact, by May 1938, RKO and

Hepburn had agreed that her future was not with the studio, and on the same day that Brandt's editorial appeared, RKO's Pandro Berman wired Hepburn his regret that her contract had been terminated.

Conveniently, Hepburn was now free to star in Cukor's adaptation of Philip Barry's play *Holiday*, filming at Columbia with Cary Grant as the male lead. Hepburn had personal ties to the project: at the beginning of her career, she had understudied Hope Williams in *Holiday* on Broadway. Her character Linda Seton was another difficult woman, the black sheep of a wealthy family who finds her soul mate in fellow societal rebel Grant. *Holiday*'s repudiation of wealth should have been in tune with the times, and Grant, in one of his most charming performances, should have been able to make audiences fall back in love with Hepburn by appearing to love her himself. But while *Holiday* seemed to have everything—including a very glamorously styled Hepburn—no one went to see it. It was like Hepburn could do nothing right.

That summer, Hepburn retreated to Fenwick. For the first time in her life, she was in no hurry to get back to work. For years her Hollywood career had been slipping, and everyone in the movie industry in a position of power who could have helped her make a comeback had lost faith in her—everyone, that is, but her boyfriend. Although Hughes's career as a film producer was for all intents and purposes dormant in 1938, his growing status as an aviation pioneer conferred on him a glowing spotlight. The nephew whom Rupert Hughes had once written off as "grasping [and] dishonorable" had become, as Rupert himself put it in a 1937 profile of Howard he wrote for *Liberty* magazine, "the most picturesque young man in the country today." (Unable to mask his still-boiling resentment, Rupert added that he was now put "in the two paradoxical positions of being the poor uncle of a rich nephew, and the biographer of one who, instead of being dead, is only half my age. But what of it?")

Katharine Hepburn seems like the actress of the 1930s least likely to embrace a myth of herself as the damsel in distress rescued by a

dashing aviator—the inverse of the tragedy she had played in *Christopher Strong*—but this was the narrative spin on the Hughes-Hepburn romance as it appeared in the papers and fan magazines. Decades later, Hepburn's documented memories of her time spent with Hughes, as if taking a cue from the headlines, were highly romantic, if not romanticized. "Howard was more glamorous than Hollywood films," she swooned long after the end of the affair, "because his life and adventures were real."

They were kindred spirits. Both had obsessions with health and cleanliness. ("I believe at that time, I was more obsessed [with germs] than he," Katharine later said. "We each spent a lot of time washing our hands.") Both used their power and wealth to buy freedom from societal strictures, and neither was used to anyone telling them no. In Hepburn's memory, much of the relationship was about private thrills. They skinny-dipped, diving off the wing of a seaplane in the middle of Long Island Sound. They devised secret codes and pseudonyms for one another; Hughes would address telegrams to Hepburn's secretary Emily Perkins, and sign his name as "Dan" or "Boss."

And then there was the sex. "Howard was the best lover I ever had," Hepburn disclosed. Of the "many reasons" the couple was "sexually a good fit," according to Hepburn? "We weren't inhibited people. We certainly weren't inhibited about our bodies. . . . Howard was not shy about sex. I think it was the only thing he wasn't shy about. He wasn't short of testosterone. He didn't like a fragile woman. I was practically a professional athlete."

Lust aside, the most important thing Hepburn and Hughes had in common, at least at this stage of their lives, was that both took pleasure in a tug-of-war with the press. Both Hughes and Hepburn, she wrote, "had a wild desire to be famous." Yet while they craved even more fame than they had, they also hated crowds and strangers. Both wanted to be the most talked-about and celebrated person in their respective fields, without ever having to reveal themselves to anyone outside of their immediate circle. Together they thrilled to outrunning

and deceiving reporters and photographers, and were delighted when their names and photos made it into the papers anyway. As Hepburn put it, "I don't think either one of us would have liked it if no one noticed us." Such desires fed their desire for one another; each considered the other an "appropriate companion" for a person of high profile such as themselves. "He was sort of the top of the available men," Hepburn summed it up. "And I of the women."

While Katie was holed up at Fenwick, Hughes was also on the East Coast, where he was preparing for the biggest aviation feat of his life. The plan was to take off from Newark and circumnavigate the globe faster than Wiley Post, then the record holder, had managed it in 1933. A big difference was that Post had done it alone—a feat Hughes, with uncharacteristic deference, compared to "pulling a rabbit out of a hat or sawing a woman in half." Hughes would bring with him a mechanic, two navigators (one celestial and one aerial), and a radio engineer. In preparation for the round-the-world flight, Katie and Howard shacked up in Laura Harding's apartment in Manhattan, hidden from the reporters constantly congregating outside Hepburn's place. Katie accompanied Howard to the airfield and then went to Fenwick, where she'd listen to the adventure on the radio—like much of the rest of the world. The spectators had cause to hold their breath: Post, holder of the previous record, had died preparing to circumnavigate the world a second time, and just a year earlier, daring aviatrix Amelia Earhart had vanished attempting the same feat.

This time there was no crash landing; the plan went off virtually without a hitch. Hughes landed at Floyd Bennett Field at 2:34 local time on July 14, 1938. He had completed his flight around the world in three days, nineteen hours, fourteen minutes, and ten seconds— shaving almost two full days off Post's record. The next day, Hughes's feat was on the front page, top of the fold, of most newspapers. Hepburn's boyfriend was suddenly the most famous man in the world.

This seems to be the moment when the kinds of games Hughes and Hepburn had played with the press—alternately ducking publicity

and courting and indulging in it—lost a bit of their appeal. Alone in a spotlight brighter than most men would experience in their lives, Hughes fiercely intensified his efforts to protect his own image. In August 1938, Dell rushed out a biographical magazine called *The Life Story of Howard Hughes*. Hughes contended the volume contained unspecified inaccuracies and made a deal to have the publisher recall all unsold copies, at Hughes's expense. This process ended up totaling $8,550.32—almost $150,000 in 2016 dollars. Hughes aide Lee Murrin reported that he personally accompanied two and a half tons' worth of magazines to the city incinerator, and "figured we burned approximately 175,000 magazines."

But for Hepburn, certain types of publicity were better than anything money could buy. The November issue of *Modern Screen* magazine would carry on its cover an inaccurate implication that Hughes apparently did nothing to try to remove from circulation. The soft-focus cover painting featured, on the left, Hepburn, smiling and staring off into the distance, her head slightly tilted upward as if she were watching the sky. On the right was Hughes, his aviator goggles on his head, a knowing smirk under his lidded eyes. The caption: "Will America's hero, Howard Hughes, marry Katharine Hepburn?"

Oddly, there was no accompanying article in that issue about Hepburn and Hughes, but in the previous issue of *Modern Screen*, under the headline "What's the Matter With Hepburn?" writer Ben Maddox had posited Hughes as Hepburn's last, best hope at proving her heterosexuality. "Before this summer is over Katharine Hepburn must decide which road she will take," Maddox declared. "Shall she remember, before it is too late, that first of all she is a woman?" If she was indeed a woman first, she would be "concerned only with one man's wishes." With Hughes, Maddox wrote, "[Hepburn] remembered she could be just a woman after all. Now—should she be? He is fascinating, and being with him is so stimulating. But he'd never play second fiddle to any woman's career. He's used to having his own way with women, too. Kate doesn't mind giving in to his whims now. But could she—

for always?" Maddox concluded that Hepburn "is on the verge of her wonderful discovery. Conquest of self, conquest of divided impulses, that must be her answer! It will be brutal if she pulls a boner."[2]

Maddox and *Modern Screen* would have been chagrined to know which way Hepburn was leaning. Before he took off for his life-changing flight, Hughes had proposed to Hepburn, more than once. And more than once, she had turned him down.

If Hughes had harbored any fantasies of putting a ring on it when his celebrity was soaring and Hepburn's career was slumping, assuming her defenses would be down, he had badly read the situation. "I did not want to marry Howard," Hepburn wrote later. With her career underwater, feeling "obsessed by my own failure," the last thing she felt she needed was the anchor of another husband. "Certainly I felt that I was madly in love with him. And I think he felt the same way about me," she recalled. But when the relationship reached the point where one would have to follow the other at the expense of serving their own careers, they chose separate paths. Hepburn stayed on the East Coast, where she had the support of her family and the chance of rebuilding her career on the stage. Hughes went back to Hollywood. "Ambition beat love," Hepburn mused.

There was no definitive break to the relationship—in Hepburn's romances, there rarely was a decisive ending; she'd avoid a confrontation, and use distance as a convenient ramp from lust into friendship. So it went with Hughes. At the end of the summer of 1938, a massive hurricane hit the East Coast. Fenwick was destroyed. Luddy showed up, camera in tow. Hughes's plane arrived with reinforcements of drinking water—but without Hughes. Hepburn said that when she saw that Howard had sent supplies but had not come himself, she knew the romance was over.

"At that moment, I wanted Howard more than bottled water. I understood Howard didn't care about how much a bottle of water cost brought in that way. I knew he never gave that kind of money any

[2] "Boner," in this context, is the Merriam-Webster definition "a clumsy or stupid mistake."

thought, but he valued his time." Hughes could only propose marriage so many times to a woman before deciding that his time was better spent elsewhere.

If their mutual desire for fame had brought them together, their fundamentally different family backgrounds had helped to tear them apart. Like Hughes, Hepburn had been marked by death in her youth: when she was thirteen, her beloved older brother Tom had suddenly, inexplicably hung himself, and it was Katie who had walked in and found the body swinging from a bedsheet. The tragedy united the Hepburns in denial; they never spoke of it, and as a family became collectively determined to move on. In adulthood, and in stardom, Hepburn's family became her rock and refuge. She never felt more herself than when at the dinner table surrounded by bickering siblings or competing toe-to-toe with her father on the golf course.

This was simply not Howard Hughes's vibe. He was not comfortable or particularly capable in groups of any size, and families seemed to make him particularly anxious. An only child orphaned at the moment of late adolescence when he was naturally driven to assert himself as his own man, Howard had cut himself off from his family and had assiduously avoided looking back. Hughes had visited Hepburn frequently at Fenwick (two long car horn bleats followed by three short braps meant he was coming up the driveway, a code that the Hepburn family folded into their own traditions), but he never fit in there.

It didn't help matters that Luddy was still hanging around. On one of Howard's trips to Fenwick, he found himself on the golf course trying to concentrate on the ball while an impatient Kate and her father looked on, and Kate's ex-husband swirled around them, Brownie camera in hand. When Hughes protested, Dr. Hepburn put the millionaire in his place: "Howard, Luddy has been taking pictures of all of us for years before you got here, and he'll be taking them years after you've gone. He's part of this family. Now drive."

If this scenario sounds familiar—the new suitor confronting the maelstrom of the headstrong would-be-bride's large, moneyed family and the ex-husband who won't go away—that's because it's more or

less the plot of *The Philadelphia Story*, the play turned film that finally brought Katharine Hepburn's career back from the dead and ensured a connection between Hepburn and Hughes that would last a lifetime.

In the summer of 1938, as the Hughes-Hepburn romance had been winding down, Philip Barry, the writer of *Holiday*, came to Fenwick to visit Hepburn and tell her about a play he was thinking about writing, about a young divorcee named Tracy Lord who was about to take as a second husband a national hero, a man who looked perfect for her on paper but who ultimately wasn't her soul mate. Hepburn told him it sounded like fun, and Barry had gone home to flesh out the story.

Barry had not been a direct witness to the dynamic between the Hepburns and Hughes, and the new man in Tracy Lord's life in *The Philadelphia Story* would bear as little resemblance to the real Hughes as lapdog-like Luddy bore to Cary Grant. Perhaps that's why both Hepburn and Hughes—who now had a heroic public persona to protect—had immediately gotten behind Barry's play. Indeed, when Hepburn told Hughes about it, he advised her that she should snatch up the movie rights, so that if the play was the hit they all hoped it would be, Hepburn would have leverage with whichever studio was most desperate to make the movie. Hughes himself bankrolled the option, and when the film was made, in 1940, by MGM, Hepburn was able to dictate the director (Cukor, of course) and negotiate with Louis B. Mayer to select two extremely desirable male costars. Grant played the irresistible ex-husband, and Jimmy Stewart the interloping reporter who becomes the wild card in the love quadrangle (the new fiancé was played by nonstar John Howard, which was stacking the deck against his character perhaps a bit too much).

After the play had become a big hit but several months before Hepburn had closed the deal to make the movie, Hepburn's brother Richard, called "Dick," who had been trying (and failing) to establish himself as a dramatist since graduating from Harvard in 1933, revealed that he had been working on a play of his own, this one much more transparently inspired by his sister's romantic life than the one she was currently starring in. *Sea-Air* was set at a wealthy family's estate over

the course of a summer that featured both an extended visit by a head-strong movie star's millionaire boyfriend and a devastating hurricane. The millionaire is depicted as so rude and domineering that it's a puzzle why the actress even needs the whole of the narrative to consider his marriage proposal.

Richard had presented his sister with his work in progress as fair warning: he intended to have this play mounted, and he wanted to do so with Hepburn's—and Hughes's—blessing. This he did not get. Katharine, who had been providing Dick with a small monthly allowance so he could live in Manhattan and pursue writing, was furious with her brother for writing what amounted to an exposé of her intimate business. By now her relationship with Howard was no longer intimate, but it *was* business—it was only because of Hughes's financial investment that she was near to becoming a producer (in action, if not on-screen credit) on the screen adaptation of *The Philadelphia Story*. Hughes had literally bought Hepburn a new lease on her film career, and he had done so because of the complicated romantic relationship that Dick Hepburn had faithfully reproduced in his play. This was a fact that Hepburn would later feel so comfortable with that she would joke about it. "I slept with Howard Hughes to get *The Philadelphia Story*," Kate told biographer Charlotte Chandler. "Well, not exactly, but that's the way it worked out. We had a lot of fun. He was a brilliant man and going to bed with him was very pleasurable. But the pleasure of owning *The Philadelphia Story* lasted longer."

Hepburn was not ready to be so candid in 1939. She began a concerted campaign within the family to suppress *Sea-Air*. Sensing he was losing the battle within his own home to translate his own lived experience into art, Dick made a Hail Mary appeal outside of the Fenwick bubble, sending copies of *Sea-Air* to fifteen Broadway producers. This only inflamed Hepburn further, of course, but she had nothing to worry about. The responses made it clear that Kate's comeback was complete: thanks to her triumph onstage in *The Philadelphia Story*, she was now again such a powerful presence and potentially valuable collaborator that no one in the New York theater world wanted to risk

offending her. One of the fifteen copies went to Lawrence Langner, whose Theater Guild was producing *The Philadelphia Story*. Langner told Dick flat-out to take *Sea-Air* and bury it: no significant producer would go near a play that sought to critique Katharine Hepburn, and Dick would only look like a jerk if he kept trying to make it happen. Dick had little choice but to take this advice.

So he gave up. If Katharine felt any guilt over handicapping her brother's career, she didn't exactly articulate it. "[T]hat play about Howard and me was cheap exploitation and would not have made his career," she insisted years later. "It would have been a stunt. If Dick really wanted the career thing badly enough, he should have written another play just as good, and another one after that." Far removed from the late 1930s, when she had had to fight to be allowed to make good work, Hepburn had little empathy for her brother's bruised ego and diminished ambition. She did, however, keep Dick (whom Hepburn's friend Irene Selznick dismissed as "that insane brother") on her payroll for the rest of his life. Brother and sister even lived together in their eccentric old age at the rebuilt Fenwick, puttering around the big family home, sometimes going days without speaking. *The Philadelphia Story* gave way to a much cleaner, more fastidious version of Grey Gardens.

A LOVE NEST IN MALIBU, A PRISON ON A HILL

After the flight around the world, Hughes was feted with a parade in New York, and he got a hero's welcome in his hometown of Houston. Then it was back to Hollywood. Among his first stops was a nothing diner on Wilshire, where he and Pat De Cicco sat down for a steak dinner. "Well, did you have a good trip?" De Cicco asked. "Yea," Hughes said. "It turned out alright." A few nights later, Hughes was an honored guest at a benefit dinner for the animal rescue organization, the Tailwaggers Society. The host of the event was the president of Tailwaggers, actress Bette Davis.

Though she was essentially the same age as Hepburn, and had in fact arrived in Hollywood earlier, Davis's stardom was slower to come. So, in a year when stars like Hepburn and Garbo were labeled "box office poison," Davis was well positioned as a relatively fresh face, and by the end of the decade she had replaced another actress from Brandt's "poison" list, Kay Francis, as the top female star at Warner Bros.

Francis had been one of the most glamorous women in the industry, but Davis's persona as a star was based on something else: acting. Where other female performers used the consistency of their image, their beauty and fashionability, as selling points, Davis thrived in roles that required her to transform and often bury her inherent aesthetic

appeal. In mid-1938, Davis had vaulted to a new level of stardom with *Jezebel*, a movie about a southern belle whose brazenness is embodied by the red dress she insists on wearing to her antebellum community's social event of the year. On set, Davis had begun an affair with the film's director, William Wyler, and she credited her performance as a woman in love with Henry Fonda to the fact that her beloved "Willie" was standing behind the camera. But Davis also had a husband, Ham Nelson, who had been her high school sweetheart. When she realized she was pregnant, probably with Wyler's baby, Davis had an abortion. When the *Jezebel* shoot was over, Davis and Wyler went their separate ways, and, holding on to her marriage vows, she attempted to move on.

The night of the Tailwaggers ball, Bette took a cue from her *Jezebel* character and dressed to impress, in a pale pink gown with a brocade bow sewn into the chest, below a very low sweetheart neckline. This dress couldn't have been better designed to attract the attention of Howard Hughes, whose interest and expertise in costuming for cleavage remained consistent throughout his Hollywood career. He took notice of Bette and approached her. "He seemed reserved, even shy," Davis later said. "He spoke softly, and I had to lean close to hear him. When he introduced himself, he looked into my eyes, not down my dress. That really impressed me, though if I didn't want men looking, why didn't I wear a higher-necked dress?"

Before the night was through, Hughes asked Davis if he could see her again. "I was flattered," Davis recalled. "I was married. I was bored. I accepted."

This event was heavily photographed, and one of the images, showing the pair standing next to one another, with Howard's hand on a table apparently inching toward Bette's hand, was published internationally. Davis kept clippings of the photos of her and Hughes at this event in a scrapbook, which she would at some point label "DIVORCE."

Davis entered into a relationship with Hughes believing that her marriage was all but over, though neither she nor her husband had

made moves toward a separation. Bette and Howard attempted to be discreet, renting a cottage in Malibu for their dinner dates. Eventually Ham found out about their secret hideaway, and by early October the papers were reporting that Davis was on "vacation" from her marriage. These were Davis's actual words, which she wired to journalists directly. On October 3, Walter Winchell breezily led his column with the news that Davis "finally admitted the separation from her groom, [and] will probably make it permanent—to wed Howard Hughes, who Certainly Gets Around. . . ." Bette kept this clipping in her DIVORCE scrapbook, too, although when asked directly about Hughes by Louella Parsons, she demurred. In an article sympathetic to Bette, Parsons noted that the actress "laughed heartily over the fable pulled out of thin air that she would marry a millionaire. 'I don't know any millionaires,' she said, 'but if I happen to meet one who asks me to share his millions I'll tell you first.'"

What Louella didn't print was that Ham had asked to be paid to go away, and Bette was annoyed that Howard had not offered financial help. She would have to borrow money from Warner Bros. in order to get out of her marriage, and no marriage to Hughes would follow.

In late November, Ham filed for divorce, presenting a narrative that Bette was so focused on her career that she had become frigid. "I think that Bette is a grand actress—the best on the screen," Ham told reporters at the courthouse, "but she has become the best to the detriment of her home life." Nelson's filing complained that Davis "had become so engrossed in her profession that she had neglected and failed to perform her duties as a wife," and that she "would become enraged and indulged in a blatant array of epithets and derision when asked to exhibit some evidence of conjugal friendliness and affection."

Ham's statements on the marriage would have been terribly unflattering to some actresses, but for Bette Davis, they were both on-brand and an apparently negotiated act of protection. It was popular perception that working women ceased to be "real" women, meaning that they were apt to neglect their husbands, lose all desire for men, and rebel as if compulsively from their "duties as a wife." So to say that

Bette Davis, an extremely successful career woman, had done these things was to say nothing that her critics had not thought before. And of course, the truth was that Davis may have neglected her husband, but she was not frigid. In fact, as she later put it, "I liked sex in a way that was considered unbecoming for a woman in my time." Indeed, she was so wantonly sexual that she had defied her marriage by uncorking her passion in a cottage in Malibu with America's most famous flying millionaire. To blame the divorce on Bette's career protected her by obscuring her infidelity and sexual appetite and left the door open for Hollywood columnists to empathize with the tragedy of her failure to balance stardom and marriage. Other actresses may be able to "have it all," but Bette Davis, this incident proved, was not like her peers. She was an artist before she was a woman, the consummate actress of her generation, and she sacrificed the joys and responsibilities of womanhood to her calling.

Davis's career not only survived the scandal of her divorce, but thrived—she took home her second Best Actress Oscar in February 1939, for *Jezebel*. The affair with Hughes, however, didn't survive the fallout of her marriage. Years later, Davis looked back on Hughes with a mixture of pride and cattiness. "You know, I was the only one who ever brought Howard Hughes to a sexual climax, or so he said at that time," Davis bragged. "It's true. That is to say, it's true that he said it. Or, let's say, I believed it when he told me that. I was wildly naive at the time. It may have been his regular seduction gambit. Anyway, it worked with me, and it was cheaper than buying gifts. But Howard Huge, he was not."

ON NEW YEAR'S EVE, 1938 going into 1939, Olivia de Havilland phoned Jimmy Stewart to cancel their date for the evening—she was sick in bed with bronchitis. At 10:30 P.M., Howard Hughes—likely having forgotten about the holiday until the last minute and going through his phone book dialing numbers until he found a potential date who was still at home—called Olivia and told her that he was on

his way over to her place, and he was going to take her to the house of Jack Warner, head of her studio, Warner Bros., for a party. Hughes wouldn't take no for an answer, so de Havilland got out of bed and put on a dress—a dress cut so low that, as she put it, "it practically asked for pneumonia."

When they arrived at Warner's house, Howard and Olivia immediately ran into Jimmy Stewart, and then Errol Flynn, de Havilland's frequent costar and sometime lover. "We sat down at the bar and Errol Flynn started serving me drinks," she recalled. "I was 22, with three of the most attractive men in the world around me. I don't know how my reputation survived but by dawn my bronchitis was gone and my temperature was back to normal."

De Havilland kept answering Hughes's calls, until one night she confronted him over the status of their relationship and he made no attempt to let her down easy. "There is love between us and we have never discussed marriage," she stated. Hughes responded, "I have no intention of marrying until I am 50. There are too many things to do."

And yet, in his mid to late thirties, he asked more than one woman to marry him.

Seven years after their first date, Hughes was once again pursuing Ginger Rogers. He had first proposed to Rogers in the summer of 1936, after he had declared interest in Hepburn but before their relationship began in earnest. (Hepburn would later acknowledge that she had assumed Hughes was not completely faithful to her: "I didn't expect him to be chaste during our separations," she said, adding, "I was only *slightly* curious about his escapades.") Rogers had separated from her second husband, Lew Ayres, but had not filed for divorce. Howard said that was just paperwork, that his lawyer could take care of that for her, and then she'd be free to marry Hughes. "What do you say to that?" With wounds still fresh from her last broken marriage, Rogers said she wasn't ready. According to Rogers, Hughes and she continued to date sporadically, but she wasn't exactly waiting by the phone. For the next three-plus years, Hughes would be involved with Hepburn and others, and Rogers had a full dance card as well.

This first marriage proposal to Rogers came right after Rogers and her on-screen dance partner Fred Astaire finished shooting their masterpiece, *Swing Time*, directed by George Stevens and released in September 1936. All of the Astaire-Rogers collaborations are notable for the ways in which they pioneered the subsumed sex scene: in a time of increasing regulation of on-screen sexuality, movies like *The Gay Divorcee* and *Top Hat* managed to communicate sophisticated stories of seduction and consummation primarily through choreographed dance. *Swing Time* did what their previous films had done, and more. Its climax is the stunning number set to the song "Never Gonna Dance," in which Astaire confesses his love to the unattainable Rogers, and then the couple shares one, last, forbidden waltz. It's the apotheosis of the Astaire-Rogers ballroom dance-as-sex scene.

Rogers and Stevens fell in love on the set of *Swing Time*, and carried on a relationship for three years—three years that encompassed Hughes's romance with Hepburn, and fell roughly into the midpoint of Stevens's seventeen-year marriage to former silent star Yvonne Howell. And then, in 1939, after his flight around the world and the fizzling of his affair with Bette Davis, Howard came back into Ginger's life with a vengeance. By early 1940, he had finally convinced her to allow his attorney Neil McCarthy to handle her divorce from Ayres. Once the papers were filed, Rogers recalled, "Howard completely dominated my personal life." He sealed the deal by giving her a five-carat emerald engagement ring.

A woman who believed in the ritual of marriage and all it symbolized, Ginger continued to live with her mother Lela after accepting Howard's proposal. Hughes still had the mansion on Muirfield Road, and in 1940, in need of temporary lodgings during the *Philadelphia Story* shoot, Hepburn moved back in, but they did not rekindle their romance. Hughes was working hard to convince Rogers—who had bested Hepburn in the battle of the RKO divas—that she was the woman he wanted to live with. One day he took her up to a parcel of land he had bought on Cahuenga Peak, overlooking Lake Hollywood. Hughes had purchased 138 acres west of the Hollywood sign, and he

explained to Ginger that he was going to build a house there just for her. "He knew I loved a view," she recalled. "My own home had a very lovely view, and this was much higher than the house I had; so he thought that would be very appealing to me, and to some extent it was."

While Rogers was imagining life with Howard Hughes in a custom-built castle in the sky, her career was at a crossroads. She and Astaire had recently made what she believed would be their final film together, the musical biopic *The Story of Irene and Vernon Castle*. Rogers had been RKO's top female star for much of the 1930s, but the studio had battled with her over contracts and struggled to figure out what to do with her in between Astaire musicals. The devoutly religious Rogers also had firm ideas about what she should be representing on-screen, and she fought back against some of the material RKO tried to cast her in.

Then Rogers was courted by producer David Hempstead to star in an adaptation of a popular novel called *Kitty Foyle*, about an independent young woman who becomes pregnant and has an abortion. One night, while Howard was driving her to dinner, Ginger started flipping through a copy of the novel that Hempstead had sent her. Somehow she flipped straight to the scenes in the book that were the least likely to pass the Production Code in a film adaptation—not just the abortion, which Rogers found repugnant, but also what censor-in-chief Joseph Breen would call "the suggestion of frequent illicit sex affairs between your two leads." Ginger threw the book down in disgust, telling Hughes she was "not flattered" that Hempstead and RKO had bought this "highly suggestive and too lurid" novel expressly with her in mind.

Ginger's mother advised her that there was no way the things that she objected to in *Kitty Foyle* could ever make it into a Hollywood movie. *Kitty Foyle* would have to be sanitized for the screen, and with a millionaire fiancé promising her the world—or, at least, a house with a view of the world as Hollywood knew it—Ginger could afford to wait.

Except, increasingly, it felt like Ginger Rogers's time was not her own. At first Howard would call Lela directly to schedule and plan his dates with Ginger. As they became more seriously involved, Hughes stopped asking either of the Rogers women for permission and started directly ordering Ginger to make sure he was the sole focus of her attention. She had begun to suspect that he was having her followed, and that her phone calls were being surveilled. Years earlier, Hughes had kept tabs on Billie Dove by physically standing outside public restrooms to make sure he didn't lose her when she emerged. Ginger's instinct that he had tapped her phones, if accurate, would have been the first indication that Hughes had begun to outsource the activity of monitoring his girlfriends to a network of aides and spies. That network would become visible to all soon enough.

After his experience with Katharine Hepburn, Hughes may have feared once again being shut out of a complicated family dynamic. Rogers didn't come from a long, storied line like the Hepburns, but that made her bond with Lela Rogers all the stronger. Ginger believed that her mother was the only person who always had her best interests at heart. Once Hughes angrily started trying to regulate the frequency with which she spoke to Lela, Ginger's increasingly bad feeling about the relationship began to crowd out her hopes for a blue-sky future. "This was too much for me," she thought.

Finally, one night in 1940, Howard called Ginger at home. He had a dentist appointment the next morning and wanted Ginger to go with him. Ginger refused. She didn't know what to tell him, or why exactly she was pushing back against his demands now, but something inside her was telling her to do it. Then something outside told her to do it, too: that same evening, Ginger recalled, she picked up the ringing phone to find screenwriter Alden Nash on the other end. Nash told Ginger that he had seen Hughes's car parked in front of the home of another actress—not just that night, but many nights.[1]

[1] This actress has been presumed by some writers to be Faith Domergue, but the dates don't line up. I believe it may have been Ruth Terry, with whom Hughes was linked in several gossip columns in the fall of 1940.

When Howard called the next morning to once again try to get Ginger to accompany him to the dentist, she again refused. She spent the day packing up all the jewelry Hughes had given her. A few hours later, she got a call from Noah Dietrich. Howard was in the hospital, Dietrich told her. Would she come see him?

Driving to the dentist, Hughes had smashed head-on into another car. Another crash meant another head injury; this time it had taken seventy stitches to close up Howard's eye. When Ginger got to the hospital, Hughes was in the recovery room, his head wrapped up like a mummy.

"How are you feeling?" Ginger asked.

"Miserable," he responded, and proceeded to explain that this was her fault. He had been so mad that Ginger refused to accompany him to the dentist, he told her, that he had driven straight into oncoming traffic.

By now Ginger was used to Hughes's patterns of manipulation. Already aware that he was cheating, she wasn't going to let him gaslight her anymore. She told him what she had found out about where he was spending his nights, and with whom. Before the sedated cad could conjure up a response, Ginger produced the box full of jewelry, which included the emerald ring. The engagement, she told him, was over.

"There was a long silence you could cut with a knife," Rogers recalled. "Howard looked at me from under his bandages; his soulful eyes were like those of a bloodhound puppy. Then I turned and walked toward the door. With a dramatic turn of the head I opened the door, slamming it as I left. That was the last time I ever saw Howard."

Dietrich soon entered the hospital room and found Hughes in tears over the breakup. "It was," Dietrich wrote, "the only time anyone saw Howard Hughes cry."

IN THE WAKE OF their breakup, Ginger Rogers edged into a new echelon of stardom, thanks to *Kitty Foyle*, the movie based on the bestselling novel that she had been convinced was too trashy to be filmed.

With a final script written by future Hollywood Ten radical Dalton Trumbo and directed by future Hollywood red-chaser Sam Wood, *Kitty Foyle* had ended up being a bizarrely moralistic film, one that took unusual satisfaction in telling women that their dreams and desires for either romantic dependence or modern independence were both foolish and wrong.

Kitty Foyle (portentously and, ultimately, sinisterly, subtitled "the natural history of a woman") begins with a prologue, filmed with inter-titles instead of dialogue, as if to play on the audience's distant memories of a simpler, silent film era. It opens with a title card explaining that in order to understand the film to come, we need to review a brief history of the "white-collar girl." We flash back to 1900, when a young woman's life is depicted as consisting of wearing a fluffy white dress and being painstakingly protected and wooed. On the streetcar, a gentleman eagerly gives up his seat so the young woman can sit down. That same man comes to her house and, obeying the rules of her father, courts her. The endgame of the 1900 girl's public life is a husband and baby. "But that was not enough," says the next title card. A dramatization of the fight for suffrage follows.

"And so the battle was won," reads the next title. "Women got their equal rights." These "equal rights" are depicted as a woman standing on a streetcar, men oblivious to her, not offering her a seat in which to rest her weary working-girl bones. Then comes a long text crawl: "Thus woman climbed down from her pedestal and worked shoulder to shoulder with men—who became so accustomed to her presence during the day that evening brought a new malady to the white-collar girl. By 1940 this had come to be known, rather gloomily, as 'That Five-Thirty Feeling.'" In other words, men don't want to date or marry working women, so working girls are left with no man to marry or date, and when the workday is over, they return to their sad, shared apartments and ponder, "Is that all there is?"

When we finally enter the movie proper, we see that Ginger Rogers's Kitty is the 1940 version of the harried working girl. Kitty's unglamorous doctor boyfriend is forever keeping her waiting for dinner, but

tonight he asks her to meet him at midnight so they can get married. There is little to no romantic chemistry between Kitty and the doctor, but this marriage is clearly the sensible thing for Kitty to do: it will allow her to quit her job selling perfume at an upscale cosmetics store and have the children she desperately wants. She goes to her apartment to pack, and who does she find waiting for her there but Wyn, her rakish ex-husband. Wyn tells her he's leaving his current wife and son and old-money family and hightailing it to South America, and he wants Kitty to come with him. He tells her to meet him at midnight at the train station. Now Kitty has two options, and as she packs, apparently swept away by her ex's romantic proposal, her reflection in the mirror starts shaming her for even imagining a life on the lam with her dashing ex. "Married people face things together. But you won't be married," Kitty's judgy mirror self cautions.

Kitty had been polite when the doctor proposed, but not passionate; when Wyn showed up, she turned into a different person, and now we see that Kitty has been putting on an act with her new suitor—and that Ginger Rogers's performance in this film is at a much higher level of difficulty than anything she's done before. In *Kitty Foyle*, Rogers plays at least four distinct characters: the Kitty who loves Wyn, the Kitty who "loves" the doctor, the tomboy fifteen-year old Kitty, and the conscience Kitty sees when she looks in the mirror.

Now come the flashbacks, showing how Kitty, a girl from the wrong side of the tracks, craved throughout childhood to be part of the high-society set. Her beleaguered widower father warned against such dreams, lambasting fairy tales for "putting ideas in little girls' heads" that working-class rubes from nowhere could end up with rich princes, and encourages her to find a workaday lad and marry him. The message is that the ambition to pass through classes, to achieve or accumulate much more than what you're born into, is dangerous. And yet it's Kitty's father who introduces her to Wyn, an heir to a massive Philadelphia fortune. She becomes his secretary, and he woos her via Dictaphone.

Their romance turns serious on the night Franklin Roosevelt is

elected president for the first time. They celebrate the victory in a New York speakeasy and Kitty's virtue soon falls like Hoover's hope of remaining in office. This is the most literal of the various different ways in which *Kitty Foyle* serves as a capsule history of the first four decades of the twentieth century through one woman's experience, placing personal choice in political context. Now politically and socially empowered to make their own choices, *Kitty Foyle* suggests, women will make those choices based on emotion—and that this is why they shouldn't have so much agency. The scene in which Kitty succumbs to Wyn's seduction takes place in a cabin, opposite a roaring fire. Though we enter the room on a wave of soft and romantic background music, the first shot of the scene ominously moves in on the raging fire, and when we then see Kitty and Wyn, they're posed and shot in an odd, unsettling angle. Moralist director Wood uses mise-en-scène to tell the audience that even though this coupling is what Kitty thinks she wants, she shouldn't be there—and a girl like her can't be trusted to make her own decisions about sex and men.

Kitty and Wyn break up the first time when his business fails, and instead of proposing to her as she expects, he offers to keep her on his payroll, because he thinks he owes it to her. "Nobody owes a thing to Kitty Foyle," the proud secretary says. "Except Kitty Foyle!" Fueled by her indignation, she goes to New York and finds the job at the perfume counter. She meets the boring doctor, who makes her starve the night of their first date rather than take her out to dinner in order to impress on her that he's not rich and that life with him means being careful about every cent spent. Then Wyn shows up again in New York, and he and Kitty elope and return to their hometown of Philadelphia. They're elated, but his family is livid, threatening to disinherit him unless Kitty immediately enrolls in finishing school. This disapproval seems to overwhelm Wyn, who we're reminded is the seventh man with his family name, so Kitty, feeling unwanted, walks out and goes back to New York—only to discover that she's pregnant. She decides that she'll raise the kid on her own, and that he'll be the toughest little boy in town. There's an incredible scene in which a de-

lirious Kitty wakes up in her hospital bed and describes the dream she's just had, in which she's saved her little boy from drowning. What she doesn't know—although she probably feels—is that she couldn't save him, that the baby died in childbirth. It's the most tragically cruel demonization of single motherhood in any movie I've ever seen.

When Kitty snaps out of the flashback, she has realized that her past life with Wyn contained incredible, romantic highs, and unbearable lows; her future life with him would promise passion, but at least as much uncertainty. Attempting to live life alone and take care of herself resulted in the horrific loss of a child. The right thing to do is to marry the doctor with whom she'll have a respectable, middle-class life, with no passion, but probably less pain.

As a star, Ginger Rogers is remembered as a trouper. The standard line on her, that she did everything that Fred Astaire did but backward and in heels, underlines the labor inherent in a woman's attempt to compete with a man without giving up their femininity. The Fred and Ginger musicals existed in fantasy spaces, where she could do just that. The message of *Kitty Foyle* was that such fantasy spaces, and the gender dynamics that could flourish there, were incompatible with an ethical life in modern times. That *Kitty Foyle* was a huge hit suggests early warning of the turn toward conservatism and conventional gender roles that would really flourish in the years after World War II.

Kitty Foyle cautioned against Cinderella fantasies, but in real life, Rogers would feel thankful that with Hughes she had gotten out before she ended up trapped in a different nightmare fairy tale: Rapunzel. "Howard wanted to get himself a wife, build her a house, and make her a prisoner in her own home while he did what he pleased," Rogers wrote. She added, "Thank heavens I escaped that."

A NEW
BOMBSHELL

Once the afterglow of the around-the-world flight had worn off, Howard Hughes began plotting his reentry into film production. Though financially backing Hepburn's purchase of the rights to *The Philadelphia Story* in 1939 had allowed him to dip a toe back into the world of Hollywood as a moneyman, before that movie was actually made in 1940, Hughes was already hungry for more. As ever, Hughes's second-go-round as a Hollywood player wasn't motivated by talent or creativity so much as a need to be known. By the end of the 1930s, he began seeing disconcerting signs that any legacy he had established in Hollywood at the beginning of the decade had faded away. "My name doesn't mean much anymore," he said. "It was brought home to me the other day when I made a telephone call and the man I wanted wasn't in his office. I left my name with his secretary, and I had to repeat it three or four times before she got it right."

Publicist Russell Birdwell was one man Hughes called to fix this problem. Another was director Howard Hawks. But the centerpiece of Hughes's Hollywood comeback would be a nineteen-year-old girl from the Valley who—thanks to the inspiration of Hughes, the grunt work of Birdwell, and her own inherent appeal—would become the most in-demand pinup of World War II before any soldier had ever seen her in a movie.

LIKE HUGHES, RUSSELL BIRDWELL was a slender Texan who developed a business of selling stars, often through the evocation of, if not pure sex, then something adjacent to it, but with a classier gloss. Birdwell called it "glamour." "Glamour is not to be confused with slutdom," Birdwell once wrote. So what was it? Birdwell made it sound like charisma mixed with narcissism: "A compelling identity with themselves that attracts and holds."

Unlike Hughes, Birdwell was invested in the survival of the studio system as an incubator of stars, if for no other reason than that he understood that studios needed to pay men like him to write the off-screen narratives that would capture the audience's imagination. In 1935 he published a series of articles in the *New York Journal* titled "Heartbreak Town." The first of the series told the story of the Studio Club, a boardinghouse in Hollywood for aspiring actresses, founded by Mary Pickford. Birdwell's initial article is a masterful example of the trick the Hollywood mythologist must pull off, of balancing ecstatic possibility with mundane probability and the off chance of tragedy. The current residents of the Studio Club, Birdwell wrote, "all remember that other unknowns have walked from that same club, from the very rooms that some of them now occupy, to the highest riches in the lofty realms of Hollywood." But nothing was guaranteed, and stalwarts of the club "have seen several of the girls go insane from the strain of frustration, unemployment and failure; have stopped some from ending their lives and have seen many, through the wearying months, disintegrate morally and mentally, a few battered down by the men who roam the confines of the world's greatest beauty marts in search of prey." And what of the "downright sensible" girl who realizes she doesn't have what it takes and heads home before it's too late? The trip to her hometown can be "accomplished without cost by arranging for a girl to accompany a corpse to the point nearest her home."

After the series was published, Birdwell—who had been a press agent for Jack Pickford, had directed three films in the early sound era, and was now working full-time as a crime reporter for the *Los Angeles*

Examiner—got a message at his newspaper desk that David O. Selznick wanted to see him. Selznick had left RKO, first for MGM and then to start his own studio, Selznick International Pictures. Curious more than ambitious, Birdwell drove to Selznick's office in Culver City. Selznick promptly offered Birdwell ten times what he was making as a reporter to serve as his director of advertising and publicity.

Birdwell joined SIP in December 1935, and in time he'd become one of the larger-than-life Selznick's most trusted employees. Birdwell's office became his boss's sanctuary, with the publicist allowing the producer to use it as a love nest (Birdwell sometimes even arranged the arrival of professional dates for Selznick to "love"). Birdwell's biggest accomplishment was his campaign to promote the search for an actress to play Scarlett O'Hara in *Gone with the Wind*. The hunt lasted for three years, a subject of mounting public anticipation all the while, and though most of the open-call audition of unknowns was pure publicity stunt, Selznick's inability to decide on an actress up until the moment he met Vivien Leigh was legitimate. The casting of Leigh, who was relatively unknown to American moviegoers, increased the must-see factor of the movie: people wanted to buy tickets and judge for themselves this unlikely Brit who had swooped in and taken the role away from dozens of good ol' American movie stars.

Birdwell left SIP in late 1938, before *Gone with the Wind* premiered, to start his own publicity firm (Selznick remained a client). A year later, Russell Birdwell and Associates announced it was launching a unit called New Faces Inc., designed to give the proper buildup to unknowns with the potential to become stars. It was around this time that Birdwell first met Hughes.

In December 1939, at the after party for *Wind*'s Los Angeles premiere, Birdwell was approached by "a skinny chap" in ill-fitting formalwear, including "little tails that he must have had in high school." This odd figure told Birdwell that he planned to contact him in two months. Birdwell said fine and went back to talking to people he believed to be important, clients like Janet Gaynor and Norma Shearer. When the

skinny chap went away, Shearer said, "Do you know who that is? That's Howard Hughes!"

That Birdwell didn't recognize Hughes—who had been the most famous man in the world just a year earlier—gave credence to Hughes's paranoia that everyone in movies had forgotten him. Two months later, he did contact Birdwell—or, he had an aide show up at the publicist's office with a note, requesting a meeting the following day at the convenient time of 3 A.M.

"I want a high-class build-up, like you gave *Gone with the Wind*," Hughes told Birdwell. "I'm sure you do," came the response. But even when *The Outlaw* was barely more than a twinkle in Hughes's eye, Birdwell could tell it wasn't "that kind of picture." So, Birdwell told him he couldn't do what he did for *Gone with the Wind*, "but maybe I can put on an original *Outlaw* campaign."

Hughes said, "That's a good answer."

NOAH DIETRICH REMEMBERED ONE day in 1940 when Hughes returned to the office from a visit to the dentist, his eyes swirling with dollar signs, thanks to a woman he had seen there answering phones. "Noah," Hughes said, "I've seen a pair today the like of which I've never seen in my life. Brother, am I going to exploit them. That's what the morons who go to the theaters want to see.'"

This account of the discovery of Jane Russell is colorful, but probably apocryphal. By Jane's own recollection, she was not working in a dentist's office when she was discovered. She had put in a couple of weeks as a receptionist at a podiatrist's office, but that job was long over by the time she got the call. According to her, "Howard hired me for *The Outlaw* without ever seeing me in person or meeting me or talking to me."

Russell grew up on a ranch in the San Fernando Valley, the oldest of five kids. Her mother, a former wannabe actress turned elocution teacher, had become a born-again Christian when Jane was six, and

had instilled in Jane an intermittent belief in faith healing and a love for churches where they spoke in tongues. As the actress would later describe it, the narrative of her life was defined by her deviations away from the path of God, and her returns to the fold.

As a kid, she had been so skinny and flat-chested that boys made fun of her. By the time she was seventeen, Jane's body had changed— she now had ample curves—but her mindset had not. Russell's mother encouraged her to go to acting school, if only because it might cure Jane of being a natural tomboy, and teach her how to more comfortably carry her new body.

Right out of high school, in 1939, Jane began studying with Max Reinhardt at his School of the Theatre on Sunset Boulevard. She didn't exactly take it seriously, frequently ditching classes to go bowling with a girlfriend. It was only after she quit school that Jane realized she had been bitten by the acting bug after all, so she enrolled in another drama school, this one taught by a Stanislavsky disciple named Maria Ouspenskaya, whom Russell remembered as a little Russian woman who drank straight vodka out of a water glass throughout the day. Jane would all but give up on acting after a screen test at Fox, where she was told she wasn't photogenic, and a meeting at Paramount, where, at five-foot-eight, she was told she was too tall.

By then Russell was living with her mom, and basically just biding time until her boyfriend, Robert Waterfield, a football star at the University of California, Los Angeles, got it together to get to the altar. And then she got the call, demanding her presence at 7000 Romaine Street, the former Multicolor film plant that Hughes had turned into his Hollywood headquarters. An agent named Levis Green had seen Jane's photo at photographer Tom Kelley's studio and brought a copy to Freddy Schlusser, who was heading a talent search on behalf of Hughes. Schlusser took one look at the brunette with the listed measurements of 38-22-36 and said, "She looks the type."

The photo that got Jane Russell in for a test with Hughes, the photo that would make her career, is no straightforward pinup. Kelley had brought the nineteen-year-old brunette in to do some "sports model-

ing," which usually meant tame bathing suit pinups, but this shot was framed to stop right under her double strands of pearls. Her heavily made-up eyes are downcast, barely open. Her top teeth are bared, turning a half pout into almost a sneer. This was no skinny, happy, compliant starlet—like Jean Harlow in the press book for *Hell's Angels*, this looked like a picture of a girl who didn't want to please you. If anything, she was daring you to try to please her. Big breasts, brunette, high drama: this would, going forward, become Howard Hughes's physical ideal. He had shown interest in a variety of physical "types" before (Katharine Hepburn and Billie Dove had no resemblance to one another, other than that they were both extremely famous when Hughes pursued them), but going forward, with exceptions so few they could be counted on a single hand, his preference would be for women so visually similar to one another that a rubber stamp would have offered more variation.

It would be months before Russell and Hughes were actually introduced. First, Russell was summoned to Romaine Street, where she met Howard Hawks, who was then slated to direct *The Outlaw*. Hawks explained to Jane that the character she was up for was Rio, a half-Irish, half-Mexican girl who tries to get revenge on Billy the Kid, who killed her brother, by attacking him with a pitchfork. In retaliation, Billy the Kid rapes her. It was this scene—the dialogue that, on-screen, culminates with Rio's rape—that had been chosen for the screen test. Jane was to test alongside four other actresses, all of them voluptuous brunettes.

Jane practiced the scene with a Mexican American girlfriend, mimicking the way her friend said the lines. At the audition, when she was finished, someone told Hawks that the Russell girl "spoke pretty good English for a Mexican." She got the part. Russell was put under personal contract to Hughes. She would be paid fifty dollars a week.

HOWARD HAWKS HAD SIGNED a contract with Hughes, his *Scarface* producer, in 1940, in part because the director was looking for some breathing room from the major studios, and in part because Hawks

knew Hughes owned the rights to Hemingway's *To Have and Have Not*, a novel that Hawks was dying to direct. (He would; Hughes would not be involved.) As part of their deal, Hughes also agreed to finance a film based on a romantic legend that Hawks had heard about Billy the Kid, which imagined that his assassination at the hands of Pat Garrett had been a setup. As Hawks explained it, "When Billy fell in love, Pat Garrett blew the face off another man, said it was Billy the Kid, and Billy and the girl went off to Mexico and lived happily ever after."

Once Russell had been cast in the pivotal role of the girl, Hawks took the newcomer under his wing, giving her important guidance as to how make an impression on-screen. "He wanted me to keep my voice low, and he said that girls should walk from the hips, not from the knees," Russell recalled. "He said I should take long strides." No doubt Hawks was trying to mold Russell into his own feminine ideal, a feat that he'd fully accomplish a few years later with Lauren Bacall, who made her debut in his *To Have and Have Not*. What stuck to Russell was a version of the laconic body language that Bacall would come to embody, but with Russell's very different body type, the effect was unique. Russell was shaped like a figure eight, and Bacall was lean and slinky, like the number two. Bacall was cool; Russell, who had been accused of lacking energy by her spirited acting teacher Ouspenskaya, seemed woozy, even lazy. As Russell herself put it, on-screen, "I seemed to be moving in slow motion."

This turned out to be the closest thing Hawks would give Russell by way of direction, although one piece of crucial career advice was to follow. Hawks spent the first days of the production filming scenes with the male leads, while Russell posed for publicity photographs. The photographers hired by Birdwell knew exactly what Hughes had seen in Russell, and they did their best to exploit it. "I couldn't have been greener," Russell later admitted. "Whenever they asked me to bend over and pick up an apple or something, I went along with the gag."

One night, Russell found herself asked to pose while bouncing up and down on a bed. In a photograph taken by Gene Lester, Russell, who is wearing a fairly demure nightgown, is captured mid-jump, and

in the midst of a laugh or squeal. She looks ecstatic, and so girlishly gleeful that you barely notice her size 38D breasts, perfectly round and floating on gravity's momentum.

But photographs can be deceptive, and as Russell would tell the story later, this was the night when she realized that she was being pushed too far. She ran to Hawks in tears and asked him to do something. He refused, telling her that this was part of the business, that there would always be men who would try to get her to do things she didn't want to do. She couldn't rely on other men—the ones she deemed to be nonthreatening saviors—to protect her. She needed to learn how to set limits, and enforce them. "I didn't get any sympathy from him," Russell noted. "And he was right."

Hawks and crew were shooting on location in the middle of the Arizona desert, in a tent city that was so remote that food had to be brought in on trucks. On the weekends, buses would pick everyone up and take them eighty miles south to Flagstaff to blow off steam. "Everybody got loaded," Russell remembered, "and we sang all the way back."

Hawks had intentionally chosen a location far from Hughes's purview. Or so he thought; banning Hughes from the set had allowed Hawks to work in peace on *Scarface*, but this time, Hughes had dailies shipped back to him in Los Angeles, and after two weeks, the producer had seen enough—or, rather, he hadn't seen what he was looking for. Hughes waited for an off day to tell Hawks he was relieved of his command.

Columnists whispered that a disagreement over the film's budget had motivated Hawks's departure, but this was, as Hughes's lawyer Neil McCarthy wrote to Noah Dietrich, "of course false. The reason Hawks was displaced was because he was not doing the picture as instructed."

What was he not doing? According to Hawks, he and Hughes "had different ideas about revealing women's bosoms, and things like that." This was probably a simplification—and definitely an easy joke— but it's true that Hughes's primary points of interest in the production seemed to be Russell's two breasts. It was an impersonal obsession. He was not trying to possess the breasts, or the woman attached to them,

the way he tended to try to with other women in his life. Instead, he treated Russell's assets as, well, assets: investments that represented the primary area of value of the picture. Birdwell had been told in no uncertain terms that it was his job to "get some mileage out of her tits." When two weeks had gone by and Hawks hadn't even shot with Russell yet, Hughes must have been impatient to see what he perceived to be the true stars of *The Outlaw* on-screen.

The whole production was moved back to Los Angeles at a moment's notice, and there, cast and crew waited for further instructions. Jane went back to her life, to her family's ranch in the Valley, to her God-fearing mom and football star boyfriend. Life was exactly the same as it always had been, except now there were pictures of her in magazines, supposedly promoting a movie that had been stalled seemingly indefinitely.

Eventually production began again, this time shooting on soundstages on the Goldwyn lot in the evenings. In Los Angeles, Hughes could manage his aviation business during the day, and direct the movie himself at night.

Jane became practiced in creating the illusion that she was giving Hughes what he wanted, while retaining her own agency. Hughes wanted Jane's Rio to appear to be braless, but Jane and her weighty breasts needed some kind of undergarment for support. Hughes took to his drafting board and sketched out a new bra, bringing to bear all of his aviation-earned knowledge of lift and structural engineering. A prototype was produced, and Jane was instructed to put it on under her costume. What Hughes was after was the look of the modern, seamless, strapless bra, but what he actually created was, according to Jane, "uncomfortable and ridiculous." She put her own bra back on, covered the seams with Kleenex, and slipped the straps down off her shoulders. She went back on set, and Hughes nodded his approval. He assumed she was wearing his creation, and Jane let him labor under that illusion. It was a small, hidden victory for Jane in a film that otherwise would exploit her body shamelessly.

Hughes's directions were always seemingly minor—*Don't raise your*

left eyebrow when you say this line. Don't move your thumb. Don't lean too far to the right. He tried to tinker with the performances, as though actors were airplanes (or undergarments) that needed mechanical adjustments in order to sustain flight. He couldn't articulate what he wanted beyond gestures, but he could push the actors to do one hundred takes until he got the indefinable something that he was looking for—or tired himself out in the process. Once Hughes made cinematographer Gregg Toland (a master of his form who had shot *Citizen Kane* and won an Oscar in 1939 for *Wuthering Heights*) take eighty-eight different shots of Jane's face, from slightly different angles. Hughes had sixty of the takes printed, and the director spent days looking at them over and over again, unable to decide which he liked best. When in doubt, Hughes told Toland to point the camera down Jane's shirt.

Predictably, this resulted in footage of a kind that no one had ever tried to get past the censors. Having completed a cut of *The Outlaw* a few months into 1941, Hughes spent years wrangling with the Production Code enforcers (who were supposed to vet scripts, finished films, and advertising before they were ever released into the wild), as well as with local censorship boards. First the issue was how to shape *The Outlaw* to preserve its raison d'être in a form that conformed to the Code enough to allow for release; later, the question became how to advertise the movie. Every step of the battle between Hughes and the censors was documented in the media, and there is some indication that Hughes enjoyed the spotlight so much that he made sure the censorship saga dragged on for as long as possible. After all, a three-year buildup hadn't hurt *Gone with the Wind*, which was then and today remains, when figures are adjusted for inflation, the highest-grossing film of all time.

On reading the shooting script in November 1940, the Breen office wrote to Hughes and told him they took issue with the fact that Billy was unpunished for his crimes, as well as with "two scenes suggestive of illicit sex between Billy and Rio." Several pages of suggestions followed. Toward the end of the year, screenwriter Jules Furthman discussed the rape scene with two of Breen's officers. The censors made suggestions, and Furthman convinced them the scene would not depict

a sex act, only violence. Three months later, Hughes himself called Breen's office and explained that he was thinking of adding a scene to the movie in which Russell's Rio would get into bed with Billy the Kid, only to use her body heat to keep him from dying of a chill. Head censor Joseph Breen, according to an internal memo, "agreed that the scene sounded fundamentally acceptable," and that was that.

But then the censors watched a cut, on March 28, 1941, and noted nineteen unacceptable lines and images, including more than half a dozen "breast shots." In a letter to Hughes, while describing the screening as a "pleasure" to witness, Breen declared that "the picture is definitely and specifically in violation of our Production Code and because of this cannot be approved." The criminality of Billy was no longer an issue. Now the problem was, as Breen explained, "two fold: (a) The inescapable suggestion of an illicit relationship" between Rio and two men, and "(b) The countless shots of Rio, in which her breasts are not fully covered." Hughes was informed that all such shots would need to be deleted. "In my more than ten years of critical examination of motion pictures, I have never seen anything quite so unacceptable as the shots of the breasts of the character of Rio," Breen carped in an interoffice memo. Russell's breasts, "which are quite large and prominent, are shockingly emphasized," Breen added, acknowledging the challenge facing Hughes: "Many of these breast shots cannot be eliminated without destroying completely the continuity of the story."

That had been exactly Hughes's idea, and he wasn't the only one pushing this particular envelope. Still in a tizzy from the *Outlaw* screening, the next day Breen wrote to original Code crafter Will Hays about a "marked tendency on the part of the studios to more and more undrape women's breasts," and cited unnamed pictures submitted by Columbia and Universal as having unacceptable "sweater shots" and such.

But Hughes was considered to be a special case. After negotiations between Breen and Hughes's lawyer McCarthy failed to reach a compromise—even after the Breen office sent Hughes a detailed memo telling him exactly which breast shots needed to be cut, in each reel—Hughes filed an appeal, the first the censors had received in years.

Russell Birdwell's version of what happened next was cheerfully hyperbolic. The censors "ordered 102 cuts in the picture," Birdwell recalled. "Howard said, 'I'm not going to make any cuts. We'll release it ourselves.' I represented him at a meeting of the Producers Association in New York. It was Hughes' suggestion that we might prove that less of Jane, in proportion to her size, was revealed than any of the present day stars."

Birdwell remembered a lesson he had learned working with Selznick: "Humor is the greatest weapon. Next is ridicule if you have to use it." He ginned up a plan to prove that *The Outlaw* wasn't revealing substantially more of Jane Russell than other movies revealed of their stars, while also poking fun of the very idea of the censors measuring the amount of breast meat seen on-screen.

Birdwell had half a dozen photo enlargements produced of stills of films made by other producers, each featuring evidence of pronounced cleavage-bearing by top-billed stars. He hired a mathematician from Columbia University to show up at the appeal presentation, and the professor went from one blowup to another with a protractor, measuring exposed flesh. "It was the greatest display of mammary glands in the history of the universe," Birdwell proclaimed. "And these tired old men saw it." The "tired old men" of the PCA appeals board were forced to acknowledge "that in relationship to her size, less of Jane was exposed than any other star in the business."

After some negotiation on the part of Birdwell and Hughes lawyer Neil McCarthy, the number of changes requested was brought down to six, involving about forty feet of film. On May 23, 1941, Joseph Breen's Production Code office stamped *The Outlaw* with their seal of approval, certificate number 7440.

And yet still Hughes did not release the movie.

IN THE MIDST OF *The Outlaw*'s production, Howard wrote a rare letter to his aunt Annette. Katharine Hepburn was leading a traveling production of *The Philadelphia Story* and she would soon be visiting

Houston. "She is an exceptionally good friend of mine, and one of the nicest people in the world—next to you, of course," Howard wrote. "Will you please invite her out to the house one afternoon? Please don't invite anyone else, as she is she and it gets her upset to meet strangers." Still highly protective of his ex, he added: "Please see that she gets back to the hotel by four-thirty for her nap before the show. This is most important, as she won't take care of herself and is headed for complete exhaustion and a break-down."

Annette did invite Hepburn to her house, and remembered the visit fondly years later. "She was the first woman I ever saw in trousers," Annette recalled. "She came out in the most beautiful yellow trousers that ever was."

Hepburn would not make it back to Hollywood for the Academy Awards ceremony on February 27, 1941. Not that she would have attended if she had. Over the course of her career, Hepburn won four Oscars but never showed up at an Academy Awards ceremony, admitting later in life that she was "unwilling to go and lose." And she did lose in 1941—to Ginger Rogers, whose performance in *Kitty Foyle* had not only revealed previously unrealized depths to her talent, but had also rescued RKO from a long slump. The studio rewarded Rogers by shifting her call time for the morning after the ceremony by a full two hours, so she could sleep in.

In 1941, Rogers would turn thirty, and Hepburn thirty-four. With her Oscar in hand, Rogers would join Hepburn on the list of rarefied female stars, and though both had major hits in their future, both were also past their ingenue prime. A new generation of girls was coming up behind them. And Howard Hughes would move from pursuing top female stars to pursuing young (sometimes *very* young) women whose careers had not yet gotten very far off the ground. More than ever before, he would become obsessed with controlling these women, seeking to tie them up via marriage proposals or long-term contracts—or both—and taking ownership over their bodies and how they were presented to the public—or weren't.

PART IV

LIFE DURING WARTIME, 1941-1946

CHAPTER 13

THE NEW GENERATION

Her mother's family had owned slaves, and her father's father had fought on the Confederate side in the Civil War, but that was a long time ago, and nothing remained of those days by the time Ava came along. Married just after the turn of the century, Molly and Jonas Gardner had settled in Grabtown, North Carolina, a rural community where residents wouldn't have electricity or running water until decades after Ava and her family were forced by their desperate finances to move on. When Jonas lost the land on which he farmed tobacco, they ended up in a neighboring town, Brogden, living in a dormitory for young female teachers, where Ava's mother cooked and cleaned, and her father sharecropped nearby. On summer break from school, Ava would help her father harvest tobacco plants. Jonas died before Ava graduated from high school, before he could see his daughter labelled "Most Beautiful" in the senior class superlative derby.

For months after graduation, Ava looked for a job, but the economy in small-town North Carolina at the tail end of the Depression was not exactly thriving. In 1940, the seventeen-year-old got a letter from her glamorous older sister Beatrice, whom Ava always called "Bappie." Bappie was living in New York City with her second husband, a commercial photographer named Larry Tarr, and she invited Ava to come stay with her and look for work in the big city.

After she arrived, Tarr took some portraits of the beautiful teenager

for fun and hung them in the window of his photography studio. One of these photos caught the eye of Barney Duhan, who worked in the legal department of Loew's, the New York–based parent company of the Metro-Goldwyn-Mayer studio in Hollywood. Duhan inquired at Tarr's studio about the girl whose picture was hanging in his window. Ava, who hadn't found a job in New York, had long since gone home to enroll in secretarial school. Tarr told Duhan the girl had returned to North Carolina, but figuring opportunity rarely knocks twice, Larry made some prints of Ava's picture and sent them to Loew's corporate headquarters. In July 1941, Bappie called Ava and told her that MGM wanted to meet her. Ava didn't know what or where MGM was. Bappie explained, "Where Clark Gable works, baby!"

Ava scrounged together bus fare and came back to New York to see Marvin Schenck, one member of the family that ran Loew's. Based on that meeting, Schenck decided Ava was worth a screen test, although her "tarheel" accent would have to be fixed. He sent the test on to Hollywood without a sound track. By the end of the summer of 1941, Ava had been offered a seven-year contract by MGM.

This was the kind of thing girls like Ava—girls from the middle of nowhere, with no connection to show business—had been encouraged to dream about. It almost never actually happened. It rarely happened to girls as unprepared for what was in store for them, and it maybe had never happened to a girl who would become so quickly jaded with what Hollywood had to offer.

Ava Gardner would eventually catch Howard Hughes's eye, and their involvement would last for nearly two decades. But in mid-1941, while he was still struggling with how to legally reveal as much of twenty-year-old Jane Russell's body on-screen as possible, another teenage girl came into his life, and this one gave Hughes a chance to try out the captive scenario that Ginger Rogers believed she had escaped. Over the next few years, while one brunette was acting as the literal poster girl for Hughes the maverick picture producer, his personal life was preoccupied by a number of other dark-haired, very young women, so similar in vital statistics to one another (and to Jane Russell)

that they all could have been pressed out of the same mold. In collecting these near-identical women, Hughes paid little mind to the fact that each of his cookie-cutter brunettes was her own person, with her own desires, liable to make her own demands. By signing a girl to a movie contract, he could exert a modicum of control, but a modicum was not enough. As ever, Howard Hughes wanted more. He would begin to test the limits of just how much power he could wield over another person, and what kinds of lies he'd have to tell in order to do it.

FAITH DOMERGUE WAS SIGNED to Warner Bros. in March 1941 under the name "Faith Dorn," because, as she put it, "Jack Warner was too stupid to pronounce Faith Domergue." (Faith pronounced it Doh-MAYR-g.)

Born in New Orleans in 1924[1], Faith had come to California as a young child, when the Depression sent her parents looking for better fortune in the West. In early 1941, Faith was lounging with her parents at the Del Mar Beach Club, north of San Diego, when a man she didn't know approached her and said, "You are such a beautiful, beautiful young girl. You really should be in pictures." As Faith well knew, even at that age, "that line was used on everybody," but this guy meant it. The man took Faith to Zeppo Marx Inc., the talent agency that a few years earlier had been the gateway to stardom for another teenage bombshell, Lana Turner. From there agent Henry Willson brought her to Warner Bros.

Faith was, by her own description, "pretty, undisciplined, a little wild," and totally without training, and Warners wasn't going to cast

[1] As with many Hollywood actresses, there has been some misinformation circulated about Faith Domergue's age at the time of her relationship with Hughes, which Warner Bros.' studio records easily clear up. Her first pay stub at Warners states her birthdate as June 16, 1924. Her first contract with WB was drawn up on March 8, 1941. She met Howard Hughes that Memorial Day, and he bought her contract from WB on October 27, 1941. Thus, Faith was sixteen years old when she and Hughes met, and seventeen when he proposed to her and signed her to a personal contract. Warner Bros. files accessed at Warner Bros. Archives, University of Southern California.

her in anything until her raw beauty had been polished into something they could use. The studio enrolled Faith in their on-the-lot school, which combined a kind of screen actor boot camp with enough tutelage to meet state education requirements into an eight-hour day. "We studied acting and anything else that might help us in a career," Faith remembered. In her case, that included speech classes to help her overcome a slight lisp.

In her drama classes at Warners, Faith discovered what she really wanted to be. "There I met the older girls," she recalled, "young ladies who were dating top name stars, pretty actresses who were constantly in the columns and movie magazines as the hopefuls of the movie industry; intimates of a world I was just beginning to peek into."

Faith got a further peek into that world on Memorial Day, when she was invited to a boat party by another Warner Bros. contract girl, Susan Carnahan. Carnahan was one of those older girls at the studio that Faith looked up to. At age twenty, she had been on the payroll at Warners for about two years, and she had racked up half a dozen uncredited walk-ons over that time before Warners changed her last name to Peters. Soon they'd cast her as the second female in *The Big Shot*, Humphrey Bogart's last gangster picture. Not long after that, she'd marry director Richard Quine. For now, though, she was just far enough ahead of Faith that the younger girl was flattered by the invitation. She thought the day sounded "glamorous."

When Faith boarded the yacht and was introduced to her host, she observed that this man in a captain's hat "needed a haircut, wore tennis sneakers, and was holding some kind of rum drink in his hand that he never put to his lips." She didn't recognize that it was Howard Hughes, if she even knew who Howard Hughes was, but she did take note of his "beautiful dark, but kind of twinkling eyes, [which] truly seemed to light up when they rested on me."

Faith was still only sixteen, although her seventeenth birthday was less than a month away. "I looked more sophisticated," she claimed twenty years later. "And I was very, very pretty."

The party consisted of Faith, Susan, Howard, a few other contract

girls, Warner Bros. publicist Johnny Meyer, and Pat De Cicco. De Cicco had survived the scandal of his ex-wife Thelma Todd's mysterious death and had been working for Hughes for five years. De Cicco claimed he had served as an advisor to Hughes in the movie business during the years when Hughes's movie business was basically dormant. (The only movie-related action De Cicco directly initiated for Hughes didn't work out: in 1938, when Hughes was on his round-the-world flight, De Cicco optioned Ernest Hemingway's *To Have and Have Not* for $10,000. His boss was not pleased—he thought it was too expensive—and unloaded the property on Howard Hawks.)

De Cicco was a useful man for a guy like Hughes to have on the payroll. Whether or not the rumors that he was connected to Lucky Luciano were true, as the first-generation son of immigrants from Calabria who had brought broccoli seeds from the homeland and made a killing cultivating the crop on Long Island, Pat was comfortable in moneyed situations, but he wasn't afraid to throw around his muscle. In 1937, De Cicco, his cousin Albert "Cubby" Broccoli, and actor Wallace Beery had gotten into a nightclub fistfight with a drunk comedian named Ted Healy, who died the next day. Healy's alcoholism surely contributed to his death, but many in Hollywood believed that De Cicco's fists had had something to do with it, too.

There's no documentation that suggests Hughes employed Pat for his powers of intimidation, but De Cicco's attractive, mysterious, and occasionally scary package made him endlessly alluring to women, particularly very young women, the kinds of girls that Hughes wanted to meet. This was enough for De Cicco to earn the title of "talent scout" in the Hughes organization.

After they all had lunch on the boat, Howard took Faith by the hand and asked if she'd like to go for a private sail with him on a smaller vessel. It was not really a question—Hughes didn't wait for an answer, and it was taken as a given that the invitation would not be declined. "Frankly I remember not being too excited about this," Faith recalled. She preferred not to leave the party, which would have meant leaving De Cicco, who in her eyes was "handsome, Latin-looking . . .

[and] rather my idea of what a Hollywood bachelor should be." But she didn't want to be rude to her host, so she went with Hughes, and, "true to my fears [Hughes] did not speak more than five words to me for the hour that it took us to complete the excursion."

When they returned to the yacht, Faith tried to attract De Cicco's attention, but to her chagrin, he "hardly seemed to realize I was there." What Faith eventually came to realize is that now that Hughes had shown an interest in her, no friend or colleague of his would make eyes at her again. "'The Boss' had spoken without saying a word," she wrote later, "and the silent message was simply that he liked this little girl and that was enough, more than enough for everybody."

Faith wasn't interested in Hughes, whose mostly silent fascination with her had done nothing to impress, but the next weekend she accepted his invitation on another cruise, this one an overnight excursion to Catalina. "The trip was not a success," she reported later. Hughes offered nothing of himself and made no effort to engage Faith in conversation. While his behavior was seemingly the opposite of aggressive, his persistent presence struck Faith as confusing and creepy. "Howard never forced himself, he was just silently always there next to me whenever I was around him." She spent the whole weekend longing to go home.

Within days, Hughes's wooing of Faith became fodder for gossip columns (almost certainly because Johnny Meyer, then a publicist for Warner Bros. but soon-to-be an employee of Hughes, called the columnists with tips), but in Domergue's recollection, Hughes strategically backed off for most of that summer. Perhaps sensing he was not getting anywhere with Faith himself, he sent two proxies to keep her innocently busy. One was Alex D'Arcy, the rare male actor under personal contract to Hughes, and the other was De Cicco. "It was obvious to everyone in Hollywood but me that they were carrying out 'The Boss's' wishes, keeping me busy and away from the perils of other Hollywood bachelors until I woke up to just what had happened in my life, just who this was who was so interested in me. But I did not wake up."

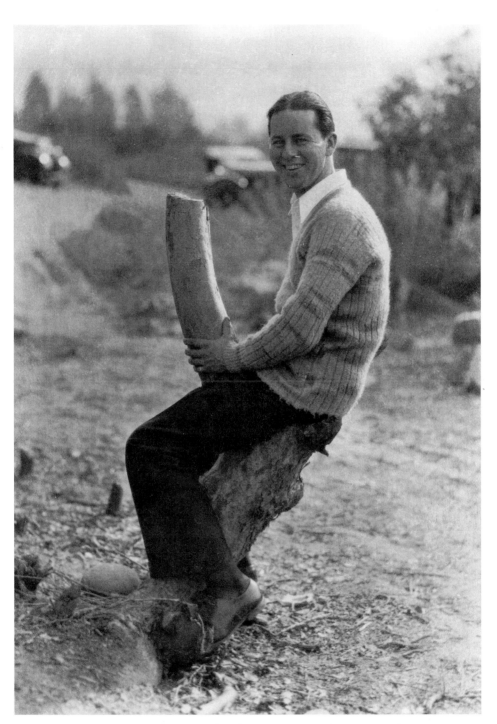

"My wife wept for hours over this thing": Ben Lyon in a personal snapshot sent to a fourteen-year-old fan in 1928. *Lincoln Quarberg papers/photographer unknown*

Jean Harlow and Ben Lyon in a publicity still for *Hell's Angels*. Harlow is wearing the evening gown that Hughes designed to turn her body into a spectacle on par with the film's airplane stunts. *John Springer Collection/ Getty Images*

RIGHT: Billie Dove in *Cock of the Air*.
Bettmann/Getty Images

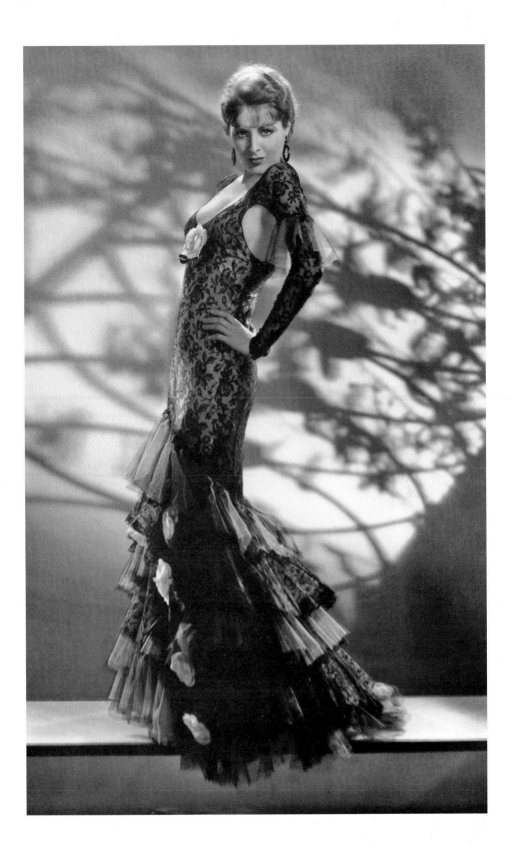

Ginger Rogers and Howard Hughes, on a date in the early 1930s.
Hulton Archive/Getty Images

An extravagantly feminized Katharine Hepburn in *A Bill of Divorcement* (1932), her film debut. *Bettmann/Getty Images*

Bette Davis met Hughes at a charity ball in 1938, shortly after his flight around the world. They then embarked on an affair that ended her first marriage. *Bettmann/Getty Images*

After countless photo shoots for *The Outlaw*, after being asked to jump on a bed in a nightgown, Jane Russell felt she had been pushed too far. *Gene Lester/Getty Images*

The photo that launched a phenomenon: Jane Russell shot by master photographer George Hurrell to promote *The Outlaw*. *Donaldson Collection/ Getty Images*

Richard Jaeckel and Terry Moore in *Come Back, Little Sheba*, for which Moore was nominated for an Oscar. *Archive Photos/Getty Images*

RIGHT: Jane Russell's costume in *The French Line* drew protests from the censors—and from Russell herself. *Silver Screen Collection/Getty Images*

Marilyn Monroe, Jean Peters, and Max Showalter on the set of *Niagara* (1953). *Sunset Boulevard/Getty Images*

RIGHT: Jean Peters and Richard Kiley in *Pickup on South Street*, a film that sexualizes domestic violence. *John Springer Collection/Getty Images*

In *The Barefoot Contessa*, Ava Gardner played a character she believed was based on herself, opposite Warren Stevens as an emotionally distant tycoon clearly modeled after Howard Hughes. *Mondadori Portfolio/Getty Images*

LEFT: Hughes and Ava Gardner in 1946, in between her marriages to Artie Shaw and Frank Sinatra. *Hulton Archive/ Getty Images*

"Legitimate widow": Terry Moore at her 1983 press conference to announce her settlement with the Hughes heirs.
Bettman/Getty Images

That summer, first De Cicco, and then Hughes, caught the eye of another beautiful brunette teenager, heiress Gloria Vanderbilt. Gloria first spotted Pat at the Beverly Hills Hotel pool, where he, agent Charlie Feldman, Fox exec Joe Schenck, and a few others who were dubbed "the Wolf Pack" met every summer afternoon to play cards. Everyone said Pat worked for Hughes, but no one knew exactly what he did. Gloria didn't care—she thought he looked like a star. "True, he wasn't much in the brain department," Gloria admitted, "but he did have a flair for gin rummy, and he was funny in his way." So while Gloria thought the scene at the pool was a bore, still she "lolled around in the sun, waiting for Pat to pay me some attention."

Pat was obligated to alert his boss to the presence of attractive "talent" in the area; before De Cicco could exercise his own prerogatives, Hughes had right of first refusal. The next thing Gloria knew, Hughes had called her mother and invited himself over to her house for tea. He told her he wanted to give her a screen test. "Me—a movie star!" Vanderbilt exclaimed. "Yes, why not!" Gloria, like so many young girls, "dreamed of fame," and Hughes's reputation for selecting young women out of thin air and turning them into stars preceded him. Vanderbilt "wanted Howard's magic wand to tap me on the shoulder."

The screen test didn't materialize, but Howard did continue to call. He and Gloria would go for long drives down the coast, making small talk and listening to the radio. These meetings often had a touch of the clandestine: a Hughes aide would pick Vanderbilt up from her house, and drop her off at Hughes's car, parked somewhere else in the neighborhood. Occasionally she was brought to the house on Muirfield Road, which she described as "a haphazardly furnished place with dust sheets over most of the furniture." As she walked through the ghostly rooms, Vanderbilt swore she heard "a recording of the 'Moonlight Sonata' playing somewhere."

Once Gloria began dating Hughes, she put De Cicco out of her mind. And then one day Pat asked her to Sunday lunch at the Beverly Hills Hotel pool.

"I said 'No,'" Vanderbilt recalled, "but it came out yes, and there

I was, back as I was before, waiting around to have Pat pay me some attention."

Hughes was furious that his underling was trying to compete with him for a girl, and decided to send De Cicco out of town to handle something for TWA, the airline in which Hughes now owned a controlling stake.

Gloria knew she should be wary of Pat. After all, "his first wife, actress Thelma Todd, had been killed in an unsolved murder, and there were rumors. . . ." And yet when Vanderbilt heard he was going to be sent away, she was surprised to find she was devastated.

Not long after, Gloria found herself on a flight to New York, the same flight as Katharine Hepburn (of course, Howard had arranged seats on the plane for both). "Hadn't Howard been in love with her?" Gloria asked herself. "How could I ever compete with someone like that?" Then in New York, she ran into Pat. He called her "Fatso" and "Stupido," and said that if she thought Howard Hughes was serious about her, she was even dumber than she looked. Gloria decided he was right. Instead of waiting for her heart to be broken by Howard, she married Pat—the guy who had convinced her she was too fat and stupid to do any better.

That summer of 1941, with the censorship situation on *The Outlaw* up in the air and romances with Domergue and Vanderbilt competing for Howard's attention, Hughes either suffered a breakdown or was willing to let various business associates think he did in order to get some breathing room. "After his close approach to a complete physical breakdown," Noah Dietrich wrote to one associate, "we finally prevailed upon Mr. Hughes to get sufficient rest and relaxation to rebuild his health." In a letter to airplane designer Sherman Fairchild, Dietrich described the breakdown as "practically a complete collapse following the completion and editing of his last picture."

If Hughes was lying low in midsummer 1941, that would explain why he missed, and failed to immediately pounce on, the arrival in Hollywood of Ava Gardner. Brought out to Los Angeles that season and set up as a standard-issue MGM contract girl, Gardner soon

learned that to be a contract girl was to be part of a system virtually rigged against her. Her contract said she would earn $50 per week (about $870 in 2017 dollars), but it also stipulated that she could be "laid off" without pay for up to fifteen weeks of the year. "So, instead of getting fifty dollars a week for the first year, it worked out at thirty-five," she recalled. With that $35, an actress was expected to be well dressed and groomed at all times, at her own expense; she also had to pay her own rent and living expenses. "That's why many of the starlets and contract players had to put out," Gardner said. "Plenty of them thought nothing of giving a little bit away when the rental was due."

Ava herself was not so pressed into such moonlighting, because soon after arriving in town, she caught the eye of the biggest star at MGM. Mickey Rooney met Ava on her first day on the lot, when the guide showing her around led her onto the set of the Rooney–Judy Garland musical *Babes on Broadway*. Mickey, dressed in drag for a Carmen Miranda–inspired number, got Ava's number. Over the weeks to come, he'd call, ask her for a date, and she'd decline. Everyone around her thought she was crazy. She spent every night at home with her sister Bappie, eating bargain hamburgers and playing cards, and her days weren't much more exciting—MGM hadn't cast her in anything yet, so she passed most of her time being made up and posing for photos. Going out with Rooney could really help her career, everyone told her, but Ava didn't think so. She had heard already of Rooney's reputation—he moved through contract girls so fast none of them had a chance to exploit his fame. Plus, he never looked down her dress—he didn't have to; he was so short that her breasts were right at his eye line. But at her sister's urging, Ava finally gave in.

At the end of their first date, Mickey Rooney asked Ava Gardner to marry him—for the first time. She'd say no twenty-five times before she said yes.

THREE MONTHS AFTER THE unpleasant Catalina cruise, Howard invited Faith to Palm Springs to join a group at his house there for

the weekend. That trip was a success, and Faith began to realize that once Howard was comfortable, he could let down his guard and show more of himself. She began going to Palm Springs to see him every weekend, and over one-on-one dinners, excursions in his seaplane, and occasional shopping sprees, "we were becoming closer and closer those months of September and October," Faith recalled. "All strain and shyness were gone and we were falling in love."

On October 19, Hughes gave Faith an engagement ring. "He turned to me and took me in his arms and in the darkness put a diamond on my engagement finger."

"I love you, Faith, I want to marry you," Hughes told her. Then, according to Faith, who would have been the only witness, Hughes proceeded to add an extremely bizarre, supposedly romantic bon mot: "You are the child I should have had."

Assuming this is not an invention or false memory on behalf of Faith Domergue, what did it mean? Presumably he wasn't referring to a real, lost opportunity. At thirty-five, Howard was old enough to be seventeen-year-old Faith's father—old enough for the pairing to seem inappropriate and creepy, especially from the vantage of today's understanding of consent and exploitation—but not so much older that it's easy to trace this comment back to an obvious event in Hughes's life. If he *had* been Faith's father, Hughes would have been seventeen when she was conceived, and when Howard was seventeen, he was attending an all-boys boarding school in the rural area of Ojai, where all reports suggest he was isolated and lonely, and spent most of his free time with a horse.

Rather than take Hughes's odd, incestuous phrasing literally and assume he regretted not siring a child when he was still a child himself, it seems like a better idea to take this comment as a sign that a switch had flipped in Howard's attitudes toward women. After more than a decade of pursuing adult, fully formed movie stars from Hollywood's highest ranks—women who were as self-possessed, independent, and powerful as a system that routinely sought to keep them under the thumb of omnipotent male moguls could be—Hughes would now

mount highly theatrical masquerades of relationships with girls so young, immature, and unformed that he would undoubtedly hold the upper hand in an enormous power imbalance. Not only would Howard's need to control Faith define their relationship, but the language they used with one another reinforced the extremely paternalistic dynamic. His pet name for her was "Little Baby," and she referred to him affectionately as her "father lover." As we'll see, Faith was not the only young woman who would use language with Hughes that suggested he encouraged her to see him as a kind of father figure with whom she was expected to have sex. Hughes didn't want to be these ladies' genetic fathers so much as he wanted to be their Father God. Faith, with no experience that would have taught her any better or any differently, thought she was the chosen one.

In some ways, with Faith, Hughes re-created the dynamic he had experienced as a child with his own supercontrolling mother, but in reverse. One of his main preoccupations was to impress on Faith his own fear of germs, dirt, and the introduction of anything foreign into his environments. He almost never bought new clothes, preferring to wear his familiar garments as long as possible and telling Faith, "Old clothes are more friendly." (They were also less likely to be recently contaminated by having been touched by strangers.) He "almost flew into a rage" when he caught Faith biting her nails, "and he used to insist many times when we were together that I wash my hands over and over again. He could not abide the thought of germs or any physical imperfection seen or unseen."

The morning after the proposal, Faith showed up at the Warner Bros. schoolhouse wearing the ring, and soon whispers of the engagement had made it into Louella Parsons's column. By the end of the month, Warner Bros. had sold Faith's contract to Hughes (technically, as Hughes didn't have an incorporated movie company at the time, to Hughes Tool). "Suddenly, within a matter of days," Faith recalled, "I and my professional and emotional destiny were completely in his hands."

He didn't officially move her into his house, but he did move her

parents into a house around the corner from the Muirfield Drive estate, so that Faith would be in arms reach every night. Faith's mom, Adabelle, was completely charmed by Hughes—the "poor woman was putty in his hands," Faith wrote. Her father, Leo, hated him, "but could not seem to do anything about it."

Domergue's description of the Muirfield house circa 1941 does Vanderbilt's Beethoven-scored mausoleum one better. The vastness of the place, its dimness and its sparse decor, "frightened me to death, and I could not bear that he leave me alone in a room for a moment." To the teenage Faith, it was truly a haunted mansion. "Many of the rooms in the house were locked," she recalled, "and there was more than one that I never entered." Those that were open were filled with the bare minimum of furniture, all musty antiques, much of it covered with drop cloths. In Howard's bedroom there were two side-by-side iron beds, and a broken airplane propeller mounted on the wall. Hughes told her it was a relic from his crash on the set of *Hell's Angels*, and when Faith asked why he kept it mounted on his wall, "he laughed and told me it served to remind him that he had the capacity to be a fool at times."

The center of the house was the den, the room where they spent the most time. There were a fireplace, comfortable sofas, and most important for Howard, a telephone hooked up to an amplifier. He'd do most of his work in the den, and in fact rarely used any of the other rooms in the thirty-room house besides his upstairs bedroom. There were wine and liquor cellars in the basement of the house, even though Howard never drank. There were five servants: a cook, a butler and his wife, a night watchman, and a maid.

It became Hughes's responsibility to make sure Faith got her high school diploma. He hired a tutor and set up a one-room schoolhouse in an office at his headquarters on Romaine Boulevard. Faith was tutored all morning, then after lunch was given speech and drama lessons, golf lessons, and sometimes a flying lesson. She was kept so busy that it took her a long time to recognize how much her life had changed, and what

being with Howard meant. "I was suddenly alone," she realized. "I had no friends any more. I was no longer allowed to drive myself; Carter, the night watchman, was promoted to the job of being my chauffeur." One of Carter's duties, according to Faith, was to "mark down every place I went during the day."

Though Hughes wanted to know everything about her, he didn't seem to want anyone to know anything about them being together. When gossip columns alerted the public that Howard had taken Faith with him on a trip to San Diego, San Francisco, and Phoenix, it gave Faith an opportunity to see how badly Hughes reacted to any mention of his name in the press other than "a filtered and authorized release by him. For the first time, but sadly hardly the last, he fell into a silence that lasted for several days after this unfortunate article appeared, and I was bewildered and did not know what to do or say." How did Howard's whereabouts make it into the newspapers without his permission? Was Faith herself reaching out to the gossips, as a desperate ploy for the attention she craved?

One morning they were in the car together, on the way to the airfield. Selfishly, more out of boredom with her new routine than any sort of fear or premonition, Faith was praying for a reprieve from her flying lesson: "I did not care what it was, if only something could occur to keep me out of the air." They stopped at a gas station, and Hughes told her he had to make a phone call. He was in the phone booth for a long time, "moving his hands as he talked in a certain way that I had learned to recognize as a sign of stress or very earnest conversation." He came back and spun the car around, away from the airfield.

"Faith, the Japanese have bombed Pearl Harbor," Hughes announced. "America will declare war before the day is over for sure, and the airfield is closed and all private craft have been grounded." Faith felt guilty for her prayers, as if they had brought on the attack—but it did free up her afternoon.

Faith spent the rest of the day on the couch, eating sandwiches and cookies while Hughes made endless phone calls. He had just built a

new aircraft plant in Culver City, specifically devoted to experimental and groundbreaking aeronautical invention. Now war contracts would dominate his business.

"From this time," Faith wrote, "we became more secluded and alone than ever." They stopped going to restaurants at night for dinner. Howard spent most every moment he was awake on the phone. All plans for Faith's stardom were put to the wayside, as moviemaking drifted far from the center of Hughes's attention.

With nothing else to keep her busy, Faith put all of her energy into decorating Howard's house for Christmas, and into planning a party that he had told her she could throw at Ciro's nightclub on New Year's Eve. Despite being betrothed to the richest man in Hollywood, it hadn't been a glamorous life for Faith thus far. She never met any stars. And while she had made a better match than any of those older girls she had looked up to at the Warner Bros. school, there was a major difference: Faith had nobody to show off to. She rarely left the house. What good was having nailed down the most eligible bachelor in town, and being able to use his expense accounts to buy whatever she wanted, if no one else could see any of it? New Year's Eve, she hoped, would change all that. "This would show Hollywood that we were together," Faith thought. This party, Faith hoped, "would change our life."

December 31 came, and Faith put on a dress that Hughes had made for her just for this occasion, by the same seamstress who made Harlow's cut-to-there gown in *Hell's Angels*. Howard's chauffeur picked her up, and she held her breath, waiting to make her entrance at Ciro's and blow the room away.

And then the driver passed Ciro's and stopped at a nondescript restaurant way down Sunset Boulevard. There Faith found Howard sitting with Johnny Meyer and Pat De Cicco and their dates.

She walked toward him in silent fury. Howard greeted her with a big smile. "Don't you think this is better than noisy Ciro's?" Faith did not. She excused herself and asked the chauffeur to take her home, and as soon as she got to her parents' house, her resolve "gave way to a really heart-breaking cry."

"So much had in my mind and heart depended on this night," she admitted. All she had wanted was "to show Hollywood that this man and I were together and to start a life a little resembling normalcy with other people in it."

Howard would make the not-unreasonable case to Faith that he had abandoned important work at his plant to have this dinner because he knew it was important to her, and that he had changed the venue because "I don't feel that I should have my name in the paper celebrating in a Hollywood night club when America is at war." Of course, that was exactly what Faith had wanted—to have their pictures in the papers, looking rich and happy and overjoyed to be celebrating their love and good fortune. She only thought about how such press would make her feel, and not about how such publicity could impact Howard's business and reputation. Howard thought of virtually nothing else.

That night, Faith gave in. She told Howard that all she cared about was being with him. Later she understood that Howard had been playing a game with her, and "his was not just a victory, it was a rout. It had taken him eight months to capture and tame me but now it was accomplished." There would be times when Hughes would let her win, but she understood quickly that these were not battles that mattered to him.

This was the night that Faith became aware of Howard's facility for a certain type of manipulation, which she called "play-acting." "He assumed attitudes which were the opposite of what he actually thought," Faith wrote, "and until a woman knew him very well it was difficult to understand which was the real emotion, and which was play-acting." From there on out, Faith Domergue's life with Howard Hughes would be a roller coaster of emotion, as the teenager desperately struggled to live with and to please a man who offered nothing but promises that she wanted to believe, in spite of mounting evidence to the contrary. She would come to feel that he got his satisfaction not out of being with her, but from successfully deceiving her.

"THE GODDAMNEDEST, UNHAPPIEST, MOST MISERABLE TIME"

Mickey Rooney finally got a "yes" out of Ava Gardner two nights after Pearl Harbor. Since their first date, Mick had proposed almost every evening, when Ava would pump the brakes as he pushed to go all the way. But this time was different. This time it felt like the world was likely to end. Saying "yes" to Mickey Rooney, Ava would claim later, "was the start of the goddamnedest, unhappiest, most miserable time I'd ever had." He gave her a massive diamond ring—and then asked for it back, so he could hock it to pay off a gambling debt.

It was the opposite of a studio-arranged marriage—MGM did not want it to happen.

"Why doesn't he fuck her?" Louis B. Mayer asked Les Peterson, Rooney's publicist. "He fucks all the others."

"He says she's holding out like no dame he's ever known, L.B."

"She ain't the fucking Virgin Mary," Mayer said.

"He says it's giving him terrible headaches," Peterson said.

"He should just boff her and get her out of my fucking hair."

In the end, MGM begrudgingly planned a depressingly small,

quickie church wedding, on January 10, 1942. Ava was not allowed to invite her out-of-town family. The couple got drunk on their wedding night and Rooney passed out before consummating the marriage. They made up for lost time the next night, engaging until dawn in what Rooney described as a "sexual symphony."

Ava still hadn't been in a movie, but her name was now in international headlines. She liked thinking about how people around the world were now wondering who she was, but being a nobody married to such a huge movie star was, as she'd later put it, "goddamn exhausting, too. Mick was so famous." When they'd go out, he'd show her off to everyone—"Look at her! Isn't she gorgeous? Isn't she going to be a huge star?"—but sometimes he'd forget to mention her name. This didn't do anything to diminish Ava's opinion of him. "We were madly in love," she would later say. "Well, we were screwing a lot." One romantic evening, Ava asked her new husband what went through his mind the first time he saw her. He didn't mince words. "I figured you were a new piece of pussy for one of the executives. The prettiest ones were usually spoken for before they even stepped off the train. I didn't give a damn. I wanted to fuck you the moment I saw you."

Having trouble getting a foothold at MGM, Ava asked publicist Peterson if there was anything Mayer liked about her. After thinking about it for a while, the publicist responded, "Well, he once told me you obviously had cunt power."

"I said, 'Am I supposed to be flattered by that, Les?'" Ava recalled. "He said, 'Well, that's just about the highest compliment L.B. can pay a girl, honey.'"

MGM had Ava taking daily dance classes and acting classes, and when there was nothing else for her to do, she'd pose for photographs. "They'd say, 'Who's got good legs and nice tits and isn't filming? Okay, Ava, you'll do; report to the stills gallery,'" she remembered. "I was always available for pinups. I was nineteen. It wasn't such a bad life, if you didn't have ambition." Ava didn't, or at least not enough to cause her to complain. "I slipped into it real easy."

Usually when a new girl with Ava's looks came to MGM, they cast

her as the romantic interest in an Andy Hardy movie. The series, in which Rooney played the titular girl-crazy scamp, had been MGM's most consistent profit center since 1937. But Mayer refused to do this with Ava, despite the fact that casting Rooney's real-life girl would have made for excellent publicity. Though coupling with Mickey had instantly made her a hot topic of every Hollywood columnist, Ava was still being used only sporadically at MGM, and only as an uncredited extra. Ava believed she was being punished for going through with the wedding that Mayer had attempted to forbid.

Like Ava, Jane Russell had been photographed like crazy, but after an initial burst of publicity, with *The Outlaw* still unreleased, magazines and newspapers had lost interest in running her photos. The original idea had been to sell Russell as a Cinderella, a penniless girl plucked out of the ether who was now supporting her whole family thanks to the genius and largesse of Howard Hughes. This wasn't exactly accurate—as Russell put it, "Little did the public know that I could barely make my car payments and eat on $50 a week, let alone support anyone"—and it was also a fairy tale that magazines weren't buying. Birdwell realized that what he needed was not more pictures, but a single picture that defined Russell as a star. So he called George Hurrell, who had established himself in the 1930s as the photographer you called when you wanted to turn an actress into an otherworldly sexual icon.

Birdwell asked Hurrell how much he'd charge for a seven-hour photo shoot, and Hurrell said $500. Birdwell said, "I'll pay you $3000 plus all costs. I'm going to deliver this girl and a load of hay and you just shoot."

Of the thousands of shots Hurrell got that day, Birdwell only needed one: a double-wide horizontal image of Russell reclining in a bed of hay, her blouse slipping off her shoulders, her head thrown back in sneering ecstasy, a pistol in her left hand, aimed at the point where her thighs touched under her skirt. Unbeknownst to most who saw this photograph in 1942, a haystack was the setting of *The Outlaw*'s rape scene.

Life magazine had agreed to run Hurrell's photo, but before they could get it into print, Jane and actress K. T. Stevens (daughter of director George Stevens) were sent with Birdwell's assistant Dale Armstrong to pose for some photos alongside some oil derricks on the Santa Barbara coast. A nearby explosion wrecked their concentration. Armstrong found a pay phone and dialed Birdwell.

"I hope you'll believe me," Armstrong told his boss. "A Japanese submarine has just surfaced off Santa Barbara and has shelled our two clients."

Before scurrying for safer ground, Armstrong had Russell pose in front of a hole created by a torpedo in the hull of a naval ship, holding a propaganda poster that originally read "A slip of a lip may sink a ship." "Sink" had been crossed out, and "may have sunk this" had been scrawled in. Dressed in a smart, high-necked shirt dress, Russell was captured with one hip jutted cockily out to the side, her right index finger pressed to her lips in a "shhhh" pose.

Birdwell was now able to call all the national photo desks and tell them that he had the first photos of the Bombardment of Ellwood, the first foreign attack on continental U.S. soil since the War of 1812. The images made front-page news nationwide and were featured in the January 26 issue of *Life*. It was hard to believe it wasn't staged, but Birdwell insisted his starlets had been in the right place at the right time by total coincidence.

And now there was a context for The Picture. Birdwell had huge enlargement prints made, sixty inches by forty. "I took a big blowup and got a sick looking G.I. to pose with it plastered on his barracks wall," Birdwell later remembered. "He was sitting there looking at Jane and knitting. He had a sweater for her half finished. This picture went all over the world."

Birdwell's accounts of working for Hughes on *The Outlaw* would give the impression that Hughes always intended for several years to pass between the announcement of *The Outlaw* and its unveiling, in order to mimic the campaign that helped make *Gone with the Wind* the biggest movie since *The Birth of a Nation*. But there were factors

in the delay that were out of Hughes's control. For one thing, Bird-well's team went looking for theaters in which to book the film in early 1942 and found a lack of enthusiasm for the movie. "General attitude from various sources is that film only fair," publicist Myer Beck cabled to Birdwell. Then, in late spring 1942, the film's original contracted distributor, 20th Century Fox, publicly backed out of its deal with Hughes after what Birdwell described as a "beef" over the publicity campaign. Fox asked Hughes's company for reimbursement of more than $35,000, which they had spent on print ads and promotional ma-terials. Hughes was contractually obligated to pay for such materials, but according to Birdwell, Hughes refused to reimburse Fox, because after his office had approved the ads in question, "so much retouch-ing had been done [by Fox] on Jane Russell that the ads were ruined." As evidence, Birdwell marked up a press book in red pen to show the places where it was evident that Fox had "changed the shape of the girl's breast, painted additions on to her shirt in various places and in general have ruined the product we are selling, namely, Jane Russell as God made her. Fox, in making these arbitrary changes, has done the same thing a manufacturer would be guilty of doing if he diluted tomato juice with water."

With Fox out of the picture, Hughes decided to book road show engagements himself, and Birdwell's team began surreptitiously going from city to city to find the most hospitable locations—that is, those that wouldn't have local censorship boards breathing down their necks.

In anticipation of her movie debut, Jane Russell had finally moved out of her family's home, and into a house in the Hollywood Hills with a girlfriend, an actress named Carol Gallagher who was also under contract to Hughes. Gallagher had romantic designs on Hughes, but she complained that on most of their dates, Hughes would just make her watch footage of *The Outlaw*. Like Jane, Carol was tall, but blond. The two went to a dressmaker and got identical outfits made, formfit-ting suits, and they'd both wear false hair down to their backs. They'd leave their sink full of dirty dishes and hit the town. "We probably

looked like a pair of hookers," Jane would later say. "But we thought we were the living end." Though she and football player Waterfield were now engaged, Jane figured that what her fiancé didn't know wouldn't hurt him.

During this time, Russell, now twenty-one, found out she was pregnant. She had lost her virginity to Waterfield on her eighteenth birthday, believing they would eventually get married, but more recently she had not been entirely faithful. She wasn't sure who the father was, and in any case, since Waterfield was preoccupied with his football career and wasn't ready to wed, having the baby wasn't an option. "I was terrified," Russell recalled. "In those days no 'nice girl' got pregnant. There was no such thing as keeping a child out of wedlock in 1942." She went to Glendale (outside of the city limits of Los Angeles, where the police had a specific squad to crack down on abortion providers), to have her pregnancy terminated.

The operation, as she put it in her autobiography, "was hell," and on the first go-round, it "didn't take." She ended up having to go through the procedure again and contracted an infection that required emergency hospitalization and weeks of outpatient treatment, her mother praying at her side all the while. (This was not an uncommon result of an illegal abortion in the 1940s; hospitals set up septic wards to treat patients who suffered infections resulting from "incomplete" abortions, a consequence faced by as many as one in three women who sought the procedure.) When she survived, Jane felt newly attached to God—and detached from Robert Waterfield, who couldn't handle sick people, and would only visit her for a few minutes at a time. She gave him back his ring and shifted her attention to actor John Payne, who had been more supportive during Jane's ordeal.

When this trading of an all-American fiancée for an older, married Hollywood boyfriend made the gossip columns in early summer 1942, Hughes called Jane in for a meeting and warned her that he didn't want her to become "one of those girls"—like, one of the girls he and his boys like Johnny Meyer, Pat De Cicco, and lawyer Greg Bautzer

traded between themselves. The sheer fact that he cared about Jane's reputation in her personal life (as opposed to the persona he was building for her to promote *The Outlaw*) meant she wasn't like those girls at all. Hughes and his male friends dated multiple women at a time, lying to them in order to get away with juggling them, with no concern for how the women would be portrayed in the press. Hughes's concern for Russell made her different. He either cared about her personally in a brotherly sort of way (which she seemed to believe), or he cared about controlling her tabloid persona.

Given the illegality of the procedure and the stigma of the pregnancy that necessitated it, and Hughes's demonstrated compulsion to micromanage his starlets, it stands to reason that Russell and her mother kept her abortion, and the traumatic aftermath, secret from Hughes and his men. But that summer, it became clear to Birdwell and his staff that something was wrong with Jane. In private memos, they discussed her frequent sick days, her begging out of rehearsals for "personal reasons," and the impact whatever was happening in her personal life was having on her appearance. On June 26, Jane's handler Dale Armstrong informed Birdwell that Russell was "under doctor's orders not to get out of bed until at least the middle of the week." A month later, Armstrong complained to Birdwell about a number of problems he was having with Jane, who "was apparently not getting proper rest as it showed in the pictures . . . she looks like hell and despite the fact I try to set the dates late in the day so she can get all possible sleep, it doesn't seem to do much good."

Armstrong seems to have had the impression that Jane was not getting enough rest because she was out partying every night. Maybe she was (Russell was never shy about the fact that she liked to party), but she was also almost certainly still recovering, emotionally and/or physically, from an illegal abortion that had made her very sick and required weeks of treatment. Not only could Jane not tell the men she worked for what was really going on with her, but even if she could have, they wouldn't have been exactly sympathetic. To them, her only

value lay in her looks. If she wasn't at 100 percent on the sex appeal scale, she wasn't worth what they were paying her.

JANE RUSSELL WAS A beautiful girl with Hollywood aspirations whom Hughes was able to find, photograph, and, eventually, turn into a star. Faith Domergue was a beautiful girl with Hollywood aspirations whom Hughes was able to find and keep within his possession without helping her ascend. Over the next twenty years, Hughes was able to play on his reputation as a star-maker, and the public knowledge of the success of girls like Russell and Jean Harlow—and to take advantage of the lack of public conversation about instances when it didn't work out like that—to subject dozens of young women to experiences that were much more like Domergue's.

Hughes had a number of aides in these pursuits. Pat De Cicco had been key to Hughes's operation, but he'd be less present as a girl wrangler after his marriage to Vanderbilt. Hughes had lured Johnny Meyer away from a job at Warner Bros., where he had been installed by Errol Flynn. (Meyer had testified at Flynn's 1934 statutory rape trial as a character witness for the defense.) The FBI, which would later take an interest in Meyer, believed he had worked as Flynn's "personal procurer"; his duties for Hughes would begin along similar lines but would expand significantly during World War II.

Later in the 1940s and into the 1950s, Hughes's key lieutenant would be Walter Kane. There was no love lost between Kane and some of the women in Howard's life. One of those women, actress Terry Moore, said she and other Hughes girls "hated Walter Kane, because Walter was always looking for 'talent.' I mean some of us called it pimping." When not finding new women for Hughes, Kane would deliver messages to those who were already waiting around for Hughes to pay attention to them. "Howard," said Moore, "told Walter what lies to tell us."

Kane had a legit background in talent management; he had been

business partners with Zeppo Marx in the 1930s and had been at Zeppo's agency when they signed fifteen-year-old discovery Lana Turner. Now it would be Kane's job to run interference for Hughes, signing girls with the right look to contracts, and controlling their access to the man himself. According to Kane, "Hughes didn't like just one woman, he liked thirty or so and he could choose one or two out of the group." The remaining twenty-eight or twenty-nine women would wait and wait and wait, sometimes kept busy with daily acting lessons or dancing classes or other types of instruction meant to increase their value. They all believed Hughes would make them into stars, but most of them were rarely if ever cast in anything while under contract to Hughes.

Jane Russell put a positive spin on Howard's protective operations concerning his contract actresses. After all, much of the struggle of being an aspiring starlet was removed from their lives. Hughes's girls were given free places to live, she noted, and drivers, and free coaching. "I met two who practically never heard from Howard—and were in no way mistresses—even though some wished they were," Russell wrote. Russell, even years later, was stuck in the perspective that for a woman of the 1940s–50s, it was an honor to be chosen for Hughes's payroll, even if that meant not working, or being tapped for sexual duty. She insisted that under Howard's watchful eyes, such aspirants were "being kept from the 'wolves.' That wouldn't have been a lifestyle for me—I'm much too independent. But if ever a mother wanted her little girl to be safe, this was among the safest situations in Hollywood. One could die from boredom, but not from harassment."

Faith Domergue certainly felt like she was dying of boredom, to the extent that by the spring of 1942, harassment would have felt to her like a relief. Just a few months after the New Year's Eve debacle, Howard himself was more distant than ever, but she was still under constant surveillance by the servants in his home and the men he assigned to drive her around. She was essentially in Hughes's version of protective custody.

Hughes had some good excuses for being absent. *The Outlaw* still

required his attention, but he was primarily busy with more ostensibly noble causes. The war had jump-started his manufacturing businesses. His companies and their factories produced 155 mm cannons, and struts for B-52s, and Hughes became the army's largest supplier of ammunition feed chutes and boosters. His commercial plants were transformed into assembly lines cranking out nothing but airplane parts for the armed forces. He was also awarded government contracts to produce a fleet of spy craft. Then there was the big whale: the Hercules, an innovative plane Hughes had designed with the wingspan of a football field, which would circumvent rations on steel by using wood (hence its eventual derogatory nickname: the Spruce Goose). Hughes had pacted with wealthy shipbuilder Henry Kaiser to secure the war contracts to pay for it.

Hughes was always a workaholic, long practiced in juggling multiple projects and relationships, but 1942 was the year when his overextension started to become unsustainable for anyone involved with him. Hughes himself hardly seemed to notice, and that was part of the problem. As Domergue observed, he had a very specific psychological quirk that allowed him to believe that his "chosen" projects and people "simply should go into a somnambulant state, a twilight sleep, and wake up or come to life only when he was ready to spend time with them." He was incapable of taking into consideration the fact that people—colleagues, lovers—were not machines that he could chose to use on a whim, and he was unable to understand that no one enjoyed being kept waiting for Howard Hughes to pay attention to them.

All of the waiting was getting to Faith. After the New Year's debacle, in the spring of 1942 she began to exhibit signs of depression—losing interest in her appearance, going on long walks alone, often on the golf course that abutted Hughes's home. "A golf course at night is like the surface of the moon," she later mused, "it is so devoid of people at that hour." She had a lot of time to think, and to worry.

Occasionally Domergue would find herself snooping around the Muirfield house, wandering through rooms that never seemed to get used, opening drawers. There were few that were unlocked—"Howard

went constantly around with a bunch of keys on his person, like Blue-beard," she recalled—but in one Faith found two tiny, carved wooden angels, and affectionate notes and cards, signed "From C.M. to C.M." She didn't know that these initials were code for a pair of Hughes and Katharine Hepburn's pet names for one another—"Country Mouse" and "City Mouse"—but she knew she wasn't supposed to have seen it.

Hughes would work all hours of the night, stopping only when he absolutely had to sleep. Faith would eat dinner alone at his house and then wait up for him, often until dawn. He'd make trips to San Francisco to meet with Kaiser, or to conduct other war business—or, at least, that's what he told her. And then one day in March, Louella Parsons gave Faith reason to doubt that alibi.

"Howard Hughes was introduced to Rita Hayworth at Palm Springs over the weekend," the gossip columnist wrote, "and he made no secret he considers her a beauty. . . ." A fairly innocuous item, but it was enough to send seventeen-year-old Faith into a tailspin. It only got worse. In late May, Hughes and Lana Turner were spotted at a night-club together; by June 2, Parsons wrote that Howard and Lana "are hotter than last Tuesday's temperature."

It wasn't Rita Hayworth who was the problem, or Lana Turner. The real problem was that Hughes was gaslighting Faith, telling her that what she was seeing and reading with her own two eyes was in fact an apparition. Faith would ask Howard about these items, and he would tell her she had nothing to worry about, that columnists made this stuff up. In what looks like a plant meant to appease Faith,[1] three days later Dorothy Kilgallen led her column with the "news" that "Howard Hughes' pursuit of Lana Turner has been getting nowhere fast—but fast enough to burn up Faith Dorn, his steady dream girl." Perhaps

[1] In later years, more than one gossip columnist would write about how Hughes would regularly call them and feed them stories to help advance his own agenda. See Sheilah Graham, "Chasing Howard Hughes," *Ladies' Home Journal*, July 1974; and Dorothy Manners, "Hughes Calls Always Came in Early Hours," *Los Angeles Herald-Examiner*, January 13, 1972. Manners said Hughes's requests would come with the demand, "Print it as I have told you . . . not quoting me, naturally."

buoyed by this gesture, Faith called Louella Parsons to set the record straight. "I am supposed to be engaged to him," she told the columnist, "and he certainly wasn't out with Lana Turner." In that same item, in response to Faith, Parsons acknowledged that Howard and Lana "were in a party, but he certainly was her escort, and although we hate to hurt Miss Dorn—she is a very nice young woman—we must print the news, and what Lana does, romantically and otherwise, is news." That may have been what hurt the most: after all this time spent as Howard's captive, after giving up her contract at Warner Bros. and her life to have him control her career, *nothing* Faith did was news, romantically or otherwise.

Meanwhile, the stories about Howard and Lana kept coming, and after Faith had embarrassed herself with that phone call, Parsons took pleasure in picking at her scab. In an item about how Howard was "plenty smitten" with Lana, Parsons added, "It's true the Texas millionaire and his former heart Faith Dorn were close to the altar at one time. But that is a closed chapter now."

Howard tried to appease Faith, not least by letting her watch his print of *Hell's Angels*, which he had kept vaulted since the film's release. But then one day his mood turned. He discovered that Faith had been in his drawer, and had seen his notes from Hepburn. She knew she was in trouble, because in the lecture that followed, he addressed her not as "Little Baby," but as "Faith." Howard had never been violent with her, but the sound of her given name, which he never used, felt like the back of his hand.

Devastated, she left his home in tears, went to her parents' house to pack a bag, and got in her never-used convertible (a gift from Howard, natch) and drove. Before she took off, Faith told her parents not to tell Howard or anyone who worked for him where she was going.

By the time she arrived in Palm Springs and called home, three Hughes aides had set up camp in her parents' living room. Her mom and dad sold her out, spilling what they knew about her whereabouts. Faith agreed to come back the next day, but refused to meet with Howard at home, instead insisting they meet at his office. When she

arrived, he was waiting for her with milk and cookies. This wasn't the parental gesture that it might seem—the treats were for Howard. As he laid out his case, he munched cookies all the while. "It was a small trick," Faith explained, "to confuse the thinking of the adversary." But she knew this trick too well, and this time she wasn't going to let it throw her. When she told him she couldn't have a relationship with him anymore—not like this—he explained to her that in times of war, most women were forcibly separated from the men in their lives. She was lucky, Hughes declared, that he was able to do his part for the war effort without having to leave her. She was lucky to have any relationship at all, in other words. Still, she wouldn't give. Faith wanted out.

But Howard could not accept defeat, and the meeting ended with Faith agreeing to spend a few weeks in Santa Barbara, accompanied by Hughes's driver and his maid, to clear her head before making a final decision. This was ingenious: it got rid of Faith, so that Hughes could have the freedom to do what he wanted to do without her, while keeping her totally under his control.

Domergue spent two months in Santa Barbara and then went to meet Hughes in San Francisco. They had a happy reunion and Hughes promised that this time, things would be different. He had a surprise for her, he said, "and as soon as we are both back in Los Angeles, I will show it to you, and I think it will solve the things that are upsetting you."

The surprise was a new house, a rental in Bel Air that was the opposite of the gloomy Muirfield manse in every way. "You never have to go into the Muirfield house again," Hughes told her. "I don't want to go there myself." Once they moved in, Hughes spent weeks throwing artifacts of his past into the fireplace—letters, mostly, from his mother, uncles, aunt Annette, and Ella. For the past decade and a half, maybe, he had been moving toward this moment, and now the time had come to fully erase anything of his past that he deemed less than useful in building his future. Or, maybe, it was just better to burn the evidence of a previous, more vulnerable incarnation of Hughes than to

have them festering in drawers, waiting for lonely and paranoid Faith to find them.

And their relationship did improve in Bel Air. Howard spent more nights at home with Faith, listening to classical music. He introduced Faith to Caruso and Tchaikovsky, whose Symphony No. 6 Hughes was planning to use as the score in *The Outlaw*. Hughes was now letting Faith drive herself, "even allowing me to attend a motion picture theater by myself."

This comparative peace wouldn't last long.

DIVORCE, MARRIAGE, AND RAPE FANTASY

"Nothing was ever an accident with Howard," Ava Gardner said. "He had people meeting every plane, train, and bus that arrived in Los Angeles with a pretty girl on board. He had to be the first to grab the new girl in town. It was a matter of pride for him." Once he learned that Ava Gardner existed, it must have destroyed him that Mickey Rooney had gotten to this one first.

In September 1942, after nine months of marriage, Ava left Mickey, their relationship having fallen apart amid his infidelities and her insecurities. Filing for divorce from a superstar was a huge career risk for a contract girl whose only public profile was as Mickey Rooney's wife, but she reached a point where she could no longer handle the humiliation. Mayer sent his attack dog, Eddie Mannix, to handle Ava, and she agreed to sue on grounds of incompatibility rather than adultery. She settled for $25,000 cash and a car (she could have asked for half of Rooney's net worth, which she was entitled to under state law), and Mickey let her keep a mink and some jewelry that he hadn't pawned away. In return MGM renewed her contract, upped her salary, and arranged for her to be loaned out to Poverty Row studio Monogram to appear with an over-the-hill Bela Lugosi in a cheapie called *Ghosts on*

the Loose. A year into her tenure at the studio, MGM had not yet cast her in a credited role in one of their pictures.

Howard Hughes saw a picture of Ava for the first time when he read about her divorce filing in the newspaper. Hughes allegedly took note of the news and gleefully snorted, "The little runt couldn't satisfy her." Hughes became determined to catch Ava on the rebound.

When Howard cold-called her, Gardner mistakenly thought he said his name was Howard Hawks, and she agreed to meet because she was hoping the director could cast her in a real part in a real movie. They made a date, but Hughes sent Johnny Meyer in his stead, to do reconnaissance on this new find. Ava would soon learn that "checking out girls for Howard Hughes was one of Johnny's regular chores." (His other main occupation was to lobby on behalf of Hughes in Washington, to aid the Boss in acquiring defense contracts.) Johnny was not tight-lipped about his work. "I don't know where all the bodies are buried," he told Ava. "But I do know where most of them are sleeping— and that's even better!"

Ava prattled on for twenty minutes about how excited she was to meet Howard Hawks. Finally, Meyer broke the news to her that she had the wrong Howard in mind. "They both made movies but Hughes also owned TWA, the airline," Ava remembered Meyer telling her. "That seemed to mean a lot more to Johnny than it did to me at the time." He also told her that his boss was crazy rich, and nearly deaf. He told Ava that if Howard "grinned at me like an idiot, I'd know he hadn't heard a word I'd said. Best advice about Howard anybody ever gave me."

Hughes could hear perfectly well over the electronically amplified phone he had at home, and the next day he called Ava and apologized for not making it to their date the night before. This meant that Meyer's report on Ava had been positive. Ava invited Howard over for a drink, and that started a ball rolling that she couldn't stop.

Ava didn't know a thing about Howard Hughes up to that point. "I didn't know about his reputation or his great wealth or his thing about

airplanes and jetting around the world," she would say. "I just knew that as soon as I got divorced from Mickey, Howard entered my life and I couldn't get rid of him for the next fifteen years, no matter who I was with or who I married."

Hughes often took Ava to the Players Club, the nightclub and restaurant owned by Hughes's friend the writer-director Preston Sturges, who had followed winning a Best Screenplay Oscar in 1941 for *The Great McGinty* by writing and directing an incredible run of smart comedic classics, including *Christmas in July*, *Sullivan's Travels*, and *The Lady Eve*. Howard would regularly pay Sturges to close his club for a night so that Hughes and his date could have the whole place to themselves. Though Howard hated being close enough to strangers that they might accidentally rub shoulders, he loved to dance and would pay whatever it cost to keep the band playing so they could have the floor to themselves all night.

After a while, Ava got bored with Hughes's seduction act. She "hated dancing with him," Ava said, "because he held me too tight, and he was a lousy dancer." She'd try to shock him by drinking too much and spouting profanities. It amused her that even though he hated drinking, he was so smitten with her that he'd put up with anything. She was less amused by the fact that he was constantly trying to buy her gifts—to buy *her*, essentially. The only gift that truly thrilled her was a German shepherd that Howard told Ava he picked because the dog was "as beautiful and perfect as you."

Just like Mickey, Howard started asking Ava to marry him early into their relationship, and he kept badgering her until finally one night she said yes. She may have given in because she knew they couldn't actually do anything about it for months, until the year had passed that made a California divorce final. Hughes told Ava that there was no reason to wait—he could take her to Vegas, where she'd get her divorce in just six weeks, but when Ava went to Louis B. Mayer to ask permission to divorce Rooney faster, the mogul refused. "Wait the year, show some respect to Mickey!" Mayer said.

Forced into stasis with Ava, Hughes had time to ease his relationship with Faith onto an off-ramp. Instead he continued to require total devotion and obedience from the teenager, and turned his attention on bringing another long-strung-along project out of mothballs: he set a date (February 5, 1943) and a location (San Francisco) for the premiere of *The Outlaw*.

After Fox backed out of its distribution deal, Hughes had put Birdwell to work planning a road show tour of the movie. Road shows were an attractive release strategy for distributors of high-budget films, because each "exclusive" engagement helped create publicity for the next city. Plus, you could charge higher ticket prices—but it was customary to give customers something extra for their money, especially if the movie itself wasn't exactly an epic. Hughes knew he needed to present some kind of live entertainment before screenings of *The Outlaw*, and, according to Jane, "some idiot convinced Howard that an added scene done 'in person' was the answer." So Jules Furthman wrote a new scene between Billy and Rio, and novice performers Jack Beutel and Russell rehearsed it every day at Goldwyn Studios, under the screenwriter's direction. These run-throughs began during the summer (when Jane was noticeably unwell) and were still going on in early November, when Hughes, who was largely absent from the rehearsals, suddenly decided that the preshow needed an out-of-town test run ASAP.

Birdwell's aides thought the abrupt urgency to get this ball rolling was inexplicable, except for the fact that the Boss had mentioned that Jane "was getting impatient." She had been doing press for the same movie for three years, with Hughes keeping her occupied so that she couldn't make another movie. Her career was totally in his hands, but his plans were as dependent on her as she was on him. Hughes's entire marketing strategy for *The Outlaw* depended on Jane being available to pose for photos and to show up at public events so that oglers could see the assets for themselves. If Jane got so fed up that she refused to do these things—or, should she, say, run away and get married, breaching her contract and ditching the prospect of stardom for matrimony

and motherhood—Hughes would have been at a total loss. *Hell's Angels* had had aviation feats to promote; *Scarface* had a righteous battle with the censors. *The Outlaw* lacked a similar hook to fire Hughes's imagination, and without one, Howard put all of his eggs in the breast basket.

The first weekend of December, Beutel and Russell were sent to Tucson to dress-rehearse the act in a place where the Hollywood trade press probably wouldn't find them. It did not go well. "Production is inadequate," reported Birdwell's man on the scene, "and Russell, for some reason or other, does not look good on the stage. All the qualities apparent in photographs are lost in the theater."

Nonetheless, they pushed forward to February. Billboards were put up around San Francisco to herald the premiere, featuring enormous blowups of the Hurrell haystack image, along with captions branding Russell as "mean, moody and magnificent," and boldly promising that, unlike other wartime commodities, "Sex has not been rationed." Newspaper reports forwarded Birdwell's inaccurate insinuations that *The Outlaw* had been denied a Production Code seal of approval because Hughes refused to shave down the Code-breaking sex within.

The Outlaw was booked at the Geary Theater for nine weeks. The prescreening one-scene stage play proved to be a disaster ("the papers crucified us," wrote Jane). It was dropped, but Russell and Beutel would still appear onstage with comedian Frank Mc Hugh, giving him lines to set up his punch lines. They did shows all day and night, before each screening of the movie, and usually to packed houses. After the late-night show, they'd go back to the hotel and booze deep into the night, then get up the next day and do it again.

The early reviews of *The Outlaw* were the definition of mixed. Some of the columnists who had taken advantage of Hughes's hospitality tried to find a bright side. Jimmie Fidler, who in 1951 would call *The Outlaw* "one of the most ludicrously inept pieces of cinematic trash ever screened," in 1943 called the movie "good entertainment" and begged his readers not to backlash against Jane Russell. "Jane had nothing to

do with the long delay in releasing her one and only picture," Fidler wrote, before forwarding Birdwell's line that *The Outlaw* "was held up by censorship problems" and that Hughes had "started the publicity wheels rolling in good faith."

But when Domergue arrived for a visit, Howard was furious about the bad reviews, particularly a takedown in *Time* that took personal shots at him. In addition to calling *The Outlaw* "a strong candidate for the flopperoo of all time," the story included behind-the-scenes details too pointed and accurate to come from Birdwell's spin, such as Hughes's habit of calling his collaborators at all hours of the night to engage in conversations that absolutely could have waited until after dawn. Jane's character was dismissed as "a half-breed moron." Most cruelly, the unsigned *Times* piece revealed that the bought-and-paid-for press corps had laughed in derision during the screening, and then explained why no one else in attendance had reported as viciously. "The critics hedged their bets a little," the anonymous *Time* critic wrote, "[because] they know that many a bad picture has been profitable."

The reviews inspired Howard to tinker with the cut of the film. Over the course of the nine-week run, he was constantly flying back and forth between San Francisco and Los Angeles, sometimes hand-carrying newly edited prints. One of his visits to San Francisco coincided with the arrival of Jane's aunt Ernestine, who was livid over the billboards featuring supine Russell. She insisted on confronting the man responsible for the imagery. "You're selling my niece as though she were some cheap stripper," Aunt Ernie declared to Hughes, "and I don't think that's right." Hughes didn't disagree, but instead protested, "I can't very well sell her like Shirley Temple."

Aunt Ernestine was not the only woman of faith who was concerned. On February 16, the Legion of Decency condemned *The Outlaw*, making it a moral crime for any Catholic to see it. This reignited the interest of the Hays Office. The censors, suddenly aware of the fact that Hughes had been reediting the movie, said that they would have to review the new cut in order to determine whether *The Outlaw*

could keep its seal. They also suggested that this was an opportunity to placate the Legion of Decency by bringing them into the editorial process. Hughes refused to do that.

For months Joseph Breen and members of his office continued to try to convince Hughes to cut portions of the film. This was an extraordinary thing for the censors to do regarding a movie to which they had already given a pass, and it happened only because the ongoing public conversation about *The Outlaw* and Russell—much of it from people who had only seen advertising and not the actual movie—made the censorship board look foolish and impotent. A rhetorical question hung in the air: why had the board employed to clean up movie screens given their seal of approval to something so supposedly filthy?

It's impossible to watch *The Outlaw* today without knowledge of how it was perceived in the 1940s, amid the public debate about "decency" and in the context of Hughes's idiosyncratic persona within Hollywood, and the country as a whole. But with distance, it's easier to see the ways in which *The Outlaw* was the first of its kind. "There had never been what you might call a sexy or bosomy western," noted one of Hughes's biographers, Albert Gerber. Russell, as seen on-screen but really as depicted in *The Outlaw*'s advertising, invented a certain kind of genre film femme fatale: a weapon-toting sexpot in a man's world, setting the template for action heroines who would populate exploitation films for the next three decades, and then bubble up to the mainstream in the blockbuster era. And Hughes's few directorial flourishes are startlingly unusual, almost avant-garde. At one point the camera assumes the point of view of Jack Beutel's Billy the Kid as Russell moves in for a kiss—and holds as the actress essentially French-kisses the lens. Hughes also takes to absurd lengths the Code-era tools of "meaningful holds" and dissolves, to imply that sex is about to happen or happening off frame.

But the thing that remains shocking about *The Outlaw* is not its creativity (which is limited), nor the exploitation of Jane Russell's body, nor anything that was articulated as criticism of the film in the 1940s. What's truly shocking is the way it lays bare Hughes's person-

ality, and what he thought was sexy. Russell's persona as put forth by
the film's marketing, summed up by the tagline "mean, moody and
magnificent," marked Rio as the opposite of the previous generation of
bombshells embodied by post–*Hell's Angels* Jean Harlow, or the then-
rising pinups like Betty Grable. Harlow or Grable were sexual with a
smile. In the Hurrell photographs, Jane's body, clad in easy-to-remove
rags and languid in repose, said "yes," or "you can have this," but the
snarl on her face said "no." Not just "no," but, "You're disgusting and I
don't want to fuck you." At the core of *The Outlaw*, and the centerpiece
of its marketing, was a rape fantasy. This publicity inspired men to
think about having sex with a woman who didn't want them, and then
the movie dramatized it, with Billy violently forcing himself on Rio.
Though the assault happens in shadow, there's little ambiguity about
what's occurring, especially after Rio squeals, "Let me go!" and Billy
responds by telling her that if she doesn't stop struggling, "you're not
going to have much dress left."

Chillingly, Billy shows no remorse for treating Rio this way—
for the rest of the film, he, and she, behave as though he did nothing
wrong. The next time we see Rio, she is roped into nursing Billy back
to health after he's shot by Pat Garrett. Before Billy pinned her down
in the hayloft, she wanted to kill him. Now, when he's delivered to her
home and tucked into her bed half dead, she snaps into maternal mode,
eventually removing her shoes and stockings and announcing her in-
tention to use her body to make sure he doesn't die of "chill." When
that works, she confides in Doc Holliday (Walter Huston) that she and
Billy are now "married," but Billy doesn't know because he's uncon-
scious. This doesn't stop Doc and Billy from jovially using Rio as a
trading chip—which also doesn't ultimately prevent her from begging
for Billy to "give it" to her, or jumping with glee onto the back of his
horse so that they can ride off together into the sunset.

The rape fantasy depicted in *The Outlaw* suggested that a man could
force himself on a tough, domineering, self-sufficient woman and
with that act of sexual violence, tame her and turn her into his lov-
ing slave. It's the ultimate dramatization of a man negating a woman's

personhood by using sex as a power tool. This is opposed to *Hell's Angels*, in which Harlow uses men as her playthings and comes out unscathed; she was the villain of the picture, but a villain whom audiences loved better than the movie's actual heroes. Hughes's shifting of the sexual power dynamic back to favoring his gender not only reflected his own sexual modus operandi, but also anticipated a coming evolution in sexual politics in the larger culture. After World War II, many of the women who had become self-sufficient in the absence of men would be returning to their prewar status of subordination—willingly or otherwise. (Because *The Outlaw*, as we'll see, did not reach wide release until after the war was over, it managed to mirror postwar sexual politics just as Harlow's character in *Hell's Angels*, though a creature of World War I, was received as a symbol of postwar hedonism.)

In the years since she had started this job, Russell's agent's business had been acquired by MCA, the most powerful agency of its era, and even before they saw the film, MCA was worried that her ties to Hughes and his dirty movie would bring down her market value. None of the postpremiere press changed their minds, so in the middle of the nine-week San Francisco run, MCA superagent Lew Wasserman came calling. Russell was still getting paid just fifty dollars a week per her original contract with Hughes (a quarter of what he paid Jean Harlow almost fifteen years earlier), and now Howard was trying to get Jane to commit to a nationwide tour. Wasserman told her that she didn't need to obey Hughes's every order.

Wasserman had in his mind a legal wrangle that would put the man he saw as an uppity upstart in his place, but the agent framed his machinations as concern for Jane. "Hughes is exploiting you," Wasserman said. He advised her to leave San Francisco and go and get married to Bob Waterfield, with whom she had reconciled. The mega-agent even loaned the couple his car to drive to Vegas in.

Wasserman's plan was to withhold Jane's services until Hughes capitulated to his demands, and to sue if necessary. But Jane didn't get the memo about the ulterior motive. She told one of Hughes's aides she was leaving and that she wasn't coming back. They warned her

that if she left, her contract would be suspended, and they success-
fully pressured her to sign a document barring her from working for
anyone but Howard. Russell didn't understand what she was doing at
the time, but with that single signature, she had both essentially guar-
anteed that Howard Hughes would control the rest of her career, and
deprived Lew Wasserman of the chance to undercut Hughes on behalf
of every mogul in town who couldn't stand him. However, Wasserman
had succeeded in stymying Hughes's efforts to release the film: with his
marketing hook unavailable, after the end of the San Francisco run,
instead of opening *The Outlaw* in other cities, as would have been cus-
tomary with a road show, Hughes put the movie on the shelf, delaying
its release until he was struck with new inspiration.

Marriage had always been, for Jane, the goal of dating Robert; the
imagined benefits of matrimony were the prize she kept her eyes on
when the relationship was not exactly living up to her romantic dreams.
From the moment they first became intimate, according to Jane, "I was
his obsession, and I was to obey his rules." She chafed under his con-
trol, but in San Francisco, working so many shows a day, she had been
"dying of unhappiness," and though Waterfield was still somewhat
reluctant to pull the trigger, with two months to go before her twenty-
second birthday, she got him to the altar.

Very shortly after the marriage, Waterfield was shipped off to
Georgia for military training. Husband and wife spent their honey-
moon on a bus and moved into a room in a house with three other cou-
ples. Because Hughes had ceased paying her salary when she left to get
married, Jane got a job at a beauty parlor in Columbus, Georgia, where
she did makeup for thirty dollars a week. She also worked in the local
bond office but got fired for being terrible at bookkeeping. Nobody in
the community around the base knew that Jane was an actress, and if
anyone in the military village had recognized the young Mrs. Water-
field in a locker-room pinup, nobody mentioned it. Jane herself wasn't
talking. "I didn't feel like admitting I was the girl whose bosom was
splashed on every billboard."

Such was married life during wartime. Russell was lucky that she

got to be near her husband, even if it meant putting her career on hold. Not that anything would have necessarily been happening in her career if she had stayed home.

Hughes's other brunette under contract, Faith Domergue, was not working, and not happy. The magic spell of the move to Bel Air had slowly dissipated. Faith was starting to suspect that Howard was back to his old ways in early spring, when she walked in on him talking on the phone just as he was saying good-bye to another "little baby."

Faith and Howard locked eyes. She was speechless, absolutely stunned that Howard would use "the same words, the same nickname he used with me. He looked so startled, so helplessly guilty, that I almost felt sorry for him."

But not quite. She yelled, she ran down the stairs, she was going to leave, for good—and then before she knew what was happening, Howard had her car keys in his hand. They would talk about this later, he said, "but you're not about to get into your little red car and go running off."

He left her standing in his bedroom, in shock. "And then," Faith recalled, "the real consequences of leaving him started to dawn on me as my temper cooled off."

Hughes had still not done anything to cast Faith in a movie, but she was technically under contract to him, so she wouldn't be able to work for anyone else without his permission. And she was not the only Domergue whose financial security was dependent on Hughes—her father and grandfather were now working at Hughes factories. "The more I considered the situation, the more I felt trapped," Faith wrote. Hughes promised her, "There is no one else but you." She didn't believe him, and she did not leave.

The two settled back into a routine. One night, when Hughes told her he had business meetings, Faith went out to see a movie. Howard promised to call her at midnight. Around eleven thirty, Faith was driving home when she noticed Howard's car. Howard was driving. In the passenger seat was Ava Gardner.

By this point, Howard had been seeing Ava for months. Ava be-

lieved the reason she and Howard hadn't married was that she wasn't yet officially divorced (although over time she would realize that she didn't love Howard, and didn't want to marry him). Faith didn't know why she and Howard hadn't married—she had heard a number of excuses, and she didn't know what to believe. These parallel romances couldn't have both gone on forever, but fate had conspired to put both of Howard's brunette paramours on Third Street, heading west at the same time, on the same night.

Howard saw Faith and sped up, trying to lose her. It didn't work. He drove into the Farmers Market parking lot on Third and Fairfax, and Faith followed. Howard stopped. Faith did not. She rammed her little red car into the passenger side of Howard's big black Buick.

"Poor little Ava seemed to bounce up and down in her seat like a yoyo," Faith observed, but she insisted she wasn't mad at or trying to hurt the other woman. "My quarrel was with him."

Faith and Howard met in front of the smashed cars. She slapped him with her right hand, and he grabbed her little wrist and held it. She raised her left hand to hit him on the other side, but he grabbed that arm, too.

Howard let an aide (who had been following him and Ava in his own vehicle) take care of the smashed cars, and Ava. Howard went home with Faith. That night, Faith told Howard she was through. She wanted out of her contract. She wanted her family to be set free of all obligations to Hughes. He protested. She insisted. "There is nothing left," she said. It wasn't just this girl, tonight. Faith now knew that she and Howard were "never going to get married." Finally, she accepted that they were "never going to build a life together, and there are no more hopes that the situation will get better later." She told him, "I can't live your life. If I go on now, I will die."

Howard let her go that night, but the next morning, the phone calls to her mother began. Mrs. Domergue was quickly and easily manipulated into service. She convinced Faith to give Howard another chance. Howard had promised to move Faith and her parents into a brand-new house, staffed with his servants. Surely by now Faith's mother realized

that Hughes's servants functioned as spies for the Boss, but she apparently didn't think this was a problem—or perhaps she was so attracted to the financial benefits that Hughes was dangling that she didn't care. Taking Hughes's side, she told her daughter, "This man really loves you."

So Faith went back to Howard, again. This time, as she later wrote, "I trusted him not at all." Hughes was as secretive as ever, but by now Faith knew all of his tells for when he was playing her. She found messages from other women in wastebaskets, and lipstick-stained cigarette butts in Howard's car. It was like he was playing a diabolical psychological game, telling Faith she was imagining his infidelities while purposely leaving evidence everywhere for her to see.

"There were few moments of pleasure between us," she recalled, "and many arguments and accusations on my part, always ending with my saying, 'I don't want to be with you.'"

Just as Russell's impatience may have pushed Hughes to finally premiere *The Outlaw*, perhaps Faith's insolence moved him to finally do something about her career. Hughes was on the verge of signing a production partnership with Preston Sturges, and he began sending Faith to Sturges's office every day to practice scenes that she'd eventually perform in a screen test. Something odd happened there one day. Jules Furthman came in to say hello. Sturges stepped out for a moment, and Furthman leaned in to Faith and said, "You know Howard hates women, don't you?" By now, she certainly suspected as much.

Faith stayed home the weekend in May that Howard flew to Nevada to test fly his Sikorsky S-43 seaplane. The Sikorsky was Hughes's baby, his favorite aircraft and one that allowed him to take pride in his own ingenuity. "It was the very first amphibian with flush riveting, an idea that Howard had been responsible for applying to aircraft, and it had a lot of other special features built to Howard's specifications," explained Joe Petrali, who would be one of Howard's closest aides in the coming months. Hughes had personally overseen the construction of the Sikorsky, and when it came time to test-fly it, he was eager to show it off.

Hughes had placated Ava Gardner after the car crash by sending her and her sister Bappie to Mexico with his aide Charlie Guest. By the time they returned to Los Angeles, Bappie and Guest were having an affair, which worked out well for Hughes—he now had a sleepover spy in Ava's house.

Hughes dropped Ava and Bappie off in Las Vegas, where they would wait while he completed the test flight at Lake Mead. Back in California, Faith spent the morning swimming and took a call from Hughes's mechanic, who told her that Howard would be in touch with her later—he was busy with a Civil Aeronautics Agency inspector who was going to go up in the plane with him.

The call came through at twilight, and it came from a pay phone in Boulder City.

"Faith, I'm all right," he told her, choking on tears. "I'm all right. Do not get worried when you hear the news. I'm not hurt." Then he hung up.

He offered a few more details in his call to Ava. "I want you to know I just killed a couple of my guys," he told her. "But don't worry, kid, I'm going to be okay."

Hughes had gone up in the S-43 with William Cline, an inspector from the aeronautics administration; another CAA inspector, Charles Von Rosenberg, who acted as copilot; mechanic Richard Felt; and Gene Blandford, a Hughes engineer. The plane took off and circled Hoover Dam three times without incident. For most of the flight, Hughes had been sitting in the rear of the aircraft, talking to Von Rosenberg, but he switched to take the controls for landing. Hughes guided the plane into a water landing on Vegas Wash. The craft hit the water and the propeller broke off, slicing through the airplane and clear through Felt's head, before knocking Cline into the water. Felt died from his head injuries. Cline's body disappeared in the confusion of the crash and was never found. The other passengers, Howard included, sustained minor injuries but were able to walk away relatively unharmed.

When Howard came home, he was so pale, Faith described him as "transparent." He believed the propeller had been meant for him.

A few days after the crash, Hughes walked into his Culver City air-craft plant with a bandage on his head. He insisted his most recent head injury wasn't serious and everyone believed him. "Now, I wonder," said Petrali in 1975. "I wonder how many of the strange things that happened in the next year or so, might have been caused, or triggered, by Howard's injury in that crash. Mental injuries as well as physical."

A week later, Ava's divorce decree from Rooney finally came through. The same day, her mother died. Hughes had paid for Mrs. Gardner's cancer treatment, but even the best care money could buy couldn't out-run what she had. In the end, Howard did the only thing he could do: he made sure Ava and her sister got on the next TWA flight to North Carolina for the funeral. Then it was back to Los Angeles, and more waiting for her career to begin.

In 1944, MGM finally gave Ava Gardner a part in one of their home-grown movies. The picture was *Three Men in White*, and it was a spin-off from the Dr. Kildare series, which had required retooling when the actor who played the doctor, Ginger Rogers's ex-husband Lew Ayres, filed as a conscientious objector and got himself fired from MGM. Never having had this many lines to speak in front of a camera, Ava called Mickey for advice. For all that had gone wrong between them, he was still the best actor Ava knew, and her career could be made or broken based on this performance.

Once they were alone in a room together, one thing led to another, and Ava and Mickey began sporadically seeing each other again. Ava—grieving her mother, bored and anxious at MGM—was also still seeing Hughes. She figured that what was good for the gander was good for the goose. After all, Hughes "was still seeing plenty of other women," Gardner acknowledged. "But that didn't stop him proposing to me all the fucking time."

DISAPPEARING ACT

Marriage proposals had become part of Hughes's courtship ritual. He counted on women to relinquish any qualms regarding premarital sex in exchange for a ring. But to Howard Hughes, an engagement ring wasn't a promise—it was a write-off, the cost of doing business.

Ava managed to cut off Howard's proposals, for marriage and for sex, until after her divorce was final. Then, she explained, "[m]y curiosity got the better of me." She wanted to test his reputation as a "cocksman." She wasn't sure what was true and what was a rumor, or a Johnny Meyer fabrication. She had heard a lot of things: that Howard was good in bed, that he was bad; that he preferred men; that he could only be satisfied by two women at a time. As Ava explained, "You got all sides of the story in the powder room."

Ava was pleasantly surprised. Hughes, she'd remember, "taught me that making love didn't always have to be rushed. 'Slow down, slow down, kid. We'll get there!' he'd say. He was like a fucking horse whisperer." When Ava complimented Howard on his sexual technique, he responded, "That's because I don't drink, kid. Especially when I'm with a lady I intend to please." Gardner enjoyed her time with Hughes, but she wasn't in love with him; she wasn't blinded by his money and she didn't believe his promises, and she saw no reason to stop seeing her ex-husband. By this point, Ava knew that Hughes was surveilling her. In addition to Charlie Guest, who was still sleeping with Ava's sister Bappie, Howard had men parked outside Gardner's house to report back to the Boss when she left and when she came home and who she

came home with. Ava knew all of this, so when she resumed sleeping with Mickey, she thought she knew enough to know how to evade Hughes's spies. She thought wrong.

It all came to a head one night when Ava refused to go with Johnny Meyer to pick Howard up from the airport. Ava refused because she had plans with Rooney, but by the time a furious Howard arrived at her home, she was asleep in bed alone. When Hughes woke her up and demanded to know where she'd been instead of at the airport, Ava told him it wasn't any of his business. "But if you want to know," she added, "I went out with Mickey."

Ava had never seen Howard angry. Now he got really angry. He swung at her, and the next thing she knew she had fallen back into a chair. Then, she recalled, Hughes "jumped at me and started to pound on my face until it was a mess."

Ava, stuck in the chair, couldn't fight back. Satisfied that he had made his point, Hughes gave up and started to walk away. Then, Ava recalled, "I looked for some weapon to attack him." She spotted an ornamental bronze bell on the mantelpiece. Knowing the partially deaf Hughes wouldn't be able to hear her coming, she followed behind him, and just as she caught up, she shouted his name. He turned, and she struck him down the front of his face, splitting his forehead open and knocking loose two teeth. Livid at what he'd done to her, Ava couldn't help but continue the beating while Howard was down. She grabbed a chair and started hitting him some more. Finally her maid walked in and put a stop to it.

"I thought I'd killed the poor bastard," Ava later said. "There was blood on the walls, on the furniture, real blood in the bloody Marys."

When it was all over, Bappie and Charlie Guest finally came downstairs, saw the condition that Hughes was in, and immediately jumped into action, calling MGM fixers, plastic surgeons, Hughes's private doctor. Ava's face was starting to bruise and the maid went to the ice box and pulled out a raw steak to stem the swelling. Otherwise, all the concern was for Hughes, not Ava. It was Ava, everyone made it

clear, who had done something wrong. Hughes faced no repercussions for punching Ava's face in.

All the fixers came and worked their magic, and once Ava's bruises faded, it was like the fight had never happened. Ava was made to feel like she was lucky to be at a studio like MGM that would help to hide that she did a bad, bad thing. But Ava had no regrets, and she didn't forget. Though Bappie never stopped telling Ava that she should have married Howard ("If she could have sold me to him," Ava said of her sister, "she would have"), as far as Ava was concerned, she and Howard Hughes were through.

PRESTON STURGES WAS A brilliant filmmaker who wrote memorable roles for a number of actresses. Barbara Stanwyck in *The Lady Eve*, Veronica Lake in *Sullivan's Travels*, Claudette Colbert in *The Palm Beach Story*—these were some of the feistiest women onscreen of their era. In real life, Sturges was less interested in female autonomy. Eddie Bracken, an actor who was part of the unofficial repertory company from which Sturges cast his films, was once asked how Sturges saw women. He answered with one word: "Slaves."

In February 1944, Hughes and Sturges made a joint statement that they were collaborating to form a new independent production company called California Pictures, or Cal-Pix. The idea was that Sturges would have creative control and Hughes would foot the bill. "I can't devote any time whatsoever to the motion picture business until the war is over," Hughes declared. Sturges was, Hughes said, the "one man in whom I have complete confidence . . . to carry on this business without any attention on my part."

It was agreed that Sturges would finally give Faith her screen debut, in a film based on the novella *Columba*, by Prosper Mérimée. But first, Sturges would get to make a passion project, a Hollywood-set comedy with a role for his own mistress, Frances Ramsden, and starring a childhood idol of his, silent comedian Harold Lloyd. Sturges

finished his script adaptation of *Columba* in July 1945, and he believed it was the best thing he had ever written. James Mason, a star in Britain who was looking for a vehicle in which to make his Hollywood debut, was interested in costarring, but Hughes wouldn't agree to pay the salary he or any other legitimate name commanded. Meanwhile, Sturges's attention was divided between the Domergue vehicle and his dream project, now called *The Sin of Harold Diddlebock*. Due to delays over Sturges's contract, his difficulty getting in touch with Hughes to confirm expenditures like Lloyd's contract, and the struggle to produce a movie without ties to a conventional studio, *Diddlebock* did not begin shooting until September 1945, and wouldn't wrap until January. Then, in the middle of postproduction, Sturges's wife, Louise, got fed up with the Ramsden affair and very publicly filed for divorce. Sturges put aside all work to deal with the chaos of his personal life, and Faith and her career were asked to hurry up and wait once again.

BY LATE 1944, HOWARD Hughes's attentions were divided among his war contracts; the management of TWA; *The Outlaw*, which Hughes couldn't decide what to do with; and his girlfriends.

And then, things started to get weird.

That fall, Hughes had started exhibiting the kind of behavior, the obsessive-compulsive tics and the apparent confusion, that would come to define his legacy in the public imagination as much or more than his aviation accomplishments. On a phone call with Noah Dietrich, Hughes repeated the same sentence thirty-three times. When Noah asked him what was going on, Hughes seemed totally unaware that he had been caught in this loop. He went to see a doctor the next day, and the doctor told him he must take some time off, get away from it all, and try to avoid stress. Hughes followed those doctor's orders in the most Howard Hughes way possible.

Hughes had had the wreck of the Sikorsky removed from Lake Mead and rebuilt. Joe Petrali, who was supervising the rebuilding, fielded calls from Hughes every week for three months after the job

was finished. Every week, Hughes would tell Petrali to get the plane ready for flight, but then Hughes would never show up to actually take the plane out. Finally one day Hughes did show up, and he and Petrali went up in the plane and flew for about half an hour. When they landed, Hughes told Petrali he wanted to take the Sikorsky on a trip. Petrali asked where they were going. Hughes said, "Las Vegas."

What Hughes did not tell Petrali was that they would be gone for months. During that period, Hughes would be completely AWOL— out of touch with Faith and any other women he had been involved with, and totally hands-off on all of his businesses, including the Sturges partnership and the progress of both Cal-Pix movies. For months on end, even Dietrich, who was managing Hughes's holdings in his absence, didn't know where he was.

It was not the stress-free time that the doctor had ordered. As if in an attempt to purge the demons of the crash, Hughes stubbornly returned to the cockpit of the plane he had crashed into Lake Mead. Now back in Nevada, the site of the initial Sikorsky wreck, Howard was able to fly the plane without incident for a stretch, and then, once again, he ran into trouble. Petrali believed the narrow landing gear of the plane was no match for the high desert winds.

"Howard couldn't wrestle her down," he explained. "We went bouncing and banging across the desert in that clumsy big amphibian and it was a miracle that it didn't cartwheel and break itself to pieces. We went ripping through bushes and we'd hit those big sand knolls and bounce five, ten, fifteen feet in the air and come slamming down hard enough to break a man's backbone."

While Hughes wasn't hurt, the Sikorsky again required repairs, leaving the pair temporarily grounded. Hughes and Petrali stayed in Vegas for about a week and a half before Howard announced that they were going to move on, but he ordered that they were not to give up their hotel rooms or rental cars—these things were at a premium during wartime, and he didn't want to hassle with getting more when they came back. They flew to Reno, where they stayed a week, acquiring more hotel rooms and cars, and then to Palm Springs, where they

did the same thing. They spent the next three months flying among the three cities.

"Each week we'd move on and all this time we kept nine hotel rooms and six rental cars," Petrali recalled. "Howard gave me orders not to talk to anybody about where we were or what we were doing. 'Nobody is to know where we are,' he told me. 'I don't want you to talk to anybody in Los Angeles or let anybody know what we're doing or anything about us.'" In between trips, Hughes would remain alone in his hotel room.

Around Christmas, Hughes pulled a disappearing act within his disappearing act. No one, Petrali included, knew where he was for more than a month. When he resurfaced in Vegas, where Petrali had been waiting for him, Hughes told him to get the plane ready. They flew to Shreveport, Louisiana—the site of Caddo Parish, where Hughes Sr. had launched his oil drill bit business. They checked into a hotel and at around 9 P.M., Hughes wandered out and found a deli and bought a bag of cupcakes and a bottle of milk—"one of his favorite meals," according to Petrali. It started to rain, and Hughes stood under the awning of a gas station to eat his dinner and wait out the storm.

A policeman cruised by, saw a man in a cheap suit with a few days' beard growth, and assumed he was a bum. The cop asked Hughes who he was and what he was doing there. The cop did not believe him when he said he was Howard Hughes, and Hughes didn't carry an ID. "If you are Howard Hughes," the cop asked, "have you got any money?'" Hughes reached into his pocket and pulled out a crumpled five-hundred-dollar bill. The cop arrested him for vagrancy.

Eventually the manager of a local Hughes Tool plant was pulled out of bed and brought down to the station to identify the Boss. Hughes was let go. "You Goddamned country policeman," Howard swore at the police chief on his way out the door.

Howard Hughes could not conceive that the planet of Los Angeles would keep on spinning in his absence, but it did; in fact, he missed much while he was away. In March 1945, Patterson Dial, Rupert Hughes's third wife, died in their Los Feliz home of a pill overdose.

Twenty years had passed since their marriage, and just over twenty-two years since Rupert's second wife, Adelaide, had also died via suicide. In the *Los Angeles Times* story reporting Patterson's death, Rupert acknowledged that she had been prescribed the pills to help with the anxiety she felt over her own writing. "She had intense depression when she became morose because she felt her own writing was not up to the goal she set for herself. Often she said life was a vanity, and that she could leave it any time." Later, he would pen a letter to Frances McLain Smith, a daughter of one of his cousins, in which he worried that the long, grueling hours he subjected Patterson to proofreading his own work might have led to her death: "I blame myself because it was more than she could take."

Even before leaving town, Howard had loosened his grip on Faith to the point where she was able to develop her own social life. She began hanging out with a group of bohemian neighbors, and then, while Hughes was away, her name started making it into gossip columns without association to Howard for the first time. In the summer and fall of 1945, she was seen out at the nightclub Mocambo with actor Paul Brooks; she was reported to have "discovered Jack March, the tennis pro"; she was photographed at clubs and parties sitting next to Kurt Kreuger, a German actor who regularly played Nazis. She was said to have "a new Mexican beau." Then, in January 1946, she suddenly eloped, with bandleader Teddy Stauffer. The marriage lasted just six months, but it had the effect of getting Faith out of Hughes's romantic clutches for good.

Furthermore, with Hughes out of town, Faith actually made a movie. Five years after *The Outlaw* saga began, Hughes agreed to loan out Jane Russell to star in *Young Widow*, a mess of an independent production in which producer Hunt Stromberg also cast Faith in a supporting role. Thus both of Hughes's contract brunettes made their nationwide theatrical debuts in a bomb long before it was possible for most people to see the movies that were supposed to be their carefully calibrated star-making debuts.

Over the last few months of Hughes's walkabout, he popped up

in Miami, where he reportedly took off his clothes and burned them in a friend's backyard. He vacationed in Acapulco with Cary Grant, and then returned to public life in New York City in late summer. By September his name was in the gossip columns as the new escort of Yvonne De Carlo.

Twenty years before she'd become a TV staple as Lily Munster, De Carlo was being promoted by producer Walter Wanger as "the most beautiful girl in the world," thanks to her starring role in his western, *Salome, Where She Danced*. After the release of *Salome*, De Carlo returned to her home town of Vancouver to play the big fish, restarting an old cabaret act that she had starred in before she was famous.

De Carlo looked just like the other Hughes girls of the 1940s: raven-haired, heavily lidded eyes, prominent cheekbones creating chiseled lines that pointed to a pillowy but unsmiling mouth. Her costume in *Salome* had featured a skimpy bra top over miles of bare midriff. Hughes flew up to Canada just to meet her.

De Carlo was in between sets when Johnny Meyer approached and said, "Mr. Hughes would like to meet you." Yvonne wasn't sure who "Mr. Hughes" was, but she said, "Fine." As the thirty-nine-year-old Hughes approached, twenty-two-year-old De Carlo observed that he looked "lanky, underfed, and remarkably sad." She thought, "Wow, this would be a terrific boyfriend for my aunt."

Toward the end of Hughes's nearly yearlong sojourn away from Los Angeles, he had been out flying with De Carlo when he decided to stop and call in for his messages. They landed, and Howard went inside the airport, telling Yvonne he would be back in five minutes. He was gone a lot longer than that, and Yvonne snuck out of the plane to see what was going on.

She found him, as she remembered later, "yelling on the phone . . . saying, 'You just don't give a damn. You don't give a damn.' And I thought, what's that?" She scrambled back to the plane, and when he finally returned, Hughes asked Yvonne, "Are you serious about me?" She found out later that Howard had been talking to Ava. "She had given him the go bye."

Actually, Ava had being trying to give him the "go bye" ever since the bronze bell incident, but Hughes had been very good at not taking no for an answer. Now Ava had told him that she was marrying Artie Shaw. The clarinetist and bandleader had already been divorced three times. His marriage in 1940 to nineteen-year-old Lana Turner began the night of their first date and was over long before Lana's next birthday.

In Ava's memory, when she told Howard she was marrying Shaw, he said, "Go ahead, kid, if that's what you want, but you'll regret it. It won't last five minutes. He doesn't love you—he just loves the idea of screwing you. Lana Turner didn't last five minutes, and neither will you, honey."

Ava would last slightly longer than Lana—a total of about eight months. Six months in, columnist Danton Walker claimed that the couple were "already discussing that old theme of the newlywed—marriage vs. career." One wonders what there was to discuss, given that Ava had still to make a film appearance that matched the outsize presence she had acquired in newspapers and fan magazines on the basis of being gorgeous and being married and/or involved with fascinating, rich, famous men. In any case, the debate between Ava and Artie came to a conclusion in July, when they announced their separation.

A month later came the release of *The Killers*, the first movie that made enough use of Ava to feature her sultry image prominently on the poster. It was *The Killers* that finally turned Ava Gardner into a movie star.

After a gripping opening, *The Killers* settles into a somewhat tedious detective plot. Then, thirty-eight minutes in, fighter Swede (Burt Lancaster) and his sweet, relatively plain girlfriend (Virginia Christine) go to a party that changes their lives. We see Ava first from behind, the asymmetrical strap of her black evening gown acting like an arrow, drawing our attention to her from afar. She's introduced to Swede in a shot wide enough to fit five adults; she briefly turns to him (and the camera) and looks away. He can't take his eyes off her, and when the camera moves closer to her, we see why. In a masterfully lit medium

shot, she dominates the frame, giving moviegoers their first real chance to contemplate Ava Gardner's odd, imperfect, beauty: the dimple in her chin, the puffiness in the cheeks and under the eyes. Moments later, we finally get a real close-up on Ava, and it's intense. We quickly cut away, as if the editor of the movie has taken on the persona of Swede, who's afraid of what might happen if he looks for too long. He should be afraid. Less than ten minutes of screen time later, to keep Ava's Kitty happy, Swede has turned into a petty crook and gone to prison.

The Killers would establish what would become Ava's cinematic brand: she was the feline creature whose sexual magnetism alone could cause otherwise good, and definitely weak, men, to momentarily lose their minds. In real life, Ava hadn't yet met any purely good men. In fact, the three with whom she'd had sustained relationships all treated her pretty badly. But eventually, the on-screen persona would seem to bleed into her real life.

NABBING A FEW DAYS of leave, Bob Waterfield and his wife headed home to Los Angeles. After two years as a war bride, Jane was now finally ready to embrace her infamy; demeaning and exploitative though much of the publicity surrounding *The Outlaw* had been, at least it had put her front and center, and after her time spent hidden in plain sight, tagging along with her husband, she craved that attention. So Jane went to Hughes and asked to be put back to work. Hughes had locked *The Outlaw* in a vault after the San Francisco run in the spring of 1943, but with Russell back in the fold, he'd have a partner in promotion should he decide to try to give the film a real release. Hughes agreed to take Jane back, and even gave her a cash bonus, despite the fact that Russell told him she intended to follow her husband wherever he was sent until the point he was shipped overseas.

But Waterfield wouldn't be shipped overseas. He suffered an injury playing in a football championship on the base, hurting his knee badly enough to merit an honorable discharge. When his knee healed, Waterfield accepted an offer to play pro football for the Cleveland Rams. So

Jane's career was put on hold again, and again she was thrown into another world of migrant wives. This time, at least, there was a flask passed around from wife to wife, to pass the time in the frozen bleachers at games.

In late 1945, Hughes made a deal with United Artists to finally give *The Outlaw* a national release, and he began planning what he assumed would be the final act of the film's unprecedented marketing campaign. Yvonne De Carlo remembered lounging around Hughes's room at the Town House Hotel in Los Angeles, which he had filled with advertising mock-ups. The pair would eat dinner, make love, and then while Yvonne slept, Howard would agonize over *The Outlaw*'s advertising deep into the night.

A couple of the promotional ideas Hughes came up with had the flavor of a dirty dream. Hughes had his aircraft team produce a blimp in a rounder, more breastlike shape than the standard, almost-phallic airship, emblazoned with the message that after three years, *The Outlaw* was "coming at last." Hughes also sent skywriters up above Los Angeles to draw, as *Variety* described it, "circles with dots in the middle of them under the title of the picture"—obviously meant to evoke Russell's endowments. In capturing the surprisingly (and possibly unintentionally) goofy, juvenile nature of the movie, these promotions unwittingly anticipated the farcical sexual surrealism that swirled through the counterculture of the 1960s, rising to more mainstream popular culture in the 1970s. Here, again, Hughes was a pioneer, although no one, including him, understood it at the time.

All films were required to have their advertising materials reviewed and approved by the Production Code office, which was now run by former U.S. Chamber of Commerce president Eric Johnston under the umbrella of what was now called the Motion Picture Association of America, or MPAA (sometimes shortened to just MPA, as though the "America" part was implied). Membership in the MPAA was technically voluntary, but in order to maintain a show of good faith in the "self-censorship" process that the association represented, all major studios and significant independent producers, including Hughes,

maintained their membership. As MPAA signatories, producers were expected to accept the organization's rulings on the content of their films and advertising.

Johnston's office was not accustomed to reviewing blimps, or anything as ephemeral as skywriting, but these stunts drew the office's attention to more traditional formats of advertising that Hughes had disseminated without seeking approval. Hughes placed in newspapers at least three ads that had not been, and possibly would not have been, MPAA approved. One included an illustration of Billy pouncing on Rio in a pile of hay—in essence, a cartoon of *The Outlaw*'s rape scene—under the caption, "BOLD—with primitive emotion." Another featured a caricature of Russell with the V-shaped neckline of her dress cut down almost to her waist, and the caption "Here They Are!"

What most angered the censors—and other producers and studios who had been playing by the rules of the censors—was not the vulgarity of any individual promotion, but the insistence of Hughes to brattily refuse to seek the permission that everyone else in the industry had been trained to bow down before. "The whole campaign on this picture is a disgrace to the industry," wrote 20th Century Fox's Darryl Zanuck—Hughes's friend—to Johnston's boss, Joseph Breen. Zanuck also complained that Hughes's publicity stunts made it a "hell of a time" trying to keep his own publicity men "in line."

Perhaps it was because of this concern for the rules that the ad that became the tipping point was one that claimed that despite the censorship battles over *The Outlaw*, the film was being released "as it was intended" to be seen, implying that Hughes had not made cuts demanded by the censors. On April 9, Hughes was notified that the Motion Picture Association was considering terminating his membership unless he withdrew a number of unapproved *Outlaw* ads and billboards, including the comparatively chaste ad in which the censors had been referenced. The MPAA's objection to this one really made Hughes mad. "The Hays office has no right to tell me that I cannot inform the public of something which is true and a fact," he fumed. "No criticism of MPA was included in the *Outlaw* advertising. The copy

discussing censorship was merely a factual history of the fight to show *The Outlaw* to the public, exactly as it was made."

Hughes resigned from the MPAA and filed a lawsuit against the censorship board, alleging restraint of trade. A judge threw out this case, and his opinion included some sharply worded criticism of Hughes, who was accused of filing the lawsuit merely to obtain "additional publicity and advertising on promotion of the picture."

Ten days later, a theater manager in San Francisco was arrested during a screening of *The Outlaw*, on charges of "violating a city ordinance prohibiting the showing of indecent pictures." Though the Associated Press reported on this event and its aftermath as straight news, it began to look more like a publicity stunt (or, at least, better publicity than money could buy) three weeks later when a San Francisco jury cleared the theater manager. This judge, at least, seems to have been in the Hughes tank: in his instructions to the jury, he gave remarks that could be confused for a defense attorney's closing statement. "We have seen Jane Russell," Judge Twain Michelsen pronounced. "She is an attractive specimen of American womanhood. God made her what she is. There are some fanatical persons who object to Miss Russell in a low-necked blouse. The scene is in the desert— hardly the place for woolens or furs. Life is sordid and obscene to those who find it so." According to the Associated Press write-up, "Some of the women in the courtroom hissed indignantly." Hughes then excerpted Michelsen's statement in a new, two-page ad, headlined "The censors may not like it . . . but the public does!"

This victory occasioned a new image of Russell—created and disseminated by Birdwell—as a kind of postwar godsend. He issued a press release attributing to a "biological expert" named Dr. Henry Victor Nier the notion that "after every war, the nations involved return to the feminine ideal of Ceres, goddess of fertility." Russell was the "well-endowed, fecund woman who will make the survival of the human race possible in an atomic age," and her stardom was, according to Nier via Birdwell, "a sign of the subconscious urge to bring the birth rate back to a healthy statistical average. Now women will stop foolish

dieting and other practices which make child-bearing a hazard. . . . The world must be repopulated, the birth rate must rise again."

Hughes wanted to double down on the notion of Jane Russell as the torchbearer for a new era—and a moneymaker for Hughes himself—but when he told Jane he wanted to send her on a personal appearance tour with the film, she put her foot down. She wasn't going to do silly skits or set up the vulgar jokes of B-grade comedians: she wanted to sing. Hughes told her what she wanted to hear, and then gave Preston Sturges the job of putting her in her place.

Sturges brought in a comedian friend of his who worked from a piano. His usual act was based on doing whatever he could to prevent his wife from attempting to sing. It seemed simple enough to slot Jane into the wife role, but it turned out there was a difference between some comedian's poor wife and Jane Russell. They did the act together one time for a crowd, at the first stop of the tour. Afterward, the theater manager came to Jane's dressing room and asked her if she could sing any songs, other than the single chorus she had been able to gasp out in the act. When she said she could, the theater manager sent the comedian home.

Jane sang four songs at the next show. "I felt wonderful," she recalled. "I had no nerves at all, and that was the start of my singing career." After six years in professional limbo, Jane Russell was finally allowed to show off her talents, thanks to a single theater manager refusing to tolerate a misogynistic act that ridiculed the main attraction.

By the end of April, *The Outlaw* was destroying box-office records. In a surefire sign that Hughes was getting under the skin of the collective film industry, *Photoplay* magazine once again devoted much magazine real estate to an exposé on his deplorable swerves outside the mainstream. This hit job on *The Outlaw*, like the one the same publication ran on *Hell's Angels*, paradoxically also served as a kind of love letter to Hughes himself, who was described as "a lean, towering forty-four-year-old Texan." (He was actually just forty.) Criticizing *The Outlaw* as "not deserving of notoriety," Fred R. Sammis predicted that "had this picture been released in the usual manner, it

would have run its course long before this and been quietly forgotten by those who saw it. That it is today the most widely discussed film of the year is the result of the ballyhoo and exploitation." He called foul on the Hughes camp claim that "censorship troubles" had delayed *The Outlaw*'s release, before accusing Hughes of "doing the film industry a disservice" for not being satisfied with the "comparative freedom of action" he enjoyed within the system and mounting a campaign that had "[provoked] a feeling throughout America that perhaps, after all, Hollywood does need some sort of policing."

The real problem, according to *Photoplay*, was that *The Outlaw* was not a film worth standing on principle for. "Had the *Outlaw* dealt with a great social wrong or the abuse of some human right, the fight against censorship of it would have won *Photoplay*'s immediate support," Sammis concluded. "The fact remains, after the shouting dies down, *The Outlaw* is just a semi-fictional story of an outlaw and a girl who put on the lowest cut blouse ever worn on a chilly desert night."

JANE'S STAR WAS FINALLY ascendant, but what about Faith? Finally, there was movement on that front, too. Preston Sturges had finished a rewrite on the *Columba* script. Hughes finally approved a budget, a cast, a new title—*Vendetta*—and writer-producer Sturges's hiring of Max Ophuls to direct. The film was finally ready to move forward, with a start date of August 13. That is, barring disaster.

AN AMERICAN HERO

The Fourth of July fell on a Thursday, but the party stretched through the weekend. On July 5, 1946, guests began to arrive at the house of Bill Cagney (brother of James), on the shore at Newport Beach. Jean Peters, a brand-new Fox contract girl, showed up on Friday with most of the rest of the party, and on Saturday, Howard Hughes joined them. That night, according to *Modern Screen* magazine, Jean Peters "fell in love for the first time in her life."

Hughes and Jean Peters did meet for the first time that weekend at Cagney's house, though whatever emotion Jean felt at first sight for Howard was likely overshadowed by the chaos that shortly followed. That Saturday night, Hughes, Peters, and a few other guests flew to Catalina for a satellite party. And then, Peters recalled, "Sunday he came back to his airport in Culver City to test the plane in which he crashed."

On July 7, 1946, Howard Hughes manned the controls for the inaugural test flight of the XF-11, a prototype reconnaissance plane that Hughes had designed for the U.S. government during wartime as part of a massive defense contract Hughes had been awarded in 1943. Hughes hadn't been able to deliver a single plane before the end of the war, after which the Defense Department had scaled back their order, from 101 planes to the two that were in the process of being built. As his test flight would prove, over a year after D-Day, the XF-11 still wasn't ready.

After lifting off from the Culver City airstrip and smoothly cruising at 400 mph over the Pacific Ocean, Hughes turned the plane around to return to Culver City, victorious—just as he had been during the speed trial that ended in the crash landing in the beet field, just as he had felt when first flying the Sikorsky. And, here, just like those other times, before he could get the plane safely on the ground, something went wrong. Though the instrument panel showed no malfunction, the aircraft began to drag to one side, as if a massive weight were pressing down on the right wing. Hughes couldn't figure out how to fix it in midair. He went looking for a place to make an emergency landing. A lifelong golf aficionado, he easily spotted the green rectangle of the Los Angeles Country Club golf course, just east of UCLA. Hughes steered the malfunctioning craft there, but there was not enough time.

The plane hurtled into a residential street in Beverly Hills, tearing half the roof off the home of a dentist. The bad right wing slashed through the upstairs bedroom of the dentist's next-door neighbor. Hughes's plane bounced off a third home's garage, took out a row of poplar trees, and finally crashed once and for all into the home of Lieutenant Colonel Charles E. Meyer, where it burst into flames.

Two other military men, Marine Sergeant William Lloyd Durkin and Captain James Guston, who happened to be in the area, dragged Hughes's unconscious body out of the wreckage. At the Beverly Hills Emergency Hospital, doctors examining his injuries weren't optimistic Hughes would live through the night.

In the days and weeks immediately following his hospitalization, whether or not Howard Hughes lived or died became a subject of national obsession. The *Los Angeles Times* referred to Hughes as "the 40 year-old, slightly deaf, handsome bachelor whose fortune has been estimated at $125,000,000."[1] The top half of their page one was taken up with a photo of the wreckage, the downed plane surrounded by the rubble of the neighborhood it took out. Depending on the publication,

[1] This was a lowball estimate; other sources claim Hughes was worth $520 million by the end of 1946. See Richard Hack and Jonathan Miles, "Howard Hughes: The Man Who Flew Too High," *Men's Journal*, July 2013.

Hughes himself was deemed either to be "near death" or given a "fight-ing chance of survival." He was said by some to be suffering from shock, and yet his brain was apparently working overtime. While in critical condition, and against doctor's orders, he called his secretary in and dictated tasks to her until the doctors made her leave the room.

Three days later, on July 11, Hughes's personal doctor, Verne R. Mason, briefed reporters. "Howard Hughes has suffered a turn for the worse in his fight for life," Mason announced. Hughes's left lung's inability to function was requiring full intubation, and yet, in what was described as an "amazing revelation," from his sickbed Hughes croaked out a message that he asked to be passed along to the army: "Find the rear half of the right propeller and find out what went wrong with it—I don't want this to happen to somebody else."

Every day there were new headlines about Hughes's condition—about how he had beaten the odds, about how he had woken from a coma with the design in his head for a new and improved hospital bed, which he then gave orders for one of his factories to produce. When grasping for dramatic details about the crash itself or Hughes's subse-quent condition, and coming up short, the papers put their reporters on the case of recounting the famous feminine faces seen in the hos-pital waiting room. Jane Russell was there, as was Lana Turner, to whom there were currently rumors that Hughes was engaged. Neither Russell nor Turner was admitted to see Hughes, with Lana reportedly waiting until dawn to no avail, "greatly upset and weeping."

Ultimately Hughes made a spectacular and miraculous recovery, but if his body bounced back better than anyone could have imagined, in some ways he was changed permanently by the crash. He was left with a scarred upper lip, the beginnings of a dependence on opiates that would eventually become paralyzing, and a seemingly skewed sense of his own mortality. A number of his actions over the remaining thirty years of his life—from the defiant congressional testimony he'd deliver a year later defending the work he had done for the Defense Department to his strip-mining of RKO Pictures under the cover of anti-Communism, to his increasingly compulsive collection of star-

lets, whom he'd stash away in apartments patrolled by bodyguards and spies, to his circa-1960s attempt to buy up nearly every casino in Las Vegas—would strike many observers as evidence of madness.

There may have been something else going on, too. Howard Hughes was a man whose early years were full of death: his mother died when he was sixteen and his father dropped dead two years later; four men died during the making of his directorial debut, *Hell's Angels*—and this was all by Howard's early thirties. He had now been involved in a number of plane crashes and accidents that killed others and all of which could have killed him. No wonder he emerged from the hospital and went on to act—first in his fearlessness and then in his recklessness, and finally with his total disregard for the sanctity of his own body—like a man who didn't believe he could be killed.

He could be, of course. In thirty years, he'd be dead. But in a dozen years, he'd be married.

FOR NEARLY TWENTY YEARS, Hughes had been paying men like Lincoln Quarberg and Russell Birdwell to promote a larger-than-life idea of "Howard Hughes." In 1946 and 1947, the American media, realizing that they had a homegrown folk hero in their midst, started doing that work for Hughes for free.

This new American hero was the most fascinating man in the world that nobody really knew anything intimate about, which only made him more fascinating. Magazines started filling this vacuum with write-arounds of his biography, each one reiterating the same public-record details, with a few minor variations to evince authenticity. For instance, a profile in *Cosmopolitan* claimed that in addition to being surrounded at all times in public by an entourage of "business managers, legal advisors, social secretaries, fixers interference-runners and other henchmen," Hughes had assembled "a kind of personal G-2 consisting of strategically placed hotel clerks, doormen, hat-check girls, headwaiters, telephone operators, and private secretaries all over the United States who feed him confidential information . . . allowing him

to locate anyone he wants at any time he chooses." And yet, with all these people at his fingertips, *Cosmopolitan* quoted an unnamed "associate" claiming that Hughes was "the loneliest guy in the world. He only knows himself—and I'm not too sure of that. . . . People don't mean a thing to him unless they have something he can use for himself."

Though Hughes's private life had been the subject of fascination before, now his marital status was occasioning reams of writing. "The best matrimonial catch on earth today is a tall swordfish of a man named Howard Hughes," wrote Lloyd Shearer in the August 1946 edition of *Pageant* magazine. "In a sentence, he is everything girls and their mothers dream about," Shearer swooned. "Unfortunately, they can't have him."

If any single columnist won this race to enshrine Hughes as America's most eligible (and unsnaggable) bachelor, it was Adela Rogers St. Johns, who published a three-part article about Howard's romantic history in April 1947. With beautiful full-color illustrations, St. Johns's story was the most spectacular entry in the wave of biographical ruminations on Hughes flooding print media in 1946–47. For one thing, she had the luxury of serialization. Unfolding over three weeks, her profile of Hughes used his various business and creative accomplishments as set dressing for the real question: why was it that America's most fascinating divorcé remained unremarried? Literally turning the life of this "great American" into soap opera by stretching the "mystery" over multiple pieces, St. Johns declared that Hughes's reputation notwithstanding, his interest in women "ran a bad third" to his obsessions with airplanes and movies. She took the mythmaking to the next level by threading throughout her account of Hughes's failed romances a stanza from Rudyard Kipling's poem "The Winners," the kicker of which is "He travels the fastest who travels alone." By the end of her third chapter on Hughes, his unwillingness to commit to any single woman for very long, even the ones that he seemed to truly love, was transformed from a character flaw into the cross he must bear as a uniquely American, individualist hero.

In all of this mythologizing, the women who had been linked to

Hughes in the past, and those who had appeared at the hospital while he was recovering, got a bump in their own profiles. The gorgeous brunette actress Linda Darnell was one who had made a nighttime visit while Hughes was incapacitated. Darnell had been one of several guests in Hughes's plane four months earlier when he had nonchalantly set a new coast-to-coast commercial plane record, piloting a Constellation from New York to Burbank in 9 hours, 46 minutes. Though the least famous of Hughes's hospital visitors, Darnell was considered one of the most beautiful women in Hollywood. A model turned actress, in 1946 she had not yet made her greatest films, *A Letter to Three Wives* and Sturges's *Unfaithfully Yours*. After bursting onto the scene in the early 1940s opposite Tyrone Power in *The Mark of Zorro* and *Blood and Sand*, Darnell hadn't found a role that let her establish herself as anything other than something lovely to look at. She was certainly that, though. When she attempted to visit Hughes at the hospital, the waiting photographers and reporters took delight in her low-cut purple skirt suit and chunky peep-toe slingback heels.

Darnell was married to cameraman Pev Marley, but Hughes had wooed her anyway, and recently their affair had intensified to the point where Linda believed Howard would marry her if only she were available. A week after Hughes's crash, Darnell announced she was filing for divorce.

One paper ran the announcement of Darnell's move to end her marriage alongside a photo of a young model named Norma Jeane Dougherty, who posed in a bathing suit made out of the covers of the five magazines that had borne her photo in a month's time. Lying in his hospital bed, perhaps in search of an antidote for the headache he felt coming on upon reading news of Darnell's divorce, Hughes saw Norma Jeane's photo and became inspired.[2] Aides were assigned to find the girl with the golden brown curls and beaming toothy smile and phenomenal curves.

[2] News of Darnell's divorce appeared directly beside Norma Jeane's photo in the *Town Talk* of Alexandria, Louisiana.

Norma Jeane's agent, Emmeline Snively, took the call, and was hit with her own wave of inspiration. Snively called gossip columnists Louella Parsons and Hedda Hopper to tell them that Howard Hughes had asked after her client. The first ladies of gossip diligently wrote this up, and because, since the crash, the mere mention of Hughes's name qualified as national news, Norma Jeane's name got coast-to-coast play.

Even before Hedda Hopper took the bait, blurbing Howard's interest in Norma Jeane in her July 29 column, Snively set about to use Hughes's name in a way that would actually benefit her client, getting Mrs. Dougherty a meeting with the casting director of 20th Century Fox, who in 1946 was none other than Ben Lyon, he of *Hell's Angels* and the tree branch.

The idea of snatching up a girl Howard was interested in before he could put the Hughes moves in motion intrigued Lyon, who authorized a color screen test shot by Leon Shamroy, a pioneering cinematographer who had already won three Oscars. As Norma Jeane sashayed in front of the camera in a borrowed sequined gown, behind the camera Shamroy, as he later put it, "got a cold chill. This girl had something I haven't seen since the days of silent pictures; this girl had sex on a piece of film like Jean Harlow had."

After showing the test to Fox chief Darryl Zanuck, Lyon presented Norma Jeane with a six-month contract, on the condition that they find a new name for her. Lyon told Norma Jeane that she reminded him of Marilyn Miller, a stage star of the 1920s and '30s who had appeared in a film with Lyon, had a romance with him, and had died tragically at the age of thirty-seven. Norma Jeane thought Marilyn Miller sounded lovely, but she didn't want to copy a dead actress's name to the letter. She suggested pairing Marilyn with her grandmother's maiden name: Monroe.

ONE CALLER TO THE hospital whose presence was not noticed by reporters was Jean Peters, the brunette beauty whom Hughes had met

in Catalina the weekend before the crash. She didn't visit Hughes right away—after all, she barely knew him. But once she was compelled to come see Howard, Jean Peters would swiftly enter his inner circle and then stay there for twenty-five years.

Jean had ended up in Hollywood by accident—and had stayed against her will. As a junior at the University of Ohio, she had won a beauty contest prize: a trip to Hollywood and a contract at 20th Century Fox. As she had shown virtually no interest in the contest itself, her friends were surprised when she jumped to accept the prize. Jean saw it as an opportunity to travel for free, and figured she wouldn't last long in California. "When they shove me up in front of a camera with Gary Cooper and tell me to act, it won't be more than five minutes before they give me my return ticket," she reportedly predicted. "I'll be lucky if they don't ride me out of town on a rail."

The type of contest Jean had won usually resulted in a token screen test, a thank-you-very-much, and, after a week or two, an invitation to go home. Jean shot her screen test, spent the rest of the week sightseeing, and then called the studio to ask for her return ticket. She was told that she couldn't leave town—she was under contract. But they weren't giving her anything to do, and the novelty had worn off, so after a few more weeks finally Jean decided, the hell with it, and bought herself a train ticket back to Ohio. From the station pay phone, as one version of the story goes, Jean called her handler at Fox, thanked him for everything, and told him she regrettably had to return home. Then she hung up and boarded the train. The Fox flunky then ran into studio chief Darryl Zanuck's office and demanded that he watch Peters's screen test. Zanuck reluctantly did, and when it was over, he demanded that someone track down Jean, get her off the train to Ohio, and send her back to Los Angeles.

On January 11, 1946, the *Los Angeles Times* elevated this narrative into a mythic origin story even as it was happening. Jean had gotten on the train, the *Times* reported, and then at Fox they began running her test, and when it was over, "Mr. Big took an extra puff of his cigar and said, 'Sign her.' All the little men began scrambling to find Jean,

eventually discovering to their horror that Jean, their big find, was choo-chooing eastward. Wires between Hollywood and stops along the train's route east were humming yesterday as studio officials tried to make connections with Jean. She doesn't know it yet, but she's in the movies."

The more conspiracy-minded believed that Howard Hughes, who was not technically involved in the management of 20th but was a friend of Zanuck and a major stockholder in the studio at the time, had been keeping tabs on Peters from the moment of her arrival in Hollywood, and even though they had not yet met in person, when he found out she had left town he ordered the studio to order her return.[3]

Whether he had been watching her or not, Peters had not yet appeared in a film by the time she officially met Hughes, six months later, on that post–July Fourth weekend of 1946. Her first role would come thanks to another of Hughes's dark-haired inamoratas, and another member of the 20th Century Fox contract girl roster.

Just before his XF-11 crash, Howard had called Ann Miller, actress and friend of Linda Darnell, for advice. He cared about Linda, Hughes told Ann, but he didn't want to marry her, he didn't want to marry anyone. Now Linda's husband, Pev Marley, was demanding a big payment from Hughes in order to let Linda go. Hughes had seen that movie before—he had been in it, with Irvin Willat and Billie Dove, and it hadn't turned out well. "It has sort of turned me off," Hughes told Miller.

When Hughes was released from the hospital after five weeks, he went to live at Cary Grant's house in Beverly Hills. Shortly thereafter, Darnell and Marley went to visit him. With Hughes still bedridden, Marley preemptively brought up the topic of a cash settlement, telling Hughes he'd essentially sell Darnell to him in exchange for a yearly

[3] This is implied in D. L. Lyons, "America's Richest Wife," *Ladies' Home Journal*, November 1968, and stated as fact in Peters's Reuters obituary. Steve Gorman, "Jean Peters, Ex-Wife of Howard Hughes, Dead at 73," Reuters, October 20, 2000.

stipend of $25,000 for life. This made Darnell livid. "Who the hell do you think you are?" she fumed. "You're discussing me like a ham. You can both go straight to hell."

The Darnell defection opened up a vacancy in Hughes's life, and Jean Peters began to fill it. "I would have dinner with him practically every night and run films," she remembered. When he was first released from the hospital, she remembered, "He wasn't able to get out of the bed, but later on he could sit in a wheel chair, and they set up a projection machine in the living room." Jean recalled that she saw Hughes almost daily, "from the time he was in the house until October, which is when I left to do a film in Mexico." The film Peters went to make in Mexico was *Captain from Castile*, a picture that Linda Darnell had hoped to star in for two years but was forced to abandon when Fox cast her in the epic *Forever Amber*. (Darnell got the better end of this deal: compared to *Captain from Castile*, *Forever Amber* offered a much bigger, more interesting part in a much better movie.)

In the two months between Hughes's release from the hospital and Peters's departure to make the movie, Hughes opened up about himself, speaking extraordinarily candidly about his state of mind and how he hoped to shape the rest of his life, telling Jean that he felt resigned to a destiny that filled him with self-loathing.

"He felt that it was immoral for one person to have that much money," she recalled. "But he felt that fate had decreed that in his particular case he had it." He told her that he hated being a businessman, that he would have preferred just inventing airplanes and testing them. But he couldn't stop running businesses because, as he put it, "Unfortunately, I am very good at it."

"He felt he was trapped," Jean added. Hughes would lament "how one problem led to another problem which led to another, and he found himself now with a lot of worries, commitments, properties, businesses that he got himself into, and he was very critical of himself for having permitted that to happen."

They were so close by the time she left for Mexico that when he

visited her there, Howard started talking about writing her into his will. As Hughes explained to Jean, "One of these days I am going to get into a really serious fight with someone. Knowing me, I am not going to give in and I may lose everything.

"So," he said, "I have got to make sure that you are protected."

TWO MONTHS AFTER THE crash, Hughes would get back in a cockpit, flying first to Kansas City and then to New York to argue with the MPAA, which was still threatening to revoke their seal of approval on *The Outlaw* over the unapproved advertising. Hughes operated the plane's controls himself, armed with a packed sack lunch of milk, crackers, and a turkey sandwich. "I am very tired," he told reporters. "I want to sleep as long as I can."

Making his postcrash public debut amid reporters and photographers, Hughes was said to be "sporting a Ronald Colmanesque mustache." In the photo the *Los Angeles Times* ran with their story, the mustache is thin and patchy, Hughes's eyes are dark, his hair slicked back, his mouth caught in a kind of dazed, open grin. He looks less like Ronald Colman than Vincent Price. Hughes would insist upon this facial hair for the rest of his public life as camouflage to cover the scars that now bisected his upper lip, the seam where his face was sewn back together after the crash.

Hughes was not able to change the MPAA's minds about the seal, and this meant that major theaters could decline to book the movie. But *The Outlaw* was proving to be such a draw that the lack of Code approval didn't matter to independent theaters. By the end of 1946, the film had run an astounding thirty-seven weeks consecutively in some houses, including the Los Angeles Music Hall, where it had smashed the first-run record with a gross of $607,000. Hughes's publicity machine would take to referring to *The Outlaw* as "the most popular picture of all time," which wasn't true in terms of raw box-office data—but given how effective the marketing proved to be for a full decade, it might as well have been.

THE OUTLAW, LIKE *HELL'S Angels* before it, had been so expensive to make that even as a blockbuster, it wasn't going to do much to increase Hughes's wealth—not that he needed it to. That had been accomplished by World War II, which massively stimulated business at all of his factories and allowed Hughes to obtain government funding for a number of experimental aircraft. But these projects, particularly the Hercules flying boat, were so innovative they couldn't just be cranked out on assembly lines like any old prop plane, and Hughes, as a result, had been unable to make good on some of his contracts before the war ended. Despite pocketing nearly $200 million in government subsidies to build three of these flying boats, by 1947 Hughes had only finished one. And while the Hercules represented a massive breakthrough in technology that, some have argued, made the transition into the jet age possible, it was still seen by critics as a phenomenal waste of money—not least because Hughes hadn't yet proven that it could actually fly.

As a result of his failure to finish all of the planes he had been contracted to produce, Congress began investigating Hughes's use of wartime government funds. In July 1947, news broke that subpoenas had been served to Judy Cook and Martha Goldthwaite, two "party girls" who were allegedly witnesses to—and beneficiaries of—Hughes's wastefulness. The theory was that Hughes spent at least some of the government's money to give the girls "handsome gifts" in exchange "for favors they may have bestowed on Hughes' male guests" at "lavish wartime parties." The papers whispered that more subpoenas were on the way, and that the first two girls "were small fry compared to big glamour-pusses almost sure to be called."

Though none of the contemporary news reports mentioned it, the FBI had been aware of these parties for a while. On April 20, 1945, Bureau director J. Edgar Hoover took a call from an employee of MGM Studios, whose name would be redacted from the FBI's files. This MGM employee called Hoover to tell him about a party he had attended twenty days earlier, in a suite at the Waldorf-Astoria in New York. The party's host was Howard Hughes, and the party's "favors"

would include what an FBI report would describe as "a large number of 'expensive females' who are well known around New York." Also at this party, the MGM man had spotted Julius Krug, who was then head of the War Production Board, which supervised the work done by private sector companies like Hughes's that had diverted their efforts to take government money to produce supplies for World War II.

After receiving this tip, Hoover recommended that his agency begin keeping tabs on Johnny Meyer, noting that Meyer was "reported to be a procurer for Howard Hughes and other prominent persons," and that he was "a friend of the present Mrs. Elliott Roosevelt." Elliott Roosevelt was FDR's son, and also an expert in reconnaissance who had recommended Hughes's spy planes to the air force.

Hughes, according to a different FBI document, had lured Meyer away from his position working for Warner Bros., where Meyer's "principal duties," according to the Bureau's report, "were the obtaining of girls for [Errol] Flynn and for other movie executives and producers." Hughes had hired Meyer as "public relations director of the Hughes Aircraft Corporation," but the FBI suspected that the "public" with whom Meyer managed relations was limited to so-called party girls. Several Bureau reports noted that a reliable source had told them that Meyer had "always been a pimp," while another supposedly reliable source claimed that he "deals essentially in sex and flesh is all he knows." This source stated that Meyer had the "telephone numbers of various women [organized] according to their complexion and sexual ability." The FBI didn't officially open an investigation into Hughes, but through their surveillance of Meyer, the Bureau was able to compile a composite image of Hughes "as an unstable person" who had racked up a number of "immoral associations with various movie actresses."

Coincidentally (or not), a few actresses known to have "associations" with Hughes were said to have been suspiciously unavailable when the subpoenas were served on Cook and Goldthwaite. Linda Darnell was in Europe, Lana Turner was "resting somewhere out of town," Faith Domergue "went to a play in La Jolla and kept on go-

ing to Mexico," and Ava Gardner was "working, and could not be disturbed." Johnny Meyer also "went missing." Gossip reporter Earl Wilson ran into Hughes at Mocambo and suggested to him that the actresses and Meyer "had lammed out of town to avoid subpoenas." Hughes responded, "Don't build that up."

The two subpoenaed girls spoke to the press before they could be interviewed by Congress. Cook readily reported seeing Krug and Roosevelt at Hughes's parties. Wilson went to her house and wrote a leering, mocking report, remarking extensively on her toes and noting in a parenthetical that her chest was "size 36½, no falsies." He simultaneously bashed Judy as a fame-chasing gold-digger and championed her for being a plucky girl who could take down powerful and corrupt men. He also noted that Congress was paying three hundred to five hundred dollars to transport these girls to Washington so they could testify about the windfalls they received of five to fifty dollars. "Talk about Hughes spending," the columnist punned.

Goldthwaite was less cooperative, denying she had been gifted anything at all. "I haven't got any money, I haven't got any jewelry," she insisted. "I never got a cent and I never expected any." She said she did go to a pool party at the Town House Hotel at Meyer's invitation, but she barely had any interaction with Hughes. "I think it's pretty mean of the government to make it look like those girls got paid—besides I think it's a little personal." Certainly, it looked like somebody got paid something, because according to news reports, Johnny Meyer had actually named the girls as entertainment expenses on his tax returns.

Hughes held a press conference defending the parties and the paid-for female guests, saying both were an effort "to maintain my company's competitive position" compared to other aviation outfits, and it was all "a matter of keeping the customers happy the way an automobile salesman gives you a cigar." The parties occurred after the contracts were awarded, Hughes said, and were a sign not of his profligacy, but his patriotism. "If I remember correctly," he mused, "during the war it was generally considered a privilege and an obligation to

entertain soldiers and officers returning from abroad with fine war records." He further said he had in fact delivered both the Hercules and the photographic plane, and that he had spent $7 million of his own money to complete these projects. "I have no hope of ever recouping this $7,000,000 or any of the large additional funds which I intend to put into this airplane [the Hercules]."

Congress was persuaded by the analogy between free cigars and alleged call girls, and on July 29, the *Daily News* reported that the senators "suddenly and very quietly shelved the beautiful party girl angles of the probe today." But the investigation into Hughes's war work continued, and in August Howard went to Washington to testify. In an admiring account of his performance, *Time* described Hughes as "the Hollywood playboy and planemaker, about whom the public had heard very much but actually knew very little." When Hughes entered the chambers, fifteen minutes late, "there was scattered applause and like a seasoned movie star he turned to nod to the spectators. They saw a lank, dark-mustached man in a rumpled, ill-fitting grey suit, his scrawny neck sticking out of a too-large collar."

He may have lacked professional costuming, and yet this was a Hollywood moment for Hughes, maybe more so than any he had actually had in Hollywood, at least not since the days of *Hell's Angels*. Hughes put on a captivating show with his testimony, redirecting all attention onto Senator Ralph Owen Brewster, a Republican from Maine with whom he had been engaged in a war of published words in the days leading up to the hearing. "I charge specifically," Hughes announced early in his performance, "that during a luncheon at the Mayflower Hotel in the week beginning Feb. 10, 1947, in the suite of Senator Brewster, that the Senator told me in so many words that if I would agree to merge Trans World Airline with Pan American and would go along with his community airline bill, there would be no further hearings in this matter." Pan Am was the key competitor to Hughes's TWA at the time, and Hughes believed that Brewster was collecting bribes from his rival. Brewster denied this accusation: "It sounds a little more like Hollywood than Washington," he said. When

Hughes was asked if he had any questions for Brewster, he responded, "Yes—200 to 500 of them."

Hughes was told to put said queries in writing, and the next day Hughes returned to the chamber armed with a list of dozens of things that he demanded Senator Brewster answer in open session. It was a stunt seemingly intended to win the hearts and minds of a public suspicious of their political servants as much as it was intended to clear Hughes of corporate wrongdoing. At one point, after Hughes demanded that the panel offer him equal time to defend himself and ask questions of his accusers, the audience exploded in applause, leading the embarrassed senators to request that the room be cleared—but reporters were allowed to stay.

Later Hughes read from a statement he had written out in longhand. "Nobody kicks around in this country without acquiring a reputation, good or bad," Hughes said. "I'm supposed to be capricious, a playboy, eccentric, but I don't believe I have the reputation of a liar. For 23 years nobody has questioned my word. I think my reputation in that respect meets what most Texans consider important."

After Hughes's testimony, the senators adjourned the inquiry until fall. Hughes told journalists that Senator Brewster was "too cowardly" to keep going without taking a time-out to lick his wounds.

Hughes went back to Los Angeles, flew the Hercules flying boat at a modest elevation of seventy feet for one mile, and then was called back to Washington a week later and asked to answer an allegation from Major General Bennett E. Meyers that Hughes offered to pay $250,000 to help remove New York City's ban on *The Outlaw*. According to Meyers, $150,000 was meant to be a "donation" to the Catholic Legion of Decency, which had been publicly protesting the film, and $100,000 would go to Meyers himself in exchange for acting as a go-between to get the money to the Catholics. Hughes responded that he had not made the bribe, and counteralleged that Meyers was responsible for *The Outlaw*'s troubles in New York in the first place. Meyers had been a top-level negotiator for air force procurement, and at the time that Hughes's government plane-building contracts were up for

renegotiation, Hughes claimed, the general approached the million-aire asking for various monies. After Hughes refused to give him a $200,000 "loan" or to invest in "some kind of a trick bicycle," Hughes alleged, Meyers "put a hex" on *The Outlaw* with the New York censors. Hughes said he then convinced Meyers to use his connections to various New York officials, such as then-mayor William O'Dwyer and former license commissioner Benjamin Fielding, to lift the ban on the movie. There was no financial quid pro quo, Hughes said, but he admitted he had asked Meyers to "remove the finger that I believe he had put on it." (Whether or not Hughes offered Meyers a cash bribe, his own records indicate that at some point he sent Meyers three bottles of 1918 bourbon, from Howard Sr.'s pre-Prohibition collection, with a personal note calling Bennett "Benny.")

That this investigation had now gone about as far afield from war profiteering as it could get was an unquestionable victory for Hughes. And yet it was not until May 1948 that Congress issued a statement clearing Hughes of wrongdoing. Long before that, though, his performance before Congress was declared a triumph by the media, and the portrait they painted was indelible.

"It was spectacular. It was combative. It obviously gave Mr. Hughes, despite tiresome and irritating moments, considerable pleasure," summed up the *New York Times Magazine*. Hughes was described as "a no-man in the land of yes-men, a leading contemporary example of the genus Rugged Individualist." The *Los Angeles Daily News* ran a series of photos of Hughes testifying, a couple of them under the banner, "Smooth witness Hughes never at a loss for an answer."

In these photos, Hughes looks significantly older than his actual age of forty-one; in the ten years since his round-the-world flight, he had aged from a cocksure boy into a world-weary man. But grown-up Hughes had more fans than his Richie Rich incarnation ever had. The *Daily News* also ran a photo of a smiling Hughes signing autographs for a crowd that formed at the airfield to see him off before he piloted back to Culver City. The caption read: "You'd Think He Was a Movie Star."

AMID THIS NEAR DEIFICATION, some in Hollywood started speaking out (albeit anonymously) about the Hughes they knew—the longtime thorn in their side, the scourge to their standards and practices, the promotional pervert. Complaining about Hughes's flagrantly sexual marketing of *The Outlaw*, one "prominent Hollywood figure" protested, "He isn't part of the industry, and he never has been. We've worked for years to overcome the old idea that pictures are undermining morals and that everybody connected with the business is a paroled sex criminal. I think on the whole we've done pretty well. Then along comes Hughes—an outsider—and puts out stuff that no self-respecting person in town would touch. Sure, the picture's making money. But the decent people will say 'That's Hollywood'—and we'll get it in the neck."

It was one thing to complain about an "outsider" muddying the waters that Hollywood was supposedly working so hard to keep clean. But in an industry in which the only barrier to entry for an adult white male was money, there was no way to keep Howard Hughes out. Soon enough, he would have bought his way into one of Hollywood's premier positions of power—and he'd bring his dirty mind with him.

A MOGUL
AND HIS CROWS

It figured that Howard Hughes would have to be totally incapacitated and possibly on the brink of death before Faith Domergue finally got her chance to star in a movie. The film Hughes and Preston Sturges had cooked up to showcase Faith, *Vendetta*, began shooting in August 1946, on location in the north San Fernando Valley (doubling for the "dirty jungles of Corsica," as the film's voiceover describes its setting). Hughes had signed off on the hiring of director Max Ophuls before the crash. An Austrian Jew who had fled the Nazi regime first for France and then the United States, Ophuls was a master stylist who had been inactive as a director since 1940.

But when Hughes's plane went down, Faith recalled, "We all thought Howard was going to die. There was no doubt in anyone's mind." When production began, all involved assumed Hughes would not be able to oversee it, or to intervene.

And the movie was not at the front of Hughes's mind until a few weeks after he left the hospital, when Sturges had some dailies delivered to his bedside to amuse him. Hughes was not amused. By this point Ophuls was quite a bit behind schedule. Obsessed with doing a good job, he'd fuss over details for so long that he was essentially shooting at one-third the usual Hollywood speed. Six weeks had gone by and there was barely anything to show for it. Hughes now told Sturges to fire Ophuls immediately and take over direction himself.

According to Sturges, the firing of Ophuls had less to do with schedule concerns and more to do with Hughes's xenophobia. Sturges recalled that, due to Howard's recovery, he only introduced the two men for the first time "well after *Vendetta* had commenced principal photography."

"Three seconds after Mr. Ophuls left the room," according to Sturges, "Howard demanded that I get rid of him. He said he didn't like foreigners and he didn't want any of them working for the company."

Sturges then stepped in as director, but he soon soured on *Vendetta*. For a filmmaker with as strong a point of view as any of his era, it was bad enough that he now found himself finishing a picture that another man started; it was worse that, now Hughes had been reminded that *Vendetta* was a thing, he wouldn't stop calling and telling Sturges what to do. This zapped the fun out of it. A visitor to the set found a despondent Sturges, who felt trapped in an assignment with no end. "It doesn't really matter," Sturges sighed. "We go on week after week; the money keeps rolling in."

Finally, the day before Halloween, Hughes gave Sturges a reprieve: he fired him from *Vendetta* and forced him to resign from their production company. Sturges took Frances Ramsden sailing, leaving the cast and crew of the movie on the soundstage, totally unaware that their director was gone, never to return.

Eventually Hughes hired a third director, Stuart Heisler. "We then started from scratch—new script, new costumes, but the same cast," Faith recalled. Heisler brought in W. R. Burnett, a screenwriter who had worked on *Scarface*, to help him try to fix *Vendetta*. Burnett looked at what the otherwise "brilliant" Sturges managed to shoot and couldn't understand how it had gone so wrong, speculating that maybe "he was sore at Hughes and it was an act of sabotage." Either that or "he had gone nuts."

Heisler shot Burnett's new script, and then Hughes let them both go. Two years later, Mel Ferrer was brought in to direct for another six weeks. As Faith remembered it, "This went on and on."

It was still nowhere near over by the end of 1947, when Faith went

to Las Vegas to obtain a divorce from Teddy Stauffer so that she could marry Hugo Fregonese, an Argentine director under contract to MGM. Six years after having fallen into Hughes's world, Faith had, as she would put it, "totally lost the enthusiasm of being a star and I never got it back. I wanted to bail out totally from the industry."

In the spring of 1948, the newly minted Mrs. Fregonese's seven-year contract with Howard Hughes was due to expire. In April, Faith took her side of the negotiations to the press, telling *The Hollywood Reporter* that though conversations with Hughes had thus far been "most amicable," they had not yet come to terms, and she was holding out to "do more pictures than I have during the years I have been under contract." In seven years, she had appeared in two movies, only one of which, *Young Widow*, had been released.

Pregnant with her first child, Faith would travel with her husband to Buenos Aires to give birth. When she returned to Hollywood a few months later, she did extend her professional relationship with Howard Hughes, but this time it would be under the auspices of his new movie studio.

IN MAY 1948, DORE Schary was head of production at RKO Pictures. Seventeen months earlier, when he had stepped into the job, he had come out with guns blazing, declaring his intention to produce progressive cinema, "courageous motion pictures" whose themes were "both timely and important." His role models were hits of the 1930s, such as *The Grapes of Wrath* and *I Am a Fugitive from a Chain Gang.*[1]

That summer, RKO released the shining example of Schary's new deal, *Crossfire*, a noirish drama about the postwar killing of a Jewish GI by an anti-Semite, starring Robert Mitchum and Robert Ryan and featuring a star-making bit turn from blond-bombshell character actress Gloria Grahame.

[1] Schary made this declaration in a trailer designed to promote *Crossfire*: https://www.you tube.com/watch?v=Qf_tJx9SwMk.

Crossfire was a huge hit. There were lines around the block in the cities, and its $2.7 million box-office gross was several multiples of its $700,000 budget; it grossed more than any other film for RKO that year not featuring major stars Cary Grant and Loretta Young. And yet, by the time of its release, the gears were already in motion to bring the film's director and producer before Congress to answer to charges that they were subversively injecting Hollywood films with Communist propaganda.

Crossfire director Edward Dmytryk and producer Adrian Scott were two members of the Hollywood Ten, the first ten men working in Hollywood to testify about their alleged Communist affiliations before the House Committee on Un-American Activities (usually abbreviated as HUAC). That fall, all ten were indicted for contempt of court for refusing to answer whether or not they had ever been members of the Communist Party. A few days later, the heads of all the major studios—including Dore Schary, the self-styled champion of courageous cinema—gathered at the Waldorf-Astoria in New York and agreed to fire or refuse to hire anyone in the film industry suspected of subversive politics. This was the day the Hollywood Blacklist went from rumor to reality.

If the pressure to fall in line with the red-hunters wasn't proof enough that this was not the time for progressive cinema, the numbers also bore it out: despite the success of *Crossfire*, RKO was losing money under Schary's supervision. The studio's net profit of $5,085,848 for 1947 represented a year-to-year drop of 50 percent of the previous year's earnings. The owner of RKO, a businessman named Floyd Odlum, blanched at the studio's falling stock price and went looking for a buyer.

Odlum did not consult Schary on the sale of RKO. "Suddenly," Schary later remembered, "much to my surprise, trade papers rumored that RKO was to be bought by Howard Hughes." Schary met with Odlum and tried to convince him not to sell to Hughes, knowing that Hughes—whose filmography showed an interest in sensation and spectacle and a disdain for anything intellectual, mature, or progressive—

would not support Schary's sensibilities. "Since my contract permitted me to resign if there was a change in management, I advised Odlum that I would quit if he abandoned RKO." Odlum told Schary, "Look, I'm not a picture man. I bought this company to make some money, and I made some money and I'm leaving."

On May 11, 1948, it was official: Hughes acquired control of RKO, purchasing 929,000 shares, amounting to a controlling interest of 26 percent of the company, for approximately eight and a half million dollars.[2] Hughes then signed his name to a letter sent to the employees of Hughes Aircraft, assuring them that his attention was not fatally divided, and apologizing for reports in the press that suggested that the aircraft company was no longer his top priority. "I assure you that *nothing* means more to me than the success of the [Hercules] flying boat."

What were Hughes's real priorities vis-à-vis RKO? There was some speculation that he had bought the studio in order to control its 124 movie theaters. If he was looking for theaters, Hughes had bought the wrong studio. RKO owned fewer theaters than any of the majors, and this put them at an automatic disadvantage in the age of block booking, wherein studios would force the movie theaters they controlled to accept packages of multiple movies, sometimes including one "A" picture and several B-movies starring low-tier talent, some of which were flat-out stinkers. This process ensured that most of the time, even films that would have failed to attract audiences on their own were kept in theaters as part of the bill with the movies people really wanted to see. The prevailing wisdom was that this vertical integration was absolutely integral to the survival of the movie business. But, with less real estate than their competitors, RKO couldn't make as much money from this business model as everyone else.

When Hughes bought RKO, the studios were desperately trying to maintain some version of the status quo by fighting the government's

[2] A document called "RKO Chronology," from Hughes's files at UNLV, says Hughes spent $8.4 million on the 929,000 shares. RKO historian Richard Jewell has the purchase price at $8,825,500. *Slow Fade to Black*, 80.

efforts to break up their monopoly on production, distribution, and exhibition of the movies. In 1940, the government had levied a consent decree, including several stipulations proposing to change the way the studios forced theaters to take their content. The studios did not want to comply with these stipulations, which would delete their guaranteed profit streams and force them to totally rethink how to make money. They haggled with the government over the consent decree in the courts until 1948, when the U.S. Supreme Court decided against the studios and ordered them to sell their theater businesses if they wanted to stay in production. Most studio heads were united in the belief that this would kill their overall ability to make money, and they intended to band together to stall or appeal such divestment.

Hughes was not most studio heads. He realized that if none of the major production companies owned any theaters, Hughes could ne-gotiate with every theater directly, the way he had as an independent, and get RKO movies in more theaters. On November 1, 1948, Hughes single-handedly brought on the end of the era of vertical integration by turning RKO into the first movie studio to accept the federal govern-ment's consent decree mandating a divestment of their exhibition busi-nesses. Hughes did this in defiance of the other studios, who believed they would be able to negotiate a deal to hold on to at least some of their theaters. Given the choice to keep either a stake in the production studio or the theaters, Hughes chose the studio. His decision forced all of the other studios in town to give up their cash cow and follow suit—rendering Hughes essentially responsible for beginning the pro-cess that would end the studio system as Hollywood had known it since the late silent era, and giving the town's power brokers yet another reason to hate Howard Hughes. (Cleverly, Hughes would push back RKO's actual divestment until after he had relinquished control of the studio—and after *The Outlaw* had one more theatrical go-round, where it grossed $300,000 in its first weekend, smashing records in all twenty-one cities in which it played.)

In later legal depositions, Hughes would claim that he thought that RKO was a good investment that wouldn't take up too much of his

time. "I certainly anticipated that I would have some connection with the company," he said in 1953, "but, frankly, I hoped to purchase a going operation and a ready-made organization and did not expect to participate to the extent that I did." Some of his critics didn't buy this. As the examining attorney in that deposition correctly alleged, throughout Hughes's life, "your experience as an executive has been in companies where you were the sole and final authority"—meaning Hughes had no experience ceding control to anyone else, and no demonstrated interest in trying it on for size. Whatever Hughes's intentions going into RKO, there was little chance he would stand for anyone running it but him.

Three days after the RKO sale, Hughes asked to meet with the head of his new studio. At their first meeting, Schary remembered, "Hughes simply touched my hand rather than shook it and then said, 'I hear you want to quit.'" Hughes easily convinced Schary that nothing would change at RKO under his ownership. "He spoke quietly and sincerely and I agreed to go back to the salt mines." It struck Schary that the Texan tycoon looked like a movie star—like Gary Cooper.

This peace lasted about a month. Hughes called Schary one June midnight and asked if they could meet in three hours. Among other things, Hughes wanted to talk about the actress Barbara Bel Geddes, a stage star who was under contract to RKO and had been cast in a film called *Bed of Roses*. Hughes didn't think she had star quality and wanted her fired. Schary said, "Well, get yourself a messenger boy to tell her you don't want her, but I won't. And as long as you're on the phone, I'd like to tender my resignation." Schary agreed to meet Hughes the following afternoon at Cary Grant's house.

Since the crash, Hughes hadn't made a permanent home for himself—he'd bounce between the houses of friends and various hotels, conducting business in private residences or inconspicuous cars, and using his supposed business headquarters on Romaine Street as a mere message center. When Schary arrived at Grant's house, it was clear that Grant had moved all of his personal items out, but Hughes hadn't moved anything in. "There wasn't a paper, a cigarette, a flower,

a match, a picture, a magazine," Schary marveled. "The only sign of life was Hughes, who appeared from a side room in which I caught a glimpse of a woman hooking up her bra before the door closed."

Hughes sat down next to Schary on a sofa and asked him if he was quitting because he didn't want to take orders. "No, I said, that wasn't the reason," Schary recalled. "I added, that if I were looking for work in an airplane factory I would take all of his orders because he knew more about planes than I did. However, since I believed I knew more about films than he did, I couldn't stay at RKO and take his instructions. Reasonably and quietly he pointed out he had to have men to run his enterprises who would take his orders. I understood that and realized that I was feeling sorry for him because I was quitting."

RKO's president, Peter Rathvon, followed Schary out the door. Hughes installed Noah Dietrich on the RKO board, gave himself the invented title of "Managing Director-Production," and began contemplating what kind of games to play with his new toy.

Over time, Hughes would foster a culture of instability and secrecy at RKO. He made sure that nothing could be put into motion at the studio without his say-so, which he often withheld. In fact, he was usually unreachable by his RKO underlings. He famously refused to work out of the studio lot, preferring to keep the office he had long held on the nearby Goldwyn lot—which was sort of comparable to the CEO of Levi Strauss renting workspace in an artisanal boutique denim factory. Hughes made sure his own men were visible presences on the RKO lot, in order to make sure that his orders were being carried out without Howard himself actually having to be present. Chief among these flunkies were Creighton J. "Tev" Tevlin and Bicknell Lockhart. Tevlin became the key gatekeeper, patrolling access to Hughes. Hughes wanted to know immediately if gossip queens Louella or Hedda were trying to reach him. Anyone else could wait.

ONE THEORY ABOUT HUGHES'S motivation for acquiring RKO that became popular among RKO's disgruntled stockholders was that

he had bought the studio so that it could serve as a clearinghouse for what sometimes Hughes girlfriend Lana Turner called "six-month option girls."

When Turner was first signed to MGM at age sixteen, she was surprised to find that many of the young actresses she saw around the studio lot and assumed were her competition for roles were in fact never cast in anything at all. They were only there, Lana learned, "to be passed around the executive offices" and "six months later [they] would have fallen by the wayside . . . those six-month option girls would never go on to a movie career—they were there for the benefit of management."

As much as Hughes might have heard stories of such practices at studios like MGM and longed for the power and privilege to replicate them, by 1948 he didn't need a studio for such purposes—prior to his involvement with RKO, he already had his own methods of luring and controlling young women under the auspices of future movie stardom. But owning RKO would allow him to turn an artisanal operation into a volume business.

And now he cast a much wider net. The process would begin with a photo of a young lady in a newspaper or magazine. Maybe she was a professional model; maybe she was a coed or a beauty queen or for some other reason had done something to get her face in the paper. Upon spotting such a picture, Hughes would have a team of men track down the intriguing girl, and then one of his personal photographers would be sent to take new pictures of her.

Hughes was very specific about the kinds of images he was looking for. There needed to be three of the subject sitting down, and another three standing up; she needed to be shot head-on and in profile and without heavy makeup or fancy hairstyling. Hughes would have the photos blown up for more intense and sometimes lengthy study. If he decided there was nothing wrong with what he was looking at, he'd have another aide contact the young lady and invite her out to Hollywood, where she'd be signed either to RKO or to a personal

contract with Howard Hughes Productions, at a starting salary of $75 per week.

The nervous system of Hughes's personal and professional endeavors remained the former Multicolor plant at 7000 Romaine in Hollywood, which he and his employees had taken to calling "Operations." The key cogs of Operations were a crew of secretaries who answered all calls from anyone, anywhere in the world, who wanted to reach Howard Hughes. They were under orders to transcribe every incoming phone call as faithfully as possible, noting vocal tics, inflections, and meaningful pauses, in order to produce a daily message log, which Hughes would call in to pick up several times a day.

Operations became the nucleus of Hughes's efforts to surveil and control everyone in his life whom he considered to be a subordinate—which was pretty much everyone, up to and including executives of RKO and TWA—but it was particularly effective when it came to procuring and maintaining new starlets. Aide Walter Kane would call in to leave messages for photographer Jack Christy, to give him instructions for future shoots, stipulate his travel plans, or make requests such as that he "stand by from 2:30 PM on Sun." in case his services were required. Christy was once flown to Florida to photograph a girl who had won a fishing contest. The photo Hughes had seen of this fisherwoman in an outdoor magazine had done her every favor. When Christy took the deglamorized shots of the same girl, she was revealed to have a face full of pockmarks and freckles, and two of her teeth were missing. Hughes wrote this kind of thing off as the cost of doing business.

Such fishing expeditions were worth mounting, because sometimes you found a real pearl. Usually they'd arrive in Los Angeles with a protective mother, but Hughes could work with a mother—most of them were at least as eager as their daughters to do whatever was asked of them to ensure the young girl's stardom. Hughes, happy to offer guidance, would tell mothers to make sure their daughter slept in her bra, and never under any circumstances was she to turn her head more

than fifteen degrees left or right. If the mother started to get impatient, Hughes would reassure her with a reference from her own generation: her daughter, Hughes would say, was the most beautiful girl he had seen since Billie Dove.

It was easier if the girl was a total nobody with no sense of how the movie industry worked, and with no one close to her to make her the wiser. Those with connections in the industry were harder to control. In 1954, a German-born brunette named Dana Wynter would fall onto Howard's radar. She had an agent who would not allow Hughes's photographers to get to her. There was a mixed report from an advanced scout, Jack Shalitt, who had seen her: "Very attractive, very 'distinct' (distinguished) looking. Smile is pretty. Underbite is evident when she talks. Ankles heavy; fingers fat and fleshy." Walter Kane suggested they bring her out to Los Angeles anyway. Wynter would work more than most of Hughes's discoveries, probably because Hughes never ended up signing her. She did, however, marry his friend and lawyer, Greg Bautzer, in 1956, the same year she starred in *Invasion of the Body Snatchers*.

Most women who were sponsored by Howard, during the RKO years and after, never landed such a plum role, or a catch of a man, through their association with Hughes. Much had changed since his discovery of Jane Russell, who had always been allowed to do pretty much whatever she wanted—she wouldn't have put up with anything else. But the experience with Russell—and with Jean Harlow before her, who had shed Hughes as soon as she outgrew him, and later Faith Domergue, who fought Hughes's control for years and escaped it as soon as she was able to—might have taught him a lesson about what he was and was not looking for. Thereafter, every young woman he signed to a contract would be given a furnished house or apartment in which to live, and an on-call driver who would double as a bodyguard and a spy for Hughes. Her days and nights would be scheduled within an inch of her life: dance, voice, and acting classes, followed by dinner out, usually at Perino's (which sat on Wilshire Boulevard blocks away

from the Ambassador), chaperoned by her driver. The contract girl would wait and wait and wait for the day, which they had been led to believe would come someday, when Hughes would call her to his office and announce that he had found the film in which she would become a star. This never happened for most of these girls. Many of them never even met Hughes. Most of them did not work in movies at all while under his employ.

Besides, there simply weren't enough movies to put them all in. Hughes had learned by now to only hire men, unlike Dore Schary, who would follow his orders, and yet he was rarely satisfied with the work of even the most compliant employee—he wasn't satisfied with anything unless he had done it himself. So starlets sat around, waiting for the perfect script, which never materialized. Movies like *Vendetta* were subjected to endless reshoots; others, seemingly completed to Hughes's satisfaction, sat on the shelf for years while he tinkered with edits or title ideas, or merely waited for marketing inspiration. This had worked for him in the past—on both *Hell's Angels* and *The Outlaw*, he had done things his way, and the industry had been forced to begrudgingly applaud him. But studios were expected to release dozens of movies a year, whereas Hughes was practiced in producing only about one movie every dozen years.

JEAN PETERS RETURNED FROM Mexico and resumed seeing Hughes almost every day. He expected her to be available whenever he wanted or needed her, and at first she was happy to comply, putting her career on the back burner when necessary. Still, when asked by columnists about her relationship with Hughes, she did what Hughes now expected his girlfriends to do: she downplayed their involvement and drew attention to her career.

In October 1947, Louella Parsons came right out and asked Jean if she and Howard Hughes were going to marry. Jean insisted marriage was not on her mind. "I'm not one to kick fate in the teeth," Jean

responded. "I have elected to be an actress, and I don't think I could be married and do a good job on the screen. I couldn't do both and do them well."

But it was difficult to sell a starlet supposedly choosing career over love when said starlet's performances hadn't exactly been of world-beating quality thus far, so Fox sought to stir up some chatter they could use to attract interest in Jean as a romantic subject. Because she had no public relationship that could be exploited, the studio tried to gin up the illusion of a romance. They asked her to go to a premiere as the date of an actor. She called Howard and explained why she wouldn't be available that particular night. He asked her not to go. "Don't be like that," she said. "This isn't pleasure, it's business," she said. "It's like part of my job. I owe the studio that."

Hughes disagreed. "You don't owe anyone anything," he told her. "Except me."

She suddenly felt scared. She didn't belong to him, she said—her life was still her own. Peters vowed that she'd go to the premiere whether he liked it or not, that he couldn't stop her from doing her job.

And then the studio called. They told her she wouldn't be needed at the premiere after all.

Clearly, this was Howard's doing. With a single phone call, he had shown who was really in charge—of her bosses, and of her. Jean rang him back. "Who are you? Do you run the whole world?" Hughes replied, "A little bit of it."

Jean misinterpreted Howard's manipulation as a declaration of intent: he wanted her all to himself, so that must mean he wanted only her. One night, at dinner, Hughes told her he would be going on a business trip. She cheerfully said she'd be happy to join him—they would just need to seal the deal before departure. Hughes was surprised she had any notion that they would marry—ever. "Jean, a man doesn't get to be my age—to be over forty—without getting married unless—unless there's some sort of reason," he told her.

She thought he loved her. He said he did love her. And then he asked her to be patient, to give them time to get to know each other better.

When Peters would give Sheilah Graham what the gossip columnist referred to as "the familiar quote"—"We are in love and Howard wants to marry me but he wants us to wait until we are sure"—Graham "felt sorry for the pretty newcomer. I was sure it would never happen."

ON JULY 19, 1948, HOWARD Hughes made the cover of *Time* magazine, with a painting of his now mustachioed face under the headline, "Money + Brains = Fun (sometimes)."

Inside the magazine—on the National Affairs pages, before the piece on Hughes—came a sad, two-and-a-half column write-up on a girl named Frances Lillian Mary Ridste, better known as Carole Landis. The article declared that because of this woman's "voracious appetite for happiness," and "because she lived in what may become known as the era of American brassiere-worship, Frances Lillian Mary Ridste became a motion-picture star." *Time* went on to explain that after a brief marriage at the age of fifteen, Ridste ended up in San Francisco, where she acquired her screen name, and then she moved on to Hollywood and the less-than illustrious life of the chorus girl/extra/B-movie player. "Life was a round of cheap rooms, skimpy meals, an endless attempt to look glamorous and 'sexy,'" reported *Time*. Her big break came in 1940 when she was cast as the babe in Hal Roach's *One Million B.C.*, which would be remade in a very different era as *One Million Years B.C.*, with Raquel Welch in the Landis role. According to *Time*, though success changed Landis's material quality of life, she remained but "a lovely torso—not an actress." Three more quick and short-lived marriages followed. The uncredited *Time* scribe implied that Landis's failure to gain purchase as an A-list star was tied to her erratic love life; he did not mention that Landis was frequently invited to join the head of her studio, Darryl Zanuck, for what one of Zanuck's biographer's referred to as a "sex siesta," and that Landis was referred to by some at Fox as "the studio hooker."

Time was not too discreet to mention that at the end of her life, Landis was in love with big-time serious actor Rex Harrison, who was

married to another woman. Two weeks before the publication of the *Time* article, Landis had dinner with Harrison, then, later that night, alone in her house in the Pacific Palisades, she had a couple of drinks, took a lot of pills, scrawled out a note asking her mother to pray for her, and then collapsed on her bathroom floor. Harrison attended Landis's funeral with his wife. It was, per *Time*, "a splendid affair."

The story on Hughes that followed was adorned with pictures of Jean Harlow and Jane Russell, Carole Landis's predecessors in busty glory, one *Time* article indulging in the "brassiere worship" that the previous one about the dead glamour girl had critiqued. Hughes was described here as a "tall, gangling, aging, sick-looking man of 42 whose life and eccentricities have built a lurid legend."

Hughes granted the magazine a rare interview, and he seemed to be in the highest of spirits. He wouldn't announce who would replace Dore Schary as executive in charge of production at RKO but promised that it would be "someone you least suspect, a shocker." He added, with evident excitement, "My life is not exactly going to be dull for the next two years. I'm really cooking at RKO and things are going to pop. I'll make news for you. The only thing that could stop me would be my death—and even that would be a story." A quote from an unnamed "crony" backed Howard up on this: "Howard will never die in an airplane. He'll die at the hands of a woman with a .38."

This wasn't the most damning statement in the story. Neither was the revelation that Hughes had slashed and burned his way through RKO, firing half the workforce and canceling all but three pictures that had been in production when he took over. Here was the bombshell (no pun intended): noting that Hughes's "women friends" could be divided into big stars like Billie Dove "with whom he was seen in public" and "young, eager and not too prudish unknowns with whom he was almost never seen in public" whom a source said Hughes called "crows," *Time* revealed Johnny Meyer's role as a procurer. Because Hughes couldn't face the possibility of taking no for an answer, "it is part of Meyer's job to see that the green light is up before Hughes ever appears on the scene."

A *Time* cover story, then as now, looms large in any self-image ob-sessed man's conception of his own legend, whether the overall tone is positive or negative. But given what we now know about Howard Hughes, it's impossible to ignore the ways in which this *Time* cover story punctured the then-current legend of Hughes the eligible bache-lor and American hero and revealed as the real Hughes a man marked by recklessness and bombast, who was secretly so afraid of failure that he couldn't even approach a woman unless he was certain she was a sure thing. Even worse, after a lifetime of paying men to trumpet him as "the greatest" in any field in which he dabbled, Hughes was starting to lose control of his own story.

PART V

TERRY, JEAN, AND RKO, 1948–1956

MARRIAGE, HOWARD HUGHES-STYLE

Lynn Baggett had the right look: the cloud of dark curls, the barely containable curves, the narrowed eyes bridging sultry and sad.[1] What she didn't have was much of a career. Signed at Warner Bros., she'd walk through the background of movies like *Mildred Pierce* and *Hollywood Canteen*, her waitress roles too small to merit credit. When one of Hughes's "talent scouts" invited her to Vegas for the weekend, she went. She didn't have anything better to do.

On the plane, Lynn found she was just one of a whole crew of prospective Hughes "dates" en route to Sin City. All the women were given their own hotel rooms, as well as one hundred dollars in cash. They were told to take the money and gamble with it on the casino floor; Hughes would watch from afar and pick the girl he liked best.

Lynn was not up for this contest. She pocketed the cash, stayed in her room, and ordered a juicy steak from room service. Eventually Hughes showed up at her room and asked her why she refused to play his game. This turned into a two-hour lecture on economics,

[1] This story comes from Arthur Laurents, who spells her name "Lynn Baguette." She was credited in films as "Lynn Baggett" or "Lynne Baggett."

and by the end of it, Lynn had decided that Hughes was actually pretty interesting. But he was tired, and left, and she never saw him again.

Baggett's story became the "nucleus," as writer Arthur Laurents put it, of the screenplay for a movie called *Caught*. After almost twenty-five years in Hollywood, Howard Hughes had now achieved a dubious honor: he had become the thinly veiled subject of a Hollywood film made by a man with a vendetta against him. That vendetta had to do with *Vendetta*.

Two years after Max Ophuls was fired from directing the Faith Domergue vehicle, *Vendetta* was still nowhere near ready for release, but Ophuls had completed two other Hollywood films. Then he was hired by Enterprise, an upstart independent studio launched by former publicist Charles Einfeld, to take over a film they had long been gestating.

Caught originated as a loose adaptation of the novel *Wild Calendar*, which was originally intended as a vehicle for Ginger Rogers. By the time the movie was made, the source material had been reshaped by Laurents, a playwright who had recently adapted *Rope* for Alfred Hitchcock. Ophuls had hired Laurents to write a new *Wild Calendar*, but the director told Laurents to forget about the novel.

"I'm not going to make a picture from that lousy book," Ophuls said. "I'm going to make a picture about Howard Hughes."

When Laurents asked Ophuls why, he laughed and said, "Because I hate him." Laurents started crafting a character with Ophuls's instructions about how to capture the essence of Hughes booming in his head. "Make him an idiot!" the director commanded. "An egomaniac! Terrible to women! Also to men!"

Once Laurents had delivered a script skewering Hughes, Ophuls insisted on casting Robert Ryan and Barbara Bel Geddes, both stars who were under contract to RKO. Lanky, square-jawed Ryan had experience embodying the banality of evil, playing the murderous anti-Semite in *Crossfire*; he also resembled Hughes, particularly in stature. Bel Geddes, pert and petite, was cute rather than extravagantly

beautiful (ten years later, Alfred Hitchcock would use her "everyday" looks in brilliant contrast to the ethereal/vulgar Kim Novak in *Vertigo*). That she seemed from the start to be at a disadvantage compared to the average bombshell would further exaggerate the power dynamic between her character, a girl with nothing from nowhere, and Ryan's man who had everything—except, perhaps, a soul. Hughes agreed to loan both performers out to Enterprise, on the condition that certain details in the script be changed so that no layperson would notice that Ryan's eccentric tycoon was based on Hughes. The alterations were superficial: the character's costuming was changed, so that he now wore decent suits instead of tennis shoes, and was seen drinking liquor instead of milk. Hughes was mollified, and yet still insisted that dailies be delivered to him for review every evening.

By the time *Caught* actually went before cameras in the late summer of 1948, Hughes had cancelled Bel Geddes's RKO contract, claiming later he did so because he "felt Geddes had no drawing value at the box office." It would eventually become legend that the real reason was that Hughes didn't think Geddes was sexy enough, although in the 1980s, former fan magazine writer and publicist Jerry Asher offered a more disturbing explanation: Asher claimed Hughes had really fired Geddes because she had performed interracial love scenes in the play *Deep Are the Roots*. According to Asher, Hughes "felt Barbara was totally unforgivable for doing that role."

In *Caught*, Geddes starred as Maud, a working-class girl who tries to turn herself into a new person, in pursuit of a new life. She puts herself through charm school, renames herself "Leonora," and gets a job as a model in a department store, where she hopes to meet a rich man who will pluck her out of her dreary, shared bedsit. (Leonora's situation is depicted as similar to, but somewhat more squalid, than Kitty's in *Kitty Foyle*.)

Her dreams come true. At the department store she's approached by the aide of millionaire Smith Olyrig (Ryan), who invites her to a party on his yacht. Though this is a version of what she said she wanted,

when it comes down to it, Leonora doesn't want to go—she knows the men there will only have one thing on their minds—but her roommate convinces her that it's an "investment in your future."

On the dock, before she can board the boat, she meets Olyrig (whose name sounds like the source of Hughes's initial, drill bit-led fortune) and doesn't recognize him (a repeat of Faith Domergue's first encounter with Hughes). Olyrig ends up marrying Leonora, not because he loves her, but instead, in the words of his analyst, "to prove no one has authority over you" (shades of Hughes's ulterior motive in marrying Ella Rice). The ensuing marriage replicates both Ella's and Faith's experiences of waiting, waiting, waiting for a man who gives them everything money can buy, but sadistically withholds the love they really want. When Leonora mopes about never seeing her husband while collapsed on a velvet couch in a ball gown and jewels, Smith's personal aide (a version of Johnny Meyer or Walter Kane made movie-sidekick fey) tells her she's greedy—what more could she want? In a moment of humiliating rejection, she wails at her husband, "Look at me! Look at what you bought!"

As vicious a gloss on Hughes as *Caught* is, with Robert Ryan's terrifyingly cold performance all the more unnerving given his natural resemblance to Hughes, the movie is even more effective as a European refugee's indictment of postwar American materialism. In a sense, Ophuls is saying Leonora deserves what she got, because she so desperately coveted the security that turned out to be a prison. Not that the film is unsympathetic toward its heroine: Ophuls, of course, understood from his experience on *Vendetta* the attraction of getting involved with a man like Hughes—and he was also intimately acquainted with how it felt to be at Hughes's mercy.

Caught's mixed-to-bad reviews did not cite the similarity between Smith Olyrig and Hughes. The movie flopped—one Illinois theater owner was quoted in the trade journal *Motion Picture Herald* angrily saying that his audiences stayed away from the film like it was scarlet fever—and Enterprise went bankrupt. Ophuls made one more money-losing Hollywood movie and then returned to Europe, where

he directed four straight classics in five years: *La Ronde*, *Le Plaisir*, *The Earrings of Madame de . . .* , and *Lola Montes*. That streak was broken when he dropped dead of a heart attack on a film set. He was fifty-four.

EVER THE MULTITASKER, DAVID O. Selznick was deep in production on *Gone with the Wind* when he spotted a young actress in a Swedish film called *Intermezzo* and decided he had to have her. Ingrid Bergman was brought to Los Angeles in 1939, leaving her doctor husband Petter Lindstrom and baby daughter Pia behind in Sweden. As with Katharine Hepburn before her, when Selznick first saw Bergman in person he was disappointed. He told her he'd supervise a full makeover. Bergman declined. She insisted that he either take her as she was or else she'd start the journey home the next morning. Selznick was hit with inspiration: why not sell this one as "untouched"?

"I've got an idea that's so simple and yet no one in Hollywood has ever tried it before," Selznick told Bergman. "You remain yourself. You are going to be the first 'natural' actress." Of course, there would be no such thing as a truly "natural" actress in movies of the 1940s: Bergman was as heavily coiffed, costumed, and made up as any of her peers, but in her case, all of the cosmetics, and the marketing that went hand in hand with it, stressed Bergman as a "natural," "untouched" beauty. It's not as if Selznick were allowing this one actress to truly "be herself"—her persona was as carefully supervised and directed by Selznick as Jane Russell's had been by Hughes.

Bergman became a superstar three years later with *Casablanca*, a great romance in which she is convinced by her lover to go back to her husband, sacrificing her libido for the good of mankind. Her Oscar win for the George Cukor–directed *Gaslight* (in which she played a naive young wife whose husband uses isolation and intimidation to control her, and send her spinning into mania) was followed by *The Bells of Saint Mary*, the sequel to the smash hit *Going My Way*, this time featuring an intense but unconsummated relationship between Bergman's nun and Bing Crosby's priest. Throughout this period of

her career, ending with *Joan of Arc* in 1948, Bergman was the innocent victim of vicious men, or she was a vessel of god, or else she was a decidedly earthy mortal who had stepped onto the wrong path but then reversed herself before it was too late. Audiences responded to her "authenticity"; they felt like they knew her.

Joan of Arc—produced independently by Walter Wanger, financed by Wanger and Ingrid—was RKO's highest-grossing film of 1948, and Bergman was voted moviegoers' favorite actress in early 1949, for the third straight year. But the film's critical reception was mixed and, unfulfilled, Ingrid thought of two Italian movies she had seen recently, *Open City* and *Paisa*, directed by Roberto Rossellini. These films, populated with nonactors often playing versions of themselves in stories drawn from their own real lives, were foundational works of a postwar wave of filmmaking spearheaded by Rossellini, Pier Paulo Pasolini, Vittorio De Sica, and others, which came to be called Italian Neorealism. Italian Neorealist films were the polar opposite of the lavish Hollywood epics in which Bergman had previously been cast. In the fall of 1948, she wrote a letter to Rossellini, telling him she'd like to work with him, if he could use an actress who could speak Swedish and English very well, French very badly, and knew only three words in Italian: "Lo ti amo," or "I love you." Bergman later admitted that she believed she had fallen in love with Rossellini the first time she watched *Open City*, and that she "probably subconsciously" wrote to him because "he offered a way out from both my problems: my marriage and my life in Hollywood."

Soon thereafter, carrying with him an outline for a potential film for Bergman to star in, Rossellini travelled to Los Angeles. He spent forty days as a houseguest in the home of the movie star and her husband, turning that outline into a screenplay in collaboration with Bergman. Then he and Bergman approached Howard Hughes.

Hughes had pursued Bergman before, both professionally and personally, and her total indifference and disinterest in him had left him intrigued. After purchasing RKO, he had called her and said, "I've just bought a film studio for you. . . . It's my present to you. Are you happy

now?" Now Hughes, in desperate need of films to release through RKO, agreed to finance Rossellini's foreign production on a budget of $600,000, which was not a lot for a film of that era, but was a significant amount of money to entrust to a foreign director with no track record of commercial Hollywood filmmaking to speak of.

Bergman arrived in Rome to shoot *Stromboli* in April 1949. A location shoot took place on the titular island, where cast and crew waited for weeks for a volcano to erupt so that they could capture it on film. This gave the director and star time to get to know one another, and Ingrid Bergman emerged profoundly changed. "When she returned from Stromboli to Rome," Adela Rogers St. Johns later wrote, "she seemed bewildered and confused like a woman coming out of a drug."

During production, the Italian media had begun to churn out stories of an affair between the Hollywood star and the Italian director. Joseph Breen, Hollywood's censor in chief, wrote to Bergman in Italy, fretting that the affair reports were "the cause of great consternation among large numbers of our people who have come to look upon you as the first lady of the screen—both individually and artistically." Breen feared that the gossip "may result in the American public becoming so thoroughly enraged that your pictures will be ignored, and your box-office value ruined." The original Hays Office had been established in response to scandals in the personal lives of stars, in an effort to displace the policing of the private activity of adults onto the public and commercial sphere of the products those adults made. But American film censors had never been in the habit of writing to actresses directly to warn them that the choices they were making off-screen were likely to prove bad for business. Here, the implication of Breen's letter to Bergman seems to be that the real crime of her adultery was that she selfishly had not considered how her sex life would impact the bottom lines of the men she worked for. Protecting the bottom line had, of course, always been the real purpose of the Production Code and its antecedents, but Breen's letter marked a new frontier in invasive, paternalistic meddling in a performer's private life in the name of commercial security. It's impossible to imagine a male actor receiving

a similar letter from Breen in the same situation; even another actress, without Bergman's untouched persona, may not have merited such personal intervention.

In August, Bergman announced that she was separating from Petter Lindstrom. Over the next four months, Lindstrom repeatedly refused to grant his wife a divorce. In December, Louella Parsons published an anonymous tipster's report that Bergman was six months' pregnant with Rossellini's child.

Who was the tipster? According to Bergman's publicist Joseph Steele, it was Hughes. Steele had gone to see Hughes at the Beverly Hills Hotel—then Hughes's primary residence and the site where he was conducting much business and pleasure at the time—to confide in him about Bergman's pregnancy. "What I have to say is intended solely for your information," Steele had stipulated, before announcing that Bergman was going to have her lover's baby, and that she and Rossellini desperately needed money—was there any way RKO could rush the picture out into theaters before news of the pregnancy broke? In the hotel room, Hughes agreed to keep the matter in confidence, and to, as Steele put it, "[g]ive Ingrid a break." Louella Parsons's column came out the next morning.

Steele was wrong to trust Hughes—wrong to believe that he would be loyal to Bergman and Rossellini, wrong to think he would do this couple a favor when he could do things his way. After all, Bergman had been rejecting Hughes for years, and now she had taken up with this Italian—a man who had no money, was hardly a looker, and, most offensive to Hughes, was a foreigner. Hughes felt particularly antagonistic toward Rossellini, who had tried to make *Stromboli* with RKO's money but without his involvement, going so far as to remain incommunicado with Hughes and his execs during filming, and refusing to allow the studio to see footage.

By now, Hughes believed that a scandal that sexualized a female star could be a gold mine if done correctly. Bergman's dilemma, contrary to Breen's warning, could, in Hughes's eyes, pave the way to profits. If his maneuvering caused pain for Rossellini and made Bergman feel

even more heavily the consequences of her choosing a man other than Hughes at the same time, so much the better.

TERRY MOORE WAS SITTING in the darkened bar of the ornate, old-world style Beverly Wilshire Hotel with Johnny Machio, an agent, and Terry's then-boyfriend, Jerome Courtland, nicknamed "Cojo." Nineteen years old, petite and devoutly Mormon, Terry didn't drink; she was at the bar to see and be seen. The agent directed Terry's attention to a man in the bar, sitting alone.

"There's Howard Hughes!" Machio cried out.

Machio invited Hughes to come sit with them. Hughes, who also wasn't a drinker, came over and ordered a round of 7-Ups for the table. It seemed like happenstance, that Machio had run into a lonely-looking friend and, feeling bad for him, invited him to join their table. But, as Terry would soon learn, nothing was happenstance when it came to Howard Hughes.

Terry Moore's real name was Helen Koford. She had made her screen debut at age eleven in 1940, and since then she had appeared in about one film per year, gradually graduating from an uncredited role as a young Ingrid Bergman in *Gaslight*, to the human star of *Son of Lassie*. Her stage name had been given to her by her studio, Columbia, to help promote *The Return of October*, a 1948 young adult film in which she starred as a teenage girl named Terry who believes her dead uncle has been reincarnated as a horse. The studio had hoped the change would help conflate in the minds of the public the childish character with the of-age actress who played her. The stage name stuck, although not everyone would use it—Howard Hughes would always call Terry "Helen."

Terry would later find out that her first meeting with Hughes had been a setup. He had seen *The Return of October* and, according to Terry, had fallen in love with her. Almost forty years later, Terry still thought that horse-loving teen was the best role she had ever had, and she also, apparently without irony, romanticized the role the film had

played in her love life. "There aren't many girls who look naive enough to believe a racehorse could be her uncle," she later wrote. "This was the quality Howard saw and fell in love with."

With her honeyed brown hair, chipmunk cheeks, and easy grin, Terry did not look like most of the women Hughes pursued. She was sunshine where they were noir. And, though significantly older than Faith Domergue had been on her first meeting with Hughes, Terry hoped her real age didn't show. ("There is only one thing I lie about," Moore would say under oath in a deposition in 1979, "and that is my age.") Terry was having so much success as a child star that she hoped she'd be able to stall off visible maturation for a while longer. With the right styling, she could still pass for a young teenager.

By that afternoon at the Beverly Wilshire, Terry had already filmed the lead in an RKO movie called *Mighty Joe Young*, a *King Kong* re-tread made by much of the same creative team as the 1933 original film. Terry played Jill, a young woman who grows up on a ranch in Africa raising a gorilla cub as a pet. Enter Max O'Hara (Robert Armstrong, who played a similar role in *Kong*) a middle-aged rich guy with a vague Texas accent and a mustache (shades of Hughes), who goes on safari to drum up publicity for his new Hollywood nightclub, where he plans to showcase the wild animals he's captured. When O'Hara discovers Jill and her now fully grown pet Joe, the tycoon promises her fame and adventure if she'll just sign a contract allowing him to bring her and Joe to Hollywood. Terry first appears twenty-four minutes into the movie, confronting one of O'Hara's hired cowboys, who is pointing a gun at Joe. She wears her hair in two ponytails, tied with bows behind her round, lineless face. Her gingham dress, accented at the waist with another bow, is demure but does nothing to conceal her well-developed figure. The next time we see her, she's wearing a full-skirted, low-cut, and yet still girlish evening gown. She has the face of a child and the body of a woman. Her character is not sophisticated, and neither is Terry's performance, but it doesn't have to be. All she has to do is evince unconditional love for the big, misunderstood ape.

At their first meeting at the Beverly Wilshire, Hughes told Terry

he had bought RKO, and thus *Mighty Joe Young* now belonged to him. "He couldn't take his eyes off me," she recalled. "It was terrifying. He was an old man of forty-three. He needed a shave. His collar was frayed. His mustache was scraggly. I was afraid of what the kids at Glendale High would say if they saw me out with an old man like this." That Terry, a professional movie actress who was pushing twenty, thought high school students were more her peers than Howard Hughes testifies to the sizable generation gap between the millionaire and the new apple of his eye. Terry also noticed that, though they had never met before that she could recall,[2] Hughes "seemed to know a great deal about my life in Glendale," where she lived with her parents and younger brother. Soon she would realize that Hughes was having her surveilled.

Any qualms she had about this at the time had vanished by thirty years later, when Terry first began speaking openly about her and Hughes's relationship. "That was the beginning of our long love affair," Moore swooned later. "He raised me. I was a baby." Nearly a decade after Faith Domergue, Hughes began another relationship that would compel a young woman to describe their romance using the language of paternal nurturing, apparently unperturbed by the incestual overtones.

Hughes soon became a ubiquitous presence in young Terry's life. The next week he took her and her boyfriend Cojo out flying. Then Howard and Terry began talking on the phone, for hours at a time. Soon Cojo was out of the picture. Still, Howard and Terry's excursions were usually chaperoned by Terry's mother, Louella "Blue" Koford, whom Howard also wooed, in his way. At one point, Terry remembered later, "he actually put his head in my mother's lap and cried. He always said, 'Helen has you. I don't have anybody. I am an orphan.'" Terry related this anecdote as evidence of Howard's charm and intimacy with her family, apparently oblivious to the strangeness of a

[2] Moore would sometimes claim that her mother had told her she had met Hughes at an audition a few years earlier, but if that meeting took place, Terry said she didn't personally remember it.

boyfriend who was old enough to be her father getting so physically close to her own mother.

By the spring of 1949, according to Terry, she and Hughes were dating full-time. "We would go to the Beverly Hills Hotel often for dinner, sometimes the Town House [Hotel], to the Cocoanut Grove, for dancing. We would go bowling. We just went everywhere where normal people go. And we would go to Goldwyn Studios," to watch movies deep into the night.

Gerald "Jeff" Chouinard, one of the private detectives Hughes employed, recalled that some of Howard and Terry's dates were not "where normal people go," but instead in Howard's parked car, a Chevrolet that had seen better days (by this point, Hughes had traded in the flashy sports cars of his youth for a fleet of unfashionable, anonymous sedans). Hughes would drive to the Warner Bros. studio lot in Burbank and wait for Terry across the street—a happy medium between his stomping grounds of Beverly Hills and Moore's family home in Glendale. Blue would drive Terry to these rendezvous. Upon reaching the predetermined street corner, Terry would get out of her mother's car, which was parked a respectful half-block distance away, and go sit in Hughes's car for an hour, maybe ninety minutes. Then Terry would return to her mother's car and go back to Glendale. In other words, there were no sleepovers.

According to Moore, between the spring and fall of 1949, Hughes proposed marriage to her many times. "I mean, he was really begging me to marry him," Moore recalled later. The first few times, Terry said no. "I didn't want to get married at that point. I was more interested in my career at that point than I was Howard." Marriage to Hughes, she was sure, would be bad for her as an actress. She explained, "I was afraid because of the types of roles I played, that his image would hurt mine." She was all too aware of Hughes's reputation as a "playboy," who had been involved with "big stars, stars who were stars before I was born." (Terry was born in 1929; the only star Hughes was involved with who was a star before she was born was Billie Dove.) She

was also worried that he wouldn't take his marriage vows seriously. She told him that he would need to be faithful to her if they got married, and he told her, "Of course."

"He always said 'Yes,'" she recalled. "He lied a lot, but I didn't know that then."

Though Hughes certainly had other women in his life, there's no reason to doubt Moore's claims that he repeatedly proposed to Terry; as we've seen, he'd frequently promise marriage to women as a way of seducing them, and secreting them away from the dating pool. It was also no surprise that he refused to take no for an answer. "Howard didn't like rejection," Terry noted. "The fact that I didn't want to marry him made him ask me all the time."

Marriage wasn't the only thing Terry was saying no to. The twenty-year-old was savvy enough to understand the motivation behind Hughes's frequent proposals. "What he figured was by asking me to marry him he could get me, you know, to go to bed with him and, you know, there was no way." Terry considered herself to be a devout Mormon. She still lived with her parents. She would not be convinced to let go of her spiritual ideas about sex and marriage so easily.

One night, before her midnight curfew, Howard took Terry up to Mulholland Drive, to a spot where teenagers went to neck. They sat in his old beater of a car, looking out onto the expanse of the San Fernando Valley, a black velvet kingdom studded with rhinestone lights. "Only God can marry us," the forty-four-year-old man told the twenty-year-old girl.

"And so," Terry recalled, "[w]e, you know, went on our knees and had a ceremony."

This "ceremony" did not accomplish what Hughes meant it to. According to Terry, afterward "he wanted me to go home with him and I said, 'Uh-uh. I feel married now but, no, we don't sleep together.'" She wanted, she said, "to feel *legally* married before I went to bed with him."

In November 1949, a few months after RKO released *Mighty Joe*

Young, and about a year after their first meeting, Hughes called Terry and told her they were going out onto his yacht to get married. "We are going to do it your way," he told her.

He picked up Terry and her mother and flew the women to where his yacht, the *Hilda*, was docked in San Diego. The boat sailed out toward Mexico. Once in international waters, the captain of the boat, Carl Flynn, presided over a brief ceremony. The only paperwork documenting the marriage was an entry made by Flynn into his captain's log. Now Terry had the veneer of legality that she needed. She and Hughes spent the night together in the boat's stateroom.

When they returned to Los Angeles, Terry considered herself Hughes's wife, but she refused to wear his ring. She didn't want anyone to know they were married, because she was still concerned about her career. Instead he gave her a string of pearls and a diamond brooch that he said had belonged to his mother, explaining they had been given to Allene by Howard Sr. as a wedding present.

Terry dreamed that she and Howard would someday have a second wedding, in the Mormon temple, because in her faith "we marry for all time and eternity, not 'til death do us part,'" she explained. "If you marry in the temple, that is an eternal marriage." This would require that Howard convert, which she hoped he would.

ON JANUARY 24, 1950, *STROMBOLI* had a bad test screening in Long Beach. "There was a lot of enthusiasm when the name came on the screen," reported the theater manager, "but the picture wasn't accepted too well. There's a lot of Italian in it." At least Bergman "got a few whistles in one scene when she got out of bed in her slip."

The next day, Father Félix Morlión, an Italian priest whom Rossellini had credited as cowriter of the *Stromboli* story, wrote to Hughes to plead with him to reverse certain edits the RKO chief had ordered. Morlión was particularly opposed to the last scene, which minimized the impact of Bergman's character's religious conversion and commu-

nion with God, and included a dubbed line that the priest believed was a too-cute reference to Bergman and Rossellini's off-screen drama, one that would inspire jeers rather than awe: "God, make me a good wife!"

Hughes's cuts to *Stromboli* were his attempt to make the film more commercial; the MPAA's files suggest the censors viewed the film once, could not find issue with its actual content, and asked for no cuts before issuing a seal of approval. (In the sense that *Stromboli* was about a feisty, independent-minded, morally dubious woman who is transformed into subservience by an encounter with God, the film itself, as opposed to the scandal around it, fit comfortably within the Production Code's essentially God-fearing worldview.)

The censors did, however, object to *Stromboli*'s ads. Because *Stromboli* was nothing if not an art film, Hughes decided the best way to promote it would be to trick gossip readers into thinking it was something like a documentary of Bergman and Rossellini's scandalous affair. Hughes had advance newspaper ads for the film produced, featuring the film's titular volcano ejaculating lava under the tagline, "Raging Island . . . Raging Passions!" The MPAA pushed back, because they had no choice—they were receiving angry letters from everyday people, such as one from a group of school administrators in Abilene, Texas, remarking on the "advertisements in nationally circulated newspapers written in such a way as to capitalize subtly, though flagrantly, upon this immoral and illicit romance" and calling on the MPAA's Johnston to "prohibit the showing of the film *Stromboli* and other pictures picturing persons whose conduct is morally shocking." A full generation after the scandals that had brought Will Hays to Hollywood, history was repeating itself.

The MPAA went looking for reasons to ban the *Stromboli* ads and punish Hughes. However, they couldn't find a legitimate excuse. "The circumstances under which these ads have appeared have caused people both in and out of our industry to see trouble in them," wrote Gordon S. White, who administered the Code office's regulations on advertising, ". . . [but] the content of the ads actually presented

no specific Code violation." The censors were also wary of giving Hughes the attention he craved. White recommended that they "add no fuel to the fire which [Hughes] fans."

Hughes didn't know what the MPAA was discussing internally, but the rumblings that the censors were going to censure him made Howard feel more defiant. Already frustrated to be stuck with a movie that made everyone think of adultery but didn't include any actual sex, when the censors recoiled against his advertising, he didn't want to go down without a fight. He sought advice from an unlikely source: Dore Schary. They met at a Hughes Tool plant in Culver City, where Hughes's employees were hard at work crafting weapons destined for use in the upcoming Korean War. After admitting that he already considered the acquisition of RKO to be a mistake, and a distraction away from the work he really wanted to be doing, Hughes asked Schary for his opinion on the *Stromboli* ads—was he right or wrong to stick to his guns? "Howard, I think you are wrong," Schary said. "They are vulgar." Hughes thanked Schary for his input. He withdrew the ads.

The consequences of the affair, however, were just beginning. By the time Bergman gave birth to Rossellini's son on February 2, their film had already been banned in Miami by the Dade County Juvenile Council, and had been refused by theater owners in Memphis, Indiana and Minnesota. Though the Catholic Legion of Decency declared *Stromboli* "acceptable," individual theaters and local groups called for boycotts and bans, solely because Bergman's personal life was deemed immoral. But *Variety* reported unusual interest in *Stromboli* in major cities. In New York, "evening business was at capacity in all situations," and within its first week it had grossed more than $1.2 million, although business dropped off after the first few days. In Chicago, a crowd of three hundred ticket buyers, mostly women, started lining up in snow and sleet on icy sidewalks forty minutes before the 8:45 A.M. show. Said the theater manager, "It's doing better than *The Outlaw*."

Less than a week later, Rossellini would disavow the RKO version of *Stromboli*, declaring he "renounced all claims to American earnings" on the film. After RKO's "mutilation" of the cut, he said, "I do not rec-

ognize it as my film." He also called the volcano-spouting advertising "pornographic."

This was the same argument made by *Stromboli*'s greatest antagonist, Congressman Edwin Johnson from Colorado, who in March railed against Ingrid Bergman on the House floor in a rant that conflated the plot of *Stromboli* with real life. "Now that the stupid film about a pregnant woman and a volcano had exploited America with the usual finesse, to the mutual delight of RKO and the debased Rossellini, are we merely to yawn wearily, greatly relieved that this hideous thing is finished and then forget it?" Johnson asked. "I hope not. A way must be found to protect the people in the future against that kind of gyp." The *New York Herald-Tribune* noted the "personal sadness" in the rant by Johnson, who said of Bergman, "She was by very long odds my own favorite actress of all time, and I have been enjoying motion pictures for over forty years." Johnson described Rossellini as "a treacherous viper," a "love pirate" and a "money-mad home wrecker." RKO's "disgusting publicity campaign," Johnson added, "permitted no revolting bedroom scene to escape and stressed passion in its worst sense."

Johnson was so stirred up by the Bergman-Rossellini scandal that he proposed legislation to exclude "immoral" actors, directors, and producers from the industry by requiring them to purchase a license from the secretary of commerce each time they worked. Each film would require a separate license for distribution, at a rate of $10,000. Johnson took credit for assigning a "special investigator" to the Hollywood beat, to gather information on "mass Hollywood behavior," which could be used to deny a license to any film made by anyone found to be guilty of "immoral acts." In other words, it was an ingenious proposal that would allow the U.S. government to both censor and pull a skim from the film industry.

The MPAA's Eric Johnston, in opposition to the proposed bill, argued that its end goal was to turn Hollywood into a "police state" and declared, "I do not wish to be nor will I be a commissar of Hollywood's morals; no one wants that job in a democracy."

In the sense that it stirred up a national conversation about sexual mores that inspired ticket sales at a lower cost than he had spent on *The Outlaw*, to Hughes *Stromboli* was a success.[3] As if hoping lightning would strike twice, Hughes began importing Italians. His next Roman target was much prettier than Rossellini.

That July, after seeing a photo in a magazine of a bikini-clad twenty-three-year-old Italian beauty named Gina Lollobrigida, Hughes had her tracked down and brought from Rome to Los Angeles. His men had promised to send two plane tickets, one for Gina's husband, Milko Skofic, a Yugoslavian doctor, but they only sent one. Lollobrigida didn't want to travel so far away without her husband. "But my husband trusted me," said Lollobrigida. "He said, 'Go. I don't want you to say one day that I didn't let you have a career.' So I went alone."

Gina was excited to see the Hollywood sights, but that wasn't in the cards. "All I saw was Howard Hughes," she complained. Gina was given a suite at the Town House Hotel, where guards were stationed outside her door. Unless accompanied by Howard, she wasn't allowed to leave the room, and Hughes had arranged with the front desk to block her phone calls. A week went by, and another. RKO promised to arrange Milko's travel to Los Angeles after Gina got settled, but after she had been in the hotel for a month and a half, they still wouldn't let her send for her husband.

Finally, Gina recalled, Hughes picked her up at the Town House and told her he was taking her to a "business conference." The next thing she knew, Gina was in Hughes's plane and he was flying them to Las Vegas. The only business Hughes wanted to discuss was when Gina was going to ditch her husband. "Hughes asked me to divorce Milko and marry him," she recalled. "Then I would have a fast, brilliant ca-

[3] The debate over censorship of Rossellini's film *The Miracle* (which was released in the United States months after *Stromboli* but had been shot before, and starred his pre-Bergman love, Anna Magnani) led to a 1952 Supreme Court decision recategorizing motion pictures from a purely commercial endeavor, into a form of expression governed by free speech. This decision sent dominoes tumbling that would eventually fully erode the Production Code and lead to the establishment of the modern-day ratings system.

reer, millions, furs, jewels . . . everything I could desire." Gina refused the proposal and demanded a screen test. Hughes gave her some script pages to read. The dialogue was in praise of divorce.

After that, Gina demanded that she be allowed to return to Rome and her husband. A plane ticket was booked, but before she went, Hughes threw her a farewell party at her hotel. At 3 A.M., after much champagne, Hughes presented Gina with a contract. Tipsy and tired— and unable to read more than a few words in English—Gina asked if someone could explain to her what she was signing. Satisfied with the explanation she got, Gina signed and went to bed. Back in Rome, Gina costarred in a hit Italian comedy called *Bread, Love, and Dreams*, and in John Huston's Italian-set *Beat the Devil*. Soon Gina was among the biggest stars in Europe. Though there was demand for her to come to America and star in Hollywood movies, she couldn't do it—the contract she had signed with Hughes precluded her from working in Hollywood for anyone but him, and she refused to work for him.

Gina's costar in *Bread* had been Vittorio De Sica, who was also the director of the Neorealist masterpiece *The Bicycle Thief*. In early 1952, Hughes brought De Sica from Rome to Hollywood to negotiate a contract to direct films at RKO. Asked why he would sign with Hughes, "a man seemingly devoid of artistic ambitions," De Sica responded through a translator, "Because he is the only American producer who had made an offer with no strings attached." No films ended up being attached, either. "I lost a year being under contract to that madman Howard Hughes," De Sica later lamented. "He kept me a whole month in Hollywood without showing up. My contract forced me to stay in Los Angeles, and people kept saying 'Don't you like Los Angeles?' 'Sure,' I answered, 'but I want to work. I'm not used to being kept, like a prostitute.'"

"MOTHER" AND A MALE IDOL

In the years since Ida Lupino and Howard Hughes first knew each other—and since the death of Ida's close friend Thelma Todd, ex-wife of enigmatic Hughes's aide Pat De Cicco—Lupino had lived several lifetimes. Gone was the bleached-blond nymphet who had been brought to Hollywood to serve as an answer to Jean Harlow. The Ida of the early 1930s, as columnist Gladys Hall put it, "was curved and provocative and always exciting but she wasn't likable. She was blonde and photogenic and the delight of cameramen and poster artists; she was movie-starrish like mad but she got nowhere in particular."

She was also bored. One day on the set of the 1937 film *Artists and Models*, future gossip columnist Hedda Hopper, then an actress, asked Ida if she thought she wanted to be a star for the long haul. Ida said she guessed she did, although she "didn't like all of this waiting around and nothing happening." Hedda suggested Ida go for a new look—or, rather, her natural look.

"Why don't you scrub your face, get all that stuff off, and become a real actress—if that's what you want," Hedda suggested. "Otherwise you'll be just another little starlet who fell by the wayside."

Ida then let her natural light brown hair grow in, and she shed the baby fat that had passed for curves in her teenage temptress phase. "I was such a wretchedly unhappy little painted doll," Ida admitted after

the transformation. Proudly, she said, "I have, deliberately, made myself an ugly girl."

Though she was working steadily and collecting a weekly salary that matched the average of what many Americans earned in a year, she had become disillusioned with the kinds of roles available to her at Paramount, and when her contract ended, she refused to renew it. She was tired, as she'd put it later, "of always being a coy thing lounging in a boat, listening to someone sing romantic songs—even at $1750 a week." Now that she looked like a serious woman (at all of age twenty), she wanted work to match.

The film that turned Lupino's career around was *The Light That Fails*, in which she played a slattern turned muse to a painter who is going blind. After that, Ida was offered a contract at Warner Bros., which hoped to groom her as a new version of their top female star and best actress, Bette Davis. The notoriously choosey Davis would decline to appear in all but the most attractive projects, so Warners needed a cheaper Bette Davis "type" to whom they could throw Bette's scraps, so that those lesser films still got made and still fed the maw of the distribution cycle. But judging by the number of fine performances Lupino gave in better-than-average movies while at Warner Bros., either Bette Davis's sloppy seconds weren't half bad, or Ida was able to elevate subpar material into something special. These supposedly lower specimens of art let her do more interesting work than most other stars her age would or could have.

These releases included a series of early noirs like *They Drive by Night* and *High Sierra*, both costarring Humphrey Bogart. In *They Drive by Night*, she's Lana, the bitter, bored, unfulfilled wife of a much older, boozed-up businessman. Nursing a crush on truck driver George Raft, the desperately unhappy Lana kills her husband, and then blames the murder on Raft when he won't love her. At the end of the movie Lana is revealed to be insane—a very 1940s Hollywood way of defanging such threatening female desire and vengeance, marking it as an aberration, and not an extreme example of the dissatisfaction of "normal" women the nation over.

In 1942, Ida was cast in *The Hard Way*, a film about two sisters who escape their dreary small town poverty when one pushes the other into show business. The film was based on the relationship between Ginger Rogers and her mother, Lela, close enough for recognition with specific details changed so that the Rogers women couldn't protest. *The Hard Way* is luridly powerful even putting aside the Rogers connections, but Ida considered it the nadir of her acting career. On the set, Lupino collapsed in exhaustion. Doctors told her she needed six months of rest; Warner Bros. gave her two weeks.

To add to her stress, Ida's beloved father died while she was making the movie. Stanley Lupino had been a mentor to his daughter, who had dreamed that someday his daughter would write and direct movies, as well as act in them. At twenty-four years old, Ida Lupino became determined to honor her late dad by becoming a director.

Nothing would happen with that dream for a few years. In the meantime, after a few box-office disappointments, Warner Bros. lost interest in her as star. Unable to agree on a new contract, in 1947 she was cut loose. Shortly thereafter, Lupino (whose first marriage, to Louis Hayward, had fallen apart when he returned from World War II stricken with post-traumatic stress disorder and told her he wanted to start a new life, away from Hollywood), began dating Collier "Collie" Young, then assistant to Columbia studio chief Harry Cohn. A frustrated yes-man to an unforgiving mogul, Collie shared Ida's desire to make movies without having to answer to anyone. She took a tentative step toward this by partnering with her new agent, Charles Feldman, to acquire the rights to a novel that she and Collie loved. Feldman flipped the rights to Fox on the condition that Ida star in the movie. That movie was *Road House*, in which Ida played a tough broad in a love triangle with two men.

In *Road House*, in character as an itinerant chanteuse making her debut at a roadside bar and grill, Ida sang a throaty, partially spoken version of "One for My Baby (and One More for the Road)." This performance makes an immediate impression on the roadhouse's regulars. "She reminds me of the first woman who slapped my face," a male

onlooker marvels. As if to counter her potentially controversial on-screen image of strength and hard living, Fox put out a number of press releases about Ida's body, stressing its real-life fragility. Claiming that her usual weight was 105 pounds (at a height of five foot three), her studio explained that Ida needed to gorge herself on things like "ginger ale and cream" and "undiluted condensed milk and toast" while shooting a movie in order to maintain an "eye-pleasing" weight of 115 pounds. These details were deemed by the studio to be useful to the promotion of *Road House*, despite the fact that the movie had nothing to do with Ida's character's diet or weight—except in the sense that all movies were, at least subtextually, "about" the bodies of the actresses in them.

One of Ida's male costars in *Road House* was Cornel Wilde, who would later recall that on the set, he and Lupino bonded over their shared concern over "that louse, [Senator] Joe McCarthy." As many have, Wilde was conflating Joseph McCarthy and what would become McCarthyism with the activities of the House Committee on Un-American Activities, or HUAC. McCarthy had not yet begun hunting red witches in 1947, but the HUAC investigation into Hollywood was in full swing.

Ida was well aware that people who had joined antifascist and even marginally left-wing or pro-Russian organizations during World War II were finding themselves with a target on their backs now that the So-viets were considered the United States' mortal enemy. Ida, who con-sidered herself to be a New Deal Democrat, began to suspect that she was herself under investigation in 1947, when she faced a roadblock in her application to become an American citizen. After completing most of the process, she was interviewed by an agent from the Immigration and Naturalization Service who asked her if she had ever been a mem-ber of any antifascist organizations. Aware that there were some red flags on her record that might be holding up her citizenship application, Ida contacted the FBI to explain her association with certain known Hollywood leftists and their organizations. In so doing, she proceeded to name the names of those associates and their organizations.

In an interview with Bureau agents on May 6, 1947, Lupino explained

that actor Sterling Hayden, a blond pretty boy who had made only two films in Hollywood before enlisting in the Marines and serving through the war, had held meetings on his yacht, with the intention of luring Ida and others into the Communist fold. Hayden had subscribed Ida and two actresses who lived at her house to the Communist paper *People's World*, which explained why Ida had three copies of multiple issues of the rag stacked up in her closet. She further told the FBI that she had asked Hayden what he would do, should the United States go to war with Russia, and he told her he "would leave the United States and go to another country where he could continue to carry on his work for the Communist cause."

Ida explained that she had no interest in joining that cause, and had continued associating with Hollywood leftists and attending meetings of groups where she suspected there was Communist infiltration, including the Screen Actors Guild and the Hollywood Independent Citizens Committee of Arts, Sciences and Professions (ICCASP), in order to gather information on the extent of subversive forces in Hollywood. She told the FBI that she believed Karen Morley—the actress who had introduced Ann Dvorak to Howard Hawks, thus helping Dvorak get cast in *Scarface*—to be a Communist, and she suspected the same of Alexander Knox (who costarred with Ida in *The Sea Wolf*) and Charles Coburn (who was known to be a member of the Motion Picture Alliance for the Preservation of American Ideals, a group of Hollywood conservatives who aided and abetted HUAC). In a closed meeting with Bureau agents, she also named the names of directors and writers Robert Rossen, Howard Da Silva, Dalton Trumbo, Albert Maltz, and Donald Ogden Stewart. In the future, she would tell the FBI that she believed the Committee for the First Amendment, a group spearheaded by Humphrey Bogart and John Huston to protest HUAC's subpoenas of screenwriters, had been infiltrated by commies. Ida would also identify a number of active members of the Screen Actors Guild as potential Communists, including Hume Cronyn, Lloyd Goff, Larry Parks, and Anne Revere. She agreed she would be "willing to assist if necessary in attacking these questionable groups."

The FBI, while appreciative of Lupino's willingness to inform on her Hollywood colleagues, also approached her with "extreme caution," as one report explained, "in view of her past contacts with persons of known Communist sympathies as well as the manner with which she has suddenly become interested in cooperating with the FBI." The deal was fraught on Ida's end, too. In December 1947, Lupino became concerned that her continued membership in ICCASP, which she maintained in order to act as a spy on the inside for the FBI, would inspire HUAC to subpoena her. The group was ostensibly devoted to keeping liberal/progressive ideals alive in Hollywood postwar and post-Roosevelt, though it also allegedly served as a place for Hollywood Communists to attempt to influence non-Communist liberals. The FBI recommended she continue to pretend to be a legitimate member of the organization in order to investigate it.

In the end, Ida Lupino was not subpoenaed by HUAC. Revere, Morley, Parks, Rossen, Da Silva, Trumbo, Maltz, Stewart, and Hayden were.

Her willingness to reveal these names to the FBI is difficult to reconcile, and not just because of her record of apparently liberal politics (in addition to her conversations with Wilde that led him to believe that he and Lupino were on the same, anti-HUAC side, Lupino spoke frequently of her adoration for FDR, who she believed saved America with the New Deal). Though she may have been legitimately worried about the Communist infiltration of Hollywood, as some people were, in the case of Hayden specifically she was informing on a man whom she frequently saw socially. Those times on Hayden's yacht that Lupino characterized to the FBI as grim sessions of Communist proselytizing were painted by Lupino's biographer William Donati, who worked in cooperation with Ida, as carefree jaunts that would often end with Ida cheerfully rejecting the married Hayden's invitation to spend the night with him.

Ida sacrificed friends and colleagues in order to save herself, as not a few people in Hollywood did during the Blacklist era. But Ida Lupino's naming of names feels different from, say, Elia Kazan's decision to

go against friends like Arthur Miller in cooperating with HUAC. For one thing, Kazan openly publicized his cooperation, and spent decades providing rationalizations for it, whereas Lupino presented herself, as Wilde's commentary makes clear, as an anti-Blacklist, anti-McCarthy liberal. She never publicly acknowledged the collaboration with Blacklist forces that her FBI files reveal.

Because of her silence, we can only guess at how Lupino would have rationalized providing undercover aid to the forces that successfully oppressed her friends and colleagues. The facts make it clear that, in cooperating with the FBI, Ida was working with the establishment, corrupt though it may have been, in order to create room for herself, and the people close to her that she was able to protect, to subvert that establishment. It's because Ida Lupino wasn't subpoenaed and blacklisted that she was able to become the only female feature film director in Hollywood during a decade defined by repression. And her career as a director was defined by the same double act she played in fronting as a good liberal while secretly working with the FBI. In her films and in life, she frequently said one thing as misdirection for the fact that she was doing the opposite. Just as Fox had promoted her off-screen fragility instead of her character in *Road House*'s uncommon strength, Ida would go on to make films that depicted real social problems created by a society in which women were expected to be subservient to men, and yet she'd use the media to put forward the idea that she believed in traditional gender roles. This subterfuge was necessary in an industry that limited the type of power that women were allowed to have on-screen to the realm of the maternal or the sexual—and, in the latter case, usually demonized or punished women who wielded it.

In this climate, Ida was not able to make the leap into writing, producing, and directing movies on her own; she needed a male partner to legitimize her. Ida would marry Collier Young in August 1948. Within six months, she was telling the press that they intended to produce movies together. Ida said she had been inspired by Roberto Rossellini, and not just by the low budgets and high creative returns of films like *Open City*. Lupino met the Italian filmmaker at a party in Los Angeles,

while he was in town working on the script for *Stromboli*. Ida had seen some of Rossellini's postwar films and was a fan of the way they captured in documentary style what it was like to be left alive in a world that had crumbled all around you. Ida knew this was not the kind of movie she acted in—she didn't need a lecture about it—but Rossellini gave her one anyway.

"In Hollywood movies, the star is going crazy, or drinks too much, or he wants to kill his wife," the Italian Neorealist complained to the movie star. "When are you going to make pictures about ordinary people, in ordinary situations?"

Lupino could have answered, "Sooner than you think." Before *Stromboli* even went into production, Ida announced that she and Collie were starting a production company called the Filmakers, dedicated to making documentary-inspired films about social issues. They'd begin with *Not Wanted*, a drama about unwed mothers. Ida and Collie commissioned a script from writer Paul Jarrico, but according to Ida, "we only used about four of his pages. I did most of the screenplay." The goal, she added, was to elicit empathy for a woman who made a mistake, "without being too messagey."

It was bold enough for an actress to produce and cowrite a feature film in Hollywood in 1948; the initial plan was that Ida's involvement in *Not Wanted* would end there. And then, right before shooting began, the man she had hired to direct *Not Wanted*, Elmer Clifton, suffered a heart attack. As the producer, Ida said, she had no choice but to step into the director's chair—she was the only option on such short notice. When speaking to a visiting reporter, Ida insisted she wasn't "really" directing, just helping out the production while the "real" director recovered, and she didn't take her entitled full credit on the movie. It was better to downplay rather than brag—to draw attention to herself as what she'd later call a "crusader" would be to risk not being able to get away with the totally uncommon thing she was doing.

On set, she used her maternal wiles—as she described them—to coax her male crews into doing things her way, craftily muffling evidence of her agency, creativity, and use of power. Sally Forrest, a

background dancer in MGM musicals whom Ida had promoted to leading lady in *Not Wanted*, started calling Ida "Mother" on set, and this caught on and fed into Ida's public persona as a director who supervised casts and crews as though she were nurturing a brood of offspring. "Darlings, Mother has a problem," Ida would say to her crew members. "I'd love to do this. Can you do it? It sounds kooky but I want to do it. Now, can you do it for me?" She insisted that she ran a set as though it were a family dinner, not a place of business that everywhere else in the industry was controlled by men.

Much of the entertainment media seemingly didn't know what to make of this actress stepping into what was perceived as a man's job. Right at the beginning of her directing career, the *Hollywood Citizen-News* ran a candid photograph of Ida on set in conference with film editor William Ziegler, with the sexist fearmongering caption, "Hollywood has succumbed to the modern woman." Going forward, Lupino's publicity strategy vis-à-vis her directing career would be to reassure the public that being the only woman succeeding at a man's job did nothing to detract from her femininity and her success in the traditionally feminine sphere of marriage and motherhood. Having a publicity strategy at all made her more like a movie star than any other then-working director. Certainly, no director of the era worked as hard to diminish the public perception of their own power.

Ida's directing career would not have been able to continue if she had not been able to give men in power what they wanted. *Not Wanted*—a movie that was as critical of men abusing their privilege and shirking responsibility as any of its year—grossed an astounding $1 million against a budget of just over $150,000. These were the kinds of numbers that Hollywood couldn't ignore.

As Collie and Ida began work on another screenplay, *Never Fear*, about an ostracized polio sufferer, their professional partnership began to wear on their marriage. Ida was obsessed with her work, and she counted on Collie to handle the business aspects so that she could deliver creatively. But Collie had a tendency to let her down. Right after she began directing *Never Fear*, Ida learned—from the assistant di-

rector, and not her husband and producing partner—that one of their investors had gone missing. With her hands full directing, Ida turned the matter over to her agent Charles Feldman, who arranged a loan so that the indie production could meet its payroll. Collie's inability to figure the problem out himself was not auspicious, and in fact, because he never managed to find replacement investors, Ida herself was forced to personally sink her life savings into the movie. Then, though Collie tried, he failed to sell the finished film to exhibitors. Any hopes they had had of being able to function outside of the studio system went down in flames.

Enter Howard Hughes, who called Ida at just the right time, when she was in desperate need of both cash and an opportunity to prove herself once again. Cash Hughes had; what he needed was content to move through the RKO distribution pipeline. If he had any inkling of the problems with *Never Fear*, Hughes either didn't care or was happy to play rescuer. He had seen how large a profit Ida had been able to turn on *Not Wanted*, and he saw an opportunity to make movies that appealed to his interests (such as sex, particularly illicit sex) while ensuring a full commitment from a filmmaker (Ida) who was in it to fulfill her own social justice ambitions. Hughes also recalled how the political relevancy of *Scarface* had ultimately bought the film some leeway with the censors, which must have looked like an appealing thing to buy after nearly a decade of life with *The Outlaw*.

Hughes offered Ida and Collie a three-picture deal. RKO would provide a $250,000 budget for each film, and the producers and the studio would split the profits. Hughes reserved the right to approve or block material based on a one-sentence synopsis. When Lupino told him the next film she wanted to make was about a rape, Hughes gave the thumbs-up. Satisfied with the creative aspect of the agreement, she left it to the men to figure out the finer details of the deal.

Sally Forrest, who starred in three of Lupino's directorial efforts, got the impression that Hughes had gotten into business with Ida because "he liked her"—meaning that he recalled their romantic history and was hoping there was some kind of future for them. If that was

the case, then Ida may have made a mistake in turning the negotiation over to Collie. In a face-to-face with another man involving a woman, Hughes would have been determined to show his own power, regardless of who ended up with the girl.

Lupino had sought refuge from her marital struggles in a relationship with actor Howard Duff, with whom she had starred in a movie called *Woman in Hiding*. Perhaps Collie was imagining that he'd win a new lease on his marriage by negotiating a second chance for their production company, but when Ida received the executed contract, a month after the negotiation, she learned that Collie had failed her: he had essentially signed over total control of their films to Hughes and RKO. Of course Hughes had protected his right to approve talent— meaning he could put the kibosh on any actress he didn't find sexy enough, which put in jeopardy Lupino's stated plan to cast unknowns "on whom Hollywood won't take a chance." But even more upsetting for Lupino, who was still very much in debt thanks to Collie's failure with the investors on *Never Fear*, was that her husband had signed a contract permitting Hughes and RKO to collect promotional expenses out of their share of profits; RKO would bill the cost of lavish promotions to the filmmakers, and Ida and Collie's production company would never see any profits. By the end of that year Ida would file for divorce and publicly take up with Duff, though she and Collie would continue to work together.

NEARLY A DECADE AFTER Hughes first took control of her career, Faith Domergue got her first serious push as a star. In January 1950, RKO sent Faith on a publicity tour to reintroduce her to the public and the press, because two movies in which she had starred— *Where Danger Lives* and the much-beleaguered *Vendetta*—were going to be released that year. The results of this press blitz included a full-color spread in *Life* magazine and a handy lesson for newbies to the Faith phenomenon: "The last name is pronounced 'Dough-merg.'"

This tour was to culminate in a junket at the Algonquin Hotel in

New York, in which Domergue was a reluctant participant. "I'd just come off a ten-city tour and I was tired, angry and pregnant," Faith explained. She told RKO she didn't want to do the New York press dates. Then Hughes called her and tried to make her feel guilty for all the money he had already spent building her up. "When I told him I was going to have a baby he said, 'OK, good-bye, Faith,' and that was the last time I ever heard his voice."

Eleven months later, after an investment of more than four years and an astounding $4 million of Hughes's money, *Vendetta* would finally hit movie theaters at Christmas 1950. It was deemed by no one to be worth the wait. The *New York Times* declared the film to be "a garrulous, slow and obvious period piece, weighed down by a profusion of exotic accents, undistinguished dialogue and unconvincing play acting." "If a star can be made by what seems to be the most extravagant star-making venture in Hollywood history, Faith's stardom should be assured," wrote *Time* magazine's critic. "But *Vendetta* is unlikely to be the picture that turns this trick."

Time also took note of the one aspect of *Vendetta* that was truly remarkable: Faith's character Columba's "more-than-sisterly affections" for her brother. As cobbled together under Hughes's supervision from the footage generated by its many directors, the dramatically turgid *Vendetta* is only interesting as a not-particularly-veiled incest fantasy. Early in the film, a gorgeous extreme close-up of Domergue's giant dark eyes dissolves slowly into the sight of a ship, sailing under ominous skies. Columba's brother is on that boat, and she confesses that she is imagining "the wind in his hair, his eyes glowing like tiny lamps . . . as only a man's eyes glow when he is at last toward home—and, when he loves." She spends the rest of the film mooning over him—sneaking into his bedroom while he's sleeping, going through his things and caressing his sleeping face; turning to the camera, heartbroken, when he tells her he's getting married and she should look for a husband— and also trying to convince him to seek murderous vengeance on behalf of their dead father. Though their personal relationship had long since dissolved by the time *Vendetta* was released, Hughes ensured a certain

fidelity from his former "fiancée": Columba's love for her brother was the only romance Hughes would allow Faith to engage in on-screen. This was perhaps only fitting as a fulfillment of his original designs for a relationship with a woman he had once referred to as "the child I should have had." When it came to the air of incest that he injected into his relationships with young women, at least Hughes was consistent.

After her final falling-out with Hughes over the New York press dates, Faith recalled, "I sat around RKO for two years, doing nothing." She was loaned to Universal to make *The Duel at Silver Creek*, and then her husband got a job directing a movie in England starring Joan Fontaine. Persuading RKO publicity man Perry Lieber to lobby on her behalf, Faith managed to break free of her contract. She walked off the RKO lot for the last time, exhilarated, finally "free as I had asked to be, and suddenly alone without the power of him"—Hughes— "behind me."

It's too bad Hughes's animosity moved him to keep Faith on the shelf, because her other movie of 1950 should have been a star-making vehicle, and unfortunately she was not able to capitalize on how good she was in it. In director John Farrow's *Where Danger Lives*, one of only two films Domergue actually filmed for RKO while under contract to the studio, she played Margo, the stunning young wife of a much older rich guy (Claude Rains). The film begins with Margo landing in the ER after a suicide attempt. She seduces the doctor who treats her, Jeff, played by Robert Mitchum as a dumb hunk/easy mark. Jeff is an upstanding citizen with an overly accommodating nurse girlfriend (Maureen O'Sullivan, Farrow's wife), but Margo's eyes are black pools, and Jeff falls in. The next thing he knows, he's drunk and probably concussed, and Margo's husband is dead. Dizzy from a head injury, Jeff goes along when Margo declares they must flee. *Where Danger Lives* turns into a vicious skewering of what can go wrong when a trusting man is lured in by the wrong pretty girl. Faith gives an excellent performance, striking the perfect balance between irresistible and terrifying as she's working her con. At the end of the film, Margo's ego gets the better of her when Jeff is accused of having killed her hus-

band. "Do you think he could kill a man?" she scoffs. "I did it. I did it alone!" Margo's the kind of femme fatale bad girl whom you almost want to root for even as she's destroying lives; she's a female version of the charismatic male outlaws who populated so many films of the era, except sex isn't her weakness—it's her lethal weapon.

Robert Mitchum was the hottest star at RKO at this point. This was thanks, in a roundabout way, to a never-was glamour girl named Lila Leeds. Leeds had put in time as a hat-check girl and cigarette peddler at Ciro's nightclub; later she had passed through MGM and Warners as a bit player without making much of an impression. Then one night in 1948 she found herself at a party at Pat De Cicco's house. There she met a real estate agent named Robin Ford. A few nights later, Robin called Lila and told her he had a friend who was dying to meet her. The friend was Robert Mitchum. Bob was separated from his wife, unhappily. "We've had a disagreement," Mitch told Lila, "but I hope she comes back." In the meantime, Lila was happy to be a temporary companion to one of the most charismatic men in town. They went to nightclubs, smoked reefer together. Lila was a cool girl, and good company.

A few weeks later, Lila moved into a new apartment above the Sunset Strip, and she and a girlfriend named Vicky Evans decided to break the place in. Lila called her pot connection, who had several joints delivered, and then she called Mitchum to invite him and Robin Ford over. The boys didn't arrive until after midnight, after they had already split a fifth of scotch in Mitchum's kitchen. Robin, Bob, and Lila lit up joints. Vicky did not. The group heard dogs making noise on the porch. Vicky said, "I'll take care of them." She flung open the door and two undercover cops burst inside. The party was over.

By the time Howard Hughes got the news, it was too late to keep the story out of the papers. There were only three things to do: bail Mitchum out of jail, make sure he kept his mouth shut, and call Jerry Giesler—the high-priced Hollywood attorney who had made sure Errol Flynn and Charlie Chaplin had failed to do time for their alleged sex crimes.

The LAPD acknowledged that Mitchum had walked into a trap they had been laying for a year, as part of a plan to hold Hollywood accountable for its debauchery. "When sources reported to me that Mitchum was using marijuana I personally started investigating him," boasted Detective Sergeant Alva Barr. "I followed him to various nightspots. I would tail him from home and follow him around all evening. We followed him to parties at several other movie stars' homes, then to late eating spots and then would wait until he went to bed. Last night we were investigating Lila Leeds when who should walk in but Mitchum."

All the dope smokers were paranoid. Mitchum figured out that his disgruntled former business manager was also Lila's former agent, which led him to suspect Leeds for setting him up. In turn, Lila suspected that Vicky was behind the sting—after all, she was the one without a joint in her hand, who let the cops in. Mitchum's sister Julie believed that RKO had set Mitchum up because he had been expressing a desire to quit acting, and that Hughes had engineered the sting so that the mogul could appear to save the actor, and thus leave Mitchum indebted to low-rent RKO, so that he wouldn't walk away.

The gossip columnists tried to play it both ways, shaming Mitchum's behavior but holding out hope for his reform. "He could still be cured," Louella Parsons wrote, "providing he wanted to be."

Hughes had hidden Mitchum at publicist Perry Lieber's house, to be sure Mitchum wouldn't stumble across the reporters camped out in front of his own front door. But soon it became clear that in the case of Mitchum, there was no such thing as bad publicity. RKO began promoting the actor's western *Rachel and the Stranger* less than a month after the scandal, betting that the fact that Mitchum's name was still all over the papers couldn't hurt. They were right: before Marlon Brando or James Dean popularized his brand of laconic rebellion, Robert Mitchum was a totally authentic-seeming on-screen bad boy who was evidently walking the walk off-screen, and audiences loved it.

Though Mitchum had been judged by the public and acquitted, he still had to face the court. Jerry Geisler made a deal with the DA:

Mitchum would waive his right to a jury trial and mount no defense to the conspiracy to possess marijuana charge, leaving Mitchum subject to whatever the judge decided on the charge of possession. They were gambling that, in exchange for the actor's cooperation, the judge would sentence Mitchum leniently. He did not: Mitchum was declared guilty and sentenced to sixty days in jail.

Hughes rushed one last Mitchum film into production before this sentence began: *The Big Steal*, directed by future action auteur Don Siegel and costarring Jane Greer, yet another former Hughes love whom Howard had vindictively been holding out of movies ever since he took over RKO. When Hughes called Greer to tell her he was casting her, he also broke the news to her that "the rabbit died."[1] She was pregnant—her doctor had slipped the news to Howard, who was not the father, before telling Jane. As Greer later explained, "He had spies everywhere."

The Big Steal is notable for its bonkers car chase scenes, which anticipate the Fast and Furious films, albeit at a much slower pace. The focus on automotive action, performed by anonymous stunt drivers, was necessary, given that the movie's male star was MIA for portions of the shoot. Mitchum filmed the studio lot–bound portions before sentencing, then spent most of his sentence on an "honor farm," a low-security agricultural labor camp an hour north of Hollywood. Hughes came to visit him, and by the end of the afternoon, he had agreed to pay Mitchum's legal fees and loan him money to buy a new house for his family. (Dorothy Mitchum had returned to the fold, to play the role of supporting wife during Bob's scandal, and the couple would remain married for the rest of their lives; Mitchum was a man who enjoyed having affairs and also enjoyed having a wife to come home to.) At the end of his sentence, Mitchum told reporters, "I feel wonderful. I

[1] Pregnancy tests, for the first few decades of their existence, were colloquially called "rabbit tests," because in an early version of the test, rabbits were injected with a woman's urine and then examined for hormonal changes. Due to an urban legend that this process killed each test subject, "the rabbit died" became slang for a positive pregnancy test.

worked hard, slept well and batted .800 on the softball team. We won seven out of eight games." He compared the prison to "Palm Springs, without the riff-raff."

Siegel had been finishing *The Big Steal* on location in Mexico without Mitchum. A few days after his release, Mitchum showed up, having ingested at least one bottle of tequila by himself on the journey. This was a problem easily solved by a half hour in the steam room. By the time he got to set, according to Jane Greer, "He looked wonderful."

Mitchum was forever loyal to Howard for standing by him during the dark times. Hughes rewarded the actor's loyalty by casting Mitchum in some of the best movies that RKO would produce during Hughes's tenure. After *Where Danger Lives*, Mitchum moved on to shooting two undersung classics of a kind, *His Kind of Woman* (directed, like *Danger*, by John Farrow) and *Macao*. Both films costarred Jane Russell as Mitchum's love interest. As Lee Server, biographer of Mitchum and Ava Gardner, put it, the pairing of Mitchum and Russell was monumental, a collision of RKO's "biggest assets, the screen's two greatest chests."

Howard put his special touch on *His Kind of Woman*—meaning he demanded rewrites and reshoots, and tinkered with the cut until it was to his liking. He would brag to Louella Parsons that this was "the best picture I've ever made," and for once, the boast was accurate. Both a complicated, romantic noir thriller plumbing much metaphorical power out of a plot dealing with false identities and risk management, and a campy-comic spoof of contrived Hollywood action and the stars who perform it, the film anticipated blockbusters of the 1980s in its ability to surf multiple genres successfully.

It's also a fine example of Hughes's preference for titles that misrepresent the content of the film in favor of justifying an ad campaign built around ogling his lead actress's prized assets. Though the romance between Mitchum's gambler and Russell's singer/gold-digger injects some much-needed sex and glamour into a production whose shoestring budget shows in everything from the stark lighting to the extremely limited locations, this is not a movie that's primarily concerned

with any kind of woman. In fact, in order to ensure that the film's
final act is a boys-only affair—in which Vincent Price, as a comically
pompous swashbuckling movie star, saves shirtless damsel-in-distress
Mitchum from gangsters who want to inject him with a zombifying
Nazi anesthetic and surgically steal his face—at some point Jane is lit-
erally locked, kicking and screaming, in a closet.

And yet *His Kind of Woman* provides the finest showcase of what
Howard Hughes saw in Jane Russell—besides for what a character in
Macao would call "her obvious talents." First seen singing for fun in
a Mexican bus stop bar, Russell's Lenore is the kind of globetrotting,
independent woman who a movie like this likes to imply is a "profes-
sional" (when Mitchum asks the bartender about her, he's warned he
can't afford her: "She's drinking champagne, fifteen dollars a bottle").
In fact, she's a con artist, who has taken a new name and a new debu-
tante identity because she thinks it'll help her marry rich. Throughout
the film, as Lenore maintains her facade when she needs to while also
slowly opening herself up to Mitchum's attentions, Russell rides a fine
line between projecting a powerful sexual confidence and exposing
an understated neediness that feels more authentic than what you'd
typically see in a 1950s Hollywood melodrama. Though Russell is cos-
tumed according to Hughes's tasteless conception of a sex goddess (a
skintight sequined gown with a tulle back skirt is one tacky highlight),
her beauty is more middle-of-the-road than ethereal, and as such, she
paired nicely with Mitchum, the everyman who always looked like he
either just rolled out of bed or just got rolled in a bar fight. Jane Rus-
sell was Howard's idea of the girl next door. Here Jane was a prize to
be won, but a realistically flawed trophy, within a men's fantasy that
was much more melancholic and world-weary than the juvenile mas-
culinity Hughes had injected into *The Outlaw*. In the film's best-written
scene, Mitchum and Price discussed Lenore:

"You in love with her?" Mitchum's Dan asks Price's Mark.

"My wife says I've never been in love with anyone except myself."

"Who has?" Mitchum shrugs.

Wistfully, as if lost in a dream, Price responds, "People have."

This exchange happens just after Mark, the actor who has been pressed into a real gunfight after acting them out in the movies for decades, has admitted to hiding behind personas: "You know something? All my life I've suspected myself of being a phony. Half of it I've been acting—a hundred lives, a hundred stories, all of them phony. This is the only time the guns have ever been loaded with anything but blanks."

His Kind of Woman imagines a scenario in which fakers and phonies, loners and drifters, can finally stop running, and stop lying, and find something real in one another. It was a B-movie through and through, but it was the most thematically substantive—and possibly personal—movie Howard Hughes had anything to do with.

Russell's character in *His Kind of Woman* gestured toward the kinds of women played in 1930s Hollywood movies by Marlene Dietrich—traveling entertainer/outlaws, frankly sexual creatures brought by love to either doom or domestication (same difference?). For Russell and Mitchum's next match-up, Hughes hired the man who had directed Dietrich in some of the most beautiful, ambiguous, and adult depictions of sex and love in the history of Hollywood film. Josef von Sternberg hit his peak working with Dietrich in the 1930s, on films like *Morocco*, *Shanghai Express*, and *Blonde Venus*, but he hadn't directed a film since *The Shanghai Gesture* in 1941. He had been brought into the RKO fold by *The Outlaw* screenwriter Jules Furthman, who had also written many of the Dietrich-Sternberg collaborations, and whose tastes Hughes trusted enough to assign him to the project most dear to him during this era, *Jet Pilot*. *Jet Pilot* was a Hughes pipe dream, an attempt to re-create the success of *Hell's Angels* in the jet age, starring Janet Leigh and John Wayne. Von Sternberg would perfunctorily shoot Furthman's script, and then Hughes and several other directors would spend years tinkering with the footage. In the meantime, Hughes would shift Sternberg over to working on *Macao*.

Macao was conceived as a sexy, exotic adventure, not unlike those earlier Von Sternberg–Dietrich films, with Russell as Julie, a singer

who has grown weary of going from port to port running various scams, and Mitchum as Nick, a drifter who shot a man in a dispute over a woman five years earlier, and has been on the run ever since. As in *His Kind of Woman*, there's a question of identity: here Nick is a petty criminal with a heart of gold who is wrongly suspected of being a cop, and Jane once again plays a singing con artist, but here her modus operandi—to manipulate men any way she needed to—was more blatant.

On a boat from Hong Kong to Macao, Julie is in a cabin with a man she hustled for ferry fare. Expecting something in return for covering her passage, he tries to force himself on her. She throws her shoe at him and it flies out the cabin window and hits Nick as he's walking by. He comes in and slugs the would-be rapist so hard he passes out. A second later, Nick takes a hero's prerogative and kisses Julie. "Now we're even," she says as she walks out on him. In the next scene she changes her stockings on the deck of the boat, throwing the old pair to the winds. They blow into Mitchum's face on the deck below. When she slinks off, disinterested in him, he tucks her stocking in his pocket—and realizes she took the opportunity of their clinch to steal his wallet.

And yet, for Julie, the thrill of petty crime is gone. Sturdy and statuesque, poured into a wiggle dress with a collar splitting the difference between sailor and Peter Pan, Julie strolls through a Macao casino where she's heard there's work for her, and every head turns. Her walk is heavy but quicksand slow. She's like a brontosaurus, plodding through an open field, with so many meals all around for the grazing that she's lost interest in food. At the job interview, the boss tells her, "We'll get along a lot better if you take that chip off your shoulder." She sighs, and then says, with palpable melancholy, "It never did me any good anyway." This is Jane Russell at her most unpretentious and over-it, and yet she's able to drop a wisecrack limned with what feels like a raw truth. She's never come across more like a female Robert Mitchum.

The affinity between the characters, and the actors, is best expressed

in a scene in which the two lazily cruise around the harbor in a small rented boat. Before she was a singer, she tells him, she was a fortune-teller. The secret to telling a stranger's fortune, she says, is under-standing that "everybody's lonely and worried and sorry. Everybody's looking for something." He invites her to join him on a near-deserted island, where he's been offered a job managing a plantation. She says she will. She looks at him like she's serious, and she can't believe it's finally happening. He asks her to wait a month, until he gets his affairs in order. Russell's face floods with silent desperation. The dream they lived in for a moment is over. She can't wait a month—who can trust a man who says he's going to do something in a month?

Jane Russell's *Macao* character arc is of a world-weary woman se-cretly longing to let down her impenetrable guard, who finally does just that when Mitchum's Nick reveals himself to be a good guy (and not a cop). You do root for her and Mitchum to get together, but at the same time, the persona Julie walks around inside is so tough, so knowing and full of contempt for the kind of bullshit that a woman who looks like her has to put up with (in the movies, in real life), that it's hard not to root for her to keep it.

No one on the set of *Macao* thought they were making a master-piece, but the material was well tailored for its stars' talents. And yet it became clear pretty quickly that Von Sternberg believed the cast-ing was the problem. He'd try to buddy up to Mitchum by negging Jane: "Now we have to bolster this beautiful girl with no talent." But Mitchum and Russell had bonded, and Mitchum's loyalty was to his costar—as was Howard's. Von Sternberg was fired.

As became typical of films in which Hughes took a special interest, no one person was allowed to put a personal stamp on the pro-duction, and thus seven writers and four directors (including Robert Stevenson, Mel Ferrer, and Nicholas Ray) each laid their hands on the film before it was done. At one point, Ray handed Mitchum a legal pad and some pencils asked him to write a scene for them to shoot in the afternoon. "The best scenes are the ones he wrote," Russell said later. "Where we acted like natural people." Directors came and went,

but Jane Russell stayed. "Instead of fingers in that pie," Von Sternberg quipped of *Macao*, "half a dozen clowns immersed parts of their anatomy in it."

Hughes had only been truly concerned with one anatomical part—well, two. After viewing footage of Russell in a gold lamé gown, he had written a detailed memo about the appearance of the actress's breasts. "The fit of the dress around her breasts is not good, and gives the impression, God forbid, that her breasts are padded or artificial," Hughes wrote. "It would be extremely valuable if the dress incorporated some kind of a point at the nipple because I know this does not ever occur naturally in the case of Jane Russell. Her breasts always appear to be round, or flat, at that point so something artificial here would be extremely desirable if it could be incorporated without destroying the contour of the rest of her breasts." To sum up, he added, "I want the rest of her wardrobe, wherever possible, to be low-necked (and by that I mean as low as the law allows) so that the customers can get a look at the part of Russell which they pay to see."

Whatever can be said against *Macao*'s cobbled-together finished form, the film's considerable lasting value lies in its few visual ideas that are distinctly Sternbergian (for instance, his insistence on filming action and women from behind nets and thin curtains, giving the mundane a voyeuristic excitement), and in the unusual chemistry between its stars. The film pits an independent woman who is bone tired of living with her guard up and doing it all alone, against a man who has never taken responsibility for anyone but is suddenly moved to stick his neck out (to borrow a phrase from this kind of character's archetype, Humphrey Bogart's Rick in *Casablanca*) for a lady he could love. In a classic Hollywood romance, the friction comes from opposites, or creatures thrown together by chance with opposite fates, finding a small piece of common ground, or recognition. In the Mitchum-Russell movies, from the beginning two iconoclastic loners each recognize themselves in one another, and thus assume the other can't be trusted. The male/female versions of one another, they spend the course of the narrative letting desire overcome instinct.

It was no accident that this RKO dream team put together by Hughes consisted of performers that each conformed to Hughes's personal ideals. Jane Russell, of course, was the first in a long line of brunettes in Hughes's life, and she set a larger-than-life template for a number of women to follow, from Ava Gardner to Faith Domergue to Jean Peters. And, according to Terry Moore, "The man that [Hughes] thought had the greatest sexual powers in the entire world was Bob Mitchum." Mitchum was everything Hughes was not: built like a brick wall, never anxious, always cool. (Hughes once admiringly told Mitchum that the actor was "like a pay toilet—you don't give a shit for nothing.") Because of these qualities, not only did women flock to Mitchum, but he was able to effortlessly get the kind of publicity that Hughes had to bend over backward over piles of money in order to generate.

Mitchum's ability to bumble upward was all the more attractive as the responsibility of running a major studio began to weigh heavily on Hughes. As RKO's output slowed to a trickle of disappointing movies under Hughes's watch, the "Managing-Director" seized on an opportunity to misdirect inquiring minds away from the studio's failures and toward the old-standby image of Hughes the American Hero.

THE MORALS CLAUSE

A dozen years into her stardom, Jane Russell was still more likely to be seen in a still photo in a newspaper than she was on a movie screen. The February 1952 premiere of *The Las Vegas Story* opened up new opportunities for Hughes's publicity team to plant photos of Russell in major publications on the flimsiest excuses for news. One February morning in 1952, she sneered out from the pages of the *Los Angeles Times*, white blouse unbuttoned dangerously far, edifying the caption: "Jane Russell's favorite way to relax is to lie in a tub of warm water scented with oil of pine. She is seen in the new picture, RKO's *The Las Vegas Story*."

The details of Jane's bathing habits were likely planted by RKO as an attempt at misdirection, to change the narrative. A few days earlier, the papers were full of reports that Russell had been seen at the *Las Vegas Story* junket, not in a bathrobe but with a shiner. While the *Los Angeles Times* had run a photo of a smiling Russell in sunglasses, the top half of the front page of their lower-rent rival the *Mirror* was occupied by massive type, declaring: "JANE RUSSELL'S BLACK EYE STIRS VEGAS STORIES." The rest of the page was taken up by a large picture of Russell in a low-cut gown, as well as smaller shots of her husband, Bob Waterfield, and comedian Ben Blue. The photo of the two men was captioned with the tease of a scoop: "Jane Russell is doctoring a black eye, made more conspicuous by huffy flight of

husband, Bob Waterfield, to Los Angeles. Hectic Las Vegas weekend started when Comic Ben Blue made remarks about Jane's assets. Blue said Bob didn't accept apology."

Inside the newspaper, the Russell camp offered an explanation. After Waterfield went home to Los Angeles to meet a previous commitment, Russell was getting into a car when the heavy desert wind blew the car door into her face. Russell told this to reporters when she landed at Los Angeles International Airport, where she was greeted by her husband. "It makes a good story, doesn't it?" she winked.

In her 1985 memoir, Jane told the real story, and it wasn't good. Her husband and a bunch of his football pals had come to Vegas for the junket. Jane and Bob had been apart and she had missed him, and she felt neglected when he seemed more interested in boozing with his bros than being with her. "We were all drinking a lot," she admitted, "and at dinner he said something nasty and I ran my fork down his face, leaving four little red lines." When they got back to the room that night, she tried to apologize, but Bob slapped her.

"He had never slapped me before," Jane wrote. "I said, 'Oh, I'm sure you can hit harder than that,' so he did."

Bob kept on hitting her until Jane's head was spinning. The next morning, her whole face was swollen. Bob took a look at her and said, "You can get a divorce in ten weeks in this state," and flew back to Los Angeles.

Nobody at the junket believed the door story, and they humiliatingly teased Jane about it. On the plane back from Vegas, in the presence of all the journalists, Jane's costar Vincent Price yelled out, "Come on with that wind story, we all know Waterfield hit you." They all laughed.

Back in Los Angeles, Bob picked Jane up at the airport, and they made up. Jane decided none of it would have ever happened if they hadn't been drinking, and that this must be a sign from God that she should dry out. "But it got very boring being the only sober person in the crowd," Jane wrote, "so eventually I went off the wagon."

All of the press generated by the *Las Vegas Story* junket caught the

eye of Paul Jarrico, who had written a script under that title for RKO, before being fired by Howard Hughes in March 1951, after receiving a subpoena from the House Un-American Activities Committee. Four years after the *Crossfire* team and the rest of the Hollywood Ten first appeared before HUAC, the Hollywood Blacklist was ongoing, and now a subpoena all but guaranteed that the suspected Communist would have to name the names of other "subversives" or else see their career opportunities in Hollywood completely dry up. Many subpoenaed writers worked for cut rates under assumed names, or went to Europe. Paul Jarrico instead chose to fight back.

Jarrico was proud to be a Communist. He had been one since his youth in the 1930s, he was one at the time of his subpoena, and he remained loyal to the party through the 1950s, long beyond the point when many of his comrades had turned their backs on it. Some argued that the Hollywood assembly line system made any attempt at injecting movies with propaganda futile, but Jarrico believed it was possible to "sneak" progressive messages into Hollywood movies, and tried to do it when the opportunity arose. The 1941 Ginger Rogers vehicle *Tom, Dick, and Harry* was, to most viewers, a hit romantic comedy; to Jarrico it was a parable that spoke to and on behalf of the workingman, suggesting he was the correct romantic match over his rich rival.

Jarrico was nominated for an Oscar for that script, suggesting that if anyone picked up on his subversion, no one thought it was a problem. But much had changed in a decade. Howard Hughes would claim later that after firing Jarrico, he immediately insisted that *The Las Vegas Story* be completely rewritten to remove the Communist taint. Only in reading about *The Las Vegas Story*'s press blitz did Jarrico learn for the first time that Hughes had removed his name from the film, giving sole credit to rewrite author Earl Felton. This had happened before to Jarrico, before he was subpoenaed, on Ida Lupino's *Not Wanted*, and then Jarrico had filed a claim with the Screen Writers Guild to demand his credit be reinstated (it was). Now Jarrico again filed an appeal to the guild on *The Las Vegas Story*, claiming that while his dialogue had almost completely been re-written, the structure of the finished film's

story remained the same as in his version. The guild determined Jarrico should share screenplay credit with Felton.

Hughes disagreed. He maintained that the guild's contract was with the writer, not the studio, and that Jarrico had voided his studio contract by violating its morals clause when he refused to declare that he was not a Communist. When Hughes issued a proclamation daring the Screen Writers Guild to strike over their support of Jarrico, the *Los Angeles Times* ran it as their top story on the morning edition front page, the headline in an uncommonly large font.

BY THE SPRING OF 1950, Ida Lupino was widely championed as Hollywood's first actress turned director of the sound era. That March, she was invited to present the Best Director prize at the Academy Awards. Winner Joseph Mankiewicz, in his speech, affectionately referred to the presenter as "the only woman in the Directors Guild, and the prettiest."

That fall, Ida's finest work as a director would hit movie theaters. *Outrage* starred Mala Powers, a raven-haired nineteen-year-old whose casting Hughes had personally approved, as Ann, a bookkeeper at a lumber yard who is raped after hours by the guy she buys coffee from every morning. *Not Wanted*'s credits had played over a flash-forward to the film's heroine at her most desperate and broken, and here, again, Lupino began the film by showing Powers at her most vulnerable, limping through the streets, totally alone. The director then flashes back to show Ann two days earlier, happy and vibrant, buying two slices of chocolate cake from a coffee counter vendor. The vendor makes an aggressive pass at her, and, like a girl who hears such things every day, she rolls her eyes and goes on with her life. That life includes a boyfriend, Jim, who tells her while they eat the cake that he's been given a raise, and they can finally get married.

Ann's American-girl dream is crushed the next evening. She gets off work late and begins to walk home alone. The coffee counter guy lies in wait for her. She walks alone through the darkened mill where she

works, whistling. The coffee guy calls out to her, "Hey, beautiful!" She doesn't stop. He follows her. She starts to become aware that something doesn't feel right. The camera, facing Powers, dollies back as she quickens her pace. The coffee guy rounds a corner and becomes visible behind her, in the middle of the frame. He whistles, and she freezes, as does the camera. She turns around, looks at him, looks around, and then starts to run. He follows her. She looks for somewhere to hide, banging on the windows of an abandoned building. In her nervousness, she knocks over a metal trash can, which gives him a clue as to where to find her. Lupino switches to an overhead camera to track Ann as she runs through a maze of empty, industrial streets. A taxi speeds around a corner and she frantically tries to hail it, to no avail. Outside a trucking company, she's able to rig a truck horn to blare. This gets the attention of a man in the upper window of the business, who looks out to see what's going on. What he can't see from his vantage point is what we've already seen: she has tripped and fallen, and her stalker has caught up with her.

In the aftermath of the attack, Ann becomes hysterical. She can't stop defending herself, as though it were her fault. "I couldn't get away!" she cries. "I couldn't move!" The next day, she decides to pretend like everything is normal and fine. But on her walk to work it feels like everyone is staring at her, that everyone knows and all they can think when they look at her is, "That's the girl who got herself raped." From here, *Outrage* becomes a psychological thriller, with Lupino using creative editing and sound design to amplify her heroine's PTSD. All the conditions are in place for Ann's quick recovery—she has people who care about her, her family and coworkers want to help, and her fiancée still wants to marry her—but startlingly, she can't handle all of this kind attention, because she feels so broken inside. Without telling anyone, she gets on a bus and skips town. She essentially becomes a fugitive and starts a new identity in a new town, where, when a man flirts too aggressively with her, she becomes consumed with the delusion that he's her rapist, and she nearly kills him.

Outrage deals with a uniquely female situation in a uniquely empathetic

way. After such a violation, it asks, how could a woman learn how to be around men again, to trust them, to let them touch her? How would you get out of the psychological head space that it was *you* who did something wrong? How do you stop running? In Ann's case, it's a purely platonic man friend who restores her faith in male goodness and puts her on the road to recovery. The ultimate thesis of the film is that women are not sex objects, and treating them as such—through full-on sexual assault, unwanted sexual advances, or even just condescending commentary—has lasting consequences. *Outrage* is not perfectly enlightened by modern standards, but in a Hollywood era in which the top female star was pinup queen Betty Grable—and especially at RKO, where the bulk of Hughes's creative decisions stemmed from his own sex drive—the film was revolutionary.

Outrage received some rave reviews. "It is a picture that every parent, as well as every woman, should see . . . the story hits home to every family in that such an occurrence might happen anytime to any girl or woman," wrote Shirle Duggan in the *Los Angeles Examiner*, singling out Ida for her direction. The *Los Angeles Daily News*, *Hollywood Citizen-News*, and the trade paper *Film Daily* all approved, as well. But the two biggest trade publications threw cold water on Ida's accomplishment. In what seemed like a misreading of the film's plot, *The Hollywood Reporter*'s review accused Ida of exploiting "rape as motivation for an old-fashioned 'find happiness on the land' drama." If *Outrage* were a "clean-cut essay with strong educational overtones," added the *Reporter*'s critic, "its sordid theme of criminal attack might have more justification." The *Variety* review was also dismissive: "Overdirected in many instances by Ida Lupino, there will be many who will take issue with her interpretation of the girl's reaction to her plight. Film throughout lacks any elements of entertainment in its desire to sock over a depressing message. Hard selling will be required here, with expected grosses slim." *Variety* did not report extensively on *Outrage*'s grosses—perhaps because there was nothing of note to report—but the movie had come in so far under budget that it didn't need to gross big.

Ida Lupino's popularity in Hollywood was untainted by her boy-friend (and eventual husband) Howard Duff having been branded a "communist sympathizer" by the witch-hunting press. In July 1950, two months before *Outrage* was released, Duff had been one of 151 entertainers whose names were named in the pamphlet *Red Channels*, which was as close to an official list as was actually printed during what became known as the Blacklist era. Duff soon thereafter lost his job as the star of the popular radio serial *The Adventures of Sam Spade*. Duff didn't understand why he had been targeted; like so many others who were the subject of finger-pointing during this era, he had been a liberal Democrat since the time when the country had been united in a hate for fascism, but he had never been a registered Communist.

That didn't mean there wasn't any evidence that the McCarthyites could use against him. Under Hughes's direction, RKO subscribed to a service provided by an outfit calling itself the American Library of Information (ALI). This was a racket run by the Better America Foundation, which compiled bare-bones dossiers on potential subversives. Few reports included information beyond mentions of the subject in various Communist publications, or the fact that the suspect had subscribed to such publications, often two decades earlier. RKO received a report from ALI on Howard Duff in March 1952 (a year in which the studio paid $1,500 for ALI's services, up 50 percent from the previous year). Duff was accused of having subscribed to *People's World* in 1939 (and only 1939), as well as having publicly supported the Hollywood Ten and the Committee for the First Amendment, the all-star band also including stars like Humphrey Bogart and Lauren Bacall, which had organized a trip to Washington to support the Ten at their hearings.

Lupino would claim that she personally visited her "buddies at the FBI" to ensure protection for Duff and another man to whom she was close who had been unfairly targeted, actor John "Julie" Garfield. This visit is not documented in the portions of Lupino's FBI file made available through a Freedom of Information Act request. If she did reach out to the FBI on Garfield's behalf, it seems her intervention could only do so much. Garfield, unable to work in studio movies, had gone back

to New York, where he was doing theater, and drinking heavily. Aware that he was not doing well, Lupino went to New York to see Garfield in Clifford Odets's *Golden Boy*, but he didn't perform that night, and when she went to check on him, he seemed to be a shell of the exuberant character he used to be—not just in bad health, but weak in spirit. Ida told Julie that she had spoken to the FBI on his behalf. He asked her to hold his hand as he drifted off to sleep. She did, and then went home to Hollywood determined to find a movie role for her friend, to help bring him back from the brink.

The problem was that Ida was under contract to make movies at RKO, and RKO was run by an increasingly eccentric, head-traumatized megamillionaire who had become obsessed with eradicating Communists from the film industry. On a base level, Communists posed the same kind of threat in Hughes's racist mind as black people and all the "others" he disliked and feared, while also firing up Hughes's capitalist imagination, in more ways than one. Not only did the reds threaten Hughes's ability to operate unchecked in a free marketplace, but in aligning himself with the anti-Communist cause, he also spotted an opportunity to shore up credibility with the power brokers who provided him with lucrative military contracts. In keeping with his lifelong germophobia, Hughes treated the supposed Communist infiltration of RKO like an infestation: he essentially tented the lot.

On April 5, Hughes released a statement announcing he was shutting down production at RKO, putting one hundred employees on "leave of absence" while he made sure that none of them were tainted. "The plain fact is they are innocent victims of the Communist problem in Hollywood," Hughes said in a statement. "It is my determination to make RKO the one studio in Hollywood where the work of Communist sympathizers is not used."

By this point, Jarrico had filed suit against RKO and Hughes, seeking lost income and punitive damages. He alleged that Hughes, who had claimed that he had suspended production at RKO in order to hunt Communists, was actually trying to distract from the fact that his stu-

dio was running at a loss and Hughes was clueless as to how to turn it around. It was an open secret in Hollywood that RKO was having trouble producing enough content to be profitable, and it was apparent that Hughes and his current publicists, Perry Lieber at RKO and the outside firm Carl Byoir and Associates, were running damage control. For every column that hinted at RKO's troubles, there'd be an obviously planted item in another paper enthusing about the impressive slate of RKO attractions on the horizon, such as one in *Film Daily* in February 1952 suggesting that independent productions like *Clash by Night* (featuring Marilyn Monroe) and *Jet Pilot* represented "the most potent product this studio has ever prepped for early distribution at any one time in its history."

Jarrico's allegation was probably, at least in part, true, but it was perceived as a desperate move in a climate in which Hughes's zero tolerance earned him plaudits from on high. Representative Donald Jackson of HUAC praised Hughes for his stance on Jarrico at a Kiwanis Club lunch in Los Angeles, and on the Senate floor, Richard Nixon declared that Hughes had earned the "approval of every man and woman who believes that forces of subversion must be wiped out." In March, a *Los Angeles Times* editorial lauded Hughes's hard-line stance on Jarrico specifically and Communists in general, predicting, "If the Screen Writers Guild calls a strike on such an issue, it will not have the sympathy of the public, nor deserve it. Most Americans will agree with Hughes that a writer who declined, before the Un-American Activities Committee, to answer a question as to his Communist affiliation on the ground that to answer might incriminate or degrade him thereby certified his unfitness for any employment that would bring his name before the public."

Hughes's campaign to exterminate Communists in the film industry had an intended audience outside Hollywood. In June 1953, gossip columnist Jimmie Fidler reported on his radio show that Hughes was "dickering with the war department for the first commercial contract to manufacture atomic weapons." This was just gossip—but given the

overall political climate, Hughes would have been wise to believe that his fortunes as a government defense contractor were related to the overall perception of him as a good American.

Whether Hughes knew it or not, the FBI had on the record a differing opinion as to his merits as a citizen. Just a few months earlier, an internal Bureau memo noted that a source, whose name they redacted but who from context appears to have been a high-ranking executive at TWA, had described Hughes as "an unscrupulous individual who at times acts like a screwball and paranoiac, to the extent that it is conceivable that he might even be capable of murder." In this light, it seems likely that the RKO shutdown was a publicity stunt aimed at selling the image of Hughes as a man who put country over company, thus bolstering a Hughes business that was worth much more financially than the movie studio ever could be.

Six weeks after Hughes shut down RKO, John Garfield died in bed, at the age of thirty-nine. The official cause of death was cited as a heart attack, but many close to him believed that being blacklisted had pushed his already weak heart to the brink, sapping him of the will to live. The passing of this once-beloved star did nothing to pause the persecution of "un-Americans." At the time, it was anathema to mention the human cost of the Blacklist, lest one wanted to see their own name blackened, and their own opportunities diminished.

Hughes did not openly punish Lupino for her associations with those under a cloud of suspicion, but he didn't make it easy for her, either. Throughout her time under contract to RKO, Hughes rejected many of her movie ideas. He put the kibosh on potential films about Mexican Americans (for whom Hughes had no empathy) and the atomic bomb (regarding which Hughes had conflicts of interest as a military contractor). Then, right after Garfield's death, when Ida was pregnant with Duff's child, her script for a film about gambling addiction was rejected, too. The excuse given was that the subject matter was not commercial. Lupino had made an unfortunate mistake in timing, proposing her casino movie just a few months after the release of *The Las Vegas Story*, which lost more than half a million dollars for the studio,

and had wider reverberations than any other bad, money-losing movie that year.

"RKO WAS SO PECULIAR," Sally Forrest remembered. "It was like a vacant studio, and the most peculiar things would happen—so strange."

While Hughes quarantined his studio and prevaricated on which films to produce and when, his contract stars could only hurry up and wait. "The only thing in production right now on the RKO lot is Bob Mitchum's truck," Jane Russell joked to Hedda Hopper. "Bob's having the vehicle converted into a living quarters to use on his ramblings. I just stand by and heckle Mitch while he works." Jane had plenty of time to talk to journalists. A misleading headline in the *New York World-Telegram* promised the scoop on the "Two Men in Russell's Life," the two being Hughes and Bob Waterfield, who, it was reported, "budgets her income, pays her bills and gives her a pretty meager portion of her salary for an allowance."

Production would resume at RKO in May, but because the studio couldn't ramp up fast enough to meet their distribution goals, it began investing heavily in foreign films. Thus Howard Hughes's mismanaged studio, led by an increasingly disturbed xenophobe who had staked its future on eradicating so-called un-Americanism, became responsible for bringing some of the most lauded non-American films of the era to American screens, including *Kon-Tiki* (the Norwegian documentary that won the Oscar in that category in 1951), *Rashomon* (Akira Kurosawa's groundbreaking drama that pioneered the showing of a single event from multiple, different perspectives), and *Umberto D*, arguably the peak of Italian Neorealism, directed by Hughes's old friend, Vittorio De Sica.

By August, the *Wall Street Journal* was voicing skepticism that Hughes had really shut down RKO to clean out the Commies: "Some industry observers claim the production cutback actually came because the firm's pictures were having a box office slump." To call it a slump

was to put it gently: RKO's fortunes had steadily plummeted in the four years that Hughes had owned the studio. So it wasn't a huge shock when, in September 1952, he agreed to sell his interest in RKO to a syndicate of Chicago-based buyers headed by Ralph E. Stolkin, who had become a millionaire by his mid-thirties thanks to an investment in television tubes. The purchase price was $7 million, at least a million dollars less than what Hughes had paid for his shares in 1948. The buyers made a down payment of $1,250,000, joined the board of RKO, and agreed to pay the rest of what they owed by the beginning of 1955.

Two months after agreeing to sell RKO, Hughes appeared in court to testify against Paul Jarrico. The key question in the trial was whether Hughes and the studio breached Jarrico's contract by firing him. The Hughes position held that, on the contrary, Jarrico breached his contract himself by violating its morals cause. It was risky for Hughes to put all of his eggs in the morals clause basket. For one thing, the history of morals clauses in Hollywood is a complicated one, rife with double and inconsistently applied standards. Inserted into all standard contracts after the scandals of the 1920s, morals clauses were mostly used to scare performers into toeing the line. Before the blacklist era, they had never actually been used as the public reasoning for any firing, although they were certainly evoked behind closed doors.[1]

Hughes's own application of the morals clause had previously been indifferent. There was the Robert Mitchum arrest, which had resulted in no censure by RKO, and if anything, the opposite. (Without naming Mitchum, Jarrico cited RKO's treatment of a star found guilty of "the use of marijuana" in his suit.) Jarrico also stated that RKO "well knows that Howard Hughes, its chief executive, is a person who in the motion picture industry generally, and in Hollywood in particular, is reputed to be an individual whose personal acts and conduct are in constant violation of generally accepted public 'conventions' and 'morals' in the

[1] To offer just two examples: in the 1920s, gay actor William Haines quit MGM when Louis B. Mayer threatened to use the morals clause to fire him unless Haines married a woman, and in 1949, Universal reportedly dropped starlet Barbara Payton for brazenly violating her morals clause by having an open affair with Bob Hope.

ordinary sense." Clearly Jarrico was hoping his lawyers would use Howard's womanizing against him, and the writer even put together a dossier to help them do it. "Since the issue was his right to take my name off a film under a morality clause," Jarrico later wrote, "I did think his morality was pertinent; after all, his name was on the film too—and remained on."

Rebutting the theory that Jarrico's morals were a liability to *The Las Vegas Story*, the writer's lawyer, after establishing that RKO had marketed the movie as "presented by Howard Hughes," asked the millionaire what kind of impact it might have had on the film to be "presented" by a man who was famously described in *Time* magazine as likely to "never die in an airplane . . . [but] at the hands of a woman with a .38." Hughes's lawyer loudly objected to the question. Howard just laughed.

Jarrico's lawyer then went back to the allegation that Hughes was using the fight against communism as a shell game to avoid responsibility for his failure to sustain RKO as a profitable enterprise. Hughes and his attorneys repeatedly denied that RKO had been "shut down" but conceded that the studio had been and was in a phase of "limited production."

When the Hughes side rested their case, Jarrico's attorney called Richard Davis, one of Howard's personal publicists, to the stand. Davis acknowledged that he had sent out press releases about Hughes's clash with Jarrico—which Jarrico's side said was evidence that Hughes had started the battle as a publicity stunt, as a smoke screen to distract attention from the real troubles at RKO. Hughes's side protested that Jarrico created the publicity himself by refusing to tell Congress whether or not he was a Communist.

The trial would go Hughes's way: by the end of the month, the judge declared he and RKO were within their rights to deny credit to Jarrico on *The Las Vegas Story* because Jarrico's conduct before HUAC brought the writer into "public disgrace," thus violating the morals clause in his contract. But by the time the verdict was issued, the overextended Hughes was hardly in a position to celebrate. A series of *Wall*

Street Journal articles had revealed Ralph Stolkin and his partners in the acquisition of RKO to be shady characters who had ties to mobster Frank Costello. It was revealed that Stolkin and crew had, among other things, presided over a phony children's charity, and drawn investigation from the Federal Trade Commission and Better Business Bureau for a number of their various commercial ventures, which ranged from the production of gambling machines to the peddling of loans through the mail. As gossip swirled that RKO had been taken over by a group of low-level Chicago gangsters, Stolkin and his men decided to quickly cut their losses. Citing what they called "a mass of unfavorable publicity," the Stolkin syndicate resigned from the RKO board and within a few months backed out of the deal entirely. Hughes got to keep their $1.25 million deposit. In a year when RKO had lost more than $10 million, Hughes's personal windfall didn't sit well with RKO shareholders.

Hughes now found himself stuck with a studio that he didn't know how to run, and couldn't get rid of. And, with the absence of suitable leadership more evident than ever, Hughes would now assume more responsibility over RKO than he ever had before: with the dust still settling from the Stolkin mess, in December 1952 Hughes begrudgingly assumed the position of chairman of the RKO board.

GIVEN THE INACTIVITY AND disarray at RKO, Ida Lupino had been one of the studio's most reliable filmmakers. She had very carefully and savvily negotiated her unusual situation, forever crediting the sexist system for giving her a chance, even publicly thanking the censors for their input on her controversial films. A publicity genius like Howard Hughes could not have asked for a better partner.

He was about to lose her.

That summer, Ida would make her final film for RKO, *The Hitch-Hiker*. As if to prove that she could make her gender invisible, Lupino sought out the story of serial killer Billy Cook and worked hard to prepare a script that the MPAA would approve. Aside from the opening

moment of the movie, in which an off-camera woman is heard scream-
ing, the film's cast is entirely male. You could read *The Hitch-Hiker* as
a straight thriller about man's inhumanity to men, and the Lupino of
1952 hoped that you would. But in hindsight, the film also works as a
parable mocking the idea of the male-bonding road trip as a vacation
from domestic life, and slyly indicting the horrors of a world free of
feminine influence.

As ever, it was the male influence in Lupino's life that got her in
trouble. After *The Hitch-Hiker* completed her commitment to RKO,
Collie Young convinced Ida it was time to go back on their own. He
believed that they could make more money distributing their movies
themselves. Twenty years after their first date, Ida Lupino's relation-
ship with Howard Hughes was over.

Free at last, Ida and Collier set out to make a film that ironically
probably would have interested Hughes more than any they'd yet made.
In a neat casting gimmick, *The Bigamist* would star Ida—Collie's ex-
wife—as well as Joan Fontaine, Collie's current wife. *The Bigamist*
is a loaded ideological weapon, a particularly dangerous one for 1953,
and with it Lupino pulled off an incredibly delicate balancing act. The
film suggests that the titular man with two wives believed he was en-
titled to take up with a second woman (played by Ida) because his first
wife was barren and had gone to work outside the home. Having seen
two marriages dissolve in part due to her professional ambition, Ida
cast herself as the opposite of a determined careerist—the agreeable
sort of lady for whom it would be a relief to give up work in exchange
for a man's love and a home to keep in order to make that man happy.

The Bigamist plays out from the husband's point of view, allowing
the film to express all of the anxieties of the postwar American male,
who had returned from combat to a world in which women had as-
sumed power in their absence—and didn't always want to give that
power up. By creating a film that dealt with these issues in a way that
seemed to be entirely sympathetic to such men, Lupino was able to
do a kind of Trojan horse act. No one could accuse her of trying to up-
end gender norms by depicting a man's frustrations with a wife who

seemed uninterested in wifely duties, or for structuring a story around the fact that to seek solace in a second woman while still married to another is both against the law and against an ethical code that ran deeper in society than the current masculinity crisis. In other words, without saying so directly, *The Bigamist* understood that men were upset by their wives' ambitions and desires outside the domestic sphere, but it also told them that finding another, different woman without those ambitions and desires was not the correct solution. The movie ends with a judge wondering aloud if either of the bigamist's wives even wanted him back—as close as a film of 1953 could get to suggesting that two adult women would be better off alone than with a selfish, duplicitous man. While most audiences at the time would have read the film literally, today we can see *The Bigamist* as a vicious parable attacking the impossible social climate in which Lupino was attempting to work as a director, in which she would never be able to reconcile her stereotypically "male" job with the era's propaganda insisting that a "normal" woman's main priority was to breed and serve a man's needs.

The Bigamist made Lupino the first actress of the sound era to direct herself in a Hollywood feature film. But once again, Collie proved to be lacking as a businessman. The independent distribution gamble he thought would make them more money than their RKO deal failed when *The Bigamist*, which was well reviewed, was not booked into enough theaters to make money at the box office. In the interest of putting her marriage first, Ida then hired Don Siegel to direct her and Howard Duff in a script she wrote, *Private Hell 36*. Siegel said he had a hell of a time working with Mr. and Mrs. Lupino, whom he wrote off as "talented but pretentious." There was also, as Siegel put it, "too much alcohol in the air" on set, and his direction and the performances suffered.

By the time that movie was finished, Ida and Collie's production company had fallen apart. Ida felt getting into distribution was their "one fatal mistake." *The Bigamist* would be the last feature film that Ida Lupino would direct for thirteen years.

RIVALRY AT FOX

For a supposed newlywed, Howard Hughes spent a lot of time away from his supposed wife. Before long, Terry Moore became paranoid that he was involved with other women. She'd make accusations, ask him to tell her the truth, but he denied it all. Finally, on one phone call, he said to her, "If you still think it's true, catch me. Go on. Catch me."

Terry almost always did what Howard told her to do.

She told her father she suspected that Hughes was really in Las Vegas, cheating on her, even though he had told her he was busy with airplane stuff in Santa Monica.

"The son-of-a-bitch," Terry's father responded. "I told you he was full of it. I never did believe there was a ship's log. I never believed you were married to him for one minute. He's never believed it for one minute either. If you catch him red-handed, will you give him up?"

Terry agreed that she would, and her father called a friend who purported to be an ex-agent for the FBI. Terry, her parents and the FBI guy headed to Vegas. They found Howard at the Desert Inn. Terry spied the man she believed to be her husband walking into the casino's restaurant with his aide Walter Kane, a very young blond woman, and several members of the blonde's family. Terry watched as the family admired a new wardrobe of bathing suits that Howard had bought for the girl, whom Terry described as "a tall string bean with an unhealthy pallor."

Terry couldn't watch any longer. She approached the table and introduced herself to the new girl. "I don't want to interrupt," Terry said

to Hughes. "I'm very, very busy." Terry made her exit, and back home in Glendale, she vowed she would never see Howard again.

Three weeks later, Terry got a call from Glenn Davis, a football star who played for the Los Angeles Rams and had dated Elizabeth Taylor, who was three years younger than Terry and one of her best friends. Terry and Glenn started going out. With Glenn, unlike with Howard, she could hang out with boys and girls her own age. She could even eat food that Hughes had banned, like garlic.

Howard called all the time, trying to defend himself for the incident in Vegas. When she would pick up the phone and hear Howard's voice, Terry's body would start to shake. "Be strong," her mother told her—after all, she had made a promise to her father. Her mother would point to a framed portrait of Glenn and make her daughter focus on what was really important to her. "Look at him, Terry," she'd say. "You can be proud to take him anywhere. You're back among the living."

But Terry still loved Howard, and she told her mother so. "Nonsense," Louella Koford said. "He has you brainwashed, but you'll get over it."

Terry focused on giving Hughes the impression that she was already over it. One night she took his call just to inform him that she and Davis were going to get married.

"Are you crazy?" she recalled Hughes firing back. "You're married to me."

"It never happened," Terry insisted. "It's all just a bad dream."

In fact, Terry didn't really want to marry Glenn Davis, but she felt that everyone around her—her friends, her family, her studio—was pushing her into it. At the last minute, she agreed to meet Hughes at the Beverly Hills Hotel. He told her he had something for her. She was hoping that he would "beg my forgiveness, slip the largest diamond in the world on my finger, and announce to the world that I couldn't marry America's Sweetheart, heartthrob Glenn Davis, because I was already Mrs. Howard Robard Hughes." (This desire for Hughes to make a bold gesture, claiming her as his for all the world to see, was inconsistent with her claims that it was she who had wanted to keep

her marriage to Hughes under wraps for the sake of her career. Then again, consistency is not necessarily the strong suit of twenty-two-year-old lovestruck actresses.)

A bold declaration of love was not what Hughes had to give. Instead, he presented Terry with three paper drugstore bags. Each one contained diaphragms and contraceptive jelly. "You can have your little fling, Helen," he told her, "but you mustn't get pregnant. If you do, your nipples will get all brown instead of pretty pink and you'll get stretch marks, and then I could never take you back."

Sadly resigned to the fact that Hughes was not going to take their supposed marriage vows any more seriously than he had already, Moore took his gifted diaphragms with her on her honeymoon with Glenn Davis, whom she married on February 9, 1951. She and Davis moved to Texas, where her husband hoped to get into the oil business. At Davis's urging, Terry reluctantly called Howard and asked for help getting Glenn a job. Hughes found a position for Glenn in Houston and then had Terry cast in a film at RKO called *High Heels*, in which Terry would play a taxi dancer,[1] and for which Hughes would personally supervise the construction of the costumes. Before the movie could begin filming, Hughes came to visit Terry during a wardrobe test. This is how Terry would describe what happened next:

> He held me fast with one hand and slid his other hand beneath the thin material of the dress he had designed, encircling my breast, holding it firmly.
>
> "They're still pink," I whispered.
>
> Howard pulled me closer and kissed me deeply. With one smooth motion of his gentle hand, he peeled the dress off my body. This was

[1] "Taxi dancers" were hired by certain nightclubs to serve as dance partners for dateless men. These ladies would be paid a fee per partner, per dance, with each coupling lasting the length of a single song. This is the subject of the song "Ten Cents a Dance." While the practice itself was inherently chaste, taxi dance halls were suspected to sometimes serve as staging grounds for prostitution.

the moment this dress was made for. It fell down around my ankles and I stood naked before him. I wondered how many times he had enacted this scene in his mind.

This was Howard's movie, and I was bound to stick to his script. He lifted me out of the dress and put me on his desk. I hungrily pulled him on top of me.

"Don't ever leave me again," he said.

We made love.

High Heels was never made; with Terry back in the Hughes fold, it didn't need to be. Hughes and his employees would soon be conducting subterfuge operations to hide Terry and Howard's ongoing affair from Glenn Davis. One afternoon, Jeff Chouinard, Hughes's top security man, got a call ordering him to come to the Beverly Hills Hotel immediately. When he got there, a driver handed Chouinard an envelope and instructed him to drive to Balboa, in Orange County, to drop it into the mail. The envelope was addressed to Davis. Terry was holed up in the hotel with Hughes, but she wanted Glenn to think she was visiting a girlfriend out of town. The following week, Jeff got another call to pick up another envelope addressed to Davis, but this time he was told to deliver it to Terry's husband in person, and then tail the football player for the rest of the day. This envelope contained Terry Moore Davis's wedding ring.

Chouinard drove to Glendale, handed Davis the envelope, and waited, but though Davis seemed upset, he didn't go anywhere but to visit Terry's sick mom in the hospital. Later, after losing Chouinard, Davis showed up at the Beverly Hills Hotel and waited until Hughes emerged from a back entrance. According to Chouinard, Davis then "pummeled Hughes into unconsciousness and left him bleeding in the grass. Within an hour [Hughes] was on his way to San Francisco for treatment in a hospital and Hughes' aides were swarming everywhere at the hotel to be sure the incident was covered up."

An FBI informant observed Hughes in San Francisco, and some-

time later J. Edgar Hoover was given a report about the fight, noting that Hughes had "suffered several broken ribs and facial bruises," and that Davis had suffered an undisclosed injury that would prevent him from playing professional football that year.

According to Terry, after this she moved in with Hughes, although not into a permanent home—ever since vacating the house on Muirfield, he liked to relocate constantly. Sometimes they stayed at a house rented at 10000 Sunset Boulevard, the driveway of which had been enshrined in Hollywood history a year earlier when it was used to film Joe Gillis's flight from debt collectors and into the web of Norma Desmond in Billy Wilder's *Sunset Boulevard*. Sometimes they stayed at Howard Hawks's house, sometimes a bungalow at the Beverly Hills Hotel. The latter, Terry would say, "was convenient, especially when I was on a picture because we could get room service."

It was also convenient for Hughes, because he could command several bungalows at once for his exclusive use: he could call Terry in her bungalow from another bungalow, tell her he had to work all night, and then carry out a rendezvous with another woman in yet another bungalow. On at least one occasion, Hughes had a new, teenage contract actress move directly into a bungalow upon her arrival in Los Angeles. This girl, like most of the new arrivals, was accompanied by her mother—at least at first, until Hughes's aides had convinced the young would-be actress that she would need to persuade her mother to go home if she was serious about her career. A month passed, and the girl had still not met Hughes—who was living in the bungalow across the way. One night he called her from his bungalow and told her he was in New York but would soon fly in to have dinner with her. Then the next night, he called her and said, "I'm in Denver and as soon as the weather clears I'm going on to Houston then I'll be in Los Angeles." Every night he called, and told her he was getting closer to her—while all the while he was just a few feet away. Finally, Hughes decided that the time was right. He told the man he had surveilling this girl to go home for the night—he could take it from here.

JEAN PETERS'S FIRST FILM, *Captain from Castile*, had been directed by Henry King, a fixture of Hollywood's old school—he had helped establish the Academy of Motion Picture Arts and Sciences, and had discovered Ronald Colman, Tyrone Power, and Gary Cooper—whose sensibility was generally old-fashioned. Jean would star in three King films, the most interesting of which was *Wait 'til the Sun Shines, Nellie*. Based on a novel called *I Can Hear Them Sing*, it tells the story of Ben (David Wayne), a barber who arrives in a brand-new, tiny town in rural Illinois at the turn of the twentieth century, determined to grow a business and a family in lockstep with the development of the community. Ben doesn't share this ambition with his new wife, Nellie (played by Jean), whose idea of the American dream is an exciting life in the big city. The movie begins with the two of them on their wedding night, on a train headed west. Ben has promised Nellie they will settle in Chicago, but instead they get off the train in nowheresville and move into the apartment in the back of a barbershop. He's just temporarily renting the shop, Ben tells Nellie, and someday soon they will get back on track to pursuing their shared dream life. In fact, this *is* Ben's dream life—he's bought the business and the building, setting up roots in this town without consulting his spouse, and lying to her that their long-term vision of the future is the same.

Nellie is a dutiful wife, at first, churning out children and keeping house while her husband continues to lie to her that they will someday leave the small town for the big city. Whenever Nellie agitates to move on to Chicago, Ben buys her something lavish, which has the dual benefit of distracting her and making it harder for the family to just pick up and go. But as time drags on, Nellie starts to lose her ability to buy in to the life her husband has locked her into, and she breaks from the chains of what's expected of her. She becomes the first woman in their small town to wear lipstick, and indulges in a flirtation with a married man. When Nellie finally finds incontrovertible proof that her husband has been deceiving her for their entire marriage, she boards a train for Chicago with the other man. They immediately die in a catastrophic wreck.

Nellie's death occurs about forty-five minutes into the two-hour-
long movie that has her name in the title—and in which the actress
who played her was first billed—and it's absolutely shocking when it
happens. By the end of the film (which turns into an epic morality play,
spanning fifty years in the life of Ben and his growing city), you realize
that what was really shocking is that for forty-five minutes, this deeply
strange movie about the darkness that underlines the American experi-
ence sympathized with a female character who wasn't satisfied playing
her role in an archetypical cornfed domestic drama.

Throughout her time on-screen, Jean Peters is fierce and feisty.
When Nellie gets mad, Peters spits out a rage that feels uncomfort-
ably naturalistic, like a precursor of the kind of acting Gena Rowlands
would be doing under the direction of her husband, John Cassavetes,
in the 1970s. *Wait 'til the Sun Shines, Nellie* was not the film that made
Jean Peters a star—that was *Viva Zapata*, a turgid but high-profile
and well-received Elia Kazan effort in which both Peters and Marlon
Brando donned brownface to play Mexicans—but *Nellie* was the film
that distinguishes her, in retrospect, as a real actress.

Peters's star-making process took some time. Two decades after his
love letter to Billie Dove's silver hair and strategically placed moles,
Sidney Skolsky was still churning out "Tintypes," and in his first
such profile of Jean, published in March 1948, he presented Peters as
almost painfully down-home. Noting that she lived on a farm in Ohio
until her arrival in Los Angeles two years earlier, Skolsky wrote that
Jean had yet "to become Hollywood. She likes to think she economizes
by making her own dresses." In addition, Skolsky claimed that Jean
didn't know how to dance, was "a better than average skeet shooter,"
and "eats three big meals a day and munches between them." Conform-
ing to his own format as if by force, Skolsky added his customary sexy
details at the end: "She prefers a shower to a bath and takes a delight in
drying herself. She is ticklish. . . . She sleeps in a short nightgown in a
double bed." This perfunctory creeping aside, the overall picture you
get is that Jean Peters is somewhere between Ingrid Bergman–natural
and Katharine Hepburn–mannish. (Skolsky was not the only one to

notice Jean's lack of polish. "While Jean was pretty," Sheilah Graham allowed, "[s]he was not particularly chic. She made her own clothes and had no use for a razor or depilatory. Jean was determined to remain as nature made her.")

By 1949, Jean had made just three films since her arrival in Hollywood three years earlier (in contrast, Ava Gardner appeared in three films released in 1949 alone), and she hadn't yet captured the imagination of either the public or the men in power at Fox who could have pushed for her to be cast in more movies. With the initial presentation of Jean as a farm girl who refused to be changed by Hollywood clearly not working as a propellant of stardom, around this time the coverage of Jean began to change, reflecting an effort to jump-start her stalling career by transitioning her star persona into something more conventionally glamorous. The *Los Angeles Times'* John L. Scott reported that Jean had changed during her three years in Hollywood, for the better: "When Jean arrived at the 20th Century Fox studio in 1946, she was a very pretty, wholesome-looking but slightly chubby girl," Scott judged. "Three years have turned her into a svelte, grown-up beauty with a fine sense of humor and a charm that is not turned on and off, in the Hollywood fashion, like a faucet." Nonsense stories about Jean's sex appeal started popping up, such as one claiming that Peters had been voted as having "the most kissable lips in Hollywood." The makeover was blessed by Louella Parsons, who allowed that "in the beginning [she] wore jeans and a funny little cap and cared very little about her appearance, but a transformation took place last year and Jean Peters, once a plain Jane, has become a real glamor girl."

By 1952, Skolsky had issued an updated Jean Peters Tintype. It included a few of the same pieces of information, such as Jean's love of sports and distaste for makeup, but it toned down the potential implications that Jean was *too* unusual. "She's a tomboy," Skolsky allowed, "but when necessary can display all the feminine charms." And this time he kicked up the sex at the end. Instead of the "short nightgown" Jean was said to wear to bed in 1948, in 1952, "She sleeps with absolutely nothing on."

As her star persona transformed from farm girl to fabulous, she was graduating to more important roles in the process (the heavily hyped *Zapata*, for which Fox chief Darryl Zanuck personally selected Jean, was a big break; it was Marlon Brando's next film after *A Streetcar Named Desire* had made him a major movie star). Now Hedda Hopper latched on to Jean's guarded "real" life as a source of mystique. In a March 1952 *Photoplay* profile, Hopper, without naming Hughes, implied that Jean's unwillingness to offer her personal life up for public consumption began when she was shooting *Captain from Castile* on location in Morelia, Mexico. "One of the most eligible bachelors landed his plane there," Hopper wrote. "Whereupon the place swarmed with reporters and photographers—and the days of Jean's free give-and-take ended abruptly." With that, Hopper added, an "iron curtain descended on her life."

If her private life was increasingly hidden, Jean was working more than ever. Nineteen fifty-three would be the only year of her career in which she'd have starring roles in four feature films. Two of these movies came and went and were swiftly forgotten: *Vicki* (a remake of the 1941 noir *I Wake Up Screaming*, in which Jean would take on the role played in the original by Carole Landis, the blonde whose suicide shared the pages of *Time* with Hughes's purchase of RKO), and *A Blueprint for Murder*, a plodding procedural in which Peters plays the most boring murderous gold-digger in midcentury cinema. The other two movies were more significant.

For all of the publicity promising that Jean was a fully functional glamour girl, she could still be useful to Fox as a comparatively sexless counterbalance to the actress who would soon prove to be the most valuable of her era. In *Niagara*, Peters was tasked with providing opposition to Marilyn Monroe, who had her first billed-above-the-title A-film role as Rose, a sexpot who drives her insecure husband George (Joseph Cotten) to murder both his wife and her lover. Peters played Polly, one half of a couple on a delayed honeymoon at the same Niagara Falls cabin complex as Rose and George. Polly's husband promises her that even though it's happening three years after their marriage,

and only because he wants to network with a colleague vacationing in
the same place, the trip will be just like a "real" honeymoon. "It should
be better," she answers. She pauses meaningfully, then looks at him
with sly eyes. "I've got my union card now."

Practiced in marital sex though Polly may be, the film places in di-
ametrically opposed boxes Peters (dressed in oversize blouses and car-
digans, at one point with a girlish bow tied around her French braid)
and Monroe (whose costumes were always simultaneously too tight
and falling off, and whose wiggle-skirted walk away from the camera
was promoted as the real sight to see in a movie set at a famed sightsee-
ing locale). When her husband catches a glimpse of Rose dancing, he
teases Polly: "Why don't you ever get a dress like that?" Polly smirks.
"Listen, for a dress like that, you've got to start laying plans when
you're about thirteen," she says.

Sex is clearly not the center of Polly's appeal, and the sentiment of
Niagara is that it's safer that way, that it's better to be a Jean Peters—not
sexually exciting, maybe, but serviceably pretty and not dangerous—
than a Marilyn Monroe. But her response also distances her from the
world of women who exist to be ogled by men, and puts her in the com-
pany of the men—namely, as the kind of woman who will join a man
in making leering jokes about other women. It's an odd spin on the
male gaze for an actress whose sexual appeal had already been a subject
of public discussion. What's even odder is that while *Niagara* portrays
men broadly dismissing women as whores or hysterics (Peters's char-
acter is at first accused of being delusional when she insists that Rose's
husband is up to no good), by the end the sympathies of the movie are
entirely with the women.

Niagara would be followed by the film in which Jean gave her fin-
est performance, in the most difficult and, to modern eyes, prob-
lematic role of her career (and given that Ohio-born Peters was twice
cast as a Mexican and once as an Apache, that's saying something). In
Pickup on South Street, Peters played Candy, a sometime streetwalker
who finds herself on the road to redemption after discovering that the
ex-boyfriend for whom she's been working as a courier is a Commu-

nist spy. When pickpocket Skip (Richard Widmark) steals a cache of microfilm that Candy was unwittingly transporting to the enemy, she tries to get it back, and finds herself instantly attracted to the thief. What follows is an unsettling and unabashedly sexualized depiction of domestic violence. Skip socks her, believing, in the dark, that she's a male intruder. When he realizes she's a beautiful woman, he seductively caresses the jaw he smashed, his lips inches away from her face as he interrogates her in a whisper. It's foreplay—it leads to a kiss, which casts a spell, which breaks when he threatens her. She leaves, but comes back. Every time Candy visits Skip, they can't keep their hands off one another, in two senses of the word: he is always violent toward her, and she is always receptive to the passion that comes with his aggression.

20th Century Fox had pushed Marilyn Monroe for the role of Candy, but director Samuel Fuller had decided to cast Jean Peters instead, and not because he liked her work (all he had seen was *Captain from Castile*, and he wasn't impressed), but because, while casting *Pickup*, Fuller was introduced to Jean at the Fox commissary, and after a brief round of hellos, had watched her walk away from him.

"I looked at Peters' pert figure and her legs and thought to myself that she had Candy's bowed legs," he wrote in his autobiography. "The kind of gams you get from streetwalking." When he auditioned her, Fuller was surprised to find that Jean was also "a very intelligent woman, a fine human being." When she asked him why he had decided to cast her, Fuller told her the truth: "Your legs, kid. They're very sexy. They're also a little arched. I'm not saying a tank could drive through them. But maybe a small Jeep."

None of Jean's previous directors had looked at her and seen a "streetwalker's gams," and her screen presence totally transformed under Fuller's gaze. In previous films, even when Jean looked beautiful or was coded as an object of desire, there seemed to be a disconnect in her performances. You never got a palpable feeling of what it felt like to be in her body, not even in her very good depiction of a deceived woman's rage in *Wait 'til the Sun Shines, Nellie*. The difference in *Pickup on South Street* is evident in its first scene. As Skip's picking her

pocketbook on the subway, he moves to face her, their bodies almost pressed together on the crowded train. Fuller's camera fixates on her gaze at the thief, her lustful, come-and-get-me eyes and busy, bitten lips. Candy is so distracted ogling Skip that she doesn't realize until it's too late that she's been robbed. The styling plays a role—Candy's overdone makeup, clunky jewelry, and deep V-cut belted dress are all new looks for Peters on-screen—but the power of Jean's projection of desire, and the physicality of that performance, can't be discounted. It's the rumbling, queasy-making engine of the whole movie.

When Candy reports to her ex that the parcel she was meant to deliver for him was stolen, he insists she use her connections to the underworld from her "past" to find the thief. "You've knocked around a lot," he says meaningfully. "You know people who know people." Candy scowls. "You going to throw that in my face again?"—confirming that he was implying that she had "knocked around" as a prostitute. We now have the idea that Candy is a "professional," and thus able to pretend she wants to have sex with a man in order to get what she really wants from him, in our heads as we watch Candy and Skip's relationship form. But even knowing that, we forget that she could be manipulating him, because her desire for him is so convincing.

"I like you," she breathes at Skip, halfway through the movie.

He doesn't want to believe her. "Everybody likes everybody when they're kissing."

"I've kissed a lot of guys, but honestly, I've never felt like this." We believe her—in spite of the fact that his every tender action toward her is matched by an act of violence.

Are Candy and Skip practicing sadomasochism—a consensual performance of violence as foreplay, or a sex act in itself? Whatever is going on here, it's not exactly portrayed as a pattern of abuse that we should be worried about. The film presents Candy as a girl who has not just "kicked around" but *been* kicked around her whole life, who not only comes to expect it but maybe even fetishizes it—with the right person. When her old boyfriend beats her up so bad she ends up in the hospital, Skip becomes protective. Has he suddenly realized

that violence against women is ugly and wrong—or is he mad that another man tread on his turf? Like much about this wildly expressionistic crime noir, made under the strictures of the Code, that is left ambiguous, but when Candy and Skip end up together at the fadeout we are meant to think it's a happy ending—and stop thinking before we wonder what that relationship will actually look like.

Pickup on South Street was read by the movie press as evidence that Jean Peters's transformation from tomboy country girl to sex goddess was complete. In interviews, she insisted that this wasn't the case, that she was no sex symbol, that how she appeared on-screen was not the real her, and that she'd still rather go to a baseball game than a nightclub. She complained that the expectations that went along with being a star on the "sexwagon" could turn "tragic for the career and for the private life, too." Candy, she said, was an aberration: "I love a flashy, sexy role—when it's in character. But to be built up purely as a sex queen—no thanks." As if deliberately throwing shade at Hughes's handling of Jane Russell, Jean said that though she might occasionally play "a sexy dish," she thought "sex has been overworked by Hollywood. Take bosoms, for example. They have been so over-exploited that nobody even notices them much anymore."

This criticism of Hughes's go-to film marketing strategy aside, Jean and Howard were still involved, but now their relationship was kept strictly out of the public eye. As one fan magazine complained: "You can scan the picture pages and gossip columns in vain for any indication that Jean is ever seen breathing heavily, as she put it, toward a male in a night spot at all." This was a noticeable change: "For a long, long time she was seen, but rarely, in the company of one producer and nobody else. After that, she wasn't seen at all, out or in print."

Fuller saw evidence that said "producer" was not only still in Jean's life, but was, in a sense, directing it. During the rehearsal period before shooting *Pickup*, Jean would arrive every day on the Fox lot in a car with a driver. The driver would wait right outside Fuller's bungalow all day while they rehearsed, sunglasses on, a newspaper stretched out on the steering wheel. "I couldn't make out his face," Fuller recalled,

"but I knew the big guy wasn't just reading. He was constantly keeping an eye on Jean too. When we finished the session, Jean went outside and got into the front seat of the waiting car and they drove away. On the second day of rehearsal, it became pretty obvious that the driver was her boyfriend."

Fuller told Jean that if she wanted to invite this man to come inside and wait for her in Fuller's office, she was welcome to. "No, no, it's fine this way,'" Jean said, with a smile on her face.

The last couple of days of rehearsal, Widmark and Peters went through the paces of their highly sexually charged scenes together. Fuller realized that from where Jean's boyfriend was parked, he could sit in his driver's seat and see through the window of the bungalow and get an eyeful of Jean and the actor going at it. It was only then that one of Fuller's secretaries told him that Peters's "chauffeur" was Howard Hughes.

HUGHES AND COLUMNIST SHEILAH Graham had a deal: she would refrain from going to print every time a Hughes girlfriend told her she expected to marry him "soon . . . but we must wait to be sure," and in exchange Hughes would answer Graham's calls and give her legit scoops.

One night in 1952, Hughes phoned Graham at midnight and told her to meet him at his bungalow at the Beverly Hills Hotel—he had a scoop. Graham was sick as a dog, but Hughes was a reliable source of information for her column, so she got out of bed. But this time it turned out Howard's "scoop" was just some trash talk about director Stanley Donen, who was romancing twenty-year-old Elizabeth Taylor—the one young brunette beauty in town who remained impervious to Hughes's advances. "I almost collapsed with annoyance and a temperature of 101," Graham recalled. "I marched out as he was saying, 'Hedda would give this a lead.' 'Then give it to her,' I flung back."

Then Graham started hearing rumors about Hughes's troubles at RKO, and Howard stopped returning her calls. She decided she'd had

enough. "I began my next column with, 'Terry Moore tells me she will marry Howard Hughes on May 18th. . . . But this is not what Howard is telling Mitzi Gaynor'"—yet another young Fox contract actress whom Hughes dated. "All hell broke loose with Howard calling me threatening to ruin me."

Graham was not the only columnist Terry Moore told, in the fall of 1952, that she and Hughes were planning to marry. Why would Moore have done this if she believed that she and Hughes had already married, and had not divorced, before her marriage to Davis began—a situation she would keep mum about for another twenty-five years? By now Terry had graduated out of the kid roles, so she was no longer worried about Hughes's reputation tarnishing her own. A public marriage to Hughes, she may have believed, would legitimize her as an adult star, as well as their relationship. Of course, Terry certainly hoped Hughes would marry her "for real," out in the open, but actresses who were not in such complicated relationships also played the rhetorical game of telling gossip columnists that they were altar-bound, whether that was accurate or not. In the context of 1950s Hollywood gossip, a relationship was salacious if it wasn't going to lead to marriage—especially when one member of that relationship sold herself as a religious devotee—so Terry could only get away with advertising herself as Hughes's consort by promising columnists that she and Howard would soon make it legal.

Terry Moore was a tabloid figure, but she was also beginning to quietly amass a resume as a serious actress. In *Come Back, Little Sheba*, she played Marie, a college coed whose sexual temptation throws the household of a middle-aged couple into chaos. Based on a play by William Inge, the great chronicler of repressed sexuality eating through the placid veneer of the twentieth-century American small town, *Sheba* takes place in the home of Doc (Burt Lancaster) and Lola (Shirley Booth, making her film debut at age fifty-five), a couple who married when their premarital sex got young, vivacious Lola into "trouble." She miscarried, and twenty years later, she's a childless matron who speaks in a baby voice to her husband, a melancholic alcoholic

who is just barely holding his sobriety together after a year in Alcoholics Anonymous. Lola invites Marie to move in as a boarder, which allows the older woman to exercise her maternal instinct—and also vicariously relive her own youthful juggling of suitors by paying too close attention to Marie's vacillation between her decent fiancé, who works out of town, and a hunky classmate who is here for her now but won't commit to a future together. Reminding her cringing husband of their own youthful indiscretion, Lola chirps, "You said you'd love me forever and ever, remember?" A decade before *Whatever Happened to Baby Jane?* would take similar themes over the edge of grotesque, *Sheba* explored the horror of a woman aging faster than a man, becoming (to quote Lola) "old and fat and sloppy" in a blink of an eye while her husband just gets more attractive as he matures. The sadness of a husband and wife on different aging tracks is exaggerated visually by the casting: Shirley Booth was fifteen years Burt Lancaster's senior.

It would be Shirley Booth, and not Terry, who would actually win *Sheba*'s only Oscar, but Moore deserved her nomination. Marie is the kind of flirt for whom banter and even playful physical struggle are autopilot, but in the few moments when we get to see her alone, not performing for a man, Moore makes real the character's inner conflict, her fear of sex commingled with her curious desire. When Marie changes her mind at the last minute about going to bed with the aggressive Turk, in her facial expression we see her understanding that though it was terrifying, she now knows she has the courage to set her own limits and enforce them—and that this is as significant a moment of coming of age as losing her virginity would have been. The movie is really about the older couple, but in order for Inge's drama of the mundane tragedy of aging to plumb the depths that it does, Terry had to embody the moment of youth before one of two roads is chosen. That she does much more with the part is a testament to her abilities—abilities that she wouldn't get many more chances to show off.

Overextended though he was, Hughes certainly made Terry a priority among his girlfriends. While Moore was in Bad Tolz and Munich, Germany, for the location shoot of Elia Kazan's *Man on a*

Tightrope, in which Terry played the daughter of a beleaguered circus owner, Moore and Hughes spoke on the phone every night. These conversations (which were a feat of technology and probably bribes, as no other calls from the United States ever seemed to get through to Bad Tolz, a remote village in Bavaria) were intimate, but Terry did not try to keep them private. Kazan, who was curious enough about Terry's relationship with Hughes to make a failed play at stealing her away, asked Terry what Hughes wanted to talk to her about every night. She explained, "He makes the alligator's love call." This was no euphemism. Kazan managed to eavesdrop on a subsequent call between the lovers, and he heard Terry herself emitting a growl that Kazan described as "the subtler cry of the female alligator." How much Glendale native Terry and Greek New Yorker Kazan knew about what alligators actually sound like is unclear.

It was while Terry was in Bavaria filming *Man on a Tightrope* that, per her own account far after the fact, Moore gave birth to Hughes's child.

Before her departure for the location shoot, Terry hadn't had her period for a couple of months. She finally told Hughes, who sent her to see his personal doctor, Verne Mason. Mason was not an obstetrician per se. What he was, was on Hughes's payroll, which meant he was paid to be discreet.

"I was pretty far along when I started the picture," she remembered in 1979. "I was really beginning to show. I had to tie in my costumes and all." One night, at the end of the shoot, when Terry was between five and six months along, she began bleeding and feeling pain. She told this to Howard when he called to check on her that night, and according to Moore, Hughes immediately put Mason on a plane to Munich, where the production had moved, to attend the premature birth of a daughter, whom Terry named Lisa Marie. The baby was taken away from Terry immediately, and the mother was told the next day that her child had died.

According to Terry, Hughes was relieved. "He didn't want a child," she said. "He didn't want anyone to have a claim on his estate and he

saw to it that I didn't get pregnant again. I really wanted a child and was heartbroken when our daughter died. I thought he was being selfish. But he argued unless you were around children constantly to create and mold them, they would hurt your image, blacken your name."

Hughes was accustomed to talking to Terry about her gynecological issues. In one phone call, he had explained to Terry that it was well within her rights to call in sick from work during the first day of her "curse." "Any studio understands that," he told her. "The rule to follow is to tell them when you think it's going to be. If it's late then that's not your fault. And then the first day you have the curse, you just don't work. Now that's an accepted rule throughout the industry and many people don't work for two. And those that follow that rule last a lot longer and don't have trouble with menstruation and the people who ignore that rule—and especially on the New York stage where certain people just feel the show has to go on and they just wreck themselves. Katie Hepburn's father, who is a doctor, told me all about that."

"I know you're right," Terry sighed. "You're always right."

We know the content of this conversation because Terry Moore tape-recorded it. Once as naive to the ways of men as a girl who acted in Hollywood movies for a living could be, Terry had learned a few things over years of being lied to by Howard Hughes.

"His motto was, 'It's okay as long as you don't get caught,'" she said later of Howard's infidelities. "He could lie better than anyone." Hughes's duplicity, his almost pathological juggling of women, had moved Terry to start using his own tactics against him. She had started surreptitiously taping her conversations with Hughes out of paranoia and jealousy, particularly over Jean Peters. Terry thought she could somehow use recordings of her conversations with Howard—which do seem to be evidence of a loving relationship—to get rid of Jean. She knew Jean wasn't the only other woman, but she was the only one who bothered Terry, because of her longevity. All the other girls eventually went away. Jean Peters kept recurring.

Whatever the initial intention had been, Terry didn't publicly reveal her secret Hughes tapes until after his death. By early 1953, before her

divorce from Davis was final, she was downplaying her relationship with Hughes in the press, referring to it in the past tense in an interview with columnist Sidney Skolsky, whose bemused Tintype of Moore noted that the twenty-four-year-old was a bundle of contradictions. "I'm a Mormon," she told Skolsky, "but I have fun." She also showed him the "500-year-old Buddha statue" in her otherwise "modern style bedroom." Skolsky's final words on Moore: "She is enthusiastic about whatever she is doing."

Sometimes Terry's "enthusiasm" could get her in trouble. Later that year she started dating Conrad "Nicky" Hilton, who had married and eight months later divorced Terry's friend Elizabeth Taylor. Hilton flew Terry to Istanbul for a party celebrating the opening of a new Hilton hotel there. A photographer snapped her picture at the party, and the image graced the cover of Turkish newspapers. To Terry's great shock, in print it appeared as though Terry had been photographed nude. She insisted that the photo had been doctored. "I can't understand it," Terry exclaimed. "I was fully clothed when he snapped the photo." When asked for an explanation, she figured that the photographer "took it from an unexpected angle and then retouched it to make it look worse."

A tabloid story a few years later included the incident as part of a pattern of events in which Terry "accidentally" appeared to be a public exhibitionist. In late 1953, Terry caused controversy when, as part of a USO show with Bob Hope in Korea, she appeared before the troops wearing a fur bikini; Moore claimed she was asked to leave Korea after rumors were published that she was planning to "strip down to it." Six months later, Moore made her Las Vegas nightclub debut wearing a bejeweled gown that appeared to be see-through in photographs. Three makes a trend, and by the mid-1950s the gossips were no longer charmed by what seemed to be Moore's brand of getting caught faux-naked and then claiming to be utterly embarrassed.

All the publicity about Moore's "oopsie" exhibitionism obscured her acting work and the fact that, professionally, she was making a case to be taken more seriously. After filming *Tightrope*, with the highest-pedigreed actor's director of the decade, Moore found out she had been

nominated for the Supporting Actress Oscar for *Come Back, Little Sheba*. This Oscar nomination was the highest honor reached by any actress whom Hughes was involved with while he was involved with them.

Terry asked Howard to accompany her to the Oscar ceremony, but he demurred, suggesting that she instead go with his aide Bill Gay.

"You'd really like that, wouldn't you?" Terry fumed. "Why don't I just take one of those detectives you have following me?" There was no chance Terry would go to the Academy Awards with some hired chaperone. "Everybody would think I was a Howard Hughes girl!"

"What's wrong with that?" Hughes wondered.

"I'm not one of your girls. I'm your wife!" She ended up going to the ceremony on a studio setup date with Robert Wagner.

At the time of *Sheba*, which she had made on loan-out to Paramount, Terry had been under contract to Columbia. She was savvy enough to realize that her career was not going anywhere at this studio, where mogul Harry Cohn gave the most attention to his casting-couch play-mates, and to larger-than-life glamour girls like Rita Hayworth. At Columbia, all that seemed in the offing for five-one Terry was play-ing the cute love interest to male movie stars of diminutive stature. "I was tired of Mr. Cohn always putting me into movies where I wore bathing suits and stood behind Mickey Rooney looking pretty," Terry said later. (For the record, Moore had only appeared in one Columbia movie to this point with Rooney, but the title perhaps speaks for itself: *He's a Cockeyed Wonder*.) "I knew I had a good thing with *Sheba* and would have a real chance at acting if I could get away from Columbia."

Pursued by three studios, Terry had decided to sign with 20th Cen-tury Fox, where director Kazan was also under contract. This had paid off in the short term, as Kazan cast Terry in *Man on a Tightrope*. "But accepting the Fox contract was ultimately my biggest mistake," Terry later lamented. "Howard had control over [Fox chief Darryl] Zanuck at the time, and if I were cast in a picture with any male actors Howard felt threatened by, I was taken out of the picture."

Zanuck's many biographers have not broached the topic of Hughes's "control over Zanuck" as alleged by Moore, but it is true that Hughes

and Zanuck were close friends, accustomed to doing favors for one another. It's also true that, by the mid-1950s, Zanuck was preoccupied with his personal life to the point where he may have welcomed Hughes's professional guidance. As if failing to learn the lessons of Hughes and Billie Dove, and Hughes and Faith Domergue, Zanuck sunk his studio chief capital into trying to make Bella Darvi—Zanuck's mistress since 1952—into a star. This turned into a spectacular and embarrassing failure, and by 1956 Zanuck would leave his wife and flee to Europe, where he licked his wounds, working as an independent producer under contract to the studio he once controlled—a long leash that kept him too distant to stop Fox from entering into the prolonged financial suicide mission that was the Elizabeth Taylor–starring *Cleopatra*.

If Hughes did indeed have such influence over Zanuck, it could help to explain why another Fox contract star and Hughes girlfriend, Jean Peters, was cast so selectively, and (with the notable exceptions of Lancaster in *Apache* and Marlon Brando in *Viva Zapata*), generally opposite less-than-strapping male stars such as Joseph Cotten and Richard Widmark.

In the 1930s, Hughes had enjoyed overlapping relationships with Katharine Hepburn and Ginger Rogers while the actresses were rivals at RKO. Now that he owned RKO, there were among the women in his life two who were professional rivals at another studio.

At least, it was a rivalry in Terry Moore's mind. "If Jean Peters walked into make-up while I was there, or if we would pass each other on the lot," Terry recalled, "we'd both look in opposite directions and would ignore each other." Terry would find herself unable to ignore Jean Peters for much longer.

Yet, if Jean was bothered by Terry's presence in Hughes's life, Peters didn't let on. Peters was, after all, a woman of mystery—and it may have been this ability to keep to herself everything going on behind her beautiful facade that gave her the ultimate edge in the fight for the most practiced smoke screen artist in town.

"A MOVIE STUDIO FILLED WITH BEAUTIFUL GIRLS WHO DRAW PAY BUT SELDOM WORK"

In the fall of 1953, Howard Hughes's habit of starlet collecting turned tragic. A nineteen-year-old girl named Rene Rosseau slit both of her wrists with a double-edged blade in her Hughes-sponsored apartment at the Sunset Tower Hotel, three months after arriving in Hollywood by way of Boston.

When deputies of the Hollywood sheriff's department arrived to care for the teenager, who survived the wrist-slashing attempt, Rene reportedly told them she was "despondent" because of her "star status," or lack thereof. While she was being questioned by the cops, she attempted to leap out the window. "I tried to restrain her and was bitten on the forefinger of my right hand," said Deputy Sergeant Henry A. Cramer.

Among the first on the scene was Walter Kane, one of Hughes's

"talent agents," and Kane's wife, actress Lynn Bari. Bari took credit for throwing the would-be suicide weapon out the window where Rosseau couldn't get it. Kane called Dr. Norman F. Crane, who called Verne Mason. "She's going to be all right in a few days," Mason said of Rosseau. "She went on a bender last night and got upset."

There is no IMDb entry for "Rene Rosseau." If this actress went on to work in Hollywood, she did so under another name, but she almost certainly never worked for Howard Hughes—as was the case with most of the "starlets" he signed. Her suicide attempt raised the first red flag that the local media, used to accepting quid pro quo and manipulations from Hughes and his publicists, dared to actually print. "Hughes Starlet Tries to Kill Self!" blared the Los Angeles tabloid the *Mirror* on its November 19 cover, linking Rene's desperation to her contract with Hughes. The *Mirror*'s inside headline put the onus not on Hughes, but on the starlet: "Hughes Starlet, Impatient to Be Star, Tries Death" implied that the suicide attempt had been not exactly a cry for help, but a plea for publicity.

HUGHES MAY HAVE COME out victorious in the fight against Paul Jarrico, but his legal troubles were just beginning. Three RKO shareholders (Eli B. Castleman, his wife, Marion V. Castleman, and Louis Feuerman) filed suit against Hughes and RKO, demanding the return of $1 million they believed was improperly spent under his management. Among other things, they levied an attack on Jane Russell, who they asserted did not deserve the $100,000 per film that Hughes was paying her. "It is the consensus of motion picture critics that the acting ability and talent of Jane Russell are of a minor nature and values that the payment by Radio Pictures [RKO] of $100,000 to Hughes Tool for her services for a feature picture constituted a waste of corporate funds," read the complaint.

The problem was perhaps not Russell's "acting ability and talent" so much as the structure of the deals Hughes made to lend her to other studios. Probably without realizing it, in an interview seven months

earlier, Russell had offered praise of Hughes that would damn him with RKO's stockholders. "You should see the kinds of terms he gets when he loans me to an outside studio," Russell said. "A fantastic sum of money." The shareholders understood that RKO *was* an outside studio: since Jane's contract was with Hughes himself, Hughes personally pocketed a loan-out fee every time she was cast in an RKO movie.

Soon came another lawsuit, this one brought by minority shareholders Louis Schiff and Jacob Sacks, which sought to put the studio and its remaining theatrical holdings into receivership. This suit alleged that Hughes "operates both corporations as though they are solely owned by him," and cited four more problematic actress contracts, with Gina Lollobrigida, Merle Oberon, Ann Sheridan, and a French ballerina named Jeanmaire. Schiff and Sacks claimed that Hughes signed these actresses "solely for the purposes of furthering his personal interests."

At a time when RKO was struggling to produce movies of any quality, and in any quantity, both groups of litigious shareholders believed Hughes should pay for what they perceived to be a wanton waste of money on useless assets. Certainly it was true that the four performers named in the Schiff-Sacks lawsuit had not actually starred in movies for RKO. But with Jane Russell, the Castlemans picked the wrong target for their frustration. By the time the lawsuits started coming to court in the fall of 1953, Russell was looking more valuable than ever.

In July 1953, she had a smash hit with *Gentlemen Prefer Blondes*, a musical directed by Howard Hawks based very loosely on the satirical fiction that had made *Red-Headed Woman* scribe Anita Loos a literary star. Jane and Marilyn Monroe starred as showgirl best friends with opposite talents: Monroe's Lorelai demanded diamonds in exchange for her total objectification by men, while Russell's Dorothy eschewed gold-digging—instead, it was she who did the objectifying of men. Russell's big solo number in *Gentlemen*, "Isn't Anyone Here for Love?," sung by Jane amid a bevy of male dancers playing the U.S. Olympic Team, reverses the typical dynamic of a Hollywood musical, in which a woman dressed to be ogled by men is depicted as the passive

prisoner of the male gaze. Here Russell, outfitted in a full-length black jumpsuit that in all but a few shots obscures her famous cleavage, sings of her desire for men (plural, not just one man) while openly admiring their bodies, which are barely clad in skintight nude-colored exercise shorts. "I like big muscles, and red corpuscles," Russell drawls, and if while doing so she thrusts her own assets, it seems less a gesture to display them to men in the audience, and more to advertise her desire to the totally oblivious men on-screen.

"Isn't Anyone Here for Love?" is an essentially comic number, but compared to what Russell had done on-screen before, particularly in *The Outlaw*, it's also ideologically potent. If her character in *The Outlaw* embodied sex under duress, her character in *Gentlemen Prefer Blondes* boldly presented a woman owning her sexuality, and embracing it as a source of fun and pleasure, without the horrible consequences usually dealt to sexually active women during the Code era (in other words, this was the polar opposite of *Kitty Foyle*). *Gentlemen Prefer Blondes* would become the pinnacle of Jane's screen career, and the actress had a simple explanation why: "It was the first time I played Jane Russell."

Buoyed in part by costar Monroe's ascendant career, *Gentlemen Prefer Blondes* opened in July and dominated the summer box office, on its way to becoming the ninth-highest-grossing movie of 1953; its $5 million take was miles beyond anything RKO had released that year. So come October 1953, when Hughes was deposed in the Castleman lawsuit, he was understandably defensive of his handpicked star. Russell's contract, Hughes stated, was worth more than any contract held by RKO.

But what of four actresses who were reportedly "put on the payroll for [Hughes's] own interests"? Gina Lollobrigida was offered a contract, Hughes said, but he insisted they had not paid the actress a salary since she had left for Rome immediately after signing and had not agreed to return to work for RKO. Asked if he had "any personal interest" in Jeanmaire, whom RKO had signed to a contract on Hughes's recommendation but was never cast in a film, Hughes said, "It is true I met this young lady and thought she was very charming, as are many

young ladies, but certainly it had no bearing on my recommendation." The other two actresses, Merle Oberon and Ann Sheridan (both of whom were on the downslope of careers begun in the early sound era), Hughes insisted he barely knew. He did acknowledge that "a number of student actresses were employed" by RKO under his watch, and that these actresses were held back from being cast in movies until "it was considered that they had the potentiality of talent and the potentiality of success." He likened the contracting of such "students" to his discovery of Russell and Harlow, two "unknown actresses . . . who achieved considerable promise."

When the line of questioning aimed to get Hughes to admit his lack of expertise in the making, marketing, and distribution of motion pictures by demonstrating that he was only sporadically involved in that business between 1932 when *Scarface* came out, and the day a decade and a half later when he took over RKO, Hughes spun his inactivity into business savvy. "There was a pause," in production, he acknowledged, "because the United States was going through what was being generally referred to as the Depression. Nobody made motion pictures during that time unless he was either a fool or he had to, one or the other."

Hughes presented the position that he was doing RKO a favor by running it, and by lending them his famous talent for finding female talent. He had had no choice but to take an active role in management, he said, because the studio couldn't afford to hire anyone who would be better for the job. He claimed he had told the board of directors in 1948 that he would accept the role of managing director, but he "could not and was not willing to give it my full time." Understanding that this was no way to run a studio, Hughes said his priority since 1948 had been "to find somebody who could take over the duties of production of RKO in whom I would have confidence and who could relieve me of this burden." Hughes said he offered the job to a number of men, including Leland Hayward and David O. Selznick, but they wanted compensation that RKO couldn't afford.

Hughes did not mention, during his deposition, something called

"Project Baker," which had been RKO's internal attempt to "rank motion picture production personnel according to their qualifications for the position of RKO executive in-charge-of-production." This report used a very unique, though chiefly qualitative, algorithm: (Projected achievement = potentiality factor x potential years); "Potentiality factor" was determined by dividing "past achievement" by "years experience in [the] industry." Project Baker produced a list of thirty qualified candidates and declared that David O. Selznick was the top choice, even though their "special service character credit report" on him revealed that he had been "involved in considerable litigation" and "prior to 1937 he had been a frequent and excessive user of intoxicants." Howard Hughes was one of the potential executives evaluated. At the end of all this math, he was not ranked among the top thirty.

AFTER THE SUCCESS OF *Gentlemen Prefer Blondes*, Hughes had rushed into production a copycat Technicolor musical starring Jane Russell as an oil heiress posing as a model in order to meet men who aren't intimidated by the size of her (financial) assets. *The French Line* was made in 3-D, for, to repeat an old joke about Jane Russell, two reasons. Or, as screenwriter Mary Loos, niece of Anita Loos, put it: "It was simply a matter of her cleavage, it had nothing to do with the plot."

RKO released *The French Line* on December 29, 1953—to the surprise of the MPAA, which had refused to give the musical its seal of approval. Hughes was not the first studio chief to release a film without the censors' seal—United Artists had defied the Code by releasing the unapproved David Niven–William Holden sex comedy *The Moon Is Blue* earlier that year—but given Hughes's history of antagonizing the censors, his unwillingness to engage in any sort of compromise over *The French Line* was perceived as an act of war. Though Hughes's action was considered the most hostile, he was not the only warrior: that same week, independent producing giant Samuel Goldwyn (who had released his movies through RKO since 1941) had published an open letter to Joseph Breen asking him to review the Code and consider

updating it to keep with the times. "Unless the Code is brought reasonably up to date," Goldwyn predicted, "the tendency to by-pass it,
which has already begun, will increase."

Two months later, eight producers and distributors (Allied Artists,
Columbia, Loew's, Paramount, Republic, 20th Century Fox, Universal, and Warner Bros.) joined together to issue a statement in support
of the Code, implicitly censuring Hughes and Goldwyn's attempts to
break it down or modernize it. The resolution was headlined "Decent
Entertainment Is the Best Entertainment," and it had the effect of the
producers positioning themselves, as Los Angeles's *Daily News* put it,
"on the opposite side of what has looked like a fence being erected by
producers Howard Hughes and Samuel Goldwyn."

Hughes had a defector in his own ranks. Jane Russell had decided
that with *The French Line*, he had gone too far. During production of
the movie, she had gone AWOL for five days.

"Well, I was sick," she told Hedda Hopper, before admitting that
she was also angry at the way Hughes intended to exploit her body
in a dance number set to a song called "Lookin' for Trouble." Russell
didn't have a problem with the number itself. She compared it to the
iconically sexy, but not overtly sexual, plot-driven scene in *Gilda*, in
which Rita Hayworth, clad in a strapless dress inspired by John Singer
Sargent's *Portrait of Madame X*, sings "Put the Blame on Mame" and
performs a quasi-striptease with her opera gloves in order to pique the
anger of her ex-lover. Jane didn't even have a problem with the resolution to the number, in which the male love interest "comes roaring
up and throws her over his shoulder and storms out with her. Which
is, you know, it's cute." The problem was that Hughes wanted her to
do all that wearing a silver fringe bikini. "At that time bikinis were
only worn by a few naughty girls in the south of France," Jane later
explained. "No one in America ever wore them."

Of course, to Hughes, appropriating the style of "naughty girls"
was the whole point. A June memo from RKO's J. E. Grainger to
Hughes regarding Jane's costumes for the film promised Hughes that
the garments being created for Jane were "extremely low-cut," adding

that costume designer Howard Greer "has been advised that on all of Jane's evening gowns and cocktail dresses he is to go the full limit on cleavage."

Jane, who was now in her thirties, decided that this was the film on which to put her foot down. "I was screaming," she told Hopper. "I said, 'Listen the dance is bad enough, but with a costume [that] isn't there, it's just going to look cheap as hell.' So that's when we had the big beef about that. I ended up sicker than the dickens. And then [Hughes] finally said, all right I could have a one-piece suit." The new costume, bespangled and featuring three connected petal-shaped cut-outs under Jane's breasts and above her pelvis, would be revealed from underneath a long white robe dress, strip-tease style, over the course of the dance.

In the original cut of *The French Line*, the "Lookin' for Trouble" number included close and medium shots, framing Jane's torso to showcase the incredible control Russell had over her body. She was able to make each breast, barely caged within the extremely low-cut bodice of her costume, appear to move independently—a feat that surely would have been all the more impressive in the 3-D format in which the film was intended to be seen. In a spoken-word style section of the song, Jane dispenses with double entendre for single entendre. "All I need is a maaaaan!" Jane drawls. "Any type, any style, just as long as he's a maaaaaannn! He can be short, tall, or elooooooongated. . . ."[1]

RKO submitted the lyrics to this song for Code compliance on August 17, 1953. The following day, they received the Breen office's standard reply of approval: "We have read the lyrics for the song entitled 'Lookin' for Trouble' . . . and are pleased to report that they seem satisfactory under the provisions of the Production Code. You understand, of course, that our final judgement will be based upon the

[1] For information on Hughes's decision to cede to the censors, see Thomas Doherty, *Hollywood's Censor: Joseph I. Breen and the Production Code Administration*, Columbia University Press, Kindle edition, locs. 309–11. The truncated version of *The French Line* airs occasionally on Turner Classic Movies. Excised shots were viewable on YouTube, https://www.youtube.com/watch?v=xVRYy_6m_T0, as of May 2018.

finished picture." When they viewed the filmed and edited scene in November, the censors noted "many troublesome elements" of this number, including the "costume and dance." As a later memo explained, "it seemed quite apparent that throughout [the film], the costumes for most female characters and especially Jane Russell, were intentionally designed to give a bosom peep-show effect beyond even extreme décolletage and far beyond anything acceptable under the Production Code." This memo singled out what was referred to as the "'I Want a Man' dance."

With the Breen office declining to offer *The French Line* their seal of approval, in December Hughes took his chances and released the movie without one. All the Code office could really do was fume and, as per their bylaws, threaten Hughes with a $25,000 fine, which it did. By January 6 Breen had received no response to this threat, so he sent another letter, and also informed Eric Johnston at the MPA of the violation. In January RKO resubmitted the film for an appeal. Code officer J. A. Vizzard noticed twenty-one violations remaining, in terms of suggestive lines of dialogue and shots of Russell deemed to show too much cleavage, and the "Lookin' for Trouble" number still included "many unacceptable breast shots." Another re-reviewer, Harry Zehner, noted that the dance sequence was "completely unacceptable as to costume, breast exposure and dance movements." The Code office informed RKO that they had failed this appeal. RKO remained defiant. "In our opinion," wrote executive J. R. Grainger to Breen, the film "was produced in consonance with the general principles of The Production Code. . . . Our picture is superior entertainment and neither its theme nor the pictorial presentation thereof in any sense is objectionable or offensive."

Jane claimed she didn't understand why her boss insisted on pushing the envelope of what was allowed on movie screens. "I don't know what all the Breen Office rulings are, but I know that in *Gentlemen Prefer Blondes* we managed to get along with the Breen Office all right," she told Hedda Hopper. She reasoned that *The French Line* went

"overboard—between the costume and the lyric and the dance. Too much. So why don't they cut it out and make it decent."

Calling the actress's bluff on what seemed like faux naivete, Hopper responded, "Because he [Hughes] likes this controversy."

"He likes this controversy and he wants to make a lot of money on the picture and have it banned," Jane concurred. "He's being stubborn."

"He's being stupid too."

"You're damn right he's being stupid, but then I went through this with *The Outlaw* and I never opened my mouth except to him." Russell insisted that the publicity surrounding her breakout film had hurt her career rather than helped it. "It's taken me all this time to crawl up out of the sewer," she told Hopper. "And I'm not about to be jammed back in."

As a result, when it came time to promote the movie, rather than get behind the Goldwyn idea that the culture was changing so the Code should also change to allow more sexual permissiveness on-screen, Jane began recasting herself as a victim of Hughes's exploitation. An article with her byline appeared in *Parade Magazine*, where she explained why she had submitted to three years' worth of posing for cheesecake photos in order to promote *The Outlaw*: "I hated it. But 19-year-old kids don't stamp their feet and say 'no' to people like Howard Hughes, who was producing the picture, or Russell Birdwell, the nationally famous public relations man, who dreamed up the publicity campaign. To them, I was just a can of tomatoes—and they put the sex label on me so they'd sell more 'tomatoes' than anybody else."

"It got so I couldn't go anywhere without people expecting me to walk in with five men under my arm and no clothes on," Jane complained to columnist James Bacon. "That's what the stinking *Outlaw* publicity did for me." Back then, Jane said, "I just didn't know how to say no." What apparently made her bitter was that now that she was an adult woman and an established star, she was still being sold like a can. "The roles get bigger," she sneered to *Look*, "the costumes smaller."

Speaking of that costume, "You should have seen the others I refused to wear. I fought, I hollered, and I beefed. Then when I became emotionally done in, I took off for the beach and stayed there for a week while the picture waited. Finally, I accepted the costume I wore."

Not everyone was buying Jane's presentation of herself as an unwilling participant in Hughes's sexual spectacles. Bacon asked her about another reporter who had apparently suggested that Russell's protestations were all part of Hughes's publicity plan. "He knows better," Jane responded, "and the next time I see him I'll punch him right in the nose."

Most mainstream movie reporters would quote Jane without comment, but the growing alternative fan and scandal magazines began to call her bluff. "Who Does Jane Russell Think She's Kidding?" asked *Top Secret* magazine in the headline of their three-page spread on the bombshell's "holier-than-thou pose" as a woman of God. "Jane Russell who for thirteen years has built her scandal-studded Hollywood career on the magic appeal of her conspicuous frontage and made sex into the sole stock of her profitable trade, has suddenly gone squeamish and puritan!!" It wasn't a pose: Jane had begun speaking in tongues after a spiritual reawakening at a church in Pasadena, and the experience inspired her to build a chapel with her family and invite anyone who was interested in casual prayer sessions and discussion of scripture to join her there on Friday nights. *Top Secret* raked further muck by suggesting that the Bible study sessions Jane led had been named as the catalyst in the divorce between Dutch actor Philip Van Zandt, who appeared in *His Kind of Woman*, and his wife, Victoria. *Top Secret* didn't mention that it was Philip who opposed Victoria's attendance of the classes, and, according to Victoria, it was Philip who socked her "right in the nose" when she came home from one of them, telling her "there was no place in Hollywood for girls of good character."

In February 1954, Breen was visited by a group of men representing RKO, including J. R. Grainger, Dietrich, and publicist Perry Lieber. The RKO contingent admitted that *The French Line* in its current state "had acquired a very great deal of very bad public reaction," and asked

what they could do to get the Breen office's approval. A full year later, in March 1955, having reached the limit of the profit Hughes could milk from *The French Line* without a seal, RKO made cuts to the film and resubmitted it to Breen's office for a review. Now, the censors were pleased to note, "the dance is played almost entirely in long shot, and very important, omits entirely the objectionable patter portion of the song delivered by Miss Russell while sitting and lying on the circular couch." On March 24, 1955, *The French Line* finally got its seal of approval.

IN 1954, THIRTY YEARS after the death of Howard Sr., Hughes Tool held firm as the top supplier of drill bits in the nation. As the oil extraction business boomed, so did Howard Jr.'s profits—and his tax bill. As a solution, Hughes filed articles of incorporation in Delaware that would divide his business into two distinct entities. There would now be a business (Hughes Aircraft) and a charity (the Howard Hughes Medical Institute). Howard had held an apparently sincere interest in funding medical research for a long while; in 1925, on the eve of marrying Ella Rice, he had created a will stipulating that after his death, most of his fortune should go to the establishment of Howard Hughes Medical Research Laboratories, which would be dedicated to finding cures and treatments for infectious diseases. But now, while still very much alive, Hughes had decided to establish the charity, with himself as the sole trustee, as a place to put the enormous Hughes Tool profits and assets and thus shield these monies from the tax collector.

The charity was endowed with all of Hughes's stock from the Hughes Aircraft Company—and he was the only stockholder. Hughes then "sold" the assets of Hughes Tool to the Medical Institute, which allowed Hughes to transform millions of the oil drill bit company's profits into debt held by the charity. Furthermore, a complicated lease and sublease arrangement was worked out so that Hughes's aircraft plants and tool factories would technically pay rent to the Medical Institute, allowing these payments to be written off. Not only that, but

the rent for the aircraft business's physical properties could be passed along to Hughes Aircraft's only employer: the United States Air Force. The IRS originally denied Hughes's application for tax-exempt status, but in March 1957, after he had made a "loan" to Vice President Richard Nixon's brother Donald, the IRS reversed their decision and gave the Hughes Tool tax dodge the green light.

Hughes installed as the nominal supervisor of his Medical Institute the ever-reliable Dr. Verne Mason, last seen on the scene of the attempted suicide of starlet Rene Rosseau. (Mason also kept Hughes supplied with prescriptions for codeine, which Howard had been taking consistently since the 1946 plane crash.) Hughes chose southern Florida as the location for the institute; Hughes had put a charm offensive on Florida governor LeRoy Collins and, after convincing the elected official that he planned to invest heavily in his state, Hughes likely believed he would be given preferential treatment when it came to regulations. But then, after promising to build a multimillion-dollar medical facility as well as an aircraft plant in Collins's state, Hughes built nothing. Rather than invest in a permanent home for the institute, Hughes rented a floor for a small staff in a building on the campus of the University of Miami, and made sure the institute distributed just enough money in research grants to keep up appearances—but not enough to hamper the profitability of the scheme.

THE IDEA THAT RKO was "a movie studio filled with beautiful girls who draw pay but seldom work," as one report put it, was so pervasive by early 1954 that Hughes dipped into his pockets to try to make the publicity problem go away.

Hughes offered to buy out not just the litigious shareholders, but all of the shareholders of RKO, at $6 per share. For a total outlay of about $23.5 million, Hughes would acquire sole ownership of the studio and its properties and assets. This was way more than the shares were considered to be worth, more than twice what they had been trading for on the last active day before Hughes's announcement. The shareholders

had estimated that the studio had lost $38 million since Hughes had been running it. By buying them out, he could effectively cancel out the lawsuits, while also using his losses on RKO to offset the profits of any of his companies that weren't failing.

The same RKO stockholders who had, as one publication put it, "registered intense dissatisfaction at Hughes' idea of collecting a stable of beauties who were put on at a salary but not put to work to bring the investment back," decided to let Hughes be Hughes. They voted to accept his offer, and by March RKO had become the first movie studio to be solely owned by one man.

Variety suggested that Hughes may have been motivated by his desire to "erase from his slate any evidence showing that his business behavior has meant losses for others." In other words, if you were never one to admit failure, this was an easy way of wiping out an unarguable record of the same. Yet the real publicity coup came at the end of the month, when a Nevada judge dismissed the stockholders' suits, pending Hughes's purchase of their stock, "ruling" that Jane Russell's "box-office appeal was—and is—large," and that the actress was "not a waste of corporate assets."

The shareholders now had no basis for criticism, but what about everyone else?

RKO was not the only studio in trouble in the mid-1950s, but given Hughes's role in hastening the demise of vertical integration, the reporting about RKO's difficulties producing enough movies to stay afloat reflected the town's schadenfreude. In September, the *Hollywood Citizen-News* revealed that RKO had completed only one film nine months into the year—*The Conqueror*—and that the studio was "the talk of the movie industry today as reports circulated that the company will stop production entirely." This lack of product was compounded by the fact that Walt Disney had pulled his films from RKO's distribution pipeline when he had created his own distribution company. Though there was no official comment from RKO, it was reported that one unnamed source "said there was no change of policy 'because the studio doesn't have any policy.'"

A few days later, an editorial criticizing Hughes's management of RKO appeared on the front page of *The Hollywood Reporter*. The royal "we" had had faith in Hughes's prospects at the studio, according to editor Billy Wilkerson, because "we thought that Mr. Hughes was a great picture enthusiast, that he liked the business and his pride would settle for nothing short of the best and plenty of that." That "opinion, now, is completely reversed. Nothing is coming out of RKO, nothing has come out of RKO other than a picture here and there, mostly from independent units financed in part by Hughes."

The bottom line: "The RKO organization, formerly one of the best in the business, is now nothing; the ranks of its employees, most of whom had been there for 12 to 20 years, are no more. The current crew is in a state of complete demoralization because of an inactivity that means nothing more than a week-to-week salary check." Wilkerson advised Hughes to get out before RKO's resale value had been completely frittered away.

That one film RKO had managed to produce in 1954 was itself plagued with problems. *The Conqueror* was an epic about Genghis Khan, starring John Wayne as the Mongol warrior and Susan Hayward as a Tartar princess. Wayne and Hayward were what Hughes would have called "extremely valuable stars": in February 1952, together they had been named the most popular film actors in the world in an international poll conducted by the Hollywood Foreign Press Association. Wayne, who like Howard was a fervent anti-Communist, had already acted in two productions for Hughes's RKO: *The Flying Leathernecks*, directed by Nicholas Ray, and the long-beleaguered *Jet Pilot*, with which Hughes was still unsatisfied and compelled to tinker. Production of *The Conqueror* commenced in the Utah desert in the spring of 1954, under the direction of Dick Powell. Powell had sung in musicals of the 1930s, become a stalwart of film noir in the 1940s, and was now trying for a career behind the camera. Having befriended Hughes while under contract as an actor to RKO, Powell had cut his teeth directing an RKO thriller called *Split Second*. Hughes

then trusted him with *The Conqueror*, the most epic film Howard would personally produce at RKO.

Of course, Hughes had an interest in *The Conqueror*'s leading lady, whom he had first met in 1938, when mutual friend Ben Medford had set them up on a blind date. "She cooked him a chicken dinner," Medford recalled. "He disliked her intensely. She disliked him. That was that." Cut to fifteen years later, and Hayward was among the top female box-office draws in town. In 1953, Hughes and Darryl Zanuck, still presiding over 20th Century Fox, worked out a deal to trade the services of Jane Russell, whom Zanuck wanted to pair opposite Marilyn Monroe in *Gentlemen Prefer Blondes*, for Hayward, whom Hughes wanted for the basically thankless girl part in Nicholas Ray's rodeo movie, *The Lusty Men*. Hughes was impressed by Hayward, and soon after *The Lusty Men* he began courting her, under the guise of securing her participation in *The Conqueror*. As Hayward's marriage to Jess Barker started to crumble, she became more receptive to Howard's attention. She believed they were involved seriously by New Year's Eve 1953, when Hughes and Hayward had a dinner date at the Beverly Hills Hotel. An oft-repeated story about that night holds that Hughes had also made dates with two other women, Jean Peters and a teenage starlet, for the same night, and that he was attempting to juggle all three, who were seated in different parts of the hotel. Eventually Hayward figured out what was happening, and—so the legend goes—confronted Hughes at the table he was sharing with Jean Peters, and stormed out.

Two months later, Howard's name popped up in the divorce proceedings between Hayward and Barker. According to Barker, his twin sons told him that a man with a "long, dark chin," whom they originally called "Mr. Magic," had come to visit their mom. When pressed for details, Barker said his sons told him, "His name is Howard Hughes, and he said he was going to take us for an airplane ride, but mother said we shouldn't tell you his name." Hayward admitted on the stand that Howard had come to her house to "take me out,"

and counteralleged that Barker had hit her and thrown her in their pool, charges that Barker admitted to. Hughes did not like this kind of publicity—the kind he couldn't control—and began ghosting Hayward after that, but she remained in the cast of *The Conqueror*.

The Conqueror is today often placed on lists of the worst films ever made, not least for the "yellowface" casting of Wayne. Hayward would later admit that she had trouble making it through a single take without "dissolv[ing] in laughter." Nevertheless, Hughes made sure the movie was lavishly promoted, and people went to see it when it was finally dumped in theaters in 1956. According to *Variety*, it sold more tickets than all but ten films released that year.

Today, *The Conqueror* is remembered for a shocking statistic: as of 1980, 91 of the 220 members of its cast and crew had been diagnosed with cancer, and many had died of the disease. Hayward, Wayne, and Powell were among the casualties. Though some of these instances of cancer, like Wayne's, could be attributed to smoking, years later a link was drawn between the sicknesses and the fact that the Utah shooting location had been downwind of an aboveground nuclear testing site. Though Powell had chosen the location, in a gesture typical of Hughes, when the RKO chief decided that location shooting had become too expensive, the cast and crew were moved to Los Angeles—and sixty tons of dirt from the radioactive desert were brought with them, to better replicate the location closer to home.

In the spring of 1955, in Miami, Hayward would try to reconcile with Hughes, but he wasn't interested. When Susan returned to Los Angeles, she had a knock-out, drag-down summit with Barker over their custody situation. That evening, Susan Hayward overdosed on sleeping pills. She survived, and she'd go on to win the Best Actress Oscar for the 1958 film *I Want to Live!* In 1961, Susan's sister Florence Marrenner sold a tell-all story to *Confidential* magazine, which promoted it on their cover with the text, "My sister has millions—BUT I'M ON RELIEF." Inside the magazine, Florence lamented that her sister seemed to have "forgotten the way mother took care of her when she tried to commit suicide":

Susan had been having a lot of marital troubles and then she went
down to Florida to see Howard Hughes. It was when she came
back that she took the pills. . . . When she came back from seeing
Mr. Hughes she was in an awful state and my mother went and stayed
over with her all that week. Finally, my mother came home and that
night, or rather the next morning about 3 o'clock, the phone rang
and it was Susan. She told my mother she had taken an overdose of
sleeping pills. . . . Susan never did explain to mother why she did it.

Florence Marrenner's story tells us less about Susan Hayward in
1955 than it tells us about Howard Hughes in 1961. A man who had
once exercised total control over his image in Hollywood was now un-
able to get a major tabloid—which had never to this point broken a sig-
nificant story about his sex life—to omit the insinuation that Hughes
had had something to do with a major actress's suicide attempt. No
one would have realized it at the time, but the very existence of these
few lines of gossip in print were an early signal that while the image of
himself that Hughes had created remained in the public imagination,
the man himself had completely disappeared into his own world.

UNDERWATER

In the fall of 1953, Jean Peters boarded a plane for Rome, where she'd film *Three Coins in the Fountain*. A romantic ensemble drama featuring Jean as one of three American secretaries wishing upon the titular fountain for love in Rome, this film (which, plot-wise, recalled *Roman Holiday*, a major hit that had opened in theaters just before *Three Coins* went into preproduction) was a typical product of a studio in survival mode at the end of this Hollywood era. None of the actresses (including Dorothy McGuire, and Audrey Hepburn look-alike Maggie McNamara) were stars large enough to command a huge salary or to demand better material. Expense and care were spared for the real star: the exotic production value offered by shooting on location in beautiful widescreen CinemaScope color. The hope was to lure jaded audiences who had abandoned the movies for their TV sets back to the theaters with the gorgeously photographed vicarious experience of a trip to Rome.

The film's trite narrative, in which the obstacles preventing each of the three romances from proceeding to the altar are not so much overcome as brushed under the rug in time for an all-encompassing happy ending, was wan even by the grasping standards of the era. After the performances she had given in *Pickup on South Street* and *Wait 'til the Sun Shines, Nellie*, Jean deserved better. But *Three Coins in the Fountain* made money, and in the wake of its success, Jean was considered a "hot" star, nearly a decade into her career.

If the success of *Three Coins* gave Peters's stardom a shot in the arm,

its shooting brought her relationship with Howard Hughes—which had been chugging along in parallel to her film career—to an inflection point. They had been dating for seven years, not exclusively; Jean surely knew that her rival on the Fox lot, Terry Moore, was also in Howard's life, even if Jean was not aware that Terry believed she and Hughes were married. Jean left for Italy hoping that Howard's heart would grow fonder in her absence, and if it didn't, maybe she'd meet someone new and float off into a reverie of Roman romance and leave the troubles of her current life behind—just like in the movie.

Hughes and Peters continued to stay in touch while she was away. Operations' call logs show that on November 5, Jean was told that Hughes wouldn't be able to phone her until after dinner, but when they did speak, "he has something very important to tell you concerning the picture you are working on." The same night, Terry Moore's mother was also told that her daughter would get a phone call after dinner. "It is very important to talk to [her because] he has some information about the Hal Wallis picture" (possibly *Come Back, Little Sheba*, which Wallis produced). So Hughes was acting not just as a boyfriend to these two women, but as their undercover agent in Hollywood. In addition to Jean and Terry, at this time Hughes was taking and making phone calls relevant to a woman code-named "Thunderbird Party."

At the Rome airport, as she was flying back from the *Three Coins in the Fountain* shoot in early 1954, Jean Peters met a young, totally normal-seeming Texas oilman named Stuart Cramer III. "I sat next to her on the plane and was attracted by her beauty and a helpless quality," Cramer later confided. "It was a compelling, unhappy quality." Cramer claimed that after their coupling, he had consulted with other men who had been involved with Peters, and they agreed with him about Jean's strange allure. "I always felt there was some kind of mystery about the girl that men had a desire to solve. She makes you want to reach out and care for her."

Back in the States, the day after their first meeting, Cramer called Peters and asked if she would show him around Hollywood. Several months later, on May 29, 1954, Cramer and Jean got married in

Washington, D.C. When they first decided to marry, she told Cramer she wanted to quit the movies. Maybe she was just looking to get away from a town that seemed to be owned by Hughes, but it didn't work out that way. Right away, the Peters-Cramer marriage was troubled, and a little over a month after the wedding, Peters left him. "How much Mr. Hughes had to do with this I can only guess at," teased Sheilah Graham. "We didn't spend much time together," Cramer recalled. "I don't think she knew what the hell she wanted to do."

Most reports about Jean's marriage to Cramer suggested it came out of nowhere. Hedda Hopper bragged that it was "no secret to me," in the preamble to a Q&A in which the gossip maven interrogated the actress for being too private. "How do you manage to keep your life so mysterious and secret?" Hedda asked Peters. Jean demurred: "I don't know that I'm mysterious. I lead a very simple life."

"But no one knows how you live," Hedda persisted.

Jean laughed. "Well, I'm not going to run an ad."

According to one tabloid report, after abandoning Cramer, Peters showed up at the office of the man she really loved, to prostrate herself. "I've come back," she said. She told Hughes she was going to file for divorce. "I want to be with you," she added. "On your terms. I don't care. I can't help it."

This jibes with Terry Moore's version of the story . . . sort of. "Jean was married to Stuart Cramer," Terry explained in 1977. "She called Howard and asked to see him again. She left Stuart. Stuart said she was alcoholic and suicidal, and Howard was worried she would kill herself, and so was Stuart, so they both met a lot to talk about her."

Four months after the wedding to Cramer, Peters was expected to report to 20th Century Fox for wardrobe tests on what no one yet realized would be her last feature film, *A Man Called Peter*. She didn't show up. Peters hadn't been seen in Hollywood all summer, and when Hedda Hopper called Darryl Zanuck for comment, he admitted that he had no idea what was going on with his contract star. "We're supposed to start shooting on location next Monday and if she doesn't make an

appearance, I don't know what we'll do. If you find out anything about her, let me know."

IN THE SUMMER OF 1954, just a year removed from her Oscar nomination, Terry Moore found herself being passed from one man to another on a Las Vegas stage. This was a nightclub act, at the Flamingo, arranged by Walter Kane per Hughes's request. Kane felt like it was quite a tall order; in his mind, Moore was uniquely talentless: she couldn't sing, she couldn't dance, she could barely walk. So Kane hired a crew of male dancers to carry Terry back and forth across the stage. When the show closed, Hughes billed Terry $15,000 to cover the cost of her costumes, including a diaphanous beaded gown that he had "designed" just for her. Even Terry was starting to realize that this was the sort of thing that husbands just didn't do.

Elsewhere in Nevada, Howard was otherwise preoccupied. Ava Gardner had gone to Lake Tahoe to establish Nevada residency, so she could divorce Frank Sinatra. This relocation, according to one newspaper account, was facilitated by the "sphinx-like" Hughes, "with whom she is reportedly immersed in a serious romance."

Even though Ava had cut off their love affair in the mid-1940s, Hughes's and Gardner's paths continued to cross. After *The Killers*, Ava worked steadily for MGM, largely in film noir, but she had a lot of bad luck, and few hit movies, for the rest of the decade. In late 1949, Hughes saw to it that Ava be cast as a sexually manic southern belle opposite Robert Mitchum in an RKO drama called *My Forbidden Past*. As he was wont to do with RKO films starring his female favorites, Hughes spent two years tinkering with the edit. He failed to improve it—the film lost an enormous sum, $700,000—but at least it gave him an excuse to look at footage of Ava obsessively.

After that, Gardner starred in the smash hit *Show Boat*, and then gave one of her finest performances—and earned her only Oscar nomination—playing the Jean Harlow role in a remake of *Red Dust*

called *Mogambo*. It was while shooting that film that her three-year marriage to Sinatra had begun to fatally break down. After a few volatile weeks with his bride on the Nairobi set, Sinatra had left Ava behind and hightailed it back to Hollywood to audition for *From Here to Eternity*. While Frank was away, Ava had reportedly fooled around with more than one crew member, and had definitely gone to London to abort Frank's baby. She didn't tell her husband about the abortion until long after the fact, when he had returned to Africa for a reunion. Sinatra had then gone off to make *Eternity*, which would revive his slumping career. Before that movie would come out, Ava would walk out on Sinatra for good.

Hughes had been a bone of contention in Gardner and Sinatra's already contentious marriage. Hughes, who had *Confidential* magazine, like most of the town's gossips, in his pocket, called Ava one day and told her they were planning to run a story claiming she was having an affair with Sinatra's friend Sammy Davis Jr. Hughes could have stopped the story—he managed to prevent the tabloid, widely considered to be among the most accurate and insidious publications of the era, from running anything damaging about his own personal life during the magazine's heyday. But instead, he told Ava to be worried: "They have pictures."

"Frank hit the roof when I told him," Ava recalled. "'Did you screw him?' he screamed. Of course I didn't, I said. Frank went through the whole there's-no-smoke-without-fire routine. How could he even think that? I said. Was he crazy? 'How the fuck does your boyfriend know all about it then?' he yelled. Howard was always 'my boyfriend.' Frank would never call him by his name. I said, 'I'll sue the fuckers, Frank. I'll sue their asses off.'"

But MGM wouldn't let her sue—they didn't want to draw attention to the article, and hoped it would just fade away. Its damage to the Gardner-Sinatra marriage was, however, permanent—which may have been Hughes's hope all along.

It wasn't a coincidence that Hughes pursued Ava in the midst of two of her divorces. Hughes had a tendency to pounce on recently single

women. "'Wet decks,' Johnny Meyer called us," Ava recalled. "God knows why, although knowing Johnny, I'm sure it had some sexual, if not downright dirty, connotation."

According to Ava, she and Howard hadn't seen one another "in three or four years," but Hughes still had spies watching her. Ava had brought a Spanish bullfighter boyfriend out to Nevada, but after a few nights of drunken fights, she began to find the Spaniard tiresome. Out of the blue came one of Hughes's aides, with an offer to put the bullfighter on a plane back to Spain. Ava accepted the offer with relief.

The day after the bullfighter left, Hughes showed up, took Ava out on a boat, and told her she ought to have a ring the same crystal blue as the water. He reached into his pocket and produced a sapphire. Once again he was asking her to marry him. This time he was basically groveling. He told her about all the money he had now, more than ever before. He could hire the best writers and the best directors so that she could star in the best movies, or they could just sail around the world if she preferred. He was crying as he bragged, confessing he was incredibly unhappy. Obviously, she was, too—wasn't that why she was on her third divorce, because none of the other men could make her happy?

Actually, she desperately wanted to stay with Sinatra, but they couldn't make it work. Putting off Howard's entreaties, she did agree to go with him to Miami. Hughes put Ava and her maid, Reenie, up in a rented house. The night they arrived, Hughes told the maid that the following day, a woman might show up, "but don't let her in and don't tell her anything." The next morning, a woman did come to the door, and she asked Reenie a whole bunch of questions: Who was renting this house? Who was paying her? Who had told her not to let anyone in?

To every question, Reenie said, "I don't know." Finally the woman at the door told Reenie, "You're either the smartest nigger I ever met, or the dumbest." Jean Peters was living in Florida around this time, so she could have been this inquisitive, racist woman; it could also have been Susan Hayward, who was seeing Hughes in Miami, too. If it was either of these famous ladies, Reenie didn't recognize her. When asked

if she ever found out who the woman was, Reenie said, "She was obviously someone Howard Hughes didn't want to know he was there."

Ava and Reenie wouldn't stay there long. Within a couple of days, Reenie heard from one of Howard's aides that he had picked up a spectacular diamond necklace that, as Ava put it, "he wanted to give me if I fucked him." Ava told Reenie to pack their bags. "And we went to Cuba. Without Howard."

Shortly after this last go-round with Howard, Gardner starred in a film written and directed by Joseph Mankiewicz, called *The Barefoot Contessa*, about a Spanish peasant dancer who is plucked out of obscurity, transformed into a Hollywood glamour queen, and married to a handsome, secretive royal—with tragic consequences. "I tried to do a bitter Cinderella story," Mankiewicz said, about "the type of woman whom I know only too well: the self-destructive, beautiful woman." (Mankiewicz was notorious for having affairs with troubled actresses, from Judy Garland to Linda Darnell; four years after *Contessa*, his wife of nearly twenty years, retired actress Rose Stradner, would commit suicide, leaving what was described as "an almost undecipherable note, in which [she] indicated that she was 'tired.'")

It was widely believed that *Contessa*'s Maria Vargas was based on Rita Hayworth—a Mexican dancer who was transformed into a Hollywood glamour queen, and who had recently extricated herself from a brief marriage to a duplicitous prince, Aly Khan. "That was crap," Ava said. "There was too much shit in the script about my affair with Howard." She added, "It could have been called 'Howard and Ava,' it was so fucking obvious." The reason why "Joe swore till he was blue in the face that it was based on Rita's life," Ava believed, was that "Howard was a friend of his—most of those guys stuck together like shit—but [Hughes] was on to him like a fucking tiger once he'd read the script."

Ava believed she was playing herself, and to hear Mankiewicz tell it, his directorial choices were hampered by Ava being unable to be anything but Ava. The film's best scene, in which Maria performs in a nightclub for the Howard Hughes character, a publicist (based par-

tially on Johnny Meyer), and Humphrey Bogart's director (who also narrates the film), was shot so that the viewer never sees Maria dancing but gets the impression from watching the club audience observe her that it was truly a sight to see. Mankiewicz admitted he had to shoot it this way, because "Ava just wasn't that good a dancer." It's effective, though: it allows us to grasp how everyone in the room—from a wide-eyed teenage busboy to women with husbands who seem jealous to women who seem inspired—is viscerally impacted by her presence.

Though Hughes was aware that *Contessa* was in production, he chose to show his power by waiting to protest the film until it was almost too late. Mankiewicz recalled that he was called to meet with Hughes and lawyer Greg Bautzer for a tense, two-hour breakfast of steak and orange juice. "I had to maintain the fiction that I hadn't been thinking of [Hughes] at all," Mankiewicz remembered. "He accepted that fiction as a friend, but pointed out that other people might not feel the same way."

There were certain things that were so baked into *Contessa*'s DNA that not much could be done. "You're saying to yourself, 'so that's what he looks like,'" the director played by Bogart comments via voice-over, as the camera moves in for the first time on a character who is said to "own Texas." What "he," Kirk Edwards, looks like, as played by Warren Stevens, is a young Howard Hughes. Meanwhile, anyone who had read about Johnny Meyer during the congressional investigation would think of him when watching that early set-piece scene in the nightclub, in which a fixer-publicist played by Edmond O'Brien (and which Mankiewicz acknowledged to be an amalgam of Meyer and later Hughes aide Walter Kane), first tries to lure Maria to the tycoon's table with a wad of cash, and then gives her a well-rehearsed pitch on behalf of his client. "Talent is what Mr. Kirk Edwards worships," the publicist declares to Maria, while the mogul sits silently. "It's his religion you might say." And when it comes to talent, he's interested in "only the top, the finest, the best that money can buy." Now that Maria has met him, the publicist explains, "the miracle has happened, and a great career is yours for the asking. No strings attached! All Mr. Edwards

wants is for the world to enjoy your talent, and for you to be happy. And all that he asks is your gratitude."

Hughes was most concerned with the depiction of the relationship between Edwards and Maria, which was one of a cold but eager benefactor and reluctant, rebellious beneficiary. Among the cuts Hughes demanded was a scene in which Maria throws heavy objects at Edwards (recalling the bronze bell incident between Ava and Hughes). Over that scene, Bogart's narration would have told us, "The next stop in Kirk's wooing was a literal kidnapping of Maria. I do not exaggerate. This was a routine procedure with Kirk. . . ." Mankiewicz admitted to a biographer that he had based this narration on a story he had heard about Hughes having "put Gina Lollobrigida under contract and then locked her in a house." (It was a hotel, but close enough.)

Mankiewicz agreed to make all of Hughes's requested cuts, and Hughes made it easy by making TWA jets available, free of charge, to Gardner and Bogart to get where they needed to be to dub new dialogue. But there were aspects of Howard's way of relating to women that had already been dispersed onto other male characters in the film, and these he did not protest. There is the South American scion (Marius Goring) who is happier having people think he was sleeping with Maria than he would have been actually sleeping with her, who loses Maria for good after he spells out his transactional view of their relationship a little too literally: "I've paid for your company and you'll come and go as I tell you!" And, in a way, the count (Rossano Brazzi) who romances Maria and marries her without telling her he's war-wound impotent is cut from the same cloth. Maria is nothing but a trophy to these men. Worse—she's a billboard, advertising to the world that each of them is more of a man than we know him to really be.

IN JANUARY 1955, RKO threw a junket in Silver Springs, Florida, for the 3-D Jane Russell movie *Underwater!*, a hunt-for-sunken-treasure clunker whose reason to exist was the promise of a "skin diving" Russell in a swimsuit. A chartered TWA plane flew from Los

Angeles carrying various RKO flunkies and friends, including colum-
nist Lloyd Shearer and what Shearer described as "a colorful assortment
of press agents, stooges, journalists and females." Those "females" in-
cluded both legitimate actresses like Debbie Reynolds, less established
starlets under contract to RKO, and what Shearer euphemistically re-
ferred to as "several commercially-minded girls who were majoring
in business administration—they conducted night school in their own
apartments."

A "topheavy" blonde sat down next to Shearer and introduced her-
self as Jayne Mansfield. A proud careerist with no bashfulness regard-
ing her figure or her ambition, Mansfield told Shearer that she was
sitting next to him because she had asked one of the publicity men
which man on board could do the most good for her future. Shearer
demurred, told her she'd been had—he was just a writer. But Mans-
field had heard he had just written a film for Marilyn Monroe (he had
not). Maybe there was a part for her in it? "I've just got to become a
screen star."

Shearer observed her "jiggling her unbrassiered bust." "You're ob-
viously talented," he told her. "But can you act?" To which Jayne Man-
sfield shot back, "Can Jane Russell act?"

As it turned out, Jane Russell, the star of the movie that occasioned
the junket, was delayed in New York and would show up a full day
late. Mansfield saw an opening and took it. According to Shearer, she
"cleverly used that one day to steal the spotlight" by posing in a tiny
bikini for every photographer she could find. Mansfield struck Shearer
as "self-exploitative, bizarre, intelligent and determined."

Russell had just signed a landmark new, twenty-year contract with
Hughes, which would guarantee her just over a million dollars, dis-
bursed in $1,000 segments per week, until she was fifty-four years
old. "Did you ask for approval of advertising in your new Hughes con-
tract?" Jane was asked by Hedda Hopper.

"I don't have it in the contract," Jane admitted, "but there will be no
more trouble I trust over ads. We have an agreement."

"Do you ever talk to [Hughes]?"

"No."

"Terry Moore does."

"She's playing a different kind of game."

As it turned out, Hughes would loan Jane out a few times to other producers, but after *Underwater!*, he never cast her in another movie.

THE HUGHES-SPONSORED VEGAS ACT didn't do much to help Terry Moore's career, and neither did being with Hughes, who wasn't encouraging of anything that made her unavailable to him. She didn't make a movie for all of 1954, and then Jean Peters, whom Terry had thought she was rid of, returned on the scene.

Jean was already separated in the fall of 1954, when she finally reported to shoot *A Man Called Peter*, on location in Atlanta and then back in Hollywood. Erskine Johnson, in his "In Hollywood" column, claimed that on set, Jean's "eyes were so swollen, and her nose so inflamed, she couldn't do close-ups," and had to be shot around; the culprit for her cry face was said to be "smog." A little over a week after that item ran, the United Press ran an interview with Jean in which she gave no indication of trouble in her marriage, and stated that she and Cramer would be settling down on the East Coast and that she would be working in Hollywood only sporadically. In fact, by Peters's later recollection, she spent the end of 1954 hiding out in Florida, where Howard came to her, checking into the Columbus Hotel in Miami. Peters stayed in Miami "through Christmas and into the spring." Howard went back and forth between her and Hollywood.

The news that Cramer and Peters were divorcing finally broke in Louella Parsons's column in September 1955, five months after *A Man Called Peter* was released. In December, Jean filed divorce papers, in which she estimated the length of her cohabitation with her first husband to be thirty-three days.

Cramer didn't hold a grudge against Hughes. "I'll say this," he later said, "if your wife is going to get a divorce, you might as well let

her marry someone who can afford to support her. It's the cheapest way out."

Now, finally, Terry Moore gave up on Howard Hughes. After so many years, she had realized that he didn't just lie the way other people lied—to avoid hurting your feelings, or to get away with doing something he wasn't supposed to be doing. He was either a sociopath, and thus not totally in control of his pathological lies, or else he got genuine pleasure out of manipulating people. Either way, Terry was through.

On New Year's Day 1956, Terry married Eugene McGrath, a Panama-based businessman. She moved to Panama, and the newspapers all claimed she was retiring from showbiz. Then she ended up coming back and costarring, at age twenty-eight, as a high school tramp in one of the biggest movies of 1958, *Peyton Place*.

Soon McGrath was gone, replaced by Stuart Cramer—Jean Peters's ex-husband.

HUGHES HAD FIRST BORROWED Janet Leigh from Dore Schary's MGM in 1949, when *Jet Pilot* first went into production. Every so often, Schary would get another call from Hughes, asking to borrow Leigh again, for reshoots. The last time Hughes called Schary about Leigh, Schary remembered, "I told him I was sorry he was having so much difficulty. He told me that the picture he was about to finish would be his last one. He said it was a ridiculous business and said, 'I have had my belly full.' That was the last time I spoke to him. The finished film was a disaster. Soon he got rid of the studio."

In July 1955, Hughes made a deal to sell RKO to General Tire and Rubber Company, headed by Thomas F. O'Neill. This time, the deal stuck. "That man didn't need a lawyer," O'Neill marveled of Hughes after the negotiations. "He knows more about corporate law than any attorney I ever knew."

So ended perhaps the most infamous, bizarre run of any mogul in Hollywood history. If what Hughes had wanted to do going into RKO

was hasten the demise of the studio system, to give independents like himself a more level playing field, he succeeded. By most other metrics, he failed. Some observers believed that giving Hughes credit for trying to do anything at RKO was a mistake.

"Hughes didn't mismanage RKO," said W. R. Burnett, one of the writers who had worked on *Vendetta*. "He didn't manage it at all. He didn't care. It was a write-off."

When asked why a tire company would want to acquire a movie studio, William O'Neill, Thomas's father and General's founder, responded, "Who says we should stick to the rubber business? Our business is to make money!" At that, they failed. RKO would continue on as an operational film studio for just two more years; ultimately the O'Neills would sell the facilities to Desi Arnaz and the back catalog to television. Though a process was by now well under way that would cause every studio to restructure or die, RKO would become the first of the major, golden-age studios to cease to exist entirely.

After the sale, Hughes started using the Sunset Boulevard home of his aide Walter Kane as an office. His aides were instructed to never call Hughes there, and women were not to be told the location even existed.

One day Hughes was working out of Kane's place alongside Walter, Pat De Cicco, and lawyer Greg Bautzer. Intending on messing with him, De Cicco asked Hughes about his plans for his estate. "What are you going to leave Kane, Bautzer and myself?"

Hughes responded, in apparent seriousness, "Not a goddamn dime."

De Cicco decided to tease further. "Well, you know, Howard, you don't have too many friends, and three pretty good friends of yours are sitting here. You have got an awful lot of money. You mean to tell me you are not going to leave either one of us anything?"

"Not a quarter."

Now De Cicco was starting to get legitimately annoyed. "Well, let me ask you, Sam," De Cicco fired back, referring to Hughes by one of his code names. "Why?"

"I don't know," Hughes shrugged. "I couldn't exist, if there's another world, knowing that you and Kane and Bautzer were out with some of my girls, using my money."

This would be one of the last times Hughes was in the same room as all three of these men, these friends who had been in his life for as long as two decades. Kane would later say that it was around the time of the RKO sale when he started to notice a change in Hughes. Kane claimed that Hughes had received from the sale a check for $25 million. One day Hughes was hanging out at Kane's house, and when he left, he absentmindedly left the check behind. A little while later he returned, picked up the check, and walked out again, without saying a word. Soon he'd stop coming around at all: over the next two years, Hughes would restructure his existence so that, if such mental lapses occurred, they happened, like the rest of his life, in almost total isolation.

PART VI

HUGHES AFTER RKO

PLAYACTING

In the months after he severed ties with RKO, Howard Hughes's next venture was a hot topic of speculation. Rumors swirled that he was planning to buy another studio, perhaps 20th Century Fox (where Jean Peters was still under contract), or that he would fly the Spruce Goose around the world. But either undertaking would have required a level of public engagement that he seemed increasingly uninterested in and perhaps incapable of maintaining. Over the next three years, Hughes would gradually recede from the public eye entirely.

Sometime during 1956, Hughes arranged a recording session for his new protégé, a seventeen-year-old would-be singer-actress named Yvonne Schubert. Twenty-two musicians had been booked to play during the session, and Yvonne was intimidated. Her nervousness touched off something in Hughes. He called Kane, upset because Yvonne was upset. Hughes began complaining about the twenty-two musicians. He kept repeating the number: "twenty-two . . . twenty-two . . . twenty-two" He didn't realize what he was doing. This is when Kane really started to wonder if Hughes was having a nervous breakdown.[1]

[1] This would soon become a common suspicion. Johnny Holmes (Hughes's closest attendant in 1958) and Jack Real (a pilot whom Holmes would call when Hughes was particularly agitated, so that Real could calm him down by talking about aviation) would feel the same in the coming months and years—but Kane seems to have noticed a change in Hughes first. See "Deposition of Raymond D. Fowler, Ph.D. Vol. 1, April 3, 1984," Fowler files.

Certainly, he was becoming more difficult to communicate with, by design. Now the only way for anyone but his closest aides to reach him was to call in to Operations to leave a message for Hughes or, if you were lucky, pick up a message he had left for you. Hughes's relationships and movements during the next few years can be traced via the voluminous call logs left behind by his staff. Through this process, Hughes was able to foster the illusion of forever being too busy to deal immediately with whichever person was trying to reach him, that whatever issue this person was trying to bring to his attention was less important than whatever he was doing. Like the work of all the publicists he had employed over the previous thirty years, the call log process was a smoke screen designed to make everyone in Hughes's life believe that he held all the power in their relationship. It was increasingly important to keep up this impression as the real Hughes began to recede from the image of him as American hero-rebel that had hung around in the ether since his last major public stand, before Congress, ten years earlier.

And it was especially useful when it came to juggling and controlling women.

Over the next year, Hughes would have detectives surveilling a number of them. In April 1956, Hughes, after reviewing photos of women under contract to him named Barbara Hilgenberg and Patte Dee, left a message for Kane happily describing them as "very good. I was amazed that we had someone that good." Kane was then instructed to make sure Dee and Hilgenberg were prevented from leaving their houses until Hughes issued further instructions: "I want them available for me this afternoon." In June 1957, detective Jeff Chouinard (who, in addition to the names "Jeff" and "Gerald," also sometimes went by the alias "Mike Conrad") was ordered to tail an actress named Joyce Taylor to "determine the following: Where this girl has been 2. Who she has been seeing 3. Who she returns with." Others under careful watch were model Pat Sheehan, a high school senior in South Gate named Mitzi Lee Anderson, and Yvonne Schubert, who went by

several code names, including "the Party," and, in a reference to the canyon avenue on which her Hughes-sponsored house sat, "Coldwater."

Schubert and Jean Peters were the primary points of Hughes's interest. He would often leave several messages for each woman every day. On April 9, a typical day, at 8:15 P.M., Hughes ordered that three copies of a script called *Pilate's Wife* be delivered to Peters. At 8:56 P.M., he instructed Operations to "dial her number every (1) minute until you get through, then tell her" that he would be busy for a while, but needed to talk to her about the scripts and "also wanted to talk to you about something else," but it would have to wait. Operations finally reached her at 9:02, and she said, "OK, fine I was trying to reach [Hughes] at the same time I guess." Peters started calling in to Operations to inform them when she was awake and when she was going to bed, and when she'd be available to take phone calls from Hughes.

Schubert was less compliant. On the same day that Hughes ordered that "a basket of real nice flowers" without "any purpose flowers, any dead flowers or those flowers from Honolulu" be sent to Jean Peters, Hughes gave a different order regarding Yvonne. Because she had not been following his instructions to the letter, he told his aides to "set up surveillance on the house around the clock except at those times when she is in custody of our people. This is to continue until I give you further instructions. If she tries to leave, I want her followed." Her activities were thus carefully monitored, at home or elsewhere. Upon learning that Yvonne was planning to go out to the Ambassador Hotel one evening, Hughes commanded: "Have someone go to the Ambassador right away to be there when they arrive and be in the kitchen to be absolutely sure on the food restrictions. Be sure the man checks each item of food for her and also see that she doesn't get anything to drink, not even champagne (also no dancing)."

After January 11, 1957, the call log for Peters would go dark until the last day of the month. The next day, Hughes and Peters would marry in Tonopah, Nevada.

Hughes romantically explained to his bride why they needed to elope

to Nevada, rather than have a wedding where they lived: "[California] is a community-property state," Jean recalled. "He didn't want to take any kind of legal action in California because he didn't want to be considered a resident of California." Another reason for the Tonopah location may have been that in Nevada, it was legal to marry under assumed names.[2] They used pseudonyms on the marriage license—J. A. Johnson and Marian Evans, aged forty-six and twenty-nine (Hughes and Peters were actually fifty-one and thirty)—because Hughes simply didn't want anyone to know he was a married man. At least, not right away. When he felt the time was right, he allowed Louella Parsons to release the scoop.

Why did this marriage happen? Sheilah Graham believed it was Jean's designed and wished-for endgame of her marriage to Cramer. "Jean had wanted to marry Howard," Graham explained. "The elopement with Stuart was perhaps to prove her independence. Where she came from if a couple were in love, they did not wait years to be sure." After the Cramer marriage, Graham added, "I am sure Howard Hughes was angry. Jean was his girl. . . . Mr. Hughes must have now realized that he loved her." Once her point had been made, according to Graham, Jean filed for divorce, and "Howard replighted his troth to Jean."

But few close to Hughes believed that the marriage was something he wanted, even if, in his way, he did love Jean and he had been dismayed when she had married Stuart Cramer, to the point of hiring Robert Maheu, an FBI- and CIA-affiliated private detective, to try to dig up dirt on Cramer that Hughes could use to drive a wedge between him and Peters. (Hughes suspected Cramer had his own ties to the CIA, which Maheu confirmed he did.) Echoing part of Graham's version, Kane would say that Peters had married Cramer in order to

[2] In 1931, Nevada state passed a law allowing marriage licenses to be obtained instantly, without waiting periods or verification. Thus, until the early 1960s, Nevada had the most lenient marriage and divorce laws in the nation; both activities became a cash cow for the state in an era when marriages and, particularly, divorces, were highly regulated in most states.

make Hughes jealous, but only so she could then "corner" Howard into liberating her from that sham marriage. Kane also blamed Peters for Hughes's increasingly evidently diminished mental state. Kane had come to believe his boss suffered a nervous breakdown in part because he had married Peters essentially against his will.

Terry Moore at first believed that Hughes had voluntarily liberated Jean from the Cramer marriage, not because he loved her (she insisted "sexually Howard wasn't interested" in Jean, and "that was all he ever thought a woman was good for anyway"), but because "Howard can't stand anybody else to have what he's got, and he was afraid she still might go back to Stuart." But when Terry posed this theory to Noah Dietrich many years later, Dietrich told her that wasn't the way he saw it. Dietrich, whose own version of events seems based mostly on hearsay and conjecture, believed that Hughes's continuing relationship with Peters broke up her marriage to Stuart Cramer, so Peters filed for divorce, assuming Hughes would marry her. Furthermore, according to Dietrich, Cramer was eager to be rid of Jean, not least because she had become an alcoholic. "'She was so polluted all the time,'" Dietrich recalled that Cramer had said of Jean, "'I don't even think she knows I was there.'"

Cramer had an added incentive to have his wife leave him for Hughes: Stuart had inherited a large amount of money since the marriage, which he didn't want to have to divide with Jean. To complicate matters, as Dietrich put it, "maybe [Cramer] had fallen in love with you [Moore] or somebody else in the meantime." Given the quickness with which the members of this circle entered into marriages and exited them, and swapped one partner for another, that certainly seemed like a possibility.

When Jean's final divorce decree from Cramer came through, Jean delayed in picking it up, perhaps because Hughes had, as he was wont to do, prevaricated on his promise to marry her. According to Dietrich, Cramer then threatened to instigate his own divorce action against Peters, which would have outed her drinking problem and would have been humiliating for her as a movie star. Dietrich believed that Peters

then went to Hughes with her own blackmail proposition. "I think that he signed something for her that would have been terribly embarrassing if made public," Dietrich speculated to Moore.

"So you think she kind of forced him into this marriage?" Terry asked.

"That's right."

It's odd that Terry Moore would need to hear this information about Stuart Cramer from Noah Dietrich, given that she wed Cramer just three years after he divorced Peters. Though she would later say that all topics having to do with Howard Hughes were verboten during her marriage to Cramer, on the call with Dietrich she claimed that Hughes called Cramer one night while this was all going on and asked if he should marry Peters, and Cramer said, "You damn well better."

"Yeah, well, she had something on him [Hughes]," Dietrich responded. "I think that's what compelled the marriage." What this something could have been, Dietrich didn't reveal to Terry Moore.

After the Nevada ceremony, Peters and Hughes moved into her house on Strada Vecchia Road, above the Hotel Bel Air, for "a couple of weeks," Jean recalled. After that "we went to the Beverly Hills Hotel briefly. Then we went to Palm Springs." This honeymoon period was over after about a month; by February 18 she was calling in to Operations frequently to try to reach Hughes. By March they were back at the Beverly Hills Hotel, living in separate bungalows and communicating through Operations. Hughes would often give Operations complicated instructions regarding his new bride. All incoming calls to her bungalow were to be blocked, other than those from her sister. He told his aides to tell her, "HRH will call you the minute he wakes up and in the meantime, anything you chose to order from Room Service will be promptly taken care of." Hughes also told Operations, "If she asks what room I'm in," tell her, "but don't volunteer it."

On March 10, Hughes issued very detailed instructions regarding how Jean's food should be prepared and served at the hotel. A "food checker" would be required. Howard would also be informed of her orders, which ranged from "1 steak, hash browns, leaf spinach, sliced

tomatoes and avacados [*sic*] w/French dressing on the side, pot of coffee, cottage cheese, and a vanilla custard" to "a pint of champagne." It was ordered that aide Stan Wilson be "advised immediately" when Jean ordered alcohol. At some point during this period, Hughes and his aides started referring to his wife by the bizarre militaristic code name "Major Bertrandez."

Finally, two months after the wedding, the marriage was reported in Parsons's column—buried, apparently, thanks to Howard's instructions.[3] By Friday, March 15, the news was syndicated nationwide. The union was not confirmed by the Hughes camp, nor by 20th Century Fox, the studio where Jean was still under contract.

Matrimony had not changed Howard Hughes the way it might conceivably change the behavior of other men. On January 28, two weeks after marrying Peters, Hughes learned that Yvonne Schubert was sick. He ordered that she be sent "some lovely flowers," a rented portable TV set ("I want one that's real beautiful, that would appeal to a young lady, because I may decide to give it to her"), and a new copy of Hemingway's *To Have and Have Not*. She swiftly recovered, and soon thereafter Hughes called Operations to order a car to retrieve Schubert from his bungalow at the Beverly Hills Hotel at 3:25 A.M. The next day, Hughes gave instructions for Yvonne to see a number of movies with "good performances," including Howard Hawks's film of *To Have and Have Not*, *Notorious* (with Ingrid Bergman), and *Top Secret Affair* (starring Susan Hayward).

HUGHES NO LONGER HAD RKO as a clearinghouse but he continued to collect young women who believed that to be under contract

[3] "You know darned well by the way it was handled that Howard dictated that story to Louella and ordered that it be buried in the column," said a Hughes aide in 1968. "He told her, 'I've been married and I want you to announce it and this is the way I want you to do it.' Louella gasped that this was headline news. Hughes told her if she dared ignore his instructions he would deny the item and call her a liar. Down in the column Louella casually mentioned she had received word that Jean Peters and Howard Hughes were married." D. L. Lyons, "America's Richest Wife," *Ladies' Home Journal*, November 1968.

to Howard Hughes was to have their future in sure hands. They did not know about the dozens of women who had preceded them who had not been transformed into Jean Harlow–level legends. Walter Kane continued to act as a procurer, finding the girls and securing their contractual obligation and proximity to Hughes. These young women were installed in houses, apartments, or bungalows at the Beverly Hills Hotel, Sunset Tower, or Chateau Marmont. A fleet of drivers remained on the Hughes payroll to chaperone the women around town, essentially restricting their movements to Hughes-approved activities. There were daily acting lessons, dance classes, and voice coaching. As each type of tutoring took place at the homes of the instructors, spread across the west side of Los Angeles and Hollywood, the girls were led to believe they needed Hughes's drivers in order to complete the tutelage that Hughes mandated before he would even think about casting them in a film.

The drivers didn't know much about the individual girls. To these chauffeurs, most of them clean-cut Mormon young men,[4] all of the girls seemed the same. "She was invariably dark haired, heavy bosomed and flat hipped," recalled Ron Kistler, a former Hughes driver. In height, shape, and coloring, Kistler observed, all of the women looked not dissimilar to Jean Peters.

Also, Hughes gave every driver the same directions for every girl. "They were allowed one ice cream cone a day," Kistler recalled. "If they wanted to argue the point, they could sit in the front seat. Hopefully they would sit in the back seat of the car." (There was no arguing the one ice cream rule.) The most important, according to Kistler? "If we saw a bump in the road, we were supposed to slow down to a maximum speed of two miles an hour and crawl over the obstruction so as not to jiggle the starlet's breasts. I learned that Hughes was one of

[4] Terry Moore took credit for the religious background of most of Howard's aides. "Howard was so impressed by my strict Mormon upbringing, and the fact that we don't smoke or drink, that he began hiring Mormons," she wrote. Obviously, another benefit of hiring devout Mormon men was that they would be less likely than the average layman to compete with Hughes for the attention of women. Moore, *The Beauty and the Billionaire*, 44.

the world's consummate tit-men and he was convinced that women's breasts would sag dangerously unless treated gently and supported at all times."

Though the drivers were under strict orders not to develop personal relationships with the aspirants they ferried around (the "no touching" rule was so severe that a driver was not even to offer a hand to help a young lady out of the car), Kistler and his cohorts found their own social lives subordinated to the highly managed night lives of the women they were assigned to drive. A few nights a week they'd be required to chaperone their starlet (and often her mother or agent) to a movie, a play, and/or one of Hughes's chosen restaurants—usually Perino's on Wilshire, or the Lanai at the Beverly Hills Hotel. Each of these restaurants would inevitably be full of Hughes drivers, at tables with Hughes girls. This put the drivers in a precarious position in regards to one of Howard's cardinal rules: "not to let the young lady know there might be other girls like her under contract to Hughes Productions." The drivers easily spotted one another; the girls had no idea—until they recognized a driver who had taken them around on another shift, in which case she would ignore him. "The starlet you had taken to dinner two nights earlier would literally look right through you when she was being escorted by another driver," Kistler remembered.

Both starlet and driver had an incentive to play by the rules: they were all being watched. "The best part of the dinner was the knowledge that lurking in the parking lot, not eating, were the private detectives," Kistler recalled. "One was assigned to each driver-starlet car to make certain there was no hanky-panky. About half the time that detective would be followed by another detective presumably to prevent any coordinated driver-detective sexual conquest." This process ensured that if one or two employees fell out of line, there would be another employee, by the law of averages loyal to Hughes, who would blow the whistle on whatever bad behavior was going on.

Of course, for the young women, the whole purpose of submitting control of their lives to Hughes was the hope that he would turn them into the next Jean Harlow or Jane Russell. They were all to be

disappointed. "None of the starlets we escorted," according to Kistler, "ever became stars." A few managed to break out of Hughes's contract and find work, but most languished. There was a simple reason: after *Jet Pilot*—which was dumped into theaters unceremoniously in 1957, eight years after its production first began—Howard Hughes never made a movie again.

TWA'S FORTUNES—AND STOCK PRICE—HAD tumbled since the end of World War II. Noah Dietrich—who had been successfully running Hughes Tool, which financed Hughes's less profitable ventures, while Hughes was otherwise occupied—blamed the airline's decline on the mismanagement of Jack Frye, who was in charge of day-to-day operations. Dietrich tried to convince Hughes to fire Frye, but Howard wouldn't do it because Frye was his shopping buddy: together they liked to spend large sums of Hughes's money on brand-new planes. Eventually, however, Hughes begged Dietrich to help TWA get back on its feet. Dietrich arranged a $40 million investment from the insurance company Equitable, on the condition that none of the funds be used to finance debt. Dietrich went back to his real job, and shortly thereafter found out that Frye had misused the Equitable funds exactly as he was not supposed to do.

A shakeup followed: Frye was fired, Hughes put $10 million of his own money into TWA, and ensured his control of the board by appointing cronies who would vote with him to drown out the remaining shareholders. Though Hughes had no official job title at TWA, he took the liberty of behaving as the company's CEO and creative force, pushing his way into matters from plane design to aeronautical regulations to (no surprise) public relations. Hughes was so determined to treat TWA like his own private company (he'd even make sudden changes to the flight schedule, canceling commercial flights and commandeering passenger planes for his own purposes) that the actual executives ostensibly hired to run the business had a difficult time doing their jobs. After Frye, a new president was hired, Ralph Damon, who

served for seven years, and then in 1955 died of a heart attack. Dietrich believed the job—working for Hughes—had killed Damon. The next president of TWA, Carter Burgess, would last less than a year before resigning, rather than have to shoulder the weight of a debacle that Hughes set into motion.

It began in January 1956, when Hughes, without consulting with anyone at the airline, began placing orders for new, state-of-the-art jets to replace TWA's aging fleet. By that summer, Hughes had pledged nearly $500 million of TWA money on the new airplanes, which would not be ready for operation for several years. The cost of these planes was far more than what the airline could afford, and while Dietrich tried to work out financing options, all of his proposed solutions involved Hughes giving up his majority ownership of TWA's shares, which Hughes refused to do. Instead Hughes wanted to finance TWA's fleet upgrade by selling Hughes Tool—but first he wanted Dietrich to go down to Houston and goose Howard's father's company's earnings by any means necessary. This was not something Dietrich was eager to do, but over the next few months he increasingly found Hughes almost impossible to get a hold of so that they could talk it over.

While this was going on, two men on Hughes's payroll—a lawyer and Doctor Verne Mason—suggested that Dietrich try to have Hughes declared mentally incompetent. This would have involved filing a legal petition, after which Hughes would have to be psychologically evaluated (by force of subpoena, if necessary). A court would then decide if Hughes was truly incapable of managing his own affairs, and if the guardian suggested by the petition (which, in this case, probably would have been Dietrich) was fit to run his affairs. If all went according to plan, Hughes could then be committed to psychiatric care, and his employees could run his company without the interference of Hughes himself.

It is possible—maybe even likely—that the Hughes employees were not seeking this intervention because they were concerned about Hughes's mental health, and instead were fed up with his erratic and yet despotic management and wanted to get him out of the way. There

was some speculation among Hughes's aides that Hughes knew about the talk of having him sidelined, and he married Jean Peters to prevent it, because a married man's wife would automatically be considered the guardian of his well-being. That said, there were behavioral signs that all close to Hughes could cite that would make a diagnosis of incompetence potentially likely. In the years since the 1946 crash, as Hughes continued to take steady doses of the codeine first prescribed for his injuries and continually provided to him by Dr. Mason, he began issuing orders to the people who worked for him to accommodate his obsessive eccentricities. His xenophobia had advanced so that he now wanted nothing to do with the typical niceties of business; employees were instructed to not attempt to touch Hughes (meaning no handshakes), or to even look directly at him. His fastidiousness and germophobia had reached the point where aides were instructed to purchase three copies of each magazine he desired to read, and hand him the single copy he needed sandwiched in between two other copies in order to keep the reading material "clean." And yet, paradoxically, the man would sometimes let his own hygiene lapse, appearing in public unwashed, his clothes filthy. Looks can be deceiving, but he sometimes looked like a man who was not in full control of his faculties.

Dietrich said he turned down the overture—"I am not about to play doctor," he insisted—but he was about to face the consequence of working for a man who was, if not clinically incompetent, then certainly indifferent to commonly accepted standards of business practice and human relationships.

On March 12, 1957, Hughes called Dietrich to the Beverly Hills Hotel. Once Dietrich arrived, Hughes wouldn't meet with him in person and made Dietrich move to three different rooms before he would finally speak to Noah on the phone. As Dietrich recalled, "He wanted to be certain that our conversation was not being recorded." Finally, Hughes reiterated his urgent desire to have Dietrich go to Houston and have him manipulate Hughes Tool's bottom line. Dietrich said he would do it—as soon as Hughes signed an agreement that they had been discussing for fifteen years, which would transfer much of Diet-

rich's salary to stock options, in order to alleviate his personal income tax burden. Hughes had been promising to do this for the man who ran most of his businesses for a decade and a half but had dickered that entire time over the exact formulation of the deal. Now Dietrich was refusing to make another move on behalf of Hughes unless he signed the agreement. Hughes refused, and Dietrich quit, leaving Howard to sort out the mounting headaches of TWA, and everything else, on his own. Before Dietrich could show up at his office to collect his personal belongings, Hughes—furious, feeling betrayed by his longest-lasting employee—ordered that the locks be changed.

There were a lot of long-term factors that led to Howard Hughes's now-legendary retreat from public visibility and total mental and physical decline, over the last twenty years of his life. The many head injuries he had suffered in plane and car crashes had left a cumulative effect, and the final, massive plane crash in 1946 had led to a dependency on painkilling drugs. But everything was markedly different after the one-two punch of the first half of 1957. First he lost his identity as a lone wolf, and a certain sense of freedom, when he married Jean Peters. Then he lost Noah Dietrich, who had been more than his always-reliable corporate fixer since 1925: Dietrich was also the person who had been in Hughes's life the longest of anyone over that time. This was an enormous amount of change in a very short period of time for a man who wasn't totally stable to begin with. He did not handle it well at all.

PRISONER

"In Hollywood, they say Jean Peters has been 'kidnapped.' Then they look around nervously and say, 'Well, not "kidnapped," exactly, But— she's—not exactly—allowed to go out.'"

About four months after her marriage to Hughes, *Modern Screen*, one of the longest-running fan magazines, and one that rarely ran anything a powerful studio would be able to call foul on, printed an incredibly dramatic story on Jean Peters and the mysterious man who, after years of on-again, off-again dating, had allegedly virtually imprisoned her and forced her to give up her acting career. This article was loosely sourced and featured a few minor inaccuracies, but big-picture-wise, its tale rang true. The entire first page was a dialogue exchange in block letters:

HE: "I LOVE YOU AND YOU BELONG TO ME. BUT I
WONT MARRY YOU."
SHE: "I TRIED TO RUN AND I CANT. I WANT TO SEE
YOU ON ANY TERMS. I CANT HELP IT."

Twentieth Century Fox, the article claimed, couldn't find their contract star. "They've written to her, wired her, phoned her. Their letters are returned: Address unknown. The wires are never accepted. The phone number has been changed. They haven't been able to speak to Jean Peters for almost four months."

Over the next few years, stories would proliferate of Jean Peters

hiding in plain sight: going to baseball games at Dodger Stadium, attending classes at UCLA, shopping up a storm, often accompanied by bodyguards, sometimes disguised and rarely using the names "Jean Peters" or "Jean Hughes." According to *Modern Screen*, not long after the wedding, Jean was spotted on the street by "an old friend" who recognized her, despite the fact she was wearing a blond wig, because "there's only one person in the world whose eyes are that unhappy."

Modern Screen may have embellished and narrativized some details, but they didn't make this story up wholesale. "After her marriage to Howard it was as though she had been swallowed by an earthquake. No one in Hollywood saw her," confirmed Sheilah Graham in 1974. "[F]rom being an active, normal woman she became almost as much of a recluse as her husband."

Graham had her order of events mixed up. Hughes had been retreating from the public eye slowly for years (in 1951 Louella Parsons lamented that Hughes had already become "curiously withdrawn"), but it was only after the marriage that his reclusion became total. By the end of 1957, Hughes had stopped seeing anyone other than people on his payroll, and Jean Peters.

By 1958, the TWA affair was a mess that Hughes couldn't see a way out of. Any action on his part would likely result in a loss of control, and until he figured out how to solve the financing and management problems at the airline, the company was hemorrhaging money, and Hughes himself was open to lawsuits, or a hostile takeover. Afraid of being pressured into a decision (and of being reached by process servers), Hughes began spending most of his waking hours, and virtually all of his nonwaking hours, in private screening rooms. These were standard screening rooms accustomed to being rented by the hour, or maybe day; Hughes would occupy one he liked for months at a time. He'd watch movies for anywhere from eighteen to seventy-two hours straight, then sleep in his chair for a full twenty-four hours, and then start again. He'd only leave the premises when absolutely necessary. The benefits of holing up in a screening room were at least twofold: protected by his spies and aides (not to mention Hollywood etiquette

that dictates private screenings proceed free from interruption), he couldn't be forced into a face-to-face meeting, or easily served a subpoena. Also, if he never went home ("home" these days being the Beverly Hills Hotel), Hughes alone could dictate the terms on which he saw his wife.

It began in Studio A on the Samuel Goldwyn lot. Hughes had aides, wearing white gloves, personally deliver and install two white leather chairs. In the evening, Hughes would go to the Beverly Hills Hotel to pick up Peters, and Jean would accompany Howard back to the screening room. They would sit in their side-by-side, his-and-hers leather chairs and watch a couple of movies. Her husband had a tendency to watch movies he liked multiple times. Sometimes he would watch a movie all the way through, but often he'd signal to the projectionist to stop it at some random interval and put on the next film. After a double feature, Howard would take Jean back to the hotel. Then he'd return to the screening room by himself, and stay there, alone but for the aides paid to project films and answer his whims, all night.

When Jean would visit, occasionally she'd show up dressed to the nines, in furs and full makeup; other times she'd be wearing jeans and sneakers, like a normal mom next door. "She seemed to enjoy Hughes' company," Ron Kistler recalled, "yet there were occasions where she'd raise her voice exclaiming, 'I don't want to watch that again.'"

The aides began to observe that Mrs. Hughes started accompanying him less frequently. Eventually she stopped coming at all. This was as Hughes preferred it: Jean's absence gave him a chance to use the screenings to hunt for new talent. Occasionally Hughes would ask the projectionist to stop the film on a specific frame, or back up, rewind, and replay the film until he spotted again the face that had caught his eye. He'd tell the projectionist, "I am interested in the gal sitting at the third table from the left top part of the screen." The projectionist would then call Operations to give them that information, plus the reel number and the film name, and then someone at Operations would track down the casting director of that particular film. Sometimes the casting director knew which girl Hughes was talking about just based

on the available information; other times a Hughes aide would have to rent a screening room, as well as a print of the film, and show that section to the casting director so that he could identify the young woman in question.

In addition to providing a barricade against subpoenas and other unpleasant realities of his business practices, screening rooms also became "clean rooms," where Hughes believed he could avoid the contaminants of the outside world. Anything could be a contaminant, if it penetrated either his physical or psychic space, but he was most worried about the two things he had been most afraid of since childhood: germs, and black people. These two were tied together for Hughes, and bundled up with sex, too: if anything horrified Howard more than the idea that a beautiful white woman could be carrying a venereal disease,[1] it was that a beautiful white woman might be sullied by the touch of a black man. There were business matters he didn't want to deal with, women with whom he didn't want to have any real intimacy, but nothing animated Hughes like the twin devils of germophobia and racism. Part of the appeal of staying in the same screening room, attended to by the same people, who were paid to make sure nothing and nobody was introduced into the environment without his say-so, was

[1] After Hughes's death, stories began to circulate that he had contracted syphilis in the 1930s or early '40s from an actress who was not faithful to him, and that he subsequently underwent a severe, experimental procedure to rid himself of the disease. These stories have somewhat different details in different tellings and, perhaps like most stories about the venereal diseases of deceased people, are generally vaguely sourced. The biography to include this story that shows its references the best is *Howard Hughes: The Untold Story* by Peter Harry Brown and Pat H. Broeske, which credits the tale to Noah Dietrich (who definitely had an ax to grind, and who in his book, *Howard*, had claimed that Hughes burned a closet full of clothes after learning that an unnamed girlfriend had exposed him to an unnamed disease); two Dietrich relatives; "anonymous sources" including a Hughes lawyer; and an interpretive reading of Hughes's autopsy report alongside a document called "Sexually Transmitted Diseases," issued by the U.S. Centers for Disease Control in 1972. Another source named is Dr. Raymond Fowler, whose extensive published writing about Hughes's medical history did not mention syphilis. Shortly after Fowler's death, I was graciously loaned Fowler's existing Hughes files by his widow, Sandy Fowler, and in the files that I examined Fowler did not mention having evidence or a suspicion that Hughes suffered from syphilis. However, Fowler did speculate about other aspects of Hughes's health, including, as we'll see, the possibility that he suffered from epilepsy.

that Hughes could believe he was in total control. When Hughes found out that Studio A had been used to screen rushes to the cast and crew of Otto Preminger's *Porgy and Bess*, a musical with an all-black cast, he told Ron Kistler, who had been his key aide at Goldwyn, to pack up. The Goldwyn lot had been Hughes's intermittent professional base since the 1920s, where he had chosen to keep an office even while he was the majority owner of RKO. He would never set foot there again.

Following the departure, Hughes moved his enterprise to a smaller, private screening house, called Nosseck Studio. He would stay there for four months in the late summer and early fall of 1958, during which time he never left once. He'd watch as many movies as he could, back to back to back for days at a time, then sleep for a full day and start the cycle again. At one point an aide killed a small lizard who had scampered into the room (not an unheard-of occurrence in Los Angeles's desert clime). Hughes breathed a sigh of relief. "I've been seeing that thing for several days," he admitted, "and I didn't say anything because you fellows would have thought I was nuts."

Hughes wasn't hallucinating the lizard, but in other ways he began to show evidence of a mounting divorce from reality. Though he would call in to Operations to leave and pick up messages, and sometimes, in between movies, take calls related to the fiasco at TWA, he ignored most matters that could have used his attention. There were no facilities to bathe at Nosseck, and Hughes wasn't motivated to go off-site to wash. Eventually his clothes became so dirty that he just took them off, remaining naked except for his shoes while watching movies. He watched cowboy movies, airplane movies, Oscar nominees, *I Was a Teenage Werewolf*.

Knowing that Jean was growing impatient living at the hotel, and wanting to mollify her without actually doing anything to change their living situation, on September 9 Howard called Operations to leave a message for "the Major." In this message, Hughes claimed he was waiting for his lawyer to bring him keys to a house he had procured for them, but they could not move in yet because the previous tenants hadn't moved out. He explained that he had no way of talking to Jean

on the phone because he had "developed a very severe pain in my right side. I am sure it is not anything serious. I think I caught cold there while I was asleep. I will explain how this happened. The doctor is on the way and I do not want to try to walk back to where the phone is located until after he gives me something to make my side feel better."

This was typical of what Faith Domergue had referred to as Hughes's "play-acting." In the decade-plus since he had tried it out on Faith, his tactics hadn't gotten much better, but they had become bigger. In this instance, there were several stories stacked on top of one another: he's waiting for the keys, he's waiting for the doctor, he's not near a phone (even though he's possibly using a phone to leave this message), he can't move; the assumption seems to be that a woman might be able to penetrate through one layer of bullshit, but not five. For good measure, as if to package the crap in sweet-smelling coating, Hughes began this missive "Darling" and ended it, "All the love in the world, Howard."

Five days later he was still in the screening room, still "sick," still "without a phone," still promising that they would move into a house soon. "I am going to make the most determined effort that I have ever made in my life to arrange for us to get into the house Tue. instead of Wed," he said in the message left for his wife the night of September 14, 1958. "I am confident this can be done, and with all those reporters underfoot plus the dust I certainly would be a lot happier to make one move instead of two. Darling, as I say, I don't know what time we will have the phone in. . . . I feel that I love you even more tonight. But of course this is impossible because there ain't no more than the most. Love again, Howard."

At some point during this period, Kistler overheard Hughes telling his wife over the phone that he was in a hospital, where doctors were working to diagnose his mysterious symptoms. The aides soon realized that Hughes was faking an illness in order to avoid spending time with either his wife or Yvonne Schubert. "When he talked with them on the phone," Kistler recalled, "I would hear him say, 'The night nurse Ruth is with me now and she's ready to give me a bath,' or, 'Nurse Hannah is about to give me an enema.'" If anyone who was

not with him in the screening room believed he was actually quaran-
tined in a hospital, then he didn't have to do anything—didn't have to
make any decisions, didn't have to disappoint any women by not being
able to give them the intimacy they wanted, didn't have to confront
angry employees or shareholders. He could strip everything away—
including his clothes—and lose himself in the movie screen.

But the sickness ruse he created became a self-fulfilling prophecy.
At Goldwyn, Hughes appeared to be "quite fit," according to Kis-
tler, who one night watched his boss running sprints back and forth
across 150 feet of hallway. "He went downhill in a big hurry at Nos-
seck's," Kistler recalled. Over the four months that he remained in the
screening room, Hughes was virtually immobile. Living on a diet of
milk, chocolate bars, nuts, and bottled water, he lost weight rapidly—
Kistler estimated that by the time he left, Hughes's weight was down
to 110 pounds. The emaciation was readily evident because, as Kistler
tactfully put it, Hughes "had become a nudist."

Kistler said Hughes "had on the same outfit" at his next location.
After four months at Nosseck's, Hughes returned to the Beverly Hills
Hotel. The screenings continued in his hotel bungalow, No. 4. The
first day after Hughes had moved back in, he threw Kistler a projec-
tor manual. "Read it," Hughes commanded to this employee who had
been hired as a driver, "and make damned sure that you know how to
operate them."

Jean Peters was living in Bungalow 10. She knew the rules by now.
She followed orders to call into the switchboard at Operations ev-
ery morning upon waking, and she understood she was banned from
ordering any of the foods on Howard's "forbidden" list from room
service. For years Hughes had instructed everyone who came into
contact with him to avoid consuming certain foods (he was particu-
larly concerned about pork, because of parasites), but patrolling Jean's
room service orders served multiple additional purposes. It was a rel-
atively simple way of showing Jean, and everyone around her, how
much power he held over her, without him actually having to be pres-
ent. And, if there was any truth to the reports of Jean's problematic

relationship with alcohol, this was one way Hughes could limit her intake—which may have been attractive, if for no other reason than because a drunk captive could potentially become more difficult to control.

According to Kistler, who spent as much as sixteen hours a day with Hughes in his hotel room, Howard almost never saw his wife in person—the only visit the aide could recall lasted about ten minutes, on Thanksgiving Day—but he spoke to her on the phone several times a day. Many of their phone conversations had to do with the fact that Jean didn't want to live at the hotel. "I disliked it," she acknowledged later. "I wanted a house of my own, a bought house, not a rented house. I agitated vociferously." Over the phone, Hughes would suggest to his wife places they could live together—Lake Tahoe, or Santa Barbara, maybe, or Rancho Santa Fe, near San Diego. One of Hughes's motifs was that he'd tell her that he had found a nice home for them, and he had guards watching it twenty-four hours a day until they found time to inspect it (they would, of course, never find that time). Kistler felt incredibly uncomfortable being in the room for these conversations, but he heard enough of them that he was able to form an opinion: "I felt that Mr. Hughes was just buying time in his relationship with Miss Peters, Mrs. Hughes." The Boss didn't want to live with his wife, but he didn't want to tell her that, so he was, according to Kistler, "stalling her off" by pretending he was making plans for their future.

Jean's willingness to put up with Hughes's charades for as long as she did perhaps gives credence to the theories that this marriage was arranged to suit one or both party's business purposes, but Jean clearly didn't fully know what she was getting into from the get-go. Howard likely hadn't known, when he married Jean, how he would actually behave in the marriage, either: his increasingly highly regimented way of life was less something he chose to enter into, and more something that came over him. But there's also the possibility that, as late as the late 1950s, even with everything else that was falling apart in his life, some glimmer remained of Hughes's youthful power to charm and manipulate people who knew better into following him down blind alleys and

submitting to his unreasonable quest for control. Or maybe Jean, who had waited more than a decade for Hughes to marry her, just so badly wished that the Hughes of 1959 was the same person as the Hughes of 1946—the Hughes she had met at that long-ago party, the weekend after July Fourth, before everything started to spiral out of control. Maybe this wish was so intense that she was able to at least sometimes delude herself into believing that everything was okay. Or that it soon would be—if only they could move into a house, and out of the damn hotel.

Hughes continued to carry on an almost entirely phone-based relationship with "the Party," Yvonne Schubert. But the Party ended in the spring of 1959. On May 4, Hughes left a message for Kane about Schubert, aka "Coldwater:" "[I]n view of what happened Saturday night I don't want her to go to Santa Ana under any circumstances until I get a chance to discuss this with her. Perhaps I can call her tonight or tomorrow. I want him to schedule her tight as a tick, so she has no chance to go there at all. I have got to talk to her before she does go, but I am just too sick; the episode on Saturday practically killed me, and I am fighting my way back from death's doorstep from what she did Saturday night. I must speak to her before she goes down there. Mark my words, I want this done at minimum expense." Kane received this message, and left one for Hughes with Operations: "I no longer feel that I am capable of accomplishing what he wants accomplished, and I feel that my effectiveness with Coldwater has been destroyed."

Whatever had happened that Saturday night, there are indications that not much was happening between Schubert and Hughes at all. One of Howard's men taped a phone conversation in which the young lady complained to Hughes, "You never come to see me. I'll bet you can't even get it up anymore, you impotent old slob!"

About a month after Walter Kane had bowed out of "Party" duty, on June 9, aide Bill Gay informed Operations that Yvonne Schubert had "been terminated, and is to be treated as a total stranger." The operators were instructed that if Schubert were to call in, "we are not

to recognize her voice or her name—not be rude, either—but treat her as we do any of the strangers who call here each day."

Hughes may have at one point intended for the dozens of girls like Schubert whom he had signed to contracts to work as actresses in movies he produced; he may have intended to have these young women all waiting in the wings, so that when one with whom he had become intimate needed to be "terminated," Hughes would easily be able to select a replacement. What none of the girls realized is that, by 1958, he was out of the business of making movies, and due to his increasing paranoia and the isolation it resulted in, he was essentially out of the business of wooing women. Thus most of the "aspirants" of the late 1950s and '60s never met Hughes at all.

Still, Hughes's diminished activity on both the cinematic and romantic fronts did not stop him from paying his men to make sure the coffers were stocked, just in case. In the fall of 1960, one of his men approached a singer named Gail Ganley after a performance at the San Diego State Fair. At the time, Ganley was a twenty-year-old UCLA student, studying Spanish. She was told by Howard's representative that if she signed with Hughes, he would turn her into the new Jane Russell.

"How was I to know," she'd later say, "that they were lying to me?"

Ganley was offered a stipend of $450 per week, sent to acting school, and given cosmetic dental work. Every week, for the next two years, Gail would drive up to Operations and honk her horn, and an envelope of money would be dropped down to her from a second-floor window on a string. Every night, seven nights a week for twenty-two months, an acting coach from the Hughes payroll came to Ganley's apartment to work with her. The only nighttime activity Gail was permitted was dinner at Perino's, where she was often accompanied by the coach, always sat at the same table, and was served personally by Mr. Perino. After a year of this, Gail put her foot down, telling Operations, "I just had to have my dinner hour free."

"I had never met Howard Hughes during that entire time," Ganley

later recalled, "or even spoke to him on the phone. But I had been told by his representatives that I would some day. In fact they told me to keep one particular dress in readiness because Mr. Hughes had seen a photo of me in that dress and liked it. Three times during that two year period I had calls telling me, 'Mr. Hughes is in town. Get ready to meet him.' But he never showed up.

"I had the feeling I was constantly being watched, and I felt awkward," Ganley added. "But, after all, it was a small enough sacrifice to make for the stardom I felt would be mine."

In July 1962, Gail Ganley sued Hughes for $553,000, charging that she never received her promised salary and was unable to work for others while under contract to Hughes. She'd filed the suit after contacting Hughes's representatives and asking them why she hadn't been given any work. "He's out of business," they told her. "He's not making any movies." In October Hughes would authorize a settlement to Ganley for $40,500 plus court costs.

JUST BEFORE HUGHES'S FIFTY-FIFTH birthday, he told Operations that if Peters were to call and ask where he was, they should tell her he went out of town. When she called in and got this message, she responded, "Do you really think he got away this time?"

"Yes, I think so," the operator said.

"Well, I don't," Mrs. Hughes fired back. "When you hear from him tell him I'm up."

Two days later would come the last entries in "the Major's" call log in reference to her trying to find her husband—because, for the next six years, she would know where he was.

On the day he turned fifty-five, Howard left the Beverly Hills Hotel and moved with Jean into a house in Rancho Santa Fe, a bucolic community of Spanish-style ranch mansions north of San Diego and inland from the coast. Here Mr. and Mrs. Hughes truly lived together for the first extended period of time, sharing a bedroom where each slept in a twin bed. They had a dog and a few cats. Howard seemed happy. He'd

work at home, deep into the night while Jean was asleep. But for some unspecified reason, Howard wouldn't let his wife receive mail at their home address. And then Jean discovered that he didn't really own the house—he was just renting it. She had thought that, after nearly five years of marriage, finally Howard had committed to a permanent home with her. But it had been another of his manipulations all along.

Jean had been as compliant a wife as any man could have asked for, and amid extremely challenging circumstances, she had striven to give her husband the benefit of the doubt—or, at least, most of the time did him the kindness of not revealing that she knew he was lying to her. But now she had finally become, as she would put it later, a "doubting Thomas" regarding her husband's promises. "He was very manipulative. And even though he was darling and charming, I'll just say my faith in him was eroded."

At the end of 1961, they moved to another rented house, a seven-thousand-square-foot manse in the tony Los Angeles enclave of Bel Air. This time Mr. and Mrs. Hughes did not share a bedroom. Howard was under twenty-four-hour-attendance by his aides, and it was now required that Jean schedule an appointment with her husband's employees should she desire to see him.

From the day they moved in until the day Hughes moved out in 1966, he didn't leave the residence. "He sometimes went throughout the house," Peters recalled, "but he primarily was in a very large suite, which was a bedroom and a dressing room and another room." He'd work whenever he felt like it, all hours of the day, then he'd stop and eat and watch a movie. If he was not working in the evening and Jean was home, they'd watch TV together, but they were never alone together; aides were always around.

Peters saw him take what she later described as "small amounts of Empirin codeine." She told him he should try to wean himself off it. Hughes told her that he "wanted to," and that he would—"someday." Instead, around this time, he began to dissolve codeine tablets in water so that he could inject the drug with a hypodermic needle. By 1963 he had added into his daily intake so much Valium that his aides would

have to drop off multiple prescriptions in other people's names at drugstores all over town, so that nobody would suspect that Howard Hughes was taking too much.

A little less than two years after Mr. and Mrs. Hughes took up residence together in Bel Air, a tabloid called the *National Insider* reported that the former Jean Peters wanted out: "Hollywood insider's [*sic*] have wondered for a long, long time how much longer Jean Peters would accept the life she's led as Mrs. Howard Hughes. The eccentric millionaire, it's been said, has kept her a virtual prisoner for years, never allowing her out of her luxurious cottage at the Beverly Hills Hotel, never allowing her to see friends. Now word has leaked out that she's had it and is asking for a divorce. I wonder if she'll have the courage to go through with her plans, whether Hughes will allow her her freedom." This information was out of date, in that husband and wife had moved on from the Beverly Hills Hotel, but it was not inaccurate.

Hughes and Peters would manage to sustain the Bel Air living arrangement for another two and a half years. Then, rather than have to appear in court and discuss his (mis)management of TWA, Hughes sold his interest in the airline. He pocketed a reported $566 million. Now he would have one primary motivating factor in life, according to his wife: "To avoid the taxes."

"I knew he wanted to be out of the state of California when the TWA matter was settled," Peters said. "I felt my whole life was being controlled by a bunch of tax lawyers. I argued with him. I said, 'Pay the tax. Life is too short.'"

One July morning, Jean lay in bed and listened as unusual sounds traveled from one side of the house to the other. The front door of the Bel Air mansion slammed shut, and then all was quiet. Howard Hughes and his entourage of aides had left for the train station. They were going to Boston. Hughes would never return to his marital home.

Jean hadn't been told where he was going—or that he was going. "I stayed in my room," she recalled, "but I heard them leave. I knew he was leaving." She only found out that Boston was her husband's destination "the next day, when I read it in the newspaper."

They spoke on the phone, and Howard told Jean he was considering Boston as a place for the two of them to live. "[B]ut by that time I don't think I paid too much attention to what he was saying," Jean later admitted. "I just didn't believe him. Let me put it that way."

Jean did go to Boston for a visit. There Hughes had commandeered the entire fifth floor of the Ritz-Carlton hotel, at a cost of $2,000 (or $15,400 in 2018 dollars) per day. He and his aides occupied three suites, overlooking the public garden; part of the daily outlay of funds was meant to ensure the remaining rooms on the floor were kept empty. Jean stayed at the Ritz for two weeks. When she left, she went back to Los Angeles, back to the house in Bel Air. Then Howard abandoned Boston for Las Vegas. Mr. and Mrs. Hughes never saw one another in the flesh again.

FROM VEGAS TO THE GRAVE

It started because he didn't want to leave his room. In December 1966, the Hughes entourage began to occupy the penthouse at the Desert Inn in Las Vegas. Howard would remain in that suite of rooms for another four years.

Hughes had checked into the penthouse on a whim, and after a few days the staff needed him to vacate for a prebooked reservation. Hughes wouldn't answer the in-room phone, so the only way for hotel management to communicate with him was to slip notes under the door. When they slipped through a note asking him to please leave to make way for a new guest, Hughes scrawled a note of his own.

"How much would I have to pay to stay if I bought the hotel?"

The answer came back: "$13 million"—possibly an attempt to outprice even Howard Hughes.

Hughes wrote back, "Sold." With half a billion dollars to play with thanks to the TWA deal, he began buying up real estate in Las Vegas.

His life was now conducted entirely from bed. He watched TV, had aides project movies, injected and swallowed drugs (which he and his aides referred to as "goodies"), handwrote and dictated voluminous memos, and talked on the phone. He barely ate; it would regularly take him eight hours to finish a can of soup. The nourishment of food couldn't compete with the fulfillment he got from the same source that

had been providing it for him for decades: Hollywood movies, starring Hollywood women.

"He would eat a spoonful and then get interested in watching a movie on his projector," remembered aide Gordon Margulis. "Often a movie he had already seen twenty times. The soup would cool down and he would send it back to be reheated. It had to be heated carefully so that it would be hot enough but not too hot. He would eat another spoonful or so, get involved in the movie again and send the soup back to be reheated. There were times when I reheated the same can of soup ten or twelve times." When he came off his marathon canned-soup diet, Hughes switched to the hotel's vegetable soup. "Now this is only a trial period," Hughes said, "because I want it just the way I like it and it has to be right."

Howard talked to Jean on the phone every day. Mainly, they discussed when she would move to Vegas to be with him.

"I had no interest in moving to Las Vegas," she later said. "It is not my kind of town." Still, she would have compromised if Howard would have done the same. "I wouldn't go unless he would move out of the hotel. I was not going to live in a Las Vegas hotel."

There had been a time when the couple had shared the same conception of their dream home. They had fantasized, Jean said, "to one day have a ranch that would have everything on it that would make him happy and would make me happy." Shockingly, given the total duplicitousness that had marked his approach to marriage previously, Howard actually attempted to make good on this promise. One day he called Jean from Vegas and said, "I bought you a ranch." It was thirty minutes southwest of the Desert Inn, outside of town. Hughes told her he was going to have an airstrip installed for him, and that there would be plenty of room for her to keep horses. He had bought the ranch from heiress Vera Krupp, the original owner of a 33-carat blue-white culet-facet, 1920s diamond that Richard Burton would buy for Elizabeth Taylor in 1968.

"He sent me pictures of it," Jean said of the Krupp Ranch. She

was not impressed, by the land or its location. Howard had told her, Jean recalled, that "it was 25 miles out of town and the road was very bumpy, so I had visions of myself being stuck on a ranch 25 miles out of Las Vegas." This was the big difference between Hughes's Krupp purchase and Burton's Krupp purchase: a ranch, located miles away from where your husband clearly intended to spend most of his time, was not the same as a diamond ring that would sit right on a woman's finger, reminding her of her husband's love all the time.

Still, Jean would have moved . . . if he had moved in first. But Howard would not leave his hotel. Unable or unwilling to see his wife in person, Hughes began calling KLAS, a local Las Vegas TV station that showed movies at night, to request that they start playing more features starring Jean Peters. This wasn't his only complaint: why not run more westerns, more aviation pictures? And how come they went dark at 1 A.M.?

Finally, one night in 1968, the owner of KLAS, a local hero named Hank Greenspun, answered the phone and told Howard that if he owned his own TV station he could do whatever he wanted. So Hughes bought KLAS. He had the station send him a list of potential movies every week, and at night when he was ready to watch, he'd have an aide call up and make requests. Fifteen minutes before a movie was about to end, the station would get a call telling them what the next movie needed to be. His most frequent requests, by far, were the movies Robert Mitchum had made for him at RKO—which, of course, also starred Jane Russell, Ava Gardner, Faith Domergue, and other actresses who had been the subject of Hughes's obsession.

Operations received frequent requests from reporters who wanted to write about Jean Peters. Hughes ordered that all of these journalists receive no cooperation from his wife or anyone around her. But the Hughes camp couldn't stop reporters from tracking Jean down and following her around Los Angeles. In a syndicated article on Peters, Vernon Scott, the first man to profile Jean as Mrs. Hughes, reported that the tycoon's wife went out in public constantly, unrecognized, accompanied by a bodyguard. He described her as a fan of baseball,

basketball, and football who spent many days voluntarily recording books for the blind at the Braille Institute, and nights at UCLA attending classes. Scott also claimed, erroneously, that Peters often flew to Las Vegas on the weekends to spend "two or three days with her busy husband."

Reporter D. L. Lyons tracked Peters down at UCLA and sat in on one of her night school classes, which she attended incognito. There he witnessed her silently taking in a discussion on capitalism, with her classmates apparently unaware that she was the wife of America's "most mysterious capitalist." Among other things, Lyons noted, "Jean Hughes is at once married and unmarried—the latter in the sense that there is no record of her having been seen in public with her husband since their marriage more than 11 years ago. During their married life, they have never been photographed together, to the best of anyone's knowledge." Lyons also reported that he had heard that Peters spent weekends in Vegas with Howard, though he quoted a Desert Inn employee as saying, "I've been here for more than a year and I've never seen the lady. At least I've never recognized her."

Hughes biographers Peter Harry Brown and Pat H. Broeske would later claim that Scott and Lyons were the same person, and that "[f]or his expose [of Jean Peters], Scott used the nom de plume D. L. Lyons." If true, Scott wrote about Peters under both his real name and his pseudonym, and used the assumed name more than once to write about Peters. And yet it does seem clear that, as opposed to the extremely sanitized Scott story, the initial Lyons story included facts that Hughes would have been less pleased to see in print, such as the absence of evidence that the married couple spent time together in Vegas. However, the Hughes camp was no doubt happy about the way the Lyons story ended: first with anonymous friends denying that Jean ever felt "isolated, lonely or hidden away," and then by describing "secret trips" that Mr. And Mrs. Hughes were said to have taken, "off for Peru or some such place on one of his jets"—making the privacy of the relationship feel wildly romantic instead of claustrophobic. A "Hughes employee" was given the last word: "Mrs. Hughes leads as interesting a

life as any woman in the country. And I can tell you this: Howard loves her more than anyone else in the world."

These last two sentences may have been true, but the Hughes-Peters marriage had never been fully functional, and now it was all but over.

By the end of the 1960s, Hughes wasn't feeling well. He told Jean he was contemplating a return to Los Angeles to get medical treatment.[1] She wasn't sure exactly what was wrong with him. Mentally, she believed, he was all there, despite the fact that he clearly "was taking too much Empirin codeine." Other than that, "I knew he didn't eat correctly. He didn't exercise, and his whole lifestyle had ruined what was once a magnificent physique."

He owned the mansion across the street from where Jean still lived in Bel Air—he kept it to house his ongoing surveillance operation on his wife—and she suggested he live there while getting medical treatment. Hughes suggested he move back into Jean's house and send Jean to the Beverly Hills Hotel.

"I didn't want to go to the Beverly Hills Hotel," Jean explained later, "and I was afraid if Howard ever got in my house I would never get him out."

They did not resolve this conundrum. In January 1970, news broke that Jean Peters was leaving Hughes.

"This is not a decision made in haste, and is done only with the greatest of regret," Jean was quoted as saying in the official statement announcing their separation. "Our marriage has endured for thirteen years, which is long by present standards. Any property settlement will be resolved privately between us."

"She will retain an affectionate loyalty toward Howard Hughes," predicted Vernon Scott, "a man who treated her kindly, showered her

[1] Hughes would not have gone to the Howard Hughes Medical Institute to seek treatment, because to the extent it functioned at all as anything but a tax dodge, it was merely a research facility. Around this time, Hughes employed former Kennedy family fixer Larry O'Brien to successfully wrangle a loophole in the Tax Reform Act of 1969 to ensure that the Medical Institute would remain protected from new tax regulations that would force other major corporate-sponsored charities to ante up.

with riches and affection and gave her everything but a happy marriage."

It was widely presumed around Hollywood that Peters would be paid untold riches in order to keep the details of the marriage private. In March, comedian Jack Carter joked of the divorce, "I can see him handing her a check for $980,000,000 and saying, 'Would you mind not cashing this until Wednesday?'"

Privately, in a letter to aide Bob Maheu, the former CIA man whom Hughes had originally hired to investigate Peters's first husband, Stuart Cramer, Hughes blamed the "complete and, I am afraid, irrevocable loss of my wife" not on his own illnesses and isolation, but on his aide Bill Gay, whom Hughes had assigned to lie to and placate Peters.

That spring, the first new photographs of Jean Peters in thirteen years began to appear in newspapers. She made her return to public life at the Oscars, which she attended with Stanley Hough, a widowed 20th Century Fox executive and former professional baseball player, and Hough's young daughter Christina. News of Peters's relationship with Hough was already public by that point: on February 22, in his nationally syndicated "Personality Parade" column, gossip writer Walter Scott noted that it had been an open secret ever since Jean and Stan had appeared together at a performance of *Hello, Dolly*. Still, Howard was interested in controlling Jean's return to public life, just as he had controlled her retreat. A memo was prepared for him detailing former RKO publicist Perry Lieber's thoughts on how to best manage photographic evidence of Hughes's soon-to-be-ex-wife on a very high-profile date with another man. Perhaps they could have photos taken of her in her dress, before the ceremony, and leak them the night of the awards, with innocuous captions, and a request the press run these instead of any photos snapped at the awards dinner of the new couple together?

In the end, these suggested preceremony photos didn't materialize, but neither did a photo of Jean and Stan. Instead, on April 9, two days after the awards, the *Los Angeles Times* ran a photo of Jean sitting at the Oscars after party with Stanley's daughter Christina. The caption

referred to Jean as "the former Jean Peters" and "Mrs. Hughes." It did not mention Stanley Hough at all.

Totally coincidentally, in early 1970 Terry Moore separated from Stuart Cramer, Peters's first husband. The split changed Moore's financial status considerably, and this was a tough transition for Terry. "It was the first time I hadn't had servants," she later recalled. "I had been a movie star since I was 8 years old, I'd always had everything taken care of. I'd never even had to mail a letter myself, and suddenly I was like everybody else. I went from yachts and racehorses and airplanes to worrying about how I was going to pay the bills every month. Suddenly I was in the mainstream of life, and it was sink or swim."

According to Moore, right after her separation, Howard made an attempt to get back into her life. He had a driver pick her up and bring her to the Hotel Bel Air, where dinner had already been ordered for her—or maybe it was the Beverly Hills Hotel, where the bungalow was filled with flowers and champagne was on ice—Terry remembered the story differently at different times. No matter which hotel it was, Terry waited there for Howard, but he didn't show. Eventually Hughes called the driver and ordered him to take Terry home and tell her he'd call her there, so she went home. Howard didn't call until quite late that night. He asked her how she looked, a decade since they had last seen each other. She asked him how he looked. The two spoke for about ten minutes, about "silly things," Terry recalled. "It was just personal."

If that call happened (in one of Terry's versions of the story, it didn't), it was the last time they spoke, but Hughes continued to be on her mind. In May 1970, Rona Barrett reported on her radio show that Terry was writing a book about her "intimacies" with Hughes, "starting at age 14." Barrett added, "14 going on 24."

In 1972, Jean returned to acting for the first time since before marrying Hughes, appearing in a public television production of *Winesburg, Ohio*. She was asked about her retirement from the screen after her marriage to Hughes. "I wasn't convinced that being a motion picture actress, under contract to a studio, was the way I wanted to spend however many years a film career would have lasted."

As she slowly began wading back into the public eye, she refused to offer specifics about her time with Hughes, and in late 1972 she even gave a press conference to talk about the fact that she was not planning to talk about her second marriage. "I'm not so naive as to think your only reason for being here is your interest in my career," she said, "but my life with Howard Hughes was and shall remain a matter on which I have no comment."

This did nothing to diminish curiosity. Indeed, reporters were only getting hungrier for any scrap of news about Hughes, because such scraps were increasingly so hard to come by. Between 1972 and 1977, Hughes would shuttle between Nicaragua, Vancouver, London, the Bahamas, and Acapulco. He would become so isolated, so elusive, that, as *Time* magazine would report, "only his death gave proof that he had still been alive."

"Am getting many wild tips that Howard Hughes is dead," reported *The Hollywood Reporter*'s Rambling Reporter, "but fact of the matter is he's still on Paradise Island in the Bahamas and healthy enough to make many cheery calls to his estranged wife Jean Peters." Thirteen months after announcing the end of their marriage, Peters still hadn't filed for divorce. A month later, the IRS started sniffing around her, demanding she answer a twelve-item questionnaire, the most pressing question being, "Why have you not filed a tax return during marriage to HRH?" The answer was that she hadn't worked at all during the marriage, and thus, "My income was such that no return was required." (Thanks to the Medical Institute and other forms of creative accounting, Hughes himself had managed to avoid paying personal income taxes for seventeen years, from 1950 to 1966.)

D. L. Lyons returned to the Peters beat, knocking on her door unannounced. She would speak to him without opening it, their voices muffled by the barrier of wood. When he identified himself as the reporter who had tracked her down on the UCLA campus three years earlier, Peters exclaimed, "Go away!"

"Do you hate me, Jean?" the reporter responded.

"Of course not. Just go away."

"She sounded," Lyons claimed, "as if she were choking back laughter."

Lyons interpreted Peters's refusal to talk to him as proof "that her 64-year-old husband is still alive—a matter of considerable conjecture recently." In an article discussing Jean's fate, Lyons added that Hughes's aides had made concerted efforts "to prevent publication of this article. While it was being written, a man known to have represented Hughes in the past offered to buy this story for $25,000. When I declined, another man rapped on my door and offered to trade a glittering new Mercedes-Benz 380SE for my old Mustang."

Lyons further noted that Jean had been seeing Stanley Hough for about a year. An anonymous friend declared in the story that it is "quite romantic" that Jean and Stan had hooked up, as he had developed a crush on her twenty years earlier when serving as an assistant director on the Fox lot.

In June, the Hughes-Peters divorce was finalized. The agreement stipulated that Peters would collect an annual income of $70,000 (roughly $434,000 in 2018 dollars) from Hughes for the next twenty years.

IN DECEMBER 1971, REPUTABLE publications started to report that Howard Hughes had dictated an autobiography to author Clifford Irving, to be published by McGraw-Hill in March 1972. From the beginning, Hughes's reps vehemently denied that the book was legit. In order to prove that his "autobiography" was a hoax, in January Hughes agreed to participate in a conference call with seven reporters who had spoken to him in the past and were deemed to be able to judge the authenticity of his voice.

On the day of the call, Hughes, who had set up camp in a hotel in the Bahamas, injected himself with a massive dose of codeine and watched several films: *Gunfight in Abilene*, *Midnight Lace*, *Daring Game*, *Once Upon a Time in the West*. He watched the first three films two times each, but after viewing the Sergio Leone movie, Hughes told his aides

the print could be returned—and ordered them not to show him any more Italian westerns. He was similarly unimpressed by *Breakfast at Tiffany's*, starring petite-chested Audrey Hepburn, but when an aide put on Alfred Hitchcock's *Topaz*, featuring German brunette beauty Karin Dor, he was happy. "I like this one," he said. He watched it twice.

Despite this unconventional method of preparation, Hughes's performance on the conference call was masterful. The reporters came away convinced that the man calling himself Howard Hughes was in fact who he claimed to be, and that he had not participated in the book purporting to be Hughes's autobiography. More than that, Hughes was able to put forth the illusion that something remained of the charming American iconoclast whom much of the American public had thought they had gotten to know so many years earlier. Even at far less than full physical strength, he was still a world-class spinner.

When asked to explain his seclusion over the previous fifteen years, Hughes said, "I don't really know. I just sort of slid into it, but I will tell you one thing. I am rapidly planning to come out of it. In other words, I am not going to continue being quite as reclusive."

The only time it got really weird was when Vernon Scott asked if Hughes had left his current hotel in the previous six months. "Well, you are getting into a pretty touchy area there," Hughes responded. "Let's say I haven't left the Bahamas. . . ."

Thanks in part to the press conference, Irving's book was proven to be a total hoax, and the "author" eventually went to prison. But the press conference did more than out the autobiography as a fraud: it also proved to the world that Hughes was alive. Several months later, he decided to give up his birthright: he sold Hughes Tool. His remaining businesses, which now included seven casinos, a couple of TV stations, a mining company, and a helicopter outfit, were reincorporated as the Summa Corporation.

IN 1973, HUGHES WENT to London. There he flew a plane for the last time, accompanied by pilot Jack Real. Real would later recall that

when he returned with Hughes to his hotel, the aides who were waiting there for Hughes told Real to leave the Boss alone. They didn't like it that Real was "getting him alive again." Soon these aides got the submissive Hughes they preferred: in his London hotel room, Howard fell and fractured his hip. The hip was successfully repaired, but Hughes refused to submit to the follow-up treatment he needed. When Dr. Wilbur Thain offered to hire a "cute little physical therapist," Hughes said, "No, Wilbur, I'm too old for that." Hughes would never walk again.

After that, he stopped watching television, which was his last link to the news or current events. He ceased keeping track of the outside world. His aides continued projecting movies for him. He liked the Sean Connery James Bond pictures, produced by his old friend Albert "Cubby" Broccoli. He liked *The Sting*, *Butch Cassidy and the Sundance Kid*, *The Klansman* (a notoriously misbegotten exploitation drama about race and rape featuring the film debut of former football player O. J. Simpson). He loved a Cold War thriller called *Ice Station Zebra*, starring Rock Hudson. He watched it regularly.

One night in the spring of 1976, entertainment columnist James Bacon picked up his ringing phone and found Hughes, now in Mexico, on the other end. Bacon had known Hughes since the early 1950s. "It wasn't too hard to know him [then]," Bacon would write. "You just had to keep late hours. He usually could be found around the old El Rancho Las Vegas around 4 A.M. eating breakfast." But Bacon hadn't seen Hughes since 1953, so he was surprised to hear from him, especially at "2 A.M. Los Angeles time, four o'clock in the morning at his suite in the Princess Hotel in Acapulco." It was, Bacon said simply, "a happy call."

In early April, Terry Moore, her mother, and a journalist met for drinks at the Polo Lounge at the Beverly Hills Hotel. Howard Hughes became the topic of conversation. Moore explained Hughes's isolation as a privilege: "With all that money he doesn't have to go anywhere. He brings everywhere to him. He's right in Acapulco, if you want to know." When asked if she still saw Hughes, Moore demurred. "That is something I can't answer.

"Howard told me he'd only been in love with three girls in his life," Terry boasted. "Katharine Hepburn, Ginger Rogers and Terry Moore. I went with him for eight years, except for one marriage—I married Glenn Davis, the football player, you know, for three months." To Terry, the eight years, about which she was happy to reminisce, were the good old days.

In Acapulco, Hughes's weight had dropped down to 100 pounds, and it became apparent to his aides that he was dying. A Dr. Montemayor, an army lieutenant colonel, was brought in to examine Howard in his hotel suite. The doctor took notice of a system, consisting of multiple movie projectors and two screens, in front of a hospital bed. Howard apparently spent his every waking moment lying in bed, operating the projectors by remote control.

In addition to marveling over Hughes's entertainment system, Dr. Montemayor confirmed that Howard's condition was not good, and that he should be moved to the United States to receive the care he needed. His aides loaded his body onto one of his planes. On April 5, 1976—with the plane still in the air, half an hour away from the Houston airport—Hughes's personal physician Dr. Wilbur Thain pronounced him dead.

On April 7, the results of the autopsy were released. The official culprit was kidney failure, described by the *New York Times* as "a common cause of death." There were, however, plenty of uncommon details. The Treasury secretary made a public statement stressing the urgency of positively identifying the corpse, so that the IRS could start taxing the Hughes estate posthaste. Hughes's face was so withered away that the FBI ran the corpse's fingerprints to make sure it was really him. He had a separated-shoulder injury that looked recent, and a head trauma that looked as though it had gone untreated. There were broken-off hypodermic needles in his arms. He was dehydrated and starving, and had possibly overdosed.

After the autopsy, the body was claimed by Howard's relatives, including Aunt Annette Lummis, who was now eighty-five. An eight-minute Episcopal ceremony was attended by Annette and Howard's

eight surviving cousins and their immediate families, about twenty people in all. Hughes hadn't seen or spoken to most of these people since 1938 at the latest. He was buried in an unmarked grave beside his mother and father in Houston's Glenwood Cemetery.

"We brought nothing into this world, and it is certain we can carry nothing out," said the priest who presided over the service. There were no vestiges of Hughes's Hollywood life at his funeral. No actresses were in attendance.

LIFE AFTER DEATH

One obituary of Howard Hughes called the deceased the "Most Publi-cized of His Time." But as much publicity and press coverage as How-ard Hughes managed to generate during his seventy years of life, it was nothing compared to what he generated simply by dying—and doing so without leaving a certified will where anyone could find it.

Over the next decade, an international search would ensue for a will, and for legitimate heirs. The legal battles over who would assume control of his estate, and which state or states would assume the privi-lege of taxing it, ensured that Hughes's legacy was a topic of discussion in the world media almost until the end of the century.

One unauthorized biography and a few magazine articles had been published before Hughes's death, divulging details of his unusual busi-ness practices and lifestyle. Still, the condition of his corpse, particu-larly the chilling detail of the broken needles found in his arms, and the fact that he had died without anyone close to him who wasn't paid to be there, did much to complicate the still-prevalent image of him as a dashing international man of mystery. The legal battles over his estate did much to reveal the "real" Hughes—as well as the limits to which it had been possible to "know" Howard Hughes at all.

In order to defend the Hughes estate from claims made by for-mer employees, Houston law firm Andrews, Kurth hired Raymond Fowler, then chairman of the psychology department at the Univer-sity of Alabama, to create what was called a "psychological autopsy" of Hughes. Over many months, Fowler studied Howard's medical records, the call logs generated by Operations, and all manner of Hughes ephemera; the psychologist also interviewed a number of sur-viving Hughes associates, including Walter Kane and Terry Moore.

Fowler concluded that Hughes had suffered from some form of undiagnosed mental illness for much of his life, and that it began in childhood with the paranoia and phobias instilled in him by his germophobic mother. Fowler also took note of the unusual number of plane and car accidents Hughes managed to get into between 1928 (the *Hell's Angels* crash) and 1946 (the near-fatal Beverly Hills crash), a sheer volume of collisions that could usually only be explained by alcohol abuse, drug addiction, or epilepsy. Though he noted that hypodermic needles had been found in various Hughes properties "apparently dating from about 1936," it was the latter hypothesis that seemed most interesting to Fowler.

"There is no record of Hughes ever having been diagnosed as epileptic," Fowler noted in a memo written for attorney George Dean, "but it is highly unlikely that such a diagnosis, even if made, would have been recorded or retained, since it would have resulted in immediate grounding by the FAA." By Hughes's last years, his condition, Fowler wrote, "resembled that of a chronic psychotic patient in the very worst mental hospitals . . . he was, for all practical purposes, incarcerated in a mental institution of his own making, but he was receiving no treatment for his mental illness and not even adequate care for his basic needs."

Before Fowler had been assigned the case, the Associated Press called a bunch of aging Hollywood beauties to play armchair psychoanalyst. "I think the sad part of his existence is that he was a loner," mused Ginger Rogers, "and I think that loners are very unhappy people." Ida Lupino downplayed her connection to Hughes, insisting that when she and Howard first met, "There was no romance—I was only 16. He used to take my mother and me out dancing: Howard loved music, and he was a good dancer." Ella Rice, now remarried, was not heard from. Jean Peters would not comment on her relationship with Hughes but did say, "I'm sorry and I'm sad that he's dead."

Later, Peters would be forced to talk, when she was deposed in the multipart battles over Hughes's legacy. She would insist that he meant for all of his money to go to the Howard Hughes Medical Institute. His

"primary goal in life," Peters said, was to "have it be the biggest and the most successful of any medical institute, research institute in the world." This, Peters added, Hughes imagined as "his monument to his life's work . . . the statement of what Howard Hughes really was. Because he was very disillusioned that many of his airplane records had been broken." (If Peters was aware that the Medical Institute had mainly served the purpose of reducing her husband's tax burden during his lifetime, she didn't disclose this in the deposition.) Based on conversations with her ex-husband, Peters assumed that Hughes had a will, and that Cary Grant had been named "either a board of director or an administrator" of Howard's estate. If this is what Hughes had intended, it had not been put on the record anywhere.

The lack of binding information about Hughes's intentions and the inexhaustible media spotlight given to his life after his death—not to mention the enormous amount of money at stake—combined to draw people out of the woodwork laying claims on the estate.

Three weeks after his death, a package was dropped off at the Mormon headquarters in Salt Lake City, Utah, containing a will signed "Howard R. Hughes." This will, referred to by lawyers and reporters as "the Mormon will," divided the estate among a number of universities and organizations (including the Mormon church and the Howard Hughes Medical Institute) and several people, including Noah Dietrich, Ella Rice, Jean Peters, and Melvin Dummar, a Mormon who claimed he had given an unrecognizable hitchhiking Hughes a ride through the Nevada desert eight years earlier. This will was declared to be a fake in jury trials in both Las Vegas and Houston.

In August 1976, the Texas judge presiding over the division of Hughes's estate appointed a lawyer named O. Theodore Dinkins Jr. to represent the interests of Howard's "unknown heirs." Multiple people had come forward claiming to have been Hughes's secret but lawful next of kin. One, who called herself Alma Cruise Hughes, claimed she had been artificially inseminated with his sperm in 1974 after having married the titan in a hospital. Another, calling herself Alyce Hovespian Gordon Hughes, said she and Hughes had married in 1946 and

never divorced. A man and a woman, Donald E. McDonald and Clare Benedict Hudenberg, came forward to claim to be Hughes's adopted son and illegitimate daughter. All four of these supposed heirs had their claims thrown out by a judge in 1981. By that point, after many years of research, Dinkins had certified that, with Hughes having sired no known children, and with his two known ex-wives prohibited from contesting his estate by their divorce agreements, Hughes's living heirs included fourteen cousins on his mother's side, as well as Barbara Lapp Cameron, Agnes Lapp Roberts, and Elspeth Lapp DePould—the three grandchildren of Rupert Hughes. Everyone who had known Howard Hughes was aware that having his estate trickle down through the family tree via his uncle Rupert was not what he would have wanted. But written evidence of what Hughes actually wanted was not available.

There was, however, a wrench in the legal works. While Hughes's ex-wives of record remained silent, Terry Moore was more than happy to comment. A week after Howard's death, she publicly declared for the first time that she and Hughes had been married in 1949, on a boat in international waters, and had remained together for eight years. This would have put their breakup in 1957, the year of his marriage to Jean, after Moore had legally and publicly married and divorced Glenn Davis, and after she had married Eugene McGrath. Moore now alleged that Hughes had destroyed the ship's log that served as the only record of their marriage. She insisted that even though she had married three men after the 1949 wedding (including Hughes's second previously known wife's ex-husband), since Terry and Howard never divorced, each of their subsequent marriages were invalid, and technically she was his widow.

Where had Terry Moore been while her "husband" was retreating from the world? After 1957's *Peyton Place*, she had mostly made B-movies (such as the lurid noir *Why Must I Die?*, released by drive-in suppliers American International Pictures), and then transitioned to TV. For two seasons she played the love interest on a western nighttime soap called *Empire*, which was notable as the first regular gig for

Ryan O'Neal. She had semiretired, she said, after being diagnosed with a rare condition called scleroderma and given a grim prognosis of just two years to live. At the time of Terry's revelation of her marriage to Hughes, she hadn't appeared in movies or TV since 1972, when she played the girl in a grind-house car chase flick called *The Daredevil*. That same year, Terry had officially divorced Stuart Cramer, Jean Peters's first husband.

"I have lost the greatest friend I ever had," she was quoted as saying by UPI. "Howard raised me. He was the greatest lover I ever had. He was the best."

A subsequent wire service piece on Moore's claims openly mocked the inconsistencies in her story. "It would have been almost impossible for Terry and Hughes to have squeezed in an eight-year marriage unless he snatched her from the playpen at an unreasonably tender age." The article allowed for "the possibility of mistaken chronology in Terry's marital calendar. She might have married Hughes in 1942 when she was 12 years old. The alleged 8 year marriage would have ended in sufficient time to allow her the required interlocutory year between a divorce from Hughes and the marriage to Davis."

When asked by *People* magazine if she was confessing bigamy, Terry admitted that she was. "All my life, I was scared something would come out about it," she said. She insisted she had only married Glenn Davis because "my family and the studio" made her do it. Once reunited with Hughes, she would have stayed with him, if not for his "need for other women," and her own desire for children.

On May 12, 1976, in Las Vegas, Terry filed a motion asking Clark County District Court to notify her of all documents filed in connection with Hughes's estate. Her filing was done by her attorney, Arthur Leeds, who claimed that Moore and Hughes "lived together as man and wife for at least six years." *Variety* noted this was inconsistent with Moore's claim "the marriage lasted eight years" and pointed out that she had two "marriages of record" during that period to men who were not Hughes. Terry and her team's inability to be precise about dates would become an easy target for critics of her credibility.

Some of those who had closely observed Hughes during the period of the alleged marriage cast further doubt on Moore's claims. Though his loyalty to Hughes was a thing long in the past, in a deposition at the end of 1977 in connection with the battle over the estate, Noah Dietrich said of Terry Moore, "She contends she was married on his yacht and that I was present and it's a goddamned lie." Walter Kane had nothing nice to add. Interviewed by Raymond Fowler, Kane said that Terry was crazy, that she was as liable to try to milk you as she was to try to lay you. When Raymond Fowler asked what Walter Kane thought should be done about Terry's marriage claims, Kane said, "Shoot her. You would never be convicted."

There was some evidence to support Terry's claim. About one year after Hughes's death, a former Paramount publicist, screenwriter, and writer of star biographies named Robert F. Slatzer[1] signed an affidavit claiming that Terry had confided in him about the marriage to Hughes while they were working together on *Come Back, Little Sheba*. Terry, Slatzer claimed, was very vexed about the fact that she was a bigamist. In the same affidavit, Slatzer claimed he had been working on a screenplay with Preston Sturges in 1953, and that the pair were sitting at the Players Club when Hughes came in, and Slatzer overheard a private conversation between Hughes and Sturges in which Hughes acknowledged that he was still married to Terry Moore. Nineteen fifty-three would have been several years after Hughes and Sturges's falling-out over *Vendetta* and other matters; also, if you trust Sturges's memory for chronology as laid out in his posthumously published memoirs, a bankrupt Sturges had been forced to auction off what was left of the failing Players Club to pay an IRS debt by February 1953, after which the club was closed and transformed into a Japanese restaurant. It's possible this meeting happened in January 1953, but given

[1] Slatzer was a questionable authority on secret marriages. In 1974, he published a book called *The Life and Curious Death of Marilyn Monroe*, in which he claimed that he and Monroe had been secretly wed in Mexico in 1952, but that Darryl Zanuck had ordered the marriage dissolved when they returned to Los Angeles. "PASSINGS Robert F. Slatzer, 77; Author Claimed Brief Marriage to Monroe."

where Sturges was in his life at the time, with his impending bank-ruptcy and his apparent lingering distaste for Hughes, it seems highly unlikely.

In 1978, Terry appeared on a TV show called *The Truth with Jack Anderson*, where she was given a lie detector test by polygraph expert and advocate Chris Gugas. Gugas asked Terry about the marriage and the baby she had claimed to have given birth to, sired by Hughes. Terry, who had been an actress since she was a very young child, passed the test. Around this time, Greg Bautzer, Howard's longtime friend and lawyer, produced a page of notes he had written after Hughes's death. It included a list of items, ordered A–H, on which Bautzer planned to investigate the impact of Hughes's passing. Several items had to do with "funds." Item D was "'Girl' contracts—expirations?" Item E? "Instructions Re: Terry Moore."

In 1979, Moore was deposed by the lawyers representing the three Rupert Hughes grandchildren who were presenting a united front in fighting for the money. Terry hadn't filed a legal challenge, but as law-yer Paul Freese put it, "It is my position that she has stated a claim against the estate publicly, that under probate procedure and practice the fact that she doesn't file a formal claim anywhere doesn't obviate the fact that she is an obstacle to the administration of the estate unless and until she disclaims, at which time there would be no problem about delaying distribution."

In the first of multiple depositions, Moore noted she wasn't surprised that Hughes had left no will. "He said he would put something aside for me and that I would be very, very well taken care of and I would never have to worry, but he didn't want his will—anybody be able to contest it," Terry said. "Just what has happened is really what he never wanted to happen."

Often during these depositions, Moore would vex her lawyer by offering information that hadn't been solicited by opposing counsel. At one point she said she didn't remember giving an interview to the UPI and claimed that if she did, she was misquoted as saying "Howard Hughes is the greatest lover." "That is something I did not say," she

insisted. "I am not that distasteful. That is why I remember it." She denied that she kept a press agent on retainer in order to facilitate getting such comments in print. Instead, she said, "I have a suppress agent that tries to keep my name out of the paper." (At the time of this deposition, Terry Moore was a client of the publicity firm Solters/Roskin/Friedman Inc.[2]) She admitted to be "terrible on [remembering] dates," adding, "I mean, really just one year goes into another. And especially the past, because I live for today."

In a later deposition, she blamed her confusion during questioning that day on a horrible-sounding incident: "I am just feeling very, very woozy and very hazy because of the blows to my head," Terry explained. "It was last Thursday that someone came and tried to choke me, tried to kill me. My stepson came home and he ran away." When asked by one of the lawyers if she was on medication, she said, "I am just on codeine and Tulenol [sic]."

Terry may have avoided coming off like a little bit of a flake if she had presented a stronger case, but what it all kept coming down to was that she had no physical proof of the marriage that she could produce. The closest she had were tapes she had made of conversations she had had with Hughes, and about Hughes.

In June 1979, the court listened to a recording of a conversation between Terry and a man who she purported was Hughes. On it, the man tenderly asked her, "Why don't you let someone take care of you? Why don't you let me have the job?" A month later, this tape ended up in the hands of the tabloid *Star*, which quoted Terry's conversation with Howard at length—allowing Moore to present her evidence in the court of public opinion before the actual court had made a decision.

Moore also submitted to the court recordings of conversations between her and Noah Dietrich, made around 1972. Under the pretense

[2] According to an April 22, 1985, five-line blurb in *Variety*, these publicists sued Moore for nonpayment after having "spearheaded Moore's campaign to establish her Howard Hughes widowhood." The firm claimed to have given Moore "advice 'over and beyond' the normal" publicity duties. *Daily Variety*, April 22. 1985; Terry Moore Clippings File, Margaret Herrick Library.

of interviewing him for a newspaper article, Terry had slipped in a few questions that seem designed to bolster her campaign to prove she had been Howard's wife—and also to find out the status of his will.

Speaking of Hughes and Jean Peters, Moore asked, "Do you know if in actuality they were ever married?"

Dietrich was not willing to play into Moore's conspiracy theory. "Yes, they were married," he said.

"Is Captain Flynn still alive?" Moore asked.

"Captain who?"

Terry immediately shifted gears back to Hughes and Peters. "Where did they get married?"

"Tonopah, Nevada," Dietrich answered. "It's in my book," he added, referencing *Howard: The Amazing Mr. Hughes*, the tell-all Noah was about to publish about his time working for Hughes.

"Oh, okay. I want stuff that isn't in your book. Is Captain Flynn still alive? His Captain?"

"No, he's dead."

"Well, did you know that he married me and Howard on a boat one night?"

"Yes, [Las Vegas real estate mogul] Del Webb told me that. I don't know if it was a legal marriage or not. Was it?"

"I don't know," Moore admitted, adding that, "if it is . . . I'm still married to him." She told Dietrich she had wanted to keep the marriage quiet, because she didn't want her children to know they were "illegal" and "illegitimate." But, she would add, "I'm actually heiress to everything he's made since nine [1949]—half of what he's made when he lived in California."

Dietrich did not dispute this during that conversation. He even gave Terry some fodder for her theory that it was Peters who was the illegitimate Hughes wife. "She said it wasn't a marriage, wasn't any real marriage," Dietrich told Moore. "But she said this: 'You know, I'm just a plain country girl; he's given me a Mercedes automobile, he's given me a little bungalow in Beverly Hills. . . .'" Dietrich added that he had advised Peters to calculate the wages lost due to the fact that Hughes

"kept you off the screen for fifteen years" and ask for that much in a settlement.

The transcript of another of Terry's tapes begins with her excitedly recapping what she apparently learned while the recorder was off. "Noah just told me that how double, how Hughes, how Howard double-crossed me, how he had the log of our marriage destroyed, 'cause it was a legal marriage, the log on the boat."

"Yea, he destroyed the evidence," Dietrich confirmed. "I know."

Milton Holt, who had given Moore the assignment to write for the *Hollywood Citizen-News*, for which Dietrich was ostensibly being interviewed, then asked Dietrich how he knew what he was claiming to know. "Well, I was told about it by one of [Hughes's] men," he replies. "I can't disclose his name."

These recordings may have complicated Dietrich's testimony, but they were not considered more compelling evidence than previous statements Terry had made in court, in the context of her previous divorces. In July 1981, probate judge Pat Gregory denied her request for a jury trial at which to prove her right to a share in Hughes's estate, when she could not produce a marriage license or any other hard documentation proving that the marriage had taken place. Terry appealed this verdict, and in February 1982, she lost the appeal, with a three-justice appellate panel noting that Terry's claims of marriage to Hughes were "clearly inconsistent" with the claims she had made in California courts when divorcing her other husbands. "Having done so, Ms. Moore cannot now be heard to maintain a contrary position in the absence of proof that the statement was made inadvertently or by mistake, fraud or duress." Terry appealed all the way to the Texas Supreme Court, which upheld the previous court's decision in June 1982.

Even as she was losing appeal after appeal, Terry was still presenting herself to the public as Howard's rightful widow. In a long interview with soft-core gentleman's magazine *Oui* in February 1982, she dismissed the idea that the marriage needed paperwork to be valid. Hughes, she said, "destroyed the log of our marriage. If the court house where you or anybody else is married is burnt down, that does

not annul or nullify your marriage. So Howard and I were never divorced." She also claimed that she had papers documenting Hughes's marriage to Peters, and that these papers were invalid because Howard hadn't signed them.

"Notice how quickly the whole world accepts her marriage and does not want to accept mine," Terry protested. "They never checked. That doesn't mean that she didn't think she was married, and I think that he fooled her and he may have fooled me but I didn't *know* he fooled me." The bottom line, according to Terry? "I was legally married to him. Jean Peters wasn't." Terry went on to explain her theory that Hughes had been murdered by the aides tasked with taking care of him: "They found hypodermic needles in his bones! Even a person with full strength has no way of shoving hypodermic needles into their bones."

In mid-May 1983, Terry informed the media that she'd be holding a press conference, at which she'd reveal "startling statements and legal documents" to bolster her case as Hughes's legal widow. When the day arrived, Moore strode into the Beverly Hills Hotel wearing a pink jumpsuit under a blazer patterned with pulsatingly bright blue, pink, and purple stripes. In her hands she carried not documents, but a single rose. She waited in the wings until her lawyer Arthur Leeds invited the assembled journalists to meet "Mrs. Howard Hughes." Terry then emerged and said, "I waited thirty years to hear those three words." Posing in front of a poster of Hughes's face, she announced that Howard's blood heirs had agreed to pay her a settlement. Terry was coy about the dollar amount, but promised it would be enough money to allow her "to live comfortably on the interest for the rest of my life."

She dramatized the payoff as the rightful happy ending to a fairy tale that had been playing out for decades. Through the years, every time she heard Howard's name linked romantically with others, she said, "My stomach would fall. I've always loved him. I'm a Mormon and I believe in eternal love. He's a hard act to follow." Terry was accompanied that day by her lawyer Leeds, and Jerry Rivers, her manager-boyfriend, whom she would marry in 1992.

Both sides agreed not to disclose the exact amount of the settlement,

but Terry's lawyer Leeds declared the dollar value to be "more than five figures and less than eight." This payment wouldn't technically come from Hughes's estate, which was still being contested, but instead from the other presumptive heirs, who wanted Terry out of the way so that they could sort out the fortune among themselves. Hughes family lawyer Tom Schubert downplayed Terry's claim to widowhood: "The family does not accept her claim to be Mr. Hughes' legal wife," he said. "Rather than have the matter tied up in courts for another two years or more, we agreed to pay her a modest sum."[3] Another lawyer for the heirs, Wayne Fisher, was more direct: "No, the estate has not acknowledged her as Howard Hughes' widow," he said, adding that the settlement amounted to "substantially less than eight figures."

Terry either didn't hear these statements or refused to acknowledge them. After the settlement was announced, Terry began referring to herself as Hughes's "legitimate widow" and signing autographs as "Terry Moore-Hughes." She gave interviews previewing the tell-all book *The Beauty and the Billionaire*, which she had sold to Simon & Schuster with the help of agent Swifty Lazar. In it, she said, she would finally spill the details on Howard's storied love life. As a preview, Terry revealed that the real reason Billie Dove and Hughes broke up was that the silent star had cheated on him with her golf instructor. The marriage to Jean Peters, Terry claimed, was entirely a matter of protecting Hughes from being forced into a mental institution, and as part of the agreement, Peters had signed away her ability to comment on Hughes or try to contest his estate. "And if I'm wrong," Moore posed to columnist Frank Swertlow, "how come there has been no Jean Peters claim to the Hughes estate?" (The answer to that question was likely that Peters had already agreed to accept her lucrative divorce

[3] Moore filed suit in Superior Court against the *Star* for the story in which Schubert was quoted, but not because she claimed it was inaccurate. Rather, it appears that the tabloid had put together a clip job under her byline, and Moore claimed she had been "negotiating rights to the material with various publishers at the time of the article" and that its publication resulted in "her inability to sell rights to the material after it appeared in print." This suit was filed weeks before the publication of her book based on said material, *The Beauty and the Billionaire*. See "Moore Files Suit," *Weekly Variety*, May 2, 1984.

settlement and nothing more.) The book, Jerry Rivers declared, was his idea—the lynchpin of what he described to one journalist in 1983 as "the scheme."

"I said, 'Forget the litigation, because it will be 500 moons before it's settled, just write the story,'" Rivers claimed he had advised Terry. "She has a story that no one else has. I said, 'We will hire the best agent in the world, Swifty Lazar, and just the noise that you have the definitive book on what Howard was like, that should give you enough publicity that people will say, "Hey, she's for real, and take a look at her! She's 50 and she's gorgeous.""'"

Terry told the world of a flurry of projects to follow. She planned to pose for a pinup poster, and for *Playboy*. She would pilot herself around the world, in an attempt to re-create Hughes's flight of 1938. She claimed her book would be turned into a TV movie. She admitted that Hollywood hadn't been "knocking down my door" prior to her revelation of the Hughes marriage, but now she was, as *People* magazine put it, "a born again celebrity." Her constant companion Rivers promised, "Terry will be the celebrity of 1984."

That year Moore's long-threatened autobiography finally hit the shelves. Reviews of *The Beauty and the Billionaire* ranged from amused ("If a court can accept Moore's 'marriage,' we can just as easily believe" her book, wrote *US Magazine*, seemingly not realizing that no court had actually accepted the marriage as legitimate) to highly skeptical ("If Hughes was emotionally cruel to her, as it seems he was, it still doesn't justify cashing in on a dead man's fame," sniffed Dale Pollock in the *Los Angeles Times*).

In 1976, shortly after Hughes's death, Terry had said that Howard "taught me secretiveness—never to put anything in writing." Now Moore announced plans to write a second book about him while she was still promoting the first one. "I'm writing it as a novel," she said in 1986. "It will be like when you read a Jackie Collins book. You know, you recognize Maria Callas and all these people in the story, even though she doesn't call them by their real names." She planned to call it *Howard's Women*.

The plan had changed by the time that book was published in 1996. Now it was called *The Passions of Howard Hughes* and billed as a biography. It also included the real names of stars like Katharine Hepburn, Ava Gardner, Billie Dove, and Terry Moore—unlike *The Beauty and the Billionaire*, this second go-round, cowritten by Jerry Rivers, played out entirely in third person. *Passions* primarily consisted of descriptions of events for which the authors could not have been present, including highly florid and explicit accounts of Howard's sexual encounters with famous actresses not named Terry Moore.

Hughes, Moore would write in the book's prologue, "was a man. A flesh and blood man with wants and desires much like every other man. He was one of the 20th century's great romantics, a swashbuckler of the highest order. Howard shared these stories of his exploits with me, and I know he would have wanted to have been remembered as something other than the portrait that history has painted of him."

Would either Hughes or Ida Lupino have wanted history to record what Terry claims was the couple's first kiss in 1935, during which Hughes took the seventeen-year-old Lupino's hand and "rubbed [it] over his crotch, and even though he was still in his pants, he came"? Would Hughes have wanted the truth to be known that he had a similar outcome "less than ten seconds" after Marilyn Monroe "guided him expertly into her mouth" in the front seat of his Chevrolet? Did Bette Davis really tell Hughes, "I'm going to show you what it's like to fuck a real woman," right before she "sat on top of his chest, grinding herself into him, moving higher until she was over his face and mouth, and he could taste how wet she was"? (According to Moore, this encounter also ended anticlimactically—at least, for Bette—when, "in what must have taken awhile, but seemed only a second, Howard came from deep inside himself as Bette smiled up at him, continuing to stroke him.")

Are these really the kinds of thing a man like Hughes would have told a girl like Terry Moore, ten or fifteen or twenty years after they happened, even as pillow talk? It's interesting to note the one relationship that Moore and Rivers cannot be accused of sexually embellishing: there are no full-on sex scenes between Terry Moore and Howard

Hughes in *Passions*. At one point, "Terry" allows Hughes to "fondle" her breasts while he's explaining to her what it was like to pilot the Spruce Goose, but when "he took her hand and began to move it behind her towards his penis, which was swollen against the inside of his slacks . . . she jerked her hand away." That scene, and the book's section about Terry, ends with Terry laying down the law: "In my family, the way I was brought up, there's only one way we're ever going to go further. Marriage." Although there were sex scenes between the two in her previous book, they were PG-rated compared to most of the sex dramatized in *Passions*.

It also seems notable that so many of the stories Moore chose to relate about other women in *Passions* involved Hughes's premature ejaculation, feeding into the image she had created of herself as Howard's true widow by making it seem like the other women were just there for quickies. (As for other women Hughes married, Ella Rice is not named at all in *Passions*, and Jean Peters is mentioned only briefly— and then, Terry has Hughes aide Bill Gay wondering if "they were married anyway.")

Most of *Passions* is un-fact-checkable. It's easy to spot a minor inaccuracy, such as that Moore has Hughes first meeting a still-married Billie Dove in early 1931—seven months after Dove's hearing in her divorce from Irvin Willat, which Hughes financed. But there are no legal documents or news stories to reference, or eyewitnesses to interview, to prove or disprove many of *Passions'* stories, such as that on their first solo date, Dove ordered Hughes to "get the champagne and pour it over my feet and up my legs and onto my pussy . . . and lick it off."

Many of the projects Terry promised on her victory lap, including the round-the-world flight and the TV movie, never happened, but the *Playboy* spread did. Terry appeared on the magazine's cover in August 1984, and inside the magazine in a variety of tasteful topless poses. At fifty-five, she was the magazine's oldest cover girl to that point—"and," she boasted, "every photo ran unretouched." In the accompanying story, Terry explained that she hadn't chased her piece of

Howard's pie because she cared about money. "To prove to the world that I had been married to him, that I wasn't some twit who was making up stories—that was what I wanted. I've always been able to make a living, so the thing I was most happy about was their admitting I was his lawful widow."

Of course, the Hughes estate hadn't admitted that Terry was Hughes's lawful widow. In fact, two lawyers had said that the exact opposite was true. But the settlement, coming after Terry's years of positioning herself as Howard Hughes's secret great love, and followed up by years of Terry telling her preferred version of the story, created the illusion that Moore had won. The outcome suggested more about Terry and Howard's connection than any of her claims to their intimacy. She had, clearly, closely observed a master at work. She had pulled off a publicity stunt worthy of Howard Hughes. It was like something out of a movie. Or, to paraphrase something Katharine Hepburn had once said of Hughes, it was better than the movies—it was real life.

NOTES ON SOURCES
AND ACKNOWLEDGMENTS

This book draws heavily on archival materials, the exploration of which took me back and forth across the United States several times.

The Howard Hughes Files at the Texas State Archives in Austin contain approximately 75,000 documents. I spent ten days there in September 2016 and in that time, was able to review only the fraction of these files that seemed most applicable to my project, but I found invaluable sources in the dozens of boxes that I opened. Some examples include communication between Hughes and his aides from the 1920s through the 1960s (particularly the "call logs" generated in the 1950s and '60s out of Hughes's desire that all incoming phone messages be transcribed word for word); Faith Domergue's unpublished autobiographical manuscript (which has a note clipped to it, suggesting the Hughes camp was responsible for it never seeing the light of day); and the thousands of pages of depositions from various legal hearings, including the RKO shareholder lawsuits and the many-year, multistate battle over the Hughes estate in probate courts. Thanks to Tonia J. Wood for answering my many questions about how to navigate this massive collection.

I took two trips to Las Vegas, to explore the Hughes-related files donated to the University of Las Vegas at Nevada by Carl Byoir and Associates, the publicity company Hughes engaged for the last few decades of his life. At their client's direction, the firm meticulously collected clippings having to do with Hughes and his associates (including women he was involved with or just interested in) and all manner of other topics (from baseball to the mafia). Few activities can give you a sense of how a person was perceived over time quite like reading newspaper clippings about them spanning decades, but the Byoir collection is extra special because of how it lays out what Hughes was

interested in, and what was on his mind, particularly as his affairs (in business, in the bedroom, in his own brain) began to become more convoluted in the 1940s and '50s. The previously untapped gem of this collection is the correspondence between Hughes and journalist Stephen White, occasioned by White's attempt to profile Hughes for *Look* magazine in 1954. White allowed Hughes to make notes and corrections on his draft of the story, and the Byoir publicists recorded and transcribed a lengthy conversation between the tycoon and the journalist in which Hughes clarified aspects of his biography and—more fascinatingly—explained why he wanted various facts massaged in certain ways in order to protect his public persona. Big thanks to Peter Michel in Special Collections at UNLV for taking the time to talk to me about these documents.

Byoir and Associates came into the Hughes fold after two charismatic individual publicists had already made their mark on Hughes's career and its perception. The files of Russell Birdwell, located at the Charles E. Young Research Library at the University of California, Los Angeles, were extremely helpful in reconstructing the publicity campaign surrounding *The Outlaw* and Jane Russell's place in it. I'm indebted to Dave Gunn for reaching out to me and helping me make the most of all of the resources at UCLA.

The copious notes and correspondence kept by Howard Hughes's first film publicist, Lincoln Quarberg, provided valuable insight into Hughes's operations in the late 1920s and early 1930s, and into the shaping of Jean Harlow and Billie Dove as stars. These files are located at the Academy of Motion Picture Arts and Science's Margaret Herrick Library in Beverly Hills, which is always my first stop for any sort of research into Hollywood's past. Other collections at the Herrick that I drew from include Marshall Neilan's autobiographical notes, Billie Dove's scrapbook, the Hedda Hopper papers, the incredibly comprehensive Production Code Administration records, and the clippings files for most of the subjects in this book, but particularly Ida Lupino and Terry Moore. Thanks to Jenny Romero, Kristen Ray, and

the whole staff of the Herrick library, as well as Heather Linville at the Academy for walking me through the restoration of *Cock of the Air*.

At the library of the Writers Guild of America West, archivist Hilary Swett guided me through boxes of files pertaining to the Guild's handling of the Blacklist, and specifically the battle between Hughes and Paul Jarrico. A hidden gem in this collection are the files collected by Howard Suber in his research on the Blacklist, in which I found files pertaining to RKO's paid-for research into the communist pasts of its potential employees. Special thanks also to Suber himself for giving me permission to use these files in my own research.

Sandy Fowler graciously loaned me the files of her late husband, Raymond Fowler, pertaining to his "psychological autopsy" of Hughes. Thanks to J. C. Johnson at Boston University for his help with the Bette Davis scrapbooks, and to Brett Service at the Warner Bros. Archives at USC for allowing me to access the documents that cleared up the confusion about Faith Domergue's birth date.

My research assistant, Lindsey D. Schoenholtz, helped with everything from making appointments with archives to making Freedom of Information Act requests for FBI files, to organizing hundreds of pages of my notes and underlinings on archival sources. I would not have been able to finish this book without her.

Special thanks to my agent, Daniel Greenberg, and Geoff Shandler at Custom House for believing in me based on a podcast that was still, in early 2015, extremely DIY and had only a small cult audience. I was only able to complete this book thanks to the support and patience of Geoff and everyone at Custom House, including Vedika Khanna and Eliza Rosenberry.

BIBLIOGRAPHY

Books

Ankerich, Michael G. "Billie Dove." In *The Sounds of Silence: Conversations with 16 Film and Stage Personalities Who Bridged the Gap Between Silents and Talkies.* Jefferson, NC: McFarland, 1998.

Bartlett, Donald L., and James B. Steele. *Howard Hughes: His Life and Madness.* New York: Norton, 2004.

Baxter, John. *Von Sternberg.* Louisville: University Press of Kentucky, 2010.

Behlmer, Rudy. "Howard Hughes and *Hell's Angels.*" In *Shoot the Rehearsal! Behind the Scenes with Assistant Director Reggie Callow.* Lanham, MD: Scarecrow Press, 2010.

Berg, A. Scott. *Goldwyn.* New York: Riverhead Books, 1998.

———. *Kate Remembered.* New York: Penguin, 2004. Kindle edition.

Bergman, Ingrid, and Alan Burgess. *Ingrid Bergman: My Story.* New York: Delacorte Press, 1972.

Bowers, Scotty. *Full Service: My Adventures in Hollywood and the Secret Sex Lives of the Stars.* New York: Grove/Atlantic, 2012.

Brown, Peter Harry, and Pat H. Broeske. *Howard Hughes: The Untold Story.* Boston: Da Capo, 2004. Kindle edition.

Brownlow, Kevin. *The Parade's Gone By.* Berkeley: University of California Press, 1968.

Burk, Margaret Tante. *Are the Stars Out Tonight? The Story of the Famous Ambassador and Cocoanut Grove[:] "Hollywood's Hotel."* Santa Ana, CA: Forum Press, 2003.

Capra, Frank. *The Name Above the Title.* Boston: Da Capo, 1997.

Cardullo, Bert. *Vittorio De Sica: Actor, Director, Auteur.* Newcastle: Cambridge Scholars, 2009.

Ceplair, Larry. *The Marxist and the Movies: A Biography of Paul Jarrico.* Screen Classics. Louisville: University Press of Kentucky, 2007. Kindle edition.

Ceplair, Larry, and Christopher Trumbo. *Dalton Trumbo: Blacklisted Hollywood Radical.* Screen Classics. Louisville: University Press of Kentucky, 2014. Kindle edition.

Chandler, Charlotte. *The Girl Who Walked Home Alone: Bette Davis, a Personal Biography.* New York: Simon & Schuster, 2006. Kindle edition.

———. *I Know Where I'm Going: Katharine Hepburn, a Personal Biography.* New York: Simon & Schuster, 2014. Kindle edition.

Critchlow, Donald T. *When Hollywood Was Right: How Movie Stars, Studio Moguls, and Big Business Remade American Politics*. New York: Cambridge University Press, 2013. Kindle edition.

Curtis, James. *Between Flops: A Biography of Preston Sturges*. James Curtis, 2011. Kindle edition.

———. *Spencer Tracy: A Biography*. New York: Knopf Doubleday, 2011. Kindle edition.

Davis, Ronald L. *Hollywood Beauty: Linda Darnell and the American Dream*. Tulsa: University of Oklahoma Press, 2000. Kindle edition.

De Carlo, Yvonne. *Yvonne*. New York: St. Martin's Press, 1987.

Dietrich, Noah. *Howard: The Amazing Mr. Hughes*. New York: Fawcett, 1976.

Dixon, Wheeler Winston. *Death of the Moguls*. New Brunswick, NJ: Rutgers University Press, 2012.

Doherty, Thomas. *Hollywood's Censor: Joseph I. Breen and the Production Code Administration*. New York: Columbia University Press, 2007. Kindle edition.

Donati, William. *Ida Lupino: A Biography*. Louisville: University Press of Kentucky, 1996.

———. *The Life and Death of Thelma Todd*. Jefferson, NC: McFarland, 2012. Kindle edition.

Drew, William M. "Billie Dove." In *At the Center of the Frame: Leading Ladies of the Twenties and Thirties*. Lanham, MD: Vestal Press, 1999.

———. "Eleanor Boardman." In *Speaking of Silents: First Ladies of the Screen*. Lanham, MD: Vestal Press, 1989.

Drosnin, Michael. *Citizen Hughes*. New York: Holt, Rinehart & Winston, 1985.

Evans, Peter, and Ava Gardner. *Ava Gardner: The Secret Conversations*. New York: Simon & Schuster, 2013. Kindle edition.

Finstad, Suzanne. *Heir Not Apparent*. Austin: Texas Monthly Press, 1984.

Fitzgerald, F. Scott. *Love of the Last Tycoon: The Authorized Text*. New York: Scribner. Kindle edition.

Fuller, Samuel. *A Third Face*. New York: Knopf, 2002.

Geist, Kenneth L., and Richard Burton. *Pictures Will Talk: The Life and Films of Joseph L. Mankiewicz*. Boston: Da Capo Press, 1983.

Goessel, Tracey. *The First King of Hollywood: The Life of Douglas Fairbanks*. Chicago: Chicago Review Press, 2015. Kindle edition.

Grobel, Lawrence. *Conversations with Ava Gardner*. Lawrence Grobel, 2013. Kindle edition.

Hepburn, Katharine. *Me: Stories of My Life*. New York: Random House, 2011. Kindle edition.

Jewell, Richard B. *RKO Radio Pictures: A Titan Is Born*. Berkeley: University of California Press, 2012. Kindle edition.

—. *Slow Fade to Black: The Decline of RKO Radio Pictures*. Berkeley: University of California Press, 2016. Kindle edition.

Johnson, William Bruce. *Miracles and Sacrilege: Robert Rossellini, the Church, and Film Censorship in Hollywood*. Toronto: University of Toronto Press. Kindle edition.

Johnston, Marguerite. *Houston, the Unknown City, 1836–1946*. College Station: Texas A&M University Press, 1991.

Kazan, Elia. *Elia Kazan: A Life*. New York: Knopf Doubleday, 2011. Kindle edition.

Kemm, James O. *Rupert Hughes: Hollywood Legend*. Beverly Hills, CA: Pomegranate Press, 1997.

Laffel, Jeff. "Joseph L. Mankiewicz." In *Joseph L. Mankiewicz Interviews*, edited by Brian Dauth. Jackson: University of Mississippi Press, 2008.

Laurents, Arthur. *Original Story By*. New York: Knopf, 2000.

Leaming, Barbara. *Katharine Hepburn*. New York: Limelight Editions, 1995.

Linet, Beverly. *Susan Hayward: Portrait of a Survivor*. New York: Atheneum, 1980.

Loos, Anita. *Kiss Hollywood Goodbye*. New York: Penguin, 1979.

Maas, Frederica Sagor. *The Shocking Miss Pilgrim: A Writer in Early Hollywood*. Louisville: University Press of Kentucky, 1999.

Mann, William J. *Kate: The Woman Who Was Hepburn*. New York: Holt, 2007.

Mate, Ken, and Pat McGilligan. "W. R. Burnett: The Outsider." In *Backstory: Interviews with Screenwriters of Hollywood's Golden Age*. Berkeley: University of California Press, 1988.

Mayne, Judith. *Directed by Dorothy Arzner*. Bloomington: Indiana University Press, 1995.

McCarthy, Todd. *Howard Hawks: The Grey Fox of Hollywood*. New York: Grove/Atlantic, 2007. Kindle edition.

McLellan, Diana. *The Girls: Sappho Goes to Hollywood*. New York: St. Martin's Griffin, 2013.

Moore, Terry. *The Beauty and the Billionaire*. New York: Pocket Books, 1984.

Moore, Terry, and Jerry Rivers. *The Passions of Howard Hughes*. Los Angeles: General, 1996.

Mosley, Leonard. *Zanuck: The Rise and Fall of Hollywood's Last Tycoon*. New York: McGraw-Hill, 1984.

Mutti-Mewse, Austin, and Howard Mutti-Mewse. *I Used to Be in Pictures: An Untold Story of Hollywood*. New York: ACC Editions, 2014.

Parla, Paul, and Pat Mitchell. "Faith Domergue." In *Screen Sirens Scream! Interviews with 20 Actresses from Science Fiction, Horror, Film Noir, and Mystery Movies, 1930s to 1960s*. Jefferson, NC: McFarland, 2009.

Rice, Christina. *Ann Dvorak: Hollywood's Forgotten Rebel*. Screen Classics. Louisville: University Press of Kentucky, 2013. Kindle edition.

Rogers, Ginger. *Ginger: My Story*. New York: HarperCollins, 1991.

Russell, Jane. *Jane Russell, an Autobiography: My Path and My Detours*. New York: Berkley, 1986.

Schickel, Richard. *D. W. Griffith: An American Life*. New York: Limelight Editions, 2004.

Schulberg, Budd. *Moving Pictures: Memories of a Hollywood Prince*. New York: Open Road, 1981. Kindle edition.

Server, Lee. *Ava Gardner: "Love Is Nothing."* New York: St. Martin's Press, 2007. Kindle edition.

———. *Robert Mitchum: "Baby I Don't Care."* New York: St. Martin's Press. Kindle edition.

Stamp, Shelley. *Lois Weber in Early Hollywood*. Berkeley: University of California Press, 2015. Kindle edition.

Steele, Joseph Henry. *Ingrid Bergman: An Intimate Portrait*. New York: David McKay, 1959.

Steinem, Gloria. *Marilyn: Norma Jeane*. New York: Open Road Media, 2013. Kindle edition.

Stenn, David. *Bombshell: The Life and Death of Jean Harlow*. New York: Doubleday, 1993.

St. Johns, Adela Rogers. *Love, Laughter and Tears*. New York: Signet, 1978.

Sturges, Preston, and Sandy Sturges. *Preston Sturges by Preston Sturges: His Life in Words*. New York: Simon & Schuster, 1991.

Thomson, David. *Showman: The Life of David O. Selznick*. New York: Knopf, 1993.

Turner, Lana. *Lana: The Lady, the Legend, the Truth*. New York: Pocket Books, 1982.

Vanderbilt, Gloria. *It Seemed Important at the Time: A Romance Memoir*. New York: Simon & Schuster, 2008. Kindle edition.

Vieira, Mark A. *Into the Dark: The Hidden World of Film Noir, 1941–1950*. Philadelphia: Running Press, 2016. Kindle edition.

Vogel, Michelle. *Olive Thomas: The Life and Death of a Silent Film Beauty*. Jefferson, NC: McFarland, 2007.

Weaver, Tom. "Faith Domergue." In *I Was a Monster Movie Maker: Conversations with 22 Science Fiction and Horror Filmmakers*. Jefferson, NC: McFarland, 2011.

Weiner, Debra. "Interview with Ida Lupino." In *Women in the Cinema: A Critical Anthology*, edited by Gerald Peary. New York: Dutton, 1977.

Williams, Gregory Paul. *The Story of Hollywood: An Illustrated History*. Los Angeles: LBL Press, 2011.

Zeruk, James, Jr. *Peg Entwistle and the Hollywood Sign Suicide: A Biography*. Jefferson, NC: McFarland, 2013. Kindle edition.

Magazine and Newspaper Articles

Amory, Cleveland. "Status Quotes." *Sacramento Bee*, April 2, 1976.

Anderson, Curtiss. "Katharine Hepburn's Personal Scrapbook." *Good Housekeeping*, January 1979.

Ankerich, Michael. "Dove Tails—Lee, Billie, and the Rest of the Story." *Close-Ups and Long Shots*," March 12, 2012, michaelgankerich.wordpress.com/2012/03/12 /dove-tails-lee-billie-and-the-rest-of-the-story/.

Arneel, Gene. "Legalistics, Taxes, 'Pride' 'Privacy' Cue $23,489,478 Bid by Hughes." *Variety*, February 10, 1954.

Associated Press. "Actress Says She Had Howard Hughes' Baby." *Los Angeles Herald-Examiner*, December 22, 1977.

Bacon, James. "His Final Call Yearned for the Vegas Nights." *Los Angeles Herald Examiner Magazine*, April 6, 1976.

———. "Jane Russell Tells Big Publicity Build-Up for 'The Outlaw' Film." *Los Angeles Herald & Express*, January 21, 1954.

Beatty, Jerome. "The Boy Who Began at the Top." *American Magazine*, April 1932.

Berg, Louis. "Star Under Wraps." *Life*, July 17, 1950.

Birdwell, Russell. "Heartbreak Town." *New York Journal*, June 15, 1935.

Breo, Dennis. "Howard Hughes' Doctor Gives a Chilling Description of His Strange Patient's Final Hours." *People*, July 30, 1970.

Brown, DeNeen L. "Seeking Justice for the Mass Hanging of Black Soldiers After the Bloody 1917 Houston Riots." *Washington Post*, August 24, 2017.

Browning, Frank. "The Secret Drug Life of Howard Hughes." *High Times*, March 1980.

Busby, Marquis. "Beauty Bows to Brains: Billie Dove, Long Praised for Bewitching Charm, Wins." *Los Angeles Times*, October 21, 1928.

Brennan, Peter. "Howard Hughes Shown as Troubled, Loving Man in Movie Star's Intimate Tapes." *Star*, July 3, 1979.

Carroll, Harrison. "Behind the Scenes in Hollywood." *Daily Clintonian*, June 11, 1945.

Cheshire, Godfrey. "Why No One Is Celebrating the 100th Anniversary of the Feature Film." *Vulture, New York*, February, 6, 2015, www.vulture.com/2015/02 /why-we-arent-celebrating-100-years-of-movies.html.

Christy, George. "Terry Moore." *Interview*, September 1986.

Collis, Clark. "The Hughes Legacy: Scramble for the Billions." *Time*, April 19, 1976.

Crowe, Earle E. "Hughes After Multicolor." *Los Angeles Times*, June 12, 1930.

Demaris, Ovid. "You and I Are Very Different from Howard Hughes." *Esquire*, March 1969.

Dietrich, Noah. "The Howard I Remember." *Life*, February 25, 1972.

Donovan, Robert J. "'Stromboli' Starts Senate on Name-Calling Spree," *New York Herald Tribune*, March 19, 1950.

Duggan, Shirle. "Outrage Wins Plaudits." *Los Angeles Examiner*, January 11, 1951.

Elliot, William Foster. "Exit Flapper, Enter Woman." *Los Angeles Times*, July 30, 1922.

Fadiman, Edwin, Jr. "Can the Real Howard Hughes . . ." *Playboy*, December 1971.

Fidler, Jimmie. "Jane Russell Is Just a Victim of Hard Luck." *Detroit Free Press*, February 12, 1943.

———. "News and Views of Hollywood." *Valley Times*, February 13, 1951.

———. "Views of Hollywood." *Valley Times*, November 20, 1952.

Fowler, Raymond D. "Howard Hughes: A Psychological Autopsy." *Psychology Today*, May 1986.

Fleming, Thomas J. "He Can Make Anybody Famous for the Right Fee." *Cosmopolitan*, August 1961.

Francis, Warren B. "General Asks $200,000 Loan, Hughes Testifies." *Los Angeles Times*, November 10, 1947.

Garrison, Omar. "The Bergman Story." *New York Post*, February 14, 1950.

———. "Refusal to Marry Hughes Revealed by Italian Beauty." *Mirror*, n.d.

Glaser, Allan. "Terry Moore's Life, Loves on and off the Screen." *Focus on Fox*, March 1983.

Goodman, Ezra. "Film Review: *Outrage*." *Daily News*, January 11, 1951

Goodyear, Dana. "Hotel California." *New Yorker*, February 7, 2005. https://www .newyorker.com/magazine/2005/02/07/hotel-california.

Gorman, Steve. "Jean Peters, Ex-Wife of Howard Hughes, Dead at 73." Reuters, October 20, 2000.

Graham, Sheilah. "Chasing Howard Hughes." *Ladies' Home Journal*, July 1974.

———. "In Hollywood." *Tampa Times*, November 27, 1952.

Green, Michelle. "Hoping to Make a Comeback, Terry Moore Cashes In on Her New Role as Mrs. Howard Hughes." *People*, September 5, 1983.

Grimes, David A. "The Bad Old Days: Abortion in America Before Roe v. Wade" *Huffington Post*, January 15, 2015. https://www.huffingtonpost.com/david-a -grimes/the-bad-old-days-abortion_b_6324610.html.

Hall, Gladys. "'I Have Made Myself an Ugly Girl!' Says Ida Lupino." *Movie Mirror*, July 17, 1940.

Halley, Joe. "'Dallas' Actress Barbara Bel Geddes Dies." *Washington Post*, August 11, 2005.

Heffernan, Harold. "Ida Lupino Clicks as Film Producer." *Detroit News*, October 10, 1949.

Heimann, Jim. "Those Hollywood Nights." *Los Angeles Times*, May 21, 2006.

Hill, Gladwin. "Hollywood's Beautiful Bulldozer." *Collier's*, May 12, 1951.

———. "No-Man in the Land of Yes-Men." *New York Times Magazine*, August 17, 1947.

Hopper, Hedda. "Hedda Hopper's Hollywood." *Los Angeles Times*, April 19, 1952.

———. "Hollywood's Mystery Girl." *Photoplay*, March 1952.

———. "Love Stirs Vitality in Quiet Jean." *Los Angeles Times*, July 11, 1954.

———. "That Harlow Book!" *Photoplay*, February 1965.

Howe, Anne. "So This Is Hollywood!" *Screen Play Magazine*, November 1932.

Hoyt, Caroline S. "Running Away From it All." *Modern Screen*, June 1938.

Hughes, Rupert. "Howard Hughes–Record Breaker, Part 1." *Liberty*, February 6, 1937.

Jackovich, Karen G., and Mark Sennet. "The Children of John Wayne, Susan Hayward and Dick Powell Fear That Fallout Killed Their Parents." *People*, November 10, 1980.

Johnson, Erskine. "Erskine Johnson (Column)." *Daily News*, January 29, 1950.

———. "In Hollywood: Jean Peters Falls Victim to L.A. Smog." *Lancaster Eagle-Gazette*, October 29, 1954.

Keats, John. "Howard Hughes: A Lifetime on the Lam." *TRUE*, May 1966.

Kilgallen, Dorothy. "Gossip in Gotham." *Broadway*, June 25, 1941.

———. "The Voice of Broadway." June 5, 1942.

Kingsley, Grace. "Airport Gardens Opens." *Los Angeles Times*, May 18, 1932.

———. "Busy U City." *Los Angeles Times*, December 3, 1925.

Kistler, Ron. "I Caught Flies for Howard Hughes." *Playboy*, December 1975.

Kriss, Nicholas C. "Hughes Pact with Jean Peters Filed." *Los Angeles Times*, June 10, 1976.

Lang, Harry. "Hollywood's Hundred Million Dollar Kid." *Photoplay*, February 1931.

Lefkowitz, Bernard. "Endowed by Hughes—but Singer Sues." *New York Post*, July 13, 1962.

Lieber, Ruth. "But I Can Unmask Jean Harlow!" *Photoplay*, November 1931.

Lupino, Ida. "Me, Mother Directress." *Action*, May/June 1967.

Lyons, D. L. "America's Richest Wife." *Ladies' Home Journal*, November 1968.

———. "Jean Peters: Howard Hughes' Ex-wife Speaks Out." *Ladies' Home Journal*, March 1973.

———. "The Liberation of Mrs. Howard Hughes." *Ladies' Home Journal*, March 1971.

Maddox, Ben. "What's the Matter with Hepburn?" *Modern Screen*, October 1938.

Manners, Dorothy. "Hughes Calls Always Came in Early Hours." *Los Angeles Herald-Examiner*, January 13, 1972.

March, Joseph Moncure. "Young Howard Hughes, Reminiscences by a Survivor of Hollywood's Golden Era." *Views and Reviews* 4 (1973).

Martindale, David. "Terry Moore." *Biography*, February 2001.

Mathison, Richard. "Howard Hughes: Cradle-Robbing Baron." *CHIC*, July 1977.

McCall, Mary C., Jr. "The Hughes-Jarrico Imbroglio and the Screen Writers' Guild." *Frontier*, May 1952.

McGraw, Carol. "Hughes' Heirs to Pay Actress." *Los Angeles Times*, May 25, 1983.

Miles, Jonathan. "Howard Hughes: The Man Who Flew Too High." *Men's Journal*, July 2013.

Muir, Florabel. "Fabled Flier's Millions Resulted from Doing What Came Naturally." *Sunday News*, September 19, 1948.

Nelson, Valerie J. "Barbara Bel Geddes, 82; Star of Stage, Screen and 'Dallas.'" *Los Angeles Times*, August 11, 2005.

Ober Peak, Mayme. "True Story of Bette Davis' Broken Romance." *Screenland*, January 1939.

Parsons, Louella O. "Ann Sheridan Gets Nora Bayes Role." *Philadelphia Inquirer*, July 1, 1942.

———. "Film planned on life of Souza." *Democrat and Chronicle*, March 30, 1942.

———. "In Hollywood with Louella O. Parsons." *Los Angeles Examiner*, October 12, 1947.

———. "In Hollywood with Louella O. Parsons." *Los Angeles Examiner*, April 8, 1951.

———. "Irene, Famed Hollywood Stylist, Quits Private Business to Design for MGM." *Fresno Bee*, June 9, 1942.

———. "Jean Harlow Said Her Only Love Was Film's Bill Powell." *Pittsburgh Post-Gazette*, June 9, 1937.

———. "Jean Peters, Who Leaped to Stardom, Plans Divorce." *Los Angeles Herald-Examiner*, September 13, 1955.

———. "Nelson Eddy to Get New Singing Partner." *Philadelphia Inquirer*, May 20, 1942.

———. "Rosalind Russell Cast in Amelia Earhart Role." *Democrat and Chronicle*, June 2, 1942.

———. "Success and Sorrow Mingle for Bette Davis." *Los Angeles Examiner*, October 9, 1938.

Perry, Charles. "Brandstatter Brought the Party to Old Hollywood." *Los Angeles Times*, April 14, 2011.

Petrali, Joe, as told to Maury Green. "O.K., Howard, Part I." *True*, February 1975.

Phelan, James. "Scenes from the Hidden Year." *Time*, December 1976.

Phillips, Stanley. "Egotist's Peak: A Candid Look into Howard Hughes." *Nugget Magazine*, October 1957.

Pita, Marylynne. "Olive Thomas, the Original 'Flapper' and a Mon Valley Native, Still Fascinates." *Pittsburgh Post-Gazette*, September 26, 2010.

Quirk, James R. "Close-Ups and Long-Shots." *Photoplay*, October 1930.

Reginato, James. "Gina Lollobrigida Breaks the Silence on Her Outrageous Tabloid Scandals." *Vanity Fair*, February 2015.

Rogers, Frank. "Kaiser Angrily Charges 'Brush-off' at Plane Quiz." *Los Angeles Daily News*, July 29, 1947.

Rogers, Frank. "Gen. Meyers $1 Million Idea to Get 'Security for Rest of Life' Told." *Los Angeles Daily News*, November 11, 1947.

Rosenfeld, Megan. "Terry Moore: Life After Howard, Mrs. Hughes Renews Her Celebrity." *Washington Post*, June 28, 1983.

Rosenwald, Michael S. "The Ku Klux Klan Was Dead. The First Hollywood Blockbuster Revived It." *Washington Post*, August 12, 2017. www.washingtonpost.com/news/retropolis/wp/2017/07/08/the-ku-klux-klan-had-been-destroyed-then-the-first-hollywood-blockbuster-revived-it/.

Rossi, Steve. "Terry Moore: The Ermine Sex Bomb Grows Up." *Oui*, February 1982.

Russell, Jane, as told to Sid Ross and Kay Sullivan. "I Have Faith In People." *Parade*, November 22, 1953.

Russell, Jane. "They Sold Me." *Parade*, November 15, 1953.

Sartain, Geraldine. "Flying Togs Do More than Set Off Beauty of Billie Dove Who Is Eager to Handle a Plane in an Aviation Movie." *World Telegram*, January 4 (no year). Billie Dove special collection, MHL.

Sammis, Fred R. "The Case Against *The Outlaw*." *Photoplay*, September 1946.

Samuels, Charles. "Hollywood's Most Fabulous Bird." *Cavalier*, February 1962.

Sarris, Andrew. "The Man in the Glass Closet." *New York Times*, December 15, 1991.

Schallert, Edwin. "Howard Hughes' Interest in RKO Studio Sold." *Los Angeles Herald-Examiner*, September 23, 1952.

Schary, Dore. "I Remember Hughes." *New York Times*, May 2, 1976.

Schuyler, Dick. "The Girl Who Said No to Howard Hughes." *Top Secret*, 1954.

Scott, Jay. "Candidly Hollywood." *Detroit Free Press*, October 14, 1945.

Scott, John L. "Change to Svelte Becomes Jean Peters." *Los Angeles Times*, April 24, 1949.

Scott, Vernon. "Weekends with Howard in Las Vegas." United Press International, n.d.

Scott, Walter. "Walter Scott's Personality Parade." *Long Beach Independent Press-Telegram*, February 22, 1970.

Shearer, Lloyd. "Howard Hughes: Hollywood Outlaw." *Pageant*, August 1946.

———. "The Tragic Pattern of Sex Symbols" *Pageant*, August 27, 1967.

Simberg, Lynn. "Studio Club Closes Doors on Memories." *Los Angeles Times*, February 1975.

Sherman, George. "A Billionaire Fights the Mafia." *This Week*, November 12, 1976.

Skolsky, Sidney. "Tintypes (Billie Dove)." No date or publication on clipping. Billie Dove special collection, MHL.

Skolsky, Sidney. "Hollywood Is My Beat: Tintypes." *Hollywood Citizen-News*, March 11, 1948.

———. "Hollywood Is My Beat: Tintypes." *Hollywood Citizen-News*, February 28, 1952.

———. "Tintypes: Terry Moore." *New York Post*, February 22, 1953.

Spensley, Dorothy. "For the Love of Billie." *Screen Play Secrets of Hollywood*, June 1931.

Stenn, David. "It Happened One Night . . . at MGM." *Vanity Fair*, April 2003.

Sterba, James P. "Cause of Hughes' Death Is Given as Kidney Failure." *New York Times*, April 7, 1976.

St. Johns, Adela Rogers. "Is Marriage a Bunco Game?" *Photoplay*, July 1921.

———. "Love, Laughter and Tears." *American Weekly*, February 4, 1951.

Stevens, Sid. "Reeling Round . . . Hollywood." *Film Daily*, February 4, 1952.

Stewart, Jocelyn Y. "Chris Gugas, 86; Leading Polygraph Expert Found That in 30,000 Tests, 70% Were Truthful." *Los Angeles Times*, November 15, 2007.

Swertlow, Frank. "Moore-ing Right Along." *Los Angeles Herald Examiner*, July 21, 1983.

Thomas, Bob. "In Hollywood . . ." *Times* (San Mateo), February 9, 1949.

———. "Jean Peters Gets Sexy Role." *Palm Beach Post*, September, 30 1952.

———. "RKO Film Studio Shutdown Looms." *Hollywood Citizen-News*, September 23, 1954.

Tinnin, David B. "The Secret Life of Howard Hughes." *Time*, December 1976.

Torre, Marie. "Two Men in Russell's Life." *New York World-Telegram*, April 19, 1952.

Varney, Ginger. "Ida Lupino, Director." *Los Angeles Weekly*, November, 12, 1982.

Vaught, Steve. "Howard Hughes: The Producer of *Hell's Angels* at Home in Los Angeles's Hancock Park." *Architectural Digest*, November 2008.

Walker, Danton. "Amos and Andy Now Reach Top Rating." *Detroit Free Press*, March 18, 1946.

Willat, Irvin V., and Robert S. Birchard. "Conversations with Irvin V. Willat." *Film History* 12, no. 1 (2000): 29–48. http://www.jstor.org/stable/3815268.

Williams, Wylie. "*Outrage* Another Triumph for Director Ida Lupino." *Hollywood Citizen-News*, January 11, 1951.

Winchell, Walter. "Along Broadway." *The Dayton Herald*, July 14, 1941.

Wisenberg, S. L. "The 1917 Houston Riot. And the Era of Black Lives Matter." *Houston Chronicle*, August 23, 2016.

Wagner, Bruce. "Still Big in Germany." *New Yorker*, July 20, 1998.

Whitaker, Alma. "Billie Dove 'At Liberty.'" *Los Angeles Times*, June 29, 1930.

———. "Ida Lupino, at 17 Oozes Confident Sophistication." *Los Angeles Times*, March 18, 1934.

Wickizer, James F. "It Happened in Hollywood." *Nevada State Journal*, October 9, 1938.

Wickware, Francis Sill. "Howard Hughes." *Cosmopolitan*, December 1946.

Wilkerson, W. R. "Trade Views." *Hollywood Reporter*, September 28, 1954.

Wilson, Earl. "California Divorce Now Hope Without Hollering." *Las Vegas Review-Journal*, March 16, 1970.

———. "Judy Cook Shows Sketchings." *Los Angeles Daily News*, July 28, 1947.

———. "Says Krug at Hughes' Shindig." *Los Angeles Daily News*, July 23, 1947.

Articles Without Bylines

"Lo, the Movies Have Achieved Revivals!" *New York Times*, March 9, 1919.

"MRS. RUPERT HUGHES A SUICIDE IN CHINA; Message from Standard Oil Man at Haiphong Tells Author of Tragedy." *New York Times*, December 15, 1923.

"Death Car Driver Free." *Los Angeles Times*, February 9, 1924.

"Praise for Histrionic Ability." *Los Angeles Times*, October 21, 1928.

"'Hell's Angels' Completed." *American Cinematographer*, January 1930.

"The Painted Angel." *Variety*, January 8, 1930.

"Lovely Billie Dove Faces Big Handicap." *Daily Mirror*, April 26, 1930.

"Stage Show Helped 'Bad One' Out to $31,500 at Penn, Ptsbg; Wk Not Good." *Variety*, June 18, 1930.

"Comparative Grosses for May." *Variety*, June 11, 1930.

"Billie Dove Obtains Divorce; Beatings by Willat, Director, Related." *Los Angeles Times*, July 2, 1930.

"Sweethearts and Wives." *Variety*, July 9, 1930.

"A Texan with Ideas of His Own Risks His Millions in Movies but Finds Originality Pays." *Kansas City Star*, August 3, 1930.

"Louisville at 130, 6-Month Drought." *Variety*, August 6, 1930.

No headline or byline, *Los Angeles Paper*, September 2, 1930.

"Fulton Opens in Ptsbgh to $8,200; Good Enough as Usual Thing There." *Variety*, October 15, 1930.

"Hughes Asserts United Artists Price Too High." *Los Angeles Paper*, October 15, 1930.

"$10,000,000 Film Merger Completed." *Los Angeles Paper*, October, 24 1930.

"Lady Who Dared." *Variety*, June 9, 1931.

"Frisco Spotty; Orph Up at $14,000; for $25,000." *Variety*, May 27, 1931.

Modern Screen, November 30, 1931.

"Screen News." *Screenland*, November, 1931.

"Shortest Run Record for 'Age,' Rivoli." *Variety*, November 18, 1931.

"Hughes Not Discoverer of Harlow: Jean Gives Credit to Jim Hall and Ben Lyon." *Syracuse Herald*, March 15, 1932.

"The Mighty Censor." *Los Angeles Times*, April 27, 1932.

"'Sold Down the River' Declares Ann Dvorak." *Los Angeles Times*, July 19, 1932.

"Bill of Divorcement." *Hollywood Reporter*, August 31, 1932.

"Color Plant Re-Acquired." *Los Angeles Paper*, September 20, 1932.

"The Theatre: New Plays in Manhattan." *Time*, February 19, 1934.

"Can Hepburn Ever Find True Love?" *Hollywood*, August 1934.

"Hughes Sets 347 MPH Air Record, Foils Crash Death." *Los Angeles Paper*, September 13, 1935.

"Irving Thalberg, Genius, Is Dead." *Pittsburgh Press*, September 15, 1936.

"Nothing Sensational." *Time*, January 27, 1936.

"Jean Harlow Recovering; William Powell Is Visitor." *Detroit Free Press*, June 4, 1937.

"Jean Harlow, Movie Star, Dies in Los Angeles." *St. Louis Post Dispatch*, June 7, 1937.

"Is Jean Harlow Dead? Her Mother Says No!" *Modern Romances*, March and April 1938.

"WAKE UP! Hollywood Producers." *Hollywood Reporter*, May 3, 1938.

"'Brushed Death 3 Times'-Hughes." New York *Daily News*, July 15, 1938.

"Walter Winchell on Broadway." *Wilkes-Barre Evening News*, October 3, 1938.

"Harmon Nelson Prepares to Divorce Film Star." *San Francisco Call-Bulletin*, November 22, 1938.

"Nelson Sues Bette Davis for Divorce." *Los Angeles Examiner*, November 23, 1938.

"MPPDA to Review Outlaw on Appeal." *Motion Picture Daily*, April 2, 1941.

"20th Begs Off on Releasing 'Outlaw,' Howard Hughes Pic." *Variety*, July 8, 1942.

"Cinema: Hughes' Western." *Time*, February 22, 1943.

"Stop Train! Films Calling Jean Peters." *Los Angeles Times*, January 11, 1946.

"Theater Manager, 'Outlaw' Film Held." *Bakersfield Californian*, April 24, 1946.

"Women Hiss as *Outlaw* Declared Clean." *Tennessean*, May 18, 1946.

"Howard Hughes Critical: Millionaire Flyer Given 50–50 Chance, Plane Hits 4 Houses in Beverly Hills." *Los Angeles Times*, July, 8 1946.

"Pneumonia Hughes Peril; Lana Turner Keeps Night Vigil." *Los Angeles Examiner*, July 10, 1946.

"Howard Hughes Near Death as Latest Plane Creation Wipes Out Three Houses in Maiden Flight." *Daily Messenger*, July 8, 1946.

"Howard Hughes Given Fighting Chance to Live as Plane He Is Flying Crashes." *Northwest Arkansas Times*, July 8, 1946.

"Hughes Still Critical, but Holds Parleys." *Hollywood Citizen-News*, July 9, 1946.

"Hughes' Lung Fails, Condition Worse." *Los Angeles Times*, July 12, 1946.

"Hughes Faces Operation." *Los Angeles Times*, July 13, 1946.

"Looking at Hollywood." *Chicago Tribune*, July 29, 1946.

"Linda Darnell to Seek Divorce." *Alexandria Daily Town Talk*, July 15, 1946.

"Howard Hughes Flies East for Film Battle." *Los Angeles Times*, September 11, 1946.

"Hughes Tells 'Em Off." *Los Angeles Daily News*, July 25, 1947.

"Gay Hughes Parties Told by Actress." *Los Angeles Herald Express*, July 23, 1947.

"The Congress: Duel Under the Klieg Lights." *Time*, August 18, 1947.

"Senators Suddenly Drop Hughes Probe; Other Business Held Reason." *Hollywood Citizen-News*, August 11, 1947.

"Hughes Denies $100,000 Offer to Lift Movie Ban." *Hollywood Citizen-News*, November 11, 1947.

"Jubilant Hughes Hops off for Home; Ready to Resume Fight in November." *Los Angeles Daily News*, August 12, 1947.

"Casualty in Hollywood." *Time*, July 19, 1948.

"The Mechanical Man." *Time*, July 19, 1948.

"*Outlaw* Gets 300G in 21 Spots." *Variety*, January 3, 1950.

"Ingrid's Film *Stromboli* Proves Flop at Preview." United Press International, January 25, 1950.

"Hollywood Calls 'Stromboli' a Gold Mine Despite Bans." *New York Post*, February 8, 1950.

"*Stromboli* Erupts Over US: Smash Biz Reported In Many Spots." *Variety*, February 16, 1950.

"*Stromboli* First Weekend Reported at $1,248,000." *Variety*, February 20, 1950.

"*Stromboli* Opens Strong in Controversial Storm." *Box Office*, February 18, 1950.

"Rossellini Renounces RKO'd *Stromboli*." United Press International, February 21, 1950.

"Movie Morals: Whose Business?" *U.S. News & World Report*, April 25, 1950.

"At the Globe." *New York Times*, December 26, 1950.

"Rep. Jackson Urges Hollywood to Regain Public Confidence." *Hollywood Reporter*, April 17, 1952.

"*Outrage* Review." *Film Daily*, August 24, 1950.

"Outrage." *Hollywood Reporter*, August 23, 1950

"Outrage." *Variety*, August 23, 1950.

"Cinema: The New Pictures." *Time*, January 22, 1951.

"Jane Russell's Black Eye Stirs Vegas Stories." *Mirror*, February 13, 1952.

"De Sica Due on Coast for Huddles with Hughes." *Variety*, March 12, 1952.

"Hughes Defies Film Writers." *Los Angeles Times*, March 18, 1952.

"Hughes' Defiance." *Los Angeles Times*, March 29, 1952.

"Short Subjects." *Wall Street Journal*, August 11, 1952.

"Jarrico Counters with Suit Against RKO for $350,000." *Los Angeles Examiner*, March 29, 1952.

"Hughes Sued on His RKO Operations." *Los Angeles Times*, December 16, 1952.

"Two Stockholders Ask RKO Receiver." *Los Angeles Times*, October 14, 1953.

"Court Cuts Jarrico's Claims Against RKO As Hughes Testifies." *Variety*, November 21, 1952.

"Her Lips 'Most Kissable' in Filmland, Says Artist." *Los Angeles Examiner*, March 6, 1952.

"Jane Russell May Break Association with Hughes." *Long Beach Press-Telegram*, August 28, 1953.

"Hughes Starlet Tries to Kill Self." *Mirror*, November 19, 1953.

"Hughes Starlet, Impatient to Be Star, Tries Death." *Mirror*, November 19, 1953.

"Movie Review: Two Gals from Texas." *Look*, December 3, 1953.

"Actor Punched Her in the Nose, Dancer Tells Court." *Los Angeles Times*, December 14, 1953.

"More Liberal Movie Code Asked." Associated Press, December 29, 1953.

"Who Does Jane Russell Think She's Kidding?" *Top Secret*, n.d. UNLV files.

"Anyone Here for Love?" *Screen Album*, Spring 1954.

"8 Top Movie Producers OK Morality Code." *Daily News*, February 15, 1954.

"Suit Cites Hughes' Dimmed-Out Stars." *New York World and Telegram*, February 10, 1954.

"Hughes Coup." *BusinessWeek*, February 13, 1954.

"'I'll Take It All,' Hughes Tells the Stockholders." *Fortnight*, March 3, 1954.

"Jane Russell Not Wasted; Judge Kills Suit Vs. Hughes." *Hollywood Citizen-News*, March 31, 1954.

"Hughes News." *Mirror*, February 26, 1954.

"Thrown in Swimming Pool, Hurled Over Hedge, Says Miss Hayward." *Los Angeles Examiner*, February 26, 1954.

"Jean Peters Missing on Eve of Film Role." *Los Angeles Times*, September 14, 1954.

"Always Carried a Torch, Says Ava." *News*, November 17, 1954.

"Jean Peters Prefers East to Hollywood." United Press, November 7, 1954.

"Jean Peters Ending 33-Day Marriage." *Los Angeles Times*, December 10, 1955.

"The Top Box-Office Hits of 1956." *Variety*, January 2, 1957.

"The Jean Peters Mystery." *Modern Screen*, May 1957.

"Probe Death of Ex-Actress Rose Stradner." *Chicago Tribune*, September 29, 1958.

"All-Time Domestic Champs." *Variety*, January 6, 1960.

"553Gs Asked for Promises." *New York Mirror*, July 14, 1962.

"Divorce." *National Insider*, October 6, 1963.

"For Norma Jeane a New Name." *Detroit Free-Press*, October 27, 1969.

"They Must Have Been Married Because They're Getting a Divorce!" *Photoplay*, April 1970.

"Rambling Reporter." *Hollywood Reporter*, February 25, 1971.

"Tell Me, Jean Peters." *Gambit*, 1972.

"Howard Hughes by Women Who Knew Him." *Ladies' Home Journal*, April 1972.

"Most Publicized of His Time: Tycoon a Ladies Man." *Los Angeles Herald-Examiner*, April 6, 1976.

"Hollywood Beauties Recall Hughes." *Salt Lake City Tribune*, April 7, 1976.

"Hughes Women Silent." *Philadelphia Bulletin*, April 6, 1976.

"Hughes Connection?" United Press International, April 12, 1976.

"Films Were Hughes' Link with World, Doctor Says." *Los Angeles Times*, April 18, 1976.

"Marriage Claims Disputed." *Lewisville Leader*, April 21, 1976.

"Howard Hughes kept Scores of Secrets, and Terry Moore Claims She Was One of Them." *People*, April 26, 1976.

"Records Show Hughes in Suite Four Years." *St. Louis Post-Dispatch*, May 11, 1976.

"Actress, Claiming to Be Hughes Ex, Wants In on Will." *Variety*, May 13, 1976.

"Picks and Pans Review: The Truth with Jack Anderson." *People*, February 13, 1978.

"Hughes: Drug Addict, Psychotic." *Pantagraph*, February 26, 1979.

"Hughes' Voice on Tape?" Associated Press, June 6, 1979.

"Texas Court Rejects Actress' Claim on Hughes Estate." *Los Angeles Times*, February 5, 1982.

"Broadway Role as Lover of Black Soldier Got TV's Miss Ellie in Trouble." *Jet*, June 14, 1982.

"Actress Moore Loses Bid for Hughes Estate Slice." *Variety*, June 17, 1982.

"Mourning Becomes Electric." *Los Angeles Herald-Examiner*, April 16, 1983.

"Rambling Reporter." *Hollywood Reporter*, May 20, 1983.

"Actress Claims She Will Get Money as Hughes' Widow." *San Bernardino County Sun*, May 25, 1983.

"My Astonishing Life as Howard Hughes' Wife—by Actress Terry Moore." *Star*, June 14, 1983.

"Moore Files Suit." *Weekly Variety*, May 2, 1984.

"Hate at First Sight Leads to a Tempestuous Secret Marriage." *Los Angeles Times*, May 27, 1984.

"Eternal Love?" *US Magazine*, June 18, 1984.

"The Merriest Widow." *Playboy*, August 1984.

"A Star Is Reborn." *Los Angeles Times*, September 7, 1984.

"PASSINGS Robert F. Slatzer, 77; Author Claimed Brief Marriage to Monroe." *Los Angeles Times*, April 15, 2006.

Websites

"Katharine Hepburn." Wikipedia, https://en.wikipedia.org/wiki/Katharine _Hepburn.

Los Angeles Conservancy. https://laconservancy.org.

"Movie." Dictionary.com. http://www.dictionary.com/browse/movie, accessed September 12, 2017.

Paul Revere Williams Project. http://www.paulrwilliamsproject.org/.

USC Digital Library. http://digitallibrary.usc.edu/.

Interviews

DeCarlo, Yvonne. Interview by Larry King. *Larry King Live.* CNN, January 20, 2002.

De Cicco, Pat. Interview. September 15, 1941. Unpublished transcript, Russell Birdwell papers, UCLA.

Dietrich, Noah. "Terry Moore–Noah Dietrich Tape Recording #1." Interview by Terry Moore. c. 1972. Transcript, TSA.

Forrest, Sally. Interview by Ronald L. Davis. May 22, 1985. Ronald L. Davis Oral History Collection, MHL.

Gerber, Albert. Interview by Louis Lomax. November 26, 1967. Transcript at UNLV.

Kane, Walter. Interviewed by Raymond Fowler. June 19, 1978. Transcript at TSA.

Loos, Mary Anita. Interview by Ronald L. Davis. July 26, 1990. Ronald L. Davis Oral History Collection, MHL.

Lupino, Ida. Interview by Hedda Hopper. May 25, 1965. Unpublished transcript, Hedda Hopper papers, MHL.

Moore, Terry. Interviewed by Raymond Fowler. May 17, 1978. Transcript at TSA.

Russell, Jane. "TCM Private Screenings Uncut: Robert Mitchum and Jane Russell." Interview by Robert Osbourne. TCM, April 1996. Audio, 1:37:21. http://www .digitalpodcast.com/feeds/45802-tcm-presents-audio-podcasts.

Russell, Jane. Interview by Hedda Hopper. December 28, 1953. Unpublished transcript, Hedda Hopper papers, MHL.

Radio Broadcasts

Fidler, Jimmie. "Howard Hughes to Manufacture Atomic Equipment." KMPC Radio, June 21, 1953. Transcript in Howard Hughes collection, UNLV.

FILMOGRAPHY

Souls for Sale, directed by Rupert Hughes. 1923. Los Angeles: Warner Home Video, 2009, DVD.

The Marriage Clause, directed by Lois Weber. 1926. Los Angeles: Universal Studios. Incomplete print at Library of Congress.

Sensation Seekers, directed by Lois Weber. 1927. Los Angeles: Alpha Video, 2016, DVD.

Hell's Angels, directed by Howard Hughes. 1930. Los Angeles: Universal Pictures Home Entertainment, 2004, DVD.

The Age for Love, directed by Frank Lloyd. 1931. Los Angeles: United Artists. Lost.

Platinum Blonde, directed by Frank Capra. 1931. Los Angeles: Columbia Pictures. Digital download.

A Bill of Divorcement, directed by George Cukor. 1932. Los Angeles: RKO Pictures. Out of print.

Blondie of the Follies, directed by Edmund Goulding. 1932. Los Angeles: Warner Archive Collection. DVD.

Christopher Strong, directed by Dorothy Arzner. 1932. Los Angeles: Warner Archive Collection. DVD.

Cock of the Air, directed by Tom Buckingham. 1932. Los Angeles: United Artists. Streaming link provided by Academy of Motion Picture Arts and Sciences.

Her First Affaire, directed by Allan Dwan. 1932. London: Sterling Films. Out of print.

Red-Headed Woman, directed by Jack Conway. 1932. Los Angeles: Warner Archive. Digital download.

Scarface, directed by Howard Hawks. 1932. Los Angeles: Universal Cinema Classics. DVD.

Red Dust, directed by Victor Fleming. 1932. Los Angeles: Warner Archive. Digital download.

Bombshell, directed by Victor Fleming. 1933. Los Angeles: Warner Archive. DVD.

Gold Diggers of 1933, directed by Lloyd Bacon. 1933. Los Angeles: Warner Archive. DVD.

Morning Glory, directed by Lowell Sherman. 1933. Los Angeles: Warner Archive. Digital download.

Sylvia Scarlett, directed by George Cukor. 1935. Los Angeles: Warner Archive. Digital download.

Wife vs. Secretary, directed by Clarence Brown. 1936. Los Angeles: Warner Archive. Digital download.

Libeled Lady, directed by Jack Conway. 1936. Los Angeles: Warner Archive. Digital download.

Swing Time, directed by George Stevens. 1936. Los Angeles: Warner Archive. Digital download.

Stage Door, directed by Gregory LaCava. 1937. Los Angeles: Warner Archive. Digital download.

Holiday, directed by George Cukor. 1938. Los Angeles: Sony Pictures Home Entertainment. Digital download.

Jezebel, directed by William Wyler. 1938. Los Angeles: Warner Archive. Digital download.

The Philadelphia Story, directed by George Cukor. 1940. Los Angeles: Warner Archive. Digital download.

Kitty Foyle, directed by Sam Wood. 1940. Los Angeles: Warner Archive. Digital download.

They Drive by Night, directed by Raoul Walsh. 1940. Los Angeles: Warner Archive. Digital download.

The Hard Way, directed by Vincent Sherman. 1943. Los Angeles: Warner Archive. DVD.

The Outlaw, directed by Howard Hughes. 1943. Los Angeles: Kino Classics. DVD.

The Killers, directed by Robert Siodmak. 1946. Los Angeles: Criterion Collection. DVD.

Crossfire, directed by Edward Dmytryk. 1947. Los Angeles: Warner Archive. Digital download.

Road House, directed by Jean Negelesco. 1948. Los Angeles: Kino Lorber. Blu-Ray.

The Return of October, directed by Joseph H. Lewis. 1948. Los Angeles: Sony Pictures Home Entertainment. Digital download.

The Big Steal, directed by Don Siegel. 1949. Los Angeles: Warner Archive. Digital download.

Caught, directed by Max Ophuls. 1949. Los Angeles: Olive Films. Blu-Ray.

Mighty Joe Young, directed by Ernest B. Schoedsack. 1949. Los Angeles: Warner Archive. Digital download.

Not Wanted, directed by Ida Lupino. 1949. Los Angeles: Reel Enterprises. Digital download.

Outrage, directed by Ida Lupino. 1950. Los Angeles. Out of print.

Vendetta, directed by Mel Ferrer. 1950. Los Angeles. Out of print.

Stromboli, directed by Roberto Rossellini. 1950. Rome: Criterion Collection. Blu-Ray.

Where Danger Lives, directed by John Farrow. 1950. Los Angeles: Warner Archive. DVD.

His Kind of Woman, directed by John Farrow. 1951. Los Angeles: Warner Archive. DVD.

Come Back, Little Sheba, directed by Daniel Mann. 1952. Los Angeles: Paramount. DVD.

Macao, directed by Josef Von Sternberg. 1952. Los Angeles: Warner Archive. Digital download.

The Las Vegas Story, directed by Robert Stevenson. 1952. Las Vegas: Warner Archive. DVD.

Wait 'til the Sun Shines, Nellie, directed by Henry King. 1952. Los Angeles: Twentieth Century Fox Film Corporation. DVD.

The Hitch-Hiker, directed by Ida Lupino. 1953. Los Angeles: Kino Classics. DVD.

The Bigamist, directed by Ida Lupino. 1953. Los Angeles: Film Chest. DVD.

The French Line, directed by Lloyd Bacon. 1953. Los Angeles. Out of print.

Gentlemen Prefer Blondes, directed by Howard Hawks. 1953. Los Angeles: Twentieth Century Fox Film Corporation. Digital download.

Mogambo, directed by John Ford. 1953. Kenya: Warner Archive. Digital download.

Niagara, directed by Henry Hathaway. 1953. Los Angeles: Twentieth Century Fox Film Corporation. Digital download.

Pickup on South Street, directed by Samuel Fuller. 1953. Los Angeles: Masters of Cinema. Blu-Ray.

The Barefoot Contessa, directed by Joseph L. Mankiewicz. 1954. Los Angeles and Rome: Twentieth Century Fox Film Corporation. DVD.

Three Coins in the Fountain, directed by Jean Negulesco. 1954. Los Angeles and Rome: Twentieth Century Fox Film Corporation. Digital download.

Peyton Place, directed by Mark Robson. 1957. Los Angeles: Twentieth Century Fox Film Corporation. Digital download.

NOTES

INTRODUCTION: THE AMBASSADOR HOTEL, 1925

3 the Cocoanut Grove: Burk, *Are the Stars Out Tonight?* Additional details about the Ambassador Hotel from Goodyear, "Hotel California."

3 On this night in 1925: Maas, *The Shocking Miss Pilgrim*, 75–78.

4 "Gross, ugly, hairy Eddie Mannix": Ibid., 77.

5 "I'd seen firsthand how Hollywood can bring you down": Ibid., 78.

7 "The romance stories were a lot of bologna": Collis, "The Hughes Legacy."

8 "Remember her?": Mathison, "Cradle-Robbing Baron."

8 "the whole equation": Fitzgerald, *The Last Tycoon*, Kindle loc. 271.

CHAPTER 1: HOLLYWOOD BABYLON

11 "Prohibitionists, suffragettes, retirees": Williams, *The Story of Hollywood*, 41.

12 driven around town: Marshall Neilan, handwritten autobiographical notes, 1954, Folder 21, Marshall Neilan Special Collection, Margaret Herrick Library.

12 the first motion picture made entirely within the community of Hollywood: Schickel, *D. W. Griffith: An American Life*, 149.

12 *Love Among the Roses:* Williams, *The Story of Hollywood*, 58.

13 resurrected the Ku Klux Klan: Rosenwald, "The Ku Klux Klan Was Dead. The First Hollywood Blockbuster Revived It."

13 "the most virulently racist major movie": Cheshire, "Why No One Is Celebrating the 100th Anniversary of the Feature Film."

13 "The picture had me on the edge of my seat": Maas, *The Shocking Miss Pilgrim*, 11.

14 "a magic name": Simberg, "Studio Club Closes Doors on Memories."

14 "I'm not psychic": Drew, "Billie Dove," 15.

15 "I wanted motion pictures": Ankerich, "Billie Dove," 76.

15 "Not that I doubted": Stamp, *Lois Weber in Early Hollywood*, Kindle locs. 352–54.

16 "The only bona fide woman's sphere": Ibid., Kindle locs. 661–63.

16 "Hollywood is honeycombed with prostitutes": Williams, *The Story of Hollywood*, 89.

16 "plainly, they were food": Brownlow, *The Parade's Gone By*, 43.

17 "She was not well dressed": Drew, "Billie Dove," 21.

17 Schulberg made the Alexandria the family's first stop: Schulberg, *Moving Pictures*, 91.

18 the Alexandria lobby: Schulberg, *Moving Pictures*, 90; and Marshall Neilan's autobiographical notes.

18 "After she finishes a picture": Schulberg, *Moving Pictures*, 91.

19 "You wouldn't hear about it": Louella Parsons Oral History, June 1959.

20 "bichloride of mercury": Pita, "Olive Thomas, the Original 'Flapper' and a Mon Valley Native, Still Fascinates."

20 cleaning product: Goessel, *The First King of Hollywood*, 261.

20 "wild cat combat": Vogel, *Olive Thomas*, Kindle loc. 1384.

21 ruptured bladder: Williams, *The Story of Hollywood*, 107.

22 Griffith built a model of Babylon: Ibid., 87.

22 "Hollywood Babylon": Ibid., 93.

22 he returned to the East Coast: "Lo, the Movies Have Achieved Revivals!"

CHAPTER 2: THE MANY MRS. HUGHESES

24 "A Motion Picture Novel": Kemm, *Rupert Hughes*, 75.

24 "a Bowery washerwoman": Finstad, *Heir Not Apparent*, 380.

25 "kiss nearly every woman": Ibid., 347.

25 "to take a cruise": Rush Hughes deposition, September 10, 1976.

25 "Hollywood wasn't even on the map": Louella Parsons Oral History.

25 "WELCOME WILL H. HAYS": Williams, *The Story of Hollywood*, 112–13.

25 "Hays was the guest of honor": Kemm, *Rupert Hughes*, 135.

26 "search for my fortune": Finstad, *Heir Not Apparent*, 60.

27 "The outermost ends of the earth": Ibid., 107.

28 Houston Riot of 1917: Wisenberg, "The 1917 Houston Riot. And the Era of Black Lives Matter"; Brown, "Seeking Justice for the Mass Hanging of Black Soldiers After the Bloody 1917 Houston Riots."

28 "I lived right in the middle of one race riot": *Citizen Hughes*, 162.

29 paranoia that he could contract polio: Fowler, "Howard Hughes: A Psychological Autopsy."

29 "She was taken for a minor operation": Annette Gano Lummis deposition, August 12, 1977.

29 "Never share control": Raymond D. Fowler, Ph.D., "A Brief History of Howard R. Hughes," Folder "Fowler—A Brief History of Howard R. Hughes 1979," Raymond Fowler files, courtesy of Sandy Fowler.

30 Annette agreed: Finstad, *Heir Not Apparent*, 117.

30 "a charming young boy": Annette Gano Lummis deposition, August 12, 1977.

30 "movie people": Finstad, *Heir Not Apparent*, 118.

30 letter from Allene to Big Howard: Dietrich, *Howard: The Amazing Mr. Hughes*, 32.

32 "the truest film play you ever saw": Kemm, *Rupert Hughes*, 129.

32 "Mrs. Rupert Hughes": Ibid., 132.

32 "There was something the matter with her": Ibid.

32 "an opportunity to expound": Ibid., 139.

32 "Marriage is the greatest bunco game in the world": St. Johns, "Is Marriage a Bunco Game?"

33 like a younger version of Adelaide: Eleanor Boardman d'Arrast deposition, March 30, 1977.

33 Rupert shot her down: Kemm, *Rupert Hughes*, 143.

33 "a brave, brilliant woman": "MRS. RUPERT HUGHES A SUICIDE IN CHINA; Message from Standard Oil Man at Haiphong Tells Author of Tragedy."

34 "Howard R. Hughes Jr., son of the late president of the Hughes Tool Company": "Death Car Driver Free."

34 Stoddard's family suspected: Allyson Malek (grand-niece of Mata Stoddard), email correspondence with author, November 2016.

34 "swathed in bandages": "Death Car Driver Free."

34 Hughes first denied: Mata Stoddard coroner's inquest, February 11, 1924, transcript.

35 "I can't remember": Ibid.

35 "constant problem": Johnston, *Houston, the Unknown City*, 328.

35 "the only two people": Fowler, "A Brief History of Howard R. Hughes."

36 its success had been inconsistent: transcript of tax hearing held in Washington, D.C., on September 30, 1926.

37 "had such a fortune": Felix T. Hughes to Howard R. Hughes Jr., January 28, 1924.

37 "My father bragged so much": Howard R. Hughes Jr., telegram to R. C. Kuldell, January 29, 1924.

37 "serious developments": R. C. Kuldell, telegram to Howard R. Hughes Jr., February 15, 1924.

37 "indiscreet in the Conlin affair": Howard R. Hughes Jr., telegram to R. C. Kuldell, February 18, 1924.

37 Hughes was sending Conlin money: Hal Conlin to "Mac" (Neil S. McCarthy), May 27, 1928.

37 "dishonorable ungenerous selfishness": Kemm, *Rupert Hughes*, 148–49.

38 "lied flatly again and again": Ibid., 149.

38 "calling me a liar, a thief and a miser": Howard Hughes to Rupert Hughes, April 29, 1924.

38 The relatives demanded: Transcript of tax hearing, September 30, 1926.

38 forcing Hughes to put up his own shares: Carl Byoir and Associates notes on Stephen White draft of "The Howard Hughes Story," written for *Look* in 1954.

38 "I may have owned it": Howard Hughes, in conversation with Stephen White, transcript dated December 23, 1953.

38 "The thing I knew": Muir, "Fabled Flier's Millions Resulted from Doing What Came Naturally."

39 "I wasn't building anything for myself ": "A Texan with Ideas of His Own Risks His Millions in Movies but Finds Originality Pays."

40 "steady, sober young man": Dietrich, "The Howard I Remember."

40 "The doctor called Ella": Ibid.

40 "never saw the slightest sign of affection": Ibid.

40 "she was the queen": Annette Gano Lummis deposition, August 12, 1977.

41 "I can't send him with all that money": Ibid.

41 "very shortly after my mother's death": Rush Hughes deposition, September 10, 1976.

42 Rush and Avis never saw Rupert again: Ibid.

42 "throw his mother down the stairs": Drew, "Eleanor Boardman," 50–51.

42 "that son-of-a-bitch": Finstad, *Heir Not Apparent*, 287.

42 twin beds: Dietrich, *Howard*, 34.

CHAPTER 3: NO TOWN FOR A LADY

44 "You'll let me watch": Keats, "Howard Hughes: A Lifetime on the Lam," 127.

44 "postproduction was not going smoothly": A. A. MacDonald, telegram to Howard R. Hughes, June 4, 1925.

44 "enthused and disgusted": A. A. MacDonald, telegram to Howard R. Hughes, June 14, 1925.

44 Graves's cut of the film: Neil S. McCarthy, telegram to Howard R. Hughes, March 10, 1926.

44 cut Graves out: Ralph Graves to Howard R. Hughes Jr., May 12, 1926.

44 "lifelong debt": Ralph Graves to Howard R. Hughes Jr., 1962.

44 "investors": unsigned letter to Lloyd Wright, October 27, 1967.

45 "I had to prove me right": Keats, "Howard Hughes," 128.

45 "Failure was unconscionable": Dietrich, *Howard*, 45.

45 "the richest man in the world": Ibid., 39.

45 "I don't carry any money": Ibid., 55.

45 "I don't want to go on record": Ibid., 57.

46 "friendship with Marshall Neilan": Publicity biography of Howard Hughes, February 1930, Lincoln Quarberg collection.

46 Hughes would request: Howard Hughes to Stephen White, December 23, 1953.

46 "roar on into the night": Marshall Neilan, handwritten notes, 1954.

46 "pretty virgins": Maas, *The Shocking Miss Pilgrim*, 74–75.

47 "protégée of mine" Neilan, handwritten notes.

47 a new young Texan oilman: Beatty, "The Boy Who Began at the Top."

48 "the screen is a powerful influence": "A Texan with Ideas of His Own . . ."

48 "If my pictures didn't make money": Ibid.

48 "any price": Vaught, "Howard Hughes: The Producer of *Hell's Angels* at Home in Los Angeles's Hancock Park."

48 built for socialite Eva K. Fudger: Ibid.

49 "Cannot understand": Ella Rice Hughes, telegram to H. R. Hughes, December 22, 1925.

49 "Love Ella": Ella Rice Hughes, telegram to H. R. Hughes, December 24, 1925.

49 wiring Dietrich instructions: Howard Hughes, telegram to N. Dietrich, December 31, 1925.

50 "a tentative deal": Neilan, handwritten notes.

50 "Let's make it": Ibid.

51 "Vaseline-haired pretty boys": Ibid.

51 Neilan made an excuse: Ibid.

53 four members of Hughes's crew to die: Rogers, "4 Million Dollars, and Four Men's Lives."

53 "Howard wanted to film": Dietrich, *Howard*, 71–72.

54 "Hughes was unfamiliar": Rogers, "4 Million Dollars, and Four Men's Lives."

54 "As he whirled earthward": Ibid.

55 "the Caddo office direct": "'Hell's Angels' Completed."

55 "For over two years": Rogers, "4 Million Dollars, and Four Men's Lives."

56 "your idea of a practical joke" and further correspondence and photograph: Lincoln Quarberg files, Folder 4, Margaret Herrick Library.

57 "a heck of a life": Finstad, *Heir Not Apparent*, 27.

58 "a spendthrift kid": Dietrich, *Howard*, 77.

58 "I think she didn't like the people": Annette Gano Lummis deposition, August 12, 1977.

58 "extroverted, voluptuous actresses": Dietrich, *Howard*, 80.

59 "all mixed up with Klan": Fred Lummis to Howard Hughes, November 8, 1928.

59 The divorce agreement: "Agreement between HRH and Ella Rice."

59 "The divorced wife of Howard Hughes": *Los Angeles Paper*, September 14, 1930.

59 "We got married and it didn't work": Muir, "Fabled Flier's Millions Resulted from Doing What Came Naturally."

59 "I have been accused of practically everything": Howard Hughes to Stephen White, transcript of conversation dated September 29, 1953.

CHAPTER 4: THE GIRL WITH THE SILVER HAIR

64 "It sounds like I'm bragging": Ankerich, "Billie Dove," 95.

64 "silver-flecked long bob": Spensley, "For the Love of Billie."

65 "Going mole hunting on Dove": Skolsky, "Tintype (Billie Dove)."

65 "I was once a fan": Busby, "Beauty Bows to Brains: Billie Dove, Long Praised for Bewitching Charm, Wins Praise for Histrionic Ability."

66 tears came to her eyes: Ankerich, "Billie Dove," 75.
67 "It was a short name": Ibid.
67 "I just sat up there smiling": Drew, "Billie Dove," 16.
67 "took it for granted": Ibid.
68 "I knew nothing about sex": Ibid., 18.
68 "only marry a Jewish girl": Ankerich, "Billie Dove," 81.
69 "We didn't kill him": Willat and Birchard, "Conversations with Irvin V. Willat."
69 "Marry me, marry me, marry me": Ankerich, "Billie Dove," 82.
69 "okay to get married": Drew, "Billie Dove," 26.
69 "Westerns and boat pictures": Ibid., 25
70 "I just stood around and looked scared": Ankerich, "Billie Dove," 83.
71 "our philosophies of life": Stamp, *Lois Weber in Early Hollywood*, Kindle loc. 4610.
71 "The producers select the stories": Ibid., loc. 4663.
72 "The real American girl": Kingsley, "Busy U City."
72 "cute little dolls": Elliot, "Exit Flapper, Enter Woman."
72 "The modern girl": Stamp, *Lois Weber in Early Hollywood*, Kindle loc. 4917.
72 "I wanted to look ill": Drew, "Billie Dove," 33.
74 "He tried to run my life": "Billie Dove Obtains Divorce; Beatings by Willat, Director, Related."
74 "Marion had a special butler": Ankerich, "Billie Dove," 88.
74 postmaster of Burbank: Drew, "Billie Dove," 36.
74 "cutting the back of my hair": Ibid., 37.
75 "a zombie": Ankerich, "Billie Dove," 88.
75 "he had me cased": Ibid.
76 "deep love": Ibid., 89.
76 3 A.M. movie: Behlmer, "Howard Hughes and *Hell's Angels*."
76 "I was still Mrs. Irvin Willat": Ankerich, "Billie Dove," 89.
76 Believing Hughes had disposable cash: Willat and Birchard, "Conversations with Irvin V. Willat."
77 "Billie and my father": Wagner, "Still Big in Germany."
77 "bought and sold": Drew, "Billie Dove," 47.
77 "I lost all the respect": Ankerich, "Billie Dove," 89.
78 "What, you go to Las Vegas?": Drew, "Billie Dove," 47.
78 "a dress, very plain and long": Ibid.
78 "After we got off the train": Lillian E. Kenaston (Billie Dove) deposition, July 23, 1981.
79 "I never asked any questions": Drew, "Billie Dove," 48.
79 "We didn't stay": Ibid.

CHAPTER 5: A BODY LIKE A DUSTPAN

81 "There's a girl who has absolutely nothing": March, "Young Howard Hughes, Reminiscences by a Survivor of Hollywood's Golden Era."
81 "Film still far from completed": Lincoln Quarberg, telegram, June 19, 1929.
82 "brown and lustrous and limpid": March, "Young Howard Hughes."
82 "rare and mysterious quality": Ibid.
82 "so bad it was embarrassing": Ibid.
83 "a beautiful, upper-class slut": Ibid.
85 "Nothing on earth": Stenn, *Bombshell: The Life and Death of Jean Harlow*, 44.
86 "It's breaking up my marriage": Ibid., 29.

87 terminated her pregnancy: Ibid., 30.

87 "Chuck went away": "Is Jean Harlow Dead? Her Mother Says No!"

87 "I had to work or starve": Stenn, *Bombshell*, 32.

88 "My dear Miss Harlow": March, "Young Howard Hughes."

89 cut the fabric: Faith Domergue, autobiographical manuscript.

89 "we all held our breath": March, "Young Howard Hughes."

90 "That's better": Ibid.

90 "she had guts": Ibid.

90 "ducks flying over the street": "A Texan with Ideas of His Own . . ."

91 "more out of curiosity": Marshall Neilan, handwritten autobiographical notes.

91 The head shot of Harlow: *Hell's Angels* program.

92 "This picture is guilty": Quirk, "Close-Ups and Long-Shots."

92 "You hate Jean Harlow": "A Texan with Ideas of His Own . . ."

93 "I hate Hollywood": Lieber, "But I Can Unmask Jean Harlow!"

93 "We sneaked in": Ankerich, "Billie Dove," 90.

93 A local character named Eddie Brandstatter: Perry, "Brandstatter Brought the Party to Old Hollywood."

94 "struck me and knocked me down": "Billie Dove Obtains Divorce."

94 Willat had never actually abused her: Ankerich, "Billie Dove," 89.

94 "I am free": Whittaker, "Billie Dove 'At Liberty.'"

CHAPTER 6: A *COCK* VS. THE CODE

96 "Miss Dove has no singing voice": "*The Painted Angel*," January 8, 1930.

96 $29,000 in its first week: "Comparative Grosses for May."

96 "It won't be long, Billie Dove": "Lovely Billie Dove Faces Big Handicap."

96 "Billie Dove carried the story": "*Sweethearts and Wives*," July 9, 1930.

96 "Billie Dove's waning popularity": "Stage Show Helped 'Bad One' Out to $31,500 at Penn, Ptsbg; Wk Not Good."

96 "Dove still needs better scripts": "Louisville at 130, 6-Month Drought."

97 "probably due to cast names": "Fulton Opens in Ptsbgh to $8,200; Good Enough as Usual Thing There."

97 "very bad": "Frisco Spotty; Orph Up at $14,000; for $25,000."

97 "weak in every department": "Lady Who Dared."

98 "I was in love with him": Drew, "Billie Dove," 50.

98 "the jealous type": Ankerich, "Billie Dove," 90.

98 Howard would follow Billie to the bathroom: Mutti-Mewse, *I Used to Be in Pictures*, 26.

98 "it hadn't been used": Ankerich, "Billie Dove," 90.

99 "most eligible young men": Spensley, "For the Love of Billie."

99 Universal Studios: *Los Angeles Paper*, September 2, 1930.

99 United Artists: "Hughes Asserts United Artists Price Too High."

99 acquire a doomed color film production company: "$10,000,000 Film Merger Completed."

99 struck a deal with Joseph Schenck: Crowe, "Hughes After Multicolor."

99 "defies traditions": Lincoln Quarberg sample article.

99 "it could not be read": Al Lichtman to Howard Hughes, September 10, 1931.

100 scale back on film production: Lincoln Quarberg to Garett Graham, September 30, 1931.

100 "!@$:*=x%-est": Lincoln Quarberg, "General Ideas for Campaign on *Front Page*."

100 "It burns Hollywood to a crisp": Lang, "Hollywood's Hundred Million Dollar Kid."

101 "I would, of course, want babies": Spensley, "For the Love of Billie."

101 "CONSENSUS OPINION": Hal Horne, telegram to Lincoln Quarberg.

101 "a first-ranking star": Lincoln Quarberg, "Billie Dove bio."

102 back and forth over whether to even include Dove: Telegrams between E. B. Carr and Al Lichtman, 1931.

102 "right eating": Lincoln Quarberg sample articles.

102 full-page ads: *Modern Screen*, November 30, 1931, 5.

102 "SHACKLED!": *The Age for Love* draft poster copy.

103 "namby-pamby": Drew, "Billie Dove," 49.

103 "feminine picture out and out": "Screen News."

103 tumbleweeds at the Rivoli: Telegrams exchanged between Hal Horne and Lincoln Quarberg, November 13–16, 1931.

103 pulled from release: "Shortest Run Record for 'Age,' Rivoli," November 18, 1931.

103 "Of course I cannot stop the publicity": Lincoln Quarberg to Hal Horne, November 19, 1931.

104 "the exhibitors do not want her": Hal Horne to Lincoln Quarberg, December 28, 1931.

104 "fans are demanding better pictures": *Cock of the Air* press book.

105 "obscene and immoral": Doherty, *Hollywood's Censor*, 252.

105 "Will Hays cut about 800 feet": Ankerich, "Billie Dove," 90.

105 "omit any suggestion of a bedroom": Jason Joy to Howard Hughes, September 1, 1931.

105 "pointed motivation": "Memorandum for the Files: *Cock of the Air*," November 18, 1931.

107 her romance with Hughes was over: Drew, "Billie Dove," 49.

107 "tearing ourselves away from Florida": Billie Dove, telegram to Lincoln Quarberg, March 17, 1932.

107 the Dove-Hughes engagement was off: *Hollywood Tatler*, March 1932.

108 "terribly sorry": Howard Hughes, telegram to Lincoln Quarberg, January 30, 1932.

108 "Will Hays and the Big-Shot Jews": Lincoln Quarberg to Howard Hughes, January 30, 1932.

109 "It becomes a serious threat": *Los Angeles Paper*, April 26, 1932.

110 "absurdities of film censorship": "The Mighty Censor."

110 they had been beaten by Hughes's manipulation: McCarthy, *Howard Hawks*, Kindle locs. 2851–60.

111 "I really had never been alone with a man": Rogers, *Ginger, My Story*, 67.

111 "third thumb": Ibid., 69.

112 "wondered what he'd be like": Ibid., 115–16.

112 horn in on their date: Albert R. Broccoli deposition, November 18, 1983.

113 Hughes entertained fourteen guests: Kingsley, "Airport Gardens Opens."

113 "will not engage in the production of a motion picture": "Agreement: Howard R. Hughes and Ella Rice Hughes," May 25, 1932.

113 "greatly in excess of its assets": Neil S. McCarthy deposition, December 13, 1940.

113 "the Caddo Company did not have any money": Neil McCarthy, "Memorandum of Dove contract," December 31, 1940.

113 "corporate fictions": Neil S. McCarthy deposition, December 13, 1940.

114 $100,000 in cash: "Memorandum of Dove contract."

114 "a damned good performance": Ankerich, "Billie Dove," 93.

114 "I couldn't sue Marion and Mr. Hearst": Ibid., 90.

114 "Let's go": Ankerich, "Dove Tails—Lee, Billie, and the Rest of the Story."
115 show to virtual strangers: Mutti-Mewse, *I Used to Be in Pictures*, 32.
115 "I was happy all the time": Ankerich, "Billie Dove," 75.

CHAPTER 7: "A BITCH IN HEAT"

116 "Would things have been different": St. Johns, *Love, Laughter and Tears*, 261.
116 "no producer in his right mind": Ibid., 261–62.
116 "I feel like a bitch in heat": Ibid., 258.
117 directed Mary Pickford's first flop: Loos, *Kiss Hollywood Goodbye*, 11.
117 "stupid little blonde": Ibid., 191.
117 "never had to bother my head with business": Ibid., 12.
117 "I'll never leave you": Ibid., 14.
117 "$3500 a week!": Ibid., 15.
118 "make fun of the sex element": Ibid., 34.
118 "Who is there for her to love": Ibid., 39.
119 "refuse to cancel contract": Stenn, *Bombshell*, 46.
119 "those wonderful breasts almost fell out": Ibid., 51–52.
120 "Harlow's breastworks": Capra, *The Name Above the Title*, 134.
121 "shimmered in the light": Arthur Landau to Irving Shulman, August 15, 1962.
122 "The guy's so frightened of germs": Loos, *Kiss Hollywood Goodbye*, 40.
122 "Why not?": Ibid.
123 "If men were stupid they'd fall for her": Ibid., 41.
123 "our sex pirate": Ibid., 43.
124 "she had no vanity": Anita Loos oral history, June 1959.
124 "Here's gratitude for you!": Lincoln Quarberg, note, March 1932.
124 "buying up beautiful girls": Howe, "So This Is Hollywood!"
125 "She was a little high": Rice, *Ann Dvorak: Hollywood's Forgotten Rebel*, Kindle locs. 885–87.
125 "shivering and shaking": Ibid., Kindle locs. 1005–06.
126 "Quantity, not quality": Ibid., Kindle locs. 1510–12.
127 "That's not going to happen to Ann": Ibid.
127 "There is little culture in Hollywood": "'Sold Down the River' Declares Ann Dvorak."
127 "some producers might be highly indignant": Ibid.
127 Hughes vanished from Hollywood: "Color Plant Re-Acquired," September 20, 1932.
128 difficulty making Ella's alimony payments: Noah Dietrich to W. S. Farish.
128 "fuck, fuck, fuck": Stenn, *Bombshell*, 74.
128 "what kind of person Paul was": St. Johns, "Love, Laughter and Tears."
128 impotent: St. Johns oral history, 1971.
128 "highest compliment": St. Johns, "Love, Laughter and Tears."
129 "Bern adored Jean": Loos, *Kiss Hollywood Goodbye*, 161.
129 "Bern had tried to drown himself": St. Johns oral history.
129 haul of books: Stenn, *Bombshell*, 86.
129 "Dearest dear": Ibid., 91.
130 "She was there in that house that night": St. Johns, *Love, Laughter and Tears*, 262.
130 "he had killed himself": Loos, *Kiss Hollywood Goodbye*, 162.
130 "prominent and respected doctor": Hopper, "That Harlow Book!"
130 "If she had hated herself before": St. Johns, *Love, Laughter and Tears*, 263.
131 "There's the best gal that ever lived": St. Johns, "Love, Laughter and Tears."

CHAPTER 8: THE BOMBSHELL IMPLODES

134 "Now you are 16": Donati, *Ida Lupino: A Biography*, 25.
135 "You cannot play naïve": Whitaker, "Ida Lupino, at 17 Ooozes Confident Sophistication." The headline shows that Ida was telling reporters that she was older than she was; at the time of the interview, she had recently turned sixteen.
136 "I wanted to look at the stars": "Howard Hughes by Women Who Knew Him."
136 cottage cheese, corn bread, and black coffee: Jean Bello letter to Gladys Hall.
137 "You don't marry someone": Stenn, *Bombshell*, 182.
137 "He's breaking my heart": Ibid., 186–87.
137 "I couldn't interfere": St. Johns, "Love, Laughter and Tears."
138 "Thelma was very considerate": Donati, *The Life and Death of Thelma Todd*, Kindle locs. 1677–78.
139 "death complex": Ibid., loc. 1262.
139 "the biggest single blow": "Irving Thalberg, Genius, Is Dead."
139 "I am so constantly trying": Parsons, "Jean Harlow Said Her Only Love Was Film's Bill Powell."
140 "virtually recovered": "Jean Harlow Recovering; William Powell Is Visitor."
140 "Fatty Arbuckle": Stenn, *Bombshell*, 206.
140 "there does not seem to be much chance": "Jean Harlow, Movie Star, Dies in Los Angeles." Other details on Harlow's last days from Stenn, *Bombshell*, 199–207.
141 "I don't want to": Ibid., 207.
141 "After Bill's rejection": Loos, *Kiss Hollywood Goodbye*, 163.
141 "a great shame about Jean": St. Johns oral history.

CHAPTER 9: THE WOMAN WHO LIVED LIKE A MAN

145 "She'll do better": "Hughes sets 347 MPH Air Record, Foils Crash Death."
145 "I wanted to go to New York": "Nothing Sensational."
146 landing at Newark on January 19, 1937: Barlett and Steele, *Howard Hughes: His Life and Madness*, Kindle locs. 13826–27.
146 " the best lover I ever had": Chandler, *I Know Where I'm Going: Katharine Hepburn: a Personal Biography*, 108.
147 rumors about her lesbianism: Hepburn, *Me*, 129.
147 "Miss Hepburn was going Miss Dietrich one better": Hoyt, "Running Away from It All."
148 Hepburn and Spencer Tracy were beards: Mann, *Kate: The Woman Who Was Hepburn*, 338.
148 "Hepburn was a lesbian": Bowers, *Full Service: My Adventures in Hollywood and the Secret Sex Lives of the Stars*, 96.
148 "part of a curious sub-genre": Curtis, *Spencer Tracy: A Biography*, Kindle edition, loc. 19131.
148 "a lot of sexual mischief": Bowers, *Full Service*, 76.
149 assumed Grant would be assigned: Elizabeth Jean Hough (Jean Peters) deposition, January 23, 1984.
149 "straight as an arrow": Bowers, *Full Service*, 98.
151 to describe Cukor as a "woman's director": Mayne, *Directed by Dorothy Arzner*, 62–63; Sarris, "The Man in the Glass Closet."
151 "a very macho director": Hepburn, *Me*, 178–80.
151 "a girl named Peggy Entwistle": David O. Selznick, interdepartment correspondence to George Cukor, May 31, 1932.

151 *Thirteen Women*: Zeruk Jr., *Peg Entwistle and the Hollywood Sign Suicide: A Biography*. chapters 17–20.

152 "What legs!": Berg, *Kate Remembered*, 86.

152 "out to make a statement": Ibid., 87.

152 "Send her back to New York": St. Johns oral history.

153 "dress like, talk like, and slouch like Greta Garbo": "Bill of Divorcement," *The Hollywood Reporter*.

154 "I was a man": Anderson, "Katharine Hepburn's Personal Scrapbook."

156 "Hollywood and the curse it puts on all its marriages": Martha Kerr, "The Truth About Katharine Hepburn's Marriage" *Modern Screen*, October 1933.

156 "I look back in horror": Hepburn, *Me*, 181–82.

156 "the gamut of emotions from A to B": "The Theatre: New Plays in Manhattan."

157 "divorce ended her romantic dreams": "Can Hepburn Ever Find True Love?"

157 "I thought she was the living end": Russell, "They Sold Me."

158 "superficial stuff": Letter from "John" to Katharine Hepburn, no date.

158 "You are a full grown woman": Russell Davenport to Katharine Hepburn, May 16, 1935.

159 "So staged": Berg, *Kate Remembered*, 143.

159 "I must say it gave me pause": Hepburn, *Me*, 192.

160 "affair of the minds": Chandler, *I Know Where I'm Going*, 98–99.

160 "You might say I lived like a man": Hepburn, *Me*, 189.

160 "always liked toasts": Berg, *Kate Remembered*, 127.

161 "quite seriously deaf": Hepburn, *Me*, 192.

161 "inevitable": Ibid.

CHAPTER 10: BOX-OFFICE POISON

162 "Katharine is just one of those peculiar girls": Jewell, *RKO Radio Pictures: A Titan Is Born*, 120.

163 "Listen, Kate": Hepburn, *Me*, 236.

163 "got sorry for me": Ibid.

163 "Kate always wanted her way": Rogers, *Ginger*, 210.

163 "If it's a real mink": Ibid.

163 "Who do you think you're fooling?": Ibid., 207.

164 "felt dependent on her looks": Chandler, *I Know Where I'm Going*, 112.

164 "We all wanted to be Katharine": Berg, *Kate Remembered*, 138.

165 "poison at the box office": "WAKE UP! Hollywood Producers."

166 "Pandro Berman wired Hepburn": Jewell, *A Titan Is Born*, 152.

166 "the poor uncle of a rich nephew": Rupert Hughes, "Howard Hughes—Record Breaker, Part 1."

167 "Howard was more glamorous": Chandler, *I Know Where I'm Going*, 107.

167 "washing our hands": Ibid., 120.

167 "sexually a good fit": Ibid., 108.

168 "if no one noticed us": Ibid., 113.

168 "appropriate companion": Hepburn, *Me*, 201.

168 "pulling a rabbit out of a hat": "'Brushed Death 3 Times'—Hughes."

169 $8,550.32: Stuart N. Updike to Neil S. McCarthy, December 3, 1938.

169 "burned approximately 175,000 magazines": Lee Murrin to Neil McCarthy, March 13, 1939.

169 "Katharine Hepburn must decide which road": Maddox, "What's the Matter with Hepburn?"

170 "Ambition beat love": Hepburn, *Me*, 201.
170 "I wanted Howard more": Chandler, *I Know Where I'm Going*, 139.
171 "He's part of this family": Berg, *Kate Remembered*, 147.
173 "I slept with Howard Hughes": Ibid., 129.
174 Dick had little choice: Leaming, *Katharine Hepburn*, 375–82.
174 "play about Howard and me": Ibid., 260.

CHAPTER 11: A LOVE NEST IN MALIBU, A PRISON ON A HILL

175 "did you have a good trip": Pat De Cicco interview, September 15, 1941.
176 "He seemed reserved": Chandler, *The Girl Who Walked Home Alone: Bette Davis, A Personal Biography*, 126.
176 "I was flattered": Ibid.
176 "DIVORCE": Bette Davis clippings, Scrapbook 21, Bette Davis Collection.
177 "vacation" from her marriage: Wickizer, "It Happened in Hollywood."
177 Davis's actual words: Clippings in Scrapbook 21, Bette Davis Collection; Peak, "True Story of Bette Davis' Broken Romance."
177 "finally admitted the separation": "Walter Winchell on Broadway."
177 "I don't know any millionaires": Parsons, "Success and Sorrow Mingle for Bette Davis."
177 "Bette is a grand actress": "Harmon Nelson Prepares to Divorce Film Star."
177 "failed to perform her duties as a wife": "Nelson Sues Bette Davis for Divorce."
178 "I liked sex": Chandler, *The Girl Who Walked Home Alone*, 128.
178 "Howard Huge": Ibid.
179 "We sat down at the bar": Keats, "Howard Hughes: A Lifetime on the Lam."
179 "I have no intention of marrying": Ibid.
179 "I didn't expect him to be chaste": Chandler, *I Know Where I'm Going*, 107.
179 "What do you say to that?": Rogers, *Ginger*, 169.
180 "dominated my personal life": Ibid., 216–24.
181 "He knew I loved a view": Ginger Rogers deposition, February 7, 1978.
181 "frequent illicit sex affairs": Ceplair, *Dalton Trumbo: Blacklisted Hollywood Radical*, Kindle edition, loc. 1827.
181 "highly suggestive and too lurid": Rogers, *Ginger*, 264.
182 "This was too much for me": Ibid., 265.
183 "the last time I ever saw Howard": Ibid., 267.
183 "Howard Hughes cry": Dietrich, *Howard;* photo insert caption.

CHAPTER 12: A NEW BOMBSHELL

188 "My name doesn't mean much": Demaris, "You and I Are Very Different from Howard Hughes."
189 "A compelling identity": Except where noted otherwise, all quotes from Birdwell in this chapter come from his autobiographical notes, Margaret Herrick Library.
189 "unknowns have walked": Birdwell, "Heartbreak Town."
190 professional dates for Selznick: Thomson, *Showman: The Life of David O. Selznick*, 262.
191 "that kind of picture": Samuels, "Hollywood's Most Fabulous Bird."
191 "That's a good answer": Birdwell notes.
191 "I've seen a pair today": Dietrich, "The Howard I Remember."
191 "Howard hired me for *The Outlaw*": "Howard Hughes by Women Who Knew Him."
192 "She looks the type": Russell, *Jane Russell, an Autobiography: My Path and My Detours*, 11.

194 "When Billy fell in love": McCarthy, *Howard Hawks: The Grey Fox of Hollywood*, Kindle edition, loc. 5450.

194 "girls should walk from the hips": McCarthy, Kindle locs. 5533–34.

194 "moving in slow motion": Russell, *My Path*, 7.

194 "I couldn't have been greener": Russell, "They Sold Me."

195 "I didn't get any sympathy": Ibid.

195 "Everybody got loaded": Russell, *My Path*, 18.

195 "The reason Hawks was displaced": Neil McCarthy to Noah Dietrich, December 13, 1940.

195 "revealing women's bosoms": McCarthy, Kindle locs. 5559–60.

196 "get some mileage out of her tits": Fadiman Jr., "Can the Real Howard Hughes . . ."

196 "uncomfortable and ridiculous": Russell, *My Path*, 58.

197 "scenes suggestive of illicit sex": Joseph Breen, letter to Howard Hughes, December 27, 1940.

197 "The censors made suggestions": Geoffrey Shurlock, memo, December 31, 1940.

198 "sounded fundamentally acceptable": "Memorandum Re *The Outlaw* (Hughes)," April 10,1941.

198 "breast shots": Breen office, memo dated March 28, 1941.

198 "I have never seen anything quite so unacceptable": Ibid.

198 "sweater shots": Joseph Breen, letter to Will Hays, March 29, 1941.

198 exactly which breast shots needed to be cut: Joseph Breen to Howard Hughes, April 6, 1941.

198 Hughes filed an appeal: "MPPDA to Review *Outlaw* on Appeal."

199 "greatest display of mammary glands": Birdwell notes.

199 forty feet of film: Letter from Joseph Breen to Howard Hughes, May 16, 1941.

199 seal of approval: *The Outlaw*, certificate No. 7440, May 23, 1941.

200 "an exceptionally good friend of mine": Howard Hughes letter to Annette Gano Lummis.

200 "the first woman I ever saw in trousers": Annette Gano Lummis deposition, August 12, 1977.

CHAPTER 13: THE NEW GENERATION

204 "Where Clark Gable works, baby!": Server, *Ava Gardner: "Love Is Nothing,"* 43.

205 signed to Warner Bros.: "Artist Agreement—Faith Domergue."

205 "Jack Warner was too stupid": Weaver, "Faith Domergue," 31.

205 "that line was used on everybody": Ibid., 30.

205 "pretty, undisciplined, a little wild": Domergue manuscript.

206 "I looked more sophisticated": Ibid.

207 De Cicco optioned: Outline of Pat De Cicco Trial Testimony, Estate of Howard R. Hughes Jr.—Probate Court, Harris County Texas, January 12, 1978.

208 "'The Boss' had spoken": Domergue manuscript.

208 "Howard never forced himself": Ibid.

208 "fodder for gossip columns": Kilgallen, "Gossip in Gotham" and "Broadway"; Winchell, "Along Broadway."

209 "wasn't much in the brain department": Vanderbilt, *It Seemed Important at the Time: A Romance Memoir*, 14.

209 "lolled around in the sun": Ibid., 15.

209 "Howard's magic wand": Ibid., 18.

209 "recording of the 'Moonlight Sonata'": Ibid., 22.

209 "I said 'No'": Ibid., 23.
210 "there were rumors": Ibid., 24.
210 "Hadn't Howard been in love with her?": Ibid., 25.
210 "close approach to a complete physical breakdown": Noah Dietrich to Jack Burlington, August 7, 1941.
210 "practically a complete collapse": Noah Dietrich to Sherman Fairchild, July 22, 1941.
211 "contract players had to put out": Evans, *Ava Gardner: The Secret Conversations*, 108.
213 Hughes Tool: Neil S. McCarthy to Roy Obringer, October 27, 1941.
214 "frightened me to death": Domergue manuscript.
216 "we became more secluded": Ibid.

CHAPTER 14: "THE GODDAMNEDEST, UNHAPPIEST, MOST MISERABLE TIME"

218 "most miserable time I'd ever had": Evans, *Ava Gardner*, 11.
218 gave her a massive diamond: Ibid., 159.
218 "He should just boff her": Ibid., 123.
219 "sexual symphony": Server, *Love Is Nothing*, 74.
219 "Mick was so famous": Evans, *Ava Gardner*, 120.
219 "Well, we were screwing a lot": Ibid., 158.
219 "a new piece of pussy": Ibid., 114.
219 "just about the highest compliment": Ibid., 124.
219 "I slipped into it real easy": Ibid., 158.
220 "I could barely make my car payments": Russell, *My Path*, 59.
220 "I'll pay you $3000": Birdwell notes.
221 "I hope you'll believe me": Ibid.
221 the right place at the right time: Fleming, "He Can Make Anybody Famous for the Right Fee."
221 "I took a big blowup": Birdwell notes.
221 Birdwell's accounts: Russell Birdwell, "Howard Hughes Notes for Robert Coughlan."
222 "film only fair": Myer Beck, telegram to Russell Birdwell, February 14, 1942.
222 "beef" over the publicity: "20th Begs Off on Releasing 'Outlaw.'"
222 "changed the shape of the girl's breast": Russell Birdwell memo to Myer P. Beck, May 11, 1942.
222 going from city to city: Russell Birdwell telegram to Emanuel Silverstein, October 6, 1942.
223 "like a pair of hookers": Russell, *My Path*, 62.
223 "I was terrified": Ibid., 62–63.
223 "was hell": Ibid., 63.
223 "incomplete" abortions: Grimes, "The Bad Old Days: Abortion in America Before Roe v. Wade."
224 "under doctor's orders": Dale Anderson, interoffice memo to Russell Birdwell, June 26, 1942.
224 "not getting proper rest": Dale Anderson, interoffice memo to Russell Birdwell, July 23, 1942.
225 Meyer had testified at Flynn's 1934 statutory rape trial: Frederick Othman, "Back on His Hollywood Beat," *Hollywood Citizen-News*, July 29. 1947. All other details about Meyer from Howard Hughes FBI files, obtained via the Freedom of Information Act.
225 "some of us called it pimping": Rossi, "Terry Moore: The Ermine Sex Bomb Grows Up."

226 "Hughes didn't like just one woman": Walter Kane interviewed by Raymond Fowler, June 19, 1978.
226 "One could die from boredom": Russell, *My Path*, 65.
228 "Hughes was introduced to Rita Hayworth": Parsons, "Film Planned on Life of Souza."
228 Hughes and Lana Turner were spotted: Parsons, "Nelson Eddy to Get New Singing Partner"; Parsons, "Rosalind Russell Cast in Amelia Earhart Role."
228 "pursuit of Lana Turner": Kilgallen, "The Voice of Broadway" June 5, 1942.
229 "we hate to hurt Miss Dorn": Parsons, "Irene, Famed Hollywood Stylist, Quits Private Business to Design for MGM."
229 "is a closed chapter now": Parsons, "Ann Sheridan Gets Nora Bayes Role."

CHAPTER 15: DIVORCE, MARRIAGE, AND RAPE FANTASY
232 "Nothing was ever an accident with Howard": Evans, *Ava Gardner*, 187.
233 "The little runt couldn't satisfy her": Server, *Ava Gardner*, 85.
233 "checking out girls": Evans, *Ava Gardner*, 189.
233 "where all the bodies are buried": Ibid., 251.
233 "Best advice about Howard": Ibid., 189.
234 "I couldn't get rid of him": Grobel, *Conversations with Ava Gardner*, Kindle locs. 1255–1257.
234 "hated dancing with him": Ibid., locs. 1586–87.
234 "as beautiful and perfect": Ibid., locs. 1546–47.
234 "Wait the year": Evans, *Ava Gardner*, 194.
235 "some idiot": Russell, *My Path*, 69.
235 Jane "was getting impatient": Memo from "Mr. McCall" to "Mr. Birdwell," November 11, 1942.
236 "Production is inadequate": Memo from "Mr. McCall" to "Mr. Birdwell," December 7, 1942.
236 Birdwell's inaccurate insinuations: May Mann, "Going Hollywood," February 15, 1943; Louella Parsons's syndicated column, February 8, 1943.
236 "the papers crucified us": Russell, *My Path*, 71.
236 "cinematic trash": Fidler, "News and Views of Hollywood," February 13, 1951.
237 "rolling in good faith": Fidler, "Jane Russell Is Just a Victim of Hard Luck."
237 "many a bad picture": "Cinema: Hughes' Western."
237 "like Shirley Temple": Russell, *My Path*, 72.
238 placate the Legion of Decency: Production Code Memo, March 4, 1943.
238 "bosomy western": Albert Gerber interviewed by Louis Lomax, November 26, 1967.
240 "Hughes is exploiting you": Russell, *My Path*, 73.
241 "I was his obsession": Ibid., 50.
241 "dying of unhappiness": Russell, "I Was Sold."
241 "I didn't feel like admitting": Russell, "I Have Faith in People."
242 "the more I felt trapped": Domergue manuscript.
243 "My quarrel was with him": Ibid.
244 "I don't want to be with you": Ibid.
244 "the very first amphibian": Petrali, "O.K., Howard, Part I."
245 "Faith, I'm all right": Domergue manuscript.
245 "I just killed a couple of my guys,": Evans, *Ava Gardner*, 191.
246 "Mental injuries": Petrali, "O.K., Howard, Part I."
246 "proposing to me" Evans, *Ava Gardner*, 247.

CHAPTER 16: DISAPPEARING ACT

247 "in the powder room": Evans, *Ava Gardner*, 249.

247 "I don't drink, kid": Ibid., 249–50.

248 "I went out with Mickey": Grobel, *Conversations with Ava Gardner*, loc. 1276.

248 "I looked for some weapon": Ibid., locs. 1277–81.

248 "real blood in the bloody Marys": Evans, *Ava Gardner*, 252.

249 "If she could have sold me": Grobel, *Conversations with Ava Gardner*, loc. 1557.

249 "Slaves": Curtis, *Between Flops: A Biography of Preston Sturges*, Kindle loc. 4748.

249 "one man in whom I have complete confidence": Ibid., loc. 4425.

251 "Howard couldn't wrestle her down": Petrali, "O.K., Howard, Part I."

253 "I blame myself": Rupert Hughes to Frances McLain Smith, quoted in Finstad.

253 Mocambo: Carroll, "Behind the Scenes in Hollywood," June 11, 1945.

253 Jack March: Kilgallen, "The Voice of Broadway."

253 Kurt Kreuger: Scott, "Candidly Hollywood."

253 "new Mexican beau": Carroll, "Behind the Scenes in Hollywood," July 16, 1945.

254 "lanky, underfed": De Carlo, *Yvonne*, 104.

254 "terrific boyfriend": DeCarlo, interview with Larry King, January 20, 2002.

254 "the go bye": Ibid.

255 "Lana Turner didn't last": Evans, *Ava Gardner*, 252.

255 "marriage vs. career": Walker, "Amos and Andy Now Reach Top Rating."

258 "hell of a time": Letter from Darryl F. Zanuck to Joseph Breen, April 2, 1946.

258 terminating his membership: MPA letter to Howard Hughes, April 9, 1946.

258 "Hays office has no right": Questionnaire answered by Hughes for *Editor & Publisher* magazine.

259 "additional publicity": "Highlights from Judge Bright's Opinion Re: *The Outlaw*," MPA press release, no date.

259 "violating a city ordinance": "Theater Manager, 'Outlaw' Film Held."

259 "hissed indignantly": "Women Hiss as *Outlaw* Declared Clean."

259 "censors may not like it": *Outlaw* print ad.

260 "The world must be repopulated": press release from Russell Birdwell and Associates, exclusive to United Press, May 2, 1946.

261 "Had *The Outlaw* dealt with a great social wrong": Sammis, "The Case Against *The Outlaw*."

CHAPTER 17: AN AMERICAN HERO

262 "fell in love for the first time": "The Jean Peters Mystery."

262 "Sunday he came back": Elizabeth Jean Hough (Jean Peters) deposition, January 23, 1984.

263 "slightly deaf, handsome bachelor": "Howard Hughes Critical: Millionaire Flyer Given 50-50 Chance, Plane Hits 4 Houses in Beverly Hills."

264 "near death": "Howard Hughes Near Death as Latest Plane Creation Wipes Out Three Houses in Maiden Flight."

264 "fighting chance": "Howard Hughes Given Fighting Chance to Live as Plane He Is Flying Crashes."

264 he called his secretary in: "Hughes Still Critical, but Holds Parleys."

264 "amazing revelation": "Hughes' Lung Fails, Condition Worse."

264 "greatly upset and weeping": "Pneumonia Hughes Peril; Lana Turner Keeps Night Vigil."

265 "a kind of personal G-2": Wickware, "Howard Hughes."

266 "loneliest guy in the world": Ibid.
266 "best matrimonial catch": Shearer, "Howard Hughes: Hollywood Outlaw."
267 low-cut purple skirt suit: "Hughes Faces Operation."
267 Darnell's move to end her marriage: "Linda Darnell to Seek Divorce."
268 Hedda Hopper took the bait: "Looking at Hollywood."
268 "sex on a piece of film": Steinem, *Marilyn: Norma Jeane*, Kindle locs. 396–97.
268 pairing Marilyn with her grandmother's maiden name: "For Norma Jeane a New Name."
269 "won't be more than five minutes": "The Jean Peters Mystery."
269 he demanded that someone track down Jean: Ibid.
269 "Mr. Big took an extra puff": "Stop Train! Films Calling Jean Peters."
270 "turned me off": Davis, *Hollywood Beauty: Linda Darnell and the American Dream*, 94.
271 "straight to hell": Ibid.
271 "dinner with him practically every night": Jean Peters Hough deposition, January 10, 1979.
271 "He felt he was trapped": Ibid.
272 "I have got to make sure that you are protected": Ibid.
272 "I am very tired": "Howard Hughes Flies East for Film Battle."
272 "Ronald Colmanesque": Ibid.
272 $607,000: *Daily Variety*, December 20, 1946.
272 "most popular picture of all time": full-page ad in *Variety*, November 6, 1947.
273 nearly $200 million in government subsidies: Fadiman Jr., "Can the Real Howard Hughes . . ."
273 "favors they may have bestowed on Hughes' male guests": Wilson, "Says Krug at Hughes' Shindig."
274 "an unstable person": Howard Hughes FBI files, obtained via Freedom of Information Act.
274 "resting somewhere out of town": "Gay Hughes Parties Told by Actress."
275 "went missing": Ibid.
275 "Don't build that up": Wilson, "Says Krug at Hughes' Shindig."
275 "no falsies": Wilson, "Judy Cook Shows Sketchings."
275 "pretty mean of the government": Wilson, "Says Krug at Hughes' Shindig."
275 entertainment expenses on his tax returns: Ibid.
275 Hughes held a press conference: "Hughes Tells 'Em Off."
276 " shelved the beautiful party girl angles": Rogers, "Kaiser Angrily Charges 'Brush-off' at Plane Quiz."
276 "Hollywood playboy and planemaker": "The Congress: Duel under the Klieg Lights."
277 a list of dozens of things that he demanded Senator Brewster answer: Ibid.
277 "capricious, a playboy, eccentric": Ibid.
277 "too cowardly": "Senators Suddenly Drop Hughes Probe; Other Business Held Reason," August 11, 1947.
277 an allegation from Major General Bennett E. Meyers: Rogers, "Gen. Meyers $1 Million Idea to Get 'Security for Rest of Life' Told."
278 "put a hex": Francis, "General Asks $200,000 Loan, Hughes Testifies."
278 three bottles of 1918 bourbon: handwritten note to "Benny" Meyers in Howard Hughes files, TSA.
278 Congress issued a statement: "Text of Minority Report on Howard Hughes Investigation," May 17, 1948.
278 "It was spectacular": Hill, "No-Man in the Land of Yes-Men."
278 "a no-man in the land of yes-men": Ibid.

278 "You'd Think He Was a Movie Star": "Jubilant Hughes Hops Off for Home; Ready to Resume Fight in November."

279 "we'll get it in the neck": Wickware.

CHAPTER 18: A MOGUL AND HIS CROWS

280 "We all thought Howard was going to die": Parla and Mitchell, "Faith Domergue," 62.

281 "Howard demanded that I get rid of him": Preston Sturges and Sandy Sturges, *Preston Sturges by Preston Sturges: His Life in Words*, 305.

281 "It doesn't really matter": Curtis, *Between Flops*, Kindle locs. 4831–32.

281 "he was sore at Hughes": Mate and McGilligan, "W. R. Burnett: The Outsider," 62.

281 "This went on": Weaver, "Faith Domergue," 31.

282 "totally lost the enthusiasm": Parla and Mitchell, "Faith Domergue," 33.

283 net profit of $5,085,848: Jewell, *Slow Fade to Black: The Decline of RKO Radio Pictures*, 77.

284 "I advised Odlum that I would quit": Schary, "I Remember Hughes."

284 "I'm not a picture man": Dore Schary Oral History, 1958.

284 *"nothing* means more to me": "To the Men and Women of Hughes Aircraft Company," letter signed by Howard Hughes, no date.

284 124 movie theaters: Fadiman Jr., "Can the Real Howard Hughes . . ."

285 grossed $300,000 in its first weekend: "*Outlaw* gets 300G in 21 Spots," January 3, 1950.

286 "your experience as an executive": Howard Hughes deposition, October 14, 1953.

286 "Hughes simply touched my hand": Schary, "I Remember Hughes."

286 "get yourself a messenger boy": Dore Schary Oral History, 1958.

287 "I was quitting": Schary, "I Remember Hughes."

287 "Managing Director-Production": Jewell, *Slow Fade to Black*, 100.

287 gossip queens Louella or Hedda were trying to reach him: Barlett and Steele, *Howard Hughes: His Life and Madness*, loc. 4516.

288 "six-month option girls": Turner, *Lana: The Lady, the Legend, the Truth*, 29.

288 Hughes was very specific about the kinds of images: Collis, "The Hughes Legacy: Scramble for the Billions."

289 "stand by from 2:30 PM on Sun": Christy-Sheppard call log.

289 a girl who had won a fishing contest: Mathison, "Howard Hughes: Cradle-Robbing Baron."

290 most beautiful girl he had seen since Billie Dove: Ibid.

290 "fingers fat and fleshy": Jack Shalitt, "Reminders" memo, April 21, 1954.

290 dinner out, usually at Perino's: Fadiman Jr., "Can the Real Howard Hughes . . ."

291 "I'm not one to kick fate in the teeth": Parsons, "In Hollywood with Louella O. Parsons."

292 "a man doesn't get to be my age": "The Jean Peters Mystery."

293 "I was sure it would never happen": Graham, "Chasing Howard Hughes."

293 better known as Carole Landis: "Casualty in Hollywood."

293 "studio hooker": Mosley, *Zanuck: The Rise and Fall of Hollywood's Last Tycoon*, 176.

294 "a splendid affair": "Casualty in Hollywood."

294 "He'll die at the hands of a woman with a .38": "The Mechanical Man."

294 "part of Meyer's job to see that the green light is up": Ibid.

CHAPTER 19: MARRIAGE, HOWARD HUGHES–STYLE

299 Lynn Baggett had the right look: Laurents, *Original Story By*, 140–45.

301 "Geddes had no drawing value": Howard Hughes deposition, October 14, 1953.

301 Hughes didn't think Geddes was sexy enough: Numerous obituaries, including: Halley, "'Dallas' Actress Barbara Bel Geddes Dies"; Nelson, "Barbara Bel Geddes, 82; Star of Stage, Screen and 'Dallas.'"

301 "felt Barbara was totally unforgivable for doing that role": "Broadway Role as Lover of Black Soldier Got TV's Miss Ellie in Trouble."

302 scarlet fever: Vieira, *Into the Dark: The Hidden World of Film Noir, 1941–1950*, Kindle loc. 3451.

303 "untouched": Thomson, *Showman*, 317.

303 "the first 'natural' actress": Ingrid Bergman and Alan Burgess, *Ingrid Bergman, My Story*, 91.

304 "Lo ti amo": Garrison, "The Bergman Story."

304 "probably subconsciously": Bergman and Burgess, *Ingrid Bergman, My Story*, 257.

304 "I've just bought a film studio for you": Ibid., 246.

305 budget of $600,000: Garrison, "The Bergman Story."

305 "bewildered and confused": St. Johns, *Love, Laughter and Tears*, 276.

305 "box-office value ruined": Johnson, *Miracles and Sacrilege: Robert Rossellini, the Church, and Film Censorship in Hollywood*, 265.

306 "[g]ive Ingrid a break": Steele, *Ingrid Bergman: An Intimate Portrait*, 259–61.

308 "There aren't many girls": Moore, *The Beauty and the Billionaire*, 18.

308 "There is only one thing I lie about": Terry Moore deposition, June 11, 1979.

309 "It was terrifying.": Collis, "The Hughes Legacy."

309 "my life in Glendale": Ibid.

309 "He raised me": Ibid.

309 "Helen has you": Terry Moore deposition, April 23, 1977.

310 "We would go bowling": Ibid.

310 some of Howard and Terry's dates: Mathison, "Howard Hughes: Cradle-Robbing Baron."

310 "his image would hurt mine": Terry Moore deposition, June 11, 1979.

310 "big stars": Ibid.

311 "He lied a lot": Ibid.

311 "to go to bed with him": Ibid.

311 "to feel *legally* married": Ibid.

312 "We are going to do it your way": Ibid.

312 didn't want anyone to know they were married: Ibid.

312 gave her a string of pearls and a diamond brooch: Terry Moore deposition, April 23, 1977.

312 "we marry for all time and eternity": Terry Moore deposition, June 11, 1979.

312 "There's a lot of Italian in it": "Ingrid's Film *Stromboli* Proves Flop at Preview."

313 the priest believed was a too-cute reference: Father Félix Morlión to Howard Hughes, January 26, 1950.

313 "prohibit the showing of the film *Stromboli*": Letter to Eric Johnston, February 5, 1950.

314 "add no fuel to the fire": Gordon S. White, memo to "Mr. Johnston," February 27, 1950.

314 "They are vulgar." Schary, "I Remember Hughes."

314 Catholic Legion of Decency declared *Stromboli* "acceptable": "Hollywood Calls 'Stromboli' a Gold Mine Despite Bans."

314 "evening business was at capacity": "Stromboli Erupts Over US: Smash Biz Reported In Many Spots."

314 grossed more than $1.2 million,: "Stromboli First Weekend Reported at $1,248,000."
314 "doing better than *The Outlaw*": "Stromboli Opens Strong in Controversial Storm."
315 "pornographic": "Rossellini Renounces RKO'd *Stromboli*."
315 "disgusting publicity campaign": "Movie Morals: Whose Business?"
315 "immoral acts": Ibid.
315 "commissar of Hollywood's morals": Ibid.
316 Italian beauty named Gina Lollobrigida: Garrison, "Refusal to Marry Hughes Revealed by Italian Beauty."
316 "I went alone": Reginato, "Gina Lollobrigida Breaks the Silence on Her Outrageous Tabloid Scandals."
316 "All I saw was Howard Hughes": Garrison, "Refusal to Marry Hughes Revealed by Italian Beauty."
317 "a fast, brilliant career": Schuyler, "The Girl Who Said No to Howard Hughes."
317 Hughes brought De Sica from Rome to Hollywood: "De Sica Due on Coast for Huddles with Hughes."
317 "like a prostitute": Cardullo, *Vittorio De Sica: Actor, Director, Auteur*, 199.

CHAPTER 20: "MOTHER" AND A MALE IDOL

318 "movie-starrish like mad": Hall, "'I Have Made Myself an Ugly Girl!' Says Ida Lupino."
318 "become a real actress": Hedda Hopper interviewing Ida Lupino, May 25, 1965.
318 "such a wretchedly unhappy little painted doll": Hall, "'I Have Made Myself an Ugly Girl!'"
319 "a coy thing lounging in a boat": Hill, "Hollywood's Beautiful Bulldozer."
321 put out a number of press releases: 20th Century Fox, press releases, 1948.
321 "that louse": Donati, *Ida Lupino: A Biography*, 141.
322 "would leave the United States": Ida Lupino FBI file.
323 "extreme caution": Ibid.
323 The FBI recommended: Ibid.
325 "pictures about ordinary people": Thomas, "In Hollywood . . ."
325 a drama about unwed mothers: Ibid.
325 "without being too messagey": Weiner, "Interview with Ida Lupino."
325 what she'd later call a "crusader": Varney, "Ida Lupino, Director."
326 "Darlings, Mother has a problem": Lupino, "Me, Mother Directress."
326 "Hollywood was succumbed": *Hollywood Citizen-News*, March 8, 1950.
327 "he liked her": Sally Forrest, interview, May 22, 1985.
328 "on whom Hollywood won't take a chance": Heffernan, "Ida Lupino Clicks."
328 full-color spread in *Life* magazine: Berg, "Star Under Wraps."
328 "'Dough-merg'": Johnson, "Erskine Johnson (Column)."
329 "OK, good-bye, Faith": Parla and Mitchell, "Faith Domergue," 66.
329 "a garrulous, slow and obvious period piece": "At the Globe," December 26, 1950.
329 "the most extravagant star-making venture": "Cinema: The New Pictures," January 22, 1951.
330 "without the power of him": Domergue manuscript.
332 "who should walk in but Mitchum": Server, *Baby I Don't Care*, 169.
332 Mitchum's sister Julie believed: Ibid., 180.
332 "He could still be cured": Ibid., 170.
333 "He had spies everywhere": Ibid., 185.
334 "two greatest chests": Ibid., 209.

334 "the best picture I've ever made": Parsons, "In Hollywood with Louella O. Parsons," April 8, 1951.

338 "beautiful girl with no talent": Russell, *My Path*, 118.

338 "acted like natural people": Russell, "*TCM Private Screenings Uncut*: Robert Mitchum and Jane Russell."

339 "half a dozen clowns": Baxter, *Von Sternberg*, 244.

339 "The fit of the dress around her breasts is not good": Server, *Baby I Don't Care*, 219.

340 "the greatest sexual powers in the entire world": Rossi, "Ermine Sex Bomb."

340 "don't give a shit": Server, *Baby I Don't Care*, 206.

CHAPTER 21: THE MORALS CLAUSE

341 "Jane Russell's favorite way to relax": *Los Angeles Times*, February 19, 1952.

341 a photo of a smiling Russell in sunglasses: *Los Angeles Times*, February 14, 1952.

341 "Jane Russell is doctoring a black eye": "Jane Russell's Black Eye Stirs Vegas Stories."

342 "we all know Waterfield hit you": Russell, *My Path*, 124.

342 "went off the wagon" Ibid.

343 insisted that *The Las Vegas Story* be completely rewritten: "Hughes Defies Film Writers."

344 The guild determined Jarrico should share screenplay credit: McCall Jr., "The Hughes-Jarrico Imbroglio."

344 Hughes issued a proclamation: "Hughes Defies Film Writers."

344 "only woman in the Directors Guild": Donati, *Ida Lupino*, 178.

346 *Outrage* received some rave reviews: Goodman, "Film Review: *Outrage*"; Williams, "*Outrage* Another Triumph."

346 "the story hits home": Duggan, "*Outrage* Wins Plaudits."

346 "its sordid theme of criminal attack": "*Outrage*," *Hollywood Reporter*, August 23, 1950.

346 "Over-directed": "*Outrage*," August 23, 1950.

347 $1,500: ALI to RKO correspondence.

347 Duff was accused: "Duff, Howard" report from American Library of Information.

348 Lupino went to New York to see Garfield: Donati, *Ida Lupino*, 182–85.

348 "innocent victims of the Communist problem": Carl Byoir and Associates, "Howard Hughes Statement on Studio Shutdown."

349 "most potent product": Stevens, "Reeling Round . . . Hollywood."

349 Representative Donald Jackson of HUAC praised Hughes: "Rep. Jackson Urges Hollywood to Regain Public Confidence."

349 "forces of subversion must be wiped out": Critchlow, *When Hollywood Was Right*, loc. 3064.

349 "If the Screen Writers Guild calls a strike": "Hughes' Defiance."

349 "dickering with the war department": Fidler, KMPC Radio.

350 "capable of murder": FBI internal memo, January 7, 1952.

351 "RKO was so peculiar": Sally Forrest, interview.

351 "heckle Mitch": Hopper, "Hedda Hopper's Hollywood," April 19, 1952.

351 "Two Men in Russell's Life": Torre, "Two Men in Russell's Life."

351 "box office slump": "Short Subjects," August 11, 1952.

352 $1,250,000: Schallert, "RKO Studio Sold."

352 "use of marijuana": "Jarrico Counters with Suit Against RKO for $350,000."

353 "I did think his morality was pertinent": Ceplair, *The Marxist and the Movies*, Kindle loc. 5421.

353 Hughes's lawyer loudly objected: "Court Cuts Jarrico's Claims Against RKO as Hughes Testifies."

353 "public disgrace": Ceplair, *The Marxist and the Movies*, 128.

354 Stolkin and crew had, among other things: Jewell, *Slow Fade to Black*, 144.

354 "a mass of unfavorable publicity": Jewell, *Slow Fade to Black*, 164.

354 assumed the position of chairman: Ibid., 149.

356 "too much alcohol in the air": Donati, *Ida Lupino*, 206.

356 "one fatal mistake": Lupino, "Me, Mother Directress."

CHAPTER 22: RIVALRY AT FOX

358 "I'm very, very busy": Moore, *Beauty and the Billionaire*, 92.

358 "brainwashed": Ibid., 97.

359 married on February 9, 1951: Ibid., 102–5.

360 "We made love": Ibid., 112.

360 "pummeled Hughes into unconsciousness": Mathison, "Cradle-Robbing Baron."

361 "suffered several broken ribs": Carson, "Memorandum for the Director." Howard Hughes FBI file.

361 "room service": Terry Moore, interviewed by Raymond Fowler, May 17, 1978.

361 "as soon as the weather clears": Mathison, "Cradle-Robbing Baron."

363 "sleeps in a short nightgown": Skolsky, "Hollywood Is My Beat: Tintypes," March 11, 1948.

364 "not particularly chic": Graham, "Chasing Howard Hughes."

364 "a svelte, grown-up beauty": Scott, "Change to Svelte Becomes Jean Peters."

364 "kissable lips": "Her Lips 'Most Kissable' in Filmland, Says Artist," *Los Angeles Examiner*, March 6, 1952.

364 "She's a tomboy": Skolsky, "Hollywood Is My Beat: Tintype," February 28, 1952.

365 "iron curtain": Hopper, "Hollywood's Mystery Girl."

367 "gams you get from streetwalking": Fuller, *A Third Face*, 300–1.

367 "small Jeep": Ibid., 303.

369 "sexwagon": "Anyone Here for Love?"

369 "sex has been overworked": Thomas, "Jean Peters Gets Sexy Role."

369 "breathing heavily": "Anyone Here for Love?"

370 Peters's "chauffeur" was Howard Hughes: Fuller, *A Third Face*, 301–2.

371 "All hell broke loose": Graham, "Chasing Howard Hughes."

371 she and Hughes were planning to marry: Fidler, "Views of Hollywood."

373 "alligator's love call": Kazan, *Elia Kazan: A Life*, 479.

373 "pretty far along": Terry Moore deposition, June 27, 1979.

373 her child had died: Ibid.

373 "He didn't want a child": "Actress Says She Had Howard Hughes' Baby."

374 "Any studio understands that": "Transcript of Telephone Conversations of Terry Moore and Howard R. Hughes Jr., Obtained in Deposition Proceedings on June 11, 1979."

374 "He could lie better than anyone": "Howard Hughes Kept Scores of Secrets," April 26, 1976.

374 Terry thought she could somehow use recordings: Terry Moore, interviewed by Raymond Fowler, May 17, 1978.

375 "She is enthusiastic": Skolsky, "Tintypes: Terry Moore."

375 A tabloid story: *Inside Magazine*, "Scandie Magazine" File, Box 93, University of Nevada Las Vegas Howard Hughes Files.

376 "I'm your wife!": Moore, *Beauty and the Billionaire*, 254.
376 "get away from Columbia": Glaser, "Terry Moore's Life, Loves on and off the Screen."
376 "Howard had control": Ibid.
377 "we'd both look in opposite directions": Ibid.

CHAPTER 23: "A MOVIE STUDIO FILLED WITH BEAUTIFUL GIRLS WHO DRAW PAY BUT SELDOM WORK"

379 "She went on a bender": "Hughes Starlet Tries to Kill Self."
379 "Hughes Starlet, Impatient to Be Star, Tries Death": "Hughes Starlet, Impatient to Be Star, Tries Death."
379 "waste of corporate funds": "Hughes Sued on His RKO Operations."
380 "fantastic sum": Torre, "Two Men in Russell's Life."
380 "furthering his personal interests": "Two Stockholders Ask RKO Receiver."
381 "first time I played Jane Russell": "Jane Russell May Break Association with Hughes."
381 was worth more than any contract: Howard Hughes deposition, Castleman lawsuit, October 14, 1953.
382 "could not and was not willing": Ibid.
383 "Project Baker": "Project Baker" report.
383 "excessive user of intoxicants": "Special Service Character Credit Report" on David Oliver Selznick, August 22, 1951.
383 "simply a matter of her cleavage": Mary Anita Loos, interview.
384 "Unless the Code is brought reasonably up to date": "More Liberal Movie Code Asked."
384 "Decent Entertainment Is the Best Entertainment": "8 Top Movie Producers OK Morality Code."
384 "bikinis were only worn": Russell, *My Path*, 145.
385 "go the full limit on cleavage": J. W. Grainger, memo to Howard Hughes, June 16, 1953.
385 "satisfactory under the provisions of the Production Code": Joseph Breen to Bill Feeder, August 18, 1953.
386 "many troublesome elements": "List of Unacceptable Items, *French Line*," November 18, 1953.
386 "a bosom peep-show effect": "Memorandum, January 13, 2:30 PM."
386 $25,000 fine: Joseph Breen, interoffice memo to Sidney Schreiber, December, 31, 1953; Breen to James R. Grainger at RKO, December 31, 1953.
386 sent another letter: Joseph Breen to Eric Johnston, January 6, 1954.
386 "many unacceptable breast shots": J. A. Vizzard, "Notes on Re-Review of *French Line*," January 14, 1954.
386 "completely unacceptable": Harry Zehner, "*French Line* notes," January 14, 1954.
386 "in consonance with the general principles of The Production Code": J. R. Grainger to Joseph Breen, January 20, 1954.
387 "crawl up out of the sewer": Jane Russell, interviewed by Hedda Hopper.
387 "just a can of tomatoes": Russell, "They Sold Me."
387 "stinking *Outlaw* publicity": Bacon, "Jane Russell Tells Big Publicity Build-Up."
387 "didn't know how to say no": Ibid.
387 "the costumes smaller": "Movie Review: Two Gals from Texas."
388 "I fought, I hollered": Bacon, "Jane Russell."
388 "I'll punch him": Ibid.
388 "holier-than-thou pose": "Who Does Jane Russell Think She's Kidding?"

388 "no place in Hollywood": "Actor Punched Her in the Nose, Dancer Tells Court."

389 "omits entirely the objectionable patter": "Memo for the Files Re: *The French Line* (RKO Radio)," March 8, 1955.

389 seal of approval: MPA Certificate No. 16570, March 24, 1955.

389 divide his business into two distinct entities: Barlett and Steele, *Howard Hughes: His Life and Madness*, loc. 4417.

390 "beautiful girls who draw pay": "Suit Cites Hughes' Dimmed-Out Stars."

390 Hughes offered to buy out: "Hughes Coup."

391 "collecting a stable of beauties": "'I'll Take It All,' Hughes Tells the Stockholders."

391 "erase from his slate": Arneel, "Legalistics, Taxes."

391 "box-office appeal": "Jane Russell Not Wasted."

391 "the studio doesn't have any policy": Thomas, "RKO Film Studio Shutdown Looms."

392 "The RKO organization": Wilkerson, "Trade Views," September 28, 1954.

393 "He disliked her intensely": Linet, *Susan Hayward*, 126.

393 New Year's Eve 1953: Versions of this story appear in ibid., *Beauty and the Billionaire*, *Howard Hughes: The Untold Story*, and many other sources.

393 Howard's name popped up in the divorce proceedings: "Hughes News," February 26, 1954.

393 "Mr. Magic": "Thrown in Swimming Pool, Hurled Over Hedge, Says Miss Hayward."

394 "dissolv[ing] in laughter": Linet, *Susan Hayward*, 178.

394 sold more tickets: "The Top Box-Office Hits of 1956."

394 been diagnosed with cancer: Jackovich and Sennet, "The Children of John Wayne, Susan Hayward and Dick Powell."

CHAPTER 24: UNDERWATER

397 Jean left for Italy hoping: "The Jean Peters Story."

397 "It is very important to talk": Helen Koford (Terry Moore) call logs.

397 "Thunderbird Party": Call Sheet, November 20, 1953.

397 "compelling, unhappy quality": Lyons, "America's Richest Wife."

398 "How much Mr. Hughes had to do with this": Graham, "Chasing Howard Hughes."

398 "didn't spend much time together": Lyons, "America's Richest Wife."

398 "no secret to me": Hopper, "Love Stirs Vitality in Quiet Jean."

398 "I want to be with you": "The Jean Peters Story."

398 "alcoholic and suicidal": Terry Moore deposition, April 23, 1977.

398 "We're supposed to start shooting": "Jean Peters Missing on Eve of Film Role."

399 Kane felt like it was quite a tall order: Walter Kane, interviewed by Raymond Fowler.

399 Hughes billed Terry $15,000: Moore, *Beauty and the Billionaire*, 288.

399 "sphinx-like": "Always Carried a Torch, Says Ava."

400 "sue their asses off": Evans, *Ava Gardner*, 239.

401 "Wet decks": Ibid., 247.

401 "or the dumbest": Grobel, *Conversations with Ava Gardner*, loc. 1509.

401 seeing Hughes in Miami: Linet, *Susan Hayward*, 182.

402 "someone Howard Hughes didn't want to know he was there": Grobel, *Conversations with Ava Gardner*, loc. 1512.

402 "Without Howard": Ibid., locs. 1477–78.

402 "bitter Cinderella story": Laffel, "Joseph L. Mankiewicz," 195.

402 "an almost undecipherable note": "Probe Death of Ex-Actress Rose Stradner."

402 "Howard was a friend of his": Evans, *Ava Gardner*, 235–36.

403 "Ava just wasn't that good a dancer": Laffel, "Joseph L. Mankiewicz," 195.

403 an amalgam of Meyer and later Hughes aide Walter Kane: Geist and Burton, *Pictures Will Talk*, 243.
404 "put Gina Lollobrigida under contract": Ibid., 247.
404 Mankiewicz agreed: Ibid., 248.
405 "self-exploitative, bizarre": Shearer, "The Tragic Pattern of Sex Symbols."
405 "approval of advertising": Jane Russell, interviewed by Hedda Hopper, September 4, 1955.
406 "she couldn't do close-ups": Johnson, "In Hollywood: Jean Peters Falls Victim to L.A. Smog."
406 settling down on the East Coast: "Jean Peters Prefers East to Hollywood."
406 hiding out in Florida: Elizabeth Jean Hough deposition, January 23, 1984.
406 Cramer and Peters were divorcing: Parsons, "Jean Peters, Who Leaped to Stardom, Plans Divorce."
406 thirty-three days: "Jean Peters Ending 33-Day Marriage."
407 "cheapest way out": Lyons, "America's Richest Wife."
407 "I have had my belly full": Schary, "I Remember Hughes."
407 "knows more about corporate law": Sherman, "A Billionaire Fights the Mafia."
408 "It was a write-off": Mate and McGilligan, "W. R. Burnett: The Outsider," 62.
408 "to make money!": Jewell, *Slow Fade to Black*, 188.
408 sell the facilities to Desi Arnaz: Dixon, *Death of the Moguls*, 34.
409 "out with some of my girls": Gregson Bautzer deposition, October 24, 1978.
409 left the check behind: Walter Kane, interviewed by Raymond Fowler.

CHAPTER 25: PLAYACTING
413 Rumors swirled: Phillips, "Egotist's Peak."
413 wonder if Hughes was having a nervous breakdown: Walter Kane, interviewed by Raymond Fowler.
414 "Barbara Hilgenberg and Patte Dee": "Walter Kane" call log, April 31, 1956.
414 Others under careful watch: "Mike Conrad" call log.
415 "dial her number every (1) minute": "Peters, Jean" call log.
415 "I want her followed": "Yvonne Schubert" call log.
415 "Have someone go to the Ambassador right away": Ibid.
416 "a community-property state": Elizabeth Jean Hough deposition, January 23, 1984.
416 "replighted his troth": Graham, "Chasing Howard Hughes."
416 Cramer had his own ties to the CIA: Drosnin, *Citizen Hughes*, 65.
417 so she could then "corner" Howard: Walter Kane, interviewed by Raymond Fowler.
417 Kane also blamed Peters: Ibid.
418 all topics having to do with Howard Hughes: Finstad, *Heir Not Apparent*, 53.
418 "she had something on him": Noah Dietrich, interviewed by Terry Moore.
418 "to the Beverly Hills Hotel briefly": Elizabeth Jean Hough deposition, January 23, 1984.
418 "HRH will call you the minute he wakes up": "Peters, Jean" call log.
418 A "food checker": Howard Hughes, memo, "Special Instructions Regarding Food for Bungalow 10."
419 "advised immediately" when Jean ordered alcohol: "Peters, Jean" call log.
419 "some lovely flowers": "Yvonne Schubert" call logs.
420 "dark haired, heavy bosomed": Kistler, "I Caught Flies for Howard Hughes."
420 "They were allowed one ice cream cone a day": Ron Kistler deposition, August 20, 1977.
421 "consummate tit-men": Kistler, "I Caught Flies for Howard Hughes."

421 "other girls like her": Ron Kistler deposition, August 20, 1977.

421 "no hanky-panky": Kistler, "I Caught Flies for Howard Hughes."

422 "None of the starlets we escorted": Ibid.

422 Ralph Damon: Dietrich, *Hughes*, 251.

424 "I am not about to play doctor": Ibid. 292.

424 "our conversation was not being recorded": Ibid., 293.

CHAPTER 26: PRISONER

426 "kidnapped": "The Jean Peters Mystery."

426 "I CANT HELP IT": Ibid.

427 "No one in Hollywood saw her": Graham, "Chasing Howard Hughes."

427 "curiously withdrawn": Parsons, "In Hollywood with Louella O. Parsons."

427 By the end of 1957: Raymond Fowler, "Summary of Roy Edward Crawford's Deposition on June 2 and 3, 1977."

428 "She seemed to enjoy Hughes' company": Kistler, "I Caught Flies for Howard Hughes."

428 The projectionist would then call Operations: Ron Kistler deposition, August 20, 1977.

430 *Porgy and Bess*: Ibid.

430 "would have thought I was nuts": Kistler, "I Caught Flies for Howard Hughes."

431 "developed a very severe pain": "Bertrandez, Major" call log.

431 "Darling": Ibid.

431 "Love again, Howard": Ibid.

431 "When he talked with them on the phone": Kistler, "I Caught Flies for Howard Hughes."

432 "had become a nudist": Ron Kistler deposition, August 20, 1977.

432 "had on the same outfit": Kistler, "I Caught Flies for Howard Hughes."

433 "I wanted a house of my own": Elizabeth Jean Hough deposition, January 23, 1984.

433 "stalling her off": Ron Kistler deposition, August 20, 1977.

434 "effectiveness with Coldwater": "Kane, Walter" call log.

434 "impotent old slob": Drosnin, *Citizen Hughes*, 172.

434 Yvonne Schubert had "been terminated": "Yvonne Schubert" call logs.

435 "they were lying to me": "553Gs Asked for Promises."

435 $450 per week: Ibid.

435 an envelope of money: Lefkowitz, "Endowed by Hughes."

435 "had to have my dinner hour free": "They Must Have been Married Because They're Getting a Divorce!"

436 "constantly being watched": Ibid.

436 Gail Ganley sued Hughes: "553Gs Asked for Promises."

436 "He's out of business": Lefkowitz, "Endowed by Hughes."

436 $40,500: Raymond M. Holliday letter to Herbert Schwab, October 26, 1962.

436 a twin bed: Fowler, "A Brief History of Howard R. Hughes."

437 "very manipulative": Elizabeth Jean Hough deposition, January 23, 1984.

437 Howard was under twenty-four-hour-attendance: Jean Peters Hough deposition, January 6, 1978.

437 "small amounts of Empirin codeine.": Elizabeth Jean Hough deposition, January 23, 1984.

437 inject the drug with a hypodermic needle: Fowler, "A Brief History of Howard R. Hughes."

438 drop off multiple prescriptions: Fowler, "Summary of Roy Edward Crawford's deposition on June 2 and 3, 1977."

438 "virtual prisoner for years": "Divorce," *National Insider*, October 6, 1963.

438 "Life is too short": Elizabeth Jean Hough deposition, January 23, 1984.

438 "I heard them leave": Jean Peters Hough deposition, January 6, 1978.

438 "read it in the newspaper": Elizabeth Jean Hough deposition, January 23, 1984.

439 "I just didn't believe him": Ibid.

439 never saw one another in the flesh again: Elizabeth Peters Hough deposition, July 26, 1977.

CHAPTER 27: FROM VEGAS TO THE GRAVE

440 four years: "Records Show Hughes in Suite Four Years."

440 "$13 million": Sherman, "A Billionaire Fights the Mafia."

440 "goodies": Jack Real deposition, March 20, 1984.

441 "He would eat a spoonful": Phelan, "Scenes from the Hidden Year."

441 "trial period": Ibid.

441 "I was not going to live in a Las Vegas hotel": Elizabeth Jean Hough deposition, January 23, 1984.

441 "to one day have a ranch": Jean Peters Hough deposition, January 6, 1978.

441 "He sent me pictures of it": Elizabeth Jean Hough deposition, January 23, 1984.

443 "two or three days with her busy husband": Scott, "Weekends With Howard in Las Vegas."

443 "married and unmarried": Lyons, "America's Richest Wife."

443 "I've never recognized her": Ibid.

443 "Scott used the nom de plume D. L. Lyons": Brown and Broeske. *Howard Hughes: The Untold Story*, loc. 4616.

444 "more than anyone else in the world": Lyons, "America's Richest Wife."

444 "too much Empirin codeine": Elizabeth Jean Hough deposition, January 23, 1984.

444 "I would never get him out": Ibid.

444 "resolved privately between us": Lyons, "The Liberation of Mrs. Howard Hughes."

445 "everything but a happy marriage": Scott, "Mystery Shrouds Jean Peters."

445 "a check for $980,000,000": Wilson, "California Divorce Now Hope Without Hollering."

445 "irrevocable loss of my wife": Howard Hughes to Bob Maheu, in Fowler, "A Brief History of Howard R. Hughes."

445 Jean and Stan had appeared together: Scott, "Walter Scott's Personality Parade."

445 have photos taken of her in her dress: Lieber, "Academy Awards Photographs" memo, April 4, 1970.

446 "the former Jean Peters": *Los Angeles Times*, April 9, 1970.

446 "sink or swim": Rosenfeld, "Terry Moore: Life After Howard."

446 "bring her to the Bel Air Hotel": Terry Moore deposition, April 23, 1979.

446 Beverly Hills Hotel: Terry Moore, interviewed by Raymond Fowler, May 17, 1978.

446 "It was just personal": Terry Moore deposition, April 23, 1979.

446 "14 going on 24": Hughes Productions internal memo, May 5, 1970.

446 "I didn't feel that I was going any place": "Tell Me, Jean Peters," *Gambit*, 1972.

447 "no comment": Lyons, "Jean Peters: Howard Hughes' Ex-wife Speaks Out."

447 "only his death gave proof": Collis, "The Hughes Legacy."

447 "Paradise Island in the Bahamas": "Rambling Reporter."

447 "no return was required": "Answers of Jean Peters Hughes to the Twelve Written

Questions Propounded by Revenue Agent James Voelkel Under Date of March 24, 1971."

447 avoid paying personal income taxes: Drosnin, *Citizen Hughes*, 488.

448 "choking back laughter": Lyons, "The Liberation of Mrs. Howard Hughes."

448 "to prevent publication of this article": Ibid.

448 the Hughes-Peters divorce was finalized: Kriss, "Hughes Pact with Jean Peters Filed."

448 On the day of the call: Browning, "The Secret Drug Life of Howard Hughes."

449 "I am not going to continue being quite as reclusive": Howard Hughes, press conference, January 7, 1972.

449 "I haven't left the Bahamas": Ibid.

450 "getting him alive again": Raymond D. Fowler deposition, April 3, 1984.

450 "I'm too old for that": Breo, "Howard Hughes' Doctor Gives a Chilling Description of His Strange Patient's Final Hours."

450 *Ice Station Zebra*: Tinnin, "The Secret Life of Howard Hughes"; Jack Real deposition, March 20, 1984.

450 "a happy call": Bacon, "His Final Call Yearned for the Vegas Nights."

451 "Katharine Hepburn, Ginger Rogers and Terry Moore": Amory, "Status Quotes."

451 operating the projectors by remote control: "Films Were Hughes' Link with World, Doctor Says."

451 "a common cause of death": Sterba, "Cause of Hughes' Death Is Given as Kidney Failure."

451 possibly overdosed: Raymond Fowler, memo to Paul Smith, "Summary interpretation of Autopsy by James Miller, M.D.," June 8, 1978.

452 "We brought nothing into this world": Collis, "The Hughes Legacy."

EPILOGUE: LIFE AFTER DEATH

453 "Most Publicized": "Most Publicized of His Time: Tycoon a Ladies Man."

454 "immediate grounding by the FAA": Raymond Fowler to George Dean, October 18, 1979.

454 "incarcerated in a mental institution of his own making": "Hughes: Drug Addict, Psychotic."

454 "loners are very unhappy": "Hollywood Beauties Recall Hughes."

454 "I'm sorry and I'm sad": "Hughes Women Silent."

455 "his monument to his life's work": Jean Peters Hough deposition, January 10, 1979.

455 "unknown heirs": Finstad, *Heir Not Apparent*, 15.

457 a rare condition called scleroderma: "Terry Moore's Life, Loves on and off the Screen."

457 "Howard raised me": "Hughes Connection?"

457 "mistaken chronology": "Marriage Claims Disputed."

457 "need for other women": "Howard Hughes Kept Scores of Secrets."

457 "marriages of record": "Actress, Claiming to Be Hughes Ex, Wants In on Will."

458 "a goddamned lie": Noah Dietrich deposition, December 29, 1977.

458 "Shoot her": Walter Kane, interviewed by Raymond Fowler.

458 Slatzer signed an affidavit: "Affidavit of Robert F. Slatzer," April 20, 1977.

458 a bankrupt Sturges had been forced to auction off: Sturges, *Preston Sturges by Preston Sturges*, 325.

459 passed the test: Terry Moore deposition, June 27, 1979; Stewart, "Chris Gugas, 86"; "Picks and Pans Review: The Truth with Jack Anderson."

459 "Instructions Re: Terry Moore": Bautzer, "Hughes Death" document, revealed October 24, 1978.

459 "an obstacle to the administration of the estate": Terry Moore deposition, April 23, 1979.
459 "He said he would put something aside for me": Ibid.
460 "terrible on [remembering] dates": Terry Moore deposition, April 23, 1979.
460 "codeine and Tulenol": Terry Moore deposition, June 11, 1979.
460 "Why don't you let someone take care of you?": "Hughes' Voice on Tape?"
460 in the hands of the tabloid *Star*: Brennan, "Howard Hughes Shown as Troubled, Loving Man in Movie Star's Intimate Tapes."
461 "I'm actually heiress": Noah Dietrich, interviewed by Terry Moore.
462 "kept you off the screen for fifteen years": Ibid.
462 "he destroyed the evidence": "Estate of Hughes/Cameron et al. Tapes produced by Terry Moore. December 12, 1980. Tape No. 2" [transcript]; Terry Moore deposition, April 27, 1979.
462 "clearly inconsistent": "Texas Court Rejects Actress' Claim on Hughes Estate."
462 Texas Supreme Court: "Actress Moore Loses Bid for Hughes Estate Slice."
463 "I was legally married to him": Rossi.
463 "startling statements and legal documents": "Rambling Reporter," May 20, 1983.
463 "I've always loved him": McGraw, "Hughes' Heirs to Pay Actress."
464 "The family does not accept her claim": "My Astonishing Life as Howard Hughes' Wife—by Actress Terry Moore."
464 "substantially less than eight figures": "Actress Claims She Will Get Money as Hughes Widow."
464 "Terry Moore-Hughes": "A Star Is Reborn."
464 "And if I'm wrong": Swertlow, "Moore-ing Right Along."
465 "She's 50 and she's gorgeous": Rosenfeld, "Terry Moore: Life After Howard."
465 a flurry of projects to follow: "Mourning Becomes Electric."
465 "a born again celebrity": Green, "Hoping to Make a Comeback . . ."
465 "a court can accept Moore's 'marriage'": "Eternal Love?"
465 "cashing in on a dead man's fame": "Hate at First Sight Leads to a Tempestuous Secret Marriage."
465 "never to put anything in writing": "Howard Hughes Kept Scores of Secrets."
465 "I'm writing it as a novel": Christy, "Terry Moore."
466 "A flesh and blood man": Moore and Rivers, *The Passions of Howard Hughes*, 13.
466 "rubbed [it] over his crotch": Ibid., 153.
466 "less than ten seconds": Ibid., 261.
466 "continuing to stroke him": Ibid., 190–91.
467 "they were married anyway": Ibid., 103.
467 "and lick it off": Ibid., 72.
467 "unretouched": Martindale, "Terry Moore."
468 "I was his lawful widow": "The Merriest Widow."

INDEX

About the author

About the book

Insights,
Interviews
& More...

Meet
Karina Longworth

Emily Berl

KARINA LONGWORTH is the creator, writer, and host of *You Must Remember This*, a podcast on the secret and forgotten history of twentieth-century Hollywood. A former film editor at *LA Weekly* and critic for the *Village Voice*, she is the author of four previous books, including *Hollywood Frame by Frame* and *Meryl Streep: Anatomy of an Actor*. She lives in Los Angeles. ∾

A Conversation with Karina Longworth

Why Howard Hughes?

I was interested in Hughes as a kind of Trojan horse through which I could tell the stories of any number of the actresses, both famous and not, whose lives and careers were impacted by his interest in them. There are a lot of male film producers from the classical Hollywood era whose actress love interests could fill a book, but Hughes was a particularly interesting entry point because so much of his filmmaking output was defined by selling what he thought was sexy, and by engaging in fights with the censors over his right to sell it. These films and those fights, over time, helped to shape Hollywood's ideas about sexuality, and the culture at large. But ultimately, I don't see this as a biography of Howard Hughes—Hughes is merely the very useful common thread connecting these actresses and their experiences in navigating their era's ideas about female power, sexuality, and stardom. ▶

A Conversation with Karina Longworth
(continued)

What surprised you most in researching and writing Seduction?

My research revealed the extent to which so much of Hughes's persona (particularly within Hollywood) as a rebel who didn't care what anyone thought about him and as a man who couldn't and didn't lose was shaped by publicists whom Hughes himself hired. In fact, he was incredibly concerned with his image, and he spent enormous amounts of money and time hiring publicists and fixers, buying off journalists, and strategizing campaigns to make sure his persona was presented as he desired. That was the most surprising theme to emerge. But the most surprising single detail was the revelation in Ida Lupino's FBI file about her voluntary cooperation with the Hollywood blacklist.

How do you describe your approach as a historian?

My background is in film criticism and personal/experimental documentary. I think as a result of the former I'm always looking for factual details that provide context to my analysis of the movies themselves, and as a result of the latter I'm always looking for narrative

angles that I can relate to—I'm always trying to understand what it felt like to be a human in these situations, at that time in history. That's the big picture. In terms of day-to-day approach, I did an enormous amount of archival research over the course of almost two years, all the while arranging the material chronologically. From there, I spent many months chipping away at my notes and research until I found the story lines, and then did more reading and watched more movies to fill in any questions and gaps that remained.

You started writing Seduction *well before #MeToo and the Weinstein story broke, which makes it even clearer that abuse of male power has been around for a long time in Hollywood. How do you see* Seduction *fitting into the current cultural moment and discussion?*

Exploitation of actresses has been woven into the fabric of Hollywood for about a hundred years. From the beginning of the industry, though there have been women who had power behind the scenes, for the most part men were in charge in both the creative and the corporate aspects of the industry, the male gaze was the default point of view of movies, and young women ▶

A Conversation with Karina Longworth
(continued)

were considered an inexhaustible resource, which resulted in many men treating many individual women as though they were expendable. This was not Hollywood's secret underbelly—the "casting couch" and other ways of dehumanizing women were endemic to the way Hollywood business worked on a daily basis. Within a climate in which women were routinely asked to trade their bodies for the promise (and not necessarily the delivery) of career advancement, Howard Hughes was not a bad apple. He was a cruder and more extreme example of many of the studio moguls, whom he emulated, competed with, and tried to beat at their own game.

So much of written film history proceeds from the point of view that the men who held most of the power in the industry were worthy of worship, and that their bad behavior, including exploitative and demeaning and even abusive behavior, is part of what makes them fascinating. This is how Harvey Weinstein was written about for decades: He was admired not despite the fact that he was feared but because of it. I knew this was a problem when I began writing the book in 2015, if only because it's "boring." Well into the twenty-first century, we don't need more books from the perspective that powerful

men should automatically be deferred to, and I knew I could offer a different perspective. When I decided to use Howard Hughes as the entry point in order to talk about these actresses, I went into it with an open mind—I was not planning on writing a takedown of Hughes, per se. But details piled up that made it impossible for me to confer on him the deference that is usually given to "great men" of the film industry. Instead of lauding a man for being a "playboy," *Seduction* tries to flip around the gaze, and explain what it felt like to be pursued by Hughes, and then seduced into submitting to the various mechanizations of stardom.

All of that said, I don't like to make one-to-one equivalencies between the current state of Hollywood and the classical Hollywood era, because the studio system of the past was a completely different economic and operational beast than that of the entertainment landscape today. The very possibility of the open dialogue we're starting to have now would not have been possible for much of the twentieth century, for many reasons. Stardom before the 1960s was about creating perfect facades and never revealing any truth behind them that didn't fit the narrative. There was no such thing as Ronan Farrow–style ▶

A Conversation with Karina Longworth
(continued)

reporting about the movie industry
and the people who had power within
it (and the people who didn't) until
the 1950s, and then it was the exception
(such as Lillian Ross's reporting on
MGM that became her book *Picture*) and
not the rule. Studios (and independent
producers like Hughes) had absolute
control over many aspects of a contract
actress's life and, for the most part,
the journalists who wrote about
Hollywood traded independence
for access. This was more than one
generation ago—my book discusses
films made by Ronan Farrow's
grandfather—but, really, not that
much had changed in terms of
investigative reporting based on
women telling unfiltered accounts of
their stories until very, very recently.

How did you know this was a book and not a podcast season?

It did start out as podcast episodes—
I produced episodes about Jean
Harlow's, Jane Russell's, Ida Lupino's,
and Katharine Hepburn's relationships
with Hughes before I began working
on the book. But as much as I try
to thoroughly research episodes and
seasons of the podcast, in order to be
able to produce the show on anything

like a regular schedule, I don't have
time to get too far into the weeds—
I have to basically stick to previously
published sources like books and
articles. Approaching this as a book
gave me a longer time line to do the
research, which allowed me to travel
in order to find and write about many
primary sources, such as telegrams,
memos, depositions, unpublished notes,
and memoirs, etc. As a result, there's
information in the book about people
such as Lupino and Russell that wasn't
in the podcast episodes, or in any
published source that I could have
drawn from when I was making the
episodes. You could think of every
podcast episode as a sketch for a book
I may or may not eventually write. ◌

Reading Group Guide

1. The events in *Seduction* took place decades ago. Do you think the movie business has changed since then in terms of how women are treated?

2. Which of the characters in the book did you find most tragic? Why?

3. It is not unheard of to have to work with someone whose personal behavior might be considered abhorrent. Were those who worked with Hughes complicit even if they disapproved and stayed clear of his personal behavior?

4. Did learning what happened behind the scenes change your opinion of any of the movies and/or characters mentioned in the book?

5. Why do you think the author chose *Seduction* as the book's title?

Discover great authors, exclusive offers, and more at hc.com.